Video Demystified

A Handbook
for the
Digital Engineer
Second Edition

by Keith Jack

LLH
Technology Publishing

Eagle Rock, Virginia
www.LLH-Publishing.com

HARRIS
SEMICONDUCTOR

About the Author

Keith Jack has been the architect for numerous multimedia ICs for the PC and consumer markets, including the world's first single-chip NTSC/PAL digital encoder/decoder (Brooktree Corporation). Currently with Harris Semiconductor, he is now working on next-generation multimedia products.

Library of Congress Cataloging-in-Publication Data
Jack, Keith, 1955–
 Video demystified: a handbook for the digital engineer / Keith Jack.-2nd ed.
 p. cm.
 Includes bibliographical references and index.
 ISBN 1-878707-36-1 casebound
 ISBN 1-878707-23-X paperbound
 1. Digital televison. 2. Microcomputers. 3. Video recordings-Data processing. I. Title.
TK6678.J33 1996
621.388-dc20 96-076446
 CIP

Many of the products designated in this book are trademarked. Their use has been respected through appropriate capitalization and spelling.

Printed in the United States of America
1 0 9 8 7 6 5

Cover design: Sergio Villarreal
Developmental editing: Carol Lewis
Production: Lynn Edwards

ISBN: 1-878707-23-X (paperbound)
ISBN: 1-878707-36-1 (casebound)
Library of Congress catalog card number: 96-076446

Foreword

The foreword to the first edition of this book started with "Video on computers is a hot topic." If it was hot then, it is now white hot. The effect that multimedia products have had on the growth rate and pervasiveness of personal computer sales has been spectacular.

To effectively service the multimedia market, companies such as Harris Semiconductor need engineers who understand the analog and digital domains of audio and video, as well as the current and emerging compression standards. It is still a case of helping to "demystify video." Standard texts are still scarce, and the subject material highly dynamic.

Keith Jack is with Harris Semiconductor, helping to define our new multimedia products. In this second edition of *Video Demystified*, he has expanded the subject material considerably by covering MPEG and video conferencing, arguably two of the most recent important advances in multimedia technology.

The first edition became the standard reference for the video engineer. This second edition will be an essential addition for all multimedia and professional video engineers. We anticipate that the reader will find this new text immensely useful.

Geoff Phillips
Vice President, Multimedia Products
Harris Semiconductor

Acknowledgments

The development of an extensive work such as this requires a great deal of research and the cooperation and assistance of many individuals. It's impossible to list everyone who contributed, but I would like to acknowledge all those who provided technical assistance and advice, as well as moral support, and David Richards for the overscan test pattern.

Contents

Chapter 6 • *NTSC/PAL Digital Decoding* *197*

Chapter 7 • *Digital Composite Video* *257*

Chapter 8 • *4:2:2 Digital Component Video* *282*

Chapter 9 • *Video Processing* 330

Chapter 10 • *MPEG 1* 426

Introduction

A popular buzzword in the computer world is "convergence"—the intersection of various technologies that, until recently, were unrelated (see Figure 1.1). Video is a key element in the convergence phenomenon. Whether you call it multimedia, "PCTV," desktop video, digital video, or some other term, one thing is certain: we are now entering an era of digital video communications that will permeate both homes and businesses. Although technical hurdles still remain, most agree that the potential for this technology has few limits.

Implementing video on computers is not without its problems, and digital engineers working on these problems often have had little previous exposure to or knowledge of video. This book is a guide for those engineers charged with the task of understanding and implementing video features into next-generation computers. It concentrates both on system issues, such as getting video into and out of a computer environment, and video issues, such as video standards and new processing technologies.

This new edition of *Video Demystified* is accompanied by a CD-ROM, readable on both PCs and Macintosh computers. It contains numerous files to assist in testing and evaluating video systems. These files include still images at various resolutions, QuickTime movies, source code for MPEG, H.261, and H.263 encoders/decoders, and several software tools. These are described in Appendix F.

In addition, supplemental reference information is also found on the CD-ROM, keyed to the appropriate book chapter. When supplemental information is available for a particular chapter, this icon will alert you.

These files, in a PDF format, are found on the CD-ROM in a folder called "Goodies." They can be viewed using Adobe™Acrobat™ Reader. Files for the Reader (both Macintosh and Windows versions) can be found on the CD-ROM in a folder called "ACRO_V2."

Emphasis is placed on the unique requirements of the computer environment. The book can be used by system design engineers who need or want to learn video, VLSI design engineers who want to build video products, or anyone who wants to evaluate or simply know more about such systems.

Chapter 2 assumes the reader has a working knowledge of the design of computer graphics systems; although not necessary for the other chapters, it is helpful.

A glossary of video terms has been included for the user's reference. If you encounter an unfamiliar term, it likely will be defined in the glossary.

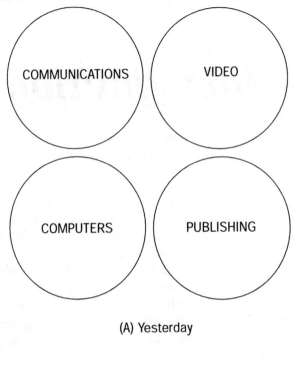

(A) Yesterday

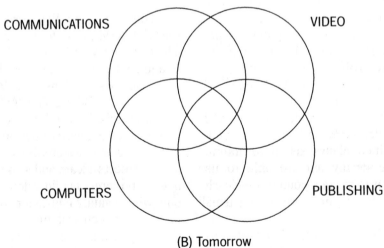

(B) Tomorrow

Figure 1.1. Technology Overlap of the Communications, Video, Computer, and Publishing Markets.

Some of the better-known applications for merging video and computers are listed below. At this point, everyone is still waiting for the broad-based application that will make video-in-a-computer a "must have" for users, similar to the spreadsheet and word processor.

Each of these applications requires real-time video decompression and possibly real-time compression. Some applications can use software compression and/or decompression, while others will require dedicated hardware for that function.

- *Video help windows.* Rather than the conventional text-only on-line help available from within applications, video help windows contain digitized audio and video, allowing moving images to be displayed. A user can see what to do, and see what the expected results will be, before actually executing a command.

- *Video notes within a document.* Video and audio can now be transferred within e-mail (electronic mail) or a document to another user. A "video note" can be included to clarify a point or just to say "Hi!" to your co-worker.

- *Video teleconferencing.* Video teleconferencing over a computer network or telephone lines allows users to interact more personally and be able to use visual aids to make a point more clearly. This application requires that a small video camera, speakers, and microphone be mounted within or near the display.

- *CD-ROM and network servers.* Digitized and compressed video and audio may be stored on CD-ROM or on a network server and later may be retrieved by any user and modified for inclusion within a presentation or document. With compression, it is possible to play back a compressed video over a network. However, performance is dependent on the number of users and network bandwidth. In some cases, it's acceptable to do a non–real-time download of the compressed video, and perform the decompression locally for viewing. CD-ROMs containing digital audio and video clips—similar to "clip art" files in desktop publishing—are now available. They include various types of audio and video for inclusion in presentations. Once the CD-ROM is purchased, the owner may have the right to use its contents whenever needed.

- *Video viewing.* This application allows one or more channels of television to be viewed, each with its own window. Users such as stock brokers would use this application to monitor business news while simultaneously using the computer to perform transactions and analysis. No compression or decompression is really required, just the ability to display live video in a window.

- *Video editing.* Some users want the ability to edit video on-line, essentially replacing multiple tape decks, mixers, special-effects boxes, and so on. This application requires up to three video windows, depending on the level of editing sophistication, and the highest video quality.

- *Video tutorials/interactive teaching.* Interactive video allows the user to learn at his or her own pace. Video tutorials allow on-line explanations, optionally in an interactive mode, of almost any topic from grammar to jet engines.

In addition to computers, audio/video compression and decompression technology has prompted new features and products in the consumer market:

- *Digital Video via Satellite (DBS)*. Several ventures now transmit compressed digital audio and video, offering up to 150 channels or more.

- *Digital Video via Cable*. Work is progressing on upgrading cable systems to handle up to 500 channels and various interactive requirements.

- *Digital Video via Phone*. Phone systems are being upgraded to handle digital video and interactivity, allowing them to compete with cable companies.

- *Digital VCRs*. VCRs that store digital audio and video on tape will be available in 1996.

- *Videophones*. Videophones are now available to the consumer.

- *Video CDs*. An entire movie can now be stored digitally on two CDs. With DVD, a 2-hour movie requires only a single CD.

An example of the impact of merging video and computers can be seen in the video editing environment, as shown in Figures 1.2 through 1.4. The analog solution, shown in Figure 1.2, uses two VCRs and an editing controller, which performs mixing, special effects, text overlays, etc. The output of the edit controller is stored using another VCR. Note that the two VCRs must be genlocked together. (Genlocking means getting the video signals to line up correctly—refer to Chapter 5 for more information on this topic.)

As computers can now generate video, they can be used to provide one of the video sources, as shown in Figure 1.3. Note that the video output of the computer must be able to be genlocked to the VCR. If not, a time base corrector for each video input source (which includes genlock capability) is required.

Advances in software now allow editing and special effects to be performed using the computer, offering the ideal video editing environment as shown in Figure 1.4. In this case, each video source is individually digitized, real-time compressed, and stored to disk. Any number of video sources may be supported, since they are processed one at a time and need not be genlocked together. Editing is done by decompressing only the frames of each video

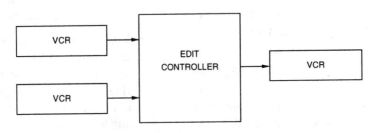

Figure 1.2. Analog Video Editing.

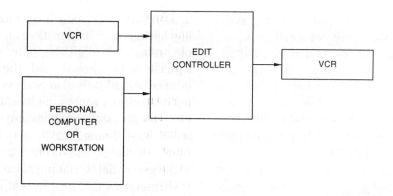

Figure 1.3. Video Editing with a Computer Providing a Video Source.

source required for the edit, performing the processing, compressing the result, and storing it back to the disk.

In addition to the standard consumer analog composite and Y/C (S-video) video formats, video editing products for the professional market should support several other video interfaces: digital composite video, digital component video, and the various analog YUV video formats. These formats are discussed in detail in later chapters.

The remainder of the book is organized as follows:

Chapter 2 discusses various *architectures for incorporating video* into a computer system, along with the advantages and disadvantages of each. Also reviewed is why scaling, interlaced/ noninterlaced conversion, and field rate conversion are required. A review of commercially available VLSI solutions for adding video capabilities to computers is presented (CD-ROM).

Chapter 3 reviews the common *color spaces*, how they are mathematically related, and when a specific color space is used. Color spaces reviewed include RGB, YUV, YIQ, YCbCr, YDbDr, HSI, HSV, HSL, and CMYK. Considerations for converting from a non-RGB to a RGB color space and gamma correction are discussed. A review of commercially available VLSI solutions for color space conversion is presented (CD-ROM).

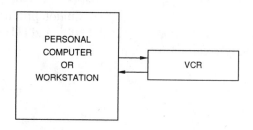

Figure 1.4. Video Editing Using the Computer.

Chapter 4 is an *overview of analog video* signals, serving as a crash course. The NTSC, PAL and SECAM composite analog video signal formats are reviewed. In addition, SuperN-TSC™ (a trademark of Faroudja Labs), the PALplus standard, and color bars are discussed.

Chapter 5 covers digital techniques used for the *encoding of NTSC and PAL* color video signals. Also reviewed are various video test signals, video encoding parameters, "clean encoding" options, timecoding, and closed captioning. Commercially available NTSC/PAL encoders are also reviewed (CD-ROM).

Chapter 6 discusses using digital techniques for the *decoding of NTSC and PAL* color video signals. Also reviewed are various luma/chroma (Y/C) separation techniques and their trade-offs. The brightness, contrast, saturation, and hue adjustments are presented, along with techniques for improving apparent resolution. Commercially available NTSC/PAL decoders are reviewed (CD-ROM).

Chapter 7 reviews the background development and applications for *composite digital video*, sometimes incorrectly referred to as D-2 or D-3 (which are really tape formats). This chapter reviews the digital encoding and decoding process, digital filtering considerations for bandwidth-limiting the video signals, video timing, handling of ancillary data (such as digital audio), and the parallel/serial interface and timing. It also discusses the SMPTE 224M and 259M standards. A review of commercially available VLSI solutions for digital composite video is presented (CD-ROM).

Chapter 8 discusses *4:2:2 digital component video*, sometimes incorrectly referred to as D-1 (which is really a tape format), providing background information on how the sample rates for digitizing the analog video signals were chosen and the international efforts behind it. It also reviews the encoding and decoding process, digital filtering considerations for bandwidth-limiting the video signals, video timing, handling of ancillary data (such as digital audio, line numbering, etc.), and the parallel/serial interface and timing. It also discusses the 4:4:4 format, and the 10-bit environment. The 4:4:4:4 (4 × 4) digital component video standard is also covered. A review of commercially available VLSI solutions for digital component video is presented (CD-ROM).

Chapter 9 covers several *video processing* requirements such as real-time scaling, deinterlacing, noninterlaced-to-interlaced conversion, field rate conversion (i.e., 72 Hz to 60 Hz), alpha mixing, and chroma keying.

Chapter 10 is a "crash course" on the *MPEG 1* standard and also compares MPEG with JPEG, motion JPEG, and H.261 compression standards.

Chapter 11 is a "crash course" on the *MPEG 2* standard.

Chapter 12 discusses *Video Teleconferencing*, over ISDN, covering H.320; H.261 (video); G.711, G.722, G.728 (audio); and H.221, H.230, H.231, H.233, H.242, and H.243 (control).

Chapter 13 covers *Video Teleconferencing* over normal phone lines, discussing H.263 (video).

Chapter 14 reviews the analog and digital "high-definition production standards" (SMPTE 240M, 260M, and ITU-R BT.709)

Video and the Computer Environment

In the early days of personal computers, televisions were used as the fundamental display device. It would have been relatively easy at that time to mix graphics and video within the computer. Many years later, here we are at the point (once again) of wanting to merge graphics and video. Unfortunately, however, the task is now much more difficult!

As personal computers became more sophisticated, higher resolution displays were developed. Now, 1280 × 1024 noninterlaced displays have become common, with 1600 × 1280 and higher resolutions now upon us. Refresh rates have increased to 75 Hz noninterlaced or higher.

However, in the video world, most video sources use an *interlaced* display format; each frame is scanned out as two fields that are separated temporally and offset spatially in the vertical direction. Although there are some variations, NTSC (the North American and Japanese video standard in common use) color composite video signals have a refresh rate of 60 Hz interlaced (actually 59.94 Hz), whereas PAL and SECAM (used in Europe and else-where) color composite video signals have a refresh rate of 50 Hz interlaced.

Digital component video and digital composite video were developed as alternate methods of transmitting, processing, and storing video digitally to preserve as much video quality as possible. The basic video timing parameters, however, remain much the same as their analog counterparts. Video and still image compression techniques have become feasible, allowing the digital storage of video and still images within a computer or on CD-ROM. Figure 2.1 illustrates one possible system-level block diagram showing many of the audio and video input and output capabilities now available to a system designer.

To incorporate video into a personal computer now requires several processing steps, with trade-offs on video quality, cost, and functionality. With the development of the graphical user interface (GUI), users expect video to be treated as any other source—displayed in a window that can be any size and positioned anywhere on the display. In most cases some type of video scaling is required. On the output

side, any portion of the display could be selected to be output to video, so scaling on this side is also required. Computer users want their displays to be noninterlaced to reduce fatigue due to refresh flicker, requiring interlaced-to-noninterlaced conversion (deinterlacing) on the video input side and noninterlaced-to-interlaced conversion on the video output side. The refresh rate difference between NTSC/PAL/SECAM video (50 or 60 Hz interlaced) and the computer display (60–80 Hz noninterlaced) must also be considered.

This chapter reviews some of the common architectures and problems for video input and output. (Of course, there are as many possible architectures as there are designers!)

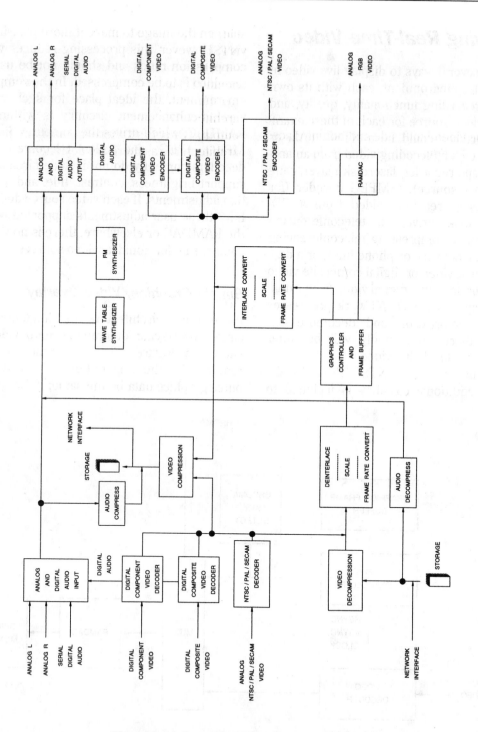

**Figure 2.1. Example of Computer Architecture
Illustrating Several Possible Video Input and Output Formats.**

Displaying Real-Time Video

There are several ways to display live video in the computer environment, each with its own trade-offs regarding functionality, quality, and cost. The video source for each of these example architectures could be a NTSC, PAL, or SECAM decoder (decoding video from an analog video tape recorder, laserdisk player, camera, or other source), a MPEG decoder (for decompressing real-time video from a CD-ROM or disk drive), a teleconferencing decoder (for decompressing teleconferencing video from a network or phone line), or a digital component video or digital composite video decoder (for decoding digital video from a digital video tape recorder). As work progresses on video compression and decompression solutions, there undoubtedly will be other future sources for digital video.

In many consumer NTSC/PAL/SECAM decoders, additional circuitry is included to sharpen the image to make it more pleasing to view. However, this processing reduces video compression ratios and should not be used if the video is to be compressed. In the computer environment, the ideal place for such video-viewing-enhancement circuitry is within the RAMDAC, which drives the computer display. MPEG, JPEG, and video teleconferencing decoders currently do not include circuitry to support brightness, contrast, hue, and saturation adjustments. If each video source does not have these user adjustments supported within the RAMDAC or elsewhere, there is no way to compensate for nonideal video sources.

Simple Graphics/Video Overlay

An example architecture for implementing simple overlaying of graphics onto video is shown in Figure 2.2. This implementation requires that the timing of the video and computer graphics data be the same; if the incom-

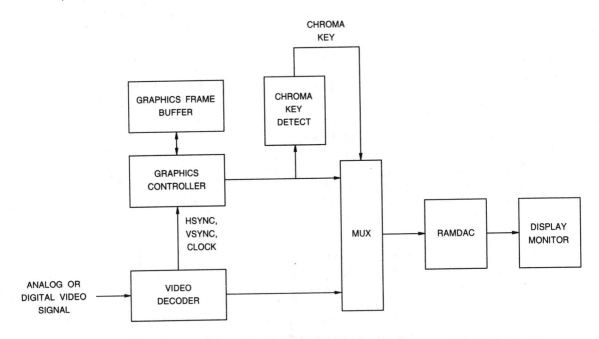

Figure 2.2. Example Architecture of Overlaying Graphics Onto Video (Digital Mixing).

ing video signal is 50 Hz or 60 Hz interlaced, the graphics controller must be able to operate at 50 Hz or 60 Hz interlaced. The display is also limited to a resolution of approximately 640 × 480 (NTSC) or 768 × 576 (PAL and SECAM); resolutions for other video formats will be different. Note that some computer display monitors may not support refresh rates this low. Timing can be synchronized by recovering the video timing signals (horizontal sync, vertical sync, and pixel clock) from the incoming video source and using them to control the video timing generated by the graphics controller. Note that the graphics controller must have the ability to accept external video timing signals—some low-end graphics controllers do not support this requirement.

A chroma key signal is used to switch between the video or graphics data. This signal is generated by detecting on a pixel-by-pixel basis a specific color (usually black) or pseudo-color index (usually the one for black) in the graphics frame buffer. While the specified chroma key is present, the incoming video is displayed; graphics information is displayed when the chroma key is not present. The RAMDAC processes the pixel data, performing gamma correction and generating analog RGB video signals to drive the computer display. If the computer system is using the pseudo-color pixel data format, the RAMDAC must also convert the pseudo-color indexes to 24-bit RGB digital data.

Software initially fills the graphics frame buffer with the reserved chroma key color. Subsequent writing to the frame buffer by the graphics processor or MPU changes the pixel values from the chroma key color to what is written. For pixels no longer containing the chroma key color, graphics data is now displayed, overlaid on top of the video data. This method works best with applications that allow a reserved color that will not be used by another application. A major benefit of this implementation is that no changes to the operating system are required.

Rather than reserving a color, an additional bit plane in the frame buffer may be used to generate the chroma key signal directly ("1" = display video, "0" = display graphics) on a pixel-by-pixel basis. Due to the additional bit plane, there may be software compatibility problems, which is why this is rarely done.

Note that the ability to adjust the gamma, brightness, contrast, hue, and saturation of the video independently of the graphics is required. Otherwise, any adjustments for video by the user will also affect the graphics.

Higher-end systems may use alpha mixing (discussed in Chapter 9) to merge the graphics and video information together. This requires the generation of an 8-bit alpha signal, either by the chroma key detection circuitry or from additional dedicated bit planes in the frame buffer. The multiplexer would be replaced with an alpha mixer, enabling soft switching between graphics and video. If the resulting mixed graphics and video signals are to be converted to NTSC/PAL/SECAM video signals, alpha mixing is very desirable for limiting the bandwidth of the resulting video signal.

A problem occurs if a pseudo-color graphics system is used. Either the true-color video data from the video decoder must be converted in real-time from true-color to pseudo-color (the color map must match that of the graphics system), or the pseudo-color graphics data must be converted to true-color before mixing with the video data and a true-color RAMDAC used. Because of this, low-cost systems may mix the graphics and video data in the analog domain, as shown in Figure 2.3.

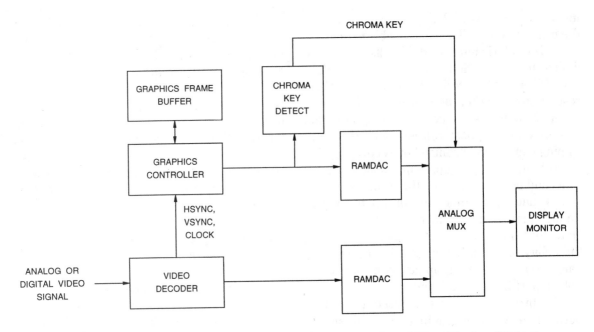

Figure 2.3. Example Architecture of Overlaying Graphics Onto Video (Analog Mixing).

Separate Graphics/Video Frame Buffers

This implementation (Figure 2.4) is more suitable to the standard computer environment, as the video is scaled to a window and displayed on a standard high-resolution monitor. The video frame buffer is typically the same size as the graphics frame buffer, and display data is output from both the video and graphics frame buffers synchronously at the same rate (i.e., about 135 Mpixels per second for a 1280×1024 display). This architecture is suited to the current graphical user interfaces (GUI) many systems now use. Switching between the video or graphics data may be done by a chroma key or alpha signal, as discussed in the previous example, or by a window-priority encoder that defines where the video window is located on the display (video is displayed inside the win-

dow and graphics is displayed outside the window). This architecture has the advantage that the graphics and video frame buffers may be independently modified.

The video frame buffer must be large enough to hold the largest video window size, whether it is a small window or the entire display. If a high-resolution display is used, the user may want the option of scaling up the video to have a more reasonable size window or even to use the entire display. Note that scaling video up by more than two times is usually not desirable due to the introduction of artifacts—a result of starting with such a bandwidth-limited video signal.

As the video source is probably interlaced, and the graphics display is noninterlaced, the video source should be converted from an interlaced format (25- or 30-Hz frame rate) to a noninterlaced format (50- or 60-Hz frame rate).

Figure 2.4. Example Architecture of Separate Graphics/Video Frame Buffers (Video Frame Buffer Size = Graphics Frame Buffer Size).

There are several ways of performing the deinterlacing. The designer must trade off video quality versus cost of implementation. Today's GUI environment also often requires scaling the video to an arbitrary-sized window; this also means a trade-off of video quality versus cost.

The video frame buffer is usually double-buffered to implement simple frame-rate conversion and eliminate "tearing" of the video picture, since the frame rate of the video source is not synchronized to the graphics display. After deinterlacing, the video will have a frame rate of 60 Hz (NTSC) or 50 Hz (PAL and SECAM) versus the 70–80 Hz frame rate of the graphics system. Ideally, the video source is frame-rate converted to generate a new frame rate that matches the computer display frame rate. In reality, frame-rate conversion is complex and expensive to implement, so most solutions simply store the video and redisplay the video frames at the computer display rate. The video frame therefore must be stored in a frame buffer to allow it to be displayed for multiple computer display frames.

Tearing occurs when a video picture is not from a single video frame, but rather is a portion of two separate frames. It is due to the updating of the video frame buffers not being synchronized to the graphics display. Switching between the video frame buffers must be done during the display vertical retrace interval only after the video frame buffer that is to be used to drive the display has been completely updated with new video information.

Alpha mixing (discussed in Chapter 9) may be used in some high-end systems to merge the graphics and video information together. An 8-bit alpha signal is generated, either by the chroma key detection circuitry or from additional dedicated bit planes in the frame buffer. An alpha mixer replaces the multiplexer, permitting soft switching between graphics and video. If the resulting mixed graphics and video signals are to be converted to NTSC/PAL/SECAM video signals, alpha mixing is very desirable for limiting the bandwidth of the resulting video signal.

If a pseudo-color graphics system is used, the pseudo-color graphics data must be converted to true-color before mixing with the video data, and a true-color RAMDAC used. Alternately, the true-color video data may be converted in real-time from true-color to pseudo-color (the color map must match that of the graphics system), although this is rarely done since it is difficult to do and affects the video color quality.

Two problems with this architecture are the cost of additional memory to implement the video frame buffer and the increase in bandwidth into the video frame buffer required when more than one video source is used. Table 2.1 illustrates some bandwidth requirements of various video sources. Due to the overhead of accessing the video frame buffer memory (such as the possible requirement of read–modify–write accesses rather than simple write-only accesses) these bandwidth numbers may need to be increased by two times in a real system. Additional bandwidth is required if the video source is scaled up; scaling the video source up to the full display size may require a bandwidth into the frame buffer of up to 300–400 Mbytes per second (assuming a 1280×1024 display resolution). Supporting more than one or two live video windows is difficult!

An "ideal" system would support multiple video streams by performing a "graceful degradation" in capabilities. For example, if the hardware can't support the number of full-featured video windows that the user wants, the windows could be made smaller or of reduced video quality. Note that the ability to adjust the gamma, brightness, contrast, hue, and satura-

Resolution		Bandwidth	
Total Resolution	Active Resolution	MBytes/sec (burst)	MBytes/sec (average)
ITU-R BT.601 (30 Frames per Second)			
QSIF	176×120	1.68	1.27
SIF	352×240	6.74	5.07
858×525	$720^1 \times 480$	27.0	20.74
ITU-R BT.601 (25 Frames per Second)			
QSIF	176×144	1.69	1.27
SIF	352×288	6.74	5.07
864×625	$720^1 \times 576$	27.0	20.74
Square Pixel (30 Frames per Second)			
QSIF	160×120	1.53	1.15
SIF	320×240	6.13	4.61
780×525	640×480	24.55	18.43
Square Pixel (25 Frames per Second)			
QSIF	192×144	1.84	1.38
SIF	384×288	7.36	5.53
944×625	768×576	29.5	22.12

Table 2.1. Bandwidths of Various Video Signals. Average column indicates entire frame time is used to transmit active video. 16-bit 4:2:2 YCbCr format assumed. Multiply these numbers by 1.5 if 24-bit RGB or YCbCr data is used. [1]704 true active pixels.

tion of the video independently of the graphics is required—otherwise, any adjustments for video by the user will also affect the graphics.

One variation on this architecture that solves the bandwidth problem into the video frame buffer allows each video input source to have its own video frame buffer. This approach, however, increases memory cost in direct proportion to the number of video sources to be supported.

A second variation, shown in Figure 2.5, is to scale the video down to a specific size (for example 320×240) prior to storing in the video frame buffer. This limits the amount (and cost) of the video frame buffer. The video is then scaled up or down to the desired resolution for

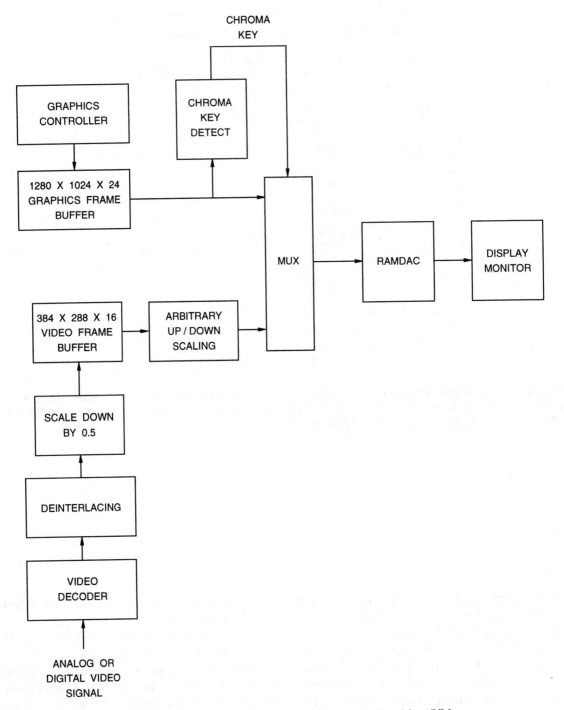

Figure 2.5. Example Architecture of Separate Graphics/Video Frame Buffers (Minimum Video Frame Buffer Size).

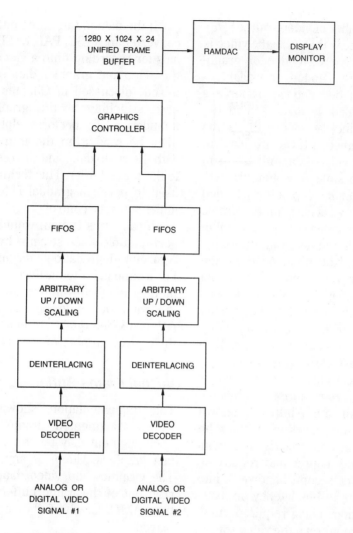

Figure 2.6. Example Architecture of a Unified Graphics/Video Frame Buffer.

mixing with the graphics and displayed. This architecture does limit the usefulness of the system for some applications, such as serious video editing, due to the limited video resolution available.

Single Unified Frame Buffer

This implementation (Figure 2.6) is also suitable to the standard computer environment, as both the video and graphics are rendered into a frame buffer. The video data is treated as any other data type that may be written into the frame buffer. Since video is usually true-color, a true-color graphics frame buffer is normally used. One advantage of this architecture is that the video is decoupled from the graphics/display subsystem. As a result, the display resolution may be changed, or multiple frame buffers and display monitors added, without affecting the video functionality. In addition, the amount of frame-buffer memory remains constant,

regardless of the number of video sources supported. A disadvantage is that once the video is mixed with another source (video or graphics), the original image is no longer available.

In this system, the decoded video source is deinterlaced and scaled as discussed in the previous example. Since access to the frame buffer is not guaranteed, FIFOs are used to temporarily store the video data until access to the frame buffer is possible. Anywhere from 16 pixels to an entire scan line of pixels are loaded into the FIFOs. When access to the frame buffer is available, the video data is read out of the FIFO at the maximum data rate the frame buffer can accept it. Note that, once written into the frame buffer, video and graphics data may not be differentiated, unless additional data is used to "tag" the video data. Each video source must have its own method of adjusting the gamma, brightness, contrast, hue, and saturation, so as not to affect the graphics data.

Frame buffer access arbitration is a major concern. Real-time video requires a high-bandwidth interface into the frame buffer, as shown in Table 2.1, while other processes, such as the graphics controller, also require access. A standard deinterlaced video source may require up to 50–100 Mbytes per second bandwidth into the frame buffer, due to bus latency or read–modify–write operations being required. Additional bandwidth is required if the video source is scaled up; scaling the video source up to the full display size may require a bandwidth into the frame buffer of up to 300–400 Mbytes per second (assuming a 1280 × 1024 display resolution). A potential problem is that the video source being displayed may occasionally become "jerky" as a result of not being able to update the frame buffer with video information, due to another process accessing the frame buffer for an extended period of time. In this instance, it is important that any audio data accompanying the video not be interrupted.

If the data in the frame buffer is also to be converted to NTSC, PAL, or SECAM video signals for recording onto a video tape recorder, the video and graphics data should be alpha-mixed (discussed in Chapter 9) to eliminate hard switching at the graphics and video boundaries. To perform alpha mixing, data must be read from the frame buffer, mixed with the video data, and the result written back to the frame buffer. This technique can also be used to perform gradual fades and dissolves under software control.

Ideally, this system would be able to support multiple video streams by performing the "graceful degradation" discussed previously. For example, if the hardware can't support the number of video windows that the user wants, the windows could be made smaller or of reduced video quality to enable the display of the desired number of windows.

Virtual Frame Buffer

This implementation, shown in Figure 2.7, uses a "segmented" frame buffer memory. Each segment may be any size and may contain graphics, video, or any other data type. The graphics and video data are individually read out of the frame buffer and loaded into the RAMDAC, where they are mixed and displayed.

The decoded video source is deinterlaced and scaled as previously discussed. Since access to the memory is not guaranteed, FIFOs are again used to store the video data until access to the memory is possible. When memory access is available, the video data is read out of the FIFO at the maximum data rate possible. Note that, once written into the memory, there *is* still a way of differentiating video and graphics data, since each has its own memory allocation.

The major limitation to this approach is the bus bandwidth required to handle all of the

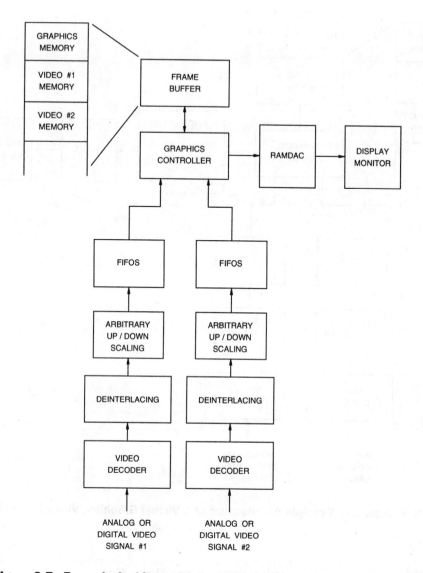

Figure 2.7. Example Architecture of a Virtual Graphics/Video Frame Buffer.

sources. For a 1280 × 1024 display, just the RAMDAC requires a bus bandwidth of up to 400 MBytes per second for the true-color graphics and 10–400 Mbytes per second for each video window (depending on the video window size). Each video input source also requires 10–400 Mbytes per second to store the video (again depending on the video win-

dow size). Don't forget the bandwidth required for drawing graphics information into the memory!

Again, if the data in the memory is to be converted also to NTSC, PAL, or SECAM video signals for recording onto a video tape recorder, the video and graphics data should be alpha-mixed at the encoder to eliminate

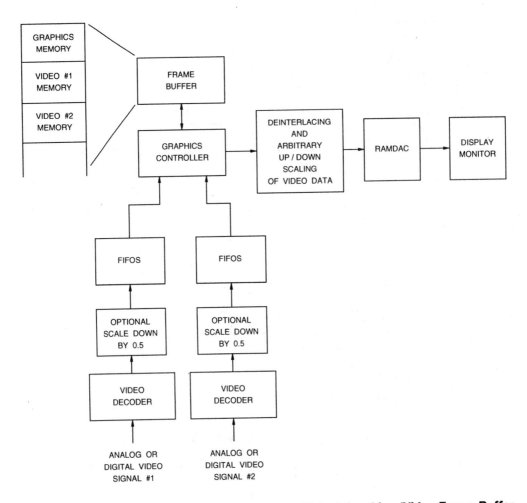

Figure 2.8. Alternate Example Architecture of a Virtual Graphics/Video Frame Buffer.

hard switching at the graphics and video boundaries.

A second variation, shown in Figure 2.8, is to store the video at a specific size (for example 640 × 480 or 320 × 240) prior to storing in the frame buffer. This limits the amount (and cost) of the frame buffer and eases bus bandwidth requirements. The video is then deinterlaced and scaled up or down to the desired resolution for mixing with the graphics and displayed.

Fast Pixel Bus

This implementation, shown in Figure 2.9, uses a high-bandwidth bus to transfer graphics and video data to the RAMDAC. The video sources are deinterlaced and scaled before being transferred to the RAMDAC and mixed with the graphics data.

The major limitation to this approach is the bus bandwidth required to handle all of the sources. For a 1280 × 1024 display, the RAM-

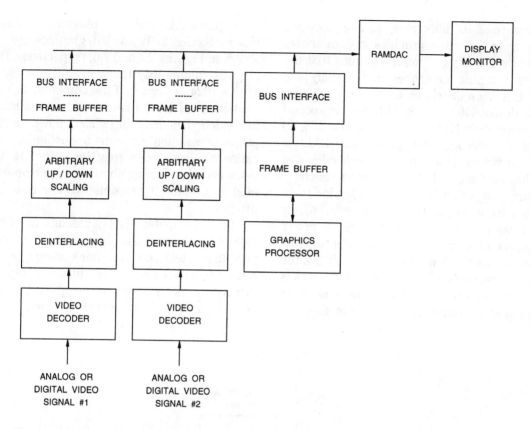

Figure 2.9. Example Architecture of a Graphics/Video System Using a Fast Pixel Bus.

DAC requires a bus bandwidth of up to 400 Mbytes per second for the true-color graphics and 10–400 Mbytes per second for each video window (depending on the video window size).

Alternately, doing the deinterlacing and scaling of the video within the RAMDAC allows additional processing. These processing functions may include determining which overlays (if any) are associated with the video and optionally disabling the cursor from being encoded into the NTSC, PAL, or SECAM video signal. A constant bandwidth for a video source is also maintained if the processing is done within the RAMDAC, rather than having the bandwidth be dependent on the scaling factors involved.

Generating Real-Time Video

Several possible implementations exist for generating "non-RGB" video in the computer environment, each with its own functionality, quality, and cost trade-offs. The video signals generated can be NTSC, PAL, or SECAM (for recording video onto a video tape recorder), a teleconferencing encoder (compressing teleconferencing video for transmission over a network), or a digital component video or digital composite video encoder (for recording digital video onto a digital tape recorder). The discussions in this chapter focus on generating analog NTSC/PAL/SECAM composite color video.

Figure 2.10 illustrates adding a video encoder to the video/graphics system shown in Figure 2.2. This example assumes that the graphics timing controller and display are operating in an interlaced mode, with a display resolution of 640 × 480, 59.94 fields per second (for generating NTSC video) or 768 × 576, 50 fields per second (for generating PAL or SECAM video). Since these refresh rates and resolutions are what the video encoder requires, no scaling, interlace conversion (converting from noninterlaced to interlaced), or frame rate conversion is required. Some newer computer display monitors may not support refresh rates this low and, even if they do, the flicker of white and highly saturated colors is worsened by the lack of movement in areas containing computer graphics information.

Figures 2.11 and 2.12 illustrate adding a video encoder to the video/graphics system shown in Figures 2.4 and 2.6, respectively. Display resolutions may range from 640 × 480 to 1280 × 1024 or higher. If the computer display resolution is higher than the video resolution, the video data may be scaled down to the proper resolution or only a portion of the entire display screen may be output to the video encoder. Scaling should be done on noninterlaced data if possible to minimize artifacts.

Since computer display resolutions of 640 × 480 or higher are usually noninterlaced, conversion to interlaced data after scaling typically must be performed. Some newer computer display monitors may not support the low refresh rates used by interlaced video, and if

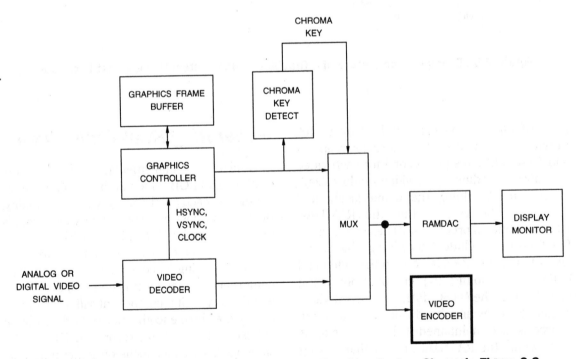

Figure 2.10. Adding a Video Encoder to the Video/Graphics System Shown in Figure 2.2.

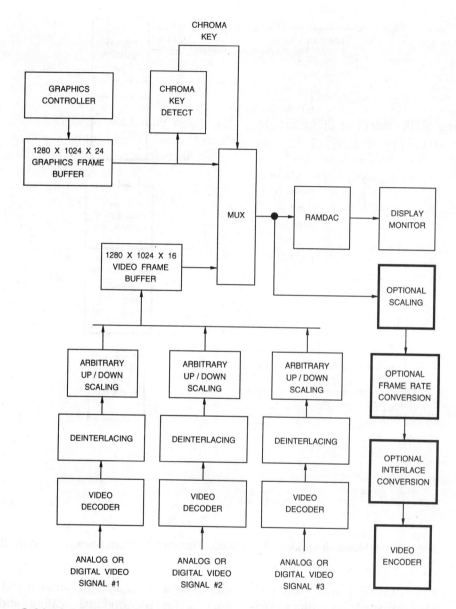

Figure 2.11. Adding a Video Encoder to the Video/Graphics System Shown in Figure 2.4.

they do, the flicker of white and highly saturated colors is worsened by the lack of movement in areas containing computer graphics information.

Computer display refresh rates higher than 50 or 60 Hz (i.e, 72 Hz) also require some type of frame-rate conversion to 50 or 60 Hz interlaced. Frame-rate conversion may be eliminated by using shadow video and graphics frame buffers. Containing the same information as the primary video and graphics frame buffers, these duplicate buffers employ a separate timing controller that allows data to be output at 59.94 Hz (NTSC)

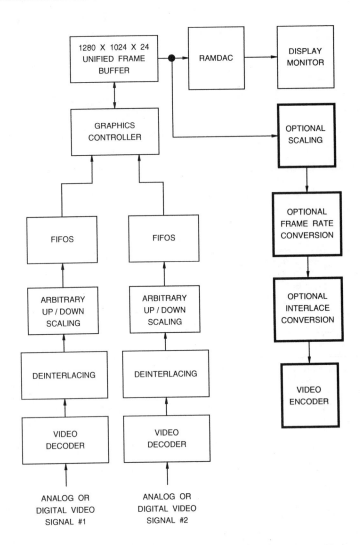

Figure 2.12. Adding a Video Encoder to the Video/Graphics System Shown in Figure 2.6.

or 50 Hz (PAL and SECAM), either interlaced or noninterlaced. Interlaced operation would eliminate the noninterlaced to interlaced conversion, but consideration of the graphics information still is required (for example, no one-pixel-wide lines or small fonts) for acceptable video quality. Alternately, using triple-port frame buffers (allowing support of two independent serial output streams) also will eliminate frame-rate conversion. One serial output port drives the RAMDAC at the dis-

play refresh rate, and the other serial output port drives the optional scaling and video encoder circuitry at the appropriate NTSC or PAL/SECAM refresh rates.

A problem arises if the RAMDAC incorporates various types of color processing, such as supporting multiple pixel formats on a pixel-by-pixel basis. For example, the RAMDAC may have the ability to input 8-bit pseudo-color, 16-bit YCbCr, or 24-bit RGB data on a pixel-by-pixel basis or provide overlay support for cur-

sors and menus. Either the circuitry performing the color processing inside the RAMDAC must be duplicated somewhere in the video encoder path or the RAMDAC must output a digital RGB version of its analog outputs to drive the video encoder path.

Color Space Issues

Most computers use the RGB color space (either 15-, 16-, or 24-bit RGB) or 8-bit pseudocolor. Although newer video encoders and decoders support both RGB and YCbCr as color space options, the video processing required (such as interlace conversion and scaling) is usually much more efficient using the YCbCr color space. As some video quality is lost with each color space conversion (for example, converting from RGB to YCbCr), care should be taken to minimize the number of color space conversions used in the video encoding and decoding paths.

For example, along the video encoding path, the RGB data from the frame buffer should be converted to YCbCr before any scaling and interlace conversion operations (the input to the scaler should support RGB-to-YCbCr conversion). The input to the video encoder then should be configured to be the YCbCr color space.

Color spaces are discussed in detail in the next chapter. To facilitate the transfer of video data between VLSI devices that support multiple color spaces, de facto standards have been developed, as shown in Tables 2.2 and 2.3.

Square Pixel Issues

Most modern displays for computers use a 1:1 aspect ratio (square pixels). Most consumer video displays currently use rectangular pixels. Without taking these differences into account, computer-generated circles will become ellipses when processed by a video encoder. Similarly, circles as displayed on a television will appear as ellipses when displayed on the computer.

To compensate for the pixel differences, NTSC/PAL/SECAM video encoders and decoders are able to operate at special pixel clock rates and horizontal resolutions. Square-pixel NTSC video encoders and decoders operate at 12.2727 MHz (640 active pixels per line), whereas square-pixel PAL and SECAM video encoders and decoders operate at 14.75 MHz (768 active pixels per line). NTSC/PAL/SECAM encoders and decoders are also available that operate at 13.5 MHz (720 active pixels per line), supporting the conventional rectangular video aspect ratio.

When processing a video stream, it is important to know its format. For example, if a NTSC decoder supports square pixels, and a MPEG encoder expects rectangular pixels, scaling between the NTSC decoder and the MPEG encoder must take place. When the video is stored in memory for processing, if the format ratio is not what is expected, major processing errors will occur.

Audio Issues

Just as there are many issues involved in getting video into and out of a computer environment, there are just as many issues regarding the audio. As seen in Figure 2.1, some of the possible audio sources are analog audio from a microphone or video tape recorder or digital audio from a digital video decoder, MPEG decoder, CD player, or digitized audio file on the disk or a CD-ROM.

Just as there are many video standards, there are even more audio standards. The audio may be sampled at one of several rates (8 kHz, 11.025 kHz, 22.05 kHz, 32 kHz, 44.1 kHz,

24-bit RGB (8, 8, 8)	16-bit RGB (5, 6, 5)	15-bit RGB (5, 5, 5)	24-bit 4:4:4 YCbCr	16-bit 4:2:2 YCbCr	12-bit 4:1:1 YCbCr
R7	-	-	Cr7	-	-
R6	-	-	Cr6	-	-
R5	-	-	Cr5	-	-
R4	-	-	Cr4	-	-
R3	-	-	Cr3	-	-
R2	-	-	Cr2	-	-
R1	-	-	Cr1	-	-
R0	-	-	Cr0	-	-
G7	R7	-	Y7	Y7	Y7
G6	R6	R7	Y6	Y6	Y6
G5	R5	R6	Y5	Y5	Y5
G4	R4	R5	Y4	Y4	Y4
G3	R3	R4	Y3	Y3	Y3
G2	G7	R3	Y2	Y2	Y2
G1	G6	G7	Y1	Y1	Y1
G0	G5	G6	Y0	Y0	Y0
B7	G4	G5	Cb7	[Cb7], Cr7	[Cb7], Cb5, Cb3, Cb1
B6	G3	G4	Cb6	[Cb6], Cr6	[Cb6], Cb4, Cb2, Cb0
B5	G2	G3	Cb5	[Cb5], Cr5	[Cr7], Cr5, Cr3, Cr1
B4	B7	B7	Cb4	[Cb4], Cr4	[Cr6], Cr4, Cr2, Cr0
B3	B6	B6	Cb3	[Cb3], Cr3	-
B2	B5	B5	Cb2	[Cb2], Cr2	-
B1	B4	B4	Cb1	[Cb1], Cr1	-
B0	B3	B3	Cb0	[Cb0], Cr0	-

Timing control signals:

graphics:
horizontal sync (HSYNC*)
vertical sync (VSYNC*)
composite blank (BLANK*)

Philips:
horizontal sync (HS)
vertical sync (VS)
horizontal blank (HREF)

ITU-R BT.601:
horizontal blanking (H)
vertical blanking (V)
even/odd field (F)

Table 2.2. Pixel Format Standards for Transferring RGB and YCbCr Video Data Over a 16-bit or 24-bit Bus. For 4:2:2 and 4:1:1 YCbCr data, the first active pixel data per scan line is indicated in brackets [].

Pixel Bus	24-bit RGB (8, 8, 8)	16-bit RGB (5, 6, 5)	15-bit RGB (5, 5, 5)	24-bit 4:4:4 YCbCr	16-bit 4:2:2 YCbCr	12-bit 4:1:1 YCbCr
P7D	–	R7	–	–	Y7	Y7
P6D	–	R6	R7	–	Y6	Y6
P5D	–	R5	R6	–	Y5	Y5
P4D	–	R4	R5	–	Y4	Y4
P3D	–	R3	R4	–	Y3	Y3
P2D	–	G7	R3	–	Y2	Y2
P1D	–	G6	G7	–	Y1	Y1
P0D	–	G5	G6	–	Y0	Y0
P7C	R7	G4	G5	Cr7	Cb7, Cr7	Cb5, Cb1
P6C	R6	G3	G4	Cr6	Cb6, Cr6	Cb4, Cb0
P5C	R5	G2	G3	Cr5	Cb5, Cr5	Cr5, Cr1
P4C	R4	B7	B7	Cr4	Cb4, Cr4	Cr4, Cr0
P3C	R3	B6	B6	Cr3	Cb3, Cr3	–
P2C	R2	B5	B5	Cr2	Cb2, Cr2	–
P1C	R1	B4	B4	Cr1	Cb1, Cr1	–
P0C	R0	B3	B3	Cr0	Cb0, Cr0	–
P7B	G7	R7	–	Y7	Y7	Y7
P6B	G6	R6	R7	Y6	Y6	Y6
P5B	G5	R5	R6	Y5	Y5	Y5
P4B	G4	R4	R5	Y4	Y4	Y4
P3B	G3	R3	R4	Y3	Y3	Y3
P2B	G2	G7	R3	Y2	Y2	Y2
P1B	G1	G6	G7	Y1	Y1	Y1
P0B	G0	G5	G6	Y0	Y0	Y0
P7A	B7	G4	G5	Cb7	[Cb7], Cr7	[Cb7], Cb3
P6A	B6	G3	G4	Cb6	[Cb6], Cr6	[Cb6], Cb2
P5A	B5	G2	G3	Cb5	[Cb5], Cr5	[Cr7], Cr3
P4A	B4	B7	B7	Cb4	[Cb4], Cr4	[Cr6], Cr2
P3A	B3	B6	B6	Cb3	[Cb3], Cr3	–
P2A	B2	B5	B5	Cb2	[Cb2], Cr2	–
P1A	B1	B4	B4	Cb1	[Cb1], Cr1	–
P0A	B0	B3	B3	Cb0	[Cb0], Cr0	–

Table 2.3. Pixel Format Standards for Transferring RGB and YCbCr Video Data Over a 32-bit Bus. For 4:2:2 and 4:1:1 YCbCr data, the first active pixel data per scan line is indicated in brackets []. For all formats except 24-bit RGB and 24-bit YCbCr data, PxA and PxB data contain pixel n data, PxC and PxD contain pixel n + 1 data. Refer to Table 2.2 for timing control signals.

or 48 kHz), be 8-bit, 12-bit, or 16-bit samples, mono or stereo, linear PCM (pulse code modulation) or ADPCM (adaptive differential pulse code modulation). Problems arise when mixing two or more digital audio signals that use different sampling rates or formats. Both audio streams must be converted to a common sample rate and format before digital mixing is done. With the CD, DAT, DCC, MD, and laserdisk machines now supporting digital audio as an option, having the ability to input and output digital audio is desirable. Although the bandwidths required for audio are much smaller than those for video (Table 2.4 illustrates the audio bandwidth requirements for various sample rates and resolutions), they must be

taken into account along with the video bandwidths when determining the maximum system bandwidth required.

When generating audio for recording with computer-generated video, system-dependent sounds should not be recorded with the video. Two solutions are to turn off the system audio during recording or to generate separate system audio signals that drive the internal speakers within the computer. The serial digital audio interface should support both the coaxial and optical formats, as both are standard in the consumer industry. Audio sample rates are 44.1 kHz for CD; DAT sample rates are 32 kHz, 44.1 kHz, or 48 kHz. A generic serial audio interface enabling interfacing to MIDI sound

Sample Rate	Mono or Stereo	Resolution	Bandwidth (kbytes per second per audio channel)
8.0 kHz	mono	8-bit μ-law PCM	8.0
	mono	8-bit A-law PCM	8.0
	mono	4-bit ADPCM	4.0
11.025 kHz	m/s	8-bit linear PCM	11.1
	m/s	4-bit ADPCM	5.6
22.05 kHz	m/s	8-bit linear PCM	22.1
	m/s	4-bit ADPCM	11.1
44.1 kHz	m/s	16-bit linear PCM	88.2
	m/s	4-bit ADPCM	22.1
48.0 kHz	m/s	16-bit linear PCM	96.0
	m/s	4-bit ADPCM	24.0

Table 2.4. Bandwidths of Common Audio Signal Formats.

synthesizers and DSP processors should be supported.

What is a RAMDAC?

With all this talk about RAMDACs, perhaps we should review the basic function of a RAMDAC for those not familiar with its function.

Each pixel on a color display monitor is composed of three phosphor "dots," one red, one green, and one blue. Using three primary colors, such as RGB, allows almost any color to be represented on the display. If a pixel is supposed to be red, the red phosphor is excited, whereas the green and blue ones are not. The amount of excitation, from 0% to 100%, determines the brightness of the phosphor.

Today, the RAMDAC function is usually incorporated within the graphics controller.

True-Color RAMDAC

Figure 2.13 illustrates a simplified block diagram of a true-color RAMDAC. True-color means the red, green, and blue phosphors of each pixel on the display are individually represented by their own red, green, and blue data in the frame buffer (although another color space may be used, RGB is the most common for computer graphics). For each pixel to be displayed, 24 bits of data (8 bits each of red, green, and blue) are transferred in real time from the frame buffer memory to the RAMDAC. Thus, for a 1280 × 1024 noninterlaced display, the 24 bits of data must be transferred every 7.4 ns.

The red, green, and blue pixel data address three "lookup table" RAMs, one each for the red, green, and blue data. The primary purpose of the lookup table RAMs in this

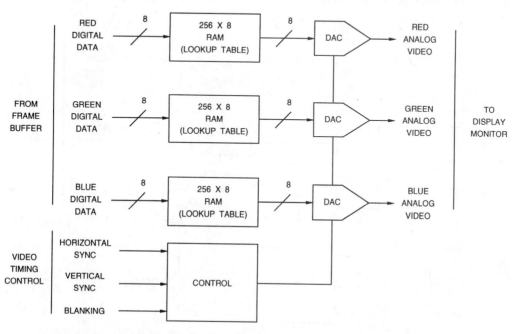

Figure 2.13. Simplified Block Diagram of a True-Color RAMDAC.

instance is to provide gamma correction (discussed in Chapter 3) for the display monitor. The lookup table RAMs are loaded by the CPU with the desired data.

The output of the lookup table RAMs drive three digital-to-analog converters (DACs) to convert the digital data to red, green, and blue analog signals used to drive the display monitor. Video timing information, such as horizontal sync, vertical sync, and blanking are optionally added to the analog signals, or sent to the monitor separately.

Pseudo-Color RAMDAC

Figure 2.14 illustrates a simplified block diagram of a pseudo-color RAMDAC. Pseudo-color means the red, green, and blue phosphors of each pixel on the display are *not* individually represented by their own red, green, and blue data in the frame buffer. Instead, the frame buffer contains an 8-bit "index" value for each pixel. The primary benefit of this implementation is the much lower cost of frame buffer memory (one-third that of a true-color system).

This 8-bit index is used to address a lookup table that "looks up" what red, green, and blue data is to be generated for a given index value. The only correlation between the 8-bit index value and the color is whatever the CPU assigns. In other words, the generated colors are artificial. For each pixel to be displayed, only 8 bits of data must be transferred in real time from the frame buffer memory to the RAMDAC. Thus, for a 1280 × 1024 noninterlaced display, 8 bits of data are transferred every 7.4 ns.

The 8 bits of pixel data simultaneously address three "lookup table" RAMs, one each for the red, green, and blue data. The primary purpose of the lookup table RAMs in this instance is to generate (look up) the red, green, and blue data and to provide gamma correction for the display (discussed in Chapter 3). The lookup table RAMs are loaded by the CPU with the appropriate data.

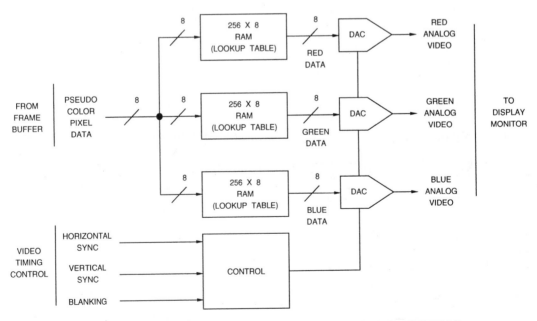

Figure 2.14. Simplified Block Diagram of a Pseudo-Color RAMDAC.

Again, the output of the lookup table RAMs drive three digital-to-analog converters (DACs) to convert the digital data to red, green, and blue analog signals used to drive the display monitor. Video timing information, such as horizontal sync, vertical sync, and blanking are optionally added to the analog signals, or sent to the monitor separately.

Hardware Assist of Software

To reduce the cost of adding multimedia to price-sensitive personal computers, as many functions as possible are implemented in software. However, some video processing functions now are handled in hardware to assist the video decompression software.

Implementing color space conversion (typically from YCbCr to RGB) and video scaling in hardware enables larger video windows, or a higher video refresh rate, to be displayed at minimum additional cost. Typically, these hardware functions are added to graphics controllers that also support graphics drawing acceleration.

In the future, even more hardware probably will be embedded in existing devices, such as graphics controllers and processors, to accelerate software video decompression.

Native Signal Processing

Intel has developed Native Signal Processing (NSP) to facilitate the incorporation of multimedia functions into a standard PC.

NSP promotes "balanced partitioning" of CPU resources, processing requirements, and system cost. Complex signal processing functions are implemented in software running on the Pentium® processor. Simple functions are implemented in silicon. The partitioning approach results in lower-cost components and add-in cards.

Some of the requirements for NSP hardware support are direct interfacing to the PCI or Pentium® bus, direct memory access control, direct access to other PCI functions, and handling the latency, bandwidth, and buffering requirements.

Common PC Video Architectures

To ensure compatibility between systems and provide a common platform, several standards have been defined for adding video to personal computers.

VESA Advanced Feature Connector

The VESA Advanced Feature Connector (VAFC) allows a graphics controller on the motherboard to have access to the digital video data from an add-in video card (Figure 2.15a). It also allows an add-in video board to have access to the digital graphics data from a graphics controller on the motherboard (Figure 2.15b). In this case, the video output of the motherboard is not used to drive the monitor. Either scheme allows mixing of the graphics and video data digitally, allowing many capabilities to be easily added.

The advantage of the VAFC is that add-in cards may be used, at the user's convenience, to add multimedia capabilities. This keeps the cost of the basic personal computer to a minimum, while still allowing users to add multimedia capability at any time.

The VAFC has a 32-bit bidirectional data bus and several timing control signals, as shown in Tables 2.5 and 2.6. Data may be transferred at a 37.5 MHz maximum clock rate, resulting in a 150 Mbyte/sec maximum bandwidth. The supported data formats are:

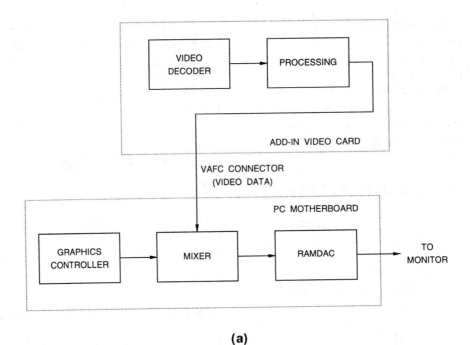

(a)

(b)

Figure 2.15. VESA Advanced Feature Connector Applications.

Name	Video Mode	I/O	Sync	Description
P0–P31	in	I	VCLK	Data from video system
	out	O	DCLK	Data from graphics system
DCLK	in/out	O		Graphics pixel clock
VCLK	in/out	I		Video pixel clock
BLANK*	in/out	O	DCLK	Graphics blanking
HSYNC	in/out	O	DCLK	Graphics horizontal sync
VSYNC	in/out	O	DCLK	Graphics vertical sync
EVIDEO*	in	I		Low = Video data present
	out	I		High = Graphics data present
EGEN*	in/out	I		Enable GENCLK
GRDY	in	O	VCLK	Graphics ready to latch data
VRDY	in	I	VCLK	Valid video data
FSTAT	in	O	VCLK	FIFO status
OFFSET (0, 1)	in	I	VCLK	Pixel offset
GENCLK	in/out	I		Genlock clock
RSRV (0–2)	tbd	tbd	tbd	

Video Mode: "In" means data coming **into** the graphics system from the video system.
"Out" means data is going **out** of the graphics system into the video system.

I/O: Pin directions are defined as seen at the graphics system.

Sync: Indicates if the pin is synchronous to DCLK, VCLK, or neither.

Table 2.5. VAFC Signals.

Pin	Name	Pin	Name	Pin	Name	Pin	Name
1	RSRV0	21	GND	41	GND	61	P6
2	RSRV1	22	P7	42	GND	62	GND
3	GENCLK	23	P8	43	GND	63	P9
4	OFFSET0	24	GND	44	GND	64	P10
5	OFFSET1	25	P11	45	GND	65	GND
6	FSTAT	26	P12	46	GND	66	P13
7	VRDY	27	GND	47	GND	67	P14
8	GRDY	28	P15	48	GND	68	GND
9	BLANK*	29	P16	49	GND	69	P17
10	VSYNC	30	GND	50	GND	70	P18
11	HSYNC	31	P19	51	GND	71	GND
12	EGEN*	32	P20	52	GND	72	P21
13	VCLK	33	GND	53	GND	73	P22
14	RSRV2	34	P23	54	GND	74	GND
15	DCLK	35	P24	55	GND	75	P25
16	EVIDEO*	36	GND	56	GND	76	P26
17	P0	37	P27	57	P1	77	GND
18	GND	38	P28	58	P2	78	P29
19	P3	39	GND	59	GND	79	P30
20	P4	40	P31	60	P5	80	GND

Table 2.6. VAFC Connector Pin Assignments.

RGB data:

> 32-bit including alpha (8, 8, 8, 8)
> 24-bit (8, 8, 8)
> 16-bit (5, 6, 5)
> 16-bit including alpha (1, 5, 5, 5)
> 15-bit (5, 5, 5)
> 8-bit (3, 3, 2)

YCbCr data:

> 24-bit 4:4:4
> 16-bit 4:2:2
> 12-bit 4:1:1

Pseudo-color data:

> 8-bit

VESA Media Channel

The VESA Media Channel (VMChannel) is a multiple-master, multiple-drop, clock-synchronous interface designed for video streams. It enables the bidirectional, real-time flow of uncompressed video between devices, as shown in Figure 2.16, regardless of the resolution or refresh rate. As with the VAFC, VMChannel allows add-in cards to be added to a personal computer at the user's convenience to add multimedia capabilities.

VMChannel requires a single "bus controller," which is anticipated to be within the graphics controller. Otherwise, it is a peer-to-peer multi-master bus. Video sources are granted ownership of the bus via various token-passing schemes. "Broadcasting" is also supported, allowing video data to be sent to any number of devices at the same time.

The VMChannel has a 32-bit bidirectional data bus and several control signals, as shown in Tables 2.7 and 2.8. Data may be transferred

at a 33-MHz maximum clock rate, resulting in a 132-Mbyte/sec maximum bandwidth. The supported data formats are (* represents baseline requirements):

RGB data:

> 32-bit including alpha (8, 8, 8, 8)*
> 24-bit (8, 8, 8)
> 16-bit (5, 6, 5)*
> 8-bit (3, 3, 2)*
> 8-bit gray-scale*

YCbCr data:

> 4:2:2
> 4:2:0
> 4:1:1

Pseudo-color data:

> 8-bit

The SA* and SB* signals, used during the configuration phase, are also used by devices to request an interrupt. This allows devices currently excluded from the token loop to get attention and reinsert themselves into the token loop.

The BS0* and BS1* signals allow dynamic bus resizing of 8, 16, or 32 bits.

PCI Bus

Many companies are pursuing using the 32-bit high bandwidth PCI bus (up to 132-MB/second bandwidth, usually implemented as a secondary PCI bus) for transferring real-time digital audio and video data between devices. This also eliminates the need for both dedicated audio/video and host processor inter-

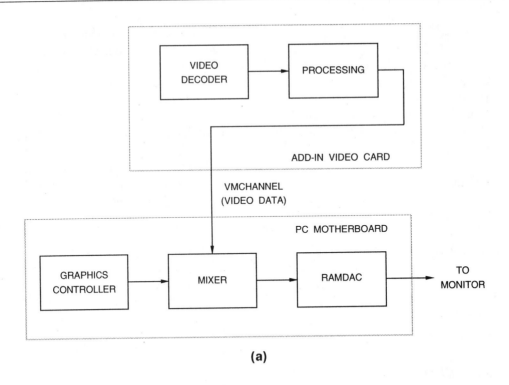

(a)

(b)

Figure 2.16. VMChannel Applications.

faces on devices. However, there is some debate as to whether the protocol overhead of the 32-bit PCI bus limits the ability to transfer real-time full-resolution video.

Work is progressing on implementing the 64-bit version (up to 264 MB/second bandwidth), along with reducing the protocol overhead, and increasing the clock to 66 MHz.

Name	I/O	Description
DATA (0–31)	in/out	
CLK	in	Bus clock provided by bus controller
CONTROL	in/out	Indicates a control rather than data transfer
BS0*, BS1*	in/out	Bus size
SNRDY*	in/out	Slave not ready
SA*, SB*	in/out	Serial in/out
RESET*	in	Reset signal
MASK (0, 1)	in/out	Pixel mask
EVST (0, 1)	out	Event status

I/O: Pin directions are defined for "non-bus controller" devices.

Table 2.7. VMChannel Signals.

Pin	Name	Pin	Name	Pin	Name	Pin	Name
1	SA*	18	DATA10	35	EVST0	52	DATA11
2	EVST1	19	GND	36	GND	53	DATA12
3	BS0*	20	DATA13	37	BS1*	54	GND
4	GND	21	DATA14	38	SNRDY*	55	DATA15
5	CONTROL	22	GND	39	GND	56	DATA16
6	RESET*	23	DATA17	40	GND	57	GND
7	CLK	24	DATA18	41	GND	58	DATA19
8		25	GND	42	GND	59	DATA20
9	MASK0	26	DATA21	43	MASK1	60	GND
10	GND	27	DATA22	44	DATA0	61	DATA23
11	DATA1	28	GND	45	GND	62	DATA24
12	DATA2	29	DATA25	46	DATA3	63	GND
13	GND	30	DATA26	47	DATA4	64	DATA27
14	DATA5	31	GND	48	GND	65	DATA28
15	DATA6	32	DATA29	49	DATA7	66	GND
16	GND	33	DATA30	50	DATA8	67	DATA31
17	DATA9	34	GND	51	GND	68	SB*

Table 2.8. VMChannel Connector Pin Assignments.

VLSI Solutions

See C2_VLSI

References

1. Alliance Semiconductor Corporation, Pro-Motion-3210™ Databook, May 1994.
2. AuraVision Corporation, VxP201 Product Brief, March 1994.
3. AuraVision Corporation, VxP202 Product Brief, August 1994.
4. AuraVision Corporation, VxP500 Product Brief, March 1994.
4. AuraVision Corporation, VxP501 Product Brief, October 1994.
6. Brooktree Corporation, Bt819 Datasheet, July 6, 1994.
7. Brooktree Corporation, Bt885 Datasheet, L885001 Rev. D.
8. Brooktree Corporation, Bt895 Datasheet, L895001 Rev. D.
9. Brooktree Corporation, BtV MediaStream Family Product Guide and Overview, BtVPG001, October 1994.
10. Chips and Technologies 69003/69004 Datasheet, January 1992.
11. Chips and Technologies 82C9001 Datasheet, April 1992.
12. Cirrus Logic, CL-PX2070 Datasheet, July 1993.
13. Cirrus Logic, CL-PX2080 Datasheet, September 1993.
14. Cirrus Logic, CL-PX4070 Datasheet, April 1994.
15. Cirrus Logic, CL-PX4080 Datasheet, April 1994.
16. S3, Trio64V+ Product Overview, June 1995.
17. S3, Scenic/MX1 Product Overview, June 1995.
18. S3, Scenic/MX2 Product Overview, June 1995.
19. S3, Sonic/AD Product Overview, June 1995.
20. Trident Microsystems, Inc., TVP9512 Datasheet.
21. Tseng Labs, VIPeR Datasheet.
22. Tseng Labs, VIPeR f/x Datasheet, March 1995.
23. Tseng Labs, W32 Datasheet.
24. Tseng Labs, W32i Datasheet.
25. Tseng Labs, W32p Datasheet.
26. VESA Advanced Feature Connector (VAFC) Standard, November 1, 1993.
27. VESA Advanced Feature Connector (VAFC) Software Interface Standard, March 30, 1994.
28. VESA Media Channel (VMChannel) Standard, December 1, 1993.
29. VESA VM-Channel (VMC) Software Interface Standard, Baseline Implementation, September 23, 1994.
30. Weitek Corporation, Power 9100 Technical Overview, November 1993.
31. Weitek Corporation, Video Power Technical Overview, October 1993.

Color Spaces

A color space is a mathematical representation of a set of colors. Three fundamental color models are RGB (used in color computer graphics and color television); YIQ, YUV, or YCbCr (used in broadcast and television systems); and CMYK (used in color printing). However, none of these color spaces are directly related to the intuitive notions of hue, saturation, and brightness. This has resulted in the development of other models, such as HSI and HSV, to simplify programming, processing, and end-user manipulation.

All of the color spaces in common use can be derived from the RGB information supplied by devices like cameras and scanners.

RGB Color Space

The red, green, and blue (RGB) color space is widely used throughout computer graphics and imaging. Red, green, and blue are three primary additive colors (individual components are added together to form a desired color) and are represented by a three-dimensional, Cartesian coordinate system (Figure 3.1). The indicated diagonal of the cube, with equal amounts of each primary component, represents various gray levels. Table 3.1 contains the RGB values for 100% amplitude, 100% saturated color bars, a common video test signal.

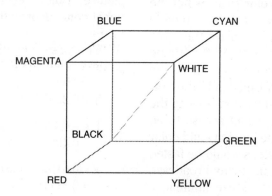

Figure 3.1. The RGB Color Cube.

	Nominal Range	White	Yellow	Cyan	Green	Magenta	Red	Blue	Black
R	0 to 255	255	255	0	0	255	255	0	0
G	0 to 255	255	255	255	255	0	0	0	0
B	0 to 255	255	0	255	0	255	0	255	0

Table 3.1. 100% Amplitude, 100% Saturated RGB Color Bars.

The RGB color space is the most prevalent choice for graphics frame buffers because color CRTs use red, green, and blue phosphors to create the desired color. Therefore, the choice of the RGB color space for a graphics frame buffer simplifies the architecture and design of the system. Also, a system that is designed using the RGB color space can take advantage of a large number of existing software routines, since this color space has been around for a number of years.

However, RGB is not very efficient when dealing with "real-world" images. All three RGB components need to be of equal bandwidth to generate any color within the RGB color cube. The result of this is a frame buffer that has the same pixel depth and display resolution for each RGB component. Also, processing an image in the RGB color space is not the most efficient method. For example, to modify the intensity or color of a given pixel, the three RGB values must be read from the frame buffer, the intensity or color calculated, the desired modifications performed, and the new RGB values calculated and written back to the frame buffer. If the system had access to an image stored directly in the intensity and color format, some processing steps would be faster. For these and other reasons, many broadcast, video, and imaging standards use luminance and color difference video signals. These may exist as YUV, YIQ, or YCbCr color spaces. Although all are related, there are some differences.

YUV Color Space

The YUV color space is the basic color space used by the PAL (Phase Alternation Line), NTSC (National Television System Committee), and SECAM (Sequentiel Couleur Avec Mémoire or Sequential Color with Memory) composite color video standards. The black-and-white system used only luma (Y) information; color information (U and V) was added in a such a way that a black-and-white receiver would still display a normal black-and-white picture. Color receivers decoded the additional color information to display a color picture.

The basic equations to convert between gamma-corrected RGB (R′G′B′) and YUV are:

$$Y = 0.299R' + 0.587G' + 0.114B'$$

$$U = -0.147R' - 0.289G' + 0.436B'$$
$$= 0.492\,(B' - Y)$$

$$V = 0.615R' - 0.515G' - 0.100B'$$
$$= 0.877\,(R' - Y)$$

(*Note*: In video applications, the terms luma and luminance are commonly interchanged; they both refer to the black-and-white information in the video signal. Chroma and chrominance, which both refer to the color information, are also commonly interchanged. Luma and chroma are the more technically correct terms.)

$$R' = Y + 1.140V$$

$$G' = Y - 0.394U - 0.581V$$

$$B' = Y + 2.032U$$

(The prime symbol indicates gamma-corrected RGB, explained at the end of this chapter.)

For digital RGB values with a range of 0 to 255, Y has a range of 0 to 255, U a range of 0 to ±112, and V a range of 0 to ±157. These equations are usually scaled to simplify the implementation in an actual NTSC or PAL digital encoder or decoder.

If the full range of (B' – Y) and (R' – Y) had been used, the modulated color information levels would have exceeded what the (then current) black-and-white television transmitters and receivers were capable of supporting. Experimentation determined that modulated subcarrier excursions of 20% of the luma (Y) signal excursion could be permitted above white and below black. The scaling factors were then selected so that the maximum level of 75% amplitude, 100% saturation yellow and cyan color bars would be at the white level (100 IRE).

YIQ Color Space

The YIQ color space is derived from the YUV color space and is used optionally by the NTSC composite color video standard. (The "I" stands for "in-phase" and the "Q" for "quadrature," which is the modulation method used to transmit the color information.) The basic equations to convert between gamma-corrected RGB (R'G'B') and YIQ are:

$$Y = 0.299R' + 0.587G' + 0.114B'$$

$$\begin{aligned} I &= 0.596R' - 0.275G' - 0.321B' \\ &= V\cos 33° - U\sin 33° \\ &= 0.736(R' - Y) - 0.268(B' - Y) \end{aligned}$$

$$\begin{aligned} Q &= 0.212R' - 0.523G' + 0.311B' \\ &= V\sin 33° + U\cos 33° \\ &= 0.478(R' - Y) + 0.413(B' - Y) \end{aligned}$$

or, using matrix notation:

$$\begin{bmatrix} I \\ Q \end{bmatrix} = \begin{bmatrix} 0 & 1 \\ 1 & 0 \end{bmatrix} \begin{bmatrix} \cos(33) & \sin(33) \\ -\sin(33) & \cos(33) \end{bmatrix} \begin{bmatrix} U \\ V \end{bmatrix}$$

$$R' = Y + 0.956I + 0.620Q$$

$$G' = Y - 0.272I - 0.647Q$$

$$B' = Y - 1.108I + 1.705Q$$

For digital RGB values with a range of 0 to 255, Y has a range of 0 to 255, I has a range of 0 to ±152, and Q has a range of 0 to ±134. I and Q are obtained by rotating the U and V axes 33°. These equations are usually scaled to simplify the implementation in an actual NTSC digital encoder or decoder.

YDbDr Color Space

The YDbDr color space is used by the SECAM composite color video standard. The black-and-white system used only luma (Y) information; color information (Db and Dr) was added in a such a way that a black-and-white receiver would still display a normal black-and-white picture; color receivers decode the additional color information to display a color picture.

The basic equations to convert between gamma-corrected RGB and YDbDr are:

$$Y = 0.299R' + 0.587G' + 0.114B'$$

$$\begin{aligned} Db &= 1.505(B' - Y) \\ &= -0.450R' - 0.883G' + 1.333B' \end{aligned}$$

$$\begin{aligned} Dr &= -1.902(R' - Y) \\ &= -1.333R' + 1.116G' + 0.217B' \end{aligned}$$

$$R' = Y - 0.526Dr$$
$$G' = Y - 0.129Db + 0.268Dr$$
$$B' = Y + 0.665Db$$

For digital RGB values with a range of 0 to 255, Y has a range of 0 to 255, and Db and Dr have a range of 0 to ±340. These equations are usually scaled to simplify the implementation in an actual SECAM digital encoder or decoder.

YCbCr Color Space

The YCbCr color space was developed as part of Recommendation ITU-R BT.601 (formerly CCIR 601) during the development of a world-wide digital component video standard (discussed in Chapter 8). YCbCr is a scaled and offset version of the YUV color space. Y is defined to have a nominal range of 16 to 235; Cb and Cr are defined to have a range of 16 to 240, with 128 equal to zero. There are several YCbCr sampling formats, such as 4:4:4, 4:2:2, 4:1:1, and 4:2:0 that are also described.

The basic equations to convert between digital gamma-corrected RGB (R′G′B′) signals with a 16 to 235 nominal range and YCbCr are:

$$Y = (77/256)R' + (150/256)G' + (29/256)B'$$

$$Cb = -(44/256)R' - (87/256)G' + (131/256)B' + 128$$

$$Cr = (131/256)R' - (110/256)G' - (21/256)B' + 128$$

$$R' = Y + 1.371(Cr - 128)$$

$$G' = Y - 0.698(Cr - 128) - 0.336(Cb - 128)$$

$$B' = Y + 1.732(Cb - 128)$$

When performing YCbCr to RGB conversion, the resulting gamma-corrected RGB (R′G′B′) values have a nominal range of 16–235, with possible occasional excursions into the 0–15 and 236–255 values. This is due to Y and CbCr occasionally going outside the 16–235 and 16–240 ranges, respectively, due to video processing. Table 3.2 lists the YCbCr values for 75% amplitude, 100% saturated color bars, a common video test signal.

Computer Systems Considerations

If the gamma-corrected RGB (R′G′B′) data has a range of 0 to 255, as is commonly found in computer systems, the following equations may be more convenient to use:

	Nominal Range	White	Yellow	Cyan	Green	Magenta	Red	Blue	Black
Y	16 to 235	180	162	131	112	84	65	35	16
Cb	16 to 240 (128 = zero)	128	44	156	72	184	100	212	128
Cr	16 to 240 (128 = zero)	128	142	44	58	198	212	114	128

Table 3.2. 75% Amplitude, 100% Saturated YCbCr Color Bars.

$$Y = 0.257R' + 0.504G' + 0.098B' + 16$$

$$Cb = -0.148R' - 0.291G' + 0.439B' + 128$$

$$Cr = 0.439R' - 0.368G' - 0.071B' + 128$$

$$R' = 1.164(Y - 16) + 1.596(Cr - 128)$$

$$G' = 1.164(Y - 16) - 0.813(Cr - 128) - 0.392(Cb - 128)$$

$$B' = 1.164(Y - 16) + 2.017(Cb - 128)$$

Note that for the YCbCr-to-RGB equations, the RGB values must be saturated at the 0 and 255 levels due to occasional excursions outside the nominal YCbCr ranges.

4:4:4 YCbCr Format

Figure 3.2 illustrates the positioning of YCbCr samples for the 4:4:4 format. Each sample has a Y, a Cb, and a Cr value. Each sample is typically 8 bits (consumer applications) or 10 bits (editing applications) per component. Each sample therefore requires 24 bits (or 30 bits for editing applications).

4:2:2 YCbCr Format

Figure 3.3 illustrates the positioning of YCbCr samples for the 4:2:2 format. For every two horizontal Y samples, there is one Cb and Cr sample. Each sample is typically 8 bits (consumer applications) or 10 bits (editing applications) per component. In a frame buffer, each sample requires 16 bits (or 20 bits for editing applications), usually formatted as shown in Figure 3.4. During display, Y samples that have no Cb and Cr data use interpolated Cb and Cr data from the previous and next samples that do.

4:1:1 YCbCr Format

Figure 3.5 illustrates the positioning of YCbCr samples for the 4:1:1 format, used in consumer video applications (it has been mostly replaced by the 4:2:2 format). For every four horizontal Y samples, there is one Cb and Cr value. Each component is typically 8 bits. In a frame buffer, each sample requires 12 bits, usually format-

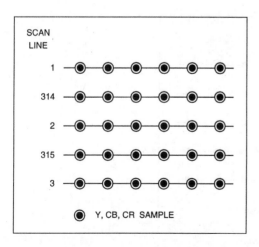

Figure 3.2. 4:4:4 Orthogonal Sampling. The position of sampling sites on the scan lines of a 625-line interlaced picture.

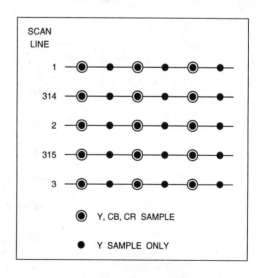

Figure 3.3. 4:2:2 Orthogonal Sampling. The position of sampling sites on the scan lines of a 625-line interlaced picture.

PIXEL 0	PIXEL 1	PIXEL 2	PIXEL 3	PIXEL 4	PIXEL 5
Y7 - 0	Y7 - 1	Y7 - 2	Y7 - 3	Y7 - 4	Y7 - 5
Y6 - 0	Y6 - 1	Y6 - 2	Y6 - 3	Y6 - 4	Y6 - 5
Y5 - 0	Y5 - 1	Y5 - 2	Y5 - 3	Y5 - 4	Y5 - 5
Y4 - 0	Y4 - 1	Y4 - 2	Y4 - 3	Y4 - 4	Y4 - 5
Y3 - 0	Y3 - 1	Y3 - 2	Y3 - 3	Y3 - 4	Y3 - 5
Y2 - 0	Y2 - 1	Y2 - 2	Y2 - 3	Y2 - 4	Y2 - 5
Y1 - 0	Y1 - 1	Y1 - 2	Y1 - 3	Y1 - 4	Y1 - 5
Y0 - 0	Y0 - 1	Y0 - 2	Y0 - 3	Y0 - 4	Y0 - 5
CB7 - 0	CR7 - 0	CB7 - 2	CR7 - 2	CB7 - 4	CR7 - 4
CB6 - 0	CR6 - 0	CB6 - 2	CR6 - 2	CB6 - 4	CR6 - 4
CB5 - 0	CR5 - 0	CB5 - 2	CR5 - 2	CB5 - 4	CR5 - 4
CB4 - 0	CR4 - 0	CB4 - 2	CR4 - 2	CB4 - 4	CR4 - 4
CB3 - 0	CR3 - 0	CB3 - 2	CR3 - 2	CB3 - 4	CR3 - 4
CB2 - 0	CR2 - 0	CB2 - 2	CR2 - 2	CB2 - 4	CR2 - 4
CB1 - 0	CR1 - 0	CB1 - 2	CR1 - 2	CB1 - 4	CR1 - 4
CB0 - 0	CR0 - 0	CB0 - 2	CR0 - 2	CB0 - 4	CR0 - 4

16 BITS PER PIXEL

```
- 0 = PIXEL 0 DATA
- 1 = PIXEL 1 DATA
- 2 = PIXEL 2 DATA
- 3 = PIXEL 3 DATA
- 4 = PIXEL 4 DATA
```

Figure 3.4. 4:2:2 Frame Buffer Formatting.

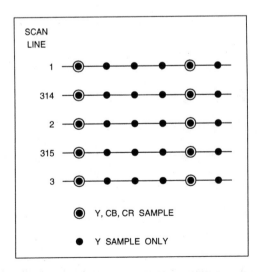

Figure 3.5. 4:1:1 Orthogonal Sampling. The position of sampling sites on the scan lines of a 625-line interlaced picture.

ted as shown in Figure 3.6. During display, Y samples with no Cb and Cr data use interpolated Cb and Cr data from the previous and next pixels that do.

4:2:0 YCbCr Format

Figure 3.7 illustrates the positioning of YCbCr samples for the 4:2:0 format used by the H.261 and H.263 video teleconferencing standards and the MPEG 1 video compression standard (the MPEG 2 4:2:0 format is slightly different). Rather than the horizontal-only 4:1 reduction of Cb and Cr used by 4:1:1, 4:2:0 implements a 2:1 reduction of Cb and Cr in both the vertical and horizontal directions.

PhotoYCC Color Space

PhotoYCC (a trademark of Eastman Kodak Company) was developed by Kodak to encode Photo CD image data. The goal was to develop a display-device-independent color space. For maximum video display efficiency, the color space is based upon Recommendation ITU-R BT.601 (formerly CCIR 601) and Recommendation ITU-R BT.709 (formerly CCIR 709).

The encoding process (RGB to PhotoYCC) assumes the illumination is CIE Standard Illuminant D_{65} and that the spectral sensitivities of the image capture system are proportional to the color-matching functions of the Recommendation ITU-R BT.709 reference primaries. The RGB values, unlike those for a computer graphics system, may be negative. The color gamut of PhotoYCC includes colors outside the Recommendation ITU-R BT.709 display phosphor limits.

RGB to PhotoYCC

Linear RGB data (normalized to have values of 0 to 1) is nonlinearly transformed to PhotoYCC as follows:

PIXEL 0	PIXEL 1	PIXEL 2	PIXEL 3	PIXEL 4	PIXEL 5	
Y7 - 0	Y7 - 1	Y7 - 2	Y7 - 3	Y7 - 4	Y7 - 5	
Y6 - 0	Y6 - 1	Y6 - 2	Y6 - 3	Y6 - 4	Y6 - 5	
Y5 - 0	Y5 - 1	Y5 - 2	Y5 - 3	Y5 - 4	Y5 - 5	
Y4 - 0	Y4 - 1	Y4 - 2	Y4 - 3	Y4 - 4	Y4 - 5	
Y3 - 0	Y3 - 1	Y3 - 2	Y3 - 3	Y3 - 4	Y3 - 5	
Y2 - 0	Y2 - 1	Y2 - 2	Y2 - 3	Y2 - 4	Y2 - 5	12 BITS
Y1 - 0	Y1 - 1	Y1 - 2	Y1 - 3	Y1 - 4	Y1 - 5	PER
Y0 - 0	Y0 - 1	Y0 - 2	Y0 - 3	Y0 - 4	Y0 - 5	PIXEL
CB7 - 0	CB5 - 0	CB3 - 0	CB1 - 0	CB7 - 4	CB5 - 4	
CB6 - 0	CB4 - 0	CB2 - 0	CB0 - 0	CB6 - 4	CB4 - 4	
CR7 - 0	CR5 - 0	CR3 - 0	CR1 - 0	CR7 - 4	CR5 - 4	
CR6 - 0	CR4 - 0	CR2 - 0	CR0 - 0	CR6 - 4	CR4 - 4	

- 0 = PIXEL 0 DATA
- 1 = PIXEL 1 DATA
- 2 = PIXEL 2 DATA
- 3 = PIXEL 3 DATA
- 4 = PIXEL 4 DATA

Figure 3.6. 4:1:1 Frame Buffer Formatting.

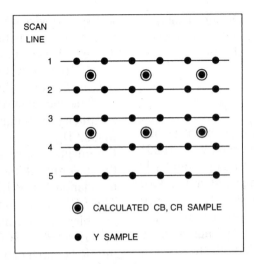

Figure 3.7. 4:2:0 Coded Picture Sampling for H.261, H.263, and MPEG 1. The position of sampling sites on the scan lines of a non-interlaced picture.

for R, G, B ≥ 0.018

$$R' = 1.099 \, R^{0.45} - 0.099$$
$$G' = 1.099 \, G^{0.45} - 0.099$$
$$B' = 1.099 \, B^{0.45} - 0.099$$

for R, G, B ≤ – 0.018

$$R' = -1.099 \, |R|^{0.45} - 0.099$$
$$G' = -1.099 \, |G|^{0.45} - 0.099$$
$$B' = -1.099 \, |B|^{0.45} - 0.099$$

for – 0.018 < R, G, B < 0.018

$$R' = 4.5 \, R$$
$$G' = 4.5 \, G$$
$$B' = 4.5 \, B$$

From R′, G′, and B′, a luminance (luma) and two chrominance signals (chroma1 and chroma2) are generated:

$$luma = 0.299R' + 0.587G' + 0.114B' = Y$$
$$chroma1 = -0.299R' - 0.587G' + 0.866B'$$
$$= B' - Y$$
$$chroma2 = 0.701R' - 0.587G' - 0.114B'$$
$$= R' - Y$$

These are quantized and limited to the 8-bit range of 0 to 255:

$$luma = (255 / 1.402) \, luma$$
$$chroma1 = (111.40 \, chroma1) + 156$$
$$chroma2 = (135.64 \, chroma2) + 137$$

As an example, a 20% gray value (R, G, and B = 0.2) would be recorded on the Photo CD disc using the following values:

$$luma = 79$$
$$chroma1 = 156$$
$$chroma2 = 137$$

PhotoYCC to RGB

Since PhotoYCC attempts to preserve the dynamic range of film, decoding PhotoYCC images requires the selection of a color space and range appropriate for the output device. Thus, the decoding equations are not always the exact inverse of the encoding equations. The following equations are suitable for gener-

ating RGB values for driving a display, and assume a unity relationship between the luminance in the encoded image and the displayed image.

$$L' = 1.3584 \text{ (luma)}$$
$$C1 = 2.2179 \text{ (chroma1 } - 156)$$
$$C2 = 1.8215 \text{ (chroma2 } - 137)$$

$$R_{display} = L' + C2$$
$$G_{display} = L' - 0.194(C1) - 0.509(C2)$$
$$B_{display} = L' + C1$$

The RGB values should be limited to a range of 0 to 255. The equations above assume the display uses phosphor chromaticities that are the same as the Recommendation ITU-R BT.709 reference primaries, and that the video signal luminance (V) and the display luminance (L) have the relationship:

for $0.0812 \leq V < 1.0$

$$L = ((V + 0.099) / 1.099)^{2.2}$$

for $0 \leq V < 0.0812$

$$L = V / 4.5$$

HSI, HLS, and HSV Color Spaces

The HSI (hue, saturation, intensity) and HSV (hue, saturation, value) color spaces were developed to be more "intuitive" in manipulating color and were designed to approximate the way humans perceive and interpret color. They were developed when colors had to be specified manually, and are rarely used now that users can select colors visually or specify Pantone colors. These color spaces are primarily discussed for "historic" interest. HLS (hue,

lightness, saturation) is similar to HSI; the term lightness is used rather than intensity.

The difference between HSI and HSV is the computation of the brightness component (I or V), which determines the distribution and dynamic range of both the brightness (I or V) and saturation (S). The HSI color space is best for traditional image processing functions such as convolution, equalization, histograms, and so on, which operate by manipulation of the brightness values since I is equally dependent on R, G, and B. The HSV color space is preferred for manipulation of hue and saturation (to shift colors or adjust the amount of color) since it yields a greater dynamic range of saturation.

Figure 3.8 illustrates the single hexcone HSV color model. The top of the hexcone corresponds to V = 1, or the maximum intensity colors. The point at the base of the hexcone is black and here V = 0. Complementary colors are 180° opposite one another as measured by H, the angle around the vertical axis (V), with red at 0°. The value of S is a ratio, ranging from 0 on the center line vertical axis (V) to 1 on the sides of the hexcone. Any value of S between 0 and 1 may be associated with the point V = 0. The point S = 0, V = 1 is white. Intermediate values of V for S = 0 are the grays. Note that when S = 0, the value of H is irrelevant. From an artist's viewpoint, any color with V = 1, S = 1 is a pure pigment (whose color is defined by H). Adding white corresponds to decreasing S (without changing V); adding black corresponds to decreasing V (without changing S). Tones are created by decreasing both S and V. Table 3.3 lists the 75% amplitude, 100% saturated HSV color bars.

Figure 3.9 illustrates the double hexcone HSI color model. The top of the hexcone corresponds to I = 1, or white. The point at the base of the hexcone is black and here I = 0. Comple-

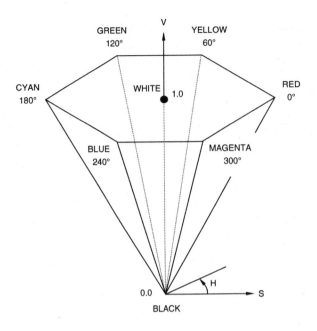

Figure 3.8. Single Hexcone HSV Color Model.

mentary colors are 180° opposite one another as measured by H, the angle around the vertical axis (I), with red at 0° (for consistency with the HSV model, we have changed from the Tektronix convention of blue at 0°). The value of S ranges from 0 on the vertical axis (I) to 1 on the surfaces of the hexcone. The grays all have S = 0, but maximum saturation of hues is at S = 1, I = 0.5. Table 3.4 lists the 75% amplitude, 100% saturated HSI color bars.

There are several ways of converting between HSI or HSV and RGB. Although based on the same principles, they are implemented slightly differently.

	Nominal Range	White	Yellow	Cyan	Green	Magenta	Red	Blue	Black
H	0° to 360°	x	60°	180°	120°	300°	0°	240°	x
S	0 to 1	0	1	1	1	1	1	1	0
V	0 to 1	0.75	0.75	0.75	0.75	0.75	0.75	0.75	0

Table 3.3. 75% Amplitude, 100% Saturated HSV Color Bars.

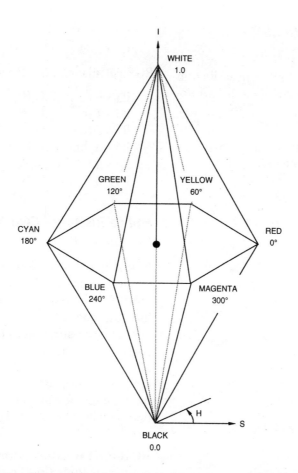

Figure 3.9. Double Hexcone HSI Color Model. For consistency with the HSV model, we have changed from the Tektronix convention of blue at 0° and depict the model as a double hexcone rather than as a double cone.

	Nominal Range	White	Yellow	Cyan	Green	Magenta	Red	Blue	Black
H	0° to 360°	x	60°	180°	120°	300°	0°	240°	x
S	0 to 1	0	1	1	1	1	1	1	0
I	0 to 1	0.75	0.375	0.375	0.375	0.375	0.375	0.375	0

Table 3.4. 75% Amplitude, 100% Saturated HSI Color Bars. For consistency with the HSV model, we have changed from the Tektronix convention of blue at 0°.

HSV-to-RGB and RGB-to-HSV Conversion

This conversion is similar to that described in the section entitled "HSI-to-RGB and RGB-to-HSI conversion."

RGB-to-HSV Conversion

Setup equations (RGB range of 0 to 1):

$$M = \max\ (R, G, B)$$
$$m = \min\ (R, G, B)$$
$$r = (M - R)\ /\ (M - m)$$
$$g = (M - G)\ /\ (M - m)$$
$$b = (M - B)\ /\ (M - m)$$

Value calculation (value range of 0 to 1):

$$V = \max\ (R, G, B)$$

Saturation calculation (saturation range of 0 to 1):

if $M = 0$ then $S = 0$ and $H = 180\ °$
if $M \neq 0$ then $S = (M - m)\ /\ M$

Hue calculation (hue range of 0 to 360):

if $R = M$ then $H = 60\,(b - g)$
if $G = M$ then $H = 60\,(2 + r - b)$
if $B = M$ then $H = 60\,(4 + g - r)$
if $H \geq 360$ then $H = H - 360$
if $H < 0$ then $H = H + 360$

HSV-to-RGB Conversion

Setup equations:

if $S = 0$ then $H = 180°$, $R = V$, $G = V$,
 and $B = V$
otherwise

if $H = 360$ then $H = 0$
$h = H\ /\ 60$
$i = $ largest integer of h
$f = h - i$
$p = V * (1 - S)$

$q = V * (1 - (S * f))$
$t = V * (1 - (S * (1 - f)))$

RGB calculations (RGB range of 0 to 1)

if $i = 0$ then $(R, G, B) = (V, t, p)$
if $i = 1$ then $(R, G, B) = (q, V, p)$
if $i = 2$ then $(R, G, B) = (p, V, t)$
if $i = 3$ then $(R, G, B) = (p, q, V)$
if $i = 4$ then $(R, G, B) = (t, p, V)$
if $i = 5$ then $(R, G, B) = (V, p, q)$

HSI-to-RGB and RGB-to-HSI Conversion (Method 1)

In this implementation, intensity is calculated as the average of the largest and smallest primary values. Saturation is the ratio between the difference and sum of the two primary values, with the difference corresponding to color content and the sum corresponding to color plus white. Two sets of equations for calculating hue are provided: one set with red at 0° (to be compatible with the HSV convention) and one set with blue at 0° (Tektronix model).

RGB-to-HSI Conversion

Setup equations (RGB range of 0 to 1):

$$M = \max\ (R, G, B)$$
$$m = \min\ (R, G, B)$$
$$r = (M - R)\ /\ (M - m)$$
$$g = (M - G)\ /\ (M - m)$$
$$b = (M - B)\ /\ (M - m)$$

Intensity calculation (intensity range of 0 to 1):

$$I = (M + m)\ /\ 2$$

Saturation calculation (saturation range of 0 to 1):

if $M = m$ then $S = 0$ and $H = 180°$
if $I \leq 0.5$ then $S = (M - m)\ /\ (M + m)$
if $I > 0.5$ then $S = (M - m)\ /\ (2 - M - m)$

Hue calculation (hue range of 0 to 360):

red = 0°
if R = M then H = 60(b – g)
if G = M then H = 60(2 + r – b)
if B = M then H = 60(4 + g – r)

if H ≥ 360 then H = H – 360
if H < 0 then H = H + 360

blue = 0°
if R = M then H = 60(2 + b – g)
if G = M then H = 60(4 + r – b)
if B = M then H = 60(6 + g – r)

if H ≥ 360 then H = H – 360
if H < 0 then H = H + 360

HSI-to-RGB Conversion

Two sets of equations for calculating RGB values are provided: one set with red at 0° (to be compatible with the HSV convention) and one set with blue at 0° (Tektronix model).

Setup equations:

if I ≤ 0.5 then M = I (1 + S)
if I > 0.5 then M = I + S – IS
m = 2I – M
if S = 0 then R = G = B = I and H = 180°

Equations for calculating R (range of 0 to 1):

red = 0°
if H < 60 then R = M
if H < 120 then R = m + ((M – m) / ((120 – H) / 60))
if H < 240 then R = m
if H < 300 then R = m + ((M – m) / ((H – 240) / 60))
otherwise R = M

blue = 0°
if H < 60 then R = m + ((M – m) / (H / 60))
if H < 180 then R = M

if H < 240 then R = m + ((M – m) / ((240 – H) / 60))
otherwise R = m

Equations for calculating G (range of 0 to 1):

red = 0°
if H < 60 then G = m + ((M – m) / (H / 60))
if H < 180 then G = M
if H < 240 then G = m + ((M – m) / ((240 – H) / 60))
otherwise G = m

blue = 0°
if H < 120 then G = m
if H < 180 then G = m + ((M – m) / ((H – 120) / 60))
if H < 300 then G = M
otherwise G = m + ((M – m) / ((360 – H) / 60))

Equations for calculating B (range of 0 to 1):

red = 0°
if H < 120 then B = m
if H < 180 then B = m + ((M – m) / ((H – 120) / 60))if H < 300 then B = M
otherwise B = m + ((M – m) / ((360 – H) / 60))

blue = 0°
if H < 60 then B = M
if H < 120 then B = m + ((M – m) / ((120 – H) / 60))
if H < 240 then B = m
if H < 300 then B = m + ((M – m) / ((H – 240) / 60))
otherwise B = M

HSI-to-RGB and RGB-to-HSI Conversion (Method 2)

This implementation is used by Data Translation in their RGB/HSI converters. Intensity is

calculated as the average of R, G, and B. Saturation (S) is obtained by subtracting the lowest value of (R/I), (G/I), or (B/I) from 1. The RGB values have a normalized range of 0 to 1.

RGB-to-HSI Conversion

Setup equations

if G = B then F = 0
if G ≠ B then F = ((2R – G – B) / (G – B)) / SQRT(3)

if F ≠ 0 then A = arctan(F)
if F = 0 and R > (G or B) then A = +90
otherwise A = –90

if G ≥ B then X = 0
if G < B then X = 180

Intensity calculation (range of 0 to 1):

$$I = (R + G + B) / 3$$

Saturation calculation (range of 0 to 1):

if I = 0 then S = 0
if I ≠ 0 then S = 1 – (min(R,G,B) / I)

Hue calculation (range of 0 to 360):

$$H = 90 – A + X$$

HSI-to-RGB Conversion

L equals the min(R,G,B) value. M is the color 120° counterclockwise from L, and N is the color 120° counterclockwise from M. The SEL_0 and SEL_1 signals are used to map L, M, and N to R, G, and B, as shown below.

	SEL_1	SEL_0	K
0° < H ≤ 120°	0	0	(cos H) / (cos (60° – H))
120° < H ≤ 240°	0	1	(cos (H – 120°)) / (cos (60° – H + 120°))
240° < H ≤ 360°	1	1	(cos (H – 240°)) / (cos (60° – H + 240°))

	SEL_1 = 0 SEL_0 = 0	SEL_1 = 0 SEL_0 = 1	SEL_1 = 1 SEL_0 = 1
L = I – IS	blue	red	green
M = I + ISK	red	green	blue
N = 3I – (L + M)	green	blue	red

CMYK Color Space

The CMYK (cyan, magenta, yellow, black) color space commonly is used in color printers, due to the subtractive properties of inks. Cyan, magenta, and yellow are the complements of red, green, and blue, respectively, as shown in Figure 3.10, and are subtractive primaries because their effect is to subtract some color from white light. Color is specified by what is removed (or subtracted) from white light. When a surface is coated with cyan ink, no red light is reflected. Cyan subtracts red from the reflected white light (which is the sum of red, green, and blue). Therefore, in terms of additive primaries, cyan is blue plus green. Similarly, magenta absorbs green so it is red plus blue, while yellow absorbs blue so it is red plus green. A surface coated with cyan and yellow ink absorbs red and blue, leaving only green to be reflected from white light. A cyan, yellow,

and magenta surface absorbs red, green, and blue, and there is black. However, to maintain black color purity, a separate black ink is used rather than printing cyan, magenta, and yellow to generate black. As an interesting side note, white cannot be generated unless a white paper is used (i.e., white cannot be generated on blue paper).

RGB-to-CMYK Considerations

Lookup tables are typically used to nonlinear process the RGB data prior to converting it to the CMY color space. This takes into account the inks and paper used and is different from the RGB gamma correction used when generating video. Some systems have additional bit planes for black data, resulting in a 32-bit frame buffer (assuming 8 bits each for red, green, blue, and black). In this case, a lookup table for the black data is also useful.

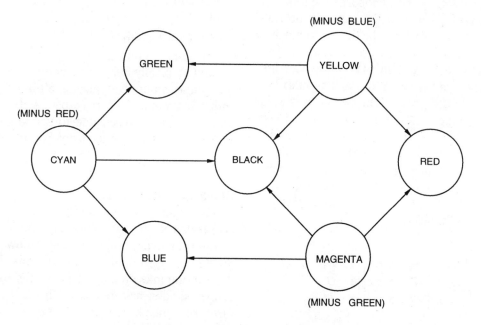

Figure 3.10. Subtractive Primaries (Cyan, Magenta, Yellow) and Their Mixtures.

Since ideally CMY is the complement of RGB, the following linear equations (known also as masking equations) were used initially to convert between RGB and CMY:

$$\begin{bmatrix} C \\ M \\ Y \end{bmatrix} = \begin{bmatrix} 1 \\ 1 \\ 1 \end{bmatrix} - \begin{bmatrix} R \\ G \\ B \end{bmatrix}$$

$$\begin{bmatrix} R \\ G \\ B \end{bmatrix} = \begin{bmatrix} 1 \\ 1 \\ 1 \end{bmatrix} - \begin{bmatrix} C \\ M \\ Y \end{bmatrix}$$

However, more accurate transformations account for the dependency of the inks and paper used. Slight adjustments, such as mixing the CMY data, are usually necessary. Yellow ink typically provides a relatively pure yellow (it absorbs most of the blue light and reflects practically all the red and green light). Magenta ink typically does a good job of absorbing green light, but absorbs too much of the blue light (visually, this makes it too reddish). The extra redness in the magenta ink may be compensated for by a reduction of yellow in areas that contain magenta. Cyan ink absorbs most of the red light (as it should) but also much of the green light (which it should reflect, making cyan more bluish than it should be). The extra blue in cyan ink may be compensated for by a reduction of magenta in areas that contain cyan. All of these simple color adjustments, as well as the linear conversion from RGB to CMY, may be done using a 3 × 3 matrix multiplication:

$$\begin{bmatrix} C \\ M \\ Y \end{bmatrix} = \begin{bmatrix} m1 & m2 & m3 \\ m4 & m5 & m6 \\ m7 & m8 & m9 \end{bmatrix} \begin{bmatrix} 1-R \\ 1-G \\ 1-B \end{bmatrix}$$

The coefficients m1, m5, and m9 are values near unity, and the other coefficients are small in comparison. The RGB lookup tables may be used to perform the normalized (1 − R), (1 − G), and (1 − B) conversion, as well as nonlinear correction. In cases where the inks and paper are known and relatively constant (such as a color laser printer), the coefficients may be determined empirically and fixed coefficient multipliers used. Note that saturation circuitry is required on the outputs of the 3 × 3 matrix multiplier. The circuitry must saturate to the maximum digital value (i.e., 255 in an 8-bit system) when an overflow condition occurs and saturate to the minimum digital value (i.e., 0) when an underflow condition occurs. Without the saturation circuitry, overflow or underflow errors may be generated due to the finite precision of the digital logic.

More sophisticated nonlinear RGB-to-CMY conversion techniques are used in high-end systems. These are typically based on tri-linear interpolation (using lookup tables) or the Neugebauer equations (which were originally designed to perform the CMYK-to-RGB conversion).

Under Color Removal

Under color removal (UCR) removes some amount (typically 30%) of magenta under cyan and some amount (typically 50%) of yellow under magenta. This may be used to solve problems encountered due to printing an ink when one or more other layers of ink are still wet.

Black Generation

Ideally, cyan, magenta, and yellow are all that are required to generate any color. Equal amounts of cyan, magenta, and yellow should create the equivalent amount of black. In reality, printing inks do not mix perfectly, and dark brown shades are generated instead. Therefore, real black ink is substituted for the mixed-black color to obtain a truer color print. Black generation is the process of calculating the amount of black to be used.

There are several methods of generating black information. The applications software may generate black along with CMY data. In this instance, black need not be calculated; however, UCR and gray component replacement (GCR) may still need to be performed. One common method of generating black is to set the black component equal to the minimum value of (C, M, Y). For example, if

$$(C, M, Y) = (0.25, 0.5, 0.75)$$

the black component (K) = 0.25.

In many cases, it is desirable to have a specified minimum value of (C,M,Y) before the generation of any black information. For example, K may increase (either linearly or nonlinearly) from 0 at $\min(C,M,Y) \leq 0.5$ to 1 at $\min(C,M,Y) = 1$. Adjustability to handle extra black, less black, or no black is also desirable. This can be handled by a programmable lookup table.

Gray Component Replacement

Gray component replacement (GCR) is the process of reducing the amount of cyan, magenta, and yellow components to compensate for the amount of black that is added by black generation. For example, if

$$(C, M, Y) = (0.25, 0.5, 0.75)$$

and

black (K) = 0.25

0.25 (the K value) is subtracted from each of the C, M, and Y values, resulting in:

$$(C, M, Y) = (0, 0.25, 0.5)$$

black (K) = 0.25

The amount removed from C, M, and Y may be exactly the same amount as the black generation, zero (so no color is removed from the cyan, magenta, and yellow components), or some fraction of the black component. Pro-grammable lookup tables for the cyan, magenta, and yellow colors may be used to implement a nonlinear function on the color data.

Desktop Color Publishing Considerations

Users of color desktop publishing have discovered that the printed colors rarely match what is displayed on the CRT. This is because several factors affect the color of images on the CRT, such as the level of ambient light and its color temperature, what type of phosphors the CRT uses and their age, the brightness and contrast settings of the display, and what inks and paper the color printer uses. All of these factors should be taken into account when accurate RGB-to-CMYK or CMYK-to-RGB conversion is required. Some high-end systems use an intermediate color space to simplify performing the adjustments. Very experienced users know what color will be printed versus the displayed color; however, this is unacceptable for the mass market.

Since the CMYK printable color gamut is less than the displayable RGB color gamut, some systems use the CMYK color space in the frame buffer and perform CMYK-to-RGB conversion to drive the display. This helps prevent the problem of trying to specify an unprintable color.

CIE 1931 Chromaticity Diagram

The color gamut perceived by a person with normal vision (the 1931 CIE Standard Observer) is shown in Figure 3.11. Color perception was measured by viewing combinations of the three standard CIE (International Commission on Illumination or Commission

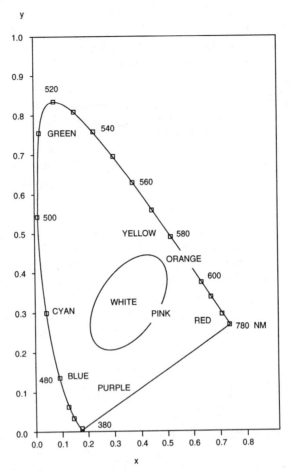

**Figure 3.11. CIE 1931 Chromaticity Diagram
Showing Various Color Regions.**

Internationale de l'Eclairage) primary colors: red with a 700-nm wavelength, green at 546.1 nm, and blue at 435.8 nm. These primary colors, and the other spectrally pure colors resulting from mixing of the primary colors, are located along the outer boundary of the diagram. Colors within the boundary are perceived as becoming more pastel as the center of the diagram (white) is approached.

Each point on the diagram, representing a unique color, may be identified by two coordinates, x and y. Typically, a camera or display specifies three of these (x, y) coordinates to define the three primary colors it uses; the triangle formed by the three (x, y) coordinates encloses the gamut of colors that the camera can capture or the display can reproduce. This is shown in Figure 3.12, which compares the

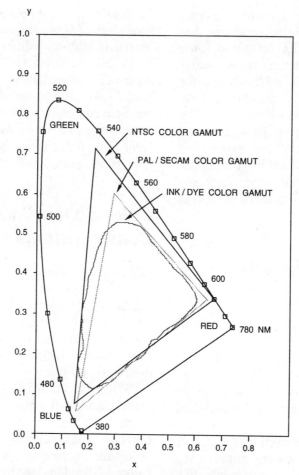

Figure 3.12. CIE 1931 Chromaticity Diagram Showing the Color Gamuts of Phosphors Used in NTSC, PAL, and SECAM Systems and of Typical Inks and Dyes.

color gamuts of NTSC, PAL/SECAM, and typical inks and dyes.

In addition, a camera or display usually specifies the (x, y) coordinate of the white color used, since pure white is not usually captured or reproduced. White is defined as the color captured or produced when all three primary signals are equal, and it has a subtle shade of color to it. The standard "white" in video is Illuminant D_{65} (at $x = 0.313$ and $y = 0.329$). Note that luminance, or brightness information, is not included in the standard CIE 1931 chromaticity diagram, but is an axis that is orthogonal to the (x, y) plane. The lighter a color is, the more restricted the chromaticity range is, much like the HSI and HSV color spaces.

It is interesting to note that over the years color accuracy of television receivers has declined while brightness has increased. Early color televisions didn't sell well because they were dim compared to their black-and-white counterparts. Television manufacturers have changed the display phosphors from the NTSC/PAL standard colors to phosphors that produce brighter images at the expense of color accuracy. Over the years, brightness has become even more important since television is as likely to be viewed in the afternoon sun as in a darkened room.

Non-RGB Color Space Considerations

When processing information in a non-RGB color space (such as YIQ, YUV, YCbCr, etc.), care must be taken that combinations of values are not created that result in the generation of invalid RGB colors. The term invalid refers to RGB components outside specified normalized RGB limits of (1, 1, 1). For example, if the luma (Y) component is at its maximum (white) or minimum (black) level, then any nonzero values of the color difference components (IQ, UV, CbCr, etc.) will give invalid values of RGB. As a specific example, given that RGB has a normalized value of (1, 1, 1), the resulting YCbCr value is (235, 128, 128). If Cb and Cr are manipulated to generate a YCbCr value of (235, 64, 73), the corresponding RGB normalized value becomes (0.6, 1.29, 0.56)—note that the green value exceeds the normalized value of 1. From this illustration it is obvious that there are many combinations of Y, Cb, and Cr that result in invalid RGB values; these YCbCr values must be processed so as to generate valid RGB values. Figure 3.13 shows the RGB normalized limits transformed into the YCbCr color space.

Best results are obtained using a constant luma and constant hue approach—Y is not altered and the color difference values (Cb and Cr in this example) are limited to the maximum valid values having the same hue as the invalid color prior to limiting. The constant hue principle corresponds to moving invalid CbCr combinations directly towards the CbCr origin (128, 128), until they lie on the surface of the valid YCbCr color block.

Color Space Conversion Considerations

ROM lookup tables can be used to implement multiplication factors; however, a minimum of 4 bits of fractional color data (professional applications may require 8 to 10 bits of fractional data) should be maintained up to the final result, which is then rounded to the desired precision.

When converting to the RGB color space from a non-RGB color space, care must be taken to include saturation logic to ensure overflow and underflow conditions do not occur due to the finite precision of digital circuitry. RGB values less than 0 must be set to 0, and values greater than 255 must be set to 255 (assuming 8-bit data).

Gamma Correction

Many display devices use the cathode-ray picture tube (CRT). The transfer function of the CRT produces intensity that is proportional to some power (usually about 2.5 and referred to as gamma) of the signal voltage. As a result, high-intensity ranges are expanded, and low-intensity ranges are compressed (see Figure 3.14). This is an advantage in combatting noise introduced by the transmission process, as the

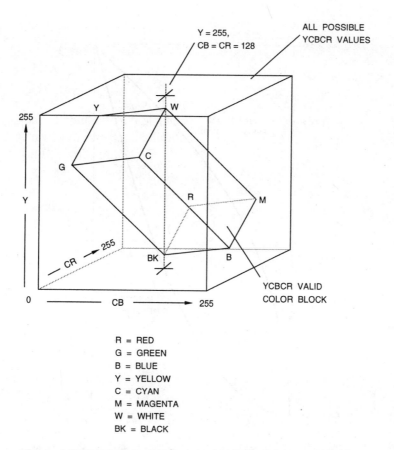

R = RED
G = GREEN
B = BLUE
Y = YELLOW
C = CYAN
M = MAGENTA
W = WHITE
BK = BLACK

Figure 3.13. RGB Limits Transformed into 3-D YCbCr Space.

eye is approximately equally sensitive to equally relative intensity changes. By "gamma correcting" the video signals before use, the intensity output of the CRT is roughly linear (the gray line in Figure 3.14), and transmission-induced noise is reduced.

Gamma factors of 2.2 are typical in the consumer video environment. Until recently, sys-

tems assumed a simple transformation (values are normalized to have a range of 0 to 1):

$$R_{display} = R_{received}^{2.2}$$
$$G_{display} = G_{received}^{2.2}$$
$$B_{display} = B_{received}^{2.2}$$

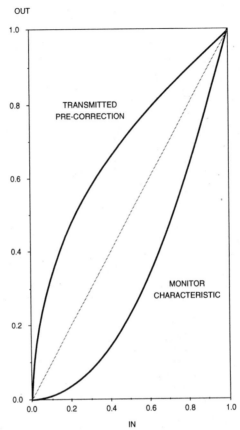

Figure 3.14. The Effect of Gamma Correction.

To compensate for the nonlinear processing at the display, linear RGB data was "gamma-corrected" prior to use (values are normalized to have a range of 0 to 1):

$$R_{transmit} = R^{0.45}$$
$$G_{transmit} = G^{0.45}$$
$$B_{transmit} = B^{0.45}$$

Although NTSC video signals typically assume the receiver has a gamma of 2.2, a gamma of 2.35 to 2.55 is more realistic. How-ever, this difference is often ignored, which improves the viewing in dimly lit environments, such as the home. More accurate viewing in brightly lit environments, such as on the office computer, may be accomplished by applying another gamma factor of 1.1 to 1.2.

To minimize noise in the darker areas of the image, modern video systems limit the gain of the curve in the black region. Assuming values are normalized to have a range of 0 to 1, gamma correction would be applied to linear RGB data prior to use as follows:

for R, G, B < 0.018
$$R_{transmit} = 4.5\ R$$
$$G_{transmit} = 4.5\ G$$
$$B_{transmit} = 4.5\ B$$

for R, G, B ≥ 0.018
$$R_{transmit} = 1.099\ R^{0.45} - 0.099$$
$$G_{transmit} = 1.099\ G^{0.45} - 0.099$$
$$B_{transmit} = 1.099\ B^{0.45} - 0.099$$

This limits the gain close to black and stretches the remainder of the curve to maintain function and tangent continuity.

Although the PAL standards specify a value of 2.8, a value of 2.2 is actually used.

The receiver is assumed to perform the inverse function (values are normalized to have a range of 0 to 1):

for $(R, G, B)_{received} < 0.0812$
$$R_{display} = R_{received} / 4.5$$
$$G_{display} = G_{received} / 4.5$$
$$B_{display} = B_{received} / 4.5$$

for $(R, G, B)_{received} \geq 0.0812$
$$R_{display} = ((R_{received} + 0.099) / 1.099)^{2.2}$$
$$G_{display} = ((G_{received} + 0.099) / 1.099)^{2.2}$$
$$B_{display} = ((B_{received} + 0.099) / 1.099)^{2.2}$$

VLSI Solutions

See C3_VLSI

References

1. Alexander, George A., *Color Reproduction: Theory and Practice, Old and New. The Seybold Report on Desktop Publishing*, September 20, 1989.
2. Benson, K. Blair, *Television Engineering Handbook*. McGraw-Hill, Inc., 1986.
3. Clarke, C.K.P., 1986, *Colour Encoding and Decoding Techniques for Line-Locked Sampled PAL and NTSC Television Signals*, BBC Research Department Report BBC RD1986/2.
4. Data Translation, DT7910/DT7911 datasheet, 1989.
5. Devereux, V. G., 1987, *Limiting of YUV digital video signals*, BBC Research Department Report BBC RD1987 22.
6. EIA Standard EIA-189-A, July 1976, *Encoded Color Bar Signal*.
7. Faroudja, Yves Charles, *NTSC and Beyond. IEEE Transactions on Consumer Electronics*, Vol. 34, No. 1, February 1988.
8. GEC Plessey Semiconductors, *VP510 datasheet*, January 1993.
9. ITU-R Report BT.470, 1994, *Characteristics of Television Systems*.
10. Philips Semiconductors, *Desktop Video Data Handbook*, 1995.
11. Poynton, Charles A., *A Technical Introduction to Digital Video*, John Wiley & Sons, 1996.
12. Raytheon Semiconductor, 1994 Databook.
13. SGS-Thomson Microelectronics, STV3300 datasheet, September 1989.
14. *Specification of Television Standards for 625-Line System-I Transmissions*, 1971. Independent Television Authority (ITA) and British Broadcasting Corporation (BBC).

Video Overview

To fully understand the NTSC, PAL, and SECAM encoding and decoding processes, it is helpful to review the background of these standards and how they came about. Although these are the primary consumer video standards, there are several component analog standards used in professional areas (the digital video standards are covered in Chapters 7, 8, and 14).

Many organizations, some of which are listed below, are involved in specifying video standards, depending on the country. Their addresses are included at the end of the chapter.

EBU	European Broadcasting Union
EIA	Electronic Industries Association
IEEE	Institute of Electrical and Electronics Engineers
ITU	International Telecommunications Union
SMPTE	Society of Motion Picture and Television Engineers

NTSC Overview

The first color television system was developed in the United States, and on December 17, 1953, the Federal Communications Commission (FCC) approved the transmission standard, with broadcasting approved to begin January 23, 1954. Most of the work for developing a color transmission standard that was compatible with the (then current) 525-line, 60-field/second, 2:1 interlaced monochrome standard was done by the National Television System Committee (NTSC).

The luma (monochrome) signal is derived from gamma-corrected red, green, and blue (R'G'B') signals, tailored in proportion to the standard luminosity curve for the particular values of dominant wavelength represented by the three color primaries chosen for the receiver:

$$Y \text{ (luma)} = 0.299R' + 0.587G' + 0.114B'$$

Due to the sound subcarrier at 4.5 MHz, a requirement was made that the color signal

must occupy the same bandwidth as a monochrome video signal (0–4.2 MHz). For economic reasons, another requirement was made that monochrome receivers must be able to display the luminance (brightness) portion of a color broadcast and that color receivers must be able to display the luminance (brightness) portion of a monochrome broadcast.

Gamma correction is applied to compensate for the nonlinear voltage-to-light characteristics of the receiver, and provides the additional benefit of increasing the signal-to-noise ratio during transmission. NTSC systems assume a gamma of 2.2 at the receiver; in other words, the transfer function of the receiver is assumed to be (values are normalized to have a value of 0 to 1):

for R′, G′, B′ < 0.0812

$$R = R'/4.5$$
$$G = G'/4.5$$
$$B = B'/4.5$$

for R′, G′, B′ ≥ 0.0812

$$R = ((R' + 0.099)/1.099)^{2.2}$$
$$G = ((G' + 0.099)/1.099)^{2.2}$$
$$B = ((B' + 0.099)/1.099)^{2.2}$$

To have the transfer function from the video source to the receiver display be linear, the total processing of the RGB signals before transmission therefore should be (values are normalized to have a value of 0 to 1):

for R, G, B < 0.018

$$R' = 4.5 R$$
$$G' = 4.5 G$$
$$B' = 4.5 B$$

for R, G, B ≥ 0.018

$$R' = 1.099 R^{0.45} - 0.099$$
$$G' = 1.099 G^{0.45} - 0.099$$
$$B' = 1.099 B^{0.45} - 0.099$$

The eye is most sensitive to spatial and temporal variations in luminance; therefore, luma information was allowed the entire bandwidth available (0–4.2 MHz). Color information, to which the eye is less sensitive and which thus requires less bandwidth, is represented as hue and saturation information. This hue and saturation information is transmitted using a 3.58-MHz subcarrier, encoded so that the receiver can separate the hue, saturation, and luma information and convert it back to RGB signals for display. Although this allows the transmission of color signals in the same bandwidth as monochrome signals, the problem still remains as to how to ideally separate the color and luma information, since they occupy the same portion of the frequency spectrum.

To transmit hue and saturation color information, color difference signals, which specify the differences between the luma signal and the basic RGB signals, are used:

$$R' - Y = 0.701R' - 0.587G' - 0.114B'$$
$$B' - Y = -0.299R' - 0.587G' + 0.886B'$$
$$U = 0.492(B' - Y)$$
$$V = 0.877(R' - Y)$$

Many equations for U used a 0.493 scaling factor due to an apparent error in the 1953 calculations (a 0.115 matrix coefficient was used instead of the correct 0.114).

I and Q were chosen as the color difference components since they more closely relate to the variation of color acuity than U and V. The color response of the eye decreases as the size of the viewed object decreases. Small objects, occupying frequencies of 1.3–2.0 MHz, provide little color sensation. Medium objects, occupying the 0.6–1.3 MHz frequency range, are acceptable if reproduced along the orange-cyan axis. Larger objects, occupying the 0–0.6 MHz frequency range, require full

three-color reproduction. The I and Q band-widths were chosen accordingly, and the preferred color reproduction axis was obtained by rotating the R′ – Y and B′ – Y axes by 33°. The Q component, representing the green-purple color axis, was band-limited to about 0.6 MHz. The I component, representing the orange-cyan color axis, was band-limited to about 1.3 MHz.

Advances in electronics, particularly in the digital area, have prompted some changes. Both I and Q may now be bandwidth-limited to 0.6 MHz (consumer) or 1.3 MHz (studio). Alternately, U and V may be used, again bandwidth-limited to either 0.6 MHz or 1.3 MHz, depending on the design. A greater amount of processing is required in the decoder to achieve acceptable results when both I and Q,

or U and V, have a 1.3-MHz bandwidth due to both components being asymmetrical signals.

I and Q may be derived from gamma-corrected RGB, U and V, or R′ – Y and B′ – Y signals as follows:

$$
\begin{aligned}
I &= 0.596R' - 0.275G' - 0.321B' \\
&= V\cos 33° - U\sin 33° \\
&= 0.736(R' - Y) - 0.268(B' - Y)
\end{aligned}
$$

$$
\begin{aligned}
Q &= 0.212R' - 0.523G' + 0.311B' \\
&= V\sin 33° + U\cos 33° \\
&= 0.478(R' - Y) + 0.413(B' - Y)
\end{aligned}
$$

The IQ vector diagram illustrating the I and Q axes is shown in Figure 4.1.

As a side note, the scaling factors to derive U and V from (B′ – Y) and (R′ – Y) were

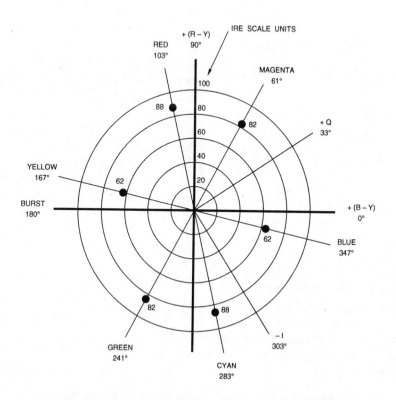

Figure 4.1. IQ Vector Diagram for 75% Amplitude, 100% Saturation EIA Color Bars.

derived due to overmodulation considerations during transmission. If the full range of (B′ − Y) and (R′ − Y) were to be used, the modulated chroma levels would exceed what the (then current) black-and-white television transmitters and receivers were capable of supporting. Experimentation determined that modulated subcarrier excursions of 20% of the luma (Y) signal excursion could be permitted above white and below black. The scaling factors were then selected so that the maximum level of 75% amplitude, 100% saturation yellow and cyan color bars would be at the white level (100 IRE).

I and Q (or U and V) are used to modulate the 3.58-MHz color subcarrier using two balanced modulators operating in phase quadrature (one modulator is driven by the subcarrier at sine phase; the other modulator is driven by the subcarrier at cosine phase). The outputs of the modulators are added together to form the composite chrominance signal:

$$C = Q \sin(\omega t + 33°) + I \cos(\omega t + 33°)$$
$$\omega = 2\pi F_{SC}$$
$$F_{SC} = 3.579545 \text{ MHz } (\pm 10 \text{ Hz})$$

or, if U and V are used instead of I and Q:

$$C = U \sin \omega t + V \cos \omega t$$

Hue information is conveyed by the chroma phase relative to the subcarrier. Saturation information is conveyed by the ratio of the chroma amplitude to the corresponding luma level. In addition, if an object has no color (such as a white, gray, or black object), the subcarrier is suppressed. The modulated chroma is added to the luma information along with appropriate horizontal and vertical sync signals, blanking signals, and color burst signals, to generate the composite color video waveform shown in Figure 4.2.

$$\text{composite NTSC} = Y + Q \sin(\omega t + 33°)$$
$$+ I \cos(\omega t + 33°)$$

or, if U and V are used instead of I and Q:

$$\text{composite NTSC} = Y + U \sin \omega t + V \cos \omega t$$

The bandwidth of the resulting composite video signal is shown in Figure 4.3. The amplitude of the modulated chroma is:

$$\sqrt{I^2 + Q^2}$$

or

$$\sqrt{U^2 + V^2}$$

The I and Q (or U and V) information can be transmitted without loss of identity as long as the proper subcarrier phase relationship is maintained at the encoding and decoding process. The color burst signal, consisting of nine cycles of the subcarrier frequency at a specific phase, follows each horizontal sync pulse and provides the decoder a reference signal so as to be able to properly recover the I and Q (or U and V) signals. The color burst phase is defined to be along the −(B′ − Y) axis as shown in Figure 4.1.

The specific choice for the color subcarrier frequency was dictated by several factors. The first is the need to provide horizontal interlace to reduce the visibility of the subcarrier, requiring that the subcarrier frequency, F_{SC}, be an odd multiple of one-half the horizontal line rate. The second factor is selection of a high enough frequency that it generates a fine interference pattern having low visibility. Third, double sidebands for I and Q (or U and V) bandwidths below 0.6 MHz must be allowed. The choice of the frequencies is:

$$F_H = (4.5 \times 10^6 / 286) \text{ Hz} = 15{,}734.27 \text{ Hz}$$

$$F_V = F_H / (525/2) = 59.94 \text{ Hz}$$

$$F_{SC} = ((13 \times 7 \times 5)/2) \times F_H = (455/2) \times F_H$$
$$= 3.579545 \text{ MHz}$$

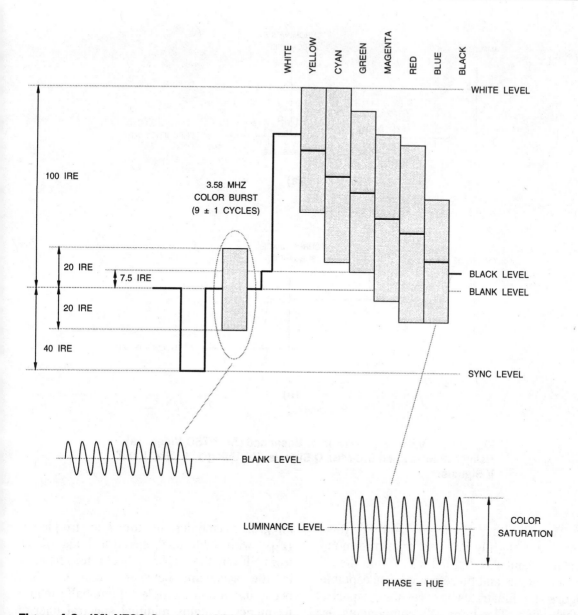

Figure 4.2. (M) NTSC Composite Video Signal for 75% Amplitude, 100% Saturation EIA Color Bars.

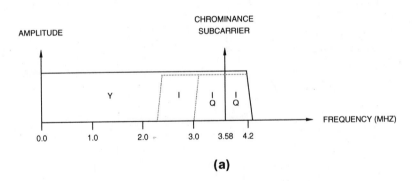

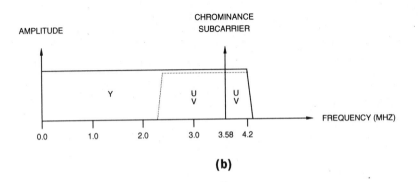

**Figure 4.3. Video Bandwidths of Baseband (M) NTSC Video. (a)
Using 1.3-MHz I and 0.6-MHz Q Signals. (b) Using 1.3-MHz U and
V Signals.**

The resulting F_V (field) and F_H (line) rates were slightly different from the monochrome standards, but fell well within the tolerance ranges and therefore were acceptable. Figure 4.4 illustrates the resulting spectral interleaving. The luma (Y) components are modulated due to the horizontal blanking process, resulting in bunches of luma information spaced at intervals of F_H. These signals are further modulated by the vertical blanking process, resulting in luma frequency components occurring at $NF_H \pm MF_V$ (N has a maximum value of about 277 with a 4.2-MHz bandwidth-limited luma). Thus, luma information is limited to areas about integral harmonics of the line frequency (F_H), with additional spectral lines offset from NF_H by the 30-Hz vertical rate. The area in the spectrum between luma bunches occurring at odd multiples of one-half the line frequency contains minimal spectral energy and therefore may be used for the transmission of chroma information. The harmonics of the color subcarrier are separated from each other by F_H since they are odd multiples of $1/2 F_H$, providing a half-line offset and resulting in an interlace pattern that moves upward. Four complete fields are required to repeat a specific pixel position, as shown in Figure 4.5.

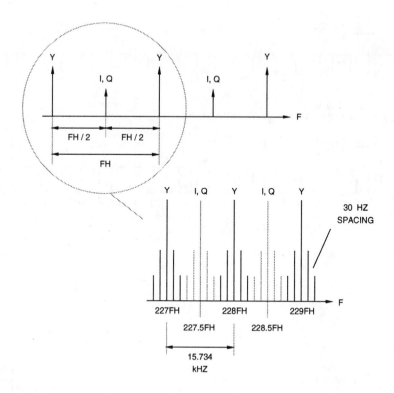

Figure 4.4. Luma/Chroma Horizontal Frequency Interleave Principle. Note that 227.5F$_H$ = F$_{SC}$.

An advantage of limiting the bandwidth of I and Q to 1.3 MHz and 0.6 MHz, respectively, at the decoder is to minimize crosstalk due to asymmetrical sidebands as a result of lowpass filtering the composite video signal to about 4.2 MHz. With the subcarrier at 3.58 MHz, the Q component is a double sideband signal; however, the I component will be asymmetrical, bringing up the possibility of crosstalk between I and Q. The symmetry of the Q component avoids crosstalk into the I component; since Q is bandwidth limited to 0.6 MHz, I crosstalk falls outside the Q component bandwidth.

There are two unofficial, but common, variations of NTSC. The first, called "NTSC 4.43," is a combination NTSC and PAL video signal sometimes used during standards conversion. The horizontal and vertical timing is the same as (M) NTSC; color encoding uses the (B, D, G, H, I) PAL modulation format and color subcarrier frequency.

The generation of 262-line, 30 frames/sec "noninterlaced NTSC," shown in Figure 4.6, is also common among video games and on-screen displays. This format is identical to standard (M) NTSC, except that there are 262 lines per field (actually, per frame since it is noninterlaced). To generate noninterlaced NTSC, the encoder is operated normally, except for the horizontal and vertical sync timing being noninterlaced.

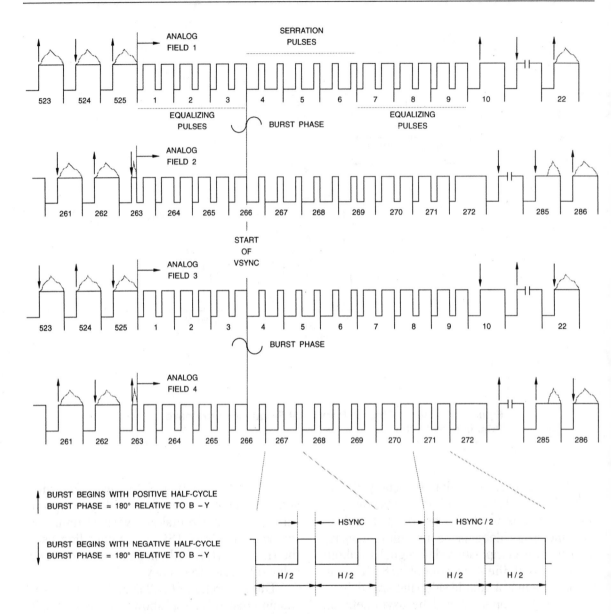

Figure 4.5. Four-field (M) NTSC Format and Burst Blanking.

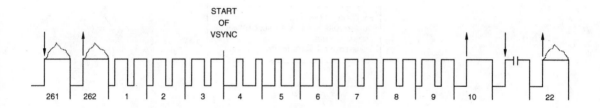

BURST BEGINS WITH POSITIVE HALF-CYCLE
BURST PHASE = REFERENCE PHASE = 180° RELATIVE TO B – Y

BURST BEGINS WITH NEGATIVE HALF-CYCLE
BURST PHASE = REFERENCE PHASE = 180° RELATIVE TO B – Y

Figure 4.6. Noninterlaced NTSC Timing.

Usage by Country

Figure 4.7 shows the ITU designations for NTSC systems. The letter "M" refers to the monochrome standard for line and field rates (525/59.94), a video bandwidth of 4.2 MHz, an audio carrier frequency 4.5 MHz above the video carrier frequency, and a RF channel bandwidth of 6 MHz. The "NTSC" refers to the technique to add color information to the monochrome signal. Detailed timing parameters can be found in Table 4.9.

The following countries use, or are planning to use, the (M) NTSC standard, according to ITU-R BT.470-3 (1994) and other sources. Unless indicated by a (V) that only VHF is supported, (M) NTSC is used for both VHF and UHF transmission.

Antigua
Aruba
Bahamas (V)
Barbados (V)
Belize (V)
Bermuda (V)
Bolivia
Burma (V)
Canada
Chile
Colombia
Costa Rica
Cuba
Curacao
Dominican Republic
Ecuador
El Salvador (V)
Guam (V)
Guatemala
Honduras

Jamaica
Japan
Korea (South)
Mexico
Montserrat (V)
Myanmar (V)
Nicaragua
Panama
Peru
Philippines
Puerto Rico
St. Christopher and
 Nevis (V)
Samoa (V)
Suriname (V)
Taiwan (V)
Trinidad/Tobago (V)
United States of
 America
Venezuela
Virgin Islands (V)

Figure 4.7. Summary ITU Designation for NTSC Systems.

RF Modulation

Figures 4.8, 4.9, and 4.10 illustrate the basic process of converting baseband (M) NTSC composite video to an RF (radio frequency) signal. Anyone interested in actually designing an RF audio/video modulator should refer to the references at the end of the chapter.

Figure 4.8a shows the frequency spectrum of a baseband composite video signal. It is similar to Figure 4.3. However, Figure 4.3 only shows the upper sideband for simplicity. The "video carrier" notation at 0 MHz serves only as a reference point for comparison with Figure 4.8b.

Figure 4.8b shows the audio/video signal as it resides within a 6-MHz video channel (such as channel 3). The video signal has been lowpass filtered, most of the lower sideband has been removed, and audio information has been added. Figure 4.8c details the information present on the audio subcarrier for stereo (MTS) operation.

As shown in Figures 4.9 and 4.10, back porch clamping of the baseband composite analog video signal ensures that the back porch level is constant, regardless of changes in the average picture level. White clipping of the baseband video signal prevents the negative polarity video modulation signal from going below 10%; below 10% may result in overmodulation and "buzzing" in television receivers. The baseband composite video signal is then lowpass filtered to 4.2 MHz and drives the AM (amplitude modulation) video modulator. The sync level corresponds to 100% modulation, the blanking corresponds to 75%, and the white level corresponds to 10%. (M) NTSC systems use an IF (intermediate frequency) for the video of 45.75 MHz.

At this point, audio information is added on a subcarrier at 41.25 MHz. A monaural audio signal is processed as shown in Figure 4.9 and drives the FM (frequency modulation) modulator. The output of the FM modulator is added to the IF video signal.

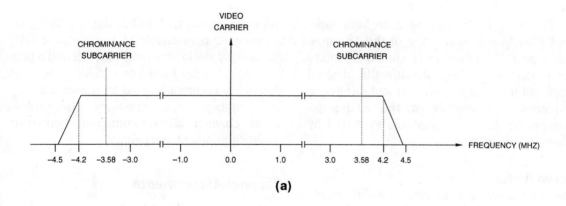

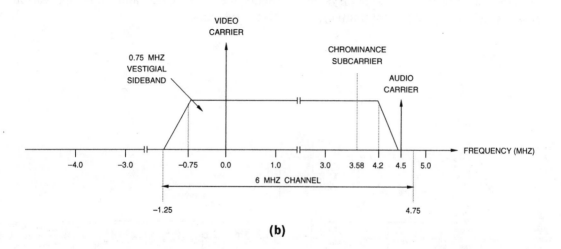

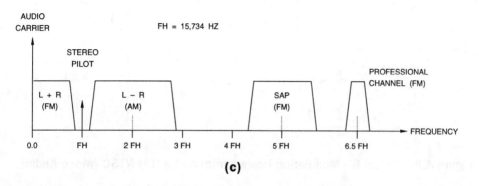

Figure 4.8. Transmission Channel for (M) NTSC: (a) Frequency Spectrum of Baseband Composite Video, (b) Frequency Spectrum of Typical Channel Including Audio Information, (c) Detailed Frequency Spectrum of Stereo Audio (MTS) Information.

The SAW filter, used as a vestigial side-band filter, provides filtering of the IF-modulated signal. The mixer, or up converter, mixes the modulated IF signal with the desired broadcast frequency. Both sum and difference frequencies are generated by the mixing process, so the difference signal is extracted by using a bandpass filter.

Stereo Audio

The implementation of stereo audio in the United States, also known as MTS (multichannel television sound) or the BTSC system (broadcast television systems committee), is shown in Figure 4.10. In addition to adding L–R information to enable stereo audio, a SAP (secondary audio program) channel and a professional channel have been added. The SAP channel is commonly used to transmit a second language or commentary. The professional channel allows communication with remote equipment and people.

Channel Assignments

Tables 4.1 through 4.4 list the channel assignments for VHF, UHF, and cable for various NTSC systems.

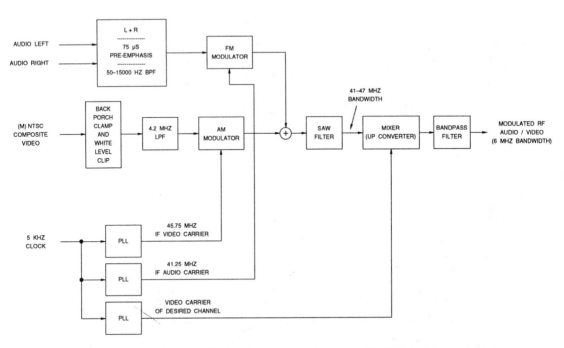

Figure 4.9. Typical RF Modulation Implementation for (M) NTSC (Mono Audio).

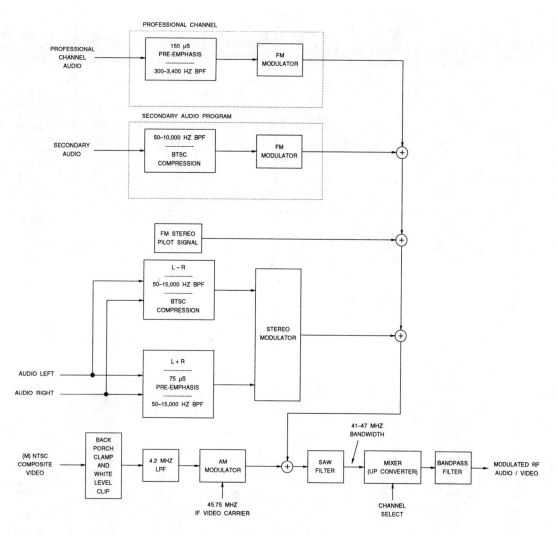

Figure 4.10. Typical RF Modulation Implementation for (M) NTSC in the USA (Stereo Audio).

Broadcast Channel	Video Carrier (MHz)	Audio Carrier (MHz)	Channel Range (MHz)	Broadcast Channel	Video Carrier (MHz)	Audio Carrier (MHz)	Channel Range (MHz)
–	–	–	–	30	567.25	571.75	566–572
–	–	–	–	31	573.25	577.75	572–578
2	55.25	59.75	54–60	32	579.25	583.75	578–584
3	61.25	65.75	60–66	33	585.25	589.75	584–590
4	67.25	71.75	66–72	34	591.25	595.75	590–596
5	77.25	81.75	76–82	35	597.25	601.75	596–602
6	83.25	87.75	82–88	36	603.25	607.75	602–608
7	175.25	179.75	174–180	37	609.25	613.75	608–614
8	181.25	185.75	180–186	38	615.25	619.75	614–620
9	187.25	191.75	186–192	39	621.25	625.75	620–626
10	193.25	197.75	192–198	40	627.25	631.75	626–632
11	199.25	203.75	198–204	41	633.25	637.75	632–638
12	205.25	209.75	204–210	42	639.25	643.75	638–644
13	211.25	215.75	210–216	43	645.25	649.75	644–650
14	471.25	475.75	470–476	44	651.25	655.75	650–656
15	477.25	481.75	476–482	45	657.25	661.75	656–662
16	483.25	487.75	482–488	46	663.25	667.75	662–668
17	489.25	493.75	488–494	47	669.25	673.75	668–674
18	495.25	499.75	494–500	48	675.25	679.75	674–680
19	501.25	505.75	500–506	49	681.25	685.75	680–686
20	507.25	511.75	506–512	50	687.25	691.75	686–692
21	513.25	517.75	512–518	51	693.25	697.75	692–698
22	519.25	523.75	518–524	52	699.25	703.75	698–704
23	525.25	529.75	524–530	53	705.25	709.75	704–710
24	531.25	535.75	530–536	54	711.25	715.75	710–716
25	537.25	541.75	536–542	55	717.25	721.75	716–722
26	543.25	547.75	542–548	56	723.25	727.75	722–728
27	549.25	553.75	548–554	57	729.25	733.75	728–734
28	555.25	559.75	554–560	58	735.25	739.75	734–740
29	561.25	565.75	560–566	59	741.25	745.75	740–746
60	747.25	751.75	746–752	65	777.25	781.75	776–782
61	753.25	757.75	752–758	66	783.25	787.75	782–788
62	759.25	763.75	758–764	67	789.25	793.75	788–794
63	765.25	769.75	764–770	68	795.25	799.75	794–800
64	771.25	775.75	770–776	69	801.25	805.75	800–806

Table 4.1. Nominal VHF and UHF Broadcast Frequencies for (M) NTSC in North and South America.

Broadcast Channel	Video Carrier (MHz)	Audio Carrier (MHz)	Channel Range (MHz)
1	91.25	95.75	90–96
2	97.25	101.75	96–102
3	103.25	107.75	102–108
4	171.25	175.75	170–176
5	177.25	181.75	176–182
6	183.25	187.75	182–188
7	189.25	193.75	188–194
8	193.25	197.75	192–198
9	199.25	203.75	198–204
10	205.25	209.75	204–210
11	211.25	215.75	210–216
12	217.25	221.75	216–222
45	663.25	667.75	662–668
46	669.25	673.75	668–674
47	675.25	679.75	674–680
48	681.25	685.75	680–686
49	687.25	691.75	686–692
50	693.25	697.75	692–698
51	699.25	703.75	698–704
52	705.25	709.75	704–710
53	711.25	715.75	710–716
54	717.25	721.75	716–722
55	723.25	727.75	722–728
56	729.25	733.75	728–734
57	735.25	739.75	734–740
58	741.25	745.75	740–746
59	747.25	751.75	746–752
60	753.25	757.75	752–758
61	759.25	763.75	758–764
62	765.25	769.75	764–770

Table 4.2. Nominal VHF and UHF Broadcast Frequencies for (M) NTSC in Japan.

Cable Channel	Video Carrier (MHz)	Audio Carrier (MHz)	Channel Range (MHz)	Cable Channel	Video Carrier (MHz)	Audio Carrier (MHz)	Channel Range (MHz)
2	55.25	59.75	54–60	30	259.25	263.75	258–264
3	61.25	65.75	60–66	31	265.25	269.75	264–270
4	67.25	71.75	66–72	32	271.25	275.75	270–276
1	73.25	77.75	72–78	33	277.25	281.75	276–282
5	79.25	83.75	76–82	34	283.25	287.75	282–288
6	85.25	89.75	82–88	35	289.25	293.75	288–294
95	91.25	95.75	90–96	36	295.25	299.75	294–300
96	97.25	101.75	96–102	37	301.25	305.75	300–306
97	103.25	107.75	102–108	38	307.25	311.75	306–312
98	109.25	113.75	108–114	39	313.25	317.75	312–318
99	115.25	119.75	114–120	–	–	–	–
14	121.25	125.75	120–126	40	319.25	323.75	318–324
15	127.25	131.75	126–132	41	325.25	329.75	324–330
16	133.25	137.75	132–138	42	331.25	335.75	330–336
17	139.25	143.75	138–144	43	337.25	341.75	336–342
18	145.25	149.75	144–150	44	343.25	347.75	342–348
19	151.25	155.75	150–156	45	349.25	353.75	348–354
20	157.25	161.75	156–162	46	355.25	359.75	354–360
21	163.25	167.75	162–168	47	361.25	365.75	360–366
22	169.25	173.75	168–174	48	367.25	371.75	366–372
–	–	–	–	49	373.25	377.75	372–378
7	175.25	179.75	174–180	50	379.25	383.75	378–384
8	181.25	185.75	180–186	51	385.25	389.75	384–390
9	187.25	191.75	186–192	52	391.25	395.75	390–396
10	193.25	197.75	192–198	53	397.25	401.75	396–402
11	199.25	203.75	198–204	54	403.25	407.75	402–408
12	205.25	209.75	204–210	55	409.25	413.75	408–414
13	211.25	215.75	210–216	56	415.25	419.75	414–420
23	217.25	221.75	216–222	57	421.25	425.75	420–426
24	223.25	227.75	222–228	58	427.25	431.75	426–432
25	229.25	233.75	228–234	59	433.25	437.75	432–438
26	235.25	239.75	234–240	–	–	–	–
27	241.25	245.75	240–246	–	–	–	–
28	247.25	251.75	246–252	–	–	–	–
29	253.25	257.75	252–258	–	–	–	–

Table 4.3a. Nominal Cable TV Frequencies for (M) NTSC in the USA for Incrementally Related Carrier (IRC) Systems. For Harmonically Related Carrier (HRC) systems, subtract 1.25 MHz.

Cable Channel	Video Carrier (MHz)	Audio Carrier (MHz)	Channel Range (MHz)	Cable Channel	Video Carrier (MHz)	Audio Carrier (MHz)	Channel Range (MHz)
60	439.25	443.75	438–444	90	619.25	623.75	618–624
61	445.55	449.75	444–450	91	625.25	629.75	624–630
62	451.25	455.75	450–456	92	631.25	635.75	630–636
63	457.25	461.75	456–462	93	637.25	641.75	636–642
64	463.25	467.75	462–468	94	643.25	647.75	642–648
65	469.25	473.75	468–474	100	649.25	653.75	648–654
66	475.25	479.75	474–480	101	655.25	659.75	654–660
67	481.25	485.75	480–486	102	661.25	665.75	660–666
68	487.25	491.75	486–492	103	667.25	671.75	666–672
69	493.25	497.75	492–498	104	673.25	677.75	672–678
70	499.25	503.75	498–504	105	679.25	683.75	678–684
71	505.25	509.75	504–510	106	685.25	689.75	684–690
72	511.25	515.75	510–516	107	691.25	695.75	690–696
73	517.25	521.75	516–522	108	697.25	701.75	696–702
74	523.25	527.75	522–528	109	703.25	707.75	702–708
75	529.25	533.75	528–534	110	709.25	713.75	708–714
76	535.25	539.75	534–540	111	715.25	719.75	714–720
77	541.25	545.75	540–546	112	721.25	725.75	720–726
78	547.25	551.75	546–552	113	727.25	731.75	726–732
79	553.25	557.75	552–558	114	733.25	737.75	732–738
80	559.25	563.75	558–564	115	739.25	743.75	738–744
81	565.25	569.75	564–570	116	745.25	749.75	744–750
82	571.25	575.75	570–576	117	751.25	755.75	750–756
83	577.25	581.75	576–582	118	757.25	761.75	756–762
84	583.25	587.75	582–588	119	763.25	767.75	762–768
85	589.25	593.75	588–594	120	769.25	773.75	768–774
86	595.25	599.75	594–600	121	775.25	779.75	774–780
87	601.25	605.75	600–606	122	781.25	785.75	780–786
88	607.25	611.75	606–612	123	787.25	791.75	786–792
89	613.25	617.75	612–618	124	793.25	797.75	792–798
–	–	–	–	125	799.25	803.75	798–804
T7	8.25		7–13	T11	32.25		31–37
T8	14.25		13–19	T13	38.25		37–43
T9	20.25		19–25	T13	44.25		43–49
T10	26.25		25–31	–	–		–

Table 4.3b. Nominal Cable TV Frequencies for (M) NTSC in the USA for Incrementally Related Carrier (IRC) Systems. For Harmonically Related Carrier (HRC) systems, subtract 1.25 MHz. T channels are reverse (return) channels for two-way applications.

Cable Channel	Video Carrier (MHz)	Audio Carrier (MHz)	Channel Range (MHz)	Cable Channel	Video Carrier (MHz)	Audio Carrier (MHz)	Channel Range (MHz)
–	–	–	–	40	325.25	329.75	324–330
–	–	–	–	41	331.25	335.75	330–336
–	–	–	–	42	337.25	341.75	336–342
13	109.25	113.75	108–114	46	343.25	347.75	342–348
14	115.25	119.75	114–120	44	349.25	353.75	348–354
15	121.25	125.75	120–126	45	355.25	359.75	354–360
16	127.25	131.75	126–132	46	361.25	365.75	360–366
17	133.25	137.75	132–138	47	367.25	371.75	366–372
18	139.25	143.75	138–144	48	373.25	377.75	372–378
19	145.25	149.75	144–150	49	379.25	383.75	378–384
20	151.25	155.75	150–156	50	385.25	389.75	384–390
21	157.25	161.75	156–162	51	391.25	395.75	390–396
22	165.25	169.75	164–170	52	397.25	401.75	396–402
23	223.25	227.75	222–228	53	403.25	407.75	402–408
24	231.25	235.75	230–236	54	409.25	413.75	408–414
25	237.25	241.75	236–242	55	415.25	419.75	414–420
26	243.25	247.75	242–248	56	421.25	425.75	420–426
27	249.25	253.75	248–254	57	427.25	431.75	426–432
28	253.25	257.75	252–258	58	433.25	437.75	432–438
29	259.25	263.75	258–264	59	439.25	443.75	438–444
30	265.25	269.75	264–270	60	445.25	449.75	444–450
31	271.25	275.75	270–276	61	451.25	455.75	450–456
32	277.25	281.75	276–282	62	457.25	461.75	456–462
33	283.25	287.75	282–288	63	463.25	467.75	462–468
34	289.25	293.75	288–294	–	–	–	–
35	295.25	299.75	294–300	–	–	–	–
36	301.25	305.75	300–306	–	–	–	–
37	307.25	311.75	306–312	–	–	–	–
38	313.25	317.75	312–318	–	–	–	–
39	319.25	323.75	318–324	–	–	–	–

Table 4.4. Nominal Cable TV Frequencies for (M) NTSC in Japan.

Luma Equation Derivation

The equation for generating luma from RGB information is determined by the chromaticities of the three primary colors (RGB) used by the receiver and what color white actually is. The chromaticities of the RGB primaries and reference white (defined to be CIE illuminate C) were specified in the 1953 NTSC standard to be:

R: $x_r = 0.67$ $y_r = 0.33$ $z_r = 0.00$

G: $x_g = 0.21$ $y_g = 0.71$ $z_g = 0.08$

B: $x_b = 0.14$ $y_b = 0.08$ $z_b = 0.78$

white: $x_w = 0.3101$ $y_w = 0.3162$
$\qquad z_w = 0.3737$

where x and y are the specified CIE 1931 chromaticity coordinates; z is calculated by knowing that x + y + z = 1. Luma is calculated as a weighted sum of RGB, with the weights representing the actual contributions of each of the RGB primaries in generating the luminance of reference white. We find the linear combination of RGB that gives reference white by solving the equation:

$$\begin{bmatrix} x_r & x_g & x_b \\ y_r & y_g & y_b \\ z_r & z_g & z_b \end{bmatrix} \begin{bmatrix} K_r \\ K_g \\ K_b \end{bmatrix} = \begin{bmatrix} x_w/y_w \\ 1 \\ z_w/y_w \end{bmatrix}$$

Rearranging to solve for K_r, K_g, and K_b yields:

$$\begin{bmatrix} K_r \\ K_g \\ K_b \end{bmatrix} = \begin{bmatrix} x_w/y_w \\ 1 \\ z_w/y_w \end{bmatrix} \begin{bmatrix} x_r & x_g & x_b \\ y_r & y_g & y_b \\ z_r & z_g & z_b \end{bmatrix}^{-1}$$

Substituting the known values gives us the solution for K_r, K_g, and K_b:

$$\begin{bmatrix} K_r \\ K_g \\ K_b \end{bmatrix} = \begin{bmatrix} 0.3101/0.3162 \\ 1 \\ 0.3737/0.3162 \end{bmatrix} \begin{bmatrix} 0.67 & 0.21 & 0.14 \\ 0.33 & 0.71 & 0.08 \\ 0.00 & 0.08 & 0.78 \end{bmatrix}^{-1}$$

$$= \begin{bmatrix} 0.9807 \\ 1 \\ 1.1818 \end{bmatrix} \begin{bmatrix} 1.730 & -0.482 & -0.261 \\ -0.814 & 1.652 & -0.023 \\ 0.083 & -0.169 & 1.284 \end{bmatrix}$$

$$= \begin{bmatrix} 0.906 \\ 0.827 \\ 1.430 \end{bmatrix}$$

Y is defined to be

$$Y = (K_r y_r)R' + (K_g y_g)G' + (K_b y_b)B'$$
$$= (0.906)(0.33)R' + (0.827)(0.71)G' + (1.430)(0.08)B'$$

or

$$Y = 0.299R' + 0.587G' + 0.114B'$$

Modern receivers use a different set of RGB phosphors, resulting in slightly different chromaticities of the RGB primaries and reference white (CIE illuminate D_{65}):

R: $x_r = 0.630$ $y_r = 0.340$ $z_r = 0.030$

G: $x_g = 0.310$ $y_g = 0.595$ $z_g = 0.095$

B: $x_b = 0.155$ $y_b = 0.070$ $z_b = 0.775$

white: $x_w = 0.3127$ $y_w = 0.3290$
$\qquad z_w = 0.3583$

where x and y are the specified CIE 1931 chromaticity coordinates; z is calculated by knowing that x + y + z = 1. Once again, substituting the known values gives us the solution for K_r, K_g, and K_b:

$$
\begin{bmatrix} K_r \\ K_g \\ K_b \end{bmatrix} = \begin{bmatrix} 0.3127/0.3290 \\ 1 \\ 0.3583/0.3290 \end{bmatrix} \begin{bmatrix} 0.630 & 0.310 & 0.155 \\ 0.340 & 0.595 & 0.070 \\ 0.030 & 0.095 & 0.775 \end{bmatrix}^{-1}
$$

$$
= \begin{bmatrix} 0.6243 \\ 1.1770 \\ 1.2362 \end{bmatrix}
$$

Since Y is defined to be

$$
\begin{aligned}
Y &= (K_r y_r)R' + (K_g y_g)G' + (K_b y_b)B' \\
&= (0.6243)(0.340)R' + (1.1770)(0.595)G' \\
&\quad + (1.2362)(0.070)B'
\end{aligned}
$$

this results in:

$$
Y = 0.212R' + 0.700G' + 0.086B'
$$

However, the standard Y = 0.299R' + 0.587G' + 0.114B' equation is still used. Adjustments are made at the camera to minimize color errors at the receiver. Newer NTSC specifications do not preclude the use of equipment designed to use the older RGB chromaticity values. The NTSC specifications still assume the receiver has gamma of 2.2, although the gamma of modern receivers is closer to 2.35; this difference is usually ignored.

PAL Overview

Europe delayed adopting a color television standard, evaluating various systems between 1953 and 1967 that were compatible with their 625-line, 50-field/second, 2:1 interlaced monochrome standard. The NTSC specification was modified to overcome the high order of phase and amplitude integrity required during broadcast to avoid color distortion. The Phase Alternation Line (PAL) system implements a line-by-line reversal of the phase of one of the color signal components, originally relying on the eye to average any color distortions to the correct color. Broadcasting began in 1967 in Germany and the United Kingdom, with each using a slightly different variant of the PAL system.

The luma (monochrome) signal is derived from gamma-corrected RGB (R′G′B′):

$$
Y \text{ (luma)} = 0.299R' + 0.587G' + 0.114B'
$$

(*Note*: Although the PAL standards specify a gamma of 2.8, a value of 2.2 is actually used.)

PAL has several variations, depending on the video bandwidth and placement of the audio subcarrier. As with NTSC, the PAL luma signal occupies the entire video bandwidth. The composite video signal has a bandwidth of 4.2, 5.0, 5.5, or 6.0 MHz, depending on the specific standard.

Once again, gamma correction is applied to compensate for the nonlinear voltage-to-light characteristics of the receiver and to provide the additional benefit of increasing the signal-to-noise ratio during transmission. All PAL systems specify a gamma of 2.8 at the receiver; however, a value of 2.2 is now used. Therefore, the same gamma-correction equations are now used for NTSC and PAL.

To transmit hue and saturation color information, U and V color difference signals, which specify the differences between the luminance signal and the basic RGB signals, are used:

$$U = 0.492(B' - Y)$$
$$V = 0.877(R' - Y)$$

U and V have a typical bandwidth of 1.3 MHz.

As in the NTSC system, U and V are used to modulate the color subcarrier using two balanced modulators operating in phase quadrature (one modulator is driven by the subcarrier at sine phase; the other modulator is driven by the subcarrier at cosine phase). The outputs of the modulators are added together to form the composite chrominance signal:

$$C = U \sin \omega t \pm V \cos \omega t$$
$$\omega = 2\pi F_{SC}$$

F_{SC} = 4.43361875 MHz (± 5 Hz) for (B, D, G, H, I, N) PAL

F_{SC} = 3.58205625 MHz (± 5 Hz) for combination (N) PAL

F_{SC} = 3.57561149 MHz (± 10 Hz) for (M) PAL

In PAL, the phase of the V component is reversed every other line. V was chosen for the reversal process since it has a lower gain factor than the U component and therefore is less susceptible to a 1/2 F_H switching rate imbalance. The result of alternating the V phase at the line rate is that any color subcarrier phase errors produce complementary errors, allowing any line-to-line averaging process at the receiver to cancel the phase (hue) error and generate the correct hue with slightly reduced saturation. This technique requires the PAL receiver to be able to determine the correct V phase. This is done using a technique known as A B sync, PAL sync, PAL SWITCH, or "swinging burst," consisting of alternating the phase of the color burst by ±45° at the line rate. The UV vector diagram illustrating the U and V axes and swinging burst is shown in Figures 4.11 and 4.12.

The modulated chrominance is added to the luminance information along with appropriate horizontal and vertical sync signals, blanking signals, and color burst signals, to generate the composite color video waveform shown in Figure 4.13.

$$\text{composite PAL} = Y + U \sin \omega t \pm V \cos \omega t$$

The bandwidth of the resulting composite video signal is shown in Figure 4.14. The amplitude of the modulated chrominance is

$$\sqrt{U^2 + V^2}$$

Like NTSC, the luminance components are also spaced at F_H intervals due to horizontal blanking. Since the V component is switched symmetrically at half the line rate, only odd

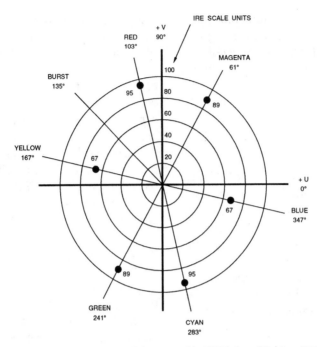

Figure 4.11. UV Vector Diagram for 75% Amplitude, 100% Saturated EBU Color Bars. Line n, PAL SWITCH = zero.

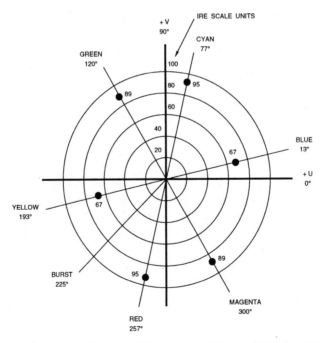

Figure 4.12. UV Vector Diagram for 75% Amplitude, 100% Saturated EBU Color Bars. Line n + 1, PAL SWITCH = one.

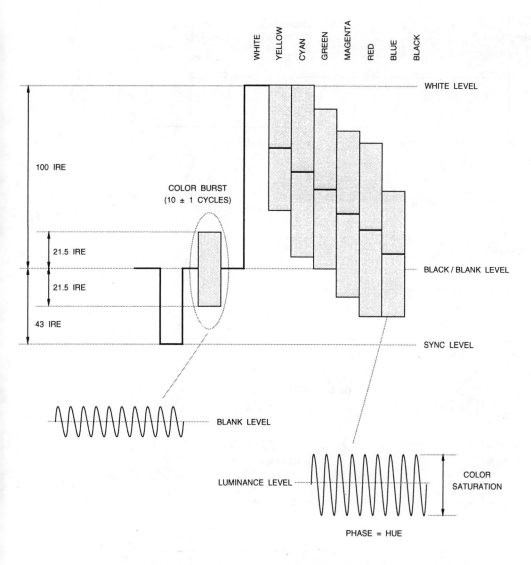

**Figure 4.13. (B, D, G, H, I, Combination N) PAL Composite
Video Signal for 75% Amplitude, 100% Saturation EBU Color Bars.**

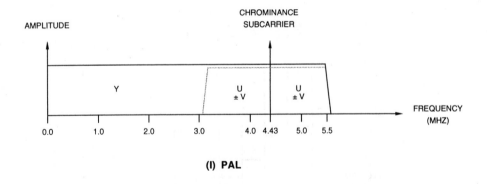

(I) PAL

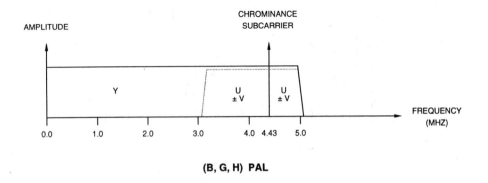

(B, G, H) PAL

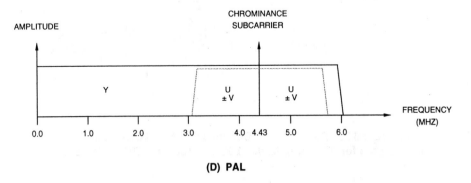

(D) PAL

Figure 4.14. Video Bandwidths of Some PAL Systems.

Figure 4.15. Luma/Chroma Horizontal Frequency Interleave Principle.

harmonics are generated, resulting in V components that are spaced at intervals of F_H. The V components are spaced at half-line intervals from the U components, which also have F_H spacing. If the subcarrier had a half-line offset like NTSC uses, the U components would be perfectly interleaved, but the V components would coincide with the Y components and thus not be interleaved, creating vertical stationary dot patterns. For this reason, PAL uses a 1/4 line offset for the subcarrier frequency:

$$F_{SC} = ((1135/4) + (1/625)) \, F_H$$
$$\text{for (B, D, G, H, I, N) PAL}$$

$$F_{SC} = (909/4) \, F_H$$
$$\text{for (M) PAL}$$

$$F_{SC} = ((917/4) + (1/625)) \, F_H$$
$$\text{for combination (N) PAL}$$

The additional (1/625) F_H factor (equal to 25 Hz) provides motion to the color dot pattern, reducing its visibility. Figure 4.15 illustrates the resulting frequency interleaving. Eight complete fields are required to repeat a specific pixel position, as shown in Figure 4.16 and Figure 4.17.

"Simple" PAL decoders rely on the eye to average the line-by-line hue errors. This implementation has the problem of Hanover bars, caused by visible luma changes at the line rate.

"Standard" PAL decoders use a 1-H delay line to separate U from V in an averaging process. Hanover bars, in which pairs of adjacent lines have a real and complementary hue error, may also occur. For current PAL systems, chroma vertical resolution is reduced as a result of the line averaging process.

The generation of 312-line, 25 frames/sec "noninterlaced PAL," shown in Figure 4.18, is also common among video games and on-screen displays. This format is identical to standard (B, D, G, H, I) PAL, except that there are 312 lines per field (actually, per frame since it is noninterlaced). To generate noninterlaced PAL, the encoder is operated normally, except for the horizontal and vertical sync timing being noninterlaced.

Use by Country

Figure 4.19 shows the ITU designations for PAL systems. The letters refer to the monochrome standard for line and field rate (typically 625/50), video bandwidth (4.2, 5.0, 5.5, or 6.0 MHz), audio carrier relative frequency, and RF channel bandwidth (6.0, 7.0, or 8.0 MHz). The "PAL" refers to the technique to add color information to the monochrome signal. Detailed timing parameters may be found in Table 4.9.

The following countries use, or are planning to use, the (I) PAL standard, according to ITU-R BT.470-3 (1994) and other sources. (I) PAL is used for both VHF and UHF transmission unless only UHF transmission is supported (indicated by a U).

Angola	Malawi
Botswana	Namibia
Gambia	Nigeria (U)
Guinea-Bissau	South Africa
Hong Kong (U)	Tanzania
Ireland	United Kingdom
Lesotho	Zanzibar

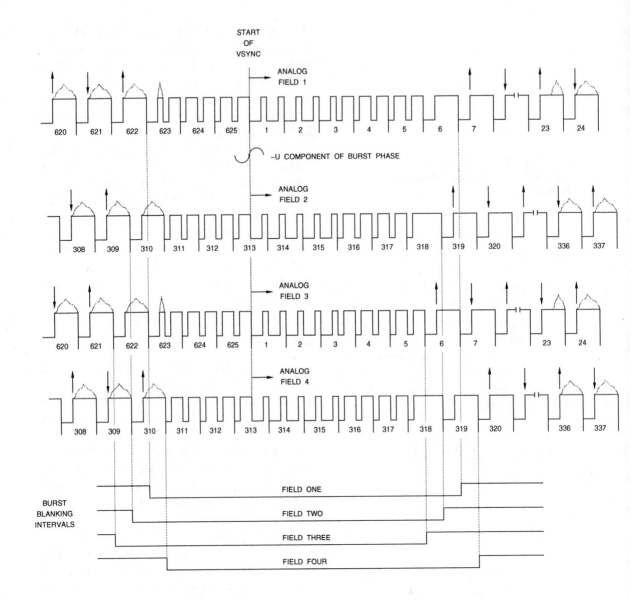

Figure 4.16a. Eight-field (B, D, G, H, I, Combination N) PAL Format and Burst Blanking. (See Figure 4.5 for equalization and serration pulse details.)

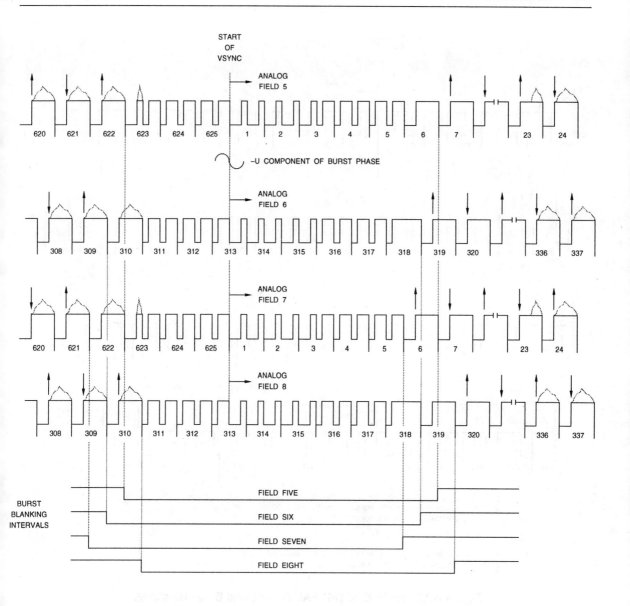

Figure 4.16b. Eight-field (B, D, G, H, I, Combination N) PAL Format and Burst Blanking. (See Figure 4.5 for equalization and serration pulse details.)

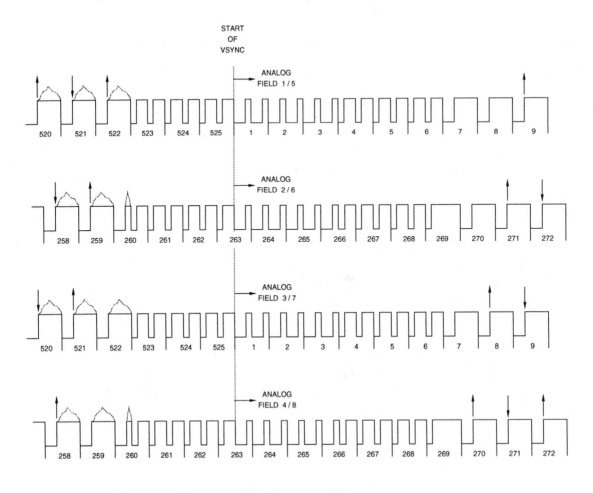

START
OF
VSYNC

ANALOG
FIELD 1 / 5

ANALOG
FIELD 2 / 6

ANALOG
FIELD 3 / 7

ANALOG
FIELD 4 / 8

BURST PHASE = REFERENCE PHASE = 135° RELATIVE TO U
PAL SWITCH = 0, + V COMPONENT

BURST PHASE = REFERENCE PHASE + 90° = 225° RELATIVE TO U
PAL SWITCH = 1, – V COMPONENT

**Figure 4.17. Eight-field (M) PAL Format and Burst Blanking.
(See Figure 4.5 for equalization and serration pulse details.)**

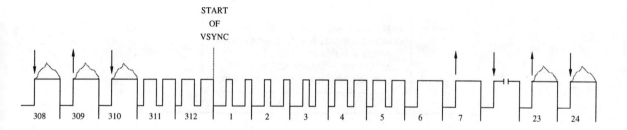

BURST PHASE = REFERENCE PHASE = 135° RELATIVE TO U
PAL SWITCH = 0, + V COMPONENT

BURST PHASE = REFERENCE PHASE + 90° = 225° RELATIVE TO U
PAL SWITCH = 1, − V COMPONENT

Figure 4.18. Noninterlaced PAL Timing.

The following countries use, or are planning to use, the (B) PAL standard, according to ITU-R BT.470-3 (1994) and other sources. (B) PAL is used for only for VHF transmission unless UHF transmission is also supported (indicated by a U).

Albania	Egypt	Kenya	Saudi Arabia
Algeria	Ethiopia	Kuwait	Seychelles
Australia (U)	Equatorial Guinea	Liberia	Sierra Leone
Austria	Finland	Libya	Singapore
Bahrain	Germany	Luxembourg	Slovenia
Bangladesh	Ghana (U)	Malaysia	Somali
Belgium	Gibraltar	Maldives	Spain
Bosnia-Herzegovina	Greenland	Malta	Sri Lanka
Brunei Darussalam	Iceland	Nepal	Sudan
Cambodia	India	Netherlands	Swaziland
Cameroon	Indonesia	New Zealand	Sweden
Croatia	Israel	Nigeria	Switzerland
Cyprus	Italy	Norway	Syria
Denmark	Jordan	Oman	Thailand
		Pakistan	Tunisia
		Papua New Guinea	Turkey
		Portugal	Uganda
		Qatar	United Arab Emirates
		Sao Tome and Principe	Yemen

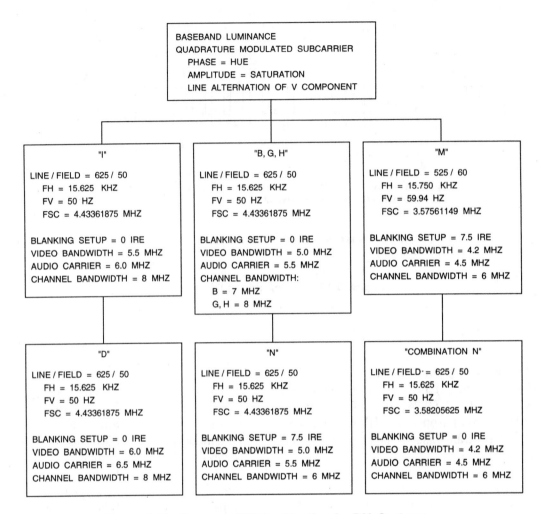

Figure 4.19. Summary ITU Designation for PAL Systems.

The following countries use, or are planning to use, the (N) PAL standard, according to ITU-R BT.470-3 (1994) and other sources. (N) PAL is used for both VHF and UHF transmission unless only VHF transmission is supported (indicated by a V). Note that Argentina uses a modified (N) PAL standard, called "combination N."

Argentina
Paraguay
Uruguay (V)

The following countries use, or are planning to use, the (M) PAL standard, according to ITU-R BT.470-3 (1994) and other sources. (M) PAL is used for both VHF and UHF transmission.

Brazil

The following countries use, or are planning to use, the (G) PAL standard, according to ITU-R BT.470-3 (1994) and other sources. (G) PAL is used for only for UHF transmission unless VHF transmission is also supported (indicated by a V).

Albania	Germany
Algeria	Gibraltar
Austria	Greenland
Bahrain	Iceland
Bosnia/Herzegovina	Israel
Cambodia	Italy
Cameroon	Jordan
Croatia	Kenya
Cyprus	Kuwait
Denmark	Liberia
Egypt	Libya
Ethiopia	Luxembourg
Equatorial Guinea	Malaysia
Finland	Monaco

Mozambique (V)	Sri Lanka
Netherlands	Sudan
New Zealand	Swaziland
Norway	Sweden
Oman	Switzerland
Pakistan	Syria
Papua New Guinea	Thailand
Portugal	Tunisia
Qatar	Turkey
Romania	United Arab Emirates
Sierra Leone	Yemen
Singapore	Zambia (v)
Slovenia	Zimbabwe (V)
Somalia	
Spain	

The following countries use, or are planning to use, the (D) PAL standard, according to ITU-R BT.470-3 (1994) and other sources. (D) PAL is used for both VHF and UHF transmission unless only VHF transmission is supported (indicated by a V).

China	Korea (North) (V)
	Romania (V)

The following countries use, or are planning to use, the (H) PAL standard, according to ITU-R BT.470-3 (1994) and other sources. (H) PAL is used for only for UHF transmission.

Belgium

A 16:9 aspect ratio version of PAL, known as PALplus, is used in Europe and is compatible with standard PAL. Further information on PALplus is available later in this chapter.

RF Modulation

Figures 4.20 and 4.21 illustrate the process of converting baseband (G) PAL composite video to an RF (radio frequency) signal. The process for (B, D, H, I, M, and N) PAL is similar, except primarily the video bandwidths and audio subcarrier frequencies are slightly different. Refer to the references at the end of the chapter for more details on designing an RF audio-video modulator.

Figure 4.20a shows the frequency spectrum of a (G) PAL baseband composite video signal. It is similar to Figure 4.14. However, Figure 4.14 only shows the upper sideband for simplicity. The "video carrier" notation at 0 MHz serves only as a reference point for comparison with Figure 4.20b.

Figure 4.20b shows the audio/video signal as it resides within a 8-MHz RF channel. The video signal has been lowpass filtered, most of the lower sideband has been removed, and audio information has been added. Note that H and I PAL have a vestigial sideband of 1.25 MHz, rather than 0.75 MHz.

Figure 4.20c details the information present on the audio subcarrier for analog stereo operation.

As shown in Figure 4.21, back porch clamping of the baseband composite analog video signal ensures that the back porch level is constant, regardless of changes in the average picture level. The baseband composite video signal is then lowpass filtered to 5.0 MHz and drives the AM (amplitude modulation) video modulator. The sync level corresponds to 100% modulation; the blanking and white modulation levels are dependent on the specific version of PAL:

blanking level (% modulation)

B, G	75%
D, H, M, N	75%
I	76%

white level (% modulation)

B, G, H, M, N	10%
D	10%
I	20%

Note that PAL systems use a variety of video and audio IF frequencies (values in MHz):

	video	audio	
B, G	38.900	33.400	
B	36.875	31.375	Australia
D	37.000	30.500	China
D	38.900	32.400	OIRT
I	38.900	32.900	
I	39.500	33.500	U.K.
M, N	45.750	41.250	

At this point, audio information is added on the audio subcarrier. A monaural audio signal is processed as shown in Figure 4.21 and drives the FM (frequency modulation) modulator. The output of the FM modulator is added to the IF video signal.

The SAW filter, used as a vestigial sideband filter, provides filtering of the IF-modulated signal. The mixer, or up converter, mixes the modulated IF signal with the desired broadcast frequency. Both sum and difference frequencies are generated by the mixing process, so the difference signal is extracted by using a bandpass filter.

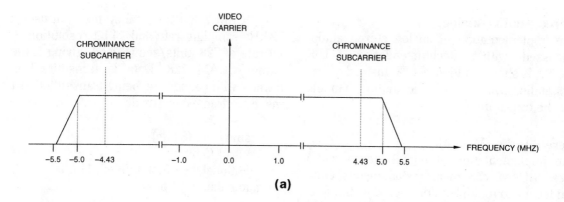

(a)

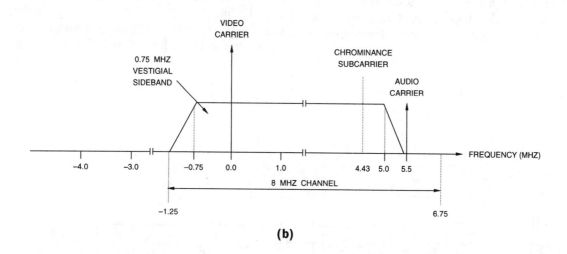

(b)

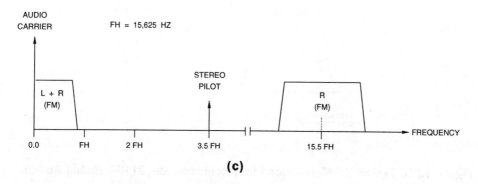

(c)

Figure 4.20. Transmission Channel for (G) PAL: (a) Frequency Spectrum of Baseband Composite Video, (b) Frequency Spectrum of Typical Channel Including Audio Information, (c) Detailed Frequency Spectrum of Analog Stereo Audio Information.

Stereo Audio (Analog)

The implementation of analog stereo audio, discussed within Recommendation ITU-R BS.707, is shown in Figure 4.22. Instead of stereo audio, two monophonic audio channels may be transmitted.

Stereo Audio (Digital)

The implementation of digital stereo audio uses NICAM 728 (near instantaneous companded audio multiplex), discussed within Recommendation ITU-R BS.707. It was developed by the BBC and IBA to increase sound quality, provide multiple channels of digital sound or data, and be more resistant to transmission interference.

NICAM 728 is a digital system that uses a 32-kHz sampling rate and 14-bit resolution. A bit rate of 728 kbits/sec is used, giving it the name NICAM 728. Data is transmitted in frames, with each frame being transmitted in 1 ms. Each frame consists of:

frame sync (8 bits)
control (5 bits)
additional data (not defined, 11 bits)
audio data (704 bits)

The bit rate is reduced by transmitting only 10 bits plus parity of each 14-bit audio sample. The largest amplitude of a sample during a frame determines which 10 bits are trans-

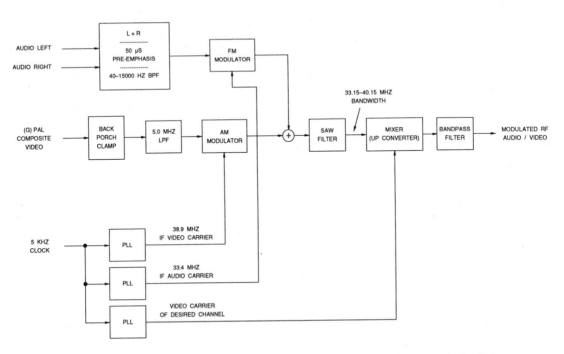

Figure 4.21. Typical RF Modulation Implementation for (G) PAL (Mono Audio).

mitted. The parity bits for the audio samples also specify the scaling factor used for that channel during that frame.

The companded audio data is interleaved to reduce the influence of dropouts, and the whole frame, except the frame sync bits, is scrambled for spectrum shaping purposes.

Three of the control bits specify the format transmitted: one stereo signal, two independent mono channels, one mono channel and one 352 kbps data channel, or one 704 kbps data channel. Another control bit indicates whether the analog sound is the same as the digital sound, allowing receivers to switch over to analog in case of a transmission problem.

The data is modulated encoded using differentially encoded quadrature phase shift keying (QPSK). The subcarrier resides either 5.85 MHz above the video carrier for (B, G, H) PAL systems or 6.552 MHz above the video carrier for (I) PAL systems.

Channel Assignments

Tables 4.5 through 4.7 list the channel assignments for VHF, UHF, and cable for various PAL systems.

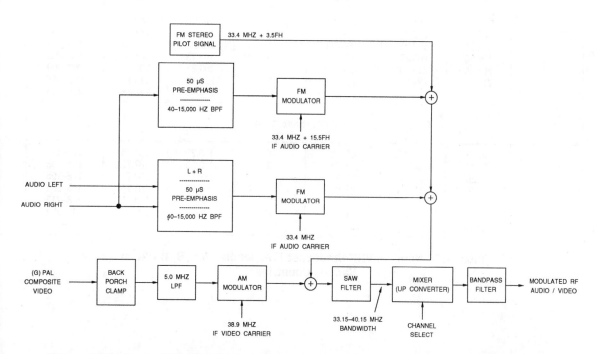

Figure 4.22. Typical RF Modulation Implementation for (G) PAL (Analog Stereo Audio).

Broadcast Channel	Video Carrier (MHz)	Audio Carrier (MHz)	Channel Range (MHz)	Broadcast Channel	Video Carrier (MHz)	Audio Carrier (MHz)	Channel Range (MHz)
(B) PAL, Europe, 7 MHz				**(B) PAL, Italy, 7 MHz**			
2	48.25	53.75	47–54	A	53.75	59.25	52.5–59.5
3	55.25	60.75	54–61	B	62.25	67.75	61–68
4	62.25	67.75	61–68	C	82.25	87.75	81–88
5	175.25	180.75	174–181	D	175.25	180.75	174–181
6	182.25	187.75	181–188	E	183.75	189.25	182.5–189.5
7	189.25	194.75	188–195	F	192.25	197.75	191–198
8	196.25	201.75	195–202	G	201.25	206.75	200–207
9	203.25	208.75	202–209	H	210.25	215.75	209–216
10	210.25	215.75	209–216	H–1	217.25	222.75	216–223
11	217.25	222.75	216–223	H–2	224.25	229.75	223–230
12	224.25	229.75	223–230	–	–	–	–
(I) PAL, Ireland, 8 MHz				**(B) PAL, New Zealand, 7 MHz**			
A	45.75	51.75	44.5–52.5	1	45.25	50.75	44–51
B	53.75	59.75	52.5–60.5	2	55.25	60.75	54–61
C	61.75	67.75	60.5–68.5	3	62.25	67.75	61–68
D	175.25	181.25	174–182	4	175.25	180.75	174–181
E	183.25	189.25	182–190	5	182.25	187.75	181–188
F	191.25	197.25	190–198	6	189.25	194.75	188–195
G	199.25	205.25	198–206	7	196.25	201.75	195–202
H	207.25	213.25	206–214	8	203.25	208.75	202–209
J	215.25	221.25	214–222	9	210.25	215.75	209–216
–	–	–	–	10	217.25	222.75	216–223
(B) PAL, Australia, 7 MHz							
0	46.25	51.75	45–52	6	175.25	180.75	174–181
1	57.25	62.75	56–63	7	182.25	187.75	181–188
2	64.25	69.75	63–70	8	189.25	194.75	188–195
3	86.25	91.75	85–92	9	196.25	201.75	195–202
4	95.25	100.75	94–101	10	209.25	214.75	208–215
5	102.25	107.75	101–108	11	216.25	221.75	215–222
5A	138.25	143.75	137–144	–	–	–	–

Table 4.5. Nominal VHF Broadcast Frequencies for (B, I) PAL in Various Countries.

Broadcast Channel	Video Carrier (MHz)	Audio Carrier (MHz)		Channel Range (MHz)
		(G, H) PAL	(I) PAL	
21	471.25	476.75	477.25	470–478
22	479.25	484.75	485.25	478–486
23	487.25	492.75	493.25	486–494
24	495.25	500.75	501.25	494–502
25	503.25	508.75	509.25	502–510
26	511.25	516.75	517.25	510–518
27	519.25	524.75	525.25	518–526
28	527.25	532.75	533.25	526–534
29	525.25	540.75	541.25	534–542
30	543.25	548.75	549.25	542–550
31	551.25	556.75	557.25	550–558
32	559.25	564.75	565.25	558–566
33	567.25	572.75	573.25	566–574
34	575.25	580.75	581.25	574–582
35	583.25	588.75	589.25	582–590
36	591.25	596.75	597.25	590–598
37	599.25	604.75	605.25	598–606
38	607.25	612.75	613.25	606–614
39	615.25	620.75	621.25	614–622
40	623.25	628.75	629.25	622–630
41	631.25	636.75	637.25	630–638
42	639.25	644.75	645.25	638–646
43	647.25	652.75	653.25	646–654
44	655.25	660.75	661.25	654–662
45	663.25	668.75	669.25	662–670
46	671.25	676.75	677.25	670–678
47	679.25	684.75	685.25	678–686
48	687.25	692.75	693.25	686–694
49	695.25	700.75	701.25	694–702

Table 4.6a. Nominal UHF Broadcast Frequencies for (G, H, I) PAL.

Broadcast Channel	Video Carrier (MHz)	Audio Carrier (MHz)		Channel Range (MHz)
		(G, H) PAL	(I) PAL	
50	703.25	708.75	709.25	702–710
51	711.25	716.75	717.25	710–718
52	719.25	724.75	725.25	718–726
53	727.25	732.75	733.25	726–734
54	735.25	740.75	741.25	734–742
55	743.25	748.75	749.25	742–750
56	751.25	756.75	757.25	750–758
57	759.25	764.75	765.25	758–766
58	767.25	772.75	773.25	766–774
59	775.25	780.75	781.25	774–782
60	783.25	788.75	789.25	782–790
61	791.25	796.75	797.25	790–798
62	799.25	804.75	805.25	798–806
63	807.25	812.75	813.25	806–814
64	815.25	820.75	821.25	814–822
65	823.25	828.75	829.25	822–830
66	831.25	836.75	837.25	830–838
67	839.25	844.75	845.25	838–846
68	847.25	852.75	853.25	846–854
69	855.25	860.75	861.25	854–862

Table 4.6b. Nominal UHF Broadcast Frequencies for (G, H, I) PAL.

Cable Channel	Video Carrier (MHz)	Audio Carrier (MHz)	Channel Range (MHz)	Cable Channel	Video Carrier (MHz)	Audio Carrier (MHz)	Channel Range (MHz)
E 2	48.25	53.75	47–54	S 13	245.25	250.75	244–251
E 3	55.25	60.75	54–61	S 14	252.25	257.75	251–258
E 4	62.25	67.75	61–68	S 15	259.25	264.75	258–265
S 01	69.25	74.75	68–75	S 16	266.25	271.75	265–272
S 02	76.25	81.75	75–82	S 17	273.25	278.75	272–279
S 03	83.25	88.75	82–89	S 18	280.25	285.75	279–286
S 1	105.25	110.75	104–111	S 19	287.25	292.75	286–293
S 2	112.25	117.75	111–118	–	–	–	–
S 3	119.25	124.75	118–125	–	–	–	–
S 4	126.25	131.75	125–132	–	–	–	–
S 5	133.25	138.75	132–139	–	–	–	–
S 6	140.75	145.75	139–146	S 20	294.25	299.75	293–300
S 7	147.75	152.75	146–153	S 21	303.25	308.75	302–310
S 8	154.75	159.75	153–160	S 22	311.25	316.75	310–318
S 9	161.25	166.75	160–167	S 23	319.25	324.75	318–326
S 10	168.25	173.75	167–174	S 24	327.25	332.75	326–334
E 5	175.25	180.75	174–181	S 25	335.25	340.75	334–342
E 6	182.25	187.75	181–188	S 26	343.25	348.75	342–350
E 7	189.25	194.75	188–195	S 27	351.25	356.75	350–358
E 8	196.25	201.75	195–202	S 28	359.25	364.75	358–366
E 9	203.25	208.75	202–209	S 29	367.25	372.75	366–374
E 10	210.25	215.75	209–216	S 30	375.25	380.75	374–382
E 11	217.25	222.75	216–223	S 31	383.25	388.75	382–390
E 12	224.25	229.75	223–230	S 32	391.25	396.75	390–398
S 11	231.25	236.75	230–237	S 33	399.25	404.75	398–406
S 12	238.25	243.75	237–244	S 34	407.25	412.75	406–414
–	–	–	–	S 35	415.25	420.75	414–422
–	–	–	–	S 36	423.25	428.75	422–430
–	–	–	–	S 37	431.25	436.75	430–438
–	–	–	–	S 38	439.25	444.75	438–446
–	–	–	–	S 39	447.25	452.75	446–454
–	–	–	–	S 40	455.25	460.75	454–462
–	–	–	–	S 41	463.25	468.75	462–470

Table 4.7. Nominal Cable TV Frequencies for (B, G) PAL.

Luma Equation Derivation

The equation for generating luma from RGB information is determined by the chromaticities of the three primary colors (RGB) used by the receiver and what color white actually is. The chromaticities of the RGB primaries and reference white (white is defined to be CIE illuminate D_{65}) are:

$R:$ $\quad x_r = 0.64 \quad y_r = 0.33 \quad z_r = 0.03$

$G:$ $\quad x_g = 0.29 \quad y_g = 0.60 \quad z_g = 0.11$

$B:$ $\quad x_b = 0.15 \quad y_b = 0.06 \quad z_b = 0.79$

white: $\quad x_w = 0.3127 \quad y_w = 0.3290$
$\qquad\quad z_w = 0.3583$

where x and y are the specified CIE 1931 chromaticity coordinates; z is calculated by knowing that x + y + z = 1. Once again, substituting the known values gives us the solution for K_r, K_g, and K_b:

$$\begin{bmatrix} K_r \\ K_g \\ K_b \end{bmatrix} = \begin{bmatrix} 0.3127/0.3290 \\ 1 \\ 0.3583/0.3290 \end{bmatrix} \begin{bmatrix} 0.64 & 0.29 & 0.15 \\ 0.33 & 0.60 & 0.06 \\ 0.03 & 0.11 & 0.79 \end{bmatrix}^{-1}$$

$$= \begin{bmatrix} 0.674 \\ 1.177 \\ 1.190 \end{bmatrix}$$

Y is defined to be

$$Y = (K_r y_r)R' + (K_g y_g)G' + (K_b y_b)B'$$
$$= (0.674)(0.33)R' + (1.177)(0.60)G'$$
$$+ (1.190)(0.06)B'$$

or

$$Y = 0.222R' + 0.706G' + 0.071B'$$

However, the standard Y = 0.299R' + 0.587G' + 0.114B' equation is still used.

SECAM Overview

SECAM (Sequentiel Couleur Avec Mémoire or Sequential Color with Memory) was developed in France, with broadcasting starting in 1967, by realizing that, if color could be relatively bandwidth-limited horizontally, why not also vertically? The two pieces of color information (hue and saturation) that need to be added to a monochrome signal (intensity) could be transmitted on alternate lines, avoiding the possibility of crosstalk between the color components. The receiver requires a one-line memory to store one line so that it is concurrent with the next line and also requires the addition of a line-switching identification technique. Like PAL, SECAM is a 625-line, 50-field/second, 2:1 interlaced system. SECAM was adopted by other countries; however, many are planning to change to PAL due to the abundance of professional and consumer PAL equipment.

The luma (monochrome) signal is derived from gamma-corrected RGB (R'G'B' = 2.8):

$$Y \text{ (luma)} = 0.299R' + 0.587G' + 0.114B'$$

Unlike NTSC and PAL, SECAM transmits the R' – Y information during one line and B' – Y information during the next line; luminance information is transmitted on each line. R' – Y and B' – Y are scaled to generate the Dr and Db color difference signals:

$$Dr = -1.902(R' - Y)$$

$$Db = 1.505(B' - Y)$$

Since there is an odd number of lines, a line contains Dr information on one field and Db information on the next field. The decoder requires a 1-H delay, switched synchronously with the Dr and Db switching, so that Dr and Db exist simultaneously in order to convert to RGB.

SECAM uses FM modulation to transmit the Dr and Db color difference information, with each component having its own subcarrier. Dr and Db are lowpass filtered to 1.3 MHz and pre-emphasis is applied to the low-frequency color difference signals. The curve for the low-frequency pre-emphasis is expressed by:

$$A = \frac{1 + j\left(\dfrac{f}{85}\right)}{1 + j\left(\dfrac{f}{255}\right)}$$

where f = signal frequency in kHz.

After low-frequency preemphasis, Dr and Db frequency modulate their respective subcarriers. The frequency of each subcarrier is defined as:

$$F_{OB} = 272\,F_H = 4.250000 \text{ MHz } (\pm 2 \text{ kHz})$$

$$F_{OR} = 282\,F_H = 4.406250 \text{ MHz } (\pm 2 \text{ kHz})$$

These frequencies represent zero color difference information. Nominal Dr deviation is ±280 kHz and the nominal Db deviation is ±230 kHz. Figure 4.23 illustrates the frequency modulation process of the color difference signals. The choice of frequency shifts reflects the idea of keeping the frequencies representing critical colors away from the upper limit of the spectrum to minimize distortion.

After modulation of Dr and Db, high-frequency subcarrier preemphasis is applied, changing the amplitude of the subcarrier as a function of the frequency deviation. The intention is to reduce the visibility of the subcarriers

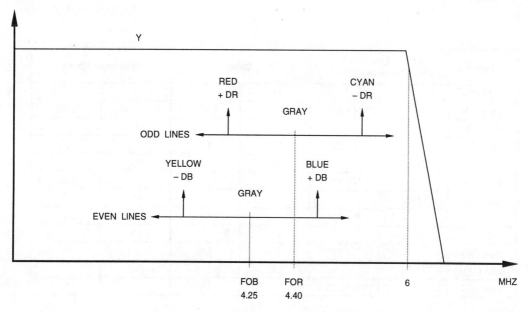

Figure 4.23. SECAM FM color modulation.

in areas of low luminance and to improve the signal-to-noise ratio of highly saturated colors. This expression is given as:

$$G = M\frac{1 + j16F}{1 + j1.26F}$$

where $F = (f/4286) - (4286/f)$, f = instantaneous subcarrier frequency in kHz, and $2M$ = $23 \pm 2.5\%$ of luminance amplitude.

After high-frequency subcarrier pre-emphasis, the subcarrier data is added to the luminance along with appropriate horizontal and vertical sync signals, blanking signals, and field ID signals to generate composite video.

As shown in Table 4.8 and Figure 4.24, Dr and Db information is transmitted on alternate scan lines. The phase of the subcarriers is also reversed 180° on every third line and between each field to further reduce subcarrier visibility. Note that subcarrier phase information in the SECAM system carries no picture information.

As with PAL, SECAM requires some means of identifying the line-switching sequence between the encoding and decoding functions. This used to be done by incorporating alternate Dr and Db color identification signals for nine lines during the vertical blanking interval following the equalizing pulses after vertical sync, as shown in Figure 4.25a. Modern practice has been to eliminate the bottle signals and use a F_{OR}/F_{OB} burst after horizontal sync to derive the switching synchro-nization information, as shown in Figure 4.25b. This method has the advantage of simplifying the exchange of program material.

Field	Line Number		Color		Subcarrier Phase	
odd (1)	N		Dr		0°	
even (2)		N + 313		Db		180°
odd (3)	N + 1		Db		0°	
even (4)		N + 314		Dr		0°
odd (5)	N + 2		Dr		180°	
even (6)		N + 315		Db		180°
odd (7)	N + 3		Db		0°	
even (8)		N + 316		Dr		180°
odd (9)	N + 4		Dr		0°	
even (10)		N + 317		Db		0°
odd (11)	N + 5		Db		180°	
even (12)		N + 318		Dr		180°

Table 4.8. SECAM Color Versus Line and Field Timing.

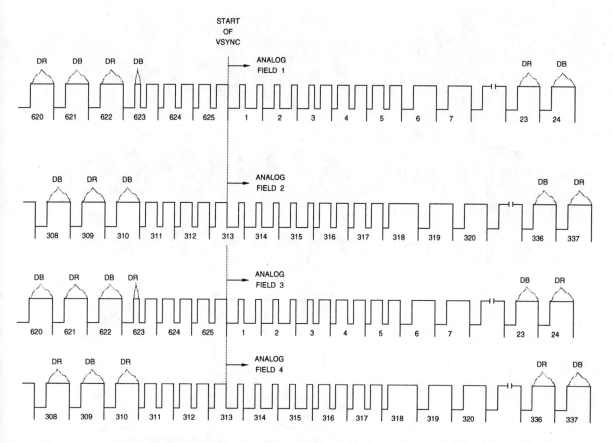

Figure 4.24. Four-field SECAM sequence. (See Figure 4.5 for equalization and serration pulse details.)

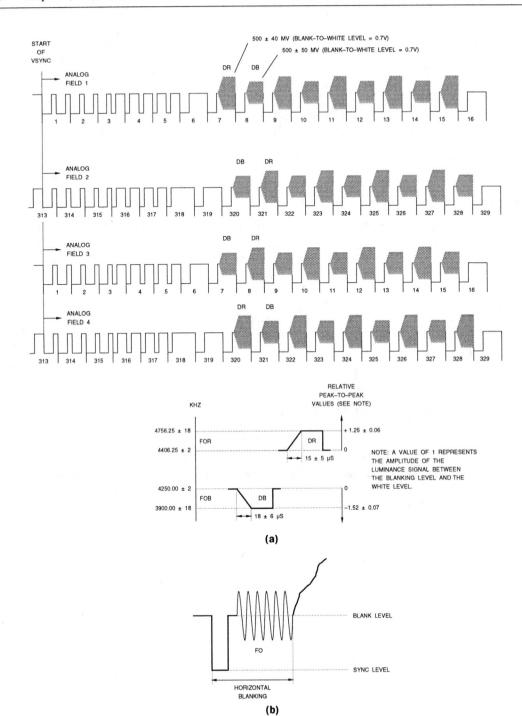

Figure 4.25. SECAM Chroma Synchronization Signals. (a) is no longer used.

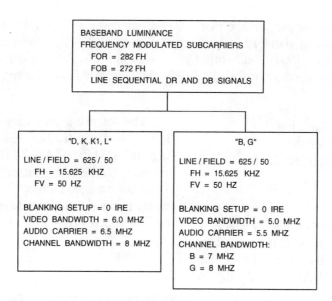

BASEBAND LUMINANCE
FREQUENCY MODULATED SUBCARRIERS
 FOR = 282 FH
 FOB = 272 FH
 LINE SEQUENTIAL DR AND DB SIGNALS

"D, K, K1, L"

LINE / FIELD = 625 / 50
 FH = 15.625 KHZ
 FV = 50 HZ

BLANKING SETUP = 0 IRE
VIDEO BANDWIDTH = 6.0 MHZ
AUDIO CARRIER = 6.5 MHZ
CHANNEL BANDWIDTH = 8 MHZ

"B, G"

LINE / FIELD = 625 / 50
 FH = 15.625 KHZ
 FV = 50 HZ

BLANKING SETUP = 0 IRE
VIDEO BANDWIDTH = 5.0 MHZ
AUDIO CARRIER = 5.5 MHZ
CHANNEL BANDWIDTH:
 B = 7 MHZ
 G = 8 MHZ

Figure 4.26. Summary ITU designation for SECAM systems.

Usage by Country

Figure 4.26 shows the ITU designations for SECAM systems. The letters refer to the monochrome standard for line and field rates (625/50), video bandwidth (5.0 or 6.0 MHz), audio carrier relative frequency, and RF channel bandwidth. The SECAM refers to the technique to add color information to the monochrome signal. Detailed timing parameters may be found in Table 4.9.

The following countries use, or are planning to use, the (B) SECAM standard, according to ITU-R BT.470-3 (1994) and other sources. (B) SECAM is used only for VHF transmission.

Djibouti	Iraq
Greece	Lebanon
Iran	Mali

Mauritania
Mauritius
Morocco

The following countries use, or are planning to use, the (D) SECAM standard, according to ITU-R BT.470-3 (1994) and other sources. (D) SECAM is used only for VHF transmission.

Afghanistan	Kazakhstan
Armenia	Lithuania
Azerbaijan	Mongolia
Belarus	Moldova
Bulgaria	Poland
Czech Republic	Russia
Estonia	Slovak Republic
Georgia	Ukraine
Hungary	Viet Nam

The following countries use, or are planning to use, the (G) SECAM standard, according to ITU-R BT.470-3 (1994) and other sources. (G) SECAM is used only for UHF transmission.

Greece
Iran
Iraq
Mali
Mauritius
Morocco
Saudi Arabia

The following countries use, or are planning to use, the (K) SECAM standard, according to ITU-R BT.470-3 (1994) and other sources. (K) SECAM is used only for UHF transmission.

Armenia
Azerbaijan
Bulgaria
Czech Republic
Estonia
Georgia
Hungary
Kazakhstan
Lithuania
Madagascar
Moldova
Poland
Russia
Slovak Republic
Ukraine
Viet Nam

The following countries use, or are planning to use, the (K1) SECAM standard, according to ITU-R BT.470-3 (1994) and other sources. (K1) SECAM is used for both VHF and UHF transmission unless only VHF or UHF transmission is supported (as indicated by a V or U, respectively).

Benin
Burkina Faso
Burundi
Chad
Cape Verde
Central African
 Republic
Niger

Comoros
Congo
Gabon
Madagascar (V)
Rwanda
Senegal
Togo
Zaire

The following countries use, or are planning to use, the (L) SECAM standard, according to ITU-R BT.470-3 (1994) and other sources. (L) SECAM is used for both VHF and UHF transmission unless only VHF or UHF transmission is supported (as indicated by a V or U, respectively).

France

Luminance Equation Derivation

The equation for generating luminance from RGB information is determined by the chromaticities of the three primary colors (RGB) used by the receiver and what color white actually is. The chromaticities of the RGB primaries and reference white (white is defined to be CIE illuminate D_{65}) are:

$R:$ $\quad x_r = 0.64$ $\quad y_r = 0.33$ $\quad z_r = 0.03$

$G:$ $\quad x_g = 0.29$ $\quad y_g = 0.60$ $\quad z_g = 0.11$

$B:$ $\quad x_b = 0.15$ $\quad y_b = 0.06$ $\quad z_b = 0.79$

$white:$ $\quad x_w = 0.3127$ $\quad y_w = 0.3290$
$\quad z_w = 0.3583$

where x and y are the specified CIE 1931 chromaticity coordinates; z is calculated by knowing that x + y + z = 1. Once again, substituting the known values gives us the solution for K_r, K_g, and K_b:

	M	N[1]	B, G	H	I	D, K	K1	L
SCAN LINES PER FRAME	525	625	625					
FIELD FREQUENCY (FIELDS / SECOND)	59.94	50	50					
LINE FREQUENCY (HZ)	15,734	15,625	15,625					
PEAK WHITE LEVEL (IRE)	100	100	100					
SYNC TIP LEVEL (IRE)	−40	(−43) −40	−43					
SETUP (IRE)	7.5 ± 2.5	7.5 ± 2.5 (0)	0					
PEAK VIDEO LEVEL (IRE)	120		133		133	115	115	124
GAMMA OF RECEIVER	2.2 (2.8)	2.8	2.8	2.8	2.8	2.8	2.8	2.8
VIDEO BANDWIDTH (MHZ)	4.2	5.0 (4.2)	5.0	5.0	5.5	6.0	6.0	6.0
LUMINANCE SIGNAL	$Y = 0.299R' + 0.685G' + 0.114B'$ (RGB ARE GAMMA–CORRECTED)							

[1] Values in parentheses apply to combination (N) PAL used in Argentina.

Table 4.9a. Basic Characteristics of Color Video Signals.

$$\begin{bmatrix} K_r \\ K_g \\ K_b \end{bmatrix} = \begin{bmatrix} 0.3127/0.3290 \\ 1 \\ 0.3583/0.3290 \end{bmatrix} \begin{bmatrix} 0.64 & 0.29 & 0.15 \\ 0.33 & 0.60 & 0.06 \\ 0.03 & 0.11 & 0.79 \end{bmatrix}^{-1}$$

$$= \begin{bmatrix} 0.674 \\ 1.177 \\ 1.190 \end{bmatrix}$$

Y is defined to be

$$Y = (K_r y_r) R' + (K_g y_g) G' + (K_b y_b) B'$$
$$= (0.674)(0.33) R' + (1.177)(0.60) G'$$
$$+ (1.190)(0.06) B'$$

or

$$Y = 0.222R' + 0.706G' + 0.071B'$$

However, the standard $Y = 0.299R' + 0.587G' + 0.114B'$ equation is still used.

Characteristics	M	N	B, D, H, H, I D, K, K1, L, N[1]
Nominal line period (μs)	63.5555	64	64
Line blanking interval (μs)	10.7 ± 0.1	10.88 ± 0.64	12 ± 0.3
0_H to start of active video (μs)	9.2 ± 0.1	9.6 ± 0.64	10.5
Front porch (μs)	1.5 ± 0.1	1.92 ± 0.64	1.65 ± 0.1
Line synchronizing pulse (μs)	4.7 ± 0.1	4.99 ± 0.77	4.7 ± 0.2
Rise and fall time of line blanking (10%, 90%) (ns)	140 ± 20	300 ± 100	300 ± 100
Rise and fall time of line synchronizing pulses (10%, 90%) (ns)	140 ± 20	≤ 250	250 ± 50

Notes
1. Combination (N) PAL used in Argentina.
2. 0_H is at 50% point of falling edge of horizontal sync.
3. In case of different standards having different specifications and tolerances, the tightest specification and tolerance is listed.
4. Timing is measured between half-amplitude points on appropriate signal edges.

Table 4.9b Details of Line Synchronization Signals.

Characteristics	M	N	B, D, H, H, I D, K, K1, L, N[1]
Field period (ms)	16.6833	20	20
Field blanking interval	20 lines	19–25 lines	25 lines
Rise and fall time of field blanking (10%, 90%) (ns)	140 ± 20	≤ 250	300 ± 100
Duration of equalizing and synchronizing sequences	3 H	3 H	2.5 H
Equalizing pulse width (µs)	2.3 ± 0.1	2.43 ± 0.13	2.35 ± 0.1
Serration pulse width (µs)	4.7 ± 0.1	4.7 ± 0.8	4.7 ± 0.1
Rise and fall time of synchronizing and equalizing pulses (10%, 90%) (ns)	140 ± 20	< 250	250 ± 50

Notes
1. Combination (N) PAL used in Argentina.
2. In case of different standards having different specifications and tolerances, the tightest specification and tolerance is listed.
3. Timing is measured between half-amplitude points on appropriate signal edges.

Table 4.9c. Details of Field Synchronization Signals.

	M / NTSC	M / PAL	B, D, G, H, I, N / PAL	B, D, G, K, K1, K / SECAM
ATTENUATION OF COLOR DIFFERENCE SIGNALS	U, V, I, Q: < 2 DB AT 1.3 MHZ > 20 DB AT 3.6 MHZ OR Q: < 2 DB AT 0.4 MHZ < 6 DB AT 0.5 MHZ > 6 DB AT 0.6 MHZ	< 2 DB AT 1.3 MHZ > 20 DB AT 3.6 MHZ	< 3 DB AT 1.3 MHZ > 20 DB AT 4 MHZ (> 20 DB AT 3.6 MHZ)	< 3 DB AT 1.3 MHZ > 30 DB AT 3.5 MHZ (BEFORE LOW FREQUENCY PRE–CORRECTION)
START OF BURST AFTER 0H (µS)	5.3 ± 0.07	5.8 ± 0.1	5.6 ± 0.1	
BURST DURATION (CYCLES)	9 ± 1	9 ± 1	10 ± 1 (9 ± 1)	
BURST PEAK AMPLITUDE	40 ± 10 IRE	42.86 ± 10 IRE	42.86 ± 10 IRE	

Note: Values in parentheses apply to combination (N) PAL used in Argentina.

Table 4.9d. Basic Characteristics of Color Video Signals.

Color Bars

Color bars are one of the standard video test signals, and there are several versions, depending on the video standard and application. For this reason, this section reviews the most common color bar formats. Color bars have two major characteristics: amplitude and saturation.

The amplitude of a color bar signal is determined by:

$$amplitude\ (\%)\ =\ \frac{max\ (R,\ G,\ B)_a}{max\ (R,\ G,\ B)_b} \times 100$$

where $max(R,G,B)_a$ is the maximum value of the gamma-corrected RGB (R'G'B') components during colored bars and $max(R,G,B)_b$ is the maximum value of the gamma-corrected RGB (R'G'B') components during reference white.

The saturation of a color bar signal is less than 100% if the minimum value of any one of the gamma-corrected RGB components is not zero. The saturation may be determined by:

saturation (%) =

$$\left[1 - \left(\frac{min(R,\ G,\ B)}{max(R,\ G,\ B)}\right)^{\gamma}\right] \times 100$$

where $min(R,G,B)$ and $max(R,G,B)$ are the minimum and maximum values, respectively, of the gamma-corrected RGB components during colored bars, and γ is the gamma exponent, typically 2.2 for NTSC and 2.8 for PAL. (*Note*: Although the PAL standards specify a value of 2.8, a value of 2.2 is actually used.)

Refer to Appendix A for more information on testing video signals.

NTSC Color Bars

In 1953, it was normal practice for the analog RGB signals to have a 7.5 IRE setup, and the original NTSC equations assumed this form of input to an NTSC encoder. Today, digital RGB signals do not include the 7.5 IRE setup. Analog RGB signals may have a 7.5 IRE setup. The 7.5 IRE setup is now typically added within the encoder, and the RGB inputs to the encoder are assumed not to have the 7.5 IRE setup.

The different color bar signals are usually described by four amplitudes, expressed in percent, separated by oblique strokes (100% saturation is implied, so saturation is not specified). The first and second numbers are the white and black amplitudes, respectively. The third and fourth numbers are the white and black amplitudes from which the color bars are derived. For example, 100/0/75/7.5 bars would be 75% bars with 7.5% setup in which the white bar has been set to 100% and the black bar to 0%. Since NTSC systems usually have the 7.5% setup, the two common color bars are 75/7.5/75/7.5 and 100/7.5/100/7.5, which are usually shortened to "75% amplitude, 100% saturation" and "100% amplitude, 100% saturation", or just "75%" and "100%," respectively. The 75% bars are most commonly used. Television transmitters do not pass chroma information with an amplitude greater than 120 IRE. Therefore, the 75/7.5/75/7.5 color bars are used for transmitter testing. The 100/7.5/100/7.5 color bars may be used for testing in situa-tions where a direct connection between equipment is possible.

The 75/7.5/75/7.5 color bars may also have the representation 77/7.5/77/7.5 in specifications that assume the RGB data used a 7.5% setup. The 75/7.5/75/7.5 color bars are a part of the Electronic Industries Association EIA-189-A Encoded Color Bar Standard (1976).

Figure 4.27 shows a typical M (NTSC) vectorscope display for full-screen EIA color bars. Some vectorscopes have a 75%/100% switch that changes the calibration of the chrominance gain to accommodate the two types of color bars.

Tables 4.10, 4.11, and 4.12 list the luma and chroma levels for the three color bar formats for NTSC.

Figure 4.28 illustrates the video waveform for 75/7.5/75/7.5 color bars, commonly referred to as 75% amplitude, 100% saturation color bars. To generate the 100/0/100/0 color bars, which are used mostly for testing, the 7.5 IRE setup circuitry within the encoder would have to be disabled and the standard RGB-to-YIQ equations modified to compensate for the loss of the 7.5 IRE setup.

For reference, the RGB and YCbCr values to generate the standard NTSC color bars are shown in Tables 4.13 and 4.14. RGB is assumed to have a range of 0–255; YCbCr is assumed to have a range of 16–235 for Y and 16–240 for Cb and Cr. It is assumed the 7.5 IRE setup is implemented within the encoder, except when generating 100/0/100/0 color bars.

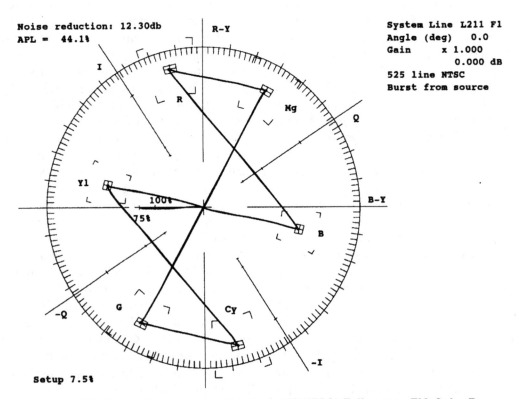

VM700A Video Measurement Set

Figure 4.27. Typical Vectorscope Display for M(NTSC) Full-screen EIA Color Bars.

	Luminance (IRE)	Chrominance Level (IRE)	Minimum Chrominance Excursion (IRE)	Maximum Chrominance Excursion (IRE)	Chrominance Phase (degrees)
white	76.9	0	–	–	–
yellow	69.0	62.1	37.9	100.0	167.1
cyan	56.1	87.7	12.3	100.0	283.5
green	48.2	81.9	7.3	89.2	240.7
magenta	36.2	81.9	–4.8	77.1	60.7
red	28.2	87.7	–15.6	72.1	103.5
blue	15.4	62.1	–15.6	46.4	347.1
black	7.5	0	–	–	–

Table 4.10. 75/7.5/75/7.5 NTSC/EIA Color Bars. These are commonly referred to as 75% amplitude, 100% saturation NTSC or EIA color bars.

	Luminance (IRE)	Chrominance Level (IRE)	Minimum Chrominance Excursion (IRE)	Maximum Chrominance Excursion (IRE)	Chrominance Phase (degrees)
white	100.0	0	–	–	–
yellow	89.5	82.8	48.1	130.8	167.1
cyan	72.3	117.0	13.9	130.8	283.5
green	61.8	109.2	7.2	116.4	240.7
magenta	45.7	109.2	–8.9	100.3	60.7
red	35.2	117.0	–23.3	93.6	103.5
blue	18.0	82.8	–23.3	59.4	347.1
black	7.5	0	–	–	–

Table 4.11. 100/7.5/100/7.5 NTSC Color Bars. These are commonly referred to as 100% amplitude, 100% saturation NTSC color bars.

	Luminance (IRE)	Chrominance Level (IRE)	Minimum Chrominance Excursion (IRE)	Maximum Chrominance Excursion (IRE)	Chrominance Phase (degrees)
white	100.0	0	–	–	–
yellow	88.6	89.5	43.9	133.3	167.1
cyan	70.1	126.5	6.9	133.3	283.5
green	58.7	118.1	–0.3	117.7	240.7
magenta	41.3	118.1	–17.7	100.3	60.7
red	29.9	126.5	–33.3	93.1	103.5
blue	11.4	89.5	–33.3	56.1	347.1
black	0	0	–	–	–

Table 4.12. 100/0/100/0 NTSC Color Bars.

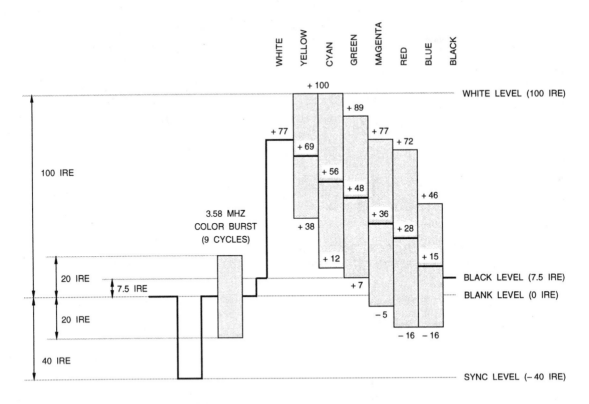

Figure 4.28. IRE values for 75/7.5/75/7.5 NTSC/EIA color bars.

	White	Yellow	Cyan	Green	Magenta	Red	Blue	Black
gamma-corrected RGB (gamma = 2.2)								
R′	191	191	0	0	191	191	0	0
G′	191	191	191	191	0	0	0	0
B′	191	0	191	0	191	0	191	0
linear RGB								
R	135	135	0	0	135	135	0	0
G	135	135	135	135	0	0	0	0
B	135	0	135	0	135	0	135	0
YCbCr								
Y	180	162	131	112	84	65	35	16
Cb	128	44	156	72	184	100	212	128
Cr	128	142	44	58	198	212	114	128

Table 4.13. RGB and YCbCr Values for 75/7.5/75/7.5 NTSC/EIA Color Bars.

	White	Yellow	Cyan	Green	Magenta	Red	Blue	Black
gamma-corrected RGB (gamma = 2.2)								
R′	255	255	0	0	255	255	0	0
G′	255	255	255	255	0	0	0	0
B′	255	0	255	0	255	0	255	0
linear RGB								
R	255	255	0	0	255	255	0	0
G	255	255	255	255	0	0	0	0
B	255	0	255	0	255	0	255	0
YCbCr								
Y	235	210	170	145	106	81	41	16
Cb	128	16	166	54	202	90	240	128
Cr	128	146	16	34	222	240	110	128

Table 4.14. RGB and YCbCr Values for 100/7.5/100/7.5 and 100/0/100/0 NTSC Color Bars.

PAL/SECAM Color Bars

Unlike NTSC, PAL and SECAM do not support a 7.5 IRE setup; the black and blank levels are the same. The different color bar signals are usually described by four amplitudes, expressed in percent, separated by oblique strokes. The first and second numbers are the maximum and minimum percentages, respectively, of gamma-corrected RGB values for an uncolored bar. The third and fourth numbers are the maximum and minimum percentages, respectively, of gamma-corrected RGB values for a colored bar. Since PAL and SECAM systems have a 0% setup, the two common color bars are 100/0/75/0 and 100/0/100/0, which are usually shortened to "75% amplitude, 100% saturation" and "100% amplitude, 100% saturation," or just 75% and 100%, respectively. The 100/0/75/0 color bars are used for transmitter testing. The 100/0/100/0 color bars may be used for testing in situations where a direct connection between equipment is possible.

Tables 4.15, 4.16, and 4.17 list the luma and chroma levels for the three color bar formats for PAL. Figure 4.29 illustrates the video waveform for 100/0/75/0 color bars. The 100/0/75/0 color bars also are referred to as EBU (European Broadcast Union) color bars. All of the color bars discussed in this section are also a part of *Specification of Television Standards for 625-line System-I Transmissions* (1971) published by the Independent Television Authority (ITA) and the British Broadcasting Corporation (BBC) and Recommendation ITU-R BT.471-1 (1986). Figure 4.30 shows a typical (B, D, G, H, I) PAL vectorscope display for full-screen EBU color bars.

For reference, the RGB and YCbCr values to generate the standard PAL (and SECAM) color bars are shown in Tables 4.18, 4.19, and 4.20. RGB is assumed to have a range of 0–255; YCbCr is assumed to have a range of 16–235 for Y and 16–240 for Cb and Cr.

	Luminance (volts)	Peak-to-Peak Chrominance			Chrominance Phase (degrees)	
		U axis (volts)	V axis (volts)	Total (volts)	Line n (135° burst)	Line n + 1 (225° burst)
white	0.700	0	–	–	–	–
yellow	0.465	0.459	0.105	0.470	167	193
cyan	0.368	0.155	0.646	0.664	283.5	76.5
green	0.308	0.304	0.541	0.620	240.5	119.5
magenta	0.217	0.304	0.541	0.620	60.5	299.5
red	0.157	0.155	0.646	0.664	103.5	256.5
blue	0.060	0.459	0.105	0.470	347	13.0
black	0	0	0	0	–	–

Table 4.15. 100/0/75/0 PAL/EBU Color Bars (100% Saturation). These are commonly referred to as 75% amplitude, 100% saturation PAL/EBU color bars.

	Luminance (volts)	Peak-to-Peak Chrominance			Chrominance Phase (degrees)	
		U axis (volts)	V axis (volts)	Total (volts)	Line n (135° burst)	Line n + 1 (225° burst)
white	0.700	0	–	–	–	–
yellow	0.620	0.612	0.140	0.627	167	193
cyan	0.491	0.206	0.861	0.885	283.5	76.5
green	0.411	0.405	0.721	0.827	240.5	119.5
magenta	0.289	0.405	0.721	0.827	60.5	299.5
red	0.209	0.206	0.861	0.885	103.5	256.5
blue	0.080	0.612	0.140	0.627	347	13.0
black	0	0	0	0	–	–

Table 4.16. 100/0/100/0 PAL Color Bars (100% Saturation). These are commonly referred to as 100% amplitude, 100% saturation PAL color bars.

	Luminance (volts)	Peak-to-Peak Chrominance			Chrominance Phase (degrees)	
		U axis (volts)	V axis (volts)	Total (volts)	Line n (135° burst)	Line n + 1 (225° burst)
white	0.700	0	–	–	–	–
yellow	0.640	0.459	0.105	0.470	167	193
cyan	0.543	0.155	0.646	0.664	283.5	76.5
green	0.483	0.304	0.541	0.620	240.5	119.5
magenta	0.392	0.304	0.541	0.620	60.5	299.5
red	0.332	0.155	0.646	0.664	103.5	256.5
blue	0.235	0.459	0.105	0.470	347	13.0
black	0	0	0	0	–	–

Table 4.17. 100/0/100/25 PAL Color Bars (98% Saturation). These are commonly referred to as 95% PAL color bars.

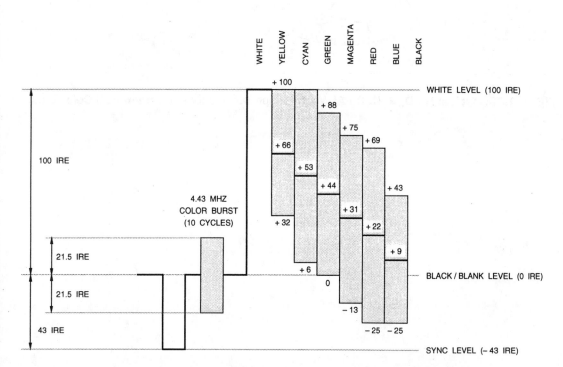

Figure 4.29. IRE values for 100/0/75/0 PAL/EBU Color Bars.

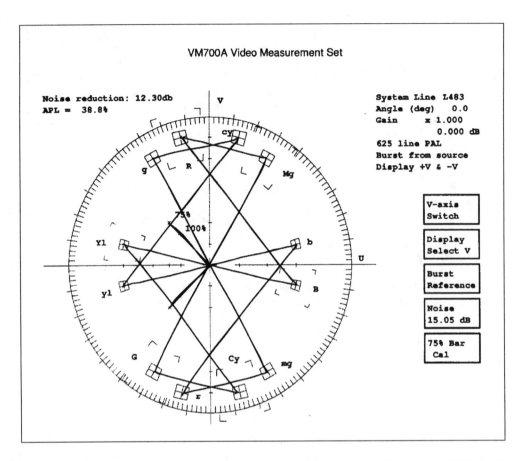

Figure 4.30. Typical (B, D, G, H, I) PAL Vectorscope Display for Full-screen EBU Color Bars.

	White	Yellow	Cyan	Green	Magenta	Red	Blue	Black
gamma-corrected RGB (gamma = 2.8)								
R′	255	191	0	0	191	191	0	0
G′	255	191	191	191	0	0	0	0
B′	255	0	191	0	191	0	191	0
linear RGB								
R	255	114	0	0	114	114	0	0
G	255	114	114	114	0	0	0	0
B	255	0	114	0	114	0	114	0
YCbCr								
Y	235	162	131	112	84	65	35	16
Cb	128	44	156	72	184	100	212	128
Cr	128	142	44	58	198	212	114	128

Table 4.18. RGB and YCbCr values for 100/0/75/0 PAL/EBU/SECAM Color Bars.

	White	Yellow	Cyan	Green	Magenta	Red	Blue	Black
gamma-corrected RGB (gamma = 2.8)								
R′	255	255	0	0	255	255	0	0
G′	255	255	255	255	0	0	0	0
B′	255	0	255	0	255	0	255	0
linear RGB								
R	255	255	0	0	255	255	0	0
G	255	255	255	255	0	0	0	0
B	255	0	255	0	255	0	255	0
YCbCr								
Y	235	210	170	145	106	81	41	16
Cb	128	16	166	54	202	90	240	128
Cr	128	146	16	34	222	240	110	128

Table 4.19. RGB and YCbCr Values for 100/0/100/0 PAL/SECAM Color Bars.

	White	Yellow	Cyan	Green	Magenta	Red	Blue	Black
gamma-corrected RGB (gamma = 2.8)								
R′	255	255	64	64	255	255	64	64
G′	255	255	255	255	64	64	64	64
B′	255	64	255	64	255	64	255	64
linear RGB								
R	255	255	5	5	255	255	5	5
G	255	255	255	255	5	5	5	5
B	255	5	255	5	255	5	255	5
YCbCr								
Y	235	216	186	167	139	120	90	16
Cb	128	44	156	72	184	100	212	128
Cr	128	142	44	58	198	212	114	128

Table 4.20. RGB and YCbCr Values for 100/0/100/25 PAL/SECAM Color Bars.

SuperNTSC™

SuperNTSC (trademarked by Faroudja Laboratories) was researched and developed by Faroudja Laboratories in an attempt to improve the NTSC video signal to its maximum potential. The intent is to pre-process the video signal, transmit it as a standard NTSC signal, and perform more processing at the receiver to improve the image quality. Note that a standard receiver would properly decode and display the SuperNTSC signal; the image quality just would not be as good as if a SuperNTSC receiver were also used. Many of the techniques, with some modification, also could be applied to PAL signals.

Faroudja considers NTSC to have three basic weaknesses, listed in the following sections. If these are corrected, then NTSC has the potential to rival RGB or HDTV in video quality:

1. *Visible line structure (525 lines, 2:1 interlaced) and poor horizontal and vertical resolution.*

 To reduce the line structure and vertical aliases, television cameras would be 525-line, 30-Hz progressive scan and a conversion from a 30-Hz progressive scan image to a 2:1 interlaced, 60-Hz image would be performed before encoding. At the receiver, the 525-line, 2:1 interlaced image would be converted into a 1050-line, 2:1 interlaced image. The vertical interpolation of the line doubler in the receiver is simplified if the television camera is progressive scan.

 Detail processing at the receiver would be done to increase small level details without modifying large transitions. In addition, the rise times of large horizontal transitions would be shortened. Both techniques would allow the displayed image to

appear as though it had a bandwidth of 7.5 MHz (525 lines) or 15 MHz (1050 lines), rather than the usual 4.2 MHz. Figure 4.31 illustrates a typical color transient improvement method that could be used (all times assume minimum rise times according to the transmission standard). The assumption is that luminance and chrominance transitions normally are congruent. However, the chrominance transition is degraded due to the narrow bandwidth of the chrominance information. By monitoring coincident luminance transitions, a faster edge is synthesized for the chrominance transitions.

2. *Interference between luminance and chrominance.*

The standard NTSC signal has three distinct deficiencies: cross color, cross luminance, and limited chrominance bandwidth. Cross color results in high-frequency luma information being interpreted as chroma information. The feeling is that cross color has been getting worse due to improved television cam-

eras with extended frequency responses up to 7 MHz and computer-generated images that generate fast transitions at all angles. Cross luminance, visible only with a comb filter decoder, is the result of mistaking chroma at vertical transitions to be luma, and it is displayed as one or two lines of dots at 3.58 MHz (the "hanging dot" pattern).

Limited chroma bandwidth is most noticeable at sharp vertical junctures between highly dissimilar colors. For example, the transition from green to magenta on the standard color bar pattern shows the effect of the slow decay of green and the slow rise of magenta. During these types of transitions, the subcarrier dot pattern is also noticeable.

The key to reducing these artifacts would be to design a new encoder and decoder. The encoder would prevent the spectral overlap between luma and chroma by prefiltering using comb filters, as shown in Figure 4.32. Luma information between 2.3 MHz and 4.2 MHz is pre-

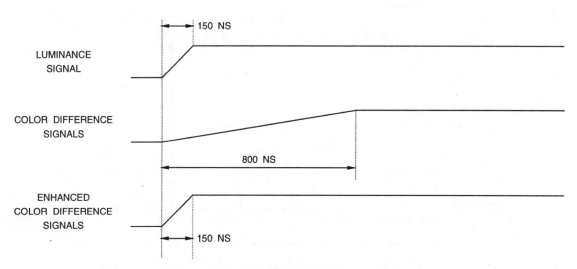

Figure 4.31. Color Transient Improvement.

combed so it will not interfere with chroma frequencies in that spectrum. The chroma also is precombed so it will not interfere with luma frequencies within the 2.3–4.2 MHz spectrum.

The comb filters for the encoder may be of various complexities, from 2H delay designs or more. Trade-offs must be made between circuit complexity, cost, and marginally improved performance (see Figure 4.33). Experiments have determined that 2H comb filters for the encoder are an adequate compromise, especially when used with decoders that use 1H or 2H comb filters (Figure 4.34). The decoder would have a vertical chrominance enhancement circuit to compensate for the loss in vertical chrominance resolution when a 2H encoder is used. In addition, the decoder adjusts the bandwidth of the chrominance channels depending on whether a large transition (wide bandwidth filter for clean, sharp transitions) or a small transition (narrow bandwidth filter to reduce chroma noise and cross color) occurs.

3. *Gamma problems.*

Present day cameras have an average gamma of 2.2, whereas color receivers have a gamma of 2.35 to 2.55. The overall transfer is not linear, and the overall displayed gamma is about 1.1 to 1.2. This results in compressed blacks and disappearing details in dark areas, with whites that are overly amplified. Significant improvements have been observed if the RGB outputs from the NTSC decoder are subjected to a gamma correction of 1.1 to 1.2, reestablishing proper gray scale and generating more natural blacks without white saturation.

PALplus

PALplus is the result of a cooperative project (started in 1990) undertaken by most of the European broadcasters. By 1995, they wanted to provide an enhanced definition television system (EDTV), compatible with existing receivers. PALplus has been transmitted by some broadcasters since 1994.

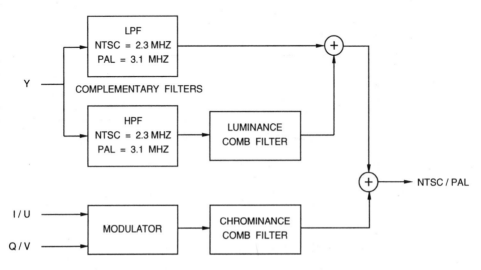

Figure 4.32. Improved Encoder.

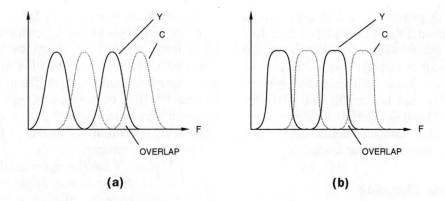

Figure 4.33. Various Encoder Comb Filter and Spectral Overlap Configurations. (a) 2H comb. (b) 6H comb.

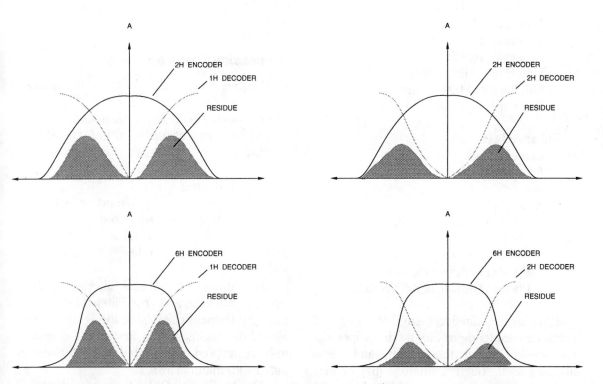

Figure 4.34. Various Encoder and Decoder Comb Filter Configurations and the Resulting Spectral Overlap.

A PALplus picture has a 16:9 aspect ratio. On conventional TVs, it is displayed as a 16:9 letterboxed image with 432 active lines. On PALplus TVs, it is displayed as a 16:9 picture with 574 active lines, with extended vertical resolution. The full bandwidth (5.0 MHz for PAL systems B and G, 5.5 MHz for PAL system I) is available for luminance detail. Cross color artifacts are reduced by clean encoding.

Wide Screen Signaling

Line 23 is devoted to a Widescreen Signalling (WSS) control signal, defined by Recommendation ITU-R BT.1119, used by PALplus TVs. This signal indicates:

> Aspect Ratio:
> Full Format 4:3
> Letterbox 14:9 Center
> Letterbox 14:9 Top
> Letterbox 16:9 Center
> Letterbox 16:9 Top
> Letterbox > 16:9 Center
> Full Format 14:9 Center
> Full Format 16:9 Anamorphic
>
> Enhanced services:
> Camera Mode
> Film Mode
>
> Subtitles:
> Teletext Subtitles Present
> Open Subtitles:
> Not Present
> Present in Active Picture
> Present Outside of Active Picture

PALplus is defined as being Letterbox 16:9 center, camera mode or film mode, helper signals present using modulation, and clean encoding used. Teletext subtitles may or may not be present, and open subtitles may be present only in active picture area.

In addition, during a PALplus transmission, the last 21 μs of line 23 contains a 10 μs black level followed by 48 cycles of the –U phase subcarrier. This is provided to fine-tune the helper-line demodulation phase and gain. During PALplus transmissions, line 623 also carries a 9.5 μs black level followed by a 10 μs white level for setting the levels in the letterbox processing circuits.

A PALplus TV has the option of deinterlacing a Film Mode signal and displaying it on a 50-Hz progressive-scan display or using field repeating on a 100-Hz interlaced display.

Ghost Cancellation

An optional ghost cancellation signal (defined by ITU-R BT.1124) on line 318 allows a suitably adapted TV to measure the ghost signal and cancel it. A PALplus TV may or may not support this feature.

Processing Overview

All PALplus sources start out as a 16:9 anamorphic image, occupying all 576 active scan lines of the standard 625 line PAL image. The format of the signal at this point is ITU-R BT.601 YCbCr.

Vertical Filtering

Before transmission, the 576 active scan lines of the 16:9 image are squeezed into only 432 scan lines. To avoid aliasing problems, the vertical resolution is reduced by lowpass filtering.

For luminance, vertical filtering is done using a Quadrature Mirror Filter (QMF) highpass and lowpass pair. Using the QMF process allows the highpass and lowpass information to be resampled, transmitted, and later recombined with minimal loss.

The luminance QMF lowpass output and the chrominance lowpass output are resam-

pled into three-quarters of their original heights; little information is lost to aliasing. After clean encoding, it is the letterboxed signal that non-PALplus TVs display.

The luma highpass output of the QMF process contains the rest of the original luma vertical frequency. It is used to generate the helper signal and is transmitted using the "black" scan lines not used by the letterbox picture.

Helper Signal: Film Mode

A film mode broadcast has both fields of a frame coming from the same image, as is usually the case with a movie scanned on a telecine.

In film mode, the maximum vertical resolution per frame is about 288 cycles per *active* picture height (cph), limited by the 576 active scan lines per frame.

The vertical resolution of the luminance image is reduced to 216 cph so it can be transmitted using only 432 active lines. The QMF lowpass and highpass filters split the luma vertical information into DC–215 cph and 216–288 cph. The color difference signals are lowpass filtered to around 80 cph.

The luma lowpass information is re-scanned into 432 lines to become the letterbox image. Since the vertical frequency is limited to a maximum of 216 cph, no information is lost.

The luma highpass output is decimated so only one in four lines are transmitted. These 144 lines are used to transmit the helper signal. Because of the QMF process, no information is lost to decimation.

The 72 lines above and 72 lines below the central 432-line of the letterbox image are used to transmit the 144 lines of the helper signal. This results in a standard 576 active line picture, but with the original image in its correct aspect ratio, centered between the helper signals. The scan lines containing helper signal are companded and modulated using the U subcarrier so they look black and are not visible to the viewer.

The 576 scan lines are transmitted as a standard interlaced PAL image.

Helper Signal: Camera Mode

Camera (or video) mode assumes the fields of a frame are independent of each other, as would be the case when an electronic camera scans a scene in motion. Therefore, the image may have changed between fields. Only intra-field processing is done.

In camera mode, the maximum vertical resolution per field is about 144 cycles per *active* picture height (cph), limited by the 288 active scan lines per field.

The vertical resolution of the luma image is reduced to 108 cph so it can be transmitted using only 216 active lines. The QMF lowpass and highpass filter pair split the luma vertical information into DC–108 cph and 108–144 cph. The color difference signals are lowpass filtered to around 40 cph.

The luma lowpass information is re-scanned into 216 lines to become the letterbox image. Since the vertical frequency is limited to a maximum of 108 cph, no information is lost.

The luma highpass output is decimated so only one in four lines is transmitted. These 72 lines are used to transmit the helper signals. Because of the QMF process, no information is lost to decimation.

The 36 lines above and 36 lines below the central 216-line of the letterbox image are used to transmit the 72 lines of the helper signal. This results in a standard 288 active line picture, but with the original image in its correct aspect ratio, centered between the helper signals. The scan lines containing helper signal are companded and modulated using the U subcarrier so they look black and are not visible to the viewer.

The 288 scan lines are transmitted as a standard field of a PAL image.

Clean PAL Encoding and Decoding

Only the letterboxed portion of the PALplus signal is clean encoded. The helper signals are not actual PAL video. However, they are close enough to video to pass through the transmission chain and remain fairly invisible on standard TVs.

Fixed ColorPlus

Film Mode uses a fixed ColorPlus technique, making use of the lack of motion between the two fields of a frame. Fixed ColorPlus transmits the same chroma and high-frequency luma (luminance above 3 MHz) on lines N and N+312 during the letterboxed portion of a frame.

During decoding, each line is split into a low-frequency component and a high-frequency component. Adding the high-frequency portions of lines N and N+312 cancels the chroma, leaving luminance (if they are subtracted, the luminance cancels, leaving the chrominance).

Luma above 3 MHz is vertically limited to 108 cph since it occupies 216 lines (per field) within the letterboxed image, and there is no contribution from the helper signal. The PALplus system allows this since fine diagonal frequencies are not very visible.

Luma below 3 MHz is processed differently. Since it is clear of interference from the chroma, it may have different information on lines N and N+312. This allows the full vertical resolution of 288 cph to be reconstructed with the aid of the helper signal (which is limited to a 3-MHz bandwidth).

Motion Adaptive ColorPlus (MACP)

Camera Mode uses a motion adaptive version of ColorPlus.

The encoder tests for a match of chrominance on lines N and N+312. If they match, the same chrominance and high-frequency luminance (luminance above 3 MHz) on lines N and N+312 during the letterboxed portion of a frame are transmitted.

If the chrominance doesn't match, it is transmitted separately for lines N and N+312. High-frequency luminance for lines N and N+312 is not transmitted.

At the decoder, a standard PAL decoder processes the video signal, and its output is saved for possible use later. The decoded U and V signals from lines N and N+1 are delayed and averaged with the U and V signals one field later (from lines N+312 and N+313). They are lowpass filtered, yielding a "reference" color difference signal for each frame.

The U and V signals from the PAL decoder are compared with the "reference" U and V signals for every pixel in the image. If there is a match, the decoder assumes Fixed ColorPlus encoding was used, so addition and subtraction is used to separate the luminance and chrominance.

If there is not a match, then Motion Adaptive ColorPlus encoding must have been used, in which case the original U and V signals from the PAL decoder are used for the display.

Component Analog Video (CAV) Formats

In addition to the standard NTSC, PAL, and SECAM composite video formats, several component analog video formats may be used in the editing and production process. These provide the advantage of maintaining separate luminance and color difference signals throughout the editing and storage processes. Newer CAV formats have no use for the 7.5 IRE setup used in NTSC, which represents a 7.5% loss in dynamic range, so they do

not use a setup pedestal. CAV formats may sample the color difference components at half the rate of the luminance signal. Table 4.21 lists the common CAV formats. Figures 4.35 and 4.36 illustrate the vertical blanking intervals of the luma channel for 525-line and 625-line systems, respectively.

References

1. Benson, K. Blair, 1986, *Television Engineering Handbook*, McGraw-Hill, Inc.
2. *Encoded Color Bar Signal*, EIA-189-A, July 1976, Electronic Industries Association.
3. Faroudja, Yves Charles, *NTSC and Beyond, IEEE Transactions on Consumer Electronics*, Vol. 34, No. 1, February 1988.
4. Hosgood, Steven, 1995, *All You Ever Wanted to Know About PALplus, But Were Afraid to Ask*, Internet article, http://iiit.swan.ac.uk/~iisteve/palplus.html
5. ITU-R Recommendation BT.470, 1994, *Television Systems*.
6. ITU-R Recommendation BT.471, 1986, *Nomenclature and Description of Colour Bar Signals*.
7. ITU-R Recommendation BT.472, 1990, *Video Frequency Characteristics of a Television System to Be Used for the International Exchange of Programmes Between Countries that Have Adopted 625-Line Colour or Monochrome Systems*.
8. ITU-R Recommendation BS.707, 1990, *Transmission of Multisound in Terrestrial PAL Television Systems B, G, H, and I.*
9. *Multichannel Television Sound*, BTSC System Recommended Practices, EIA Television Systems Bulletin No. 5, July 1985, Electronic Industries Association.
10. Pritchard, D.H. and Gibson, J.J., *Worldwide Color Television Standards—Similarities and Differences*, Volume 80, February 1980, SMPTE Journal.
11. *SMPTE 230M-1991, American National Standard for Video Recording, 1/2-in Type L Mode 1 Electrical Parameters—Video, Audio, Time and Control Code and Tracking Control*, September 2, 1987.
12. *Specification of Television Standards for 625-Line System-I Transmissions*, 1971, Independent Television Authority (ITA) and British Broadcasting Corporation (BBC).

Addresses

EBU European Broadcasting Union
The Technical Center of the EBU
32, Avenue Albert Lancaster
B-1180 Brussels
Belgium

EIA Electronic Industries Association
2001 Pennsylvania Avenue, NW
Washington, DC 20006
Headquarters: (202) 457-4936
Standards: (800) 854-7179
http://www.eia.org/

IEEE Institute of Electrical and
Electronics Engineers
Headquarters:
345 East 47th Street
New York, NY 10017
(212) 705-7900
Standards Office:
IEEE Service Center
P.O. Box 1331
Piscataway, NJ 00855
(908) 981-0060
http://www.ieee.org

Format	Output Signal	Signal Amplitudes (volts)	Notes
BetaCam (see Note 1)	Y	+ 0.714	7.5% setup on Y only 75% saturation three wire = (Y + sync), (R′ – Y), (B′– Y)
	sync	– 0.286	
	R′ – Y, B′ – Y	± 0.350	
M-2 (see Note 2)	Y	+ 0.700	7.5% setup on Y only 100% saturation three wire = (Y + sync), (R′ – Y), (B′– Y)
	sync	– 0.300	
	R′ – Y, B′ – Y	± 0.324	
SMPTE (see Note 3)	Y	+ 0.700	0% setup on Y 100% saturation three wire = (Y + sync), (Pr + sync), (Pb + sync)
	sync	– 0.300	
	Pr, Pb	± 0.350	
	G′	+ 0.700	0% setup on R′, G′, and B′ 100% saturation three wire = (G′ + sync), (B′ + sync), (R′ + sync)
	B′	+ 0.700	
	R′	+ 0.700	
	sync	– 0.300	

Notes:
1. Trademark of Sony Corporation.
2. Trademark of Matsushita Corporation.
3. SMPTE 253 proposed standard. GBR notation is used to differentiate from standard RGB signals.

Table 4.21. Popular Component Analog Video Formats.

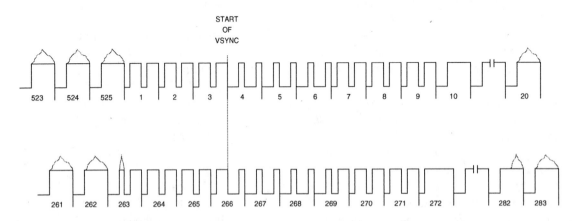

Figure 4.35. 525-line Luma Channel Vertical Intervals. Timing is the same as for (M) NTSC. (See Figure 4.5 for equalization and serration pulse details.)

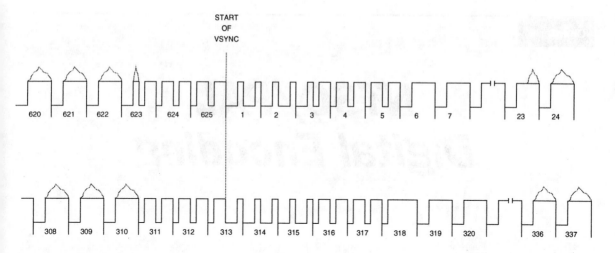

Figure 4.36. 625-line Luma Channel Vertical Intervals. Timing is the same as for (B, D, G, H, I) PAL. (See Figure 4.5 for equalization and serration pulse details.)

ITU International Telecommunications Union
Place Des Nations
CH-1211 Geneva
20 Switzerland
(011) 4122 730 5800
http://www.itu.ch/

SMPTE Society of Motion Picture and Television Engineers
595 West Hartsdale Ave.nue
White Plains, NY 10607
(914) 761-1100
http://www.smpte.org/

VESA Video Electronics Standards Association
2150 North First Street, Suite 440
San Jose, CA 95131
(408) 435-0333
http://www.vesa.org/

To subscribe to BBC research reports (there is a charge), write to:

Alec Booker
BBC Research & Development Dept.
Kingswood Warren
Tadworth
Surrey KT20 6NP
UK

NTSC/PAL
Digital Encoding

Although not exactly "digital" video, the NTSC and PAL composite color video formats are currently the most common formats for video, and therefore should be supported in a graphics/video system. Although the video signals themselves are analog, they can be generated almost entirely digitally. Analog NTSC and PAL encoders have been available for some time. However, they have been difficult to use, required adjustment, and offered limited video quality. Using digital techniques to implement NTSC and PAL encoding offers many advantages, such as ease of use, minimum analog adjustments, and excellent video quality.

In addition to generating composite video, S-video should also be supported in graphics/video systems, as many high-end consumer and industrial implementations are based on S-VHS or Hi-8. S-video uses separate luminance and chrominance analog video signals so higher quality may be maintained by eliminating the Y/C separation process.

A NTSC/PAL encoder designed for the computer environment requires several unique features. First, it should implement a simple, drop-in solution, as easy to use as any other MPU peripheral. Both the RGB and YCbCr input formats, with programmable input lookup tables, should be supported to allow the system designer flexibility in interfacing to a processing function or frame store before the encoder. RGB is a common input format, as many computer systems use the RGB color space for graphics, whereas the YCbCr input format is useful if video processing (such as decompression or scaling) is to be done.

A digital encoder should support several pixel clock rates and pixel input configurations, as shown in Table 5.1. Supporting square pixels directly as an input format on an encoder greatly simplifies integrating video into the computer environment. The other formats shown are commonly used in video editing equipment.

Standard computer-oriented video timing signals should be used by the encoder. These include horizontal sync, vertical sync, and blanking. Additional input control signals to ease system design include field identification signals, useful for video editing.

A robust encoder design will also provide test functions to allow the designer to debug the encoder, and the system, as easily as possible. Color bar generation can easily be added

	Pixel Clock Rate	Applications	Active Resolution	Total Resolution
(M) NTSC	13.5 MHz	MPEG 1, 2	$720^1 \times 485$	858×525
	12.27 MHz	square pixels	640×480	780×525
	10.43 MHz	MPEG 2	544×480	663×525
(B, D, G, H, I) PAL	14.75 MHz	square pixels	768×576	944×625
	13.5 MHz	MPEG 1, 2	$720^1 \times 576$	864×625
	10.43 MHz	MPEG 2	544×576	668×625

Table 5.1. Common Input Pixel Rates and Resolutions. [1]704 true active pixels.

to the encoder to ease system and device checking.

In some applications, both NTSC/PAL video and 4:2:2 digital component video (Chapter 8) are video output formats. In this instance, since the NTSC/PAL encoder has all the necessary timing information, it may be advantageous for it to generate the H (horizontal blanking), V (vertical blanking), and F (field) control signals required by the 4:2:2 encoder.

This chapter discusses the design of a digital encoder (whose block diagram is shown in Figure 5.1) that generates baseband composite (M) NTSC and (B, D, G, H, I) PAL video signals, and also has separate Y/C outputs for supporting S-video. (M) and (N) PAL are easily accommodated with some slight modifications. The highest possible quality video should be used in video editing environments to minimize artifacts produced during editing and mixing. Timecode support (vertical interval timecode or VITC, and longitudinal timecode or LTC) is reviewed here, along with various video test signals.

Baseband audio is transmitted using one or two (for stereo) conventional analog or digital audio channels.

Color Space Conversion

At a minimum, the digital RGB and YCbCr color spaces should be supported as input formats. These are converted to the YIQ (for NTSC) or YUV (for PAL) color spaces for further processing. Where ranges of values are mentioned, it is assumed 8-bit (plus sign) data values are used; 9-bit or 10-bit (plus sign) data values will result in more accurate computations at the expense of more circuitry. Encoders supporting only pseudocolor as an input pixel format could perform the color space conversion in the software driver that loads the lookup table RAMs, reducing the hardware requirements in the encoder. Tables 5.2 and 5.3 list some of the common pixel bus formats and timing signals used.

The YCbCr input data has a nominal range of 16–235 for Y and 16–240 for Cb and Cr. As

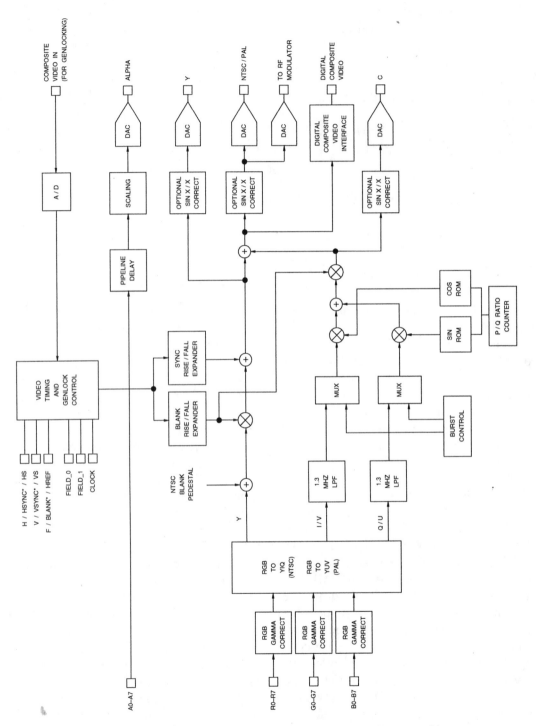

Figure 5.1. Typical NTSC/PAL Digital Encoder Implementation.

24-bit RGB (8, 8, 8)	16-bit RGB (5, 6, 5)	15-bit RGB (5, 5, 5)	24-bit 4:4:4 YCbCr	16-bit 4:2:2 YCbCr	12-bit 4:1:1 YCbCr
R7	–	–	Cr7	–	–
R6	–	–	Cr6	–	–
R5	–	–	Cr5	–	–
R4	–	–	Cr4	–	–
R3	–	–	Cr3	–	–
R2	–	–	Cr2	–	–
R1	–	–	Cr1	–	–
R0	–	–	Cr0	–	–
G7	R7	–	Y7	Y7	Y7
G6	R6	R7	Y6	Y6	Y6
G5	R5	R6	Y5	Y5	Y5
G4	R4	R5	Y4	Y4	Y4
G3	R3	R4	Y3	Y3	Y3
G2	G7	R3	Y2	Y2	Y2
G1	G6	G7	Y1	Y1	Y1
G0	G5	G6	Y0	Y0	Y0
B7	G4	G5	Cb7	[Cb7], Cr7	[Cb7], Cb5, Cb3, Cb1
B6	G3	G4	Cb6	[Cb6], Cr6	[Cb6], Cb4, Cb2, Cb0
B5	G2	G3	Cb5	[Cb5], Cr5	[Cr7], Cr5, Cr3, Cr1
B4	B7	B7	Cb4	[Cb4], Cr4	[Cr6], Cr4, Cr2, Cr0
B3	B6	B6	Cb3	[Cb3], Cr3	–
B2	B5	B5	Cb2	[Cb2], Cr2	–
B1	B4	B4	Cb1	[Cb1], Cr1	–
B0	B3	B3	Cb0	[Cb0], Cr0	–

Timing control signals:

graphics:
horizontal sync (HSYNC*)
vertical sync (VSYNC*)
composite blank (BLANK*)

ITU-R BT.601:
horizontal blanking (H)
vertical blanking (V)
even/odd field (F)

Philips:
horizontal sync (HS)
vertical sync (VS)
horizontal blank (HREF)

Table 5.2. Pixel Format Standards for Transferring RGB and YCbCr Video Data Over a 16-bit or 24-bit Bus. For 4:2:2 and 4:1:1 YCbCr data, the first active pixel data per scan line is indicated in brackets [].

Pixel Bus	24-bit RGB (8, 8, 8)	16-bit RGB (5, 6, 5)	15-bit RGB (5, 5, 5)	24-bit 4:4:4 YCbCr	16-bit 4:2:2 YCbCr	12-bit 4:1:1 YCbCr
P7D	–	R7	–	–	Y7	Y7
P6D	–	R6	R7	–	Y6	Y6
P5D	–	R5	R6	–	Y5	Y5
P4D	–	R4	R5	–	Y4	Y4
P3D	–	R3	R4	–	Y3	Y3
P2D	–	G7	R3	–	Y2	Y2
P1D	–	G6	G7	–	Y1	Y1
P0D	–	G5	G6	–	Y0	Y0
P7C	R7	G4	G5	Cr7	Cb7, Cr7	Cb5, Cb1
P6C	R6	G3	G4	Cr6	Cb6, Cr6	Cb4, Cb0
P5C	R5	G2	G3	Cr5	Cb5, Cr5	Cr5, Cr1
P4C	R4	B7	B7	Cr4	Cb4, Cr4	Cr4, Cr0
P3C	R3	B6	B6	Cr3	Cb3, Cr3	–
P2C	R2	B5	B5	Cr2	Cb2, Cr2	–
P1C	R1	B4	B4	Cr1	Cb1, Cr1	–
P0C	R0	B3	B3	Cr0	Cb0, Cr0	–
P7B	G7	R7	–	Y7	Y7	Y7
P6B	G6	R6	R7	Y6	Y6	Y6
P5B	G5	R5	R6	Y5	Y5	Y5
P4B	G4	R4	R5	Y4	Y4	Y4
P3B	G3	R3	R4	Y3	Y3	Y3
P2B	G2	G7	R3	Y2	Y2	Y2
P1B	G1	G6	G7	Y1	Y1	Y1
P0B	G0	G5	G6	Y0	Y0	Y0
P7A	B7	G4	G5	Cb7	[Cb7], Cr7	[Cb7], Cb3
P6A	B6	G3	G4	Cb6	[Cb6], Cr6	[Cb6], Cb2
P5A	B5	G2	G3	Cb5	[Cb5], Cr5	[Cr7], Cr3
P4A	B4	B7	B7	Cb4	[Cb4], Cr4	[Cr6], Cr2
P3A	B3	B6	B6	Cb3	[Cb3], Cr3	–
P2A	B2	B5	B5	Cb2	[Cb2], Cr2	–
P1A	B1	B4	B4	Cb1	[Cb1], Cr1	–
P0A	B0	B3	B3	Cb0	[Cb0], Cr0	–

Table 5.3. Pixel Format Standards for Transferring RGB and YCbCr Video Data Over a 32-bit Bus. For 4:2:2 and 4:1:1 YCbCr data, the first active pixel data per scan line is indicated in brackets []. For all formats except 24-bit RGB and 24-bit YCbCr data, PxA and PxB data contain pixel n data, PxC and PxD contain pixel n + 1 data. Refer to Table 5.2 for timing control signals.

YCbCr values outside these ranges result in overflowing the standard YIQ or YUV ranges for some color combinations, one of four things may be done, in order of preference: (a) allow the NTSC/PAL video signal to be generated using the extended YIQ or YUV ranges; (b) limit the color saturation after chrominance modulation to ensure a legal video signal is generated; or (c) clip the YIQ or YUV levels to the valid ranges. Note that 4:1:1, 4:2:0, or 4:2:2 YCbCr data must be converted to 4:4:4 YCbCr data before being converted to YIQ or YUV data. The chrominance lowpass digital filters will not perform the interpolation properly. YCbCr data must be derived from gamma-corrected RGB (R'G'B') data assuming a gamma value of 2.2.

NTSC Color Space Conversion

Arbitrarily choosing to generate the NTSC digital composite video levels (white = 200, blank = 60, sync = 4), and knowing that the blank-to-white amplitude is 0.714 V, the full-scale output of the D/A converters is therefore set to 1.3 V. Of the 140 levels between blank and white, 129.5 are used for luminance. Since computers commonly use linear RGB data, linear RGB data is converted to gamma-corrected RGB (R'G'B') data as follows (values are normalized to have a value of 0 to 1):

for R, G, B < 0.018

$$R' = 4.5 R$$
$$G' = 4.5 G$$
$$B' = 4.5 B$$

for R, G, B ≥ 0.018

$$R' = 1.099 R^{0.45} - 0.099$$
$$G' = 1.099 G^{0.45} - 0.099$$
$$B' = 1.099 B^{0.45} - 0.099$$

The gamma-corrected digital RGB data is then converted to YIQ data by scaling the general RGB-to-YIQ equations in Chapter 3 by 129.5/255:

RGB to YIQ

$$Y = 0.152R' + 0.298G' + 0.058B'$$
$$I = 0.303R' - 0.140G' - 0.163B'$$
$$Q = 0.108R' - 0.266G' + 0.158B'$$

YCbCr to YIQ

$$Y = 0.591(Y - 16)$$
$$I = 0.597(Cr - 128) - 0.274(Cb - 128)$$
$$Q = 0.387(Cr - 128) + 0.422(Cb - 128)$$

The color space conversion should maintain a minimum of 4 bits of fractional data, with the final results rounded to the desired accuracy. The R'G'B' input data has a range of 0 to 255. Rounding to 8 bits, Y has a range of 0 to 130, I a range of 0 to ±78, and Q a range of 0 to ±68.

Professional video systems may use the gamma-corrected RGB color space, with R'G'B' having a nominal range of 16 to 235. Occasional values less than 16 and greater than 235 are allowed, resulting in YIQ values outside their nominal ranges. In this instance, R'G'B' may be converted to YIQ by scaling the RGB-to-YIQ equations by 255/219:

$$Y = 0.177(R' - 16) + 0.347(G' - 16) + 0.067(B' - 16)$$

$$I = 0.353(R' - 16) - 0.163(G' - 16) - 0.190(B' - 16)$$

$$Q = 0.126(R' - 16) - 0.310(G' - 16) + 0.184(B' - 16)$$

PAL Color Space Conversion

The color space conversion equations for PAL operation are derived so that the full-scale output of the D/A converters is still 1.3 V to avoid using two D/A voltage references. Using the same sync tip value of 4 and white value of 200 to generate a 1-V signal places the blanking level at 63, resulting in 137 levels being used for luminance. Since computers commonly use linear RGB data, linear RGB data is converted to gamma-corrected RGB data. A gamma value of 2.2 is now used for both NTSC and PAL.

The gamma-corrected digital RGB (R′G′B′) data is then converted to YUV data by scaling the general RGB-to-YUV equations in Chapter 2 by 137/255:

RGB to YUV

$$Y = 0.161R' + 0.315G' + 0.061B'$$
$$U = -0.079R' - 0.155G' + 0.234B'$$
$$V = 0.330R' - 0.277G' - 0.053B'$$

YCbCr to YUV

$$Y = 0.626(Y - 16)$$
$$U = 0.533(Cb - 128)$$
$$V = 0.751(Cr - 128)$$

The color space conversion should maintain a minimum of 4 bits of fractional data, with the final results rounded to the desired accuracy. The R′G′B′ input data has a range of 0 to 255. Rounding to 8 bits, Y has a range of 0 to 137, U a range of 0 to ±60, and V a range of 0 to ±85.

Low-cost PAL encoders may also use YCbCr-to-YUV or RGB-to-YUV color space conversion based on simple shifts and adds at the expense of color accuracy:

YCbCr to YUV

$$Y = (1/2)(Y - 16) + (1/8)(Y - 16)$$
$$U = (1/2)(Cb - 128) + (1/32)(Cb - 128)$$
$$V = (1/2)(Cr - 128) + (1/4)(Cr - 128)$$

RGB to YUV

$$Y = (1/8)R' + (1/32)R' + (1/4)G'$$
$$+ (1/16)G' + (1/16)B'$$

$$U = -(1/16)R' - (1/32)R' - (1/8)G'$$
$$- (1/32)G' + (1/4)B'$$

$$V = (1/4)R' + (1/16)R' + (1/32)R'$$
$$- (1/4)G' - (1/32)G'$$
$$- (1/16)B'$$

Professional video systems may use the gamma-corrected RGB color space, with R′G′B′ having a nominal range of 16 to 235. Occasional values less than 16 and greater than 235 are allowed, resulting in YUV values outside their nominal ranges. In this instance, R′G′B′ may be converted to YUV by scaling the RGB-to-YUV equations by 255/219:

$$Y = 0.187(R' - 16) + 0.367(G' - 16)$$
$$+ 0.071(B' - 16)$$

$$U = -0.092(R' - 16) - 0.180(G' - 16)$$
$$+ 0.272(B' - 16)$$

$$V = 0.384(R' - 16) - 0.322(G' - 16)$$
$$- 0.062(B' - 16)$$

Composite Luminance Generation

NTSC Operation

As NTSC requires a 7.5 IRE blanking pedestal, a value of 10 must be added to the digital luminance data during active video (0 is added during the blank time). The digital luminance data (after the blanking pedestal is added) is clamped by a blanking signal that has a raised cosine distribution (between 0 and 1) to slow the slew rate of the blanked video signal to within composite video specifications and avoid ringing. A typical blank rise/fall time for NTSC and PAL is 140 ± 20 and 300 ± 100 ns, respectively.

Digital composite sync information also must be added to the luminance data after the blank processing has been performed. Digital values of 4 (sync present) or 60 (no sync) are assigned. The sync rise and fall times should be processed so as to generate a raised cosine distribution (between 4 and 60) to slow the slew rate of the sync signal to within composite video specifications and avoid ringing. A typical sync rise/fall time for NTSC is 140 ns, although the encoder should generate sync rise/fall edges of about 130 ns to compensate

for the analog output filters slowing down the sync edges. At this point, we have luminance with sync and blanking information, as shown in Table 5.4.

PAL Operation

When generating (B, D, G, H, I) PAL composite video, there is a 0 IRE blanking pedestal. Thus, no blanking pedestal is added to the digital luminance data. Luminance video blanking should be performed in the same manner as that used for NTSC.

Digital composite sync information also must be added to the luminance data after the blank processing has been performed. Digital values of 4 (sync present) or 63 (no sync) are assigned. The sync rise and fall times should be processed to generate a raised cosine distribution (between 4 and 63) to slow the slew rate of the sync signal to within composite video specifications and avoid ringing. A typical sync rise/fall time for PAL is 250 ±50 ns, although the encoder should generate sync rise/fall edges of about 240 ns to compensate for the analog output filters slowing down the sync edges. At this point, we have luminance with sync and blanking information, as shown in Table 5.5.

Video Level	8-bit Digital Value	10-bit Digital Value
white	200	800
black	70	280
blank	60	240
sync	4	16

Table 5.4. (M) NTSC Composite Luminance Digital Values.

Video Level	8-bit Digital Value	10-bit dDgital Value
white	200	800
black	63	252
blank	63	252
sync	4	16

Table 5.5. (B, D, G, H, I) PAL Composite Luminance Digital Values.

Analog Luminance Generation

The digital composite luminance data (ignoring the sign information) may drive an 8-bit D/A converter that generates a 0–1.3 V output to generate the Y video signal of an S-video (Y/C) interface. Figures 5.2 and 5.3 show the luminance video waveforms for 75% amplitude, 100% saturated EIA (NTSC) and EBU (PAL) color bars. The numbers on the luminance levels indicate the data value for an 8-bit D/A converter with a full-scale output value of 1.3 V. Tables 5.6 and 5.7 show the luminance IRE levels. Luminance IRE levels may be calculated by adding 0 (PAL) or 10.5 (NTSC) to the Y value and dividing the result by 1.37 (PAL) or 1.4 (NTSC). The 8-bit and 10-bit D/A values also contain sync and blank information.

As the sample-and-hold action of the D/A converter introduces a $(\sin x)/x$ characteristic, the digital composite Y data may be digitally filtered by a $(\sin x)/x$ correction filter to compensate. Alternately, as an analog lowpass filter (after the D/A converter) usually is used to limit the luminance bandwidth, the $(\sin x)/x$ correction may take place in the analog filter. The video signal at the connector should have a source impedance of 75 Ω.

As an option, the ability to delay the digital Y information a programmable number of clock cycles before driving the D/A converter may be useful. If the analog luminance video is lowpass filtered after the D/A conversion, and the analog chrominance video is bandpass filtered after the D/A conversion (see Analog Chrominance Generation), the chrominance video path will have a longer delay (typically up to about 400 ns) than the luminance video path. By adjusting the delay of the digital Y data before the D/A conversion, the analog luminance and chrominance video after filtering may be aligned more closely (to within one clock cycle), simplifying the analog design.

Color Difference Lowpass Digital Filters

The type of digital filters used to lowpass filter the I and Q (NTSC operation) or U and V (PAL operation) color difference signals are dependent on the application. Although early NTSC specifications called for 0.6-MHz lowpass filtering for Q, many current designs maintain the full 1.3-MHz bandwidth of both color difference signals and also use the U and V color difference signals instead of I and Q; the NTSC specifications have been modified to reflect this changing technology.

The color difference signals are usually digitally lowpass filtered using a Gaussian filter to minimize ringing and overshoot. Typical filter characteristics for a 1.3-MHz lowpass fil-

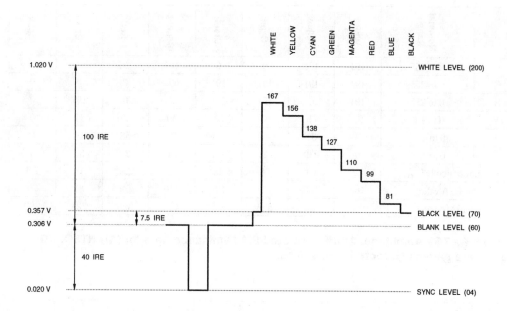

Figure 5.2. (M) NTSC Luminance (Y) Video Signal for 75% Amplitude, 100% Saturated EIA Color Bars. Indicated luminance levels are 8-bit values.

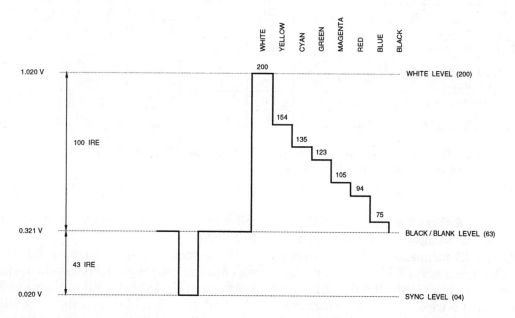

Figure 5.3. (B, D, G, H, I) PAL Luminance (Y) Video Signal for 75% Amplitude, 100% Saturated EBU Color Bars. Indicated luminance levels are 8-bit values.

	Nominal Range	White	Yellow	Cyan	Green	Magenta	Red	Blue	Black
R'	0 to 255	191	191	0	0	191	191	0	0
G'	0 to 255	191	191	191	191	0	0	0	0
B'	0 to 255	191	0	191	0	191	0	191	0
Y	0 to 130	97	86	68	57	40	29	11	0
I	0 to ±78	0	31	−58	−27	27	58	−31	0
Q	0 to ±68	0	−30	−21	−51	51	21	30	0
luminance IRE		77	69	56	48	36	28	15	7.5
8-bit D/A value		167	156	138	127	110	99	81	70
10-bit D/A value		668	624	552	508	440	396	324	280

Table 5.6. 75% Amplitude, 100% Saturated EIA Luminance Bars for (M) NTSC. RGB values are gamma-corrected RGB values.

	Nominal Range	White	Yellow	Cyan	Green	Magenta	Red	Blue	Black
R'	0 to 255	255	191	0	0	191	191	0	0
G'	0 to 255	255	191	191	191	0	0	0	0
B'	0 to 255	255	0	191	0	191	0	191	0
Y	0 to 137	137	91	72	60	42	31	12	0
U	0 to ±60	0	−45	15	−30	30	−15	45	0
V	0 to ±85	0	10	−63	−53	53	63	−10	0
luminance IRE		100	66	53	44	31	23	9	0
8-bit D/A value		200	154	135	123	105	94	75	63
10-bit D/A value		800	616	540	492	420	376	300	252

Table 5.7. 75% Amplitude, 100% Saturated EBU Luminance Bars for (B, D, G, H, I) PAL. RGB values are gamma-corrected RGB values.

ter (see Figure 5.4) are less than 2 dB (NTSC) or 3 dB (PAL) attenuation at 1.3 MHz and more than 20 dB attenuation at 3.6 MHz (more than 30 dB attenuation at 3.5 MHz if the design is to also support SECAM). If a 0.6-MHz low-pass filter for Q is used, typical filter characteristics are less than 2 dB attenuation at 0.4 MHz, less than 6 dB attenuation at 0.5 MHz, and more than 6 dB attenuation at 0.6 MHz (see Figure 5.5).

If the encoder is to be used in a video editing environment, the digital filters should have a maximum ripple of ±0.1 dB in the passband (0–0.6 MHz or 0–1.3 MHz). This is needed to minimize the cumulation of gain and loss artifacts due to the filters, especially when multi-

AMPLITUDE

FREQUENCY (MHZ)

AMPLITUDE

FREQUENCY (MHZ)

Figure 5.4. Typical 1.3-MHz Lowpass Digital Filter Characteristics.

Figure 5.5. Typical 0.6-MHz Lowpass Digital Filter Characteristics.

ple passes through the encoding and decoding processes are required. At the final encoding point, the Gaussian filters may be used.

Filter Considerations

The modulation process is shown in spectral terms in Figures 5.6 through 5.9. The frequency spectra of the modulation process are the same as those if the modulation process were analog, but are also repeated at harmonics of the sample rate. Using wide-band (i.e.,

1.3 MHz) filters, the modulated chrominance spectra may overlap near the zero frequency regions, resulting in aliasing. Also, there may be considerable aliasing just above the subcarrier frequency. For these reasons, the use of narrower-band lowpass filters may be more appropriate.

Wide-band Gaussian filters ensure optimum compatibility with monochrome displays by minimizing the artifacts at the edges of colored objects. A narrower, sharper-cut lowpass filter would emphasize the subcarrier signal at

Figure 5.6. Frequency Spectra in Digital NTSC Chrominance Modulation (F_S = 13.5 MHz, F_{SC} = 3.58 MHz): (a) Gaussian Filtered I and Q Signals, (b) Subcarrier Sinewave, (c) Modulated Chrominance Spectrum Produced by Convolving (a) and (b).

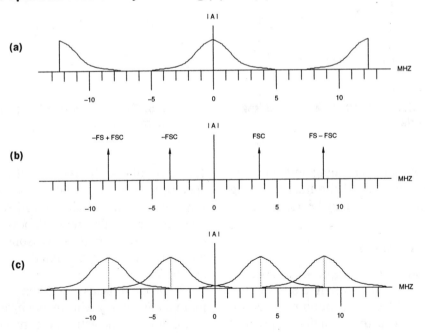

Figure 5.7. Frequency Spectra in Digital NTSC Chrominance Modulation (F_S = 12.27 MHz, F_{SC} = 3.58 MHz): (a) Gaussian Filtered I and Q Signals, (b) Subcarrier Sinewave, (c) Modulated Chrominance Spectrum Produced by Convolving (a) and (b).

Figure 5.8. Frequency Spectra in Digital PAL Chrominance Modulation (F_S = 13.5 MHz, F_{SC} = 4.43 MHz): (a) Gaussian Filtered U and V Signals, (b) Subcarrier Sinewave, (c) Modulated Chrominance Spectrum Produced by Convolving (a) and (b).

Figure 5.9. Frequency Spectra in Digital PAL Chrominance Modulation (F_S = 14.75 MHz, F_{SC} = 4.43 MHz): (a) Gaussian Filtered U and V Signals, (b) Subcarrier Sinewave, (c) Modulated Chrominance Spectrum Produced by Convolving (a) and (b).

these edges, resulting in ringing. If monochrome compatibility can be ignored, a beneficial effect of narrower filters would be to reduce the spread of the chrominance into the low-frequency luminance (resulting in low-frequency cross-luminance), which is difficult to suppress in a decoder.

Also, although the encoder may maintain a wide chrominance bandwidth, the bandwidth of the color difference signals in a decoder is usually much narrower. In the decoder, loss of the chrominance upper sidebands (due to low-pass filtering the video signal to 4.2–5.5 MHz, depending on the video standard) contributes to ringing and IQ or UV crosstalk on color transitions. Any increase in the decoder chrominance bandwidth causes a proportionate increase in cross-color.

Chrominance (C) Generation

During active video, the I and Q (NTSC) or U and V (PAL) data are modulated with sin and cos subcarrier data, resulting in digital chrominance (C) data. As described in Chapter 4, the (M) NTSC chrominance signal is represented by:

$$Q \sin (\omega t + 33°) + I \cos (\omega t + 33°)$$
$$\omega = 2\pi F_{SC}$$
$$F_{SC} = 3.579545 \text{ MHz } (\pm 10 \text{ Hz})$$

The (B, D, G, H, I, N) PAL chrominance signal is represented by:

$$U \sin \omega t \pm V \cos \omega t$$

$$\omega = 2\pi F_{SC}$$

$$F_{SC} = 4.43361875 \text{ MHz } (\pm 5 \text{ Hz}) \text{ for (B, D, } \\ \text{G, H, I, N) PAL}$$

$$F_{SC} = 3.58205625 \text{ MHz } (\pm 5 \text{ Hz}) \text{ for the } \\ \text{version of (N) PAL used in } \\ \text{Argentina}$$

with the sign of V alternating from one line to the next (known as the PAL SWITCH). The color difference components are multiplied by their respective subcarrier phases, as shown in Figure 5.1. Note that for this design during NTSC operation, the 11-bit reference subcarrier phase (see Figure 5.20) and the burst phase are the same (180°). Thus, 213° must be added to the 11-bit reference subcarrier phase during active video time so the output of the sin and cos ROMs have the proper subcarrier phases (33° and 123°, respectively).

During PAL operation, when PAL SWITCH = zero, the 11-bit reference subcarrier phase (see Figure 5.20) and the burst phase are the same (135°). Therefore, 225° must be added to the 11-bit reference subcarrier phase during active video time so the output of the sin and cos ROMs have the proper subcarrier phases (0° and 90°, respectively). When PAL SWITCH = one, 90° is added to the 11-bit reference subcarrier phase, resulting in a 225° burst phase, and an additional 135° must be added to the 11-bit reference subcarrier phase during active video time so the output of the sin and cos ROMs have the proper phases (0° and 90°, respectively). Note that while PAL SWITCH = one, the –V subcarrier is generated, effectively implementing the –V component required.

The subcarrier sin and cos values should have a minimum of 7 bits plus sign of accuracy, resulting in a range of 0 to ±127/128. The modulation multipliers must have saturation logic on the outputs to ensure overflow and underflow conditions are saturated to the maximum and minimum values, respectively. After the modulated I and Q (NTSC) or U and V (PAL) signals are added together, the result is rounded to the desired accuracy (it should be the same accuracy as the luminance to ease adding the two together later). At this point, the digital modulated chrominance, rounded to 8 bits, has a range of 0 to ±82 for NTSC and 0 to ±87 for PAL. The resulting digital chromi-

nance data is clamped by a blanking signal that has the same raised cosine values and timing as the one used to blank the luminance data.

Note that if YCbCr input data is used, and the YUV color space is used for both NTSC and PAL generation, the values in the sin and cos ROMs may be adjusted to allow the modulation multipliers to accept (Cr − 128) and (Cb −128) data directly, avoiding separate color space conversion. During NTSC operation, the sin ROM should have a range of 0 to ±258/512, and the cos ROM should have a range of 0 to ±364/512. During PAL operation, the sin ROM should have a range of 0 to ±273/512, and the cos ROM should have a range of 0 to ±385/512.

PAL SWITCH

In theory, since the sin ωt and cos ωt subcarriers are orthogonal, the I and Q (NTSC) or U and V (PAL) signals can be perfectly separated from each other in the decoder. However, if the chrominance or composite signal is subjected to distortion, such as asymmetrical attenuation of the sidebands due to lowpass filtering, the orthogonality is degraded, resulting in crosstalk between the I and Q (NTSC) or U and V (PAL) signals.

PAL uses alternate line switching of the V signal to provide a frequency offset between the U and V subcarriers, in addition to the subcarrier phase offset. When decoded, crosstalk components appear modulated onto the alternate line carrier frequency, in solid color areas producing a moving pattern known as Hanover bars. This pattern may be suppressed in the decoder by a comb filter that averages equal contributions from switched and unswitched lines.

Burst Generation

As shown in Figure 5.1, the lowpass filtered I and Q (NTSC) or U and V (PAL) data are mul-

tiplexed with the color burst gate information. During the color burst time, the color difference data should be ignored and the burst envelope signal inserted on the Q (NTSC) or U (PAL) channel (the I or V channel is forced to zero).

The burst gate rise and fall times should be processed to generate a raised cosine distribution (between 0 and 28 for NTSC, between 0 and 30 for PAL), to slow the slew rate of the burst envelope to within composite video specifications. A typical burst envelope rise/fall time is 300 ±100 ns. The burst envelope signal should be wide enough to generate either nine cycles of burst information for (M) NTSC and (M) PAL, and combination (N) PAL, or ten cycles of burst information for (B, D, G, H, I, N) PAL, with an amplitude of 50% or greater. When the burst envelope signal is multiplied by the output of the sin ROM (which has a range of 0 to ± 1), the color burst is generated and will have a range of 0 to ± 28 (NTSC) or 0 to ± 30 (PAL).

For a multistandard encoder that may operate at various clock rates (and therefore have various numbers of pixels per scan line), note that the beginning and end of the burst gate envelope signal may be calculated based on the total number of pixels per scan line (HCOUNT). These calculations specify the 50% point of the burst envelope amplitude. A value of half the rise and fall time (in clock cycles) must be added to the (stop) value and subtracted from the (start) value to allow for the raised cosine rise and fall times. Truncation is assumed in the division process.

For (M) NTSC:

burst gate start = (HCOUNT/16)
+ (HCOUNT/64) + (HCOUNT/256)
+ (HCOUNT/512) + 1

burst gate stop = burst gate start
+ (HCOUNT/32) + (HCOUNT/128) + 1

For (B, D, G, H, I, N) and combination (N) PAL:

burst gate start = (HCOUNT/16)
+ (HCOUNT/64) + (HCOUNT/128) + 3

burst gate stop = burst gate start
+ (HCOUNT/32) + (HCOUNT/256) + 1

The phase of the color burst should be user programmable over a 0 to 360° range to provide optional system phase matching with external video signals. This can be done by adding a programmable value to the 11-bit subcarrier reference phase during the burst time (see Figure 5.20). Table 5.8 shows the results of adding the digital chrominance and burst information.

Analog Chrominance Generation

The digital chrominance data may drive an 8-bit D/A converter that generates a 0–1.3 V output to generate the C video signal of an S-video (Y/C) interface. Figures 5.10 and 5.11 show the modulated chrominance video waveforms for 75% amplitude, 100% saturated EIA (NTSC) and EBU (PAL) color bars. The numbers in parentheses indicate the data value for an 8-bit D/A converter with a full-scale output value of 1.3 V. If the D/A converter can't handle the generation of bipolar video signals, an offset must be added to the chrominance data (and the sign information dropped) before driving

the D/A converter. In this instance, an 8-bit offset of +128 was used, positioning the blanking level at the midpoint of the D/A converter output level, as shown in Figures 5.10 and 5.11.

Chrominance ranges are

$$\pm\sqrt{I^2 + Q^2}$$

for NTSC, or

$$\pm\sqrt{U^2 + V^2}$$

for PAL. Chrominance IRE levels may be calculated by dividing the peak chrominance range by 1.4 (NTSC) or 1.37 (PAL). Tables 5.9 and 5.10 show the chrominance IRE levels and phase angles for 75% amplitude, 100% saturated EIA (NTSC) and EBU (PAL) color bars, respectively. Figure 5.12 illustrates the IQ vector diagram and values for 75% amplitude, 100% saturated EIA (NTSC) color bars. Figures 5.13 and 5.14 illustrate the UV vector diagrams and values for 75% amplitude, 100% saturated EBU (PAL) color bars.

As the sample-and-hold action of the D/A converter introduces a $(\sin x)/x$ characteristic, the digital chrominance data may be digitally filtered by a $(\sin x)/x$ correction filter to compensate. Alternately, as an analog lowpass filter (after the D/A converter) is usually used to limit the chrominance bandwidth, the $(\sin x)/x$ correction may take place in the analog filter. The video signal at the connector should have a source impedance of 75 Ω.

Video Level	NTSC 8-bit Digital Value	NTSC 10-bit Digital Value	PAL 8-bit Digital Value	PAL 10-bit Digital Value
peak chroma	82	328	87	347
peak burst	28	112	30	118
blank	0	0	0	0
peak burst	−28	−112	−30	−118
peak chroma	−82	−328	−87	−347

Table 5.8. Chrominance Digital Values for (M) NTSC and (B, D, G, H, I) PAL.

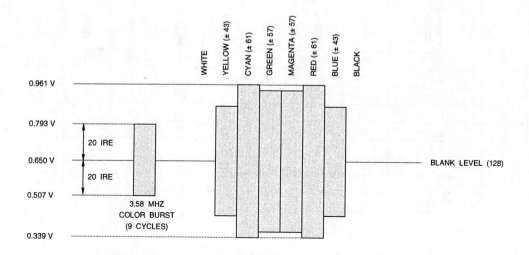

Figure 5.10. (M) NTSC Chrominance (C) Video Signal for 75% Amplitude, 100% Saturated EIA Color Bars. Indicated video levels are 8-bit values.

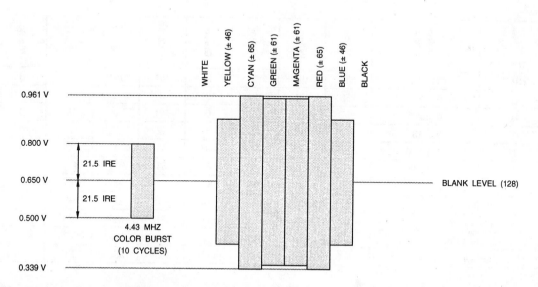

Figure 5.11. (B, D, G, H, I) PAL Chrominance (C) Video Signal for 75% Amplitude, 100% Saturated EBU Color Bars. Indicated video levels are 8-bit values.

	Nominal Range	White	Yellow	Cyan	Green	Magenta	Red	Blue	Black
R′	0 to 255	191	191	0	0	191	191	0	0
G′	0 to 255	191	191	191	191	0	0	0	0
B′	0 to 255	191	0	191	0	191	0	191	0
Y	0 to 130	97	86	68	57	40	29	11	0
I	0 to ±78	0	31	−58	−27	27	58	−31	0
Q	0 to ±68	0	−30	−21	−51	51	21	30	0
chroma IRE		0	62	88	82	82	88	62	0
8-bit D/A value		0	±43	±61	±57	±57	±61	±43	0
10-bit D/A value		0	±173	±245	±229	±229	±245	±173	0
phase		−	167°	283°	241°	61°	103°	347°	−

Table 5.9. 75% Amplitude, 100% Saturated EIA Color Bars for (M) NTSC. Chrominance IRE levels are peak-to-peak. RGB values are gamma-corrected RGB values.

	Nominal Range	White	Yellow	Cyan	Green	Magenta	Red	Blue	Black
R′	0 to 255	255	191	0	0	191	191	0	0
G′	0 to 255	255	191	191	191	0	0	0	0
B′	0 to 255	255	0	191	0	191	0	191	0
Y	0 to 137	137	91	72	60	42	31	12	0
U	0 to ±60	0	−45	15	−30	30	−15	45	0
V	0 to ±85	0	10	−63	−53	53	63	−10	0
chroma IRE		0	67	95	89	89	95	67	0
8-bit D/A value		0	±46	±65	±61	±61	±65	±46	0
10-bit D/A value		0	±184	±260	±242	±242	±260	±184	0
phase: line n (burst = 135°)		−	167°	283°	241°	61°	103°	347°	−
phase: line n + 1 (burst = 225°)		−	193°	77°	120°	300°	257°	13°	−

Table 5.10. 75% Amplitude, 100% Saturated EBU Color Bars for (B, D, G, H, I) PAL. Chroma IRE levels are peak-to-peak. RGB values are gamma-corrected RGB values. Line n corresponds to odd-numbered scan lines in fields 1, 2, 5, and 6; even numbered scan lines in fields 3, 4, 7, and 8. Line n + 1 corresponds to even-numbered scan lines in fields 1, 2, 5, and 6; odd-numbered scan lines in fields 3, 4, 7, and 8.

Video Level	NTSC 8-bit Digital Value	NTSC 10-bit Digital Value	PAL 8-bit Digital Value	PAL 10-bit Digital Value
peak chroma	243	972	245	980
white	200	800	200	800
peak burst	88	352	93	370
black	70	280	63	252
blank	60	240	63	252
peak burst	32	128	33	134
peak chroma	26	104	18	72
sync	4	16	4	16

Table 5.11. Composite (M) NTSC and (B, D, G, H, I) PAL Digital Video Levels.

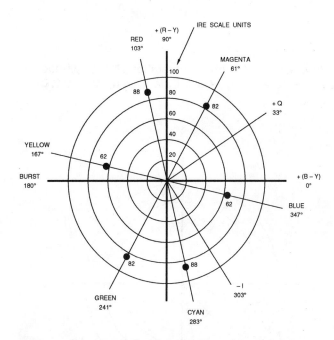

Figure 5.12. IQ Vector Diagram for 75% Amplitude, 100% Saturated EIA Color Bars.

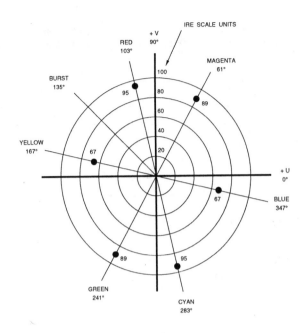

Figure 5.13. UV Vector Diagram for 75% Amplitude, 100% Saturated EBU Color Bars. Line n, PAL SWITCH = zero.

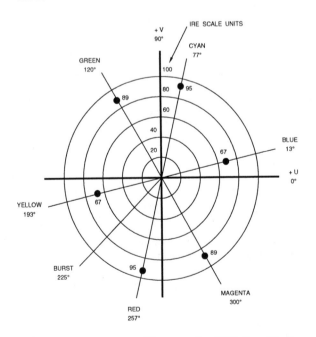

Figure 5.14. UV Vector Diagram for 75% Amplitude, 100% Saturated EBU Color Bars. Line n + 1, PAL SWITCH = one.

Analog Composite Video

The digital composite luminance (Y) data and the digital chrominance (C) data are added together, generating digital composite color video with the levels shown in Table 5.11.

The result may drive an 8-bit D/A converter that generates a 0–1.3 V output to generate the composite video signal. A second D/A converter may be used to generate a second, identical, composite video signal to drive an external RF modulator, reducing external circuitry. Figures 5.15 and 5.16 show the video waveforms for 75% amplitude, 100% saturated EIA (NTSC) and EBU (PAL) color bars. The numbers in parentheses indicate the data value for an 8-bit D/A converter with a full-scale output value of 1.3 V.

As the sample-and-hold action of the D/A converter introduces a $(\sin x)/x$ characteristic, the digital composite data may be digitally filtered by a $(\sin x)/x$ correction filter to compensate. Alternately, as an analog lowpass filter (after the D/A converter) usually is used to limit the video bandwidth, the $(\sin x)/x$ correction may take place in the analog filter. The video signal at the connector should have a source impedance of 75 Ω.

As an option, the encoder can generate a black burst (or house sync) video signal that can be used to synchronize multiple video sources. Figures 5.17 and 5.18 show the video waveforms for NTSC and PAL black burst video signals. Note that these are the same as analog composite, but do not contain any active video information. The numbers in

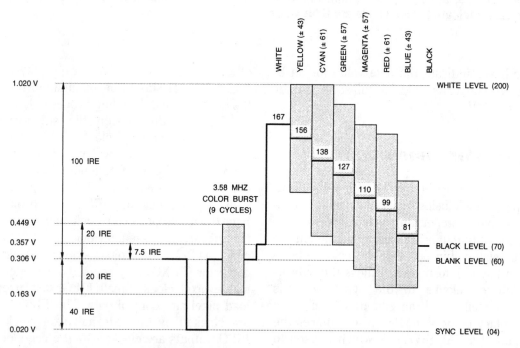

Figure 5.15. (M) NTSC Composite Video Signal for 75% Amplitude, 100% Saturated EIA Color Bars. Indicated video levels are 8-bit values.

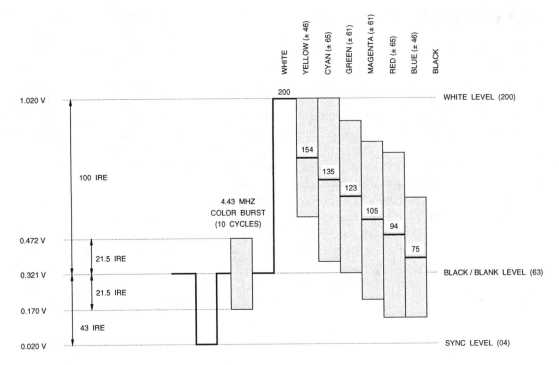

Figure 5.16. (B, D, G, H, I) PAL Composite Video Signal for 75% Amplitude, 100% Saturated EBU Color Bars. Indicated video levels are 8-bit values.

parentheses indicate the data value for an 8-bit D/A converter with a full-scale output value of 1.3 V.

Subcarrier Generation

The color subcarrier can be generated from the pixel clock using p:q ratio counter techniques. When generating video that may be used for editing, it is important to maintain the phase relationship between the color subcarrier and sync information. Unless the subcarrier phase relative to the sync phase is properly maintained, an edit may result in a momentary color shift. PAL also requires the addition of a PAL SWITCH, which is used to invert the polarity of the V video data every

other scan line. Note that the polarity of the PAL SWITCH should be maintained through the encoding and decoding process.

Since in this design the subcarrier is derived from the pixel clock, any jitter in the pixel clock frequency will result in a corresponding subcarrier frequency jitter. In some computer systems, the pixel clock is generated using a phase-lock loop (PLL), which may not have the necessary pixel clock stability to keep the subcarrier phase jitter below 2°–3°. In this case, a PLL and voltage-controlled crystal oscillator (VCXO) may be used to regenerate a stable pixel clock. Small FIFOs are used to load pixel and control data. The FIFO inputs are clocked by the external pixel clock; the FIFO outputs are clocked by the regenerated pixel clock. The PLL requires a long time con-

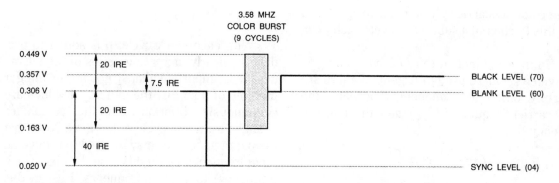

Figure 5.17. (M) NTSC Black Burst Video Signal. Indicated video levels are 8-bit values.

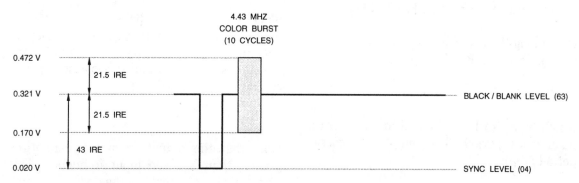

Figure 5.18. (B, D, G, H, I) PAL Black Burst Video Signal. Indicated video levels are 8-bit values.

stant to minimize jitter in the regenerated clock.

Frequency Relationships

In the (M) NTSC and (B, D, G, H, I, N) PAL color composite video standards, there are defined relationships between the subcarrier frequency (F_{SC}) and the line frequency (F_H):

PAL: $F_{SC}/F_H = (1135/4) + (1/625)$

NTSC: $F_{SC}/F_H = 910/4$

Assuming (for example only) a 13.5-MHz pixel clock rate (F_S):

PAL: $F_S = 864 \, F_H$

NTSC: $F_S = 858 \, F_H$

Combining these equations produces the relationship between F_{SC} and F_S:

PAL: $F_{SC}/F_S = 709379/2160000$

NTSC: $F_{SC}/F_S = 35/132$

which may also be expressed in terms of the pixel clock period (T_S) and the subcarrier period (T_{SC}):

PAL: $T_S/T_{SC} = 709379/2160000$

NTSC: $T_S/T_{SC} = 35/132$

The color subcarrier phase must be advanced by this fraction of a subcarrier cycle each pixel clock.

In the combination (N) PAL color composite video standard used in Argentina, there are slightly different relationships between the subcarrier frequency (F_{SC}) and the line frequency (F_H):

$$F_{SC}/F_H = (917/4) + (1/625)$$

Assuming (for example only) a 13.5-MHz pixel clock rate (F_S):

(N) PAL for Argentina: $F_S = 864\ F_H$

Combining these equations produces the relationship between F_{SC} and F_S:

$$F_{SC}/F_S = 573129/2160000$$

which may also be expressed in terms of the pixel clock period (T_S) and the subcarrier period (T_{SC}):

$$T_S/T_{SC} = 573129/2160000$$

The color subcarrier phase must be advanced by this fraction of a subcarrier cycle each pixel clock. Otherwise, this version of combination (N) PAL has the same timing as (B, D, G, H, I) PAL.

Quadrature Subcarrier Generation

A ratio counter consists of an accumulator in which a smaller number p is added modulo to another number q. The counter consists of an adder and a register as shown in Figure 5.19. The contents of the register are constrained so that if they exceed or equal q, q is subtracted from the contents. The output signal (X_N) of the adder is:

$$X_N = (X_{N-1} + p)\ \text{modulo } q$$

With each clock cycle, p is added to produce a linearly increasing series of digital values. It is important that q not be an integer multiple of p so that the generated values are continuously different and the remainder changes from one cycle to the next. Note that the p:q ratio counter may be used to reduce an input frequency F_S (in this case the pixel clock frequency) to another frequency, F_{SC} (in this case the subcarrier frequency):

$$F_{SC} = (p/q)\ F_S$$

Since the p value is of finite word length, the p:q ratio counter output frequency can be varied only in steps. With a p word length of w, the lowest p step is 0.5w and the lowest p:q ratio counter frequency step is:

$$F_{SC} = F_S/2^w$$

Note that the output frequency cannot be greater than half the input frequency. This means that the output frequency F_{SC} can only be varied by the increment p and within the range:

$$0 < F_{SC} < F_S/2$$

In this application, an overflow corresponds to the completion of a full cycle of the subcarrier. Since only the remainder (which represents the subcarrier phase) is required,

Figure 5.19. p:q Ratio Counter.

the number of whole cycles completed is of no interest. During each clock cycle, the output of the q register shows the relative phase of a subcarrier frequency in qths of a subcarrier period. By using the q register contents to address a ROM containing a sine wave characteristic, a numerical representation of the sampled subcarrier sine wave can be generated.

Note that, although a brute force approach to generating the 132 phases that NTSC requires is not a problem, PAL would require a ROM with 2,160,000 words of storage. To avoid this, a single 24-bit modulo q register may be used, with the 11 most significant bits providing the subcarrier reference phase. Alternately, more accuracy is achieved if the ratio is partitioned into two fractions, the more significant of which provides the subcarrier reference phase, as shown in Figure 5.20. To use the full capacity of the ROM and make the overflow of the ratio counter automatic, the denominator of the more significant fraction is made a power of two (in this instance, a value of 2048 is used). The 4× HCOUNT denominator of the least significant fraction is used to simplify hardware calculations.

Subdividing the subcarrier period into 2048 phase steps, and using the total number of pixels per scan line (HCOUNT), the ratio may be partitioned as follows:

$$\frac{FSC}{FS} = \frac{P1 + \dfrac{(P2)}{(4)(HCOUNT)}}{2048}$$

P1 and P2 therefore may be programmed to generate correct chrominance subcarrier frequencies although different pixel clock rates (which result in different values of HCOUNT) may be used.

The subcarrier generation ratio counters are shown in Figure 5.20. The modulo 4× HCOUNT and modulo 2048 counters should be reset at the beginning of each vertical sync of field one to ensure the generation of the correct subcarrier reference (as shown in Figures 5.21 and 5.22). The less significant stage produces a sequence of carry bits which correct the approximate ratio of the upper stage by altering the counting step by one: from P1 to P1 + 1. The upper stage then produces an accurate 11-bit subcarrier phase output to address the sine and cosine ROMs.

Although the upper stage adder automatically overflows to provide modulo 2048 operation, the lower stage requires additional circuitry because 4× HCOUNT may not be (and usually isn't) an integer power of two. In this case, the 16-bit register has a maximum capacity of 65535 and the adder generates a carry for any value greater than this. To produce the correct carry sequence, it is necessary, each time the adder overflows, to adjust the next number added to make up the difference between 65535 and 4× HCOUNT. This requires:

$$P3 = 65536 - (4)(HCOUNT) + P2$$

Although this changes the contents of the lower stage register, the sequence of carry bits is unchanged, ensuring that the correct phase values are generated.

The P1 and P2 values are determined for (M) NTSC operation using the following equation:

$$\frac{FSC}{FS} = \frac{P1 + \dfrac{(P2)}{(4)(HCOUNT)}}{2048}$$

$$= \left(\frac{910}{4}\right)\left(\frac{1}{HCOUNT}\right)$$

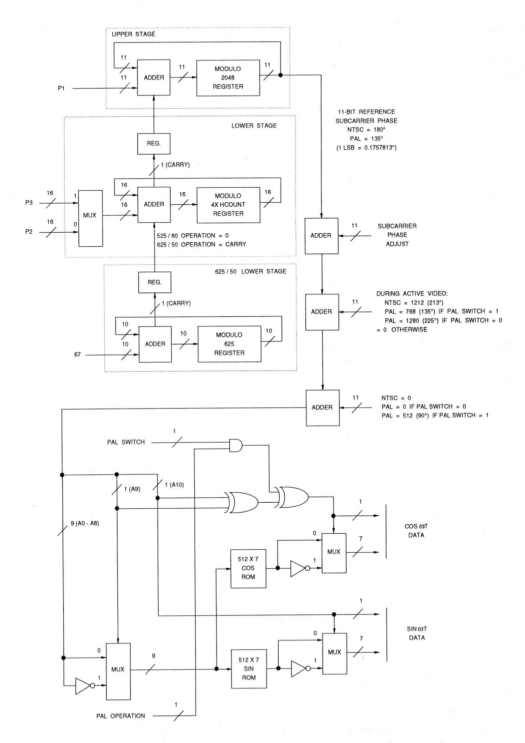

Figure 5.20. Chrominance Subcarrier Generation.

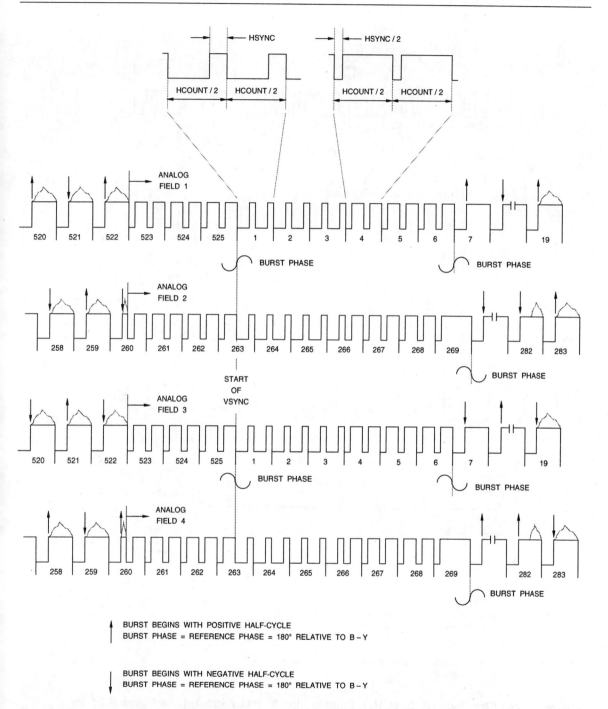

Figure 5.21. Four-field (M) NTSC Format. Note: to simplify the implementation, the line numbering does not match that used in standard practice for NTSC video signals.

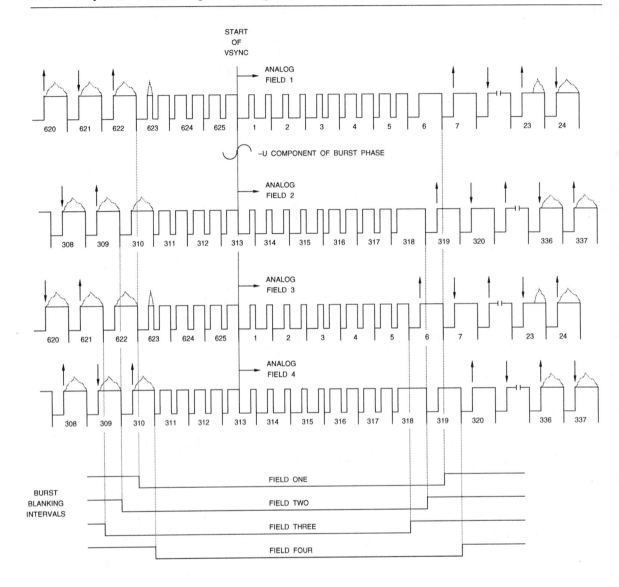

Figure 5.22a. Eight-field (B, D, G, H, I, Combination N) PAL Format. (See Figure 5.21 for equalization and serration pulse details.)

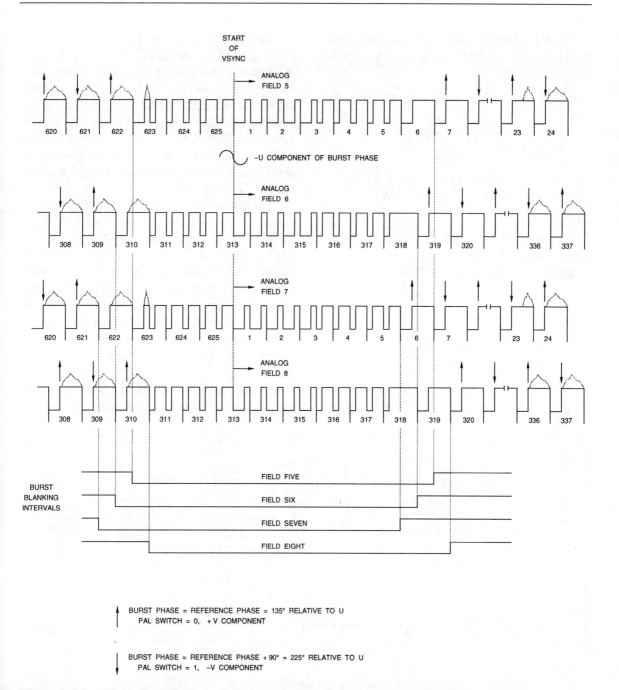

Figure 5.22b. Eight-field (B, D, G, H, I, Combination N) PAL Format. (See Figure 5.21 for equalization and serration pulse details.)

The P1 and P2 values are determined for (B, D, G, H, I, N) PAL operation using the following equation:

$$\frac{FSC}{FS} = \frac{P1 + \dfrac{P2}{(4)(HCOUNT)}}{2048}$$

$$= \left(\frac{1135}{4} + \frac{1}{625}\right)\left(\frac{1}{HCOUNT}\right)$$

The P1 and P2 values are determined for the version of combination (N) PAL used in Argentina using the following equation:

$$\frac{FSC}{FS} = = \frac{P1 + \dfrac{P2}{(4)(HCOUNT)}}{2048}$$

$$= \left(\frac{917}{4} + \frac{1}{625}\right)\left(\frac{1}{HCOUNT}\right)$$

The modulo 625 counter, with a "p value" of 67, is used during 625/50 operation (shown in Figure 5.20) to more accurately adjust subcarrier generation due to the 0.1072 remainder after calculating the P1 and P2 values. During 525/60 operation, the carry signal should always be forced to be zero. Table 5.12 lists some of the common horizontal resolutions, pixel clock rates, and their corresponding HCOUNT, P1, and P2 values.

Each value of the 11-bit subcarrier phase signal corresponds to one of 2048 waveform values taken at a particular point in the subcarrier cycle period and stored in ROM. The sample points are taken at odd multiples of one 4096th of the total period to avoid end-effects when the sample values are read out in reverse order. Note only one quadrant of the subcarrier wave shape is stored in ROM, as shown in Figure 5.23. The values for the other quadrants are produced using the symmetrical properties of the sinusoidal waveform. The maximum phase error using this technique is ±0.09° (half

Typical Application	Total Pixels per Scan Line (HCOUNT)	Active Pixels	4x HCOUNT	P1	P2
13.5 MHz (M) NTSC	858	720	3432	543	104
13.5 MHz (B, D, G, H, I) PAL	864	720	3456	672	2061
12.27 MHz (M) NTSC	780	640	3120	597	1040
14.75 MHz (B, D, G, H, I) PAL	944	768	3776	615	2253
4x F_{SC} (M) NTSC	910	768	3640	512	0
4x F_{SC} (B, D, G, H, I) PAL	1135	948	4540		
10.43 MHz (M) NTSC	663	544	2652	702	1959
10.43 MHz (B, D, G, H, I) PAL	668	544	2672	869	2525

Notes
1. "12.27-MHz NTSC" and "14.75-MHz PAL" are square pixel formats.
2. "4× F_{SC} (M) NTSC" clock rate is 14.32 MHz; "4× F_{SC} (B, D, G, H, I) PAL" clock rate is 17.72 MHz.

Table 5.12. Typical HCOUNT, P1, and P2 Values. [1]704 true active pixels.

Figure 5.23. Positions of the 512 Stored Sample Values in the sin and cos ROMs for One Quadrant of a Subcarrier Cycle. Samples for other quadrants can be generated by inverting the addresses and/or sign values.

of 360/2048), which corresponds to a maximum amplitude error of ±0.08%, relative to the peak-to-peak amplitude, at the steepest part of the sine wave signal.

Better color accuracy in areas of highly saturated colors is attained if the subcarrier information is stored and read out at two times the pixel clock. This also implies that two times interpolation is performed on the luminance and color difference data. In addition to reducing the (sin x)/x frequency roll-off due to the D/A converters, the extra oversampling results in less subcarrier amplitude error after analog lowpass filtering.

Figure 5.20 shows a circuit arrangement for generating quadrature subcarriers from an 11-bit subcarrier phase signal. This uses two ROMs with 9-bit addresses to store quadrants

of sine and cosine waveforms. XOR gates invert the addresses for generating time-reversed portions of the waveforms and to invert the output polarity to make negative portions of the waveforms. An additional gate is provided in the sign bit for the V subcarrier to allow injection of a PAL SWITCH square wave to implement phase inversion of the V signal on alternate scan lines.

Horizontal and Vertical Timing

To control the horizontal and vertical timing, either separate horizontal and vertical sync signals (notated as HSYNC* and VSYNC*,

respectively, and assumed to be active low) or a composite sync signal (notated as CSYNC* and also assumed to be active low) may be used. The CSYNC* signal is separated into the necessary horizontal and vertical sync signals needed by the encoder to control horizontal and vertical counters. The HSYNC* and VSYNC* signals (or CSYNC*) may be control inputs or optionally they may be generated by the encoder, as it has the ability to provide all of the necessary timing information.

In a 4:2:2 digital component video application (discussed in Chapter 8), horizontal blanking (H), vertical blanking (V), and even/odd field (F) information are used. In this application, the encoder would operate at 13.5 MHz, and would use (or optionally generate) the H, V, and F control signals directly, rather than depending on HSYNC* and VSYNC*. Logically NORing the H and V signals will generate the composite blanking signal (BLANK*) which should be processed to have the raised cosine rise/fall time required for blanking the active video.

General Horizontal Timing

An 11-bit horizontal counter is used to determine where along each scan line to enable and disable sync information, burst information, and serration and equalization pulses, and it should increment on each rising edge of the pixel clock. The horizontal counter value is compared to various values to determine when to assert and negate various control signals, such as burst gate, and so on. It may optionally be reset to 001_H after reaching the count specified by HCOUNT (the total number of pixels per scan line) in case a horizontal sync control pulse is missing.

If the HSYNC* control signal is an input, the falling edge should reset the horizontal counter to 001_H. In many cases, the encoder may be configured automatically by counting the number of pixel clock cycles between leading edges of HSYNC* (as shown in Table 5.12, each mode of operation has a unique number of pixel clock cycles per scan line).

If HSYNC* is an output, it should be asserted to a logical zero when the horizontal counter resets to 001_H due to reaching the HCOUNT value, and negated 4.7 µs later.

If the H control signal is used as an input in a Recommendation ITU-R BT.601 (formerly CCIR 601) 4:2:2 digital component video application, the horizontal counter should be reset to 001_H 16 (525/60 operation) or 12 (625/50 operation) clock cycles after the rising edge of H. Referring to Table 8.3, 525/60 or 625/50 operation may be automatically determined by counting the number of clock cycles between rising edges of H.

If the encoder is generating H as an output, H should be asserted to a logical one when the horizontal counter reaches a value of 842 (525/60 operation) or 852 (625/50 operation), and negated to a logical zero when the horizontal counter reaches a value of 122 (525/60 operation) or 132 (625/50 operation). Refer to Figures 8.9 and 8.13.

Note the HSYNC value (which specifies the width of the horizontal analog sync pulse to generate) may be determined automatically from the HCOUNT value (the total number of pixels per scan line) as follows:

HSYNC (start) = when the horizontal counter is reset to 001_H

HSYNC (stop) = (HCOUNT/16) + (HCOUNT/128) + (HCOUNT/256) + 1

These calculations are valid for (M) NTSC, (B, D, G, H, I) PAL, and combination (N) PAL, and specify the 50% point of the sync rising and falling edges. A value of half the rise/fall time (in clock cycles) must be added to the (stop) value and subtracted from the (start) value to allow for the raised cosine rise and fall times. Truncation is assumed in the division process.

Table 5.13 lists the typical horizontal blank timing for the common pixel clock rates.

General Vertical Timing

A 10-bit vertical counter, which increments on each falling edge of HSYNC*, provides information on which scan line is being generated. Also, the vertical counter may be reset optionally to 001_H after reaching a count of 525 (525/60 operation) or 625 (625/50 operation) in case a vertical control pulse is missing. To simplify the implementation, the line numbering in Figure 5.21 does not match that used in standard practice for NTSC video signals.

If the VSYNC* control signal is an input, coincident falling edges of VSYNC* and HSYNC* should reset the horizontal counter to 001_H (assuming the number one scan line is the first scan line of the vertical sync interval at the beginning of field one as shown in Figures 5.21 and 5.22). Rather than exactly coincident falling edges, a "coincident window" of about ±64 clock cycles should be used to ease interfacing to some video timing controllers; if both the HSYNC* and VSYNC* falling edges are detected within 64 clock cycles of each other, it is assumed to be the beginning of an odd field and the vertical counter should be reset to 001_H.

If VSYNC* is an output, it should be asserted to a logical zero for three scan lines, starting when the vertical counter resets to 001_H due to reaching the 525 (525/60 operation) or 625 (625/50 operation) value. This falling edge of VSYNC* should be coincident with the falling edge of HSYNC*. VSYNC* should also be asserted to a logical zero for three scan lines starting at horizontal count (HCOUNT/2) + 1 on scan line 263 (525/60 operation) or 313 (625/50 operation). Note that in professional video applications, it may be desirable to generate 2.5 scan line VSYNC* pulses during

625/50 operation. However, this may cause even/odd field detection problems in some commercially available VLSI devices.

If the V and F control signals are used as inputs in a Recommendation ITU-R BT.601 (formerly CCIR 601) 4:2:2 digital component video application, the F signal should be synchronized to the internally generated HSYNC* signal, and the vertical counter should be reset to 001_H when a falling edge of F has been detected while both H and V are a logical one.

If the encoder is generating V and F as outputs, the vertical counter should reset to 001_H after reaching the count of 525 (525/60 operation) or 625 (625/50 operation). V should be asserted to a logical one when the vertical counter reaches values of 261 and 523 (525/60 operation) or 311 and 624 (625/50 operation) and should be negated to a logical zero when the vertical counter reaches values of 18 and 280 (525/60 operation) or 23 and 336 (625/50 operation). F should be asserted to a logical one when the vertical counter reaches values of 263 (525/60 operation) or 313 (625/50 operation) and should be negated to a logical zero when the vertical counter is reset to 001_H. Note that V and F must be output coincident with the rising edge of H to meet Recommendation ITU-R BT.601 4:2:2 digital component video timing requirements. Refer to Figures 8.11 and 8.15; 525/60 line numbering previously discussed corresponds to the line numbering scheme used in Figure 5.21.

NTSC-Specific Timing

The composite sync timing must be generated from the vertical and horizontal counters, including all of the required serration and equalization pulses (see Figure 5.21). By noting that all timing parameters and positions are a fixed percentage of HCOUNT (the total number of pixels per scan line), the calculations to determine what to do and when

Typical Application	Sync + Back Porch Blanking (Pixels)	Front Porch Blanking (Pixels)
13.5 MHz NTSC	122	16
13.5 MHz PAL	132	12
12.27 MHz NTSC	117	23
14.75 MHz PAL	153	23
10.43 MHz NTSC	100	19
10.43 MHz PAL	108	16

Table 5.13. Typical BLANK* Input Horizontal Timing.

are easily done automatically within the encoder, regardless of the pixel clock rate. Note that the line numbering in Figure 5.21 does not conform to standard NTSC notation to ease the design.

Color burst information should be disabled on scan lines 1–6, 261–269, and 523–525, inclusive, using the line numbering scheme in Figure 5.21. On the remaining scan lines, color burst information should be enabled and disabled at the calculated horizontal count values. A blanking control signal (BLANK*) is used to specify when to generate active video.

PAL-Specific Timing

The composite sync timing must be generated from the vertical and horizontal counters, including all of the required serration and equalization pulses (see Figure 5.22). By noting that all timing parameters and positions are a fixed percentage of HCOUNT (the total number of pixels per scan line), the calculations to determine what to do and when are easily auto-

matically done within the encoder, regardless of the pixel clock rate.

For (B, D, G, H, I, N) PAL, during fields 1, 2, 5, and 6, color burst information should be disabled on scan lines 1–6, 310–318, and 623–625, inclusive. During fields 3, 4, 7, and 8, color burst information should be disabled on scan lines 1–5, 311–319, and 622–625, inclusive. Early receivers produced colored "twitter" at the top of the picture due to the swinging burst. To fix this, Bruch blanking was implemented to ensure that the phase of the first burst is the same following each vertical sync pulse. Analog encoders used a "meander gate" to control the burst reinsertion time by shifting one line at the vertical field rate. A digital encoder simply keeps track of the scan line and field number. Modern receivers do not require Bruch blanking, but it is useful for determining which field is being processed. On the remaining scan lines, color burst information should be enabled and disabled at the calculated horizontal count values. A blanking control signal (BLANK*) is used to specify when to generate active video.

NTSC Field ID

Although the timing relationship between the horizontal sync (HSYNC*) and vertical sync (VSYNC*) signals, or the F signal, may be used to specify whether to generate an even or odd field, another signal also must be used to specify which one of four fields to generate. This additional signal (which will be referred to as FIELD_0), specifies whether to generate fields 1 and 2 (FIELD_0 = logical zero) or fields 3 and 4 (FIELD_0 = logical one). As an input to the encoder, FIELD_0 should change state only at the beginning of vertical sync during fields 1 and 3. As an output from the encoder, FIELD_0 should change state at the beginning of vertical sync during fields 1 and 3 (this may be done by monitoring the subcarrier phase). If the encoder is generating a FIELD_0 control signal as an output in a 13.5-MHz 4:2:2 digital component video application, FIELD_0 should change state coincident with F. Table 5.14 lists NTSC field generation information.

PAL Field ID

Although the timing relationship between the horizontal sync (HSYNC*) and vertical sync (VSYNC*) signals, or the F signal, may be used to specify whether to generate an even or odd field, two additional signals also must be used to specify which one of eight fields to generate. We will refer to these additional control signals as FIELD_0 and FIELD_1.

As an input to the encoder, FIELD_0 should change state only at the beginning of vertical sync during fields 1, 3, 5, and 7. FIELD_1 should change state only at the beginning of vertical sync during fields 1 and 5.

As outputs from the encoder circuit, FIELD_0 should change state only at the beginning of vertical sync during fields 1, 3, 5, and 7. FIELD_1 should change state only at the beginning of vertical sync during fields 1 and 5 (this may be done by monitoring the –U component of the burst). If the encoder is generating FIELD_0 and FIELD_1 control signals as outputs in a 13.5-MHz 4:2:2 digital component video application, they should change state coincident with F. Information on PAL field generation is listed in Table 5.15.

FIELD_0 Signal	HSYNC*/VSYNC* Timing Relationship or F Indicator	Generated Field
0	odd field	1
0	even field	2
1	odd field	3
1	even field	4

Table 5.14. (M) NTSC Field Generation.

FIELD_1 Signal	FIELD_0 Signal	HSYNC*/VSYNC* Timing Relationship or F Indicator	Generated Field
0	0	odd field	1
0	0	even field	2
0	1	odd field	3
0	1	even field	4
1	0	odd field	5
1	0	even field	6
1	1	odd field	7
1	1	even field	8

Table 5.15. (B, D, G, H, I, M, N) PAL Field Generation.

NTSC Encoding Using YUV

For NTSC, the YUV color space may be used rather than the YIQ color space. Since computers commonly use linear RGB data, linear RGB data is converted to gamma-corrected RGB data as follows (values are normalized to have a value of 0 to 1):

for R, G, B < 0.018

$$R' = 4.5 R$$
$$G' = 4.5 G$$
$$B' = 4.5 B$$

for R, G, B ≥ 0.018

$$R' = 1.099 R^{0.45} - 0.099$$
$$G' = 1.099 G^{0.45} - 0.099$$
$$B' = 1.099 B^{0.45} - 0.099$$

The gamma-corrected RGB with a range of 0 to 255 or the YCbCr data then is converted to YUV data by scaling all the coefficients in the PAL RGB-to-YUV and YCbCr-to-YUV equa-

tions by 0.945 (129.5/137) to provide the proper YUV levels for NTSC:

RGB to YUV

$$Y = 0.152R' + 0.298G' + 0.058B'$$
$$U = -0.074R' - 0.147G' + 0.221B'$$
$$V = 0.312R' - 0.262G' - 0.050B'$$

YCbCr to YUV

$$Y = 0.592(Y - 16)$$
$$U = 0.503(Cb - 128)$$
$$V = 0.710(Cr - 128)$$

The 33° subcarrier phase shift during active video is not required since sampling is along the U and V axes. Thus, the Q sin (ωt + 33°) + I cos (ωt + 33°) equation for generating modulated chrominance may be simplified to be U sin (ωt) + V cos (ωt). Standard NTSC decoders are capable of decoding these NTSC YUV-oriented video signals. If, however, the same encoder design is to implement both analog composite NTSC and digital composite

NTSC video (discussed in Chapter 7), the YIQ color space should be used.

Low-cost NTSC encoders may use YCbCr-to-YUV or RGB-to-YUV color space conversion based on simple shifts and adds at the expense of color accuracy:

YCbCr to YUV

$$Y = (1/2)(Y - 16) + (1/16)(Y - 16)$$
$$\quad + (1/32)(Y - 16)$$
$$U = (1/2)(Cb - 128) + (1/256)(Cb - 128)$$
$$V = (1/2)(Cr - 128) + (1/8)(Cr - 128)$$
$$\quad + (1/16)(Cr - 128) + (1/64)(Cr - 128)$$
$$\quad + (1/128)(Cr - 128)$$

RGB to YUV

$$Y = (1/8)R' + (1/32)R' + (1/4)G'$$
$$\quad + (1/32)G' + (1/64)G' + (1/16)B'$$
$$U = -(1/16)R' - (1/64)R' - (1/8)G'$$
$$\quad - (1/64)G' + (1/8)B' + (1/16)B'$$
$$\quad + (1/32)B'$$
$$V = (1/4)R' + (1/16)R' - (1/4)G'$$
$$\quad - (1/64)G' - (1/32)B' - (1/64)B'$$

Professional video systems may use the gamma-corrected RGB color space, with R'G'B' having a nominal range of 16 to 235. Occasional values less than 16 and greater than 235 are allowed, resulting in YUV values outside their nominal ranges. In this instance, R'G'B' may be converted to YUV by scaling the previous RGB-to-YUV equations by 255/219:

$$Y = 0.177(R' - 16) + 0.347(G' - 16)$$
$$\quad + 0.067(B' - 16)$$
$$U = -0.086(R' - 16) - 0.171(G' - 16)$$
$$\quad + 0.257(B' - 16)$$
$$V = 0.363(R' - 16) - 0.305(G' - 16)$$
$$\quad - 0.058(B' - 16)$$

NTSC/PAL Encoding Using YCbCr

For (M) NTSC and (B, D, G, H, I) PAL, by adjusting the sin and cos subcarrier full-scale amplitudes, the modulator may directly accept Cr and Cb data, rather than U and V. Cr and Cb have a range of 16 to 240, with 128 equal to zero. The luminance information, with a range of 16 to 235, must be scaled and offset to have a range of either 0 to 130 (NTSC) or 0 to 137 (PAL).

Since computers commonly use linear RGB data with a range of 0 to 255, linear RGB data is converted to gamma-corrected RGB data as follows (values are normalized to have a value of 0 to 1):

for R, G, B < 0.018

$$R' = 4.5\,R$$
$$G' = 4.5\,G$$
$$B' = 4.5\,B$$

for R, G, B ≥ 0.018

$$R' = 1.099\,R^{0.45} - 0.099$$
$$G' = 1.099\,G^{0.45} - 0.099$$
$$B' = 1.099\,B^{0.45} - 0.099$$

Although the PAL standard specifies a gamma of 2.8, a value of 2.2 is now used. Therefore, the same gamma-correction equations are used for both NTSC and PAL.

Gamma-corrected RGB (R′G′B′) data with a range of 0 to 255 may be converted to YCbCr data as follows:

$$Y = 0.257R' + 0.504G' + 0.098B' + 16$$
$$Cb = -0.148R' - 0.291G' + 0.439B' + 128$$
$$Cr = 0.439R' - 0.368G' - 0.071B' + 128$$

The 33° subcarrier phase shift during active video is not required since sampling is along the U and V axes. Thus, the Q sin (ωt + 33°) + I cos (ωt + 33°) equation for generating modulated chrominance may be simplified to be U sin (ωt) + V cos (ωt). If, however, the same encoder design is to implement both analog composite and digital composite video (discussed in Chapter 7), the YIQ (NTSC) and YUV (PAL) color spaces should be used.

Professional video systems may use the gamma-corrected RGB color space, with R′G′B′ having a nominal range of 16 to 235. Occasional values less than 16 and greater than 235 are allowed, resulting in YCbCr values outside their nominal ranges. In this instance, RGB may be converted to YCbCr as follows:

$$Y = (77/256)R' + (150/256)G' + (29/256)B'$$
$$Cb = -(44/256)R' - (87/256)G'$$
$$+ (131/256)B' + 128$$
$$Cr = (131/256)R' - (110/256)G'$$
$$- (21/256)B' + 128$$

(N) PAL Encoding Considerations

Although (B, D, G, H, I) PAL are the common PAL formats, there are two variations of PAL

referred to as (N) PAL and combination (N) PAL. Combination (N) PAL is used in Argentina and has been covered in the previous subcarrier generation discussion, since the only difference between baseband combination (N) PAL and baseband (B, D, G, H, I) PAL video signals is the change in subcarrier frequency.

Standard (N) PAL is also a 625/50 system and is used in Uruguay and Paraguay. Some of the timing is different from baseband (B, D, G, H, I) PAL video signals, such as having serration and equalization pulses for three scan lines rather than 2.5 scan lines and a –40 IRE sync tip. Since computers commonly use linear RGB data, linear RGB data is converted to gamma-corrected RGB data.

Although the PAL standard specifies a gamma of 2.8, a value of 2.2 is now used. Therefore, the same gamma-correction equations are used for both NTSC and PAL.

The gamma-corrected RGB data then is converted to YUV data by scaling all the coefficients in the standard PAL RGB-to-YUV and YCbCr-to-YUV equations by 0.927 (127/137) to compensate for the addition of a 7.5 IRE blanking pedestal:

RGB to YUV

$$Y = 0.152R' + 0.298G' + 0.058B'$$
$$U = -0.074R' - 0.147G' + 0.221B'$$
$$V = 0.312R' - 0.262G' - 0.050B'$$

YCbCr to YUV

$$Y = 0.592(Y - 16)$$
$$U = 0.503(Cb - 128)$$
$$V = 0.710(Cr - 128)$$

The sync tip is –40 IRE rather than –43 IRE. Therefore, the luminance and composite digital video levels are the same as (M) PAL as shown in Tables 5.16 and 5.17, respectively.

Due to the timing differences from (B, D, G, H, I) PAL, standard (N) PAL and combination (N) PAL are not compatible with the digital composite video standards discussed in Chapter 7. Because many of the timing parameters (such as horizontal sync width, start and end of burst, etc.) are different from standard (B, D, G, H, I) PAL, the equations used by the encoder to automatically calculate these parameters must be modified for standard (N) PAL operation.

(M) PAL Encoding Considerations

Although (B, D, G, H, I) PAL are the common PAL formats, there is another variation of PAL referred to as (M) PAL, which is an 8-field 525/60 system with slight timing differences from baseband (M) NTSC, and it is used in Brazil.

(M) PAL uses the same RGB-to-YUV and YCbCr-to-YUV equations as standard (N) PAL to compensate for the addition of a 7.5 IRE blanking pedestal. A gamma of 2.2 is assumed at the receiver (although 2.8 is specified) and the sync tip is –40 IRE. The luminance and composite digital video levels are shown in Tables 5.16 and 5.17, respectively.

The subcarrier frequency generation for (M) PAL is implemented in the encoder as:

$$\frac{FSC}{FS} = \frac{P1 + \dfrac{(P2)}{(4)(HCOUNT)}}{2048}$$

$$= \left(\frac{909}{4}\right)\left(\frac{1}{HCOUNT}\right)$$

resulting in a subcarrier frequency of 3.57561149 MHz (± 10 Hz). Note that the third stage p:q ratio counter in the subcarrier generator circuit shown in Figure 5.20 should be disabled.

For (M) PAL, during fields 1, 2, 5, and 6, color burst information should be disabled on scan lines 1–8, 260–270, and 523–525, inclusive. During fields 3, 4, 7, and 8, color burst information should be disabled on scan lines 1–7, 259–269, and 522–525, inclusive. On the remaining scan lines, color burst information should be enabled and disabled at the calculated horizontal count values. Figure 5.24 illustrates the 8-field (M) PAL timing and burst blanking intervals. Due to the timing differences from (B, D,

Video Level	8-bit Digital Value	10-bit Digital Value
white	200	800
black	70	280
blank	60	240
sync	4	16

Table 5.16. (M,N) PAL Composite Luminance Digital Values.

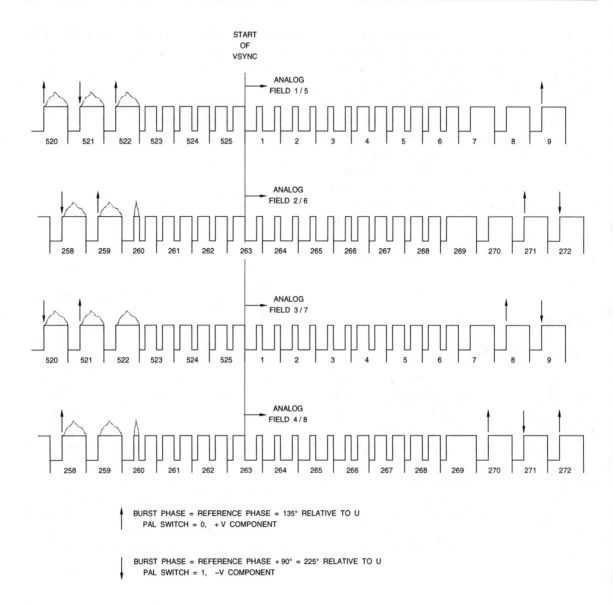

Figure 5.24. Eight-field (M) PAL Format. (See Figure 5.21 for equalization and serration pulse details.)

Video Level	8-bit Digital Value	10-bit Digital Value
peak chroma	243	972
white	200	800
peak burst	90	360
black	70	280
blank	60	240
peak burst	30	120
peak chroma	26	104
sync	4	16

Table 5.17. Composite (M,N) PAL Digital Video Levels.

G, H, I) PAL and (M) NTSC, (M) PAL is not compatible with the digital composite video standards discussed in Chapter 7. Because many of the timing parameters (such as horizontal sync width, start and end of burst, etc.) are different from (B, D, G, H, I) PAL or (M) NTSC, the equations used by the encoder to automatically calculate these parameters must be modified for (M) PAL operation.

SECAM Encoding Considerations

The horizontal and vertical timing for baseband (B, D, G, H, K, K1, L) SECAM is the same as for baseband (B, D, G, H, I) PAL; the main difference is that SECAM uses FM modulation to convey color information. SECAM uses the YDbDr color space, and the color space conversion equations for SECAM operation are derived so that the full-scale output

of the D/A converters is still 1.3 V to avoid using multiple D/A voltage references. Using the same sync tip value of 4 and white value of 200 to generate a 1-V signal places the blanking level at 63, resulting in 137 levels being used for luminance. Since computers commonly use linear RGB data, linear RGB data is converted to gamma-corrected RGB data.

Although the SECAM standard specifies a gamma of 2.8, a value of 2.2 is now used. Therefore, the same gamma-correction equations are used for both NTSC and SECAM.

The gamma-corrected digital RGB data then is converted to YDbDr data by scaling the general RGB-to-YDbDr equations in Chapter 3 by 137/255:

RGB to YDbDr

$$Y = 0.161R' + 0.315G' + 0.061B'$$
$$Db = -0.242R' - 0.474G' + 0.716B'$$
$$Dr = -0.716R' + 0.600G' + 0.116B'$$

YCbCr to YDbDr

$$Y = 0.625(Y - 16)$$
$$Db = 1.630(Cb - 128)$$
$$Dr = -1.630(Cr - 128)$$

However, Db and Dr are processed by a low-frequency pre-emphasis filter that has a maximum gain of + 9.125 dB. To drive the FM modulation process, Dr (after low-frequency pre-emphasis) must have a range of 0 to ±17.92 and Db (after low-frequency pre-emphasis) must have a range of 0 to ±14.72. For these reasons the color space conversion equations are changed to be:

RGB to YDbDr

$$Y = 0.161R' + 0.315G' + 0.061B'$$
$$Db = -0.0024R' - 0.0047G' + 0.0071B'$$
$$Dr = -0.0086R' + 0.0072G' + 0.0014B'$$

YCbCr to YDbDr

$$Y = 0.625(Y - 16)$$
$$Db = 0.0161(Cb - 128)$$
$$Dr = -0.0196(Cr - 128)$$

In an 8-bit digital system, for RGB values with a range of 0 to 255, Y has a range of 0 to 137, Dr has a range of 0 to ±2.193, and Db has a range of 0 to ±1.810. At least nine fractional data bits should be maintained for the Dr and Db data due to further processing.

After the lowpass filtering of Dr and Db to 1.3 MHz, low-frequency pre-emphasis is applied. The curve for the low-frequency pre-emphasis amplitude is shown in Figure 5.25a, and is expressed by:

$$A = \frac{1 + j\left(\frac{f}{85}\right)}{1 + j\left(\frac{f}{255}\right)}$$

where f = signal frequency in kHz. The 1.3 MHz lowpass filter cascaded with the low-frequency pre-emphasis filter should result in the maximum pre-emphasis (9.123 dB) occurring around 750 kHz. Figure 5.25b shows the resulting frequency response above 750 kHz as a result of cascading the 1.3-MHz lowpass and low-frequency pre-emphasis filters. At this point, Dr has a range of 0 to ±17.94 and Db has a range of 0 to ±14.76.

Dr and Db, after low-frequency pre-emphasis, are used to frequency modulate their respective subcarriers, F_{OR} and F_{OB}, as shown in Figure 5.26. The nominal center frequencies and tolerances for the subcarriers are:

$$F_{OR} = 4.406250 \text{ MHz} \pm 2000 \text{ Hz} = 282F_H$$
$$F_{OB} = 4.250000 \text{ MHz} \pm 2000 \text{ Hz} = 272F_H$$

The nominal deviations of F_{OR} and F_{OB} are:

$$\Delta F_{OR} = 280 \pm 9 \text{ kHz}$$
$$\Delta F_{OB} = 230 \pm 7 \text{ kHz}$$

The FM modulation may be done using two p:q ratio counters, as shown in Figure 5.27. Although only one color difference signal is sent per scan line, two subcarrier counters are required to maintain correct subcarrier timing for each of the color difference signals. The output of the appropriate p:q ratio counter is used to address the cos ROM, as determined by whether the scan line is an even or odd scan line. Both p:q counters should maintain a minimum of nine fractional bits of data due to the low integer range of Db and Dr. Dr information is transmitted on even scan lines and Db information is transmitted on odd scan lines.

To generate the nominal deviations of F_{OR} and F_{OB}, Dr (after low-frequency pre-emphasis) requires a range of 0 to ±17.92 and Db (after low-frequency pre-emphasis) requires a range of 0 to ±14.72. As shown previously, the Dr and Db we generated have ranges of 0 to

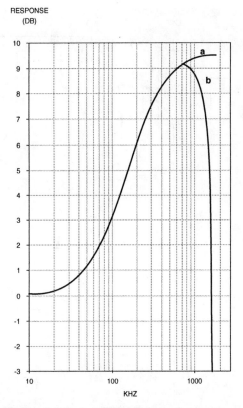

Figure 5.25. (a) SECAM Low Frequency Pre-emphasis. (b) Result of Cascading Low-frequency Pre-emphasis and 1.3-MHz Lowpass Filtering.

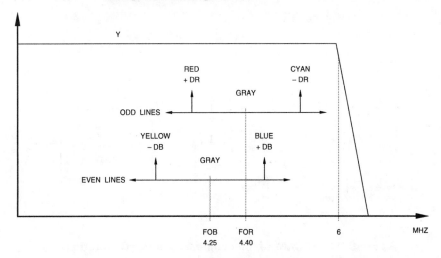

Figure 5.26. SECAM FM Color Modulation System.

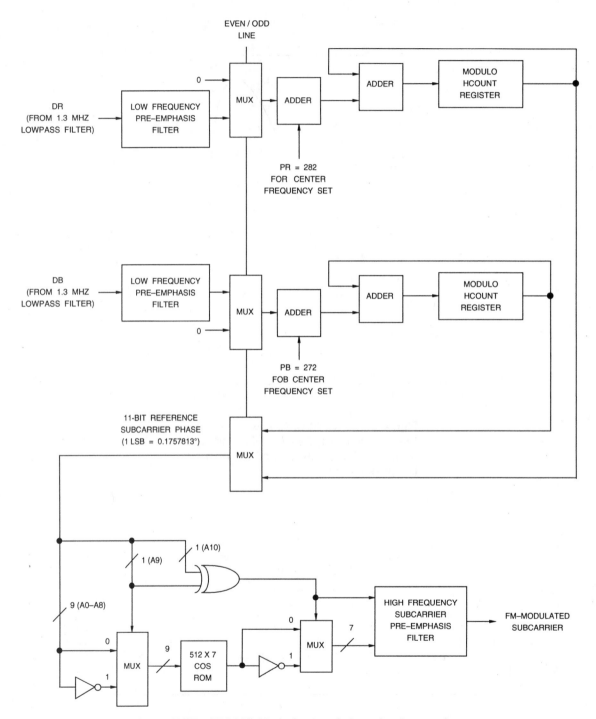

Figure 5.27. SECAM Chrominance Subcarrier Generation.

17.94 and 0 to ± 14.76, respectively, resulting in nominal deviations of F_{OR} and F_{OB} of 280.3 kHz and 230.6 kHz, respectively. These are well within the tolerances previously specified.

A high-frequency subcarrier pre-emphasis is implemented on the subcarrier, where the amplitude of the subcarrier is changed as a function of the frequency deviation. The intention is to reduce the visibility of the subcarriers in areas of low luminance and to improve the signal-to-noise ratio of highly saturated colors. The expression is given as:

$$G = M\frac{1 + j16F}{1 + j1.26F}$$

where $F = (f/4286) - (4286/f)$, f = instantaneous subcarrier frequency in kHz, and 2M = 23 ±2.5% of luminance amplitude. Figure 5.28 illustrates the frequency response. After high-frequency pre-emphasis, the subcarrier data is added to the luminance, horizontal and vertical sync information, and field ID data to generate composite video.

As shown in Table 5.18 and Figure 5.29, Db and Dr information is transmitted on alternate scan lines. The phase of the subcarriers is also reversed 180° on every third line and between each field to further reduce subcarrier visibility. Note that subcarrier phase information in the SECAM system carries no picture information.

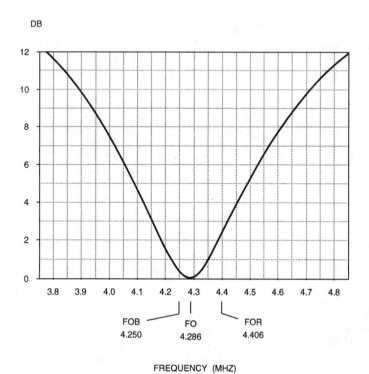

Figure 5.28. SECAM High-Frequency Subcarrier Pre-emphasis.

Field	Line Number		Color		Subcarrier Phase	
odd	N		F_{OR}		0°	
even		N + 313		F_{OB}		180°
odd	N + 1		F_{OB}		0°	
even		N + 314		F_{OR}		0°
odd	N + 2		F_{OR}		180°	
even		N + 315		F_{OB}		180°
odd	N + 3		F_{OB}		0°	
even		N + 316		F_{OR}		180°
odd	N + 4		F_{OR}		0°	
even		N + 317		F_{OB}		0°
odd	N + 5		F_{OB}		180°	
even		N + 318		F_{OR}		180°

Table 5.18. SECAM Color Versus Line and Field Timing.

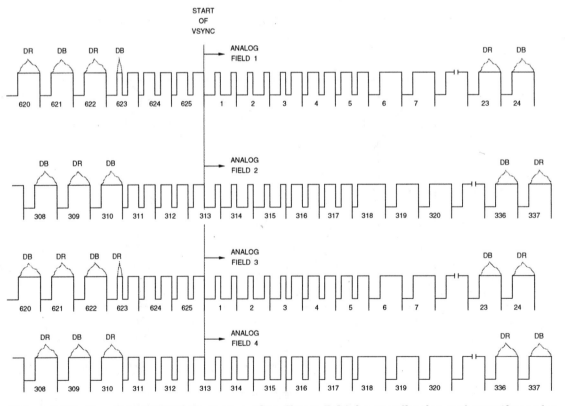

Figure 5.29. Four-field SECAM Sequence. (See Figure 5.21 for equalization and serration pulse details.)

As with PAL, SECAM requires some means of identifying the line-switching sequence between the encoding and decoding functions. This used to be done by incorporating alternate Dr and Db color identification signals for nine lines during the vertical blanking interval following the equalizing pulses after vertical sync, as shown in Figure 5.30a. These bottle-shaped signals occupied the entire scan line. Recent practice eliminates the bottle signals and uses a F_{OR}/F_{OB} burst after horizontal sync to derive the switching synchronization information, as shown in Figure 5.30b. This method has the advantage of simplifying the exchange of program material.

Clean Encoding Systems

Typically, the only filters present in a conventional encoder are the color difference lowpass filters. This results in considerable spectral overlap between the luminance and chrominance components, making it almost impossible to separate the signals completely at the decoder using simple filtering. However, additional filtering at the encoder can be used to reduce the severity of subsequent cross-color (luminance-to-chrominance crosstalk) and cross-luminance (chrominance-to-luminance crosstalk) artifacts. Cross-color appears as a coarse rainbow pattern or random colors in regions of fine detail. Cross-luminance appears as a fine pattern on chrominance edges, which are mostly vertical.

Cross-color in a simple decoder may be reduced by removing some of the high-frequency luminance data in the encoder (using a notch or lowpass digital filter). However, while reducing the cross-color, luminance detail is lost.

A better method is to use vertical and temporal comb filtering on either (or both as shown in Figure 5.31) the luminance or modulated chrominance information in the encoder. Luminance information above 2.3 MHz (NTSC) or 3.1 MHz (PAL) is precombed to minimize interference with chrominance frequencies in that spectrum. Chrominance information also is combed by averaging over a number of lines, reducing cross-luminance or the "hanging dot" pattern. This technique allows fine, moving luminance (which tends to generate cross-color at the decoder) to be removed while retaining full resolution for static luminance. Note, however, that there is a small loss of diagonal luminance resolution due to it being averaged over three lines (assuming two line stores are used to implement the comb filter). This is offset by an improvement in the chrominance signal-to-noise ratio (SNR). Figure 5.32 shows an arrangement that has a negative impact on a decoder's comb filter, and should not be used.

Bandwidth-Limited Edge Generation

Smooth sync and blank edges may be generated by integrating a T, or raised cosine, pulse to generate a T step (Figure 5.33). NTSC systems use a T pulse with T = 125 ns; therefore, the 2T step has little signal energy beyond 4 MHz. PAL systems use a T pulse with T = 100 ns; in this instance, the 2T step has little signal energy beyond 5 MHz.

The T step provides a fast risetime, without ringing, within a well-defined bandwidth. The risetime of the edge between the 10% and 90% points is 0.964T. By choosing appropriate sam-

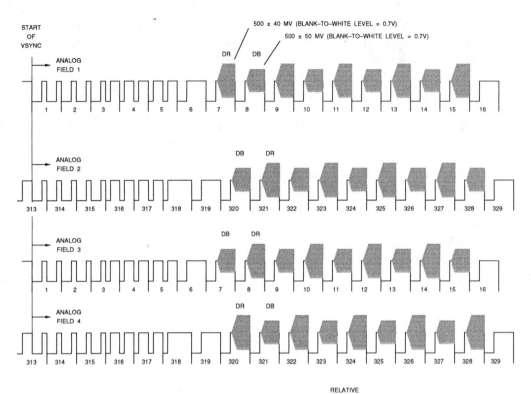

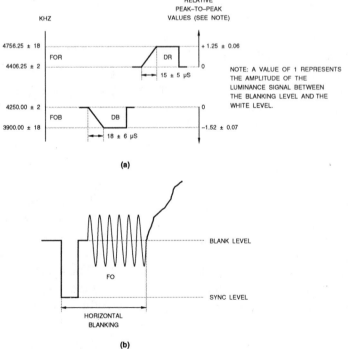

Figure 5.30. SECAM Chrominance Synchronization Signals. (Note that (a), using nine lines during the vertical blanking interval, is no longer used.)

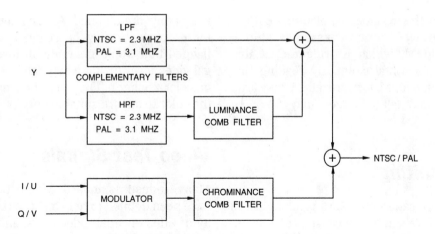

Figure 5.31. Removal of Vertical and Temporal Chrominance to Reduce Cross-luminance Vertical and Temporal Luminance to Reduce Cross-color.

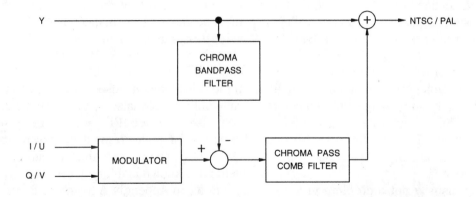

Figure 5.32. A Poor Implementation of a Complementary Clean Coder.

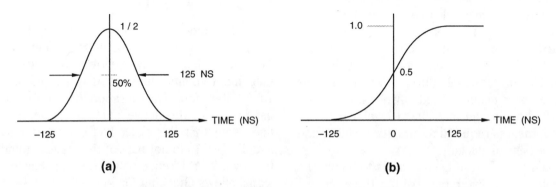

Figure 5.33. Bandwidth-limited Edge Generation: (a) the NTSC T Pulse, and (b) the T Step, the Result of Integrating the T Pulse.

ple values for the sync edges, blanking edges, and burst envelope, these values can be stored in a small ROM, which is triggered at the appropriate horizontal count. By reading the contents of the ROM forward and backward, both rising and falling edges may be generated.

Level Limiting

Certain highly saturated colors produce composite video levels that may cause problems in downstream equipment. Invalid video levels greater than 100 IRE or less than –20 IRE (relative to the blank level) may be transmitted, but may cause distortion in VCRs or demodulators and cause sync separation problems. Illegal video levels greater than 120 IRE (NTSC), 133 IRE (PAL), or 115 IRE (SECAM) or less than –40 IRE (NTSC) or –43 IRE (PAL and SECAM), relative to the blank level, may not be transmitted. Unfortunately, some fully saturated colors generate NTSC composite video levels approaching 131 IRE, exceeding the 100 IRE white level; PAL and SECAM encoders have similar restrictions.

Although usually not a problem in a conventional video environment, computer systems commonly use highly saturated colors, which may generate invalid or illegal video levels. It may be desirable to optionally limit these invalid or illegal video signal levels to around 110 IRE, compromising between limiting the available colors and generating legal video levels. In a professional editing environment, the option of transmitting all the video information (including invalid and illegal levels) between equipment is required to minimize editing and processing artifacts.

One method of correction is to adjust the luminance or saturation (within the encoder) of invalid and illegal pixels until the desired

peak limits are attained. Alternately, the frame buffer contents may be scanned, and pixels flagged that would generate an invalid or illegal video level (using a separate overlay plane or color change). The user then may change the color to a more suitable one.

Video Test Signals

Many industry-standard video test signals have been defined to help test the relative quality of video encoders, decoders, and the transmission path, and to perform calibration. By providing the appropriate RGB or YCbCr data to the encoder to generate these test signals, video test equipment may be used to evaluate the encoder's performance. Note that some video test signals cannot be properly generated by providing RGB data to a digital encoder; in this case, YCbCr data may be used. If the video standard uses a 7.5-IRE setup, typically only test signals used for visual examination use the 7.5-IRE setup. Test signals designed for measurement purposes typically use a 0-IRE setup, providing the advantage of defining a known blanking level.

Refer to Appendix A for more information on video test signals.

EIA Color Bars (NTSC)

The EIA color bars (Figure 5.34 and Table 5.19) are a part of the EIA-189-A standard. The seven bars (gray, yellow, cyan, green, magenta, red, and blue) are at 75% amplitude, 100% saturation. The duration of each color bar is 1/7 of the active portion of the scan line. Note that the black bar in Figure 5.34 and Table 5.19 is not part of the standard and is shown for reference only. The color bar test signal allows checking for hue and color saturation accuracy.

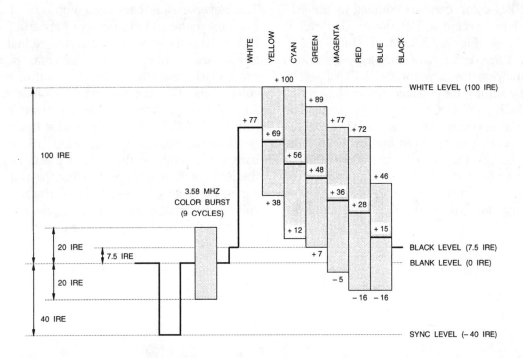

Figure 5.34. IRE Values of EIA Color Bars for (M) NTSC (75% Amplitude, 100% Saturation).

	Nominal Range	White	Yellow	Cyan	Green	Magenta	Red	Blue	Black
R′	0 to 255	191	191	0	0	191	191	0	0
G′	0 to 255	191	191	191	191	0	0	0	0
B′	0 to 255	191	0	191	0	191	0	191	0
Y	16 to 235	180	162	131	112	84	65	35	16
Cb	16 to 240	128	44	156	72	184	100	212	128
Cr	16 to 240	128	142	44	58	198	212	114	128
luminance (IRE)		77	69	56	48	36	28	15	7.5
chrominance (IRE)		0	62	88	82	82	88	62	0
chrominance (phase)		–	167°	283°	241°	61°	103°	347°	–

Table 5.19. EIA Color Bars for (M) NTSC (75% Amplitude, 100% Saturation). Chroma IRE levels are peak-to-peak. RGB values are gamma corrected RGB values.

EBU Color Bars (PAL)

The EBU color bars are similar to the EIA color bars, except a 100 IRE white level is used (see Figure 5.35 and Table 5.20). Again, these color bars are easily generated by supplying the appropriate RGB values internally within the encoder, rather than inputting RGB or YCbCr video pixel data. The duration of each color bar is 1/7 of the active portion of the scan line. Note that the black bar in Figure 5.34 and Table 5.20 is not part of the standard and is shown for reference only. The color bar test signal allows checking for hue and color saturation accuracy.

Reverse Blue Bars

The Reverse Blue bars are composed of the blue, magenta, and cyan colors bars from the EIA/EBU color bars, but are arranged in a different order—blue, black, magenta, black, cyan, black, and white. The duration of each color bar is 1/7 of the active portion of the scan line. Typically, Reverse Blue bars are used with the EIA/EBU color bars signal in a split-field arrangement, with the EIA/EBU color bars comprising the first 3/4 of the field and the Reverse Blue bars comprising the remainder of the field (also see SMPTE Bars). This split-field arrangement eases adjustment of chrominance and hue on a color monitor.

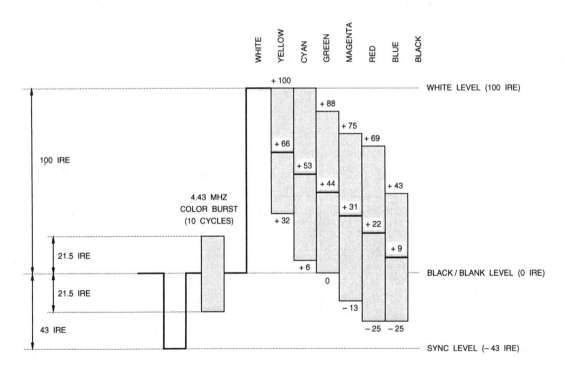

Figure 5.35. IRE Values of EBU Color Bars for (B, D, G, H, I) PAL (75% Amplitude, 100% Saturation).

	Nominal Range	White	Yellow	Cyan	Green	Magenta	Red	Blue	Black
R′	0 to 255	255	191	0	0	191	191	0	0
G′	0 to 255	255	191	191	191	0	0	0	0
B′	0 to 255	255	0	191	0	191	0	191	0
Y	16 to 235	235	162	131	112	84	65	35	16
Cb	16 to 240	128	44	156	72	184	100	212	128
Cr	16 to 240	128	142	44	58	198	212	114	128
luminance (IRE)		100	66	53	44	31	22	9	0
chrominance (IRE)		0	67	95	89	89	95	67	0
chrominance phase burst = 135°		–	167°	283°	241°	61°	103°	347°	–
chrominance phase burst = 225°		–	193°	77°	120°	300°	257°	13°	–

Table 5.20. EBU Color Bars for (B, D, G, H, I) PAL (75% Amplitude, 100% Saturation). Chroma IRE levels are peak-to-peak. Line n corresponds to odd-numbered scan lines in fields 1, 2, 5, and 6; even-numbered scan lines in fields 3, 4, 7, and 8. Line n + 1 corresponds to even-numbered scan lines in fields 1, 2, 5, and 6; odd-numbered scan lines in fields 3, 4, 7, and 8. RGB values are gamma-corrected RGB values.

SMPTE Bars (NTSC)

This split-field test signal is composed of the EIA color bars for the first 2/3 of the field, the Reverse Blue bars for the next 1/12 of the field, and the PLUGE test signal for the remainder of the field. For PAL, a split-field test signal composed of the EBU color bars for the first 2/3 of the field, the Reverse Blue bars for the next 1/12 of the field, and the PLUGE test signal for the remainder of the field may be used.

PLUGE (Picture Line-Up Generating Equipment)

PLUGE is a visual black reference, with one area blacker than black, one area at black, and one area lighter than black. The brightness of the monitor is adjusted so that the black and blacker than black areas are indistinguishable from each other and the lighter than black area is slightly lighter (the contrast should be at the normal setting). Additional test signals, such as a white pulse and modulated IQ or UV signals usually are added to facilitate testing and monitor alignment.

The NTSC PLUGE test signal (shown in Figure 5.36) is composed of a 7.5 IRE (black level) pedestal with a 40 IRE "– I" phase modulation, a 100 IRE white pulse, a 7.5 IRE (black level) pedestal with a 40 IRE "+ Q" phase modulation, and a 7.5 IRE pedestal with 3.5 IRE, 7.5 IRE, and 11.5 IRE pedestals. Typically, PLUGE is used with the EIA color bars signal in a split-field arrangement, with the EIA color bars

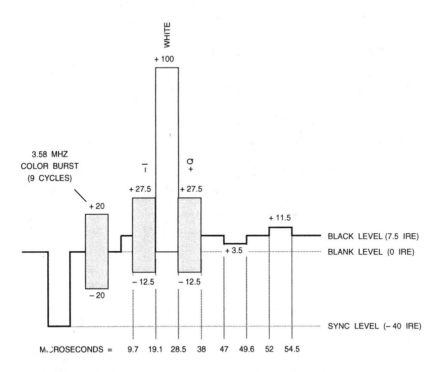

Figure 5.36. IRE Values of PLUGE Test Signal for (M) NTSC. IRE values are indicated.

comprising the first 3/4 of the field and the PLUGE test signal comprising the remainder of the field (also see SMPTE Bars).

For PAL, each country has its own slightly different PLUGE configuration, with most differences being the black pedestal level used, and work is being done on a standard test signal. Figure 5.37 illustrates a typical PAL PLUGE test signal. Usually used as a full-screen test signal, it is composed of a 0 IRE pedestal with PLUGE (–2 IRE, 0 IRE, and 2 IRE pedestals) and a white pulse. The white pulse may have five levels of brightness (0, 25, 50, 75, and 100 IRE), depending on the scan line number, as shown in Figure 5.37. The PLUGE is displayed on scan lines that

have non-zero IRE white pulses. As an option, a 0 IRE pedestal with a 43 IRE "–V" phase modulation and a 0 IRE pedestal with a 43 IRE "+U" phase modulation could be added before and after the white pulse, respectively, to provide additional testing and monitor alignment. Report ITU-R BT.1221 discusses considerations for various PAL systems.

Y Color Bars

The Y color bars consist of the luminance-only levels of the EIA/EBU color bars; however, the black level (7.5 IRE for NTSC and 0 IRE for PAL) is included and the color burst is still present. The duration of each luminance bar is

therefore 1/8 of the active portion of the scan line. Y color bars are useful for color monitor adjustment and measuring luminance nonlinearity. Typically, the Y color bars signal is used with the EIA/EBU color bars signal in a split-field arrangement, with the EIA/EBU color bars comprising the first 3/4 of the field and the Y color bars signal comprising the remainder of the field.

Red Field

The Red Field signal consists of a 75% amplitude, 100% saturation red chrominance signal. This is useful as the human eye is sensitive to static noise intermixed in a red field. Distortions that cause small errors in picture quality can be examined visually for the effect on the picture. Typically, the Red Field signal is used with the EIA/EBU color bars signal in a split-field arrangement, with the EIA/EBU color bars comprising the first 3/4 of the field, and the Red Field signal comprising the remainder of the field.

10-Step Staircase

This test signal is composed of ten unmodulated luminance steps of 10 IRE each, ranging from 0 IRE to 100 IRE, shown in Figure 5.38. This test signal may be used to measure luminance nonlinearity.

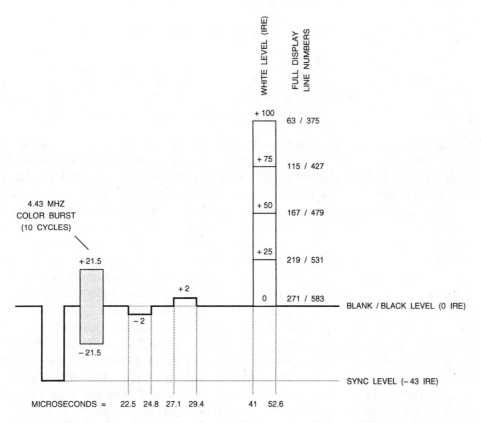

Figure 5.37. IRE Values of Typical PAL PLUGE Test Signal. IRE values are indicated.

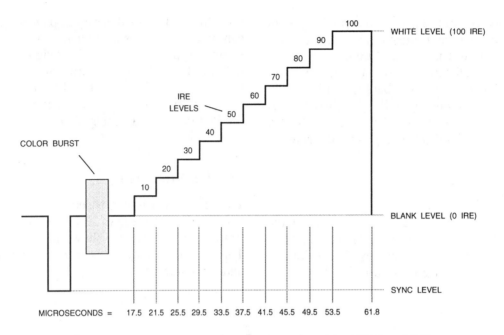

Figure 5.38. Ten-step Staircase Test Signal for NTSC and PAL.

Modulated Ramp

The modulated ramp test signal, shown in Figure 5.39, is composed of a luminance ramp from 0 IRE to either 80 or 100 IRE. The 80 IRE ramp provides testing of the normal operating range of the system; a 100 IRE ramp may be used to optionally test the entire operating range. The peak-to-peak modulated chrominance is 40 ±0.5 IRE for (M) NTSC and 43 ±0.5 IRE for (B, D, G, H, I) PAL. The modulated chrominance has a phase of 0° ±1° relative to the burst. Note a 0 IRE setup is used. This test signal may be used to measure differential gain. The modulated ramp signal is preferred over a 5-step or 10-step modulated staircase signal when testing digital systems. The rise and fall times at the start and end of the modulated ramp envelope are 400 ±25 ns (NTSC systems) or approximately 1 µs (PAL systems).

Modulated Staircase

The 5-step modulated staircase signal (a 10-step version is also used), shown in Figure 5.40, consists of 5 luminance steps. The peak-to-peak modulated chrominance is 40 ±0.5 IRE for (M) NTSC and 43 ±0.5 IRE for (B, D, G, H, I) PAL. The modulated chrominance has a phase of 0° ±1° relative to the burst. Note a 0 IRE setup is used. The rise and fall times of each modulation packet envelope are 400 ±25 ns (NTSC systems) or approximately 1 µs (PAL systems). The luminance IRE levels for the 5-step modulated staircase signal are shown in Figure 5.40. This test signal may be used to measure differential gain. The modulated ramp signal is preferred over a 5-step or 10-step modulated staircase signal when testing digital systems.

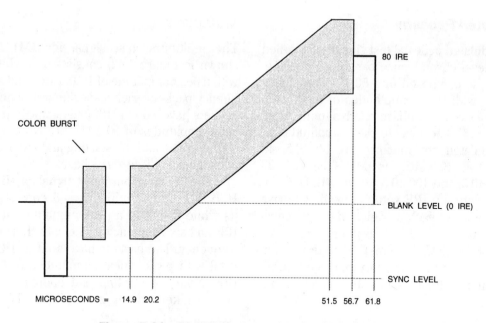

COLOR BURST

80 IRE

BLANK LEVEL (0 IRE)

SYNC LEVEL

MICROSECONDS = 14.9 20.2 51.5 56.7 61.8

Figure 5.39. 80 IRE Modulated Ramp Test Signal.

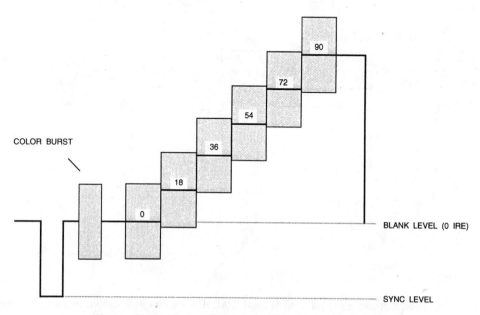

90

72

54

36

18

0

COLOR BURST

BLANK LEVEL (0 IRE)

SYNC LEVEL

Figure 5.40. 5-step Modulated Staircase Test Signal.

Modulated Pedestal

The modulated pedestal test signal (also called a three-level chrominance bar), shown in Figure 5.41, is composed of a 50 IRE luminance pedestal, with three amplitudes of modulated chrominance with a phase relative to the burst of –90° ±1°. The peak-to-peak amplitudes of the modulated chrominance are 20 ±0.5, 40 ±0.5, and 80 ±0.5 IRE for (M) NTSC and 20 ±0.5, 60 ±0.5, and 100 ±0.5 IRE for (B, D, G, H, I) PAL. Note a 0 IRE setup is used. The rise and fall times of each modulation packet envelope are 400 ±25 ns (NTSC systems) or approximately 1 μs (PAL systems). This test signal may be used to measure chrominance-to-luminance intermodulation and chrominance nonlinear gain.

Multiburst

The multiburst test signal for (M) NTSC, shown in Figure 5.42, consists of a white flag with a peak amplitude of 100 ±1 IRE and six frequency packets, each a specific frequency. The packets have a 40 ±1 IRE pedestal with peak-to-peak amplitudes of 60 ±0.5 IRE. Note a 0 IRE setup is used and the starting and ending point of each packet is at zero phase.

The ITU multiburst test signal for (B, D, G, H, I) PAL, shown in Figure 5.43, consists of a 4 μs white flag with a peak amplitude of 80 ±1 IRE and six frequency packets, each a specific frequency. The packets have a 50 ±1 IRE pedestal with peak-to-peak amplitudes of 60 ±0.5 IRE. Note the starting and ending points of each packet are at zero phase. The gaps

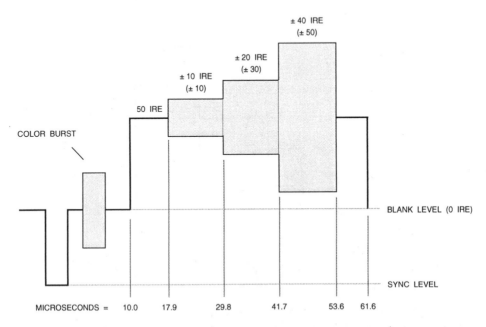

Figure 5.41. Modulated Pedestal Test Signal. PAL IRE values are shown in parentheses.

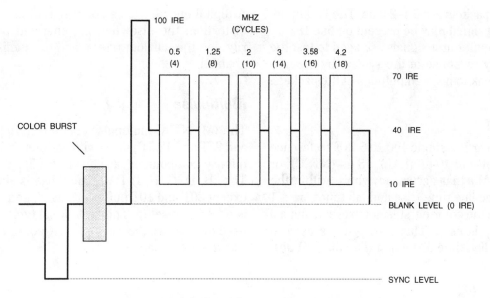

Figure 5.42. (M) NTSC Multiburst Test Signal.

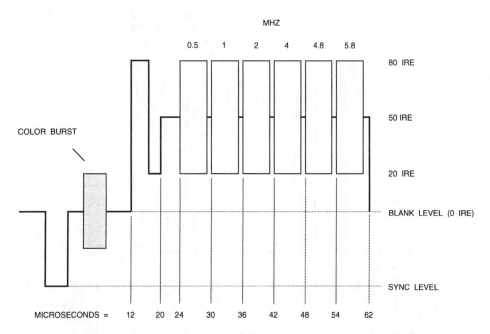

Figure 5.43. (B, D, G, H, I) PAL ITU Multiburst Test Signal.

between packets are 0.4–2.0 µs. The ITU multi-burst test signal may be present on line 18.

The multiburst signals are used to test the frequency response of the system by measuring the peak-to-peak amplitudes of the packets.

Line Bar

The line bar is a single 100 ±0.5 IRE (reference white) pulse of 10 µs (PAL), 18 µs (NTSC), or 25 µs (PAL) that occurs anywhere within the active scan line time (rise and fall times are ≤ 1 µs). Note the color burst is not present, and a 0 IRE setup is used. This test signal is used to measure line time distortion (line tilt or H tilt).

A digital encoder does not generate line time distortion; the distortion is generated primarily by the analog filters and transmission channel.

Multipulse

The (M) NTSC multipulse contains a 2T pulse and 25T and 12.5T pulses with various high-frequency components, as shown in Figure 5.44. The (B, D, G, H, I) PAL multipulse is similar, except 20T and 10T pulses are used, and there is no 7.5 IRE setup. This test signal typically is used to measure the frequency response of the transmission channel.

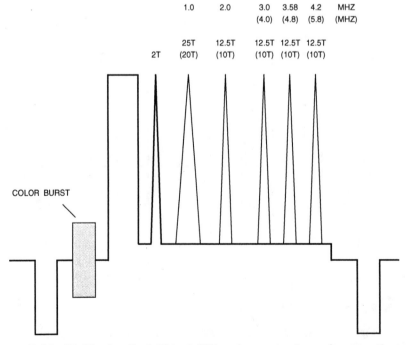

Figure 5.44. Multipulse Test Signal. PAL values are shown in parentheses.

Field Square Wave

The field square wave contains 100 ±0.5 IRE pulses for the entire active line time for odd fields and blanked scan lines for even fields. Note the color burst is not present and a 0 IRE setup is used. This test signal is used to measure field time distortion (field tilt or V tilt). A digital encoder does not generate field time distortion; the distortion is generated primarily by the analog filters and transmission channel.

NTC-7 Composite Test Signal

The NTC (U. S. Network Transmission Committee) has developed a composite test signal that may be used to test several video parameters, rather than using multiple test signals. The NTC-7 composite test signal for NTSC

systems (shown in Figure 5.45) consists of a 100 IRE line bar, a 2T pulse, a 12.5T chrominance pulse, and a 5-step modulated staircase signal.

The line bar has a peak amplitude of 100 ±0.5 IRE, and 10–90% rise and fall times of 125 ±5 ns with an integrated sine-squared shape. It has a width at the 60 IRE level of 18 μs.

The 2T pulse has a peak amplitude of 100 ±0.5 IRE, with a half-amplitude width of 250 ±10 ns.

The 12.5T chrominance pulse has a peak amplitude of 100 ±0.5 IRE, with a half-amplitude width of 1562.5 ±50 ns.

The 5-step modulated staircase signal consists of 5 luminance steps that have a 40 ±0.5 IRE chrominance amplitude with a chrominance phase relative to the burst of 0° ±1°. The rise and fall times of each modulation packet envelope are 400 ±25 ns.

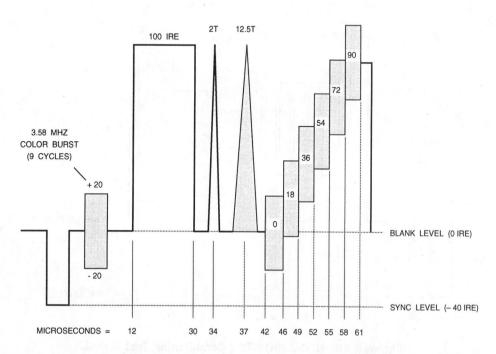

Figure 5.45. NTC-7 (M) NTSC Composite Test Signal, with Corresponding IRE Values.

The NTC-7 composite test signal may be present on line 17 (line 14 per Figure 5.21).

NTC-7 Combination Test Signal

The NTC (U. S. Network Transmission Committee) also has developed a combination test signal that may be used to test several NTSC video parameters, rather than using multiple test signals. The NTC-7 combination test signal for NTSC systems (shown in Figure 5.46) consists of a white flag, a multiburst, and a modulated pedestal signal.

The white flag has a peak amplitude of 100 ±1 IRE and a width of 4 µs.

The multiburst has a 50 ±1 IRE pedestal with peak-to-peak amplitudes of 50 ±0.5 IRE. The starting point of each frequency packet is at zero phase. The width of the 0.5 MHz packet is 5 µs; the width of the remaining packets is 3 µs.

The 3-step modulated pedestal is composed of a 50 IRE luminance pedestal, with three amplitudes of modulated chrominance (20 ±0.5, 40 ±0.5, and 80 ±0.5 IRE peak-to-peak) with a phase relative to the burst of –90° ±1°. The rise and fall times of each modulation packet envelope are 400 ±25 ns.

The NTC-7 combination test signal may be present on line 280 (line 277 per Figure 5.21).

ITU Composite Test Signal

The ITU (Report ITU-R BT.628 and Recommendation ITU-R BT.473) has developed a composite test signal that may be used to test several PAL video parameters, rather than using multiple test signals. The ITU composite

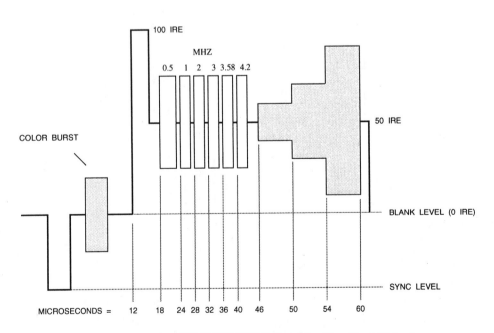

Figure 5.46. NTC-7 (M) NTSC Combination Test Signal.

test signal for PAL systems (shown in Figure 5.47) consists of a white flag, a 2T pulse, and a 5-step modulated staircase signal.

The white flag has a peak amplitude of 100 ±1 IRE and a width of 10 µs.

The 2T pulse has a peak amplitude of 100 ±0.5 IRE, with a half-amplitude width of 200 ±10 ns.

The 5-step modulated staircase signal consists of 5 luminance steps (whose IRE values are shown in Figure 5.47) that have a 43 ±0.5 IRE chrominance amplitude, with a chrominance phase relative to the U axis of 60° ±1°. The rise and fall times of each modulation packet envelope are approximately 1 µs.

The ITU composite test signal may be present on line 330.

The United Kingdom allows the use of a slightly different test signal since the 10T pulse is more sensitive to delay errors than the 20T pulse (at the expense of occupying less chrominance bandwidth). Selection of an appropriate pulse width is a trade-off between occupying the PAL chrominance bandwidth as fully as possible and obtaining a pulse with sufficient sensitivity to delay errors. Thus, the national test signal (developed by the British Broadcasting Corporation and the Independent Television Authority) in Figure 5.48 may be present on lines 19 and 332 for (I) PAL systems in the United Kingdom.

The white flag has a peak amplitude of 100 ±1 IRE and a width of 10 µs.

The 2T pulse has a peak amplitude of 100 ±0.5 IRE, with a half-amplitude width of 200 ±10 ns.

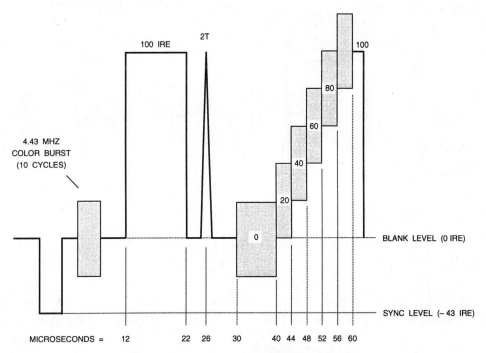

Figure 5.47. ITU Composite Test Signal.

The 10T chrominance pulse has a peak amplitude of 100 ±0.5 IRE.

The 5-step modulated staircase signal consists of 5 luminance steps (whose IRE values are shown in Figure 5.48) superimposed with a 21.5 ±0.5 IRE subcarrier with a phase of 60° ±1° relative to the U axis. The rise and fall times of each modulation packet envelope is approximately 1 μs.

ITU Combination Test Signal

The ITU (Report ITU-R BT.628 and Recommendation ITU-R BT.473) has developed a combination test signal that may be used to test several PAL video parameters, rather than using multiple test signals. The ITU combination test signal for PAL systems (shown in Figure 5.49) consists of a white flag, a 2T pulse, a 20T modulated chrominance pulse, and a 5-step luminance staircase signal.

The line bar has a peak amplitude of 100 ±1 IRE and a width of 10 μs.

The 2T pulse has a peak amplitude of 100 ±0.5 IRE, with a half-amplitude width of 200 ±10 ns.

The 20T chrominance pulse has a peak amplitude of 100 ±0.5 IRE, with a half-amplitude width of 2.0 ±0.06 μs.

The 5-step luminance staircase signal consists of 5 luminance steps, at 20, 40, 60, 80 and 100 ±0.5 IRE.

The ITU combination test signal may be present on line 17.

ITU Combination ITS

The ITU (Recommendation ITU-R BT.473) has developed a combination ITS (insertion test signal) that may be used to test several PAL video parameters, rather than using multiple test signals. The ITU combination ITS for PAL

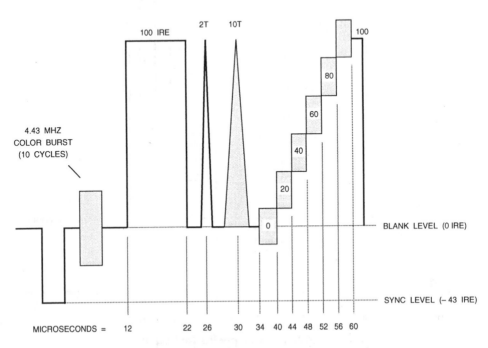

Figure 5.48. United Kingdom (I) PAL National Test Signal #1.

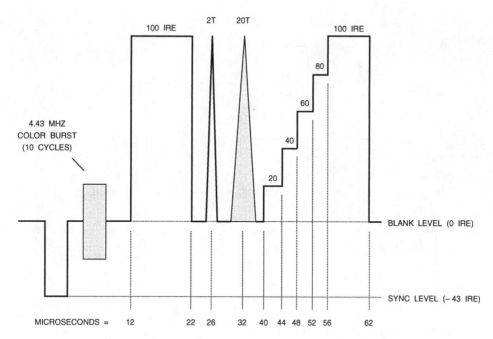

Figure 5.49. ITU Combination Test Signal.

systems (shown in Figure 5.50) consists of a 3-step modulated pedestal with peak-to-peak amplitudes of 20, 60, and 100 ±1 IRE, and an extended subcarrier packet with a peak-to-peak amplitude of 60 ±1 IRE. The rise and fall times of each subcarrier packet envelope are approximately 1 μs. The phase of each subcarrier packet is 60° ±1° relative to the U axis. The tolerance on the 50 IRE level is ±1 IRE.

The ITU composite ITS may be present on line 331.

The United Kingdom allows the use of a slightly different test signal (developed by the British Broadcasting Corporation and the Independent Television Authority), as shown in Figure 5.51. It may be present on lines 20 and 333 for (I) PAL systems in the United Kingdom.

The test signal consists of a 50 IRE luminance bar, part of which has a 100 IRE subcarrier superimposed that has a phase of 60° ±1° relative to the U axis, and an extended burst of subcarrier on the second half of the scan line.

T Pulse

Square waves with fast rise times cannot be used for testing video systems, since attentuation and phase shift of out-of-band components cause ringing in the output signal, obscuring the in-band distortions being measured. T, or \sin^2, pulses are bandwidth-limited, so are used for testing video systems.

The 2T pulse is shown in Figure 5.52 and, like the T pulse, is obtained mathematically by squaring a half-cycle of a sine wave. T pulses are specified in terms of half amplitude duration (HAD), which is the pulse width measured at 50% of the pulse amplitude. Pulses with HADs that are multiples of the time interval T are used to test video systems. As seen in Figures 5.44 through 5.49, T, 2T, 12.5T and 25T pulses are common when testing NTSC video systems, whereas T, 2T, 10T, and 20T pulses are common for PAL video systems.

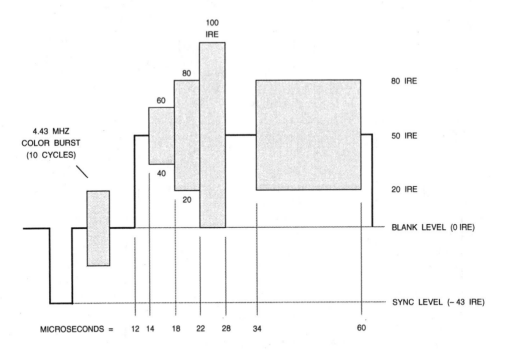

Figure 5.50. ITU Combination ITS.

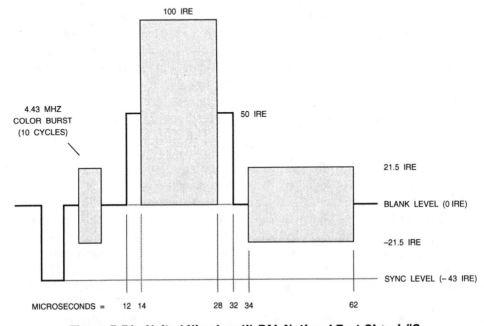

Figure 5.51. United Kingdom (I) PAL National Test Signal #2.

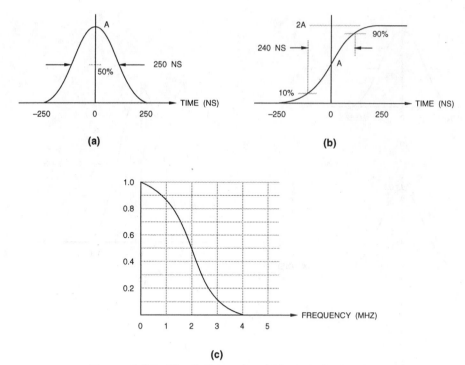

Figure 5.52. The T Pulse: (a) 2T Pulse, (b) 2T Step, (c) Frequency Spectra of the 2T Pulse.

T is the Nyquist interval or

$$1/2F_C$$

where F_C is the cutoff frequency of the video system. For NTSC, F_C is 4 MHz, whereas F_C for PAL systems is 5 MHz. Therefore, T for NTSC systems is 125 ns and for PAL systems it is 100 ns. For a T pulse with a HAD of 125 ns, a 2T pulse has a HAD of 250 ns, and so on. The frequency spectra for the 2T pulse is shown in Figure 5.52 and is representative of the energy content in a typical character generator waveform.

To generate smooth rising and falling edges of most video signals, a T step (generated by integrating a T pulse) typically is used. T steps have 10–90% rise/fall times of 0.964T and a well-defined bandwidth. The 2T step generated from a 2T pulse is shown in Figure 5.52.

The 12.5T chrominance pulse, illustrated in Figure 5.53, is a good test signal to measure any chrominance-to-luminance timing error since its energy spectral distribution is bunched in two relatively narrow bands. Using this signal detects differences in the luminance and chrominance phase distortion, but not between other frequency groups.

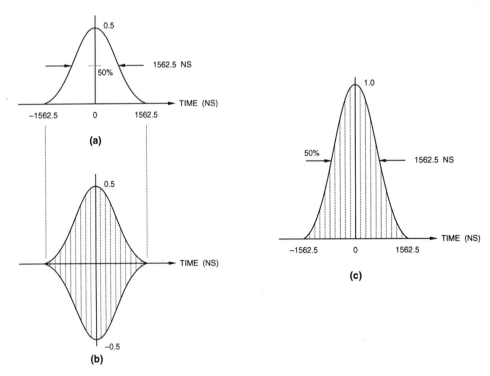

Figure 5.53. The 12.5T Chrominance Pulse: (a) Luminance Component, (b) Chrominance Component, (c) Addition of (a) and (b).

Video Parameters

Many industry-standard video parameters have been defined to specify the relative quality of NTSC/PAL encoders. To measure these parameters, the output of the NTSC/PAL encoder (while generating various video test signals such as those previously described) is monitored using video test equipment. Along with a description of several of these parameters, typical AC parameter values for both consumer and studio-quality encoders are shown in Table 5.21.

Several AC parameters, such as group delay and K factors, are dependent on the quality of the video filters and are not discussed here. In addition to the AC parameters discussed in this section, there are several others that should be included in an encoder specification, such as burst frequency and tolerance, horizontal frequency, horizontal blanking time, sync rise and fall times, burst envelope rise and fall times, video blanking rise and fall times, and the bandwidths of the YIQ or YUV baseband video signals.

Parameter	Consumer Quality		Studio Quality		Units
	NTSC[1]	PAL[2]	NTSC[1]	PAL[2]	
differential phase	4		≤ 1		degrees
differential gain	4		≤ 1		%
luminance nonlinearity	2		≤ 1		%
hue accuracy	3		≤ 1		degrees
color saturation accuracy	3		≤ 1		%
residual subcarrier	0.5		0.01		IRE
SNR (per ITU-R BT.410 or EIA RS-250-B)	48		> 60		dB
SCH phase	0 ± 40	0 ± 20	0 ± 2		degrees
analog Y/C video output skew	5		≤ 2		ns
H tilt	< 1		< 1		%
V tilt	< 1		< 1		%
subcarrier tolerance	10	5	10	5	Hz

Notes
1. (M) NTSC.
2. (B, D, G, H, I) PAL.

Table 5.21. Typical Video AC Parameters for NTSC and PAL Encoders.

There are also several DC parameters (such as white level and tolerance, blanking level and tolerance, sync height and tolerance, peak-to-peak burst amplitude and tolerance) that should be specified, as shown in Table 5.22.

Differential Phase

Differential phase distortion, commonly referred to as differential phase, specifies how much the chrominance phase is affected by the luminance level—in other words, how much hue shift occurs when the luminance level changes. Both positive and negative phase errors may be present, so differential phase is expressed as a peak-to-peak measurement, expressed in degrees of subcarrier

phase. This parameter is measured using a test signal of uniform phase and amplitude chrominance superimposed on different luminance levels, such as the modulated ramp test signal or the modulated 5-step portion of the composite test signal. The differential phase parameter for a studio-quality analog encoder may approach 0.2° or less.

Differential Gain

Differential gain distortion, commonly referred to as differential gain, specifies how much the chrominance gain is affected by the luminance level—in other words, how much color saturation shift occurs when the luminance level changes. Both attenuation and amplification may occur, so differential gain is

Parameter	NTSC[1]	PAL[2]	Units
white relative to blank	714 ±7	700 ±7	mV
black relative to blank	54 ±7	0	mV
sync relative to blank	−286 ±7	−300 ±7	mV
burst amplitude (nominal, peak-to-peak)	286 ±7	300 ±7	mV

Notes
1. (M) NTSC.
2. (B, D, G, H, I) PAL.

Table 5.22. Typical Video DC Parameters for NTSC and PAL Encoders.

expressed as the largest amplitude change between any two levels, expressed as a percentage of the largest chrominance amplitude. This parameter is measured using a test signal of uniform phase and amplitude chrominance superimposed on different luminance levels, such as the modulated ramp test signal or the modulated 5-step portion of the composite test signal. The differential gain parameter for a studio-quality analog encoder may approach 0.2% or less.

Luminance Nonlinearity

Luminance nonlinearity, also referred to as differential luminance and luminance nonlinear distortion, specifies how much the luminance gain is affected by the luminance level—in other words, a nonlinear relationship between the generated luminance level and the ideal luminance level. Using an unmodulated 5-step or 10-step staircase test signal, or the modulated 5-step portion of the composite test signal, the difference between the largest and smallest steps, expressed as a percentage of the largest step, is used to specify the luminance nonlinearity. Although this parameter is included within the differential gain and phase

parameters, it traditionally is specified independently.

Chrominance Nonlinear Phase Distortion

Chrominance nonlinear phase distortion specifies how much the chrominance phase (hue) is affected by the chrominance amplitude (saturation)—in other words, how much hue shift occurs when the saturation changes. Using a modulated pedestal test signal, or the modulated pedestal portion of the combination test signal, the phase differences between each chrominance packet and the burst are measured. The difference between the largest and the smallest measurements is the peak-to-peak value, expressed in degrees of subcarrier phase. This parameter usually is not independently specified, but is included within the differential gain and phase parameters.

Chrominance Nonlinear Gain Distortion

Chrominance nonlinear gain distortion specifies how much the chrominance gain is affected by the chrominance amplitude (saturation)—in other words, a nonlinear relation-

ship between the generated chrominance amplitude levels and the ideal chrominance amplitude levels, usually seen as an attenuation of highly saturated chrominance signals. Using a modulated pedestal test signal, or the modulated pedestal portion of the combination test signal, the test equipment is adjusted so that the middle chrominance packet is 40 IRE. The largest difference between the measured and nominal values of the amplitudes of the other two chrominance packets specifies the chrominance nonlinear gain distortion, expressed in IRE or as a percentage of the nominal amplitude of the worst-case packet. This parameter usually is not independently specified, but is included within the differential gain and phase parameters.

Chrominance-to-Luminance Intermodulation

Chrominance-to-luminance intermodulation, commonly referred to as cross-modulation, specifies how much the luminance level is affected by the chrominance. This may be the result of clipping highly saturated chrominance levels or quadrature distortion and may show up as irregular brightness variations due to changes in color saturation. Using a modulated pedestal test signal, or the modulated pedestal portion of the combination test signal, the largest difference between the normalized 50 IRE pedestal level and the measured luminance levels (after removal of chrominance information) specifies the chrominance-to-luminance intermodulation, expressed in IRE or as a percentage. This parameter usually is not independently specified, but is included within the differential gain and phase parameters.

Hue Accuracy

Hue accuracy specifies how closely the generated hue is to the ideal hue value. Both positive and negative phase errors may be present, so hue accuracy is the difference between the worst-case positive and worst-case negative measurements from nominal, expressed in degrees of subcarrier phase. This parameter is measured using EIA or EBU color bars as a test signal.

Color Saturation Accuracy

Color saturation accuracy specifies how closely the generated saturation is to the ideal saturation value, using EIA or EBU color bars as a test signal. Both gain and attenuation may be present, so color saturation accuracy is the difference between the worst-case gain and worst-case attenuation measurements from nominal, expressed as a percentage of nominal.

Residual Subcarrier

The residual subcarrier parameter specifies how much subcarrier information is present during white or gray (note that, ideally, none should be present). Excessive residual subcarrier is visible as noise during white or gray portions of the picture. Using an unmodulated 5-step or 10-step staircase test signal, the maximum peak-to-peak measurement of the subcarrier (expressed in IRE) during active video is used to specify the residual subcarrier relative to the burst amplitude.

SCH Phase

SCH (Subcarrier to Horizontal) phase refers to the phase relationship between the leading edge of horizontal sync (at the 50% amplitude point) and the zero crossings of the color burst (by extrapolating the color burst to the leading edge of sync). The error is referred to as SCH phase and is expressed in degrees of subcarrier phase.

For PAL, the definition of SCH phase is slightly different due to the more complicated relationship between the sync and subcarrier frequencies—the SCH phase relationship for a given line repeats only once every eight fields. Therefore, PAL SCH phase is defined, per EBU Technical Statement D 23-1984 (E), as "the phase of the +U component of the color burst extrapolated to the half-amplitude point of the leading edge of the synchronizing pulse of line 1 of field 1."

SCH phase in important when merging two or more video signals. To avoid color shifts or "picture jumps," the video signals must have the same horizontal, vertical, and subcarrier timing and the phases must be closely matched. To achieve these timing constraints, the video signals must have the same SCH phase relationship since the horizontal sync and subcarrier are continuous signals with a defined relationship. It is common for an encoder to allow adjustment of the SCH phase to simplify merging two or more video signals. Maintaining proper SCH phase is also important since NTSC and PAL decoders may monitor the SCH phase to determine which color field is being decoded.

Analog Y/C Video Output Skew

The output skew between the analog luminance (Y) and modulated chrominance (C) video signals should be minimized to avoid phase shift errors between the luminance and chrominance information. Excessive output skew is visible as artifacts along sharp vertical edges when viewed on a monitor.

H Tilt

H tilt, also known a line tilt and line time distortion, causes a tilt in line-rate signals, predominantly white bars. This type of distortion causes variations in brightness between the left and right edges of an image. For a digital encoder, such as that described in this chapter, H tilt is primarily an artifact of the analog output filters and the transmission medium. H tilt is measured using a line bar (such as the one in the NTC-7 NTSC composite test signal) and measuring the peak-to-peak deviation of the tilt (in IRE or percent of white bar amplitude), ignoring the first and last microsecond of the white bar.

V Tilt

V tilt, also known as field tilt and field time distortion, causes a tilt in field-rate signals, predominantly white bars. This type of distortion causes variations in brightness between the top and bottom edges of an image. For a digital encoder, such as that described in this chapter, V tilt is primarily an artifact of the analog output filters and the transmission medium. V tilt is measured using a 18 μs, 100 IRE white bar in the center of 130 lines in the center of the field or using a field square wave. The peak-to-peak deviation of the tilt is measured (in IRE or percent of white bar amplitude), ignoring the first and last three lines.

Genlocking and Alpha

In many instances, it is desirable to be able to genlock the output (align the timing signals) of an encoder to another composite analog video signal to facilitate downstream video processing. This requires locking the horizontal, vertical, and color subcarrier frequencies and phases together, as discussed in Chapter 6, along with the luminance and chrominance amplitudes. A major problem in genlocking is that the regenerated pixel clock usually has excessive jitter, resulting in color artifacts.

One genlocking variation is to send an advance house sync (also known as black burst or house sync) to the encoder. The advancement compensates for the delay from the house

sync generator to the encoder output being used in the downstream processor, such as a mixer. Each video source has its own advanced house sync signal, so each video source is time-aligned at the mixing or processing point.

Another genlocking variation allows adjustment of the subcarrier phase so it can be matched with other video sources at the mixing or processing point. The subcarrier phase must be able to be adjusted from 0° to 360°. Either zero SCH phase is always maintained or another adjustment is allowed to independently position the sync and luminance information in about 10-ns steps.

The output delay variation between products should be within ±0.8 ns to allow video signals from different genlocked devices to be properly mixed. Mixers usually assume the two video signals are perfectly genlocked, and excessive time skew between the two video signals results in poor mixing performance.

An encoder designed for the analog video editing environment also should support an alpha channel. Eight or 10 bits of digital alpha data are input, pipelined to match the pipeline of the encoding process, and converted to an analog alpha signal (discussed in Chapter 9). In computer systems that support 32-bit pixels, 8 bits typically are available for alpha information. Including the alpha channel on the encoder allows designers to change encoders (which may have different pipeline delays) to fit specific applications without worrying about the alpha channel pipeline delay. Alpha is usually linear, with the digital data generating an analog alpha signal (also called a key) with a range of 0 to 100 IRE. There is no blanking pedestal or sync information present.

Timecode Generation

Two types of time coding commonly are used, as defined by ANSI/SMPTE 12M and IEC 461:

longitudinal timecode (LTC) and vertical interval timecode (VITC). The LTC is recorded on a separate audio track; as a result, the VCR must use high-bandwidth amplifiers and audio heads. This is due to the time code frequency increasing as tape speed increases, until the point that the frequency response of the system results in a distorted time code signal that may not be read reliably. At slower tape speeds, the time code frequency decreases, until at very low tape speeds or still pictures, the time code information is no longer recoverable. The VITC is recorded as part of the video signal; as a result, the time code information always is available, regardless of the tape speed. However, the LTC allows the time code signal to be written without writing a video signal; the VITC requires the video signal to be changed if a change in time code information is required. The LTC therefore is useful for synchronizing multiple audio or audio/video sources.

Longitudinal Timecode (LTC)

The LTC information is transmitted using a separate serial interface, using the same electrical interface as the AES/EBU digital audio interface standard, AES3 (ANSI S4.40), and is recorded on a separate audio channel. The basic structure of the time data is based on the BCD system. Tables 5.23 and 5.24 list the LTC bit assignments and arrangement. Note the 24-hour clock system is used.

LTC Timing

The modulation technique is such that a transition occurs at the beginning of every bit period. "1" is represented by a second transition one half a bit period from the start of the bit. "0" is represented when there is no transition within the bit period (see Figure 5.54). The rise and fall times are to be 25 ±5 µs (10% to 90% amplitude points).

Bit(s)	Function	Note	Bit(s)	Function	Note
0–3	units of frames		59 (525/60)	binary group flag	
4–7	user group 1		59 (625/50)	phase correction	note 3
8–9	tens of frames		60–63	user group 8	
10	drop frame flag	note 1	64	sync bit	fixed"0"
11	color frame flag	note 2	65	sync bit	fixed"0"
12–15	user group 2		66	sync bit	fixed"1"
16–19	units of seconds		67	sync bit	fixed"1"
20–23	user group 3		68	sync bit	fixed"1"
24–26	tens of seconds		69	sync bit	fixed"1"
27 (525/60)	phase correction	note 3	70	sync bit	fixed"1"
27 (625/50)	binary group flag		71	sync bit	fixed"1"
28–31	user group 4		72	sync bit	fixed"1"
32–35	units of minutes		73	sync bit	fixed"1"
36–39	user group 5		74	sync bit	fixed"1"
40–42	tens of minutes		75	sync bit	fixed"1"
43	binary group flag		76	sync bit	fixed"1"
44–47	user group 6		77	sync bit	fixed"1"
48–51	units of hours		78	sync bit	fixed"0"
52–55	user group 7		79	sync bit	fixed"1"
56–57	tens of hours				
58	unassigned	fixed "0"			

Notes
1. 525/60 systems: "1" if frame numbers are being dropped; "0" if no frame dropping is done. 625/50 systems: "0". See Frame Dropping—(M) NTSC and (M) PAL.
2. 525/60 systems: "1" if even units of frame numbers identify fields 1 and 2 and odd units of field numbers identify fields 3 and 4. 625/50 systems: "1" if timecode is locked to the video signal in accordance with 8-field sequence and the video signal has the "preferred subcarrier-to-line-sync phase."
3. This bit shall be put in a state so that every 80-bit word contains an even number of logical zeros.

Table 5.23. LTC Bit Assignments.

Frames (count 0–29 for 525/60 systems, 0–24 for 625/50 systems)	
units (bits 0–3)	4-bit BCD arranged 1, 2, 4, 8 (count 0–9); bit 0 is LSB
tens of units (bits 8–9)	2-bit BCD arranged 1, 2 (count 0–2); bit 8 is LSB

Seconds	
units (bits 16–19)	4-bit BCD arranged 1, 2, 4, 8 (count 0–9); bit 16 is LSB
tens of units (bits 24–26)	3-bit BCD arranged 1, 2, 4 (count 0–5); bit 24 is LSB

Minutes	
units (bits 32–35)	4-bit BCD arranged 1, 2, 4, 8 (count 0–9); bit 32 is LSB
tens of units (bits 40–42)	3-bit BCD arranged 1, 2, 4 (count 0–5); bit 40 is LSB

Hours	
units (bits 48–51)	4-bit BCD arranged 1, 2, 4, 8 (count 0–9); bit 48 is LSB
tens of units (bits 56–57)	2-bit BCD arranged 1, 2 (count 0–2); bit 56 is LSB

Table 5.24. LTC Bit Arrangement.

Figure 5.54. LTC Data Bit Transition Format.

Because the entire frame time is used to generate the 80-bit LTC information, the bit rate (in bits per second) may be determined by:

$$F_C = 80 \, F_V$$

where F_V is the vertical frame rate in frames per second. The 80 bits of time code information are output serially, with bit 0 being first. The LTC word occupies the entire frame time, and the data must be evenly spaced throughout this time. The start of the LTC word occurs at the beginning of line 2 (±1 line) in fields 1 and 3 for 525/60 systems and at the beginning of line 2 (±1 line) in fields 1, 3, 5, and 7 for 625/50 systems. Note these 525/60 system scan line numbers correspond to the line numbering scheme shown in Figure 5.21.

User Bits

The user group bits are intended for storage of data by users, and the 32 bits within the 8 groups may be assigned in any manner without restriction if the character set used for the data is not specified and both binary group flag bits are zero. The binary group flag bits should be set as shown in Table 5.25.

If an 8-bit character set conforming to ISO Standards 646 and 2022 is indicated by the binary group flags, the characters are to be inserted as shown in Figure 5.55. Note that some user bits will be decoded before the binary group flags are decoded; therefore, the decoder must store the early user data before any processing is done.

Frame Dropping—(M) NTSC and (M) PAL

One second of real time is defined as the time elapsed during the scanning of 60 fields (or any multiple). One second of color time is defined as the time elapsed during the scanning of 60 fields (or any multiple) of a system that has a vertical field rate of about 59.94 fields per second.

Since the vertical field rate of the color signal is not exactly 60, straight counting at 30 frames per second (60 fields per second) yields an error of 108 frames (216 fields) for each hour of running time. This may be corrected in one of two ways:

Nondrop frame: During a continuous recording, each time count increases by 1 frame. In this mode, the drop frame flag will be a "0."

Drop frame for (M) NTSC: To resolve the color timing error, the first two frame numbers (0 and 1) at the start of each minute, except for minutes 0, 10, 20, 30, 40, and 50, are omitted from the count. In this mode, the drop frame flag will be a "1."

525/60 systems	Bit 43	Bit 59
625/50 systems	Bit 27	Bit 43
character set not specified	0	0
8-bit character set*	0	1
reserved	1	0
reserved	1	1

* conforming to ISO Standards 646 and 2022.

Table 5.25. Binary Group Flag Bit Definitions.

Figure 5.55. Use of Binary Groups to Describe ISO Characters Coded with 7 or 8 Bits.

Drop frame for (M) PAL: To resolve the color timing error, the first four frame numbers (1 to 4) at the start of every second minute (even minute numbers) are omitted from the count, except for minutes 0, 20, and 40. In this mode, the drop frame flag will be a "1."

Vertical Interval Time Code (VITC)

The VITC is recorded during the vertical blanking interval of a composite video signal onto two nonconsecutive scan lines in both fields. Since it is recorded with the video, it can be read in still mode. However, it cannot be rerecorded (or restriped). Restriping requires dubbing down a generation, deleting and inserting a new time code. Note that for S-video signals (separate luminance and chrominance signals), the VITC is present only on the Y channel.

As with the LTC, the basic structure of the time data is based on the BCD system. Tables 5.26 and 5.27 list the VITC bit assignments and arrangement. Note the 24-hour clock system is used.

VITC Timing
The modulation technique is such that each state corresponds to a binary state, and a tran-

sition occurs only when there is a change in the data between adjacent bits from a "1" to "0" or "0" to "1". No transitions occur when adjacent bits contain the same data. This commonly is referred to as "non-return to zero" (NRZ). Synchronization bit pairs are inserted throughout the VITC data to assist the receiver in maintaining the correct frequency lock.

The bit rate (F_C) is defined to be (with an allowable error of ±200 bits per second):

525/60 systems: $F_C = (455/4) \, F_H = F_{SC}/2$

625/50 systems: $F_C = 116 \, F_H$

where F_H is the horizontal line frequency. The 90 bits of time code information are output serially during video blanking, with bit 0 being first. Two nonconsecutive available scan lines per field during the vertical blanking interval may be used (to protect the VITC reading process against drop-outs). For 625/50 systems, the VITC may not be earlier than lines 6 or 319 or later than lines 22 or 335. For 525/60 systems, lines 11 and 274 commonly are used for the VITC. Note these 525/60 system scan line numbers correspond to the line numbering scheme shown in Figure 5.21.

Bit(s)	Function	Note	Bit(s)	Function	Note
0	sync bit	fixed "1"	42–45	units of minutes	
1	sync bit	fixed "0"	46–49	user group 5	
2–5	units of frames		50	sync bit	fixed "1"
6–9	user group 1		51	sync bit	fixed "0"
10	sync bit	fixed "1"	52–54	tens of minutes	
11	sync bit	fixed "0"	55	binary group flag	
12–13	tens of frames		56–59	user group 6	
14	drop frame flag	note 1	60	sync bit	fixed "1"
15	color frame flag	note 2	61	sync bit	fixed"0"
16–19	user group 2		62–65	units of hours	
20	sync bit	fixed "1"	66–69	user group 7	
21	sync bit	fixed "0"	70	sync bit	fixed"1"
22–25	units of seconds		71	sync bit	fixed"0"
26–29	user group 3		72–73	tens of hours	
30	sync bit	fixed "1"	74	unassigned	fixed "0"
31	sync bit	fixed "0"	75 (525/60)	binary group flag	
32–34	tens of seconds		75 (625/50)	field mark flag	note 4
35 (525/60)	field mark flag	note 3	76–79	user group 8	
35 (625/50)	binary group flag		80	sync bit	fixed"1"
36–39	user group 4		81	sync bit	fixed"0"
40	sync bit	fixed "1"	82–89	CRC group	
41	sync bit	fixed "0"			

Notes
1. 525/60 systems: "1" if frame numbers are being dropped; "0" if no frame dropping is done. 625/50 systems: "0". See Frame Dropping—(M) NTSC and (M) PAL.
2. 525/60 systems: "1" if even units of frame numbers identify fields 1 and 2 and odd units of field numbers identify fields 3 and 4. 625/50 systems: "1" if timecode is locked to the video signal in accordance with 8-field sequence and the video signal has the "preferred subcarrier-to-line-sync phase".
3. 525/60 systems: "0" during fields 1 and 3. "1" during fields 2 and 4.
4. 625/50 systems: "0" during fields 1, 3, 5, and 7. "1" during fields 2, 4, 6, and 8.

Table 5.26. VITC Bit Assignments.

Frames (count 0–29 for 525/60 systems, 0–24 for 625/50 systems)	
units (bits 2–5)	4-bit BCD arranged 1, 2, 4, 8 (count 0–9); bit 2 is LSB
tens of units (bits 12–13)	2-bit BCD arranged 1, 2 (count 0–2); bit 12 is LSB

Seconds	
units (bits 22–25)	4-bit BCD arranged 1, 2, 4, 8 (count 0–9); bit 22 is LSB
tens of units (bits 32–34)	3-bit BCD arranged 1, 2, 4 (count 0–5); bit 32 is LSB

Minutes	
units (bits 42–45)	4-bit BCD arranged 1, 2, 4, 8 (count 0–9); bit 42 is LSB
tens of units (bits 52–54)	3-bit BCD arranged 1, 2, 4 (count 0–5); bit 52 is LSB

Hours	
units (bits 62–65)	4-bit BCD arranged 1, 2, 4, 8 (count 0–9); bit 62 is LSB
tens of units (bits 72–73)	2-bit BCD arranged 1, 2 (count 0–2); bit 72 is LSB

Table 5.27. VITC Bit Arrangement.

Figure 5.56 illustrates the timing of the VITC data on the scan line. The data must be evenly spaced throughout the VITC word. The 10% to 90% rise and fall times of the VITC bit data should be 200 ±50 ns before adding it to the video signal to avoid possible distortion of the VITC signal by downstream chrominance circuits. In most circumstances, the analog lowpass filters after the video D/A converters should suffice for the filtering.

User Bits

The user group bits are intended for storage of data by users, and the 32 bits within the 8 groups may be assigned in any manner without restriction if the character set used for the data is not specified and both binary group flag bits are zero. The binary group flag bits should be set as shown in Table 5.28.

If an 8-bit character set conforming to ISO Standards 646 and 2022 is indicated by the binary group flags, the characters are to be inserted as shown in Figure 5.55. Note that user data must be the same in both fields of a frame to avoid problems when transferring from VITC to LTC. Also, some user bits will be decoded before the binary group flags are decoded; therefore, the decoder must store the early user data before any processing is done.

VITC Cyclic Redundancy Check

Eight bits (82–89) are reserved for the code word for error detection by means of cyclic

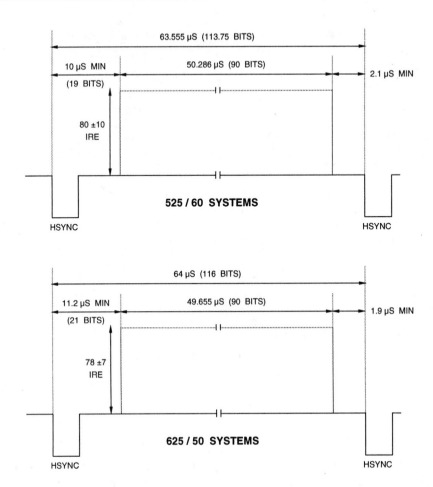

Figure 5.56. VITC Positions and Timing.

	Bit 55	Bit 75
525/60 systems		
625/50 systems	Bit 35	Bit 55
character set not specified	0	0
8-bit character set*	0	1
reserved	1	0
reserved	1	1

* conforming to ISO Standards 646 and 2022.

Table 5.28. Binary Group Flag Bit Definitions.

redundancy checking. The generating polynomial, $x^8 + 1$, applies to all bits from 0 to 81, inclusive. Figure 5.57 illustrates implementing the polynomial using a shift register. During passage of information data, the multiplexer is in position 0 and the data is output while the division is done simultaneously by the shift register. After all the information data has been output, the shift register contains the CRC value, and switching the multiplexer to position 1 enables the CRC value to be output. When the process is repeated on decoding, the shift register should contain all zeros if no errors exist.

Closed Captioning (USA)

This section reviews closed captioning for the hearing impaired in the United States. Closed captioning and text are transmitted during the blanked active line-time portion of lines 21 and 284 (lines 18 and 281 using the line numbering scheme shown in Figure 5.21).

Extended data services (EDS or XDS) also may be transmitted during the blanked active line-time portion of line 284 (line 281 using the line numbering scheme shown in Figure 5.21). XDS may specify the call sign, program name, time into the show, time remaining to the end, and so on.

Waveform

The data format for both lines consists of a clock run-in signal, a start bit, and two 7-bit plus parity words of ASCII data (per X3.4-1967). To support S-video applications, caption information also should be available on the Y channel.

Figure 5.58 illustrates the waveform and timing for transmitting the closed captioning information and conforms to the standard Television Synchronizing Waveform for Color Transmission in Subpart E, Part 73 of the FCC Rules and Regulations and EIA-608. The clock run-in is a 7-cycle sinusoidal burst that is frequency-locked and phase-locked to the caption data and is used to provide synchronization for the decoder. The nominal data rate is 32x F_H. However, decoders should not rely on this timing relationship due to possible horizontal timing variations introduced by video processing circuitry and VTRs. After the clock run-in signal, the blanking level is maintained for a two data bit duration, followed by a "1" start bit. The start bit is followed by 16 bits of data, composed of two 7-bit + odd parity ASCII characters. Caption data is transmitted using a non–return-to-zero (NRZ) code; a digital "1" corresponds to the 50 ± 2 IRE level and a digital "0" corresponds to the blanking level (0–2

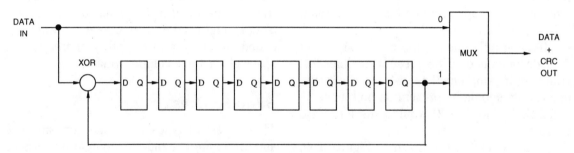

Figure 5.57. CRC Generation.

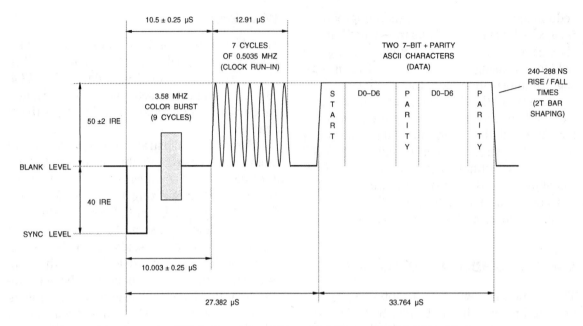

Figure 5.58. NTSC Line 21 and Line 284 Closed Captioning Timing.

IRE). The negative-going crossings of the clock are coherent with the data bit transitions.

Typical decoders specify the time between the 50% points of sync and clock run-in to be 10.5 ±0.5 μs, with a ±3% tolerance on F_H, 50 ±12 IRE for a logical one bit, and −2 to +12 IRE for a logical zero bit. Decoders must also handle bit rise/fall times of 240–480 ns.

NUL characters (00_H) should be sent when no display or control characters are being transmitted. This, in combination with the clock run-in, enables the decoder to determine whether captioning or text transmission is being implemented.

If using only line 21, the clock run-in and data do not need to be present on line 284. However, if using only line 284, the clock run-in and data should be present on both lines 21 and 284; data for line 21 would consist of NUL characters.

At the decoder, as shown in Figure 5.59, the total display area is 15 rows high and 34 columns wide. The vertical display area begins on line 43 and ends on line 237. The horizontal display area begins 13 μs and ends 58 μs, after the leading edge of horizontal sync.

In text mode, all rows are used to display text; each row contains a maximum of 32 characters, with at least a one-column wide space on the left and right of the text. The only transparent area is around the outside of the display area.

In caption mode, text usually appears only on rows 1–4 and 12–15; rows 5–11 usually are transparent. Each row contains a maximum of 32 characters and each character is always preceded and followed by another character or a space at least one column wide.

Basic Services

There are two types of display formats: text and captioning. In understanding the operation of the decoder, it is easier to visualize an invisi-

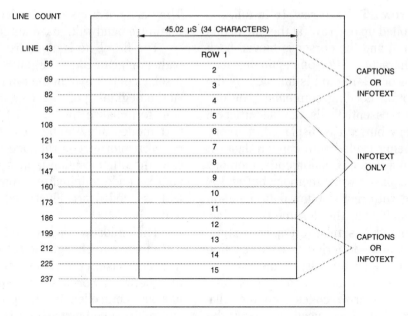

Figure 5.59. Display Format. The line numbering corresponds to that used in standard practice for NTSC.

ble cursor that marks the position where the next character will be displayed. Note that if you are designing a decoder, you should obtain the latest FCC Rules and Regulations and EIA-608 to ensure correct operation, as this section is only a summary.

Text Mode

Text mode uses 7–15 rows of the display and is enabled upon receipt of the Resume Text Display or Text Restart code. When text mode has been selected, and the text memory is empty, the cursor starts at the top-most row, character 1 position. Once all the rows of text are displayed, scrolling is enabled.

With each carriage return received, the top-most row of text is erased, the text is rolled up one row (over a maximum time of 0.433 seconds), the bottom row is erased, and the cursor is moved to the bottom row, character 1 position. If new text is received while scrolling, it is seen scrolling up from the bottom of the display area. If a carriage return is received while scrolling, the rows are immediately moved up one row to their final position.

Once the cursor moves to the character 32 position on any row, any text received before a carriage return, preamble address code, or backspace will be displayed at the character 32 position, replacing any previous character at that position. The Text Restart command erases all characters on the display and moves the cursor to the top row, character 1 position.

Captioning Mode

Captioning has several modes available, including roll-up, pop-on, and paint-on. Roll-up captioning is enabled by receiving one of the miscellaneous control codes to select the number of rows displayed. "Roll-up captions, 2 rows" enables rows 14 and 15; "roll-up captions, 3 rows" enables rows 13–15, "roll-up captions, 4 rows" enables rows 12–15. Regardless of the number of rows enabled, the cursor

remains on row 15. Once row 15 is full, the rows are scrolled up one row (at the rate of one dot per frame), and the cursor is moved back to row 15, character 1. Pop-on captioning may use rows 1–4 or 12–15, and is initiated by the Resume Caption Loading command. The display memory essentially is double-buffered. While memory buffer 1 is displayed, memory buffer 2 is being loaded with caption data. At the receipt of a End of Caption code, memory buffer 2 is displayed while memory buffer 1 is being loaded with new caption data. Paint-on captioning, enabled by the Resume Direct Captioning command, is similar to Pop-on captioning, but no double-buffering is used; caption data is loaded directly into display memory.

Three types of control codes (preamble address codes, midrow codes, and miscellaneous control codes) are used to specify the format, location, and attributes of the characters. Each control code consists of two bytes, transmitted together on line 21 or line 284. On line 21, they normally are transmitted twice in succession to help ensure correct reception.

They are not transmitted twice on line 284 to minimize bandwidth used for captioning.

The first byte is a nondisplay control byte with a range of 10_H to $1F_H$; the second byte is a display control byte in the range of 20_H to $7F_H$. At the beginning of each row, a control code is sent to initialize the row. Caption roll-up and text modes allow either a preamble address code or midrow control code at the start of a row; the other caption modes use a preamble address code to initialize a row. The preamble address codes are illustrated in Figure 5.60 and Table 5.29.

The midrow codes typically are used within a row to change the color, italics, underline, and flashing attributes and should occur only between words. Color, italics, and underline are controlled by the preamble address and midrow codes; flash on is controlled by a miscellaneous control code. An attribute remains in effect until another control code is received or the end of row is reached. Each row starts with a control code to set the color and underline attributes (white nonunderlined

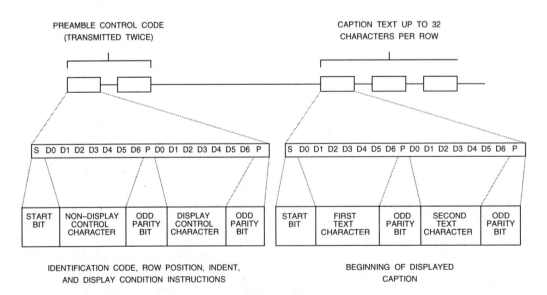

Figure 5.60. Preamble Address Code Format.

Non-display Control Byte							Display Control Byte							Row Position
D6	D5	D4	D3	D2	D1	D0	D6	D5	D4	D3	D2	D1	D0	
				0	0	1	1	0						1
							1	1						2
				0	1	0	1	0						3
							1	1						4
				1	0	1	1	0						5
							1	1						6
				1	1	0	1	0						7
0	0	1	CH				1	1	A	B	C	D	U	8
				1	1	1	1	0						9
							1	1						10
				0	0	0	1	0						11
				0	1	1	1	0						12
							1	1						13
				1	0	0	1	0						14
							1	1						15

U: "0" = no underline, "1" = underline
CH: "0" = data channel 1, "1" = data channel 2

Table 5.29a. Preamble Address Codes. In text mode, the indent codes may be used to perform indentation; in this instance, the row information is ignored.

A	B	C	D	Attribute
0	0	0	0	white
0	0	0	1	green
0	0	1	0	blue
0	0	1	1	cyan
0	1	0	0	red
0	1	0	1	yellow
0	1	1	0	magenta
0	1	1	1	italics
1	0	0	0	indent 0, white
1	0	0	1	indent 4, white
1	0	1	0	indent 8, white
1	0	1	1	indent 12, white
1	1	0	0	indent 16, white
1	1	0	1	indent 20, white
1	1	1	0	indent 24, white
1	1	1	1	indent 28, white

Table 5.29b. Preamble Address Codes. In text mode, the indent codes may be used to perform indentation; in this instance, the row information is ignored.

is the default if no control code is received before the first character on an empty row). The color attribute can be changed only by the midrow code of another color; the italics attribute does not change the color attribute. However, a color attribute turns off the italics attribute. The flash on command does not alter the status of the color, italics, or underline attributes. However, a color or italics midrow control code turns off the flash. Note that the underline color is the same color as the character being underlined; the underline resides on dot row 11 and covers the entire width of the character column.

Table 5.30, Figure 5.61, and Table 5.31 illustrate the midrow and miscellaneous control code operation. For example, if it were the end of a caption, the control code could be End of Caption (transmitted twice). It could be followed by a preamble address code (transmitted twice) to start another line of captioning.

Characters are displayed using a dot matrix format. Each character cell is typically 13 dots high and 8 dots wide, as shown in Figure 5.62. Each vertical dot is one pair of interlaced scan lines; therefore, with a video field, a character cell is 13 scan lines high, and within a video frame a character cell is 26 scan lines high. Dot rows 0 and 12 usually are blanked to provide vertical spacing between characters, and underlining typically is done on dot row 11. Dot rows 1–9 usually are used for actual character outlines, leaving dot row 10 as a space between the bottom of a character and the underline attribute. Dot columns 0 and 7 are blanked to provide horizontal spacing between characters, except on dot row 11 when the underline is displayed. Table 5.32 shows the basic character set.

Non-display Control Byte							Display Control Byte							
D6	D5	D4	D3	D2	D1	D0	D6	D5	D4	D3	D2	D1	D0	Attribute
										0	0	0		white
										0	0	1		green
										0	1	0		blue
0	0	1	CH	0	0	1	0	1	0	0	1	1	U	cyan
										1	0	0		red
										1	0	1		yellow
										1	1	0		magenta
										1	1	1		italics

U: "0" = no underline, "1" = underline CH: "0" = data channel 1, "1" = data channel 2
Note: Italics is implemented as a two-dot slant to the right over the vertical range of the character. Underline resides on dot row 11 and covers the entire column width.

Table 5.30. Midrow Codes.

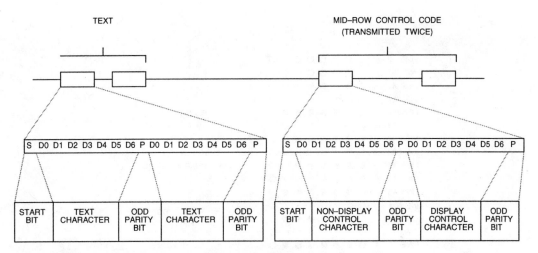

Figure 5.61. Caption Midrow Code Format. Miscellaneous control codes also may be transmitted in place of the midrow control code.

Non-display Control Byte							Display Control Byte							Command
D6	**D5**	**D4**	**D3**	**D2**	**D1**	**D0**	**D6**	**D5**	**D4**	**D3**	**D2**	**D1**	**D0**	
0	0	1	CH	1	0	F	0	1	0	0	0	0	0	resume caption loading
										0	0	0	1	backspace
										0	0	1	0	reserved
										0	0	1	1	reserved
										0	1	0	0	delete to end of row
										0	1	0	1	roll-up captions, 2 rows
										0	1	1	0	roll-up captions, 3 rows
										0	1	1	1	roll-up captions, 4 rows
										1	0	0	0	flash on
										1	0	0	1	resume direct captioning
										1	0	1	0	text restart
										1	0	1	1	resume text display
										1	1	0	0	erase displayed memory
										1	1	0	1	carriage return
										1	1	1	0	erase nondisplayed memory
										1	1	1	1	end of caption (flip memories)
0	0	1	CH	1	1	1	0	1	0	0	0	0	1	tab offset (1 column)
										0	0	1	0	tab offset (2 columns)
										0	0	1	1	tab offset (3 columns)

CH: "0" = data channel 1, "1" = data channel 2 F: "0" = line 21, "1" = line 284
Note: "flash on" blanks associated characters for 0.25 seconds once per second.

Table 5.31. Miscellaneous Control Codes.

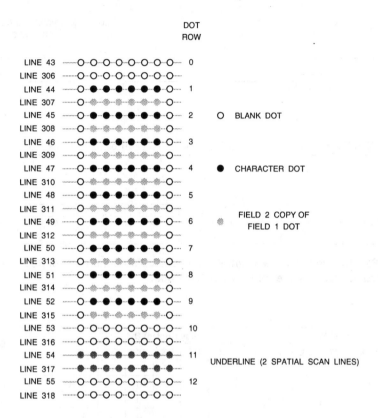

Figure 5.62. Typical Character Cell Format. Line numbers correspond to row 1. The line numbering corresponds to that used in standard practice for NTSC.

Nondisplay Control Byte							Display Control Byte							Special Characters
D6	D5	D4	D3	D2	D1	D0	D6	D5	D4	D3	D2	D1	D0	
0	0	1	CH	0	0	1	0	1	1	0	0	0	0	®
										0	0	0	1	°
										0	0	1	0	1/2
										0	0	1	1	¿
										0	1	0	0	™
										0	1	0	1	ç
										0	1	1	0	£
										0	1	1	1	music note
										1	0	0	0	à
										1	0	0	1	transparent space
										1	0	1	0	è
										1	0	1	1	â
										1	1	0	0	ê
										1	1	0	1	î
										1	1	1	0	ô
										1	1	1	1	û

D6 D5 D4 D3 → D2 D1 D0 ↓	0100	0101	0110	0111	1000	1001	1010	1011	1100	1101	1110	1111
000		(0	8	@	H	P	X	ú	h	p	x
001	!)	1	9	A	I	Q	Y	a	i	q	y
010	"	á	2	:	B	J	R	Z	b	j	r	z
011	#	+	3	;	C	K	S	[c	k	s	ç
100	$,	4	<	D	L	T	é	d	l	t	÷
101	%	–	5	=	E	M	U]	e	m	u	Ñ
110	&	.	6	>	F	N	V	í	f	n	v	ñ
111	'	/	7	?	G	O	W	ó	g	o	w	■

Table 5.32. Basic Character Set.

Optional Captioning Features

Two sets of optional features are available for advanced captioning decoders.

Optional Attributes

Additional color choices are available for advanced captioning decoders, as shown in Table 5.33.

If a decoder doesn't support semitransparent colors, the opaque colors may be used instead. If a specific background color isn't supported by a decoder, it should default to the black background color. However, if the black foreground color is supported in a decoder, all the background colors should be implemented.

A background attribute appears as a standard space on the display, and the attribute remains in effect until the end of the row or until another background attribute is received.

The foreground attributes provide an eighth color (black) as a character color. As with MidRow codes, a foreground attribute code turns off italics and blinking, and the least significant bit controls underlining.

Background and foreground attribute codes have an automatic backspace for back-

Non-display Control Byte							Display Control Byte							Background Attribute
D6	D5	D4	D3	D2	D1	D0	D6	D5	D4	D3	D2	D1	D0	
										0	0	0		white
										0	0	1		green
										0	1	0		blue
										0	1	1		cyan
0	0	1	CH	0	0	0	0	1	0	1	0	0	T	red
										1	0	1		yellow
										1	1	0		magenta
										1	1	1		black
0	0	1	CH	1	1	1	0	1	0	1	1	0	1	transparent
D6	**D5**	**D4**	**D3**	**D2**	**D1**	**D0**	**D6**	**D5**	**D4**	**D3**	**D2**	**D1**	**D0**	**Foreground Attribute**
0	0	1	CH	1	1	1	0	1	0	1	1	1	0	black
													1	black underline

T: "0" = opaque, "1" = semi-transparent CH: "0" = data channel 1, "1" = data channel 2
Underline resides on dot row 11 and covers the entire column width.

Table 5.33. Optional Attribute Codes.

ward compatibility with current decoders. Thus, an attribute must be preceded by a standard space character. Standard decoders display the space and ignore the attribute. Extended decoders display the space, and on receiving the attribute, backspace, then display a space that changes the color and opacity. Thus, text formatting remains the same regardless of the type of decoder.

Optional Closed Group Extensions

To support custom features and characters not defined by the standards, the EIA/CEG maintains a set of code assignments requested by various caption providers and decoder manufacturers. These code assignments (currently used to select various character sets) are not compatible with caption decoders in the United States and videos using them should not be distributed in the U. S. market.

Closed group extensions require two bytes. Table 5.34 lists the currently assigned closed group extensions to support captioning in the Asian languages.

Optional Extended Characters

An additional 64 accented characters (eight character sets of eight characters each) may be supported by decoders, permitting the display of other languages such as Spanish, French, Portuguese, German, Danish, Italian, Finnish, and Swedish. If supported, these accented characters are available in all caption and text modes.

Non-display Control Byte							Display Control Byte							
D6	D5	D4	D3	D2	D1	D0	D6	D5	D4	D3	D2	D1	D0	**Background Attribute**
										0	1	0	0	standard character set (normal size)
										0	1	0	1	standard character set (double size)
										0	1	1	0	first private character set
0	0	1	CH	1	1	1	0	1	0	0	1	1	1	second private character set
										1	0	0	0	People's Republic of China character set (GB 2312)
										1	0	0	1	Korean Standard character set (KSC 5601-1987)
										1	0	1	0	first registered character set

CH: "0" = data channel 1, "1" = data channel 2

Table 5.34. Optional Closed Group Extensions.

Each of the extended characters incorporates an automatic backspace for backward compatibility with current decoders. Thus, an extended character must be preceded by the standard ASCII version of the character. Standard decoders display the ASCII character and ignore the accented character. Extended decoders display the ASCII character, and on receiving the accented character, backspace, then display the accented character. Thus, text formatting remains the same regardless of the type of decoder.

Extended characters require two bytes. The first byte is 12_H or 13_H for data channel one ($1A_H$ or $1B_H$ for data channel two), followed by a value of 20_H–$3F_H$.

Extended Data Services

Line 284 may contain extended data service information when bandwidth is available. These may be interleaved with the caption and text information, as bandwidth is available. In this case, control codes are not transmitted twice, as they may be for the caption and text services.

Information is transmitted as packets and operates as a separate unique data channel. Data for each packet may or may not be contiguous and may be separated into subpackets that can be inserted anywhere space is available in the line 284 information stream.

There are four types of extended data characters:

Control: Control characters are used as a mode switch to enable the extended data mode. They are the first character of two and have a value of 01_F to $0F_H$.

Type: Type characters follow the control character (thus, they are the second character of two) and identify the packet type. They have a value of 01_F to $0F_H$.

Checksum: This always follows the control character that specifies the end of a packet. Thus, they are the second character of two and have a value of 00_F to $7F_H$.

Informational: These characters may be ASCII data (20_H to $7F_H$) or non-ASCII data (40_H to $7F_H$). They are transmitted in pairs up to and including 32 characters. A NUL character (00_H) is used to ensure pairs of characters are always sent.

Control Characters

Table 5.35 lists the control codes. The *current class* describes a program currently being transmitted. The *future class* describes a program to be transmitted later. It contains the same information and formats as the current class. The *channel class* describes non-program-specific information about the channel. The *miscellaneous class* describes miscellaneous information. The *public class* transmits data or messages of a public service nature. The *undefined class* is used in a proprietary system for whatever that system wishes.

Type Characters (Current, Future Class)
Program Identification Number (01_H)
This packet uses four characters to specify the program start time and date relative to Coordinated Universal Time (UTC). The format is shown in Table 5.36.

Minutes have a range of 0–59. Hours have a range of 0–23. Dates have a range of 1–31. Months have a range of 1–12. "T" indicates if a program is routinely tape delayed for the Mountain and Pacific time zones. The "D," "L," and "Z" bits are ignored by the decoder.

Control Code	Function	Class
01_H 02_H	start continue	current
03_H 04_H	start continue	future
05_H 06_H	start continue	channel
07_H 08_H	start continue	miscellaneous
09_H $0A_H$	start continue	public service
$0B_H$ $0C_H$	start continue	reserved
$0D_H$ $0E_H$	start continue	undefined
$0F_H$	end	all

Table 5.35. Extended Data Services Control Codes.

D6	D5	D4	D3	D2	D1	D0	Character
1	m5	m4	m3	m2	m1	m0	minute
1	D	h4	h3	h2	h1	h0	hour
1	L	d4	d3	d2	d1	d0	date
1	Z	T	m3	m2	m1	m0	month

Table 5.36. Program Identification Number Format.

Program Length (02_H)
This packet has 2, 4, or 6 characters and indicates the scheduled length of the program and elapsed time for the program. The format is shown in Table 5.37.

Minutes and seconds have a range of 0–59. Hours have a range of 0–63.

Program Name (03_H)
This packet contains 2–32 ASCII characters that specify the title of the program.

Program Type (04_H)
This packet contains 2–32 ASCII characters that specify the type of program. Each ASCII character is assigned a keyword, as shown in Table 5.38.

Program Rating (05_H)
This packet contains the information shown in Table 5.39 to indicate the program rating.

D6	D5	D4	D3	D2	D1	D0	Character
1	m5	m4	m3	m2	m1	m0	length, minute
1	h5	h4	h3	h2	h1	h0	length, hour
1	m5	m4	m3	m2	m1	m0	elapsed time, minute
1	h5	h4	h3	h2	h1	h0	elapsed time, hour
1	s5	s4	s3	s2	s1	s0	elapsed time, second
0	0	0	0	0	0	0	null character

Table 5.37. Program Length Format.

Code (hex)	Keyword	Code (hex)	Keyword	Code (hex)	Keyword
20	education	30	business	40	fantasy
21	entertainment	31	classical	41	farm
22	movie	32	college	42	fashion
23	news	33	combat	43	fiction
24	religious	34	comedy	44	food
25	sports	35	commentary	45	football
26	other	36	concert	46	foreign
27	action	37	consumer	47	fund raiser
28	advertisement	38	contemporary	48	game/quiz
29	animated	39	crime	49	garden
2A	anthology	3A	dance	4A	golf
2B	automobile	3B	documentary	4B	government
2C	awards	3C	drama	4C	health
2D	baseball	3D	elementary	4D	high school
2E	basketball	3E	erotica	4E	history
2F	bulletin	3F	exercise	4F	hobby

Table 5.38a. Program Types.

Code (hex)	Keyword	Code (hex)	Keyword	Code (hex)	Keyword
50	hockey	60	music	70	romance
51	home	61	mystery	71	science
52	horror	62	national	72	series
53	information	63	nature	73	service
54	instruction	64	police	74	shopping
55	international	65	politics	75	soap opera
56	interview	66	premiere	76	special
57	language	67	prerecorded	77	suspense
58	legal	68	product	78	talk
59	live	69	professional	79	technical
5A	local	6A	public	7A	tennis
5B	math	6B	racing	7B	travel
5C	medical	6C	reading	7C	variety
5D	meeting	6D	repair	7D	video
5E	military	6E	repeat	7E	weather
5F	miniseries	6F	review	7F	western

Table 5.38b. Program Types.

D6	D5	D4	D3	D2	D1	D0	Character
1	–	–	–	r2	r1	r0	rating
0	0	0	0	0	0	0	null character

000	N/A
001	"G"
010	"PG"
011	"PG-13"
100	"R"
101	"NC-17"
110	"X"
111	not rated

Table 5.39. Program Rating Format.

Program Audio Services (06_H)
This packet contains two characters as shown in Table 5.40 to indicate the program audio services available.

Program Caption Services (07_H)
This packet contains 2–8 characters as shown in Table 5.41 to indicate the program caption services available. L2–L0 are coded as shown in Table 5.40.

D6	D5	D4	D3	D2	D1	D0	Character
1	L2	L1	L0	T2	T1	T0	main audio program
1	L2	L1	L0	S2	S1	S0	second audio program (SAP)

| L2–L0: | | |
|---|---|
| 000 | unknown |
| 001 | english |
| 010 | spanish |
| 011 | french |
| 100 | german |
| 101 | italian |
| 110 | other |
| 111 | none |

T2–T0:		S2–S0:	
000	unknown	000	unknown
001	mono	001	mono
010	simulated stereo	010	video descriptions
011	true stereo	011	non-program audio
100	stereo surround	100	special effects
101	data service	101	data service
110	other	110	other
111	none	111	none

Table 5.40. Program Audio Services Format.

D6	D5	D4	D3	D2	D1	D0	Character
1	L2	L1	L0	F	C	T	service code

FCT: 000 line 21, data channel 1 captioning
001 line 21, data channel 1 text
010 line 21, data channel 2 captioning
011 line 21, data channel 2 text
100 line 284, data channel 1 captioning
101 line 284, data channel 1 text
110 line 284, data channel 2 captioning
111 line 284, data channel 2 text

Table 5.41. Program Caption Services Format.

Program Aspect Ratio (09_H)
This packet contains two or four characters as shown in Table 5.42 to indicate the aspect ratio of the program.

S0–S5 specify the first line containing active picture information. The value of S0–S5 is calculated by subtracting 22 from the first line containing active picture information. The valid range for the first line containing active picture information is 22–85.

E0–E5 specify the last line containing active picture information. The last line containing active video is calculated by subtracting the value of E0–E5 from 262. The valid range for the last line containing active picture information is 199–262.

When this packet contains all zeros for both characters, or the packet is not detected, an aspect ratio of 4:3 is assumed.

The Q0 bit specifies whether the video is squeezed ("1") or normal ("0"). Squeezed video is the result of compressing a 16:9 aspect ratio picture into a 4:3 aspect ratio picture without cropping side panels.

The aspect ratio is calculated as follows:

$$320 / (E - S) : 1$$

Program Description (10_H–17_H)
This packet contains 1–8 packet rows, with each packet row containing 0–32 ASCII characters. A packet row corresponds to a line of text on the display.

Each packet is used in numerical sequence, and if a packet contains no ASCII characters, a blank line will be displayed.

D6	D5	D4	D3	D2	D1	D0	Character
1	S5	S4	S3	S2	S1	S0	start
1	E5	E4	E3	E2	E1	E0	end
1	–	–	–	–	–	Q0	other
0	0	0	0	0	0	0	null

Table 5.42. Program Aspect Ratio Format.

Type Characters (Channel Class)

Network Name (01_H)
This packet uses 2–32 ASCII characters to specify the network name.

Network Call Letters (02_H)
This packet uses four or six ASCII characters to specify the call letters of the channel. When six characters are used, they reflect the over-the-air channel number (2–69) assigned by the FCC. Single-digit channel numbers are preceded by a zero or a null character.

Channel Tape Delay (03_H)
This packet uses two characters to specify the number of hours and minutes the local station typically delays network programs. The format of this packet is shown in Table 5.43.

Minutes have a range of 0–59. Hours have a range of 0–23. This delay applies to all programs on the channel that have the "T" bit set in their Program ID packet.

Type Characters (Miscellaneous Class)

Time of Day (01_H)
This packet uses six characters to specify the current time of day, month, and date relative to Coordinated Universal Time (UTC). The format is shown in Table 5.44.

Minutes have a range of 0–59. Hours have a range of 0–23. Dates have a range of 1–31.

Months have a range of 1–12. Days have a range of 1 (Sunday) to 7 (Saturday). Years have a range of 0–63 (added to 1990).

"T" indicates if a program is routinely tape delayed for the Mountain and Pacific time zones. "D" indicates whether daylight savings time currently is being observed. "L" indicates whether the local day is February 28th or 29th when it is March 1st UTC. "Z" indicates whether the seconds should be set to zero (to allow calibration without having to transmit the full 6 bits of seconds data).

Impulse Capture ID (02_H)
This packet carries the program start time and length, and can be used to tell a VCR to record this program. The format is shown in Table 5.45.

Start and length minutes have a range of 0–59. Start hours have a range of 0–23; length hours have a range of 0–63. Dates have a range of 1–31. Months have a range of 1–12. "T" indicates if a program is routinely tape delayed for the Mountain and Pacific time zones. The "D," "L," and "Z" bits are ignored by the decoder.

Supplemental Data Location (03_H)
This packet uses 2–32 characters to specify other lines where additional VBI data may be found. Table 5.46 shows the format.

"F" indicates field one ("0") or field two ("1"). N may have a value of 7–31, and indicates a specific line number.

D6	D5	D4	D3	D2	D1	D0	Character
1	m5	m4	m3	m2	m1	m0	minute
1	–	h4	h3	h2	h1	h0	hour

Table 5.43. Channel Tape Delay Format.

D6	D5	D4	D3	D2	D1	D0	Character
1	m5	m4	m3	m2	m1	m0	minute
1	D	h4	h3	h2	h1	h0	hour
1	L	d4	d3	d2	d1	d0	date
1	Z	T	m3	m2	m1	m0	month
1	–	–	–	D2	D1	D0	day
1	Y5	Y4	Y3	Y2	Y1	Y0	year

Table 5.44. Time of Day Format.

D6	D5	D4	D3	D2	D1	D0	Character
1	m5	m4	m3	m2	m1	m0	start, minute
1	D	h4	h3	h2	h1	h0	start, hour
1	L	d4	d3	d2	d1	d0	start, date
1	Z	T	m3	m2	m1	m0	start, month
1	m5	m4	m3	m2	m1	m0	length, minute
1	h5	h4	h3	h2	h1	h0	length, hour

Table 5.45. Impulse Capture ID Format.

D6	D5	D4	D3	D2	D1	D0	Character
1	F	N4	N3	N2	N1	N0	location

Table 5.46. Supplemental Data Format.

Local Time Zone (04$_H$)

This packet uses two characters to specify the viewer time zone and whether the locality observes daylight savings time. The format is shown in Table 5.47.

Hours have a range of 0–23. This is the nominal time zone offset, in hours, relative to UTC. "D" is a "1" when the area is using daylight savings time.

Out-of-Band Channel Number (40$_H$)

This packet uses two characters to specify a channel number to which all subsequent out-of-band packets refer. This is the CATV channel number to which any following out-of-band packets belong to. The format is shown in Table 5.48.

Closed Captioning (Europe)

Closed captioning also may be used with PAL videotapes and laserdisks in Europe. Closed captioning may be present during the blanked active line-time portion of lines 22 and 335.

The data format, amplitudes, and rise/fall times are the same as for closed captioning in

D6	D5	D4	D3	D2	D1	D0	Character
1	D	h4	h3	h2	h1	h0	hour
0	0	0	0	0	0	0	null

Table 5.47. Local Time Zone Format.

D6	D5	D4	D3	D2	D1	D0	Character
1	c5	c4	c3	c2	c1	c0	channel low
1	c11	c10	c9	c8	c7	c6	channel high

Table 5.48. Out-of-Band Channel Number Format.

the United States. The timing, as shown in Figure 5.63, is slightly different due to the PAL horizontal timing. Older closed captioning decoders designed for use only with NTSC systems may not work due to these timing differences.

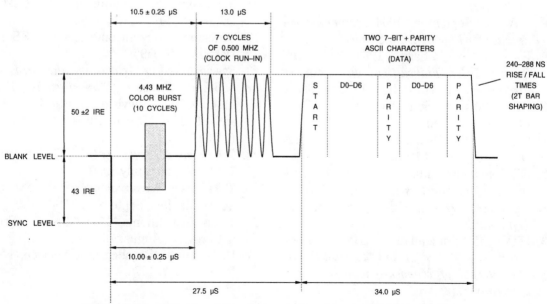

Figure 5.63. PAL Line 22 and Line 335 Closed Captioning Timing.

VLSI Solutions

See C5_VLSI

References

1. Arvo, James, *Graphics Gems II*, Academic Press, Inc., 1991.
2. Benson, K. Blair, 1986, *Television Engineering Handbook*, McGraw-Hill, Inc.
3. Brooktree Corporation, Bt851 Datasheet, L851001 Rev. B.
4. Brooktree Corporation, Bt857 Datasheet, L857001 Rev. B.
5. Brooktree Corporation, Graphics and Imaging Product Databook, Fourth Edition.
6. Cirrus Logic, CL-PX4080 Datasheet, April 1994.
7. Clarke, C.K.P., 1986, *Colour Encoding and Decoding Techniques for Line-Locked Sampled PAL and NTSC Television Signals*, BBC Research Department Report BBC RD1986/2.
8. EIA–608, September 1994, *Recommended Practice for Line 21 Data Service.*
9. Faroudja, Yves Charles, 1988, *NTSC and Beyond. IEEE Transactions on Consumer Electronics*, Vol. 34, No. 1, February 1988.
10. GEC Plessey Semiconductors, VP536 Datasheet, September 1993.
11. GEC Plessey Semiconductors, VP536A Datasheet, August 1993.
12. ITU-R Recommendation BT.569, 1986, *Definition of Parameters for Simplified Automatic Measurement of Television Insertion Test Signals.*
13. ITU-R Recommendation BT.473, 1990, *Insertion of Test Signals in the Field-Blanking Interval of Monochrome and Colour Television Signals.*
14. ITU-R Report BT.470, 1994, *Television Systems.*
15. ITU-R Report BT.628, 1990, *Automatic Monitoring and Control of Television Operation.*
16. ITU-R Report BT.1221, 1990, *Specifications and Alignment Procedures to Picture Signal Sources and Displays.*
17. National Captioning Institute, *TeleCaption II Decoder Modulate Performance Specification*, November 1985.
18. Philips Semiconductors, *Desktop Video Data Handbook*, 1995.
19. Public Broadcasting Service, Report No. E-7709-C, *Television Captioning for the Deaf: Signal and Display Specifications*, May 1980.
20. Raytheon Semiconductor, 1994 Databook.
21. Raytheon Semiconductor, TMC22090 Datasheet, Rev. E, July 1994.
22. Samsung Semiconductor KS0119 Datasheet 070595.
23. *Specification of Television Standards for 625-Line System-I Transmissions*, 1971, Independent Television Authority (ITA) and British Broadcasting Corporation (BBC).
24. *Television Measurements, NTSC Systems*, Tektronix, Inc., July 1990.
25. *Television Measurements, PAL Systems*, Tektronix, Inc., September 1990.
26. Texas Instruments, TMS320AV420 Product Preview, August 1994.
27. U. S. Public Broadcasting Service, NTC Report No. 7, 1976.

NTSC/PAL
Digital Decoding

Although the luminance and chrominance components in a NTSC/PAL encoder usually are combined by simply adding the two signals together, separating them in a decoder is much more difficult. Analog NTSC and PAL decoders have been around for some time. However, they have been difficult to use, required adjustment, and offered limited video quality. Using digital techniques to implement NTSC and PAL decoding offers many advantages, such as ease of use, minimum analog adjustments, and excellent video quality. The use of digital circuitry also enables the design of much more robust and sophisticated Y/C separator and genlock implementations. In addition to baseband composite NTSC and PAL, support for S-video (Y/C) is easily incorporated. S-video uses separate luminance and chrominance analog video signals so higher quality may be maintained by eliminating the composite encoding and decoding processes.

A NTSC/PAL decoder designed for the computer environment requires several unique features. It should implement a simple, drop-in solution, as easy to use as any other MPU peripheral. Saturation, contrast, bright-

ness, and hue adjustments should be supported. Otherwise, adjusting the video data will modify the graphics data. Linear RGB is a common output format, as many computer systems use the linear RGB color space for graphics, whereas the 4:2:2 YCbCr output format is useful if video processing (such as compression, deinterlacing, or scaling) is to be done.

Although it may not be a direct function of the decoder, a video multiplexer usually is required in the system so that one of several video sources may be decoded. The genlock must be robust enough to handle any video source reasonably, as users expect their expensive computers to handle video problems just as well as, if not better than, a low-cost television. In the absence of a video signal, the genlock should be designed to optionally free-run, continually generating the video timing to the system, without missing a beat. During the loss of an input signal, any automatic gain circuits should be disabled and the decoder should provide the option to either be transparent (so the input source can be monitored), to auto-freeze the output data (to compensate for short duration dropouts), or to autoblack the

output data (to avoid potential problems driving a mixer or video tape recorder).

A useful system debugging feature for the decoder is the ability to generate both 75% amplitude, 100% saturation and 100% amplitude, 100% saturation color bars. These should be able to be generated using either the input video timing or internally generated video timing.

As with the digital encoder, a digital decoder should support several pixel clock rates and pixel output configurations, as shown in Table 6.1. Supporting square pixels directly as an output format on a decoder greatly simplifies integrating video into the computer environment. The other formats commonly are used in video editing equipment.

Standard computer-oriented video timing signals should be generated by the decoder. These include horizontal sync, vertical sync, and blanking. Additional output control signals

to ease system design include field identification signals, useful for video editing. The ability to optionally output only odd or even fields simplifies interfacing to some video compression encoders; the ability to monitor timecode information is useful in editing situations.

The quality of Y/C separation plays a major role in the overall video quality generated by the decoder. Still video requires field-based Y/C separation to minimize artifacts, whereas active video probably will require some type of comb filtering. If the output of the decoder will be MPEG/JPEG compressed, or re-encoded into a NTSC/PAL video signal, many of the "visually pleasing" enhancements done within consumer decoders should not be used. These purposely induced high-frequency video components may introduce objectional artifacts when re-encoded into NTSC/PAL video signals and will also affect MPEG/JPEG compression ratios.

	Pixel Clock Rate	Applications	Active Resolution	Total Resolution
(M) NTSC	13.5 MHz	MPEG 1, 2	$720^1 \times 485$	858×525
	12.27 MHz	square pixels	640×480	780×525
	10.43 MHz	MPEG 2	544×480	663×525
(B, D, G, H, I) PAL	14.75 MHz	square pixels	768×576	944×625
	13.5 MHz	MPEG 1, 2	$720^1 \times 576$	864×625
	10.43 MHz	MPEG 2	544×576	668×625

Table 6.1. Common Output Pixel Rates and Resolutions. [1]**704 true active pixels.**

This chapter discusses a typical digital decoder that decodes baseband composite (M) NTSC and (B, D, G, H, I, N) PAL video signals, and also has separate Y/C inputs for supporting S-video (the block diagram is shown in Figure 6.1). Also reviewed are various Y/C separation techniques. It is recommended that the reader review Chapter 5 on digital encoding before attempting to understand digital decoding.

Digitizing the Analog Video

The first step in digital decoding of NTSC or PAL video signals is to digitize the entire composite video signal using an A/D converter. For our example, 8-bit A/D converters are used; therefore, indicated values are 8-bit values. Video inputs to equipment usually are AC-coupled and have a 75-Ω input impedance; therefore, the video signal must be DC restored every scan line during horizontal sync to position the sync tips at a known voltage level. The video signal also must be lowpass filtered (typically to 4–6 MHz) prior to digitization to remove any high-frequency components that may result in aliasing. Although the video bandwidth for broadcast is rigidly defined (4.2 MHz for NTSC and 5.0–5.5 MHz for PAL), there is no standard for consumer equipment. The video source generates as much bandwidth as it can; the receiving equipment accepts as much bandwidth as it can process.

Video signals with active video and/or sync amplitudes of 0.5 to 2 times nominal are common, especially in the consumer arena. The active video and/or sync signal may change amplitude, especially in editing situations where the video signal may be composed of several different video sources merged together.

Composite Video

When decoding composite video signals, the analog video signal is DC restored to ground during the horizontal sync time, setting the sync tip to a zero value. An automatic gain control is used to ensure that 56 (NTSC) or 59 (PAL) is generated during blanking, and a value of four is added as a constant to generate the same video levels (see Table 6.2) as used in the digital encoder (discussed in Chapter 5). Figures 6.2 and 6.3 show the composite video levels and the corresponding digital values for NTSC and PAL composite video signals, respectively, after DC restoration and offset addition.

If the digital blanking level is low or high, the video signal may be amplified or attenuated (preferably in the analog domain) until the digital blanking level is correct. One method of determining the blanking level is to digitally lowpass filter the video signal (to remove subcarrier information and noise) and sample the back porch multiple times to determine the average value. To limit line-to-line variations and clamp streaking (the result of quantizing errors), the back porch level may be averaged using values from four consecutive blanked scan lines (at the end of vertical blanking during each field) and the result used for the entire field. The difference between the calculated back porch level and 56 (NTSC) or 59 (PAL) is the error value. This error value can be processed and used in several ways to generate the correct blanking level:

(a) controlling a voltage-controlled video amplifier
(b) adjusting the REF+ voltage of the A/D converter
(c) multiplying the outputs of the A/D converter
(d) adding a constant DC offset to the video signal

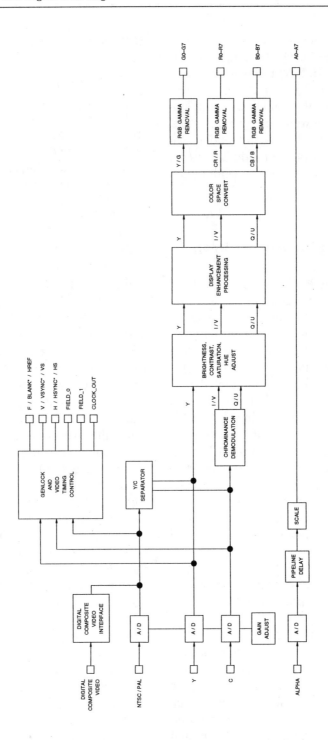

Figure 6.1. Typical NTSC/PAL Digital Decoder Implementation.

Video Level	(M) NTSC	(B, D, G, H, I,) PAL
peak chroma	243	245
white	200	200
peak burst	88	93
black	70	63
blank	60	63
peak burst	32	33
peak chroma	26	18
sync	4	4

Table 6.2. Digital Composite Video Levels after Digitization and Gain Correction.

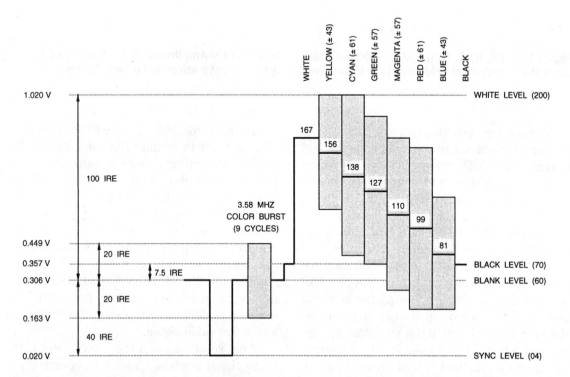

Figure 6.2. (M) NTSC Composite Video Signal for 75% Amplitude, 100% Saturated EIA Color Bars. Indicated video levels are 8-bit values after DC restoration and offset during sync tip.

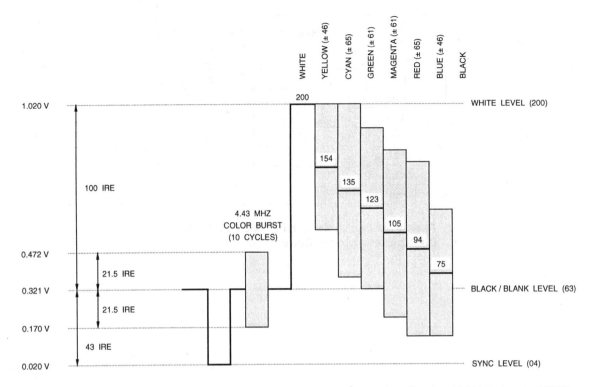

Figure 6.3. (B, D, G, H, I) PAL Composite Video Signal for 75% Amplitude, 100% Saturated EBU Color Bars. Indicated video levels are 8-bit values after DC restoration and offset during sync tip.

Approaches (a), (b), and (c) increase or decrease the entire video signal by the amount of sync height adjustment. In some instances this is unacceptable, as there may be no correlation between sync height and active video. This is the case if a video signal was edited, resulting in the active video and sync information being generated by different sources.

Another technique is to modify luminance levels between 80 and 120 IRE so they are positioned at 100 IRE, after adjusting the blanking level to 56 (NTSC) or 59 (PAL); adjusting the blanking level should have no effect on the burst or active video amplitude. The disadvantage with this method is that minor scene-to-scene variations will occur.

A third method of automatic amplitude adjustment is to monitor the color burst information. Many times, there is a strong correlation between the burst amplitude and the active video amplitude. After adjusting the blanking level to 56 (NTSC) or 59 (PAL)—adjusting the blanking level should have no effect on the burst or active video amplitude—the burst amplitude is determined. This is compared to the ideal burst amplitude and the difference used to calculate how much to increase or decrease the gain of the subcarrier and active video signal.

For some applications, such as if the video signal levels are known to be correct, if all the video levels except the sync height are

correct, or if there is excessive noise on the video signal, it is desirable to be able to disable the automatic gain control. In this instance, which is approach (d), the blanking level error signal is processed and used to adjust the blanking level by adding a constant DC offset to the video signal (preferably in the analog domain).

An analog signal for controlling the gain of a video amplifier or the voltage level on the REF+ pin of the video A/D converter may be generated by either a D/A converter or charge pump. If a D/A converter is used, it should have twice the resolution of the A/D converter to avoid quantizing noise. For this reason, a charge pump implementation may be more suitable.

Figure 6.4 and Table 6.3 show the chrominance IRE levels and phase angles for 75% amplitude, 100% saturation EIA color bars for NTSC. Figures 6.5 and 6.6 and Table 6.4 show the chrominance IRE levels and phase angles for 75% amplitude, 100% saturation EBU color bars for PAL.

S-Video (Y/C)

When decoding S-video (which consists of separate Y and C analog video signals), the analog Y video signal is processed by the same method as that used when digitizing composite analog video (see the previous section). The only difference is the analog Y video signal has no burst or modulated chrominance

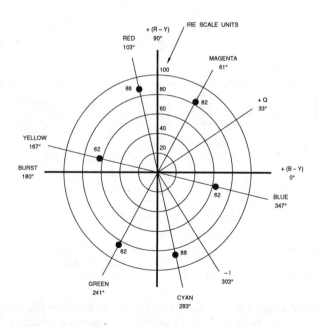

Figure 6.4. IQ Vector Diagram for 75% Amplitude, 100% Saturated EIA Color Bars.

	Nominal Range	White	Yellow	Cyan	Green	Magenta	Red	Blue	Black
R′	0 to 255	191	191	0	0	191	191	0	0
G′	0 to 255	191	191	191	191	0	0	0	0
B′	0 to 255	191	0	191	0	191	0	191	0
Y	0 to 130	97	86	68	57	40	29	11	0
I	0 to ±78	0	31	−58	−27	27	58	−31	0
Q	0 to ±68	0	−30	−21	−51	51	21	30	0
chroma IRE		0	62	88	82	82	88	62	0
chroma range (8-bit)		0	±43	±61	±57	±57	±61	±43	0
phase		−	167°	283°	241°	61°	103°	347°	−

Table 6.3. 75% Amplitude, 100% Saturated EIA Color Bars for (M) NTSC. Chrominance IRE levels are peak-to-peak. RGB values are gamma-corrected RGB values.

	Nominal Range	White	Yellow	Cyan	Green	Magenta	Red	Blue	Black
R′	0 to 255	255	191	0	0	191	191	0	0
G′	0 to 255	255	191	191	191	0	0	0	0
B′	0 to 255	255	0	191	0	191	0	191	0
Y	0 to 137	137	91	72	60	42	31	12	0
U	0 to ±60	0	−45	15	−30	30	−15	45	0
V	0 to ±85	0	10	−63	−53	53	63	−10	0
chroma IRE		0	67	95	89	89	95	67	0
chroma range (8-bit)		0	±46	±65	±61	±61	±65	±46	0
phase: line n (burst = 135°)		−	167°	283°	241°	61°	103°	347°	−
phase: line n + 1 (burst = 225°)		−	193°	77°	120°	300°	257°	13°	−

Table 6.4. 75% Amplitude, 100% Saturated EBU Color Bars for (B, D, G, H, I) PAL. Chroma IRE levels are peak-to-peak. RGB values are gamma-corrected RGB values. Line n corresponds to odd-numbered scan lines in fields 1, 2, 5, and 6, even-numbered scan lines in fields 3, 4, 7, and 8. Line n + 1 corresponds to even-numbered scan lines in fields 1, 2, 5, and 6, odd-numbered scan lines in fields 3, 4, 7, and 8.

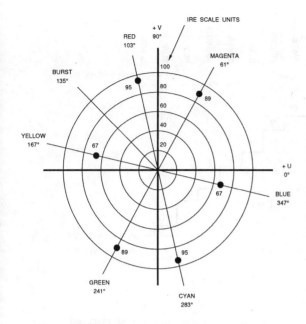

Figure 6.5. UV Vector Diagram for 75% Amplitude, 100% Saturated EBU Color Bars. Line n, PAL SWITCH = zero.

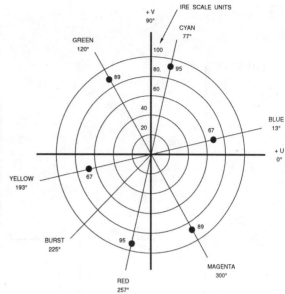

Figure 6.6. UV Vector Diagram for 75% Amplitude, 100% Saturated EBU Color Bars. Line n + 1, PAL SWITCH = one.

information. After the A/D conversion, a value of four is added to the digitized Y data, to match composite video levels. At this point, we have digital composite luminance data as shown in Table 6.5. Figures 6.7 and 6.8 show the luminance video levels and the corresponding digital values for NTSC and PAL, respectively, after DC restoration of the analog video signal.

The analog C video signal must be DC restored during the sync time to a voltage level that is the midpoint of the reference ladder on the A/D converter (this is because the modulated chrominance video signal is bipolar—see

Video Level	(M) NTSC	(B, D, G, H, I) PAL
white	200	200
black	70	63
blank	60	63
sync	4	4

Table 6.5. Digital Luminance Levels after Digitization and Gain Correction.

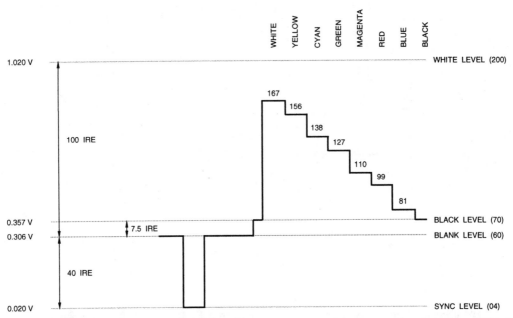

Figure 6.7. (M) NTSC Luminance (Y) Video signal for 75% Amplitude, 100% Saturated EIA Color Bars. Indicated video levels are 8-bit values after DC restoration and offset during sync tip.

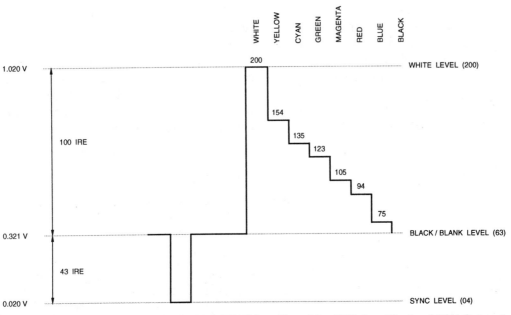

Figure 6.8. (B, D, G, H, I) PAL Luminance (Y) Video Signal for 75% Amplitude, 100% Saturated EBU Color Bars. Indicated video levels are 8-bit values after DC restoration and offset during sync tip.

Figures 6.9 and 6.10). Thus, the blanking level of the modulated chrominance video signal will generate a 128 value from the A/D converter. The same amount of automatic gain applied to the luminance video signal also should be applied to the chrominance video signal. At this point, we have digital chrominance data as shown in Table 6.6. Figures 6.9 and 6.10 show the chrominance video levels and the corresponding digital values for NTSC and PAL, respectively.

Y/C Separation

When decoding composite video, the luminance (Y) and chrominance (C) must be separated. The many techniques for doing this are discussed in detail later in the chapter. After Y/ C separation, Y has a range of 4–200; note that the luminance still contains sync and blanking information. Modulated chrominance has a range of 0 to ± 82 (NTSC) or 0 to ± 87 (PAL).

Chrominance Demodulator

The chrominance demodulator (Figure 6.11) accepts modulated digital chrominance information from either the Y/C separator (when digitizing composite NTSC or PAL) or the chrominance A/D converter (when digitizing Y/C) and generates baseband IQ (NTSC) or UV (PAL) color difference video data.

NTSC Operation

The (M) NTSC chrominance signal processed by the demodulator may be represented by:

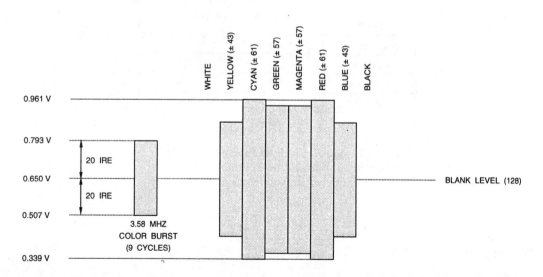

Figure 6.9. (M) NTSC Chrominance (C) Video Signal for 75% Amplitude, 100% Saturated EIA Color Bars. Indicated video levels are 8-bit values after DC restoration to the midpoint of the A/D ladder during the luminance sync tip.

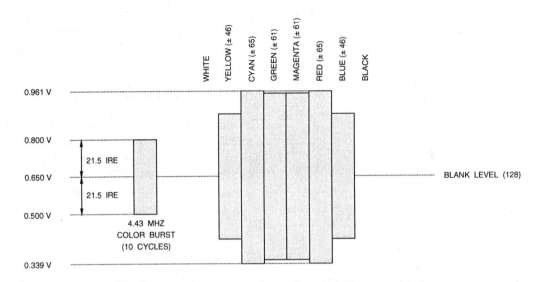

Figure 6.10. (B, D, G, H, I) PAL Chrominance (C) Video Signal for 75% Amplitude, 100% Saturated EBU Color Bars. Indicated video levels are 8-bit values after DC restoration to the midpoint of the A/D ladder during the luminance sync tip.

Video Level	(M) NTSC	(B, D, G, H, I) PAL
peak chroma	210	215
peak burst	156	158
blank	128	128
peak burst	100	98
peak chroma	46	41

Table 6.6. Digital Chrominance Levels after Digitization and Gain Correction.

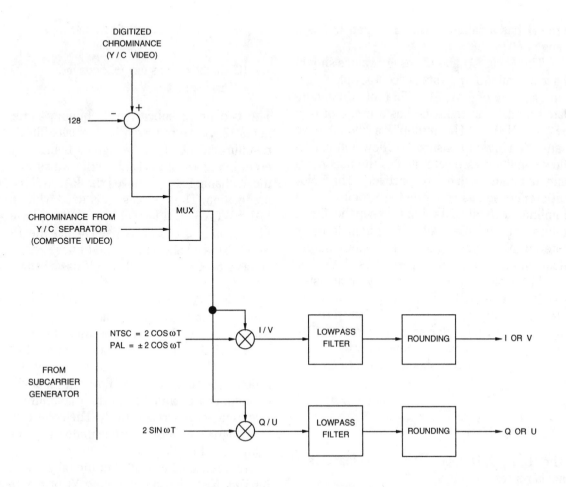

Figure 6.11. Chrominance Demodulation Example.

Q sin ωt + I cos ωt
ω = 2πF$_{SC}$
F$_{SC}$ = 3.579545 MHz

The subcarrier generator of the decoder provides a 33° phase offset during active video, cancelling the sin and cos 33° phase term normally in the equation. The color information is demodulated by multiplying the chrominance signal by appropriate phases of a locally generated subcarrier and lowpass filtering the results. Q is obtained by multiplying the chrominance data by 2 sin ωt, and I is obtained by multiplying by 2 cos ωt:

(Q sin ωt + I cos ωt) (2 sin ωt)
= Q – Q cos 2ωt + I sin 2ωt

(Q sin ωt + I cos ωt) (2 cos ωt)
= I + I cos 2ωt + Q sin 2ωt

The two times subcarrier frequency components (2ωt) are removed by lowpass filtering, resulting in the I and Q signals being recov-

ered. I has a range of 0 to ±78, and Q has a range of 0 to ±68.

The (2 sin ωt) and (2 cos ωt) values should have at a minimum 8 bits of accuracy plus sign, with a range of 0 to ±511/256 (note the modulated digital chrominance has a range of 0 to ±82 for NSTC). The multipliers should have saturation logic to ensure overflow and underflow conditions are saturated to the maximum and minimum values, respectively. The color difference signals generated are rounded to a minimum of 8 bits plus sign (to keep the digital filters a reasonable size) and digitally lowpass filtered. Note that if generating YCbCr output data, and the YUV color space is used, the values in the sin and cos ROMs may be adjusted to allow the demodulation multipliers to generate (Cr – 128) and (Cb – 128) data directly, avoiding separate color space conversion. The sin ROM should have a range of 0 to ±1018/256 and the cos ROM should have a range of 0 to ±721/256.

PAL Operation

The (B, D, G, H, I, CN) PAL chrominance signal is represented by:

$$U \sin \omega t \pm V \cos \omega t$$
$$\omega = 2\pi F_{SC}$$

$$F_{SC} = 4.43361875 \text{ MHz for (B, D, G, H, I)}$$
PAL

$$F_{SC} = 3.58205625 \text{ MHz for (CN) PAL}$$

with the sign of V alternating from one line to the next. The color information is demodulated by multiplying the chrominance signal by appropriate phases of the locally generated subcarrier and lowpass filtering the results. U is obtained by multiplying the chrominance data by 2 sin ωt and V is obtained by multiplying by ±2 cos ωt:

$$(U \sin \omega t \pm V \cos \omega t)(2 \sin \omega t)$$
$$= U - U \cos 2\omega t \pm V \sin 2\omega t$$

$$(U \sin \omega t \pm V \cos \omega t)(\pm 2 \cos \omega t)$$
$$= V \pm U \sin 2\omega t + V \cos 2\omega t$$

The two times subcarrier frequency components (2ωt) are removed by lowpass filtering, resulting in the U and V signals being recovered. Using a switched subcarrier waveform in the V channel also removes the PAL SWITCH modulation. Thus, +2 cos ωt is used while the PAL SWITCH is a logical zero (burst phase = +135°) and –2 cos ωt is used while the PAL SWITCH is a logical one (burst phase = 225°). U has a range of 0 to ±60, and V has a range of 0 to ±85.

The (2 sin ωt) and (2 cos ωt) values should have at a minimum 8 bits of accuracy plus sign, with a range of 0 to ±511/256 (note the modulated digital chrominance has a range of 0 to ±87 for PAL). The multipliers should have saturation logic to ensure overflow and underflow conditions are saturated to the maximum and minimum values, respectively. The color difference signals generated are rounded to a minimum of 8 bits plus sign (to keep the digital filters a reasonable size) and digitally lowpass filtered. Note that if generating YCbCr output data, the values in the sin and cos ROMs may be adjusted to allow the demodulation multipliers to generate (Cr – 128) and (Cb – 128) data directly, avoiding separate color space conversion. The sin ROM should have a range of 0 to ±961/256 and the cos ROM should have a range of 0 to ±681/256.

If the locally generated subcarrier phase is incorrect, a line-to-line pattern known as Hanover bars results in which pairs of adjacent lines have a real and complementary hue error. As shown in Figure 6.12 with an ideal color of green, two adjacent lines of the display have a hue error (towards yellow), the next two have the complementary hue error (towards cyan), and so on.

TOWARDS YELLOW

LINE 25

LINE 338

LINE 26

LINE 339

TOWARDS CYAN

Figure 6.12. Example Display of Hanover Bars. Green is the ideal color.

This can be shown by introducing a phase error (θ) in the locally generated subcarrier:

(U sin ωt ± V cos ωt) (2 sin (ωt – θ))
= (after lowpass filtering) U cos θ –/+ V sin θ

(U sin ωt ± V cos ωt) (±2 cos (ωt – θ))
= (after lowpass filtering) V cos θ +/– U sin θ

In areas of constant color, averaging equal contributions from even and odd lines (either visually or because of a delay line, for example), cancels the alternating crosstalk component, leaving only a desaturation of the true component by cos θ.

Introducing a phase error (θ) in the locally generated subcarrier of NTSC decoders yields:

(Q sin ωt + I cos ωt) (2 sin (ωt – θ))
= (after lowpass filtering) Q cos θ – I sin θ

(Q sin ωt + I cos ωt) (2 cos (ωt – θ))
= (after lowpass filtering) I cos θ + Q sin θ

which are the same equations shown later for adjusting the hue using baseband I and Q signals, without adjusting the subcarrier.

Color Difference Lowpass Digital Filters

The decoder requires sharper roll-off filters than the digital encoder to ensure adequate suppression of the sampling alias components; note that with a 13.5-MHz sampling frequency, they start to become significant above 3 MHz. The demodulation process for NTSC is shown spectrally in Figures 6.13 and 6.14; the process is similar for PAL. In both figures, (a) represents the baseband spectrum of the video signal and (b) represents the spectrum of the subcarrier used for demodulation. Convolution of (a) and (b), equivalent to multiplication in the time domain, produces the spectrum shown in (c), in which the baseband spectrum has been shifted to be centered about F_{SC} and $-F_{SC}$. The chrominance is now a baseband signal, which may be separated from the low-frequency luminance, centered at F_{SC}, and the chrominance, centered at $2F_{SC}$, by a lowpass filter.

NTSC may be demodulated along either the I and Q or U and V axes. If demodulating along the I and Q axes, Q may be either a 0.6-MHz double sideband signal or a 1.3-MHz asymmetrical sideband signal, whereas I probably will be a 1.3-MHz asymmetrical sideband

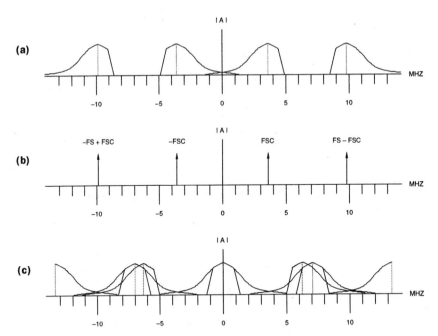

Figure 6.13. Frequency Spectra in Digital NTSC Chrominance Demodulation (F_S = 13.5 MHz, F_{SC} = 3.58 MHz) (a) Gaussian Filtered I and Q Signals, (b) Subcarrier Sinewave, (c) Modulated Chrominance Spectrum Produced by Convolving (a) and (b).

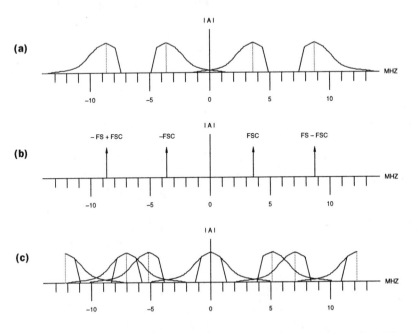

Figure 6.14. Frequency Spectra in Digital NTSC Chrominance Demodulation (F_S = 12.27 MHz, F_{SC} = 3.58 MHz): (a) Gaussian Filtered I and Q Signals, (b) Subcarrier Sinewave, (c) Modulated Chrominance Spectrum Produced by Convolving (a) and (b).

signal. If demodulating along the U and V axes, both U and V are either a 0.6-MHz double sideband signal or a 1.3-MHz asymmetrical sideband signal, depending on the encoding process. For PAL, U and V probably will be 1.3-MHz asymmetrical sideband signals. The asymmetrical sideband signals are a result of lowpass filtering the composite video signals to 4.2 MHz (NTSC) or 5.5 MHz (PAL) during the encoding process, removing most of the upper sidebands.

The lowpass filters after the demodulator are a compromise between several factors. Simply using a 1.3-MHz filter, such as the one

shown in Figure 6.15, to extract all of the available chrominance information increases the amount of cross-color since a greater number of luminance frequencies are included. When using lowpass filters with a passband greater than 0.6 MHz for NTSC (4.2 MHz – 3.58 MHz) or 1.07 MHz for PAL (5.5 MHz – 4.43 MHz), the loss of the upper sidebands of chrominance also introduces ringing and color difference crosstalk. Filters with a sharp cutoff accentuate chrominance edge ringing; for these reasons slow roll-off 0.6-MHz filters, such as the one shown in Figure 6.16, usually are used, resulting in poorer color resolution

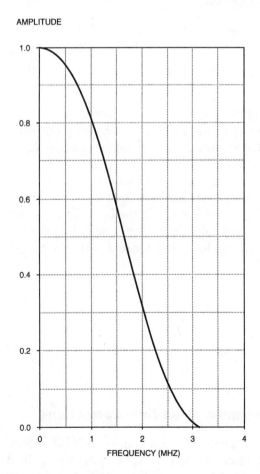

Figure 6.15. Typical 1.3-MHz Lowpass Digital Filter Characteristics.

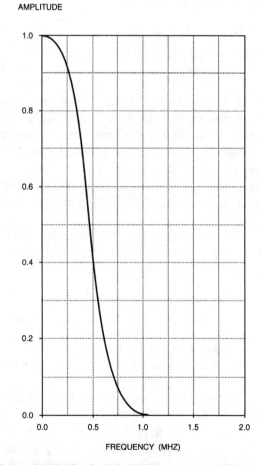

Figure 6.16. Typical 0.6-MHz Lowpass Digital Filter Characteristics.

but minimizing cross-color, ringing, and color difference crosstalk on edges. If a 1.3-MHz lowpass filter is used, the filter may include some gain for frequencies between 0.5 MHz and 1.3 MHz to compensate for the loss of part of the upper sideband.

If the decoder is to be used in a video editing environment, the digital filters should have a maximum ripple of ±0.1 dB in the passband. This is needed to minimize the cumulation of gain and loss artifacts due to the filters, especially when multiple passes through the encoding and decoding processes are required.

Hue Adjustment

Programmable hue adjustment is used to compensate for transmission problems. For NTSC decoders, a programmable hue value (which is really a subcarrier phase offset) may be added to the 11-bit reference subcarrier phase during the active video time (see Figure 6.23). The result is to shift the phase (by a constant amount) of the sin and cos subcarrier information going to the chrominance demodulator. An 11-bit hue adjustment value allows adjustments in hue from 0° to 360°, in increments of 0.176°.

This may be shown by introducing a phase offset (θ) in the locally generated subcarrier of NTSC decoders, yielding:

$$(Q \sin \omega t + I \cos \omega t) \ (2 \sin (\omega t - \theta))$$
$$= \text{(after lowpass filtering) } Q \cos \theta - I \sin \theta$$

$$(Q \sin \omega t + I \cos \omega t) \ (2 \cos (\omega t - \theta))$$
$$= \text{(after lowpass filtering) } I \cos \theta + Q \sin \theta$$

This technique must be modified to work with PAL decoders to avoid the desaturation of colors as a function of the amount of hue shift. This is shown by introducing a simple phase offset (θ) in the locally generated subcarrier:

$$(U \sin \omega t \pm V \cos \omega t) \ (2 \sin (\omega t - \theta))$$
$$= \text{(after lowpass filtering) } U \cos \theta -/+ V \sin \theta$$

$$(U \sin \omega t \pm V \cos \omega t) \ (\pm 2 \cos (\omega t - \theta))$$
$$= \text{(after lowpass filtering) } V \cos \theta +/- U \sin \theta$$

In areas of constant color, averaging equal contributions from even and odd lines (either visually or because of a delay line, for example), cancels the alternating crosstalk component, leaving only a desaturation of the true component by cos θ. To avoid this, the sign of the phase offset (θ) is set to be the opposite of the V component:

$$(U \sin \omega t \pm V \cos \omega t) \ (2 \sin (\omega t -/+ \theta))$$
$$= \text{(after lowpass filtering) } U \cos \theta + V \sin \theta$$

$$(U \sin \omega t \pm V \cos \omega t) \ (\pm 2 \cos (\omega t -/+ \theta))$$
$$= \text{(after lowpass filtering) } V \cos \theta - U \sin \theta$$

A negative sign of the phase offset (θ) is equivalent to adding 180° to the desired phase shift. PAL decoders do not usually have a hue adjustment feature.

An alternate implementation, that works with both NTSC and PAL decoders, and shown in Figure 6.17, is to mix the I and Q or U and V baseband color difference signals after demodulation and lowpass filtering (θ is the hue angle in degrees):

$$U' = U \cos \theta + V \sin \theta$$
$$V' = V \cos \theta - U \sin \theta$$

$$I' = I \cos \theta + Q \sin \theta$$
$$Q' = Q \cos \theta - I \sin \theta$$

Automatic Flesh Tone Correction

Flesh tone correction is used in NTSC decoders since the eye is very sensitive to flesh tones, and the actual colors may become

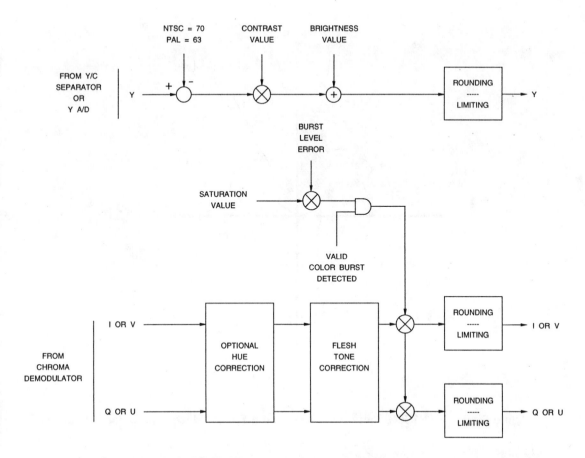

Figure 6.17. Typical Contrast, Brightness, and Saturation Adjustment Circuitry.

slightly corrupted during the broadcast processes. If the grass is not quite the proper color of green, it is not noticeable; however, a flesh tone that has a green or orange tint is unacceptable. Since the flesh tones are located close to the +I axis, a typical flesh tone corrector looks for colors in a specific area (Figure 6.18), and any colors within that area are made a color that is closer to the flesh tone.

A simple flesh tone corrector may halve the Q value for all colors that have a corresponding +I value. However, this implementa-

tion also changes nonflesh tone colors. A more sophisticated typical implementation (easily implemented digitally) is if the color has a value between 25% and 75% of full-scale, and is within ±30° of the +I axis, then Q is halved. This moves any colors within the flesh tone region closer to "ideal" flesh tone. It should be noted that the phase angle for flesh tone varies between equipment manufacturers; phase angles from 116° to 126° are used (the +I axis is at 123°); however, using 123° (the +I axis) simplifies the processing.

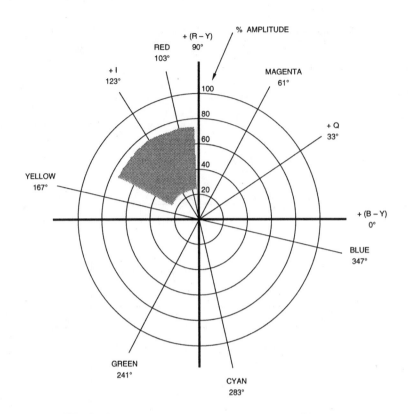

Figure 6.18. (M) NTSC Subcarrier Phases and a Typical Flesh Tone Color Range.

Contrast, Brightness, and Saturation Adjustment

Programmable brightness, contrast, and saturation controls are used to compensate for poor video sources and also are easily implemented, as shown in Figure 6.17.

Either 70 (NTSC) or 63 (PAL) is subtracted from the composite luminance to position the black level at 0. This is to remove the DC offset to avoid the contrast circuitry from varying the black level.

Contrast is adjusted by multiplying the digital luminance data (after sync and blank information have been removed) by a constant.

Brightness information is added or subtracted from the digital luminance data. The brightness adjustment is done after the contrast adjustment to avoid introducing a varying DC offset due when adjusting the contrast.

Finally, luminance values greater than 130 (NTSC) or 137 (PAL) should be made 130 (NTSC) or 137 (PAL); values less than 0 should be made 0. At this point, Y has a range of 0 to 130 (NTSC) or 0 to 137 (PAL).

Saturation is adjusted by multiplying the digital color difference signals, as shown in Figure 6.17.

The "burst level error" signal and the saturation value are multiplied together, and the result is used to adjust the gain or attenuation of the color difference signals. The intent here

is to minimize the amount of circuitry in the color difference signal path. The "burst level error" signal is used in the event the burst (and thus the modulated chrominance information) is not at the correct amplitude and adjusts the saturation of the color difference signals appropriately.

Alternately, the saturation adjustment may be done on the sin ωt and cos ωt subcarriers driving the demodulator. This implementation has the advantage of minimizing the circuitry in the data path, reducing noise introduced into the color difference signals.

Color Burst Detection

If a color burst of 50% or less of normal amplitude is detected for 128 consecutive scan lines, the color difference signals should be forced to zero. Once a color burst of 60% or more of normal amplitude is detected for 128 consecutive scan lines, the color difference signals may again be enabled. This hysteresis prevents wandering back and forth between enabling and disabling the color information in the event the burst amplitude is borderline. Providing the ability for the MPU to disable the color information (by forcing the color difference data to zero) also is useful for special effects.

The color burst level may be determined by forcing all burst samples positive and sampling the result multiple times to determine an average value. This should be averaged with the previous three scan lines having a color burst to limit line-to-line variations. If the average result is greater than 60% of the ideal burst amplitude, the burst is valid. The "burst level error" is the ideal amplitude divided by the average result. If no burst is detected, this should be used to force the color difference signals to zero and to disable any filtering in the luminance path, allowing maximum resolution luminance to be output.

Display Enhancement Processing

This section describes two processing steps that may be used to improve the viewing quality of decoded NTSC and PAL images. Since they artificially increase the high-frequency component of the YIQ and YUV signals, they should not be used if the output of the decoder will be compressed, since they will affect the compression ratio.

Color Transient Improvement

Figure 6.19 illustrates a color transient improvement technique. The assumption is that the luminance and color difference transitions normally are aligned. However, the color difference transitions are degraded due to the narrow bandwidth of the color information.

By monitoring coincident luminance transitions, a faster edge is synthesized for the color difference transitions. These edges are then aligned with the luminance edge.

Small level details also may be increased without modifying larger transitions. Combined, these techniques allow a displayed picture to appear as though it has a bandwidth of 7–8 MHz, rather than 4–5 MHz.

Sharpness Enhancement

The apparent sharpness of a picture may be increased by increasing the amplitude of high-frequency luminance information.

As shown in Figure 6.20, a simple band-pass filter with selectable gain (also called a peaking filter) may be used. The frequency where maximum gain occurs may be selectable to be at the subcarrier frequency or at about 2.6 MHz. A coring circuit usually is used after the filter to reduce low-level noise.

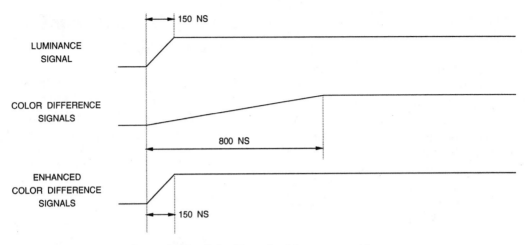

Figure 6.19. Color Transient Improvement.

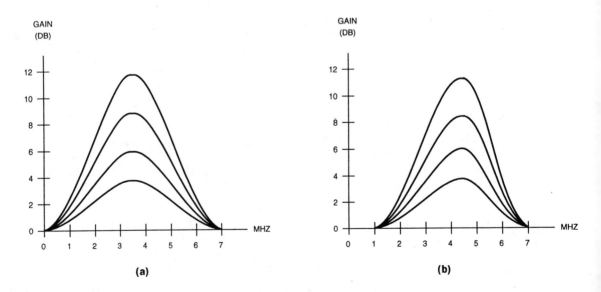

Figure 6.20. Simple Adjustable Sharpness Control: (a) NTSC, (b) PAL.

Figure 6.21 illustrates a more complex sharpness control circuit. The pre-filter increases high-frequency luminance to compensate for the chrominance trap filter. The chrominance trap filter eliminates most of the color carrier and should be bypassed if the video signal is from a S-video signal. The high-frequency luminance then is increased using the variable bandpass filter, with adjustable gain. The coring function (typically ±1 LSB) removes low-level noise. The modified luminance then is added to the original luminance signal.

Color Space Conversion

At a minimum, the digital RGB and YCbCr color spaces should be supported as output formats in a graphics/video system. These must be generated from the YIQ (for NTSC) or YUV (for PAL) color spaces.

Tables 6.7 and 6.8 list some of the common pixel bus formats and timing signals used.

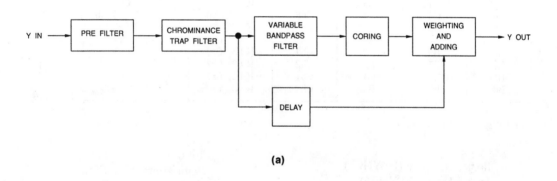

(a)

(b)

Figure 6.21. More Complex Sharpness Control: (a) Typical Implementation, (b) Coring Function.

24-bit RGB (8, 8, 8)	16-bit RGB (5, 6, 5)	15-bit RGB (5, 5, 5)	24-bit 4:4:4 YCbCr	16-bit 4:2:2 YCbCr	12-bit 4:1:1 YCbCr
R7	–	–	Cr7	–	–
R6	–	–	Cr6	–	–
R5	–	–	Cr5	–	–
R4	–	–	Cr4	–	–
R3	–	–	Cr3	–	–
R2	–	–	Cr2	–	–
R1	–	–	Cr1	–	–
R0	–	–	Cr0	–	–
G7	R7	–	Y7	Y7	Y7
G6	R6	R7	Y6	Y6	Y6
G5	R5	R6	Y5	Y5	Y5
G4	R4	R5	Y4	Y4	Y4
G3	R3	R4	Y3	Y3	Y3
G2	G7	R3	Y2	Y2	Y2
G1	G6	G7	Y1	Y1	Y1
G0	G5	G6	Y0	Y0	Y0
B7	G4	G5	Cb7	[Cb7], Cr7	[Cb7], Cb5, Cb3, Cb1
B6	G3	G4	Cb6	[Cb6], Cr6	[Cb6], Cb4, Cb2, Cb0
B5	G2	G3	Cb5	[Cb5], Cr5	[Cr7], Cr5, Cr3, Cr1
B4	B7	B7	Cb4	[Cb4], Cr4	[Cr6], Cr4, Cr2, Cr0
B3	B6	B6	Cb3	[Cb3], Cr3	–
B2	B5	B5	Cb2	[Cb2], Cr2	–
B1	B4	B4	Cb1	[Cb1], Cr1	–
B0	B3	B3	Cb0	[Cb0], Cr0	–

Timing control signals:

graphics:
 horizontal sync (HSYNC*)
 vertical sync (VSYNC*)
 composite blank (BLANK*)

ITU-R BT.601:
 horizontal blanking (H)
 vertical blanking (V)
 even/odd field (F)

Philips:
 horizontal sync (HS)
 vertical sync (VS)
 horizontal blank (HREF)

Table 6.7. Pixel Format Standards for Transferring RGB and YCbCr Video Data Over a 16-bit or 24-bit Bus. For 4:2:2 and 4:1:1 YCbCr data, the first active pixel data per scan line is indicated in brackets [].

Pixel Bus	24-bit RGB (8, 8, 8)	16-bit RGB (5, 6, 5)	15-bit RGB (5, 5, 5)	24-bit 4:4:4 YCbCr	16-bit 4:2:2 YCbCr	12-bit 4:1:1 YCbCr
P7D	–	R7	–	–	Y7	Y7
P6D	–	R6	R7	–	Y6	Y6
P5D	–	R5	R6	–	Y5	Y5
P4D	–	R4	R5	–	Y4	Y4
P3D	–	R3	R4	–	Y3	Y3
P2D	–	G7	R3	–	Y2	Y2
P1D	–	G6	G7	–	Y1	Y1
P0D	–	G5	G6	–	Y0	Y0
P7C	R7	G4	G5	Cr7	Cb7, Cr7	Cb5, Cb1
P6C	R6	G3	G4	Cr6	Cb6, Cr6	Cb4, Cb0
P5C	R5	G2	G3	Cr5	Cb5, Cr5	Cr5, Cr1
P4C	R4	B7	B7	Cr4	Cb4, Cr4	Cr4, Cr0
P3C	R3	B6	B6	Cr3	Cb3, Cr3	–
P2C	R2	B5	B5	Cr2	Cb2, Cr2	–
P1C	R1	B4	B4	Cr1	Cb1, Cr1	–
P0C	R0	B3	B3	Cr0	Cb0, Cr0	–
P7B	G7	R7	–	Y7	Y7	Y7
P6B	G6	R6	R7	Y6	Y6	Y6
P5B	G5	R5	R6	Y5	Y5	Y5
P4B	G4	R4	R5	Y4	Y4	Y4
P3B	G3	R3	R4	Y3	Y3	Y3
P2B	G2	G7	R3	Y2	Y2	Y2
P1B	G1	G6	G7	Y1	Y1	Y1
P0B	G0	G5	G6	Y0	Y0	Y0
P7A	B7	G4	G5	Cb7	[Cb7], Cr7	[Cb7], Cb3
P6A	B6	G3	G4	Cb6	[Cb6], Cr6	[Cb6], Cb2
P5A	B5	G2	G3	Cb5	[Cb5], Cr5	[Cr7], Cr3
P4A	B4	B7	B7	Cb4	[Cb4], Cr4	[Cr6], Cr2
P3A	B3	B6	B6	Cb3	[Cb3], Cr3	–
P2A	B2	B5	B5	Cb2	[Cb2], Cr2	–
P1A	B1	B4	B4	Cb1	[Cb1], Cr1	–
P0A	B0	B3	B3	Cb0	[Cb0], Cr0	–

Table 6.8. Pixel Format Standards for Transferring RGB and YCbCr Video Data Over a 32-bit Bus. For 4:2:2 and 4:1:1 YCbCr data, the first active pixel data per scan line is indicated in brackets []. For all formats except 24-bit RGB and 24-bit YCbCr data, PxA and PxB data contain pixel n data, PxC and PxD contain pixel n + 1 data. Refer to Table 6.7 for timing control signals.

NTSC Color Space Conversion

When generating gamma-corrected RGB or YCbCr data, it may be converted from YIQ data using the following equations (which are the inverse used for the digital encoder discussed in Chapter 5):

YIQ to RGB

$$R' = 1.969Y + 1.879I + 1.216Q$$
$$G' = 1.969Y - 0.534I - 1.273Q$$
$$B' = 1.969Y - 2.183I + 3.354Q$$

YIQ to YCbCr

$$Y = 1.692Y + 16$$
$$Cb = -1.081I + 1.668Q + 128$$
$$Cr = 1.179I + 0.765Q + 128$$

The R'G'B' output data has a range of 0 to 255. Values less than 0 should be made 0 and values greater than 255 should be made 255. The YCbCr output data has a nominal range of 16 to 235 for Y; the Cb and Cr output data has a nominal range of 16 to 240, with 128 equal to zero. For both sets of equations, a minimum of 4 bits of fractional data should be maintained with the final results rounded to the desired accuracy. YIQ input ranges for both sets of equations are 0 to 130 for Y, 0 to ±78 for I, and 0 to ±68 for Q.

For computer applications, the gamma-correction may be removed to generate linear RGB data (values are normalized to have a value of 0 to 1):

for R', G', B' < 0.0812

$$R = R' / 4.5$$
$$G = G' / 4.5$$
$$B = B' / 4.5$$

for R', G', B' ≥ 0.0812

$$R = ((R' + 0.099)/1.099)^{2.2}$$
$$G = ((G' + 0.099)/1.099)^{2.2}$$
$$B = ((B' + 0.099)/1.099)^{2.2}$$

Professional video systems may use the gamma-corrected RGB color space, with R'G'B' having a nominal range of 16 to 235. Occasional values less than 16 and greater than 235 are allowed. In this instance, YIQ may be converted to R'G'B' by scaling the previous YIQ-to-RGB equations by 219/255 and adding an offset of 16:

$$R' = 1.691Y + 1.614I + 1.044Q + 16$$
$$G' = 1.691Y - 0.459I - 1.093Q + 16$$
$$B' = 1.691Y - 1.875I + 2.880Q + 16$$

PAL Color Space Conversion

When generating (gamma corrected) RGB or YCbCr data, it may be converted from YUV data using the following equations (which are the inverse used for the digital encoder discussed in Chapter 5).

YUV to RGB

$$R' = 1.862Y - 0.005U + 2.121V$$
$$G' = 1.862Y - 0.731U - 1.083V$$
$$B' = 1.862Y + 3.788U - 0.002V$$

YUV to YCbCr

$$Y = 1.597Y + 16$$
$$Cb = 1.876U + 128$$
$$Cr = 1.331V + 128$$

The R'G'B' output data has a range of 0, to 255. Values less than 0 should be made 0 and values greater than 255 should be made 255.

$$F_{SC} = (p/q) \, F_S$$

Since the p value is of finite word length, the p:q ratio counter output frequency can only be varied in steps. With a p word length of w, the lowest p step is 0.5w and the lowest p:q ratio counter frequency step is:

$$F_{SC} = F_S/2^w$$

Note that the output frequency cannot be greater than half the input frequency. Thus, the output frequency F_{SC} can only be varied by the increment p and within the range:

$$0 < F_{SC} < F_S/2$$

In this application, an overflow corresponds to the completion of a full cycle of the subcarrier. Since only the remainder (which represents the subcarrier phase) is required, the number of whole cycles completed is of no interest. During each clock cycle, the output of the q register shows the relative phase of a subcarrier frequency in qths of a subcarrier period. By using the q register contents to address a ROM containing a sine wave characteristic, a numerical representation of the sampled subcarrier sine wave can be generated.

Figure 6.23 shows a circuit arrangement for generated quadrature subcarriers from an 11-bit subcarrier phase signal. This uses two ROMs with 9-bit addresses to store quadrants of sine and cosine waveforms. XOR gates invert the addresses for generating time-reversed portions of the waveforms and to invert the output polarity to make negative portions of the waveforms. An additional gate is provided in the sign bit for the V subcarrier to allow injection of a PAL SWITCH square wave to implement phase inversion of the V signal on alternate scan lines.

Unlike the subcarrier circuit used by the digital encoder discussed in Chapter 5, the decoder uses a single-stage ratio counter, as shown in Figure 6.23, due to the difficulty in dividing the F_{SC} phase error signal into multiple pieces to drive each segment of a partitioned ratio counter. Also, the decoder need not have the subcarrier accuracy of the encoder, since there will be variations in subcarrier frequency due to genlocking.

Each value of the 11-bit subcarrier phase signal corresponds to one of 2048 waveform values taken at a particular point in the subcarrier cycle period and stored in ROM. The sample points are taken at odd multiples of one 4096th of the total period to avoid end-effects when the sample values are read out in reverse order. Note only one quadrant of the subcarrier wave shape is stored in ROM, as shown in Figure 6.24. The values for the other quadrants are produced using the symmetrical properties of the sinusoidal waveform. The maximum phase error using this technique is ±0.09° (half of 360/2048), which corresponds to a maximum amplitude error of ±0.08%, relative to the peak-to-peak amplitude, at the steepest part of the sine wave signal.

An F_{SC} error signal is added to the p value to continually adjust the step size of the p:q ratio counter, adjusting the phase of the generated subcarrier to match that of the video signal being digitized. The subcarrier locking circuitry phase compares the generated subcarrier and the incoming subcarrier, resulting in an F_{SC} error signal indicating the amount of phase error (Figure 6.28).

As the p:q ratio counter is used to divide down a frequency (in this case the pixel clock) to generate the subcarrier, the P value is determined as follows:

$$F_{SC}/F_S = (P/4194303) = (P/(2^{22} - 1))$$

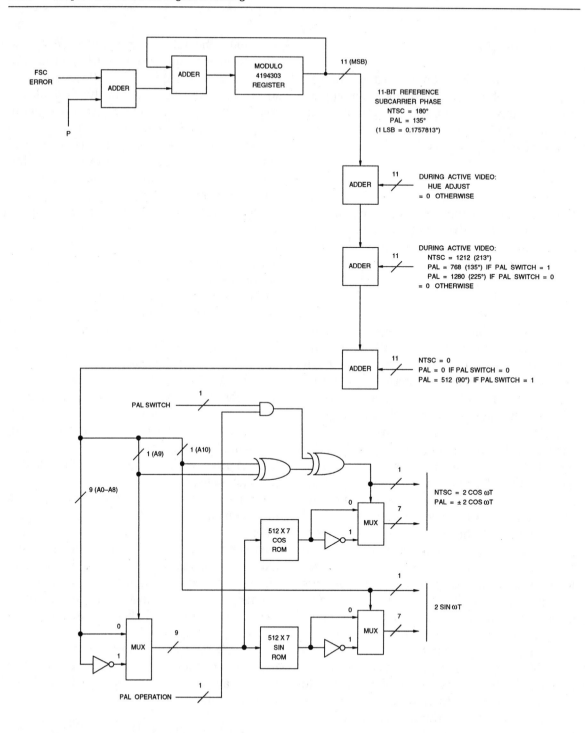

Figure 6.23. Chrominance Subcarrier Generator.

where F_{SC} = the desired subcarrier frequency and F_S = the pixel clock rate. Some values of P for popular pixel clock rates are shown in Table 6.9.

Genlocking

The purpose of the genlock circuitry is to recover the original pixel clock and timing control signals (such as horizontal sync, vertical sync, and the color subcarrier) from the video signal. Since the pixel clock is not directly available, it usually is generated by multiplying the horizontal line frequency, F_H, by the desired number of pixel clocks per scan line, using a phase-lock loop (PLL). Also,

the subcarrier must be regenerated and locked to the subcarrier of the video signal being digitized.

There are, however, several problems. Video signals may contain a lot of noise, making the determination of the sync edges unreliable. The amount of time between horizontal sync edges may vary slightly each scan line, particularly in video tape recorders (VCRs) due to mechanical limitations. For VCRs, instantaneous line-to-line variations are up to ±100 ns; line variations between the beginning and end of a field are up to ±1–5 μs. When VCRs are in a "special feature" mode, such as fast-forwarding or still-picture, the amount of time between horizontal sync signals may vary up to ±20% from nominal.

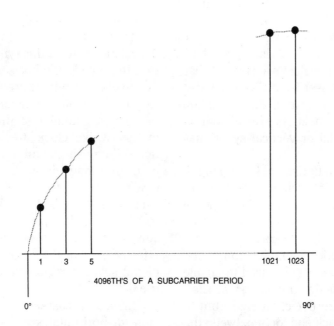

Figure 6.24. Positions of the 512 Stored Sample Values in the sin and cos ROMs for One Quadrant of a Subcarrier Cycle. Samples for other quadrants can be generated by inverting the addresses and/or sign values.

Pixel Clock	P
12.27 MHz (M) NTSC	1,223,338
13.5 MHz (M) NTSC	1,112,126
10.43 MHz (M) NTSC	1,439,209
13.5 MHz (B, D, G, H, I) PAL	1,377,477
14.75 MHz (B, D, G, H, I) PAL	1,260,742
10.43 MHz (B, D, G, H, I) PAL	1,781,647

Table 6.9. Values of P for Several Common Pixel Clock Rates.

Vertical sync, as well as horizontal sync, information must be recovered. Unfortunately, analog VCRs, in addition to destroying the SCH phase relationship, perform head switching at field boundaries, usually somewhere between the end of active video and the start of vertical sync. When head switching occurs, one video signal (for field n) is replaced by another video signal (for field n + 1) which has an unknown phase offset from the first video signal. There may be up to a ±1/2 line variation in vertical timing each field. As a result, longer-than-normal horizontal or vertical syncs may be generated.

By monitoring the horizontal line timing, it is possible to automatically determine whether the video source is in the "normal" or "special feature" mode. During "normal" operation, the horizontal line time typically varies by no more than ±5 μs over an entire field. Line timing outside this ±5 μs window may be used to enable "special feature" mode timing. Hysteresis should be used in the detection algorithm to prevent wandering back and forth between the "normal" and "special feature" operations in the event the video timing is borderline between the two modes. A typical digital cir-cuit for performing the horizontal and vertical sync detection is shown in Figure 6.25.

Horizontal Sync Detection

Early decoders typically used analog sync slicing techniques to determine the midpoint of the falling edge of the sync pulse and used a PLL to multiply the horizontal sync rate up to the pixel clock rate. However, the lack of accuracy of the analog sync slicer, combined with the limited stability of the PLL, resulted in excessive pixel clock jitter and noise amplification. When using comb filters for Y/C separation, the long delay between writing and reading the digitized video data means that even a small pixel clock frequency error results in a delay that is a significant percentage of the subcarrier period, negating the effectiveness of the comb filter. Therefore, a digital solution is preferred, as shown in Figure 6.25.

Initially, a coarse indication of the falling edge of horizontal sync is established by an analog sync slicer that is AC-coupled to the analog video source. This initializes the digital timing and performs initial timing for DC

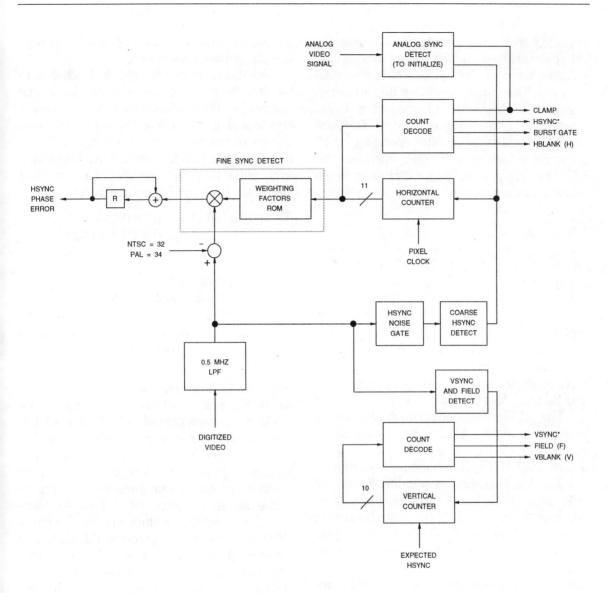

Figure 6.25. Sync Detection and Phase Comparator Circuitry.

restoring the video signals. The analog circuitry should be used for a minimum of 16 consecutive lines to "sail through" the vertical intervals. The analog sync slicer initially determines the leading edge of horizontal sync and resets the 11-bit horizontal counter (clocked by pixel clock) to 001_H. After operating for 16 consecutive lines, sync detection operation and DC restoration timing may switch over to all-digital operation.

Coarse Horizontal Sync Locking

The coarse sync locking enables a faster lock-up time to be achieved than if only the fine sync locking circuitry were used. Digitized video is digitally lowpass filtered to about 0.5 MHz (using a sharp cutoff filter) to remove high-frequency information, such as noise and subcarrier information. Performing the sync detection on lowpass filtered data also provides edge shaping for fast sync edges (rise and fall times less than one clock cycle).

The 11-bit horizontal counter is incremented each pixel clock cycle, resetting to 001_H after counting up to the HCOUNT value, where HCOUNT specifies the number of total clock cycles, or pixels, per scan line. A value of 001_H indicates that the beginning of a horizontal sync is expected. When the horizontal counter value is (HCOUNT – 64), a noise gate is enabled, allowing recovered sync information to be detected. Up to five consecutive missing sync pulses should be detected before any correction to the clock frequency or other adjustments are done. Once recovered sync information has been detected, the noise gate is disabled until the next time the horizontal counter value is (HCOUNT – 64). This helps filter out noise, serration, and equalization pulses. If the falling edge of recovered horizontal sync is not within ±64 clock cycles (approximately ±5 µs) of where it is expected to be, the

horizontal counter is reset to 001_H to realign the edges more closely.

Additional circuitry may be included to monitor the width of the recovered horizontal sync pulse. If the horizontal sync pulse is not approximately the correct pulse width (too narrow or too wide), ignore it and treat it as a missing sync pulse. The nominal horizontal sync pulse may be calculated for any pixel clock rate using the following equation:

$$\begin{aligned}
\text{HSYNC width} = &\ (\text{HCOUNT}/16) \\
&+ (\text{HCOUNT}/128) \\
&+ (\text{HCOUNT}/256) + 1
\end{aligned}$$

If the falling edge of recovered horizontal sync is within ±64 clock cycles (approximately ±5 µs) of where it is expected to be, the fine horizontal sync locking circuitry is used to fine-tune the pixel clock frequency.

Fine Horizontal Sync Locking

32 (NTSC) or 34 (PAL) is subtracted from the 0.5-MHz lowpass-filtered video data so the sync timing reference point (50% sync amplitude) is at zero. The recovered falling horizontal sync edge may be determined by summing a series of weighted samples from the region of the digital sync edge. To perform the filtering, the weighting factors are read from a ROM by a counter triggered by the horizontal counter. When the central weighting factor (A0) is coincident with the falling edge of sync, the result integrates to zero. Typical weighting factors are:

A0 = 102/4096
A1 = 90/4096
A2 = 63/4096
A3 = 34/4096
A4 = 14/4096
A5 = 5/4096
A6 = 2/4096

The 50% sync amplitude point should align with A0 weighting factor. This arrangement uses more of the timing information from the sync edge and suppresses noise. Note that circuitry should be included to avoid processing the rising edge of horizontal sync.

Figure 6.26 shows the operation of the fine sync phase comparator. Figure 6.26a shows the falling sync edge for NTSC. Figure 6.26b shows the weighting factors being generated, and when multiplied by the sync information (after it has 32 subtracted from it), produces the waveform shown in Figure 6.26c. When the A0 coefficient is coincident with the 50% amplitude point of sync, the waveform integrates to zero. Distortion of sync edges, resulting in the locking point being slightly shifted, is minimized by the lowpass filtering, effectively shaping the sync edges prior to processing.

Pixel Clock Generation

The horizontal sync phase error signal from the sync detection and phase comparison circuit (Figure 6.25) is used to adjust the frequency of a free-running VCO or VCXO, as shown in Figure 6.27. The free-running frequency of the VCO or VCXO should be the nominal pixel clock frequency required (for example, 13.5 MHz).

Using the VCO has the advantages of a wider range of pixel clock frequency adjustment, useful for handling video timing variations outside the normal video specifications. A disadvantage is that, due to jitter in the pixel clock, there may be visible hue artifacts and poor Y/C separation. The VCXO has the advantage of having minimal pixel clock jitter. However, the pixel clock frequency range may be adjusted only a small amount, limiting the ability of the decoder to handle nonstandard video timing. Ideally, with both designs, the pixel clock is aligned with the falling edge of

horizontal sync, with a fixed number of pixel clock cycles per scan line (HCOUNT).

An alternate method is to asynchronously sample the video signal with a fixed-frequency clock (for example, 13.5 MHz). Since in this case the pixel clock is not aligned with horizontal sync, there is a phase difference between the actual sample position and the ideal sample position. As with the standard genlock solution, this phase difference is determined by the phase difference between the recovered and expected horizontal syncs. The ideal sample position is defined to be aligned with a pixel clock generated by a standard genlock solution using a VCO or VCXO. Rather than controlling the pixel clock frequency, the horizontal sync phase error signal is used to control interpolation between two actual samples of YCbCr or RGB data to generate the ideal YCbCr or RGB sample value. If using comb filtering for Y/C separation, the digitized composite video may be interpolated to generate the ideal sample points, providing better Y/C separation by aligning the pixels more precisely.

Vertical Sync Detection

Sync detection is done digitally on the digitized composite video. Digitized video is digitally lowpass filtered to about 0.5 MHz (using a sharp cutoff filter) to remove high-frequency information, such as noise and subcarrier information. The vertical counter is incremented by each expected horizontal sync, resetting to 001_H after counting up to 525 (NTSC) or 625 (PAL). A value of 001_H indicates that the beginning of a vertical sync for an odd field is expected.

The end of vertical sync intervals is detected and used to set the value of the 10-bit vertical counter according to the mode of oper-

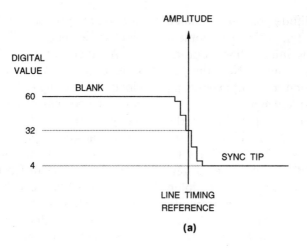

(a)

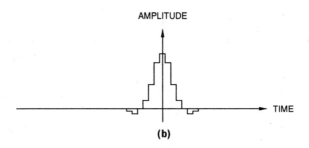

(b)

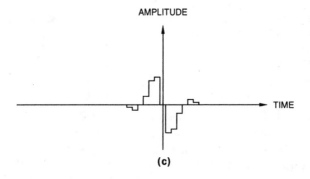

(c)

Figure 6.26. Fine Lock Phase Comparator Waveforms: (a) The NTSC sync leading edge, (b) The series of weighting factors, and (c) The weighted sync leading edges samples.

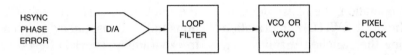

Figure 6.27. Pixel Clock Generation.

ation (NTSC or PAL). By monitoring the relationship of recovered vertical sync to the expected horizontal sync, even and odd field information is detected. If a recovered horizontal sync occurs more than 64, but less than (HCOUNT/2), clock cycles after expected horizontal sync, the vertical counter is not adjusted to avoid double incrementing the vertical counter. If a recovered horizontal sync occurs (HCOUNT/2) or more clock cycles after the vertical counter has been incremented, the vertical counter is again incremented.

During "special feature" operation, there is no longer any correlation between the vertical and horizontal timing information, so even or odd field detection cannot be done. Thus, every other detection of the end of vertical sync should set the vertical counter accordingly in order to synthesize even/odd field timing.

Subcarrier Locking

The purpose of the subcarrier locking circuitry (Figure 6.28) is to phase lock the generated subcarrier to the subcarrier of the video signal being digitized. Digital composite video has 60 (NTSC) or 63 (PAL) subtracted from it, whereas digital chrominance video has 128 subtracted from it, to position the burst at 0 to ±28 (NTSC) or 0 to ±30 (PAL). It also is gated with the burst gate to ensure that the video data has a value of zero outside the burst time. The burst gate control signal is generated by the video timing circuitry and is enabled at horizontal count:

$$(HCOUNT/16) + (HCOUNT/64)$$
$$+ (HCOUNT/256)$$
$$+ (HCOUNT/512) + 9$$

and is disabled 16 clock cycles later. This is to eliminate the edges of the burst, which may have transient distortions that will reduce the accuracy of the phase measurement. Also, some low-cost VCRs may generate a burst that starts during horizontal sync and ends just before active video. Note that the HCOUNT value specifies the total number of pixels per scan line.

The digital burst data is phase compared to the locally generated burst. Note that the sign information also must be compared so lock will not occur on 180° out-of-phase signals. The burst accumulator averages the 16 samples, and the accumulated values from two adjacent scan lines are averaged to produce the error signal. When the local subcarrier is correctly phased, the accumulated values from alternate lines cancel, and the phase error signal is zero. The error signal is sampled at the line rate and processed by the loop filter, which should be designed to achieve a lock-up time of about ten lines (50 or more lines may be required for noisy video signals). It is desirable to avoid updating the error signal during vertical intervals due to the lack of burst. The resulting F_{SC} error signal is used to adjust the p:q ratio counter that generates the local subcarrier (Figure 6.23).

During PAL operation, the phase detector also recovers the PAL SWITCH information used in generating the switched V subcarrier. The PAL SWITCH D flip-flop is synchronized to the incoming signal by comparing the local switch sense with the sign of the accumulated burst values. If the sense is consistently incorrect for 16 lines, then the flip-flop is reset.

Note the subcarrier locking circuit should be able to handle short-term frequency variations (over a few frames) of ±200 Hz, long-term frequency variations of ±500 Hz, and color burst amplitudes of 50–200% of normal with short-term amplitude variations (over a few frames) of up to 5%. The lock-up time of 10 lines is desirable to accommodate video signals that may have been incorrectly edited

(i.e., not careful about the SCH phase relationship) or nonstandard video signals due to freeze-framing, special effects, and so on. The 10 lines enable the subcarrier to be locked before the active video time, ensuring correct color representation at the beginning of the picture.

Field Identification

In some instances, particularly in editing situations, it may be desirable for the decoder to indicate which one of four (NTSC) or eight (PAL) fields is being decoded. The field may be indicated by two additional output signals from the decoder, which we call FIELD_0 and FIELD_1.

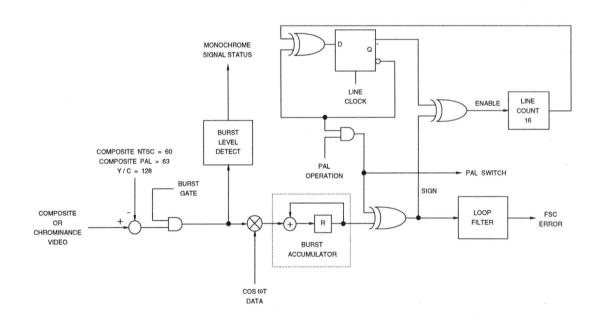

Figure 6.28. Subcarrier Phase Comparator Circuitry.

FIELD_0 Signal	HSYNC*/VSYNC* Timing Relationship or F Indicator	Decoded Field
0	odd field	1
0	even field	2
1	odd field	3
1	even field	4

Table 6.10. (M) NTSC Field Indication.

NTSC Field Identification

Although the timing relationship between the horizontal sync (HSYNC*) and vertical sync (VSYNC*) output signals, or the F output signal, may be used to specify whether an even or odd field is being decoded, another signal also must be used to specify which one of four fields is being decoded, as shown in Table 6.10. This additional signal (which we will refer to as FIELD_0), specifies whether fields 1 and 2 (FIELD_0 = logical zero) or fields 3 and 4 (FIELD_0 = logical one) are being decoded. FIELD_0 should change state at the beginning of vertical sync during fields 1 and 3.

The beginning of field 1 and field 3 may be determined by monitoring the relationship of the subcarrier phase relative to sync. As shown in Figure 6.29, at the beginning of field 1, the subcarrier phase is ideally 0° relative to sync; at the beginning of field 3, the subcarrier phase is ideally 180° relative to sync. In the real world, there is a tolerance in the SCH phase relationship. For example, although the ideal SCH phase relationship may be perfect at the source, transmitting the video signal over a coaxial cable may result in a shift of the SCH

phase relationship due to cable characteristics. Thus, the ideal phase plus or minus a tolerance should be used. Although ±40° (NTSC) or ±20° (PAL) is specified as an acceptable tolerance by the video standards, many designs use a tolerance of up to ±80°. In the event that a SCH phase relationship not within the proper tolerance is detected, the decoder should proceed as if nothing were wrong; if the condition persists for several frames, indicating that the video source no longer may be a "stable" video source, operation should change to that for an "unstable" video source.

For "unstable" video sources that do not maintain the proper SCH relationship (such as VCRs), a synthesized FIELD_0 output should be generated (for example, by dividing the F output signal by two) in the event the signal is required for memory addressing or downstream processing.

By monitoring the SCH phase relationship, the decoder can determine automatically whether the input video source is "stable" (such as from a camera or video generator) or "unstable" (such as from a VCR), and configure for optimum operation.

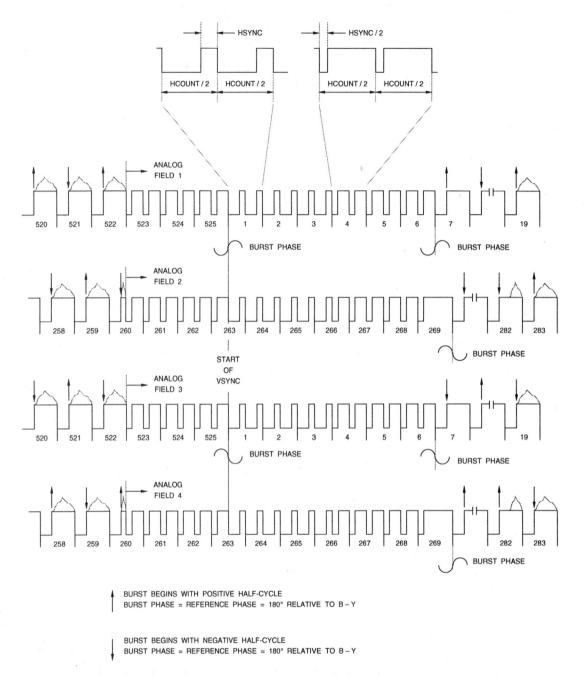

Figure 6.29. Four-field (M) NTSC Format. Note: to simplify the implementation, the line numbering does not match that used in standard practice for NTSC video signals.

FIELD_1 Signal	FIELD_0 Signal	HSYNC*/VSYNC* Timing Relationship or F Indicator	Decoded Field
0	0	odd field	1
0	0	even field	2
0	1	odd field	3
0	1	even field	4
1	0	odd field	5
1	0	even field	6
1	1	odd field	7
1	1	even field	8

Table 6.11. (B, D, G, H, I) PAL Field Indication.

PAL Field Identification

Although the timing relationship between the horizontal sync (HSYNC*) and vertical sync (VSYNC*) output signals, or the F output signal, may be used to specify whether an even or odd field is being decoded, two additional signals also must be used to specify which one of eight fields is being decoded, as shown in Table 6.11. We will refer to these additional control signals as FIELD_0 and FIELD_1. FIELD_0 should change state at the beginning of vertical sync during fields 1, 3, 5, and 7. FIELD_1 should change state at the beginning of vertical sync during fields 1 and 5.

The beginning of field 1 and field 5 may be determined by monitoring the relationship of the –U component of the extrapolated burst relative to sync. As shown in Figure 6.30, at the beginning of field 1, the phase is ideally 0° relative to sync; at the beginning of field 5, the phase is ideally 180° relative to sync. Either the burst blanking sequence or the subcarrier phase may be used to differentiate between fields 1 and 3, fields 2 and 4, fields 5 and 7, and

fields 6 and 8. All of the considerations discussed for NTSC in the previous section also apply for PAL.

Video Timing Generation

Horizontal Sync HSYNC*) Generation

Each time the 11-bit horizontal counter (incremented on each rising edge of the pixel clock) is reset to 001_H, the HSYNC* output should be asserted to a logical zero for 4.7 μs.

Horizontal Blanking (H) Generation

The H output should be asserted to a logical one (blanking) when the horizontal counter is reset to 001_H. A programmable value (HBLANK) specifies the horizontal count value at which active video begins. The H output is negated to a logical zero (indicating active video) when the horizontal counter reaches the HBLANK register value. A programmable value (HACTIVE) specifies the number of active pixels per scan line. H is

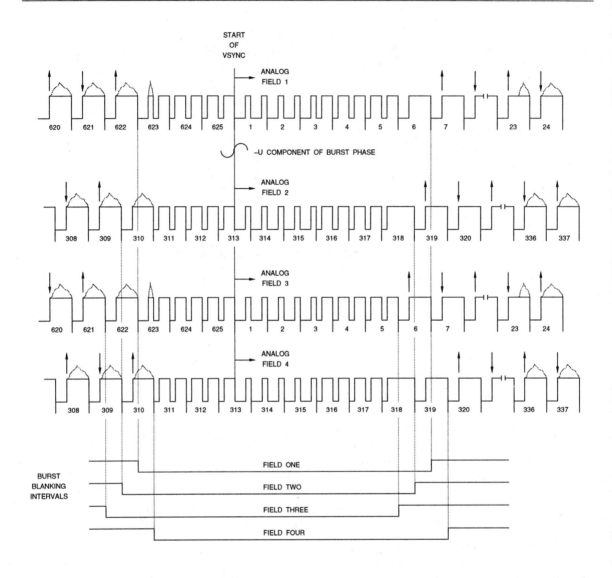

Figure 6.30a. Eight-field (B, D, G, H, I, Combination N) PAL Format. (See Figure 6.29 for equalization and serration pulse details.)

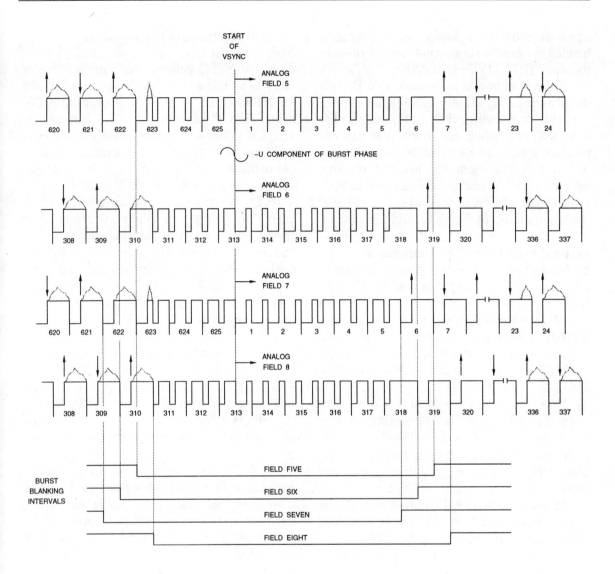

Figure 6.30b. Eight-field (B, D, G, H, I, Combination N) PAL Format. (See Figure 6.29 for equalization and serration pulse details.)

again asserted to a logical one (indicating blanking) when the horizontal counter reaches the value (HACTIVE + HBLANK).

If the H output is to be used in a Recommendation ITU-R BT.601 4:2:2 digital component video application, H should be asserted to a logical one when the horizontal counter reaches a value of 842 (525/60 operation) or 852 (625/50 operation), and negated to a logical zero when the horizontal counter reaches a value of 122 (525/60 operation) or 132 (625/50 operation). Refer to Figure 8.9 and Figure 8.13.

Vertical Sync (VSYNC*) Generation

Each time the 10-bit vertical counter is reset to 001_H, the VSYNC* output should be a logical zero for 3 scan lines, starting coincident with the falling edge of HSYNC* for odd fields. The VSYNC* output also should be a logical zero for 3 scan lines starting at horizontal count (HCOUNT/2) + 1 on scan line 263 (NTSC) or 313 (PAL) for even fields.

Note that in professional video applications, it may be desirable to generate 2.5 scan line VSYNC* pulses during 625/50 operation. However, this may cause even/odd field detection problems in some commercially available VLSI devices.

In instances where the output of a VCR is being decoded, and the VCR is in a special effects mode (such as still or fast-forward), there is no longer enough timing information to separate odd and even field timing from the vertical intervals. Thus, the odd/even field timing as specified by the VYSNC*/HSYNC* relationship (or the F output) is synthesized and may not reflect the true odd/even field timing of the video signal being decoded.

Vertical Blanking (V) Generation

Note that VCOUNT has a value of 525 when digitizing NTSC video signals and a value of 625 when digitizing PAL video signals; x = 263 for NTSC and 313 for PAL. A programmable value (VACTIVE) specifies the number of active scan lines per frame. Another programmable value (VBLANK − 1) specifies the number of blanked scan lines from the beginning of vertical sync to active video.

The V output should be asserted to a logical one (blanking) when the vertical counter is reset to 001_H. The V output is negated to a logical zero (indicating active video) when the vertical counter increments to the VBLANK register value. V should be asserted to a logical one when the vertical counter increments to the integer value of VBLANK + ((VACTIVE + 1)/2).

V is negated to a logical zero when the vertical counter increments to the value VBLANK + x. The V output again is asserted to a logical one when the vertical counter increments to the integer value of VBLANK + x + (VACTIVE/2). V should be pipelined to maintain synchronization with the pixel data.

If the V output is to be used in a Recommendation ITU-R BT.601 4:2:2 digital component video application, V should be asserted to a logical one when the vertical counter reaches values of 261 and 523 (525/60 operation) or 311 and 624 (625/50 operation) and should be negated to a logical zero when the vertical counter reaches values of 18 and 280 (525/60 operation) or 23 and 336 (625/50 operation). Note that F must be output coincident with the rising edge of H to meet 4:2:2 digital component video timing requirements.

Composite Blanking (BLANK*) Output

The composite blanking output, BLANK*, is the logical NOR of the H and V signals. Although BLANK* is a logical zero, RGB data may optionally be forced to be a logical zero; YCbCr data may be forced to a value of 16 (for Y) and 128 (for Cr and Cb). Alternately, the RGB or YCbCr data outputs may not be blanked, allowing vertical interval test signals, closed captioned signals, and vertical interval timecode information to be passed through the decoder.

FIELD (F) Output

The field output, F, specifies whether an even or odd field is being decoded. It is used primarily in Recommendation ITU-R BT.601 4:2:2 digital component video applications. F should be asserted to a logical one when the vertical counter reaches values of 263 (525/60 operation) or 313 (625/50 operation) and should be negated to a logical zero when the vertical counter is reset to 001_H. Note that F must be output coincident with the rising edge of H to meet Recommendation ITU-R BT.601 4:2:2 digital component video timing requirements. Refer to Figure 8.11 and Figure 8.15; 525/60 line numbering previously discussed corresponds to the line numbering scheme used in Figure 6.29.

NTSC Decoding Using YUV

For (M) NTSC, the YUV color space may be used rather than the YIQ color space. The equations are determined by taking the inverse matrix of the equations used for encoding (discussed in Chapter 5). Y has a range of 0 to 130, U has a range of 0 to ±57, and V has a range of 0 to ±80.

YUV to RGB

$$R' = 1.969Y - 0.009U + 2.244V$$
$$G' = 1.969Y - 0.775U - 1.143V$$
$$B' = 1.969Y + 4.006U - 0.009V$$

YUV to YCbCr

$$Y = 1.689Y + 16$$
$$Cb = 1.988U + 128$$
$$Cr = 1.408V + 128$$

The 33° subcarrier phase shift during active video is not required if the YUV color space is used. If the same decoder design is to implement both analog composite NTSC and digital composite NTSC video (discussed in Chapter 7), the YIQ color space should be used. The gamma-corrected RGB values have a range of 0 to 255; values less than 0 should be made 0 and values greater than 255 should be made 255.

Low-cost (M) NTSC decoders that use the YUV color space may use YUV-to-YCbCr or YUV-to-RGB color space conversion based on simple shifts and adds at the expense of color accuracy:

$$Y = Y + (1/2)Y + (1/8)Y + (1/16)Y + 16$$

$$Cb = U + (1/2)U + (1/4)U + (1/8)U$$
$$\quad + (1/16)U + (1/32)U + (1/64)U + 128$$
$$Cr = V + (1/4)V + (1/8)V + (1/32)V + 128$$

$$R' = 2Y - (1/128)U + 2V + (1/4)V$$

$$G' = 2Y - (1/2)U - (1/4)U - V - (1/8)V$$
$$\quad - (1/64)V$$

$$B' = 2Y + 4U - (1/128)V$$

The gamma-corrected RGB values have a range of 0 to 255; values less than 0 should be made 0 and values greater than 255 should be made 255. For computer applications, gamma-corrected RGB data may be converted to linear RGB data as follows (values are normalized to have a value of 0 to 1):

for R′, G′, B′ < 0.0812

$$R = R' / 4.5$$
$$G = G' / 4.5$$
$$B = B' / 4.5$$

for R′, G′, B′ ≥ 0.0812

$$R = ((R' + 0.099) / 1.099)^{2.2}$$
$$G = ((G' + 0.099) / 1.099)^{2.2}$$
$$B = ((B' + 0.099) / 1.099)^{2.2}$$

Professional video systems may use the gamma-corrected RGB color space, with R′G′B′ having a nominal range of 16 to 235. Occasional values less than 16 and greater than 235 are allowed. In this instance, YUV may be converted to R′G′B′ by scaling the previous YUV-to-RGB equations by 219/255 and adding an offset of 16:

$$R' = 1.691Y - 0.008U + 1.927V + 16$$
$$G' = 1.691Y - 0.666U - 0.982V + 16$$
$$B' = 1.691Y + 3.440U - 0.008V + 16$$

NTSC/PAL Decoding Using YCbCr

For (M) NTSC and (B, D, G, H, I) PAL, by adjusting the full-scale amplitudes of the sin and cos subcarriers, the demodulator may directly generate Cb and Cr, rather than U and V. Cb and Cr have a range of 16 to 240, with 128 equal to zero. The luminance information, after Y/C separation, has a range of either 0 to 130 (NTSC) or 0 to 137 (PAL); this must be scaled and offset to have a range of 16 to 235. The YCbCr data may be converted to gamma-corrected RGB data as follows:

$$R' = 1.164(Y - 16) + 1.596(Cr - 128)$$
$$G' = 1.164(Y - 16) - 0.813(Cr - 128)$$
$$- 0.391(Cb - 128)$$
$$B' = 1.164(Y - 16) + 2.018(Cb - 128)$$

For NTSC, the 33° subcarrier phase shift during active video is not required since demodulation occurs along the U and V axes. If the same decoder design is to implement both analog composite and digital composite video (discussed in Chapter 7), the YIQ (NTSC) and YUV (PAL) color spaces should be used. The gamma-corrected RGB values have a range of 0 to 255; values less than 0 should be made 0 and values greater than 255 should be made 255.

For computer applications, the gamma-correction may be removed to generate linear RGB data (values are normalized to have a value of 0 to 1):

for R′, G′, B′ < 0.0812

$$R = R' / 4.5$$
$$G = G' / 4.5$$
$$B = B' / 4.5$$

for R′, G′, B′ ≥ 0.0812

$$R = ((R' + 0.099) / 1.099)^{2.2}$$
$$G = ((G' + 0.099) / 1.099)^{2.2}$$
$$B = ((B' + 0.099) / 1.099)^{2.2}$$

Although the PAL standard specifies a gamma of 2.8, a value of 2.2 is now used. Therefore, the same gamma-correction equations are used for both NTSC and PAL.

Professional video systems may use the gamma-corrected RGB color space, with R′G′B′ having a nominal range of 16 to 235. Occasional values less than 16 and greater than 235 are allowed. In this instance, YCbCr may be converted to R′G′B′ as follows:

$$R' = Y + 1.371(Cr - 128) - 0.002(Cb - 128)$$
$$G' = Y - 0.698(Cr - 128) - 0.336(Cb - 128)$$
$$B' = Y + 1.732(Cb - 128)$$

(N) PAL Decoding Considerations

Although (B, D, G, H, I) PAL are the common PAL formats, there are two variations of PAL referred to as (N) PAL and combination (N) PAL. Combination (N) PAL is used in Argentina and has been covered in the previous subcarrier generation discussion, since the only difference between baseband combination (N) PAL and baseband (B, D, G, H, I) PAL baseband video signals is the change in subcarrier frequency.

Standard (N) PAL is also a 625/50 system and is used in Uruguay and Paraguay. Some of the timing is different from that of baseband (B, D, G, H, I) PAL baseband video signals, such as having serration and equalization

pulses for three scan lines rather than 2.5 scan lines, as shown in Chapter 4. The YUV-to-RGB and YUV-to-YCbCr equations are determined by taking the inverse matrix of the equations used for encoding:

YUV to RGB

$$R' = 1.969Y - 0.009U + 2.244V$$
$$G' = 1.969Y - 0.775U - 1.143V$$
$$B' = 1.969Y + 4.006U - 0.009V$$

YUV to YCbCr

$$Y = 1.689Y + 16$$
$$Cb = 1.988U + 128$$
$$Cr = 1.408V + 128$$

The sync tip is –40 IRE rather than –43 IRE. Therefore, the luminance and composite digital video levels are as shown in Tables 6.12 and 6.13, respectively. Again, for computer applications, the gamma-correction may be removed to generate linear RGB data.

Although the (N) PAL standard specifies a gamma of 2.8, a value of 2.2 is now used. Therefore, the same gamma-correction equations are used for both NTSC and (N) PAL.

Due to the timing differences from (B, D, G, H, I) PAL, standard (N) PAL and combination (N) PAL are not compatible with the digital composite video standards discussed in Chapter 7. As many of the timing parameters (such as horizontal sync width, start and end of burst, etc.) are different from standard (B, D, G, H, I) PAL, the equations used by the

Video Level	8-bit digital value	10-bit digital value
white	200	800
black	70	280
blank	60	240
sync	4	16

Table 6.12. (M, N) PAL Composite Luminance Digital Values.

Video Level	8-bit digital value	10-bit digital value
peak chroma	243	972
white	200	800
peak burst	90	360
black	70	280
blank	60	240
peak burst	30	120
peak chroma	26	104
sync	4	16

Table 6.13. Composite (M, N) PAL Digital Video Levels.

decoder to automatically calculate these parameters must be modified for standard (N) PAL operation.

(M) PAL Decoding Considerations

There is still another variation of PAL, referred to as (M) PAL, which is an 8-field 525/60 system with slight timing differences from baseband (M) NTSC. It is used in Brazil.

(M) PAL uses the same YUV-to-RGB and YUV-to-YCbCr equations as standard (N) PAL to compensate for the addition of a 7.5 IRE blanking pedestal. A gamma of 2.2 is assumed

at the receiver (although 2.8 is specified), and the sync tip is –40 IRE. The luminance and composite digital video levels are the same as standard (N) PAL, as shown in Tables 6.12 and 6.13, respectively.

The subcarrier frequency generation for (M) PAL is implemented in the decoder as:

$$\frac{FSC}{FS} = \frac{P}{4194303} = \left(\frac{909}{4}\right)\left(\frac{1}{HCOUNT}\right)$$

resulting in a subcarrier frequency of 3.57561149 MHz.

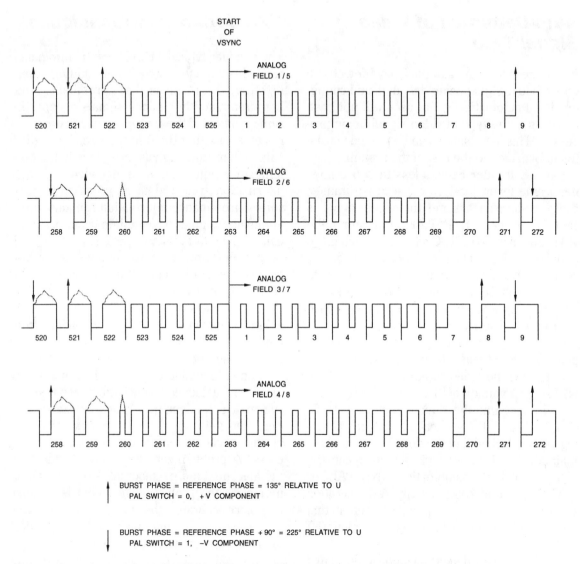

Figure 6.31. Eight-field (M) PAL Format. (See Figure 6.29 for equalization and serration pulse details.)

Figure 6.31 illustrates the 8-field (M) PAL timing and burst blanking intervals. Due to the timing differences from (B, D, G, H, I) PAL and (M) NTSC, (M) PAL is not compatible with the digital composite video standards discussed in Chapter 7. As many of the timing parameters (such as horizontal sync width, start and end of burst, etc.) are different from (B, D, G, H, I) PAL or (M) NTSC, the equations used by the decoder to automatically calculate these parameters must be modified for (M) PAL operation.

Auto-Detection of Video Signal Type

If the decoder can automatically detect the type of video signal being decoded, and configure itself automatically, the user will not have to guess at the type of video signal being processed. This information can be passed via status information to the rest of the system.

If the decoder detects less than 575 lines per frame for at least 16 consecutive frames, the decoder can assume the video signal is (M) NTSC or (M) PAL. First, assume the video signal is (M) NTSC as that is much more popular. If the vertical and horizontal timing remain locked, but the decoder is unable to maintain subcarrier locking, the video signal may be (M) PAL. In that case, try (M) PAL operation and verify the burst blanking.

If the decoder detects more than 575 lines per frame for at least 16 consecutive frames, it can assume the video signal is (B, D, G, H, I, N) PAL or a version of SECAM.

First, assume the video signal is (B, D, G, H, I, N) PAL. If the vertical and horizontal timing remain locked, but the decoder is unable to maintain a subcarrier lock, it may mean the video signal is combination (N) PAL or SECAM. In that case, try SECAM operation (as that is much more popular), and if that doesn't subcarrier lock, try combination (N) PAL operation.

If the decoder detects a video signal format that it does not support, this should be indicated by the status bits so the software can notify the user.

Note that auto-detection cannot be performed during "special feature" modes of VCRs, such as fast-forwarding. If the decoder detects a "special feature" mode of operation, it should disable the auto-detection circuitry. Auto-detection probably should only be done when a video signal has once again been detected after the loss of an input video signal.

Y/C Separation Techniques

The encoder typically combines the luminance and chrominance signals by adding them together; the result is that chrominance and high-frequency luminance signals occupy the same portion of the frequency spectrum. As a result, separating them in the decoder is difficult. When the signals are decoded, some luminance information is decoded as color information (referred to as cross-color), and some chrominance information remains in the luminance signal (referred to as cross-luminance). Due to the stable performance of digital decoders, much more complex separation techniques can be used than is possible with analog decoders.

The presence of crosstalk is bad news in editing situations; crosstalk components from the first decoding are encoded, possibly causing new or additional artifacts when decoded the next time. In addition, when a still frame is captured from a decoded signal, the frozen residual subcarrier on edges may beat with the subcarrier of any following encoding process, resulting in edge flicker in colored areas. Although the crosstalk problem cannot be solved entirely at the decoder, more elaborate Y/C separation minimizes the problem. The intent is to separate more accurately the chrominance and luminance signals, mixing horizontal and vertical filtering (also known as comb filtering).

If the decoder is to be used in an editing environment, the suppression of cross-luminance and cross-chrominance is more important than the appearance of the decoded picture. When a picture is decoded, processed, encoded, and again decoded, cross-effects can introduce substantial artifacts. It may be better to limit the luminance bandwidth (to reduce cross-luminance), producing "softer" pictures. Also, limiting the chrominance bandwidth to less than 1 MHz reduces cross-color, at the expense of losing chrominance definition.

Complementary filtering preserves all of the input signal, either in the chrominance or luminance signal. If the separated chrominance and luminance signals are added together again, the original composite video signal is generated (assuming proper recoding phase). Noncomplementary filtering introduces some irretrievable loss, resulting in gaps in the frequency spectrum when the separated chrominance and luminance signals are again added together to generate a composite video signal. The loss is due to the use of narrower filters to reduce cross-color and cross-luminance. Therefore, noncomplementary filtering usually is unsuitable when multiple encoding and decoding operations must be performed, as the frequency spectrum gaps continually increase as the number of decoding operations increase. It does, however, enable the "tweaking" of luminance and chrominance response for optimum viewing.

Simple Y/C Separation

The most basic Y/C separator assumes frequencies below a certain point are luminance and above this point are chrominance. An example of this is the Y/C separator shown in Figure 6.32a. Frequencies below 2.3 MHz (NTSC) or 3.1 MHz (PAL) are assumed to be luminance. Frequencies above 2.3 MHz (NTSC) or 3.1 MHz (PAL) are assumed to be chrominance. These values are obtained by using a chrominance bandwidth of 1.3 MHz. Thus, 2.3 MHz = 3.58 − 1.3 MHz and 3.1 MHz = 4.43 − 1.3 MHz. Not only is high-frequency luminance information lost, but it is assumed to be chrominance information, resulting in cross-color. The Y/C separator is noncomplementary since Y + C may not equal the input signal due to the filter characteristics.

Restricting the chrominance bandwidth to 0.6 MHz usually produces better pictures by reducing cross-color (at the expense of increased cross-luminance). Crosstalk between the I and Q or U and V components also is reduced, since both will be symmetrical about the color subcarrier. Figure 6.32b shows a Y/C separator using a 0.6 MHz chrominance bandwidth. Frequencies below 3.0 MHz (NTSC) or 3.8 MHz (PAL) are assumed to be luminance. Frequencies above 3.0 MHz (NTSC) or 3.8 MHz (PAL) are assumed to be chrominance. Note that 3.0 MHz = 3.58 − 0.6 MHz and 3.8 MHz = 4.43 − 0.6 MHz. Again, the Y/C separator is noncomplementary since Y + C may not equal the input signal due to the filter characteristics.

Although broadcast NTSC and PAL systems are strictly bandwidth-limited, this may not be true of other video sources. Luminance information may be present all the way out to 6 or 7 MHz or even higher. For this reason, the Y/C separators in Figure 6.33 are usually more appropriate, as they allow high-frequency luminance to pass, resulting in a sharper picture. Again, the Y/C separators are noncomplementary since Y + C may not equal the input signal due to the filter characteristics.

Figures 6.34a and 6.34b illustrate complementary versions of the Y/C separator in Figure 6.33. In this case, Y + C will equal the input signal—nothing is lost. Figure 6.34c illustrates a noncomplementary version of Figure 6.34a. This Y/C separator is noncomplementary since Y + C will not equal the input signal due to the different filter characteristics

Figure 6.35 illustrates another complementary Y/C separator. Full-bandwidth composite video is presented to the chrominance demodulator, and the results lowpass filtered to obtain the baseband color difference signals (I and Q or U and V). These are remodulated (in phase with the composite video signal) and the result subtracted from the composite video signal to recover the luminance information.

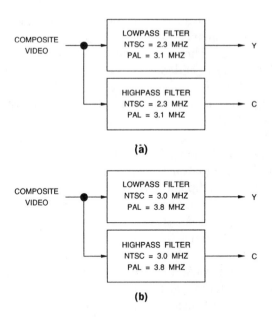

(a)

(b)

Figure 6.32. Simple Y/C Separator Using Noncomplementary Filtering: (a) 1.3 MHz Chrominance Bandwidth, (b) 0.6 MHz Chrominance Bandwidth.

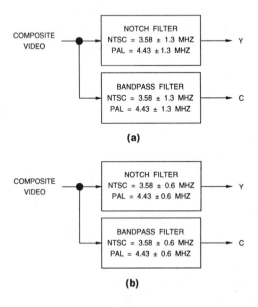

(a)

(b)

Figure 6.33. Simple Y/C Separator for Wide-Band Luminance Signals Using Noncomplementary Filtering: (a) 1.3 MHz Chrominance Bandwidth, (b) 0.6 MHz Chrominance Bandwidth.

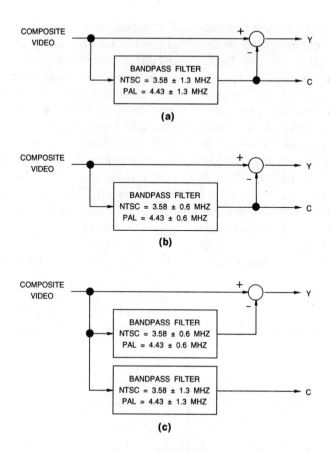

Figure 6.34. Simple Y/C Separator: (a) 1.3 MHz Chrominance Bandwidth and Complementary Filtering, (b) 0.6 MHz Chrominance Bandwidth and Complementary Filtering, (c) 1.3 MHz Chrominance Bandwidth and Noncomplementary Filtering.

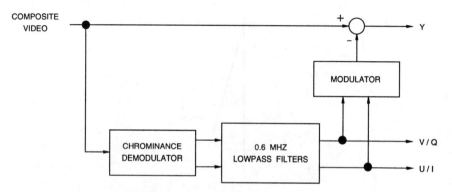

Figure 6.35. Simple Y/C Separator Using Complementary Filtering of Baseband Color Difference Signals.

Although all of the Y/C separators in this section have their performance influenced by the passband and cut-off characteristics of the filters, this is especially true for Figure 6.35.

Noticeable artifacts of simple Y/C separators are color artifacts on vertical edges. These include color ringing, color rainbows, color smearing, and the display of color rainbows in place of high-frequency gray-scale information.

With all of these implementations, there is no loss of vertical chrominance resolution, but there is also no suppression of cross-color. For PAL, line-to-line errors due to differential phase distortion are not suppressed, resulting in the vertical pattern known as Hanover bars.

PAL Delay Line

As mentioned before, PAL uses "normal" and "inverted" scan lines, referring to whether the V component is normal or inverted, to help correct color shifting effects due to differential phase distortions.

For example, differential phase distortion may cause the green vector angle on "normal" scan lines to lag by 45° from the ideal 241° shown in Figure 6.5. This results in a vector at 196°, effectively shifting the resulting color towards yellow. On "inverted" scan lines, the vector angle also will lag by 45° from the ideal 120° shown in Figure 6.6. This results in a vector at 75°, effectively shifting the resulting color towards cyan.

Figure 6.36, made by flipping Figure 6.6 180° about the U axis and overlaying the result onto Figure 6.5, illustrates the cancellation of the phase errors. The average phase of the two errors, 196° on "normal" scan lines and 286° on "inverted" scan lines, is 241°, which is the

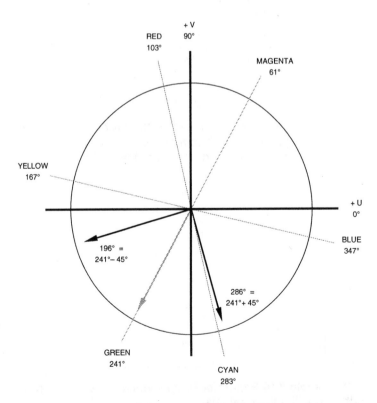

Figure 6.36. Phase Error "Correction" for PAL.

correct phase for green. For this reason, simple PAL decoders usually use a delay line (or line store) to facilitate averaging between two scan lines. In many instances, this delay line or line store also is used to improve the Y/C separation.

Using delay lines in PAL Y/C separators has unique problems. The subcarrier reference changes by –90° (or 270°) over one line period, and the V subcarrier is inverted on alternate lines. Thus, there is a 270° phase difference between the input and output of a line delay. If we want to do a simple addition or subtraction between the input and output of the delay line to recover chrominance information, the phase difference must be 0° or 180°. And there is still that switching V floating around. Thus, we would like to find a way to align the subcarrier phases between lines and compensate for the switching V.

Simple circuits, such as the noncomplementary Y/C separator shown in Figure 6.37, use a delay line that is not a whole line (283.75 subcarrier periods), but rather 284 subcarrier periods. This small difference acts

as a 90° phase shift at the subcarrier frequency.

Since there are an integral number of subcarrier periods in the delay, the U subcarriers at the input and output of the 284 T_{SC} delay line are in phase, and they can simply be added together to recover the U subcarrier. The V subcarriers are 180° out of phase at the input and output of the 284 T_{SC} delay line, due to the switching V, so the adder cancels them out. Any remaining high-frequency vertical V components are rejected by the U demodulator.

Due to the switching V, subtracting the input and output of the 284 T_{SC} delay line recovers the V subcarrier while cancelling the U subcarrier. Any remaining high-frequency vertical U components are rejected by the V demodulator.

Since the phase shift through the 284 T_{SC} delay line is a function of frequency, the subcarrier sidebands are not phase shifted exactly 90°, resulting in hue errors on vertical chrominance transitions. Also, the chrominance and luminance are not vertically

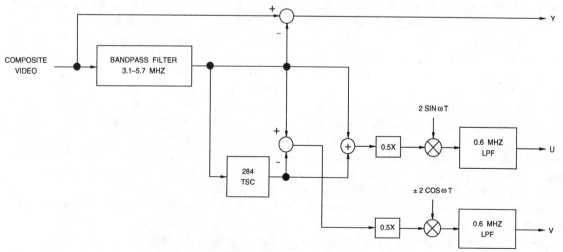

Figure 6.37. Single Delay Line PAL Y/C Separator.

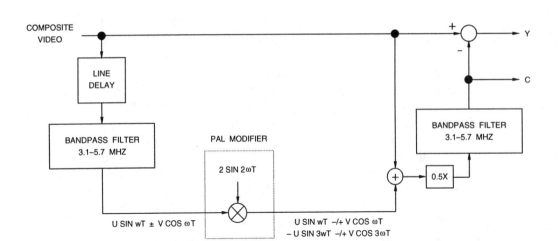

Figure 6.38. Single Line Delay PAL Y/C Separator Using a PAL Modifier.

aligned since the chrominance is shifted down by one-half line.

Although the performance of the circuit in Figure 6.37 usually is adequate, the 284 T_{SC} delay line may be replaced by a full line delay followed by a PAL modifier, as shown in Figure 6.38. The PAL modifier provides a 90° phase shift and inversion of the V subcarrier. Chrominance from the PAL modifier is now in phase with the line delay input, allowing the two to be combined using a single adder and share a common path to the demodulators. The averaging sacrifices some vertical resolution. However, Hanover bars are suppressed.

Since the chrominance at the demodulator input is in phase with the composite video, it can be used to cancel the chrominance in the composite signal to leave luminance. However, the chrominance and luminance still are not vertically aligned since the chrominance is shifted down by one-half line.

The PAL modifier produces a luminance alias centered at twice the subcarrier frequency. Without the bandpass filter before

the PAL modifier and the averaging between lines, mixing the original and aliased luminance components would result in a 12.5-Hz beat frequency, noticeable in high-contrast areas of the picture.

Comb Filtering

In the previous Y/C separators, high-frequency luminance information is treated as chrominance information; no attempt is made to differentiate between the two. As a result, the luminance information is interpreted as chrominance information (cross-color) and passed on to the demodulators to recover color information. The demodulators cannot differentiate between chrominance and high-frequency luminance, so they go ahead and generate color where color is not supposed to exist. Thus, occasional display artifacts are generated.

Comb filtering attempts to improve the separation of chrominance and luminance at the expense of reduced vertical resolution. Comb filters get their name by having luminance and chrominance frequency responses

that look like a comb. Ideally, these frequency responses would match the "comb-like" frequency responses of the interleaved luminance and chrominance signals shown in Figures 4.4 and 4.15.

Modern comb filters typically use two line delays for storing the last two lines of video information (there is a one-line delay in decoding using this method). Using more than two line delays usually results in excessive vertical filtering, reducing vertical resolution.

The BBC has done research (Reference 7) on various Y/C comb filtering implementations (Figures 6.39 through 6.42). Each was evaluated for artifacts and frequency response. The vertical frequency response for each comb filter is shown in Figure 6.43.

In the comb filter design of Figure 6.39, the phase of U and V are inverted over two lines of delay. A subtracter cancels most of the luminance, leaving double-amplitude, vertically filtered chrominance. A PAL modifier provides a 90° phase shift and removal of the PAL switch inversion to phase align the chrominance with the one line-delayed composite video signal. Subtracting the chrominance from the composite signal leaves luminance. This design has the advantage of vertical alignment of the chrominance and luminance. However, there is a loss of vertical resolution and no suppression of Hanover bars. In addition, it is possible under some circumstances to generate double-amplitude luminance due to the aliased luminance components produced by the PAL modifier.

The comb filter design of Figure 6.40 is similar to the one in Figure 6.39. However, the chrominance after the PAL modifier and one line-delayed composite video signal are added to generate double-amplitude chrominance (since the subcarriers are in phase). Again, subtracting the chrominance from the composite signal leaves luminance. In this design, luminance over-ranging is avoided

since both the true and aliased luminance signals are halved. There is less loss of vertical resolution and Hanover bars are suppressed, at the expense of increased cross-color.

The comb filter design in Figure 6.41 has the advantage of not using a PAL modifier. Since the phase of U and V are inverted over two lines of delay, adding them together cancels most of the chrominance, leaving double-amplitude luminance. This is subtracted from the one line-delayed composite video signal to generate chrominance. Chrominance is then subtracted from the one line-delayed composite video signal to generate luminance (this is to maintain vertical luminance resolution). UV crosstalk is present as a 12.5-Hz flicker on horizontal chrominance edges, due to the chrominance signals not cancelling in the adder since the line-to-line subcarrier phases are not aligned. Since there is no PAL modifier, there is no luminance aliasing or luminance over-ranging.

The comb filter design in Figure 6.42 is a combination of Figures 6.39 and 6.41. The phase of U and V are inverted over two lines of delay. An adder cancels most of the chrominance, leaving double-amplitude luminance. This is subtracted from the one line-delayed composite video signal to generate chrominance signal (A). In a parallel path, a subtracter cancels most of the luminance, leaving double-amplitude, vertically filtered chrominance. A PAL modifier provides a 90° phase shift and removal of the PAL switch inversion to phase align to the (A) chrominance signal. These are added together, generating double-amplitude chrominance. Chrominance then is subtracted from the one line-delayed composite signal to generate luminance. The chrominance and luminance vertical frequency responses are the average of those for Figures 6.39 and 6.41. UV crosstalk is similar to that for Figure 6.41, but has half the ampli-

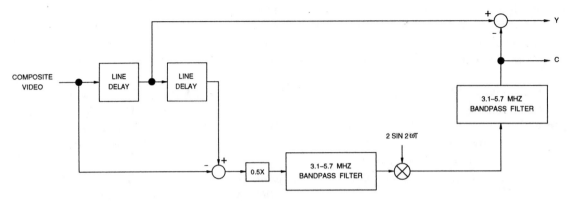

Figure 6.39. Two Line Roe PAL Y/C Separator.

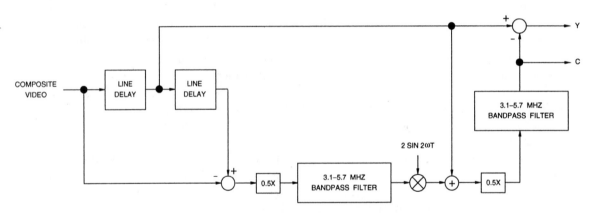

Figure 6.40. Two Line –6 dB Roe PAL Y/C Separator.

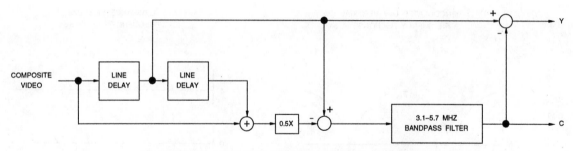

Figure 6.41. Two Line Cosine PAL Y/C Separator.

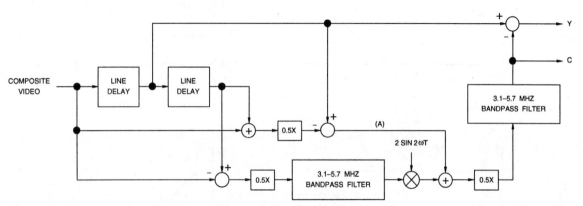

Figure 6.42. Two Line Weston PAL Y/C Separator.

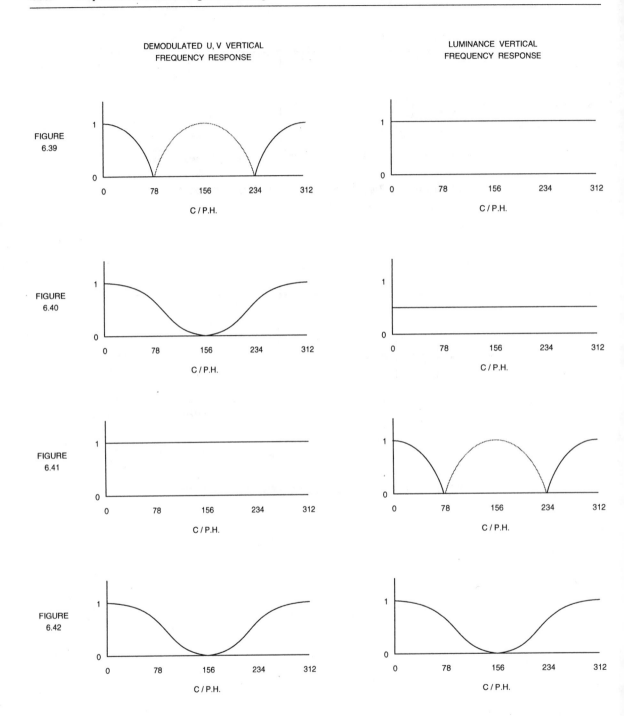

Figure 6.43. Vertical Frequency Characteristics of the Comb Filters In Figures 6.39 through 6.42.

tude. The luminance alias is also half that of Figure 6.39, and Hanover bars are suppressed.

From these comb filter designs, the BBC has derived designs optimized for general viewing (Figure 6.44) and standards conversion (Figure 6.45).

For PAL applications, the best luminance processing (Figure 6.41) was combined with the optimum chrominance processing (Figure 6.40). The difference between the two designs is the chrominance recovery. For standards conversion (Figure 6.45), the chrominance signal is just the full-bandwidth composite video signal. Standards conversion uses vertical interpolation which tends to reduce moving and high vertical frequency components, including cross-luminance and cross-color. Thus, vertical chrominance resolution after processing usually will be better than that obtained from the circuits for general viewing. The circuit for general viewing (Figure 6.44) recovers chrominance with a goal of reducing cross-effects, at the expense of chrominance vertical resolution.

For NTSC applications, the design of comb filters is easier. There are no switched subcarriers to worry about, and the chrominance phases are a 180° per line, rather than 270°. In addition, there is greater separation between the luminance and chrominance fre-

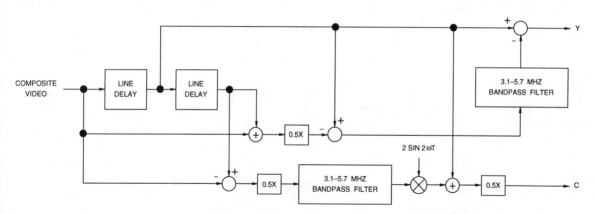

Figure 6.44. Two Line Delay PAL Y/C Separator Optimized for General Viewing.

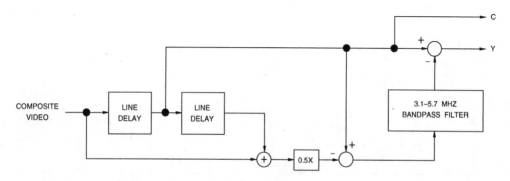

Figure 6.45. Two Line Delay PAL Y/C Separator Optimized for Standards Conversion and Video Processing.

quency bands than in PAL, simplifying the separation requirements.

In Figures 6.46 and 6.47, the adder generates a double-amplitude composite video signal since the subcarriers are in phase. There is a 180° subcarrier phase difference between the output of the adder and the one line-delayed composite video signal, so subtracting the two cancels most of the luminance, leaving double amplitude chrominance.

The main disadvantage of the design in Figure 6.46 is the unsuppressed cross-luminance on vertical color transitions. However, this is offset by the increased luminance resolution over simple lowpass filtering. The reasons for processing chrominance in Figure 6.47 are the same as for PAL in Figure 6.45.

2D Adaptive Y/C Separator

Conventional comb filters still have problems with diagonal lines and vertical color changes.

With diagonal lines, after Y/C separation, the chrominance information also includes the difference between adjacent luminance values, which also may be interpreted as chrominance information. This shows up as cross-color artifacts, such as a rainbow appearance along the edge of the line.

Sharp vertical color transitions generate the "hanging dot" pattern commonly seen on the scan line between the two color changes. After Y/C separation, the luminance information contains the color subcarrier. The amplitude of the color subcarrier is determined by

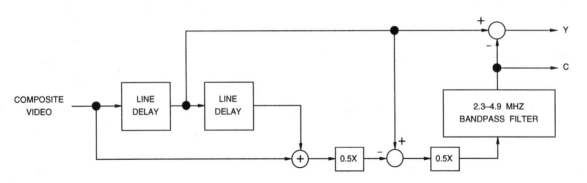

Figure 6.46. Two Line Delay NTSC Y/C Separator for General Viewing.

Figure 6.47. Two Line Delay NTSC Y/C Separator for Standards Conversion and Video Processing.

the difference between the two colors. Thus, different colors modulate the luminance intensity differently, crating a "dot" pattern on the scan line between two colors.

The 2D adaptive Y/C separator (also sometimes called an intra-field Y/C separator), whose basic operation and block diagram is shown in Figure 6.48, attempts to solve these problems. The vertical correlation detector determines the amount of line-to-line correlation (K). If L1 and L2 are highly correlated, K = 0 and L2 – L1 is used. If L2 and L3 are highly correlated, K = 1 and L2 – L3 is used. If there is no correlation, K = 0. Some designs calculate the value of K as a fraction, allowing a proportional combination of scan line pairs to be used.

Some 2D adaptive Y/C separators go a step further and detect both horizontal and vertical transitions to determine the optimum algorithm to use. An example of this type of 2D adaptive Y/C separator is shown in Figure 6.49. The coring function (detailed in Figure 6.50) removes low-level noise from the con-

touring data, reducing graininess. The contouring circuit enhances the horizontal and vertical edge transitions for more pleasing viewing. The circuit must be slightly modified for PAL operation.

For NTSC, some decoders sample along the ±I and ±Q axes, or optionally along the ±U and ±V axes, at 4 × F_{SC} to simplify chrominance demodulation. This results in 910 samples per scan line (or 227.5 cycles of F_{SC}), with the chrominance phase alternating by 180° each scan line. Vertical up and down difference combs therefore yield twice the chrominance value with luminance generally cancelling. Vertical up and down summing combs yield twice the luminance value with the chrominance cancelling.

With many PAL systems, however, the line-to-line vertical changes of the subcarrier phase are only –90° (270°) since there are 1135 samples per scan line at four times F_{SC} (283.75 cycles of F_{SC}). Single line vertical combs do not function correctly unless the sampling phase is changed to be the ±(V + U)

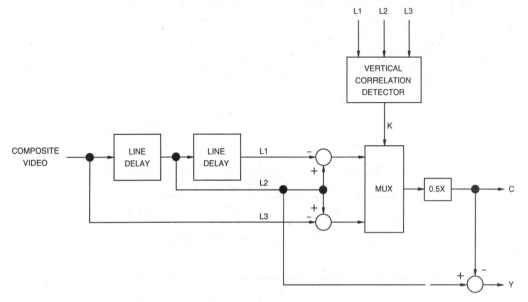

Figure 6.48. Typical 2D Adaptive Y/C Separator for NTSC.

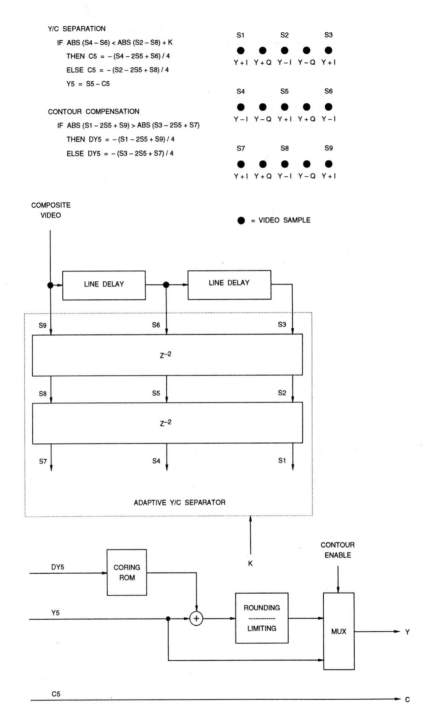

Figure 6.49. Typical 2D Adaptive Y/C Separator Example for NTSC. Four times F$_{SC}$ operation with sampling along the ±I and ±Q axes.

Figure 6.50. Coring Function Detail.

and ±(V – U) components, which are 45° relative to the burst, rather than the ±U and ±V components. Figure 6.51 illustrates the vertical comb filtering for 4 × F_{SC} NTSC and most PAL systems.

Note that when using 2D adaptive Y/C separators with real-world video, there may not be sufficiently correlated lines to adequately separate the luminance and chrominance signals. The more detail that is present, the greater the artifacts.

Inter-Frame Y/C Separator

This technique uses composite video data from the current field and composite video data from two fields (NTSC) or four fields (PAL) ago (on a pixel-by-pixel basis). Adding the two cancels the chrominance (since it is 180° out of phase), leaving luminance. Subtracting the two cancels the luminance, leaving chrominance. This provides near-perfect Y/C separation for stationary pictures. However, if there is any movement between frames, the resulting Y/C separation is erroneous. For this reason, inter-frame Y/C separators usually are not used, unless as part of a 3D motion adaptive Y/C separator.

3D Motion Adaptive Y/C Separator

This implementation (Figures 6.52 through 6.55) uses inter-frame Y/C separation of still areas of a picture, and intra-field Y/C separation (2D adaptive Y/C separation) for areas of the picture that contain movement.

In the design shown in Figure 6.52, only the chrominance output of the Y/C separators

● = VIDEO SAMPLE

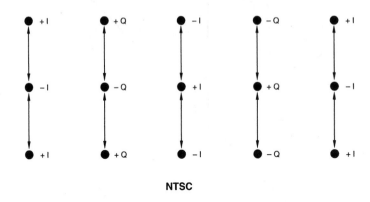

NTSC

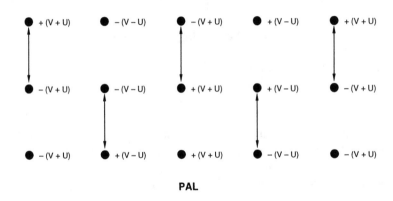

PAL

CHROMINANCE COMBING DIRECTION

Figure 6.51. NTSC and PAL Vertical Chrominance Combing Example.
Four times F$_{SC}$ operation with sampling along the ±I and ±Q components
(NTSC) and along the ±(V + U) and ±(V − U) components (PAL).

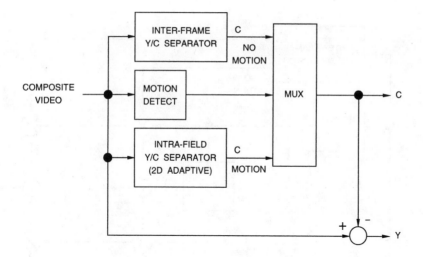

Figure 6.52. 3D Motion Adaptive Y/C Separator.

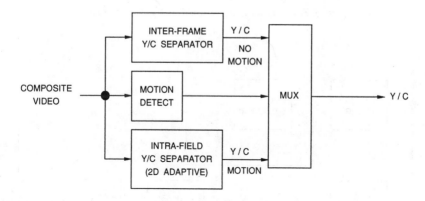

Figure 6.53. 3D Motion Adaptive Y/C Separator.

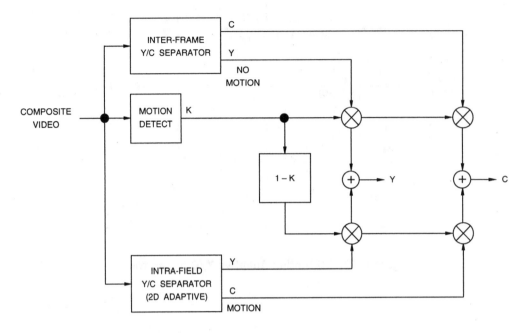

Figure 6.54. 3D Motion Adaptive Y/C Separator.

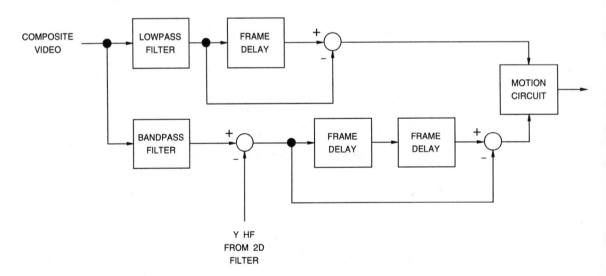

Figure 6.55. Simple Motion Detector Block Diagram for NTSC.

is used. When no motion is detected, the chrominance information from the inter-frame Y/C separator is used. When motion is detected, the chrominance information from the intra-field (2D adaptive) Y/C separator is used. In this case, the motion detector generates only a 0 or 1 signal.

The circuit in Figure 6.53 is similar. However, in this case, both the luminance and the chrominance outputs of the Y/C separators are used. This design allows more flexibility in filtering the signals. In this case, the motion detector again generates only a 0 or 1 signal.

For the design in Figure 6.54, the motion detector generates a fractional value (K), allowing the luminance and chrominance signals from the Y/C separators to be proportionally mixed.

Figure 6.55 illustrates a simple motion detector block diagram. The performance of the motion detector determines, to a large degree, the quality of the image. The only error the motion detector should make is to use the intra-field Y/C separator on stationary areas of the image.

The concept behind the motion detector is to compare frame-to-frame changes in the low frequency luminance signal. A comparison is also done on the chrominance signal, which requires using two frame delays for NTSC since the phase of the chrominance is inverted on alternate frames.

Closed Captioning Support

Closed captioning (discussed in Chapter 5) can be supported in several ways. If the video is displayed in a window large enough to read the caption information, the caption data may be contained within the video window. In this case, caption decoding may be able to be incor-porated within the NTSC/PAL decoder, with the caption data placed over the digital video data before being output.

If the video window is too small to display the caption information, it may be desirable to optionally display the caption data at the bottom of the full-screen display. Again, caption decoding may be able to be incorporated within the NTSC/PAL decoder, with the caption data being output via the digital video outputs during the blanking intervals. Additional circuitry recovers and processes the caption data from the video stream, converts it to bit-mapped characters, and positions it on the display. Alternately, the bit-mapped caption data may be output from the NTSC/PAL decoder for loading directly into the frame buffer.

If compressing the video (using MPEG or JPEG, for example), the caption data may have to be recovered by the NTSC/PAL decoder, and passed on to the MPEG/JPEG encoder for special handling.

When a poor signal condition is detected, the captioning should be disabled and not displayed. Poor signal conditions are defined as 45 consecutive frames containing one or more parity errors. A good signal condition is indicated when 15 consecutive error-free frames are received.

Copy Protection Support

The decoder should be designed so that copy-protected video signals are properly decoded with no reduction in video quality. This is done by knowing how the video signal is modified during copy-protection. If the decoder detects a video signal that is copy-protected, a status bit may be used to indicate to the operating system that video compression and storage should not be allowed.

Timecode Support

If the decoder provides timecode support (discussed in Chapter 5), the ability to decode video only between two specified timecodes can be added easily, simplifying the editing process. During this time, audio capture can be hardware-enabled automatically. Timecode information, if present, also should be passed on to the MPEG/JPEG encoder. The decoder should be able to handle decoding timecode information from VCRs during fast forward and backward operation to aid finding specific video segments.

Alpha (Keying) Channel

By incorporating an additional A/D converter within the NTSC/PAL decoder, an analog alpha signal (also called a key) may be digitized, and pipelined with the video data to maintain synchronization. This allows the designer to change decoders (which may have different pipeline delays) to fit specific applications without worrying about the alpha channel pipeline delay. Alpha is usually linear, with an analog range of 0 to 100 IRE. There is no blanking pedestal or sync information present. In computer systems that support 32-bit pixels, 8 bits are typically available for alpha information. Alpha support also is discussed in Chapter 5 and Chapter 9.

Video Test Signals

Many industry-standard video test signals have been defined to help test the relative quality of NTSC/PAL decoders. By providing these test signals to the decoder, video test equipment may be used to evaluate the decoder's performance. Many of the same video test signals described in Chapter 5 for evaluating encoders also are useful for evaluating decoder performance.

Video Parameters

Many industry-standard video parameters have been defined to specify the relative quality of NTSC/PAL decoders. To measure these parameters, the output of the NTSC/PAL decoder (while decoding various video test signals such as those previously described) is monitored using video test equipment (see Appendix A for more information on video testing). Along with a description of several of these parameters, typical AC parameter values for both consumer and studio-quality decoders are shown in Table 6.14.

Several AC parameters, such as short-time waveform distortion, group delay, and K factors, are dependent on the quality of the analog video filters and are not discussed here. In addition to the AC parameters discussed in this section, there are several others that should be included in a decoder specification, such as burst frequency and tolerance, and the bandwidths of the YIQ or YUV baseband video signals.

There are also several DC parameters (such as white level and tolerance, blanking level and tolerance, sync height and tolerance, peak-to-peak burst amplitude and tolerance) that should be specified, as shown in Table 6.15. Although genlock capabilities are not usually specified, except for "clock jitter," we have attempted to generate a list of genlock parameters, shown in Table 6.16.

Differential Phase

Differential phase distortion, commonly referred to as differential phase, specifies how

Parameter	Consumer Quality	Studio Quality	Units
differential phase	4	≤ 1	degrees
differential gain	4	≤ 1	%
luminance nonlinearity	2	≤ 1	%
hue accuracy	3	≤ 1	degrees
color saturation accuracy	3	≤ 1	%
SNR (per CCIR 410 or EIA RS-250-B)	48	> 60	dB
chrominance-to-luminance crosstalk	< − 40	< − 50	dB
luminance-to-chrominance crosstalk	< − 40	< − 50	dB
H tilt	< 1	< 1	%
V tilt	< 1	< 1	%
Y/C sampling skew	< 5	< 2	ns
demodulation quadrature	90 ±2	90 ±0.5	degrees

Table 6.14. Typical AC Video Parameters for NTSC and PAL Decoders.

Parameter	NTSC[1]	PAL[2]	Units
sync input amplitude	40 ±20	43 ±22	IRE
burst input amplitude	40 ±20	43 ±22	IRE
video input amplitude (1v nominal)	0.5 to 2.0	0.5 to 2.0	volts

Notes
1. (M) NTSC.
2. (B, D, G, H, I) PAL.

Table 6.15. Typical DC Video Parameters for NTSC and PAL Decoders.

Parameter	Min	Max	Units
sync locking time[1]		2	fields
sync recovery time[2]		2	fields
short-term sync lock range[3]	±100		ns
long-term sync lock range[4]	±5		µs
number of consecutive missing horizontal sync pulses before any correction	5		sync pulses
vertical correlation[5]		±5	ns
short-term subcarrier locking range[6]	±200		Hz
long-term subcarrier locking range[7]	±500		Hz
subcarrier locking time[8]		10	lines
subcarrier accuracy		±2	degrees

Notes
1. Time from start of genlock process to vertical correlation specification is achieved.
2. Time from loss of genlock to vertical correlation specification is achieved.
3. Range over which vertical correlation specification is maintained. Short-term range assumes line time changes by amount indicated slowly between two consecutive lines.
4. Range over which vertical correlation specification is maintained. Long-term range assumes line time changes by amount indicated slowly over one field.
5. Indicates vertical pixel accuracy. For a genlock system that uses a VCO or VCXO, this specification is the same as clock jitter.
6. Range over which subcarrier locking time and accuracy specifications are maintained. Short-term time assumes subcarrier frequency changes by amount indicated slowly over 2 frames.
7. Range over which subcarrier locking time and accuracy specifications are maintained. Long-term time assumes subcarrier frequency changes by amount indicated slowly over 24 hours.
8. After instantaneous 180° phase shift of subcarrier, time to lock to within ±2°. Subcarrier frequency is nominal ±500 Hz.

Table 6.16. Typical Genlock Parameters for NTSC and PAL Decoders. Parameters assume a video signal with ≥ 30 dB SNR and over the range of DC parameters in Table 6.15.

much the chrominance phase is affected by the luminance level—in other words, how much hue shift occurs when the luminance level changes. Both positive and negative phase errors may be present, so differential phase is expressed as a peak-to-peak measure-ment, expressed in degrees of subcarrier phase. This parameter is measured using a test signal of uniform-phase and amplitude chrominance superimposed on different luminance levels, such as the modulated ramp test signal, or the modulated five-step portion of the com-

posite test signal. The differential phase parameter for a studio-quality analog decoder may approach 1° or less.

Differential Gain

Differential gain distortion, commonly referred to as differential gain, specifies how much the chrominance gain is affected by the luminance level—in other words, how much color saturation shift occurs when the luminance level changes. Both attenuation and amplification may occur, so differential gain is expressed as the largest amplitude change between any two levels, expressed as a percentage of the largest chrominance amplitude. This parameter is measured using a test signal of uniform phase and amplitude chrominance superimposed on different luminance levels, such as the modulated ramp test signal, or the modulated five-step portion of the composite test signal. The differential gain parameter for a studio-quality analog decoder may approach 1% or less.

Luminance Nonlinearity

Luminance nonlinearity, also referred to as differential luminance and luminance nonlinear distortion, specifies how much the luminance gain is affected by the luminance level. In other words, there is a nonlinear relationship between the decoded luminance level and the ideal luminance level. Using an unmodulated five-step or ten-step staircase test signal, or the modulated five-step portion of the composite test signal, the difference between the largest and smallest steps, expressed as a percentage of the largest step, is used to specify the luminance nonlinearity. Although this parameter is included within the differential gain and phase parameters, it traditionally is specified independently.

Chrominance Nonlinear Phase Distortion

Chrominance nonlinear phase distortion specifies how much the chrominance phase (hue) is affected by the chrominance amplitude (saturation)—in other words, how much hue shift occurs when the saturation changes. Using a modulated pedestal test signal, or the modulated pedestal portion of the combination test signal, the decoder output for each chrominance packet is measured. The difference between the largest and the smallest hue measurements is the peak-to-peak value. This parameter usually is not specified independently, but is included within the differential gain and phase parameters.

Chrominance Nonlinear Gain Distortion

Chrominance nonlinear gain distortion specifies how much the chrominance gain is affected by the chrominance amplitude (saturation). In other words, there is a nonlinear relationship between the decoded chrominance amplitude levels and the ideal chrominance amplitude levels—this is usually seen as an attenuation of highly saturated chrominance signals. Using a modulated pedestal test signal, or the modulated pedestal portion of the combination test signal, the decoder is adjusted so that the middle chrominance packet (40 IRE) is decoded properly. The largest difference between the measured and nominal values of the amplitudes of the other two decoded chrominance packets specifies the chrominance nonlinear gain distortion, expressed in IRE or as a percentage of the nominal amplitude of the worst-case packet. This parameter usually is not specified independently, but is included within the differential gain and phase parameters.

Chrominance-to-Luminance Crosstalk

Chrominance-to-luminance intermodulation, commonly referred to as cross-modulation, specifies how much the luminance level is affected by the chrominance. This may be the result of clipping highly saturated chrominance levels or quadrature distortion and may show up as irregular brightness variations due to changes in color saturation. Using a modulated pedestal test signal, or the modulated pedestal portion of the combination test signal, the largest difference between the decoded 50 IRE luminance level and the decoded luminance levels from the modulated pedestals specifies the chrominance-to-luminance intermodulation, expressed in IRE or as a percentage. This parameter usually is not specfied independently, but is included within the differential gain and phase parameters.

Hue Accuracy

Hue accuracy specifies how closely the decoded hue is to the ideal hue value. Both positive and negative phase errors may be present, so hue accuracy is the difference between the worst-case positive and worst-case negative measurements from nominal, expressed in degrees of subcarrier phase. This parameter is measured using EIA or EBU color bars as a test signal.

Color Saturation Accuracy

Color saturation accuracy specifies how closely the decoded saturation is to the ideal saturation value, using EIA or EBU color bars as a test signal. Both gain and attenuation may be present, so color saturation accuracy is the difference between the worst-case gain and worst-case attenuation measurements from nominal, expressed as a percentage of nominal.

H Tilt

H tilt, also known as line tilt and line time distortion, causes a tilt in line-rate signals, predominantly white bars. This type of distortion causes variations in brightness between the left and right edges of an image. For a digital decoder, such as that described in this chapter, H tilt is primarily an artifact of the analog input filters and the transmission medium. H tilt is measured using a line bar (such as the one in the NTC-7 NTSC composite test signal) and measuring the peak-to-peak deviation of the tilt (in IRE or percentage of white bar amplitude), ignoring the first and last microsecond of the white bar.

V Tilt

V tilt, also known as field tilt and field time distortion, causes a tilt in field-rate signals, predominantly white bars. This type of distortion causes variations in brightness between the top and bottom edges of an image. For a digital decoder, such as that described in this chapter, V tilt is primarily an artifact of the analog input filters and the transmission medium. V tilt is measured using an 18-µs, 100-IRE white bar in the center of 130 lines in the center of the field or using a field square wave. The peak-to-peak deviation of the tilt is measured (in IRE or percentage of white bar amplitude), ignoring the first and last three lines.

VLSI Solutions

See C6_VLSI

References

1. Benson, K. Blair, 1986, *Television Engineering Handbook*, McGraw-Hill, Inc.
2. Brooktree Corporation, Bt812 Datasheet, L812001, Rev. E.
3. Brooktree Corporation, Bt819 Datasheet, L819001 Rev. B.
4. Cirrus Logic, CL-PX4070 Datasheet, April 1994.
5. Cirrus Logic, CL-PX4072 Datasheet, November 1994.
6. Clarke, C.K.P., 1986, "Colour encoding and decoding techniques for line-locked sampled PAL and NTSC television signals," BBC Research Department Report BBC RD1986/2.
7. Clarke, C.K.P., 1982, "Digital Standards Conversion: comparison of colour decoding methods," BBC Research Department Report BBC RD1982/6.
8. Clarke, C.K.P., 1982, "High quality decoding for PAL inputs to digital YUV studios," BBC Research Department Report BBC RD1982/12.
9. Clarke, C.K.P., 1988, "PAL Decoding: Multi-dimensional filter design for chrominance-luminance separation," BBC Research Department Report BBC RD1988/11.
10. ITU-R Recommendation BT.470, 1994, *Characteristics of Television Systems*.
11. Motorola MC141621 Datasheet, 1993.
12. Motorola MC141625 Datasheet, 1993.
13. Perlman, Stuart S, Schweer, Rainer, "An Adaptive Luma-Chroma Separator Circuit for PAL and NTSC TV Signals," International Conference on Consumer Electronics, Digest of Technical Papers, June 6–8, 1990.
14. Philips Semiconductors, *Desktop Video Data Handbook*, 1995.
15. Philips Semiconductors, SAA5233 Datasheet, June 1994.
16. Philips Semiconductors, SAA5249 Datasheet, December 1993.
17. Raytheon Semiconductor, TMC22x5y Multistandard Digital Video Decoder Datasheet, Rev. B, January 1995.
18. Samsung Semiconductor KS0117 NTSC Decoder Product Announcement, November 1993.
19. Samsung Semiconductor KS0122 Datasheet, 070595.
20. Sandbank, C. P., *Digital Television*, John Wiley & Sons, Ltd., 1990.
21. Sony Corporation Computer Audio/Video Databook, 1992.
22. Sony SBX1762–01 Datasheet, March 1993.
23. *Specification of Television Standards for 625-Line System-I Transmissions*, 1971, Independent Television Authority (ITA) and British Broadcasting Corporation (BBC).
24. Trundle, Eugene, *Newnes Guide to TV & Video Technology*, Heinemann Professional Publishing Ltd., 1988.

25. Watkinson, John, *The Art of Digital Video*, Focal Press, 1990.

26. Yoshimoto, Masahiko, et.al., 1986, "A Digital Processor for Decoding of Composite TV Signals using Adaptive Filtering," IEEE International Solid-State Circuits Conference Digest of Technical Papers, 1986.

Digital Composite Video

The digital composite video format was developed as a way of easing into the digital video world. It was developed after the digital component video standards (discussed in the next chapter) to act as a stepping stone between analog video and digital component video.

Although the video signal is in composite format, 20 or more editing operations are possible before visual artifacts appear. Remaining in the composite format is therefore not as much of a disadvantage as it might seem at first, especially as many editing operations can be done directly on the composite video, avoiding the encoding and decoding processes.

This chapter discusses digital composite video encoder and decoder architectures, transmission of digital composite video, and ancillary data capabilities such as digital audio. Audio is transmitted digitally either over a separate digital channel (using the AES/EBU digital audio protocol) or during the digital video sync intervals (as ancillary data).

Digital Encoding

The generation of digital composite (M) NTSC and (B, D, G, H, I) PAL video signals from digital RGB or YCbCr data is similar to that used for the NTSC and PAL encoder discussed in Chapter 5. The major differences are: (a) only digital composite video data is generated, and (b) the pixel clock rate is four times F_{SC}: 14.32 MHz for (M) NTSC, 17.72 MHz for (B, D, G, H, I) PAL. Where ranges of values are mentioned, it is assumed 8-bit (plus sign) data values are used; 10-bit (plus sign) data values will result in more accurate computations at the expense of more circuitry.

Table 7.1 contains digital composite video encoding parameter values for both M(NTSC) and (B, D, G, H, I) PAL.

NTSC Considerations

Gamma-corrected RGB (R'G'B') or YCbCr data is converted to YIQ data using the same equations as those used for the NTSC encoder

Parameters	(M) NTSC	(B, D, G, H, I) PAL
Number of samples	910 total per line	709,379 total per frame
Sampling frequency	4x F_{SC}	
Sampling phase	±I and ±Q axes	±U and ±V axes
Form of coding	Uniformly quantized PCM, 8 or 10 bits per sample	
Number of samples per digital active line	768	948
Correspondence between video signal levels and the quantization levels: 8-bit system white level blanking level sync level 10-bit system white level blanking level sync level	 200 60 4 800 240 16	 211 64 1 844 256 4
Code word usage	Code words used exclusively for synchronization and not available for video or ancillary information: 8-bit system: 00_H, FF_H 10-bit system: 000_H, 001_H, 002_H, 003_H, $3FC_H$, $3FD_H$, $3FE_H$, $3FF_H$	

Table 7.1. Encoding Parameter Values for Digital Composite Video.

discussed in Chapter 5, and the same considerations apply. Y has a range of 0 to 130, I a range of 0 to ±78, and Q a range of 0 to ±68. Since computers commonly use linear R'G'B' data, linear RGB may be converted to R'G'B' as follows (values are normalized to have a value of 0 to 1):

for R, G, B < 0.018

$$R' = 4.5 R$$
$$G' = 4.5 G$$
$$B' = 4.5 B$$

for R, G, B ≥ 0.018

$$R' = 1.099 R^{0.45} - 0.099$$
$$G' = 1.099 G^{0.45} - 0.099$$
$$B' = 1.099 B^{0.45} - 0.099$$

A value of 10 is added to the digital luminance data during active video to incorporate the 7.5 IRE blanking pedestal. Digital composite sync information is added to the luminance data; digital values of 4 (sync present) or 60 (no sync) are assigned. For digital composite video, the sync edge values, and the horizontal counts at which they occur, are defined as shown in Figure 7.1 and Table 7.4. Horizontal count 0 corresponds to the start of active video, and a horizontal count of 768 corresponds to the start of horizontal blanking, as shown in Figure 7.2. The horizontal counter increments from 0 to 909 every scan line. To maintain zero SCH phase, horizontal count 784 occurs 25.6 ns (33° of the subcarrier phase) before the 50% point of the falling edge of horizontal sync, and horizontal count 785 occurs 44.2 ns (57° of the subcarrier phase) after the 50% point of the falling edge of horizontal sync. This is due to the clock phase being along the ±I and ±Q axes (33°, 123°, 213°, and 303°). The sampling phase at horizontal count 0 of line 10 (line 7 as defined in Figure 5.21), field one is on the +I axis (123°).

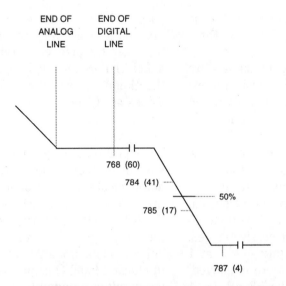

END OF ANALOG LINE

END OF DIGITAL LINE

768 (60)
784 (41)
50%
785 (17)
787 (4)

Figure 7.1. Digital Composite (M) NTSC Sync Timing. The horizontal counts with the corresponding 8-bit sample values are in parentheses.

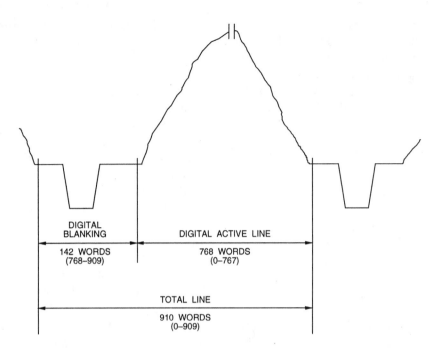

Figure 7.2. Digital Composite (M) NTSC Analog and Digital Timing Relationship.

At this point, we have luminance with sync and blanking information, as shown in Table 7.2.

The I and Q color difference signals are lowpass filtered, with the same considerations as those used for the NTSC encoder discussed in Chapter 5. Note, however, that the lowpass filters should be optimized for 14.32 MHz in this instance. Because there may be many cascaded conversions, the filters should be designed to very tight tolerances to avoid a buildup of visual artifacts; departure from flat amplitude and group delay response due tc filtering is amplified through successive stages. For example, if filters exhibiting –1 dB at 1 MHz and –3 dB at 1.3 MHz were employed, the overall response would be –8 dB (at 1 MHz) and –24 dB (at 1.3 MHz) after four stages (assuming two filters per stage). The

passband flatness and group-delay characteristics therefore are very important.

Since the pixel clock rate is four times the subcarrier frequency, F_{SC}, and aligned along the ±I and ±Q axes, the subcarrier sin and cos values are 0 and ±1. There is no need for the sin and cos subcarrier ROMs and the associated p:q ratio counters used on the NTSC encoder discussed in Chapter 5. The 33° phase shift of the subcarrier during active video is automatically accommodated by aligning the pixel clock along the ±I and ±Q axes. At four times F_{SC}, a 90° subcarrier phase shift is a single clock cycle; therefore, a one clock cycle delay implements a 90° phase shift. After the modulated I and Q signals are added together, the result is rounded to the desired accuracy; the modulated chrominance has an 8-bit range of 0 to ±82. Burst information is multiplexed

Video Level	8-bit Digital Value	10-bit Digital Value
white	200	800
black	70	280
blank	60	240
sync	4	16

Table 7.2. Sync, Blanking, Black, and White Video Levels for Digital Composite (M) NTSC Video Signals.

with the digital chrominance information. During the color burst time, the modulated chrominance data should be ignored, and the burst information inserted. At this point, we have modulated chrominance and burst information, as shown in Table 7.3. Burst values for one subcarrier cycle (requiring four clock cycles) are 45, 83, 75, and 37. The burst envelope starts at horizontal count 857, and lasts for 43 clock cycles, as shown in Table 7.4. Note that the peak amplitudes of the burst are not sampled.

The digital composite luminance data and the digital chrominance data are added together, generating digital composite video with the levels shown in Table 7.5. Tables 7.6 and 7.7 list the digital values during the vertical blanking intervals.

The horizontal and vertical timing is implemented the same as for the NTSC encoder discussed in Chapter 5, with the exception of the horizontal count positions. That encoder used a horizontal count starting at 1, rather than 0; in addition, the horizontal count started at 50% of the falling edge of horizontal sync rather than at the beginning of active video.

PAL Considerations

Gamma-corrected RGB or YCbCr data is converted to YUV data using different equations from those used for the PAL encoder dis-

Video Level	8-bit Digital Value	10-bit Digital Value
peak chroma	82	328
peak burst	28	112
blank	0	0
peak burst	−28	−112
peak chroma	−82	−328

Table 7.3. Chrominance Levels for Digital Composite (M) NTSC Video Signals.

Sample	8-bit Hex Value		10-bit Hex Value	
	Fields 1, 3	Fields 2, 4	Fields 1, 3	Fields 2, 4
768–782	3C	3C	0F0	0F0
783	3A	3A	0E9	0E9
784	29	29	0A4	0A4
785	11	11	044	044
786	04	04	011	011
787–849	04	04	010	010
850	06	06	017	017
851	17	17	05C	05C
852	2F	2F	0BC	0BC
853	3C	3C	0EF	0EF
854–856	3C	3C	0F0	0F0
857	3C	3C	0F0	0F0
858	3D	3B	0F4	0EC
859	37	41	0DC	104
860	36	42	0D6	10A
861	4B	2D	12C	0B4
862	49	2F	123	0BD
863	25	53	096	14A
864	2D	4B	0B3	12D
865	53	25	14E	092
866	4B	2D	12D	0B3
867	25	53	092	14E
868	2D	4B	0B3	12D
869	53	25	14E	092
870	4B	2D	12D	0B3
871	25	53	092	14E
872	2D	4B	0B3	12D
873	53	25	14E	092

Table 7.4a. Digital Values During the Horizontal Blanking Intervals for Digital Composite (M) NTSC Video Signals.

Sample	8-bit Hex Value		10-bit Hex Value	
	Fields 1, 3	Fields 2, 4	Fields 1, 3	Fields 2, 4
874	4B	2D	12D	0B3
875	25	53	092	14E
876	2D	4B	0B3	12D
877	53	25	14E	092
878	4B	2D	12D	0B3
879	25	53	092	14E
880	2D	4B	0B3	12D
881	53	25	14E	092
882	4B	2D	12D	0B3
883	25	53	092	14E
884	2D	4B	0B3	12D
885	53	25	14E	092
886	4B	2D	12D	0B3
887	25	53	092	14E
888	2D	4B	0B3	12D
889	53	25	14E	092
890	4B	2D	12D	0B3
891	25	53	092	14E
892	2D	4B	0B3	12D
893	53	25	14E	092
894	4A	2E	129	0B7
895	2A	4E	0A6	13A
896	33	45	0CD	113
897	44	34	112	0CE
898	3F	39	0FA	0E6
899	3B	3D	0EC	0F4
900–909	3C	3C	0F0	0F0

Table 7.4b. Digital Values During the Horizontal Blanking Intervals for Digital Composite (M) NTSC Video Signals.

Video Level	8-bit Digital Value	10-bit Digital Value
peak chroma	243	972
white	200	800
peak burst	88	352
black	70	280
blank	60	240
peak burst	32	128
peak chroma	26	104
sync	4	16

Table 7.5. Video Levels for Digital Composite (M) NTSC Video Signals.

cussed in Chapter 5, although the same considerations apply. Y has a range of 0 to 147, U a range of 0 to ±64, and V a range of 0 to ±91. Since computers commonly use linear RGB data, linear RGB can be converted to gamma-corrected RGB.

Although the PAL standard specifies a gamma of 2.8, a value of 2.2 is now used. Therefore, the same gamma-correction equations are used for both NTSC and PAL.

RGB to YUV

$$Y = 0.172R' + 0.338G' + 0.066B'$$
$$U = -0.085R' - 0.167G' + 0.252B'$$
$$V = 0.355R' - 0.297G' - 0.058B'$$

YCbCr to YUV

$$Y = 0.671(Y - 16)$$
$$U = 0.572(Cb - 128)$$
$$V = 0.809(Cr - 128)$$

Professional video systems may use the gamma-corrected RGB color space, with R'G'B' having a nominal range of 16 to 235. Occasional values less than 16 and greater than 235 are allowed, resulting in YUV values outside their nominal ranges. In this instance, R'G'B' can be converted to YUV by scaling the RGB-to-YUV equations by 255/219:

$$Y = 0.200(R' - 16) + 0.394(G' - 16)$$
$$+ 0.077(B' - 16)$$
$$U = -0.099(R' - 16) - 0.194(G' - 16)$$
$$+ 0.293(B' - 16)$$
$$V = 0.413(R' - 16) - 0.346(G' - 16)$$
$$- 0.067(B' - 16)$$

Digital composite sync information is added to the luminance data; digital values of 1 (sync present) or 64 (no sync) are assigned. Horizontal count 0 corresponds to the start of active video, and a horizontal count of 948 corresponds to the start of horizontal blanking, as shown in Figure 7.3. The horizontal counter increments from 0 to 1134 (or 1136) every scan line. There are 1135 samples per line, except for lines 313 and 625 which have 1137

Fields 1, 3			Fields 2, 4		
Sample	8-bit Hex Value	10-bit Hex Value	Sample	8-bit Hex Value	10-bit Hex Value
768–782	3C	0F0	313–327	3C	0F0
783	3A	0E9	328	3A	0E9
784	29	0A4	329	29	0A4
785	11	044	330	11	044
786	04	011	331	04	011
787–815	04	010	332–360	04	010
816	06	017	361	06	017
817	17	05C	362	17	05C
818	2F	0BC	363	2F	0BC
819	3C	0EF	364	3C	0EF
820–327	3C	0F0	365–782	3C	0F0
328	3A	0E9	783	3A	0E9
329	29	0A4	784	29	0A4
330	11	044	785	11	044
331	04	011	786	04	011
332–360	04	010	787–815	04	010
361	06	017	816	06	017
362	17	05C	817	17	05C
363	2F	0BC	818	2F	0BC
364	3C	0EF	819	3C	0EF
365–782	3C	0F0	820–327	3C	0F0

Table 7.6. Equalizing Pulse Values During the Vertical Blanking Intervals for Digital Composite (M) NTSC Video Signals.

Fields 1, 3			Fields 2, 4		
Sample	**8-bit Hex Value**	**10-bit Hex Value**	**Sample**	**8-bit Hex Value**	**10-bit Hex Value**
782	3C	0F0	327	3C	0F0
783	3A	0E9	328	3A	0E9
784	29	0A4	329	29	0A4
785	11	044	330	11	044
786	04	011	331	04	011
787–260	04	010	332–715	04	010
261	06	017	716	06	017
262	17	05C	717	17	05C
263	2F	0BC	718	2F	0BC
264	3C	0EF	719	3C	0EF
265–327	3C	0F0	720–782	3C	0F0
328	3A	0E9	783	3A	0E9
329	29	0A4	784	29	0A4
330	11	044	785	11	044
331	04	011	786	04	011
332–715	04	010	787–260	04	010
716	06	017	261	06	017
717	17	05C	262	17	05C
718	2F	0BC	263	2F	0BC
719	3C	0EF	264	3C	0EF
720–782	3C	0F0	265–327	3C	0F0

Table 7.7. Serration Pulse Values During the Vertical Blanking Intervals for Digital Composite (M) NTSC Video Signals.

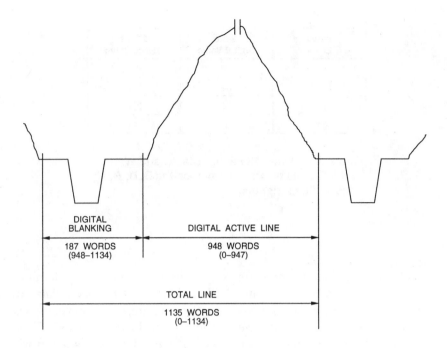

Figure 7.3. Digital Composite (B, D, G, H, I) PAL Analog and Digital Timing Relationship.

samples per line, making a total of 709,379 samples per frame. Sampling is therefore not H-coherent as with (M) NTSC, and the position of the sync pulses change from line to line. Zero SCH phase is now defined when alternate burst samples have a value of 64. For a digital encoder, the 50% point of the leading edge of sync pulses typically are designed to occur equidistant between two consecutive samples (typically at horizontal counts 957 and 958). The clock phase is along the ±U and ±V axes (0°, 90°, 180°, and 270°), with the sampling phase at horizontal count 0 of line 1, field one on the +V axis (90°).

At this point, we have luminance with sync and blanking information as shown in Table 7.8.

The U and V color difference signals are lowpass filtered, with the same considerations as those used for the analog PAL encoder. Note, however, that the lowpass filters should be optimized for 17.73 MHz in this instance. Because there may be many cascaded conversions, the filters should be designed to very tight tolerances to avoid a buildup of visual artifacts; departure from flat amplitude and group delay response due to filtering is amplified through successive stages. For example, if filters exhibiting –1 dB at 1 MHz and –3 dB at 1.3 MHz were employed, the overall response would be –8 dB (at 1 MHz) and –24 dB (at 1.3 MHz) after four stages (assuming 2 filters per stage). The passband flatness and group-delay characteristics are very important. Usually, there is temptation to relax passband accuracy, but a better approach is to reduce the rate of cut-off and keep the passband as flat as possible.

Video Level	8-bit Digital Value	10-bit Digital Value
white	211	844
black	64	256
blank	64	256
sync	1	4

Table 7.8. Sync, Blanking, Black, and White Video Levels for Digital Composite (B, D, G, H, I) PAL Video Signals.

Since the pixel clock rate is four times the subcarrier frequency, F_{SC}, and aligned along the ±U and ±V axes, the subcarrier sin and cos values are 0 and ±1. There is no need for the sin and cos subcarrier ROMs and the associated p:q ratio counters used on the PAL encoder. At four times F_{SC}, a 90° subcarrier phase shift is a single clock cycle; therefore, a one clock cycle delay implements a 90° phase shift. Note that the PAL SWITCH, used to alternate the sign of V from one line to the next, also must be incorporated.

After the modulated U and V signals are added together, the result is rounded to the desired accuracy; the modulated chrominance has an 8-bit range of 0 to ±93. Burst information is multiplexed with the digital chrominance information. During the color burst time, the modulated chrominance data should be ignored, and the burst information inserted. Burst values are 95, 64, 32, and 64, continuously repeated. The swinging burst causes the peak burst (32 and 95) and zero burst (64) samples to change places.

Note that burst starts at horizontal count 1058, and lasts for 40 pixel clock cycles (10 subcarrier cycles). At this point, we have modulated chrominance and burst information as shown in Table 7.9.

The digital composite luminance data and the digital chrominance data are added together, generating digital composite video with the levels shown in Table 7.10. The digital composite video data is gated with the blanking control signal (BLANK*), forcing the blanking level outside of active digital video.

The horizontal and vertical timing is implemented the same as for the PAL encoder discussed in Chapter 5, with the exception of the horizontal count positions. That PAL encoder used a horizontal count starting at 1, rather than 0; in addition, the horizontal count started at the 50% of the falling edge of horizontal sync rather than at the beginning of active video.

Transmission Timing

8-bit/10-bit Parallel Transmission Interface

Due to many additional timing constraints not discussed here, the reader should obtain any relevant specifications before attempting an actual design. The parallel interface is based on that used for 4:2:2 digital component video (discussed in the next chapter), except for the timing differences.

Video Level	8-bit Digital Value	10-bit Digital Value
peak chroma	93	372
peak burst	31	124
blank	0	0
peak burst	−32	−128
peak chroma	−93	−372

Table 7.9. Chrominance Levels for Digital Composite (B, D, G, H, I) PAL Video Signals.

Video Level	8-bit Digital Value	10-bit Digital Value
peak chroma	260 (limited to 255)	1040 (limited to 1023)
white	211	844
peak burst	95	380
black	64	256
blank	64	256
peak burst	32	128
peak chroma	32	128
sync	1	4

Table 7.10. Video Levels for Digital Composite (B, D, G, H, I) PAL Video Signals. Note that not all 100% amplitude, 100% saturation signals are possible.

Eight-bit or 10-bit data and a four times F_{SC} clock signal are transmitted using 12 pairs of cables. The individual bits are labeled Data 0–Data 9, with Data 9 being the most significant bit. The pin allocations for the signals are shown in Table 7.11. Equipment inputs and outputs both use 25-pin D-type subminiature female sockets so that interconnect cables can be used in either direction. Signal levels are compatible with ECL-compatible balanced

drivers and receivers (although use of ECL technology is not specified). With the NRZ data format, transmission distances up to 50 m (unequalized) or 200 m (equalized) may be used.

The generator must have a balanced output with a maximum source impedance of 110 Ω; the signal must be between 0.8 V peak-to-peak and 2.0 V peak-to-peak measured across a 110-Ω resistor connected to the output termi-

Pin	Signal	Pin	Signal
1	clock +	14	clock −
2	system ground	15	system ground
3	data 9 +	16	data 9 −
4	data 8 +	17	data 8 −
5	data 7 +	18	data 7 −
6	data 6 +	19	data 6 −
7	data 5 +	20	data 5 −
8	data 4 +	21	data 4 −
9	data 3 +	22	data 3 −
10	data 2 +	23	data 2 −
11	data 1 +	24	data 1 −
12	data 0 +	25	data 0 −
13	cable shield		

Table 7.11. Parallel Connector Contact Assignments. For 8-bit interfaces, data 9–data 2 are used.

nals without any transmission line. The transmitted clock signal is a 14.32 MHz or 17.72 MHz (four times F_{SC}) square wave, with a clock pulse width of 35 ±5 ns for (M) NTSC or 28 ±5 ns for (B, D, G, H, I) PAL. The positive transition of the clock signal occurs midway between data transitions with a tolerance of ±5 ns (as shown in Figure 7.4)—a difficult problem to solve without using adjustable delay lines and performing periodic tweaking. At the receiver, the transmission line must be terminated by 110 ±10 Ω.

To permit reliable operation at the longer interconnect lengths, the line receiver may incorporate frequency equalization, which should conform to the nominal characteristics shown in Figure 7.5. This example enables operation with a range of cable lengths down to zero.

10-bit Serial Transmission Interface

To support both the 8-bit and 10-bit environment, a 143 or 177 Mbit-per-second serial protocol was developed (Figure 7.6). This protocol makes use of 10 bits of parallel data latched at 4 times F_{SC}. A 10-times PLL generates a 40-times F_{SC} clock from the 4-times F_{SC} clock signal. The 10 bits of data are serialized (LSB first) and processed using a scrambled NRZI format as follows:

$$G(x) = (x^9 + x^4 + 1)(x + 1)$$

The input signal to the scrambler (Figure 7.7) must use positive logic (the highest voltage represents a logical one; lowest voltage represents a logical zero). The formatted serial data is output at a 40-times F_{SC} bit-per-

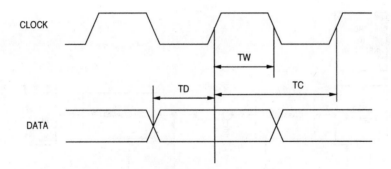

TW = 35 ± 5 NS (M) NTSC; 28 ± 5 NS (B, D, G, H, I) PAL

TC = 69.84 NS (M) NTSC; 56.39 NS (B, D, G, H, I) PAL

TD = 35 ± 5 NS (M) NTSC; 28 ± 5 NS (B, D, G, H, I) PAL

Figure 7.4. Parallel Transmitted Waveforms.

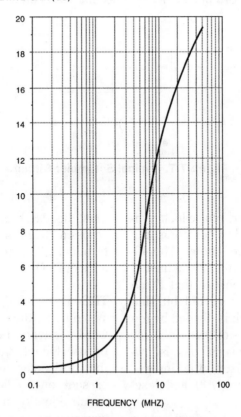

Figure 7.5. Line Receiver Equalization Characteristics for Small Signals.

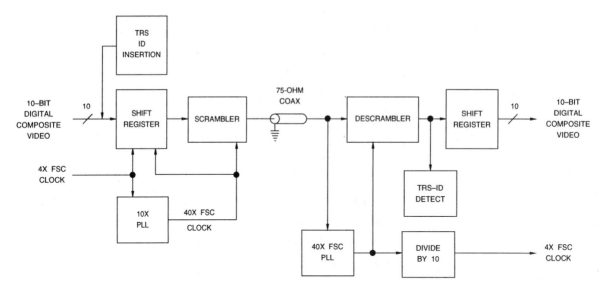

Figure 7.6. 143 or 177 Mbit-per-second Serial Interface Circuitry.

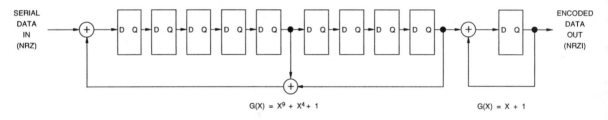

$$G(X) = X^9 + X^4 + 1 \qquad G(X) = X + 1$$

Figure 7.7. Typical Scrambler Circuit.

second rate. At the receiver, phase-lock synchronization is achieved by detecting the TRS-ID sequences (described later). The 40-times F_{SC} PLL is continuously adjusted slightly each scan line to ensure that these patterns are detected and to avoid bit slippage. The 40-times Fsc clock is divided by ten to generate the 4-times F_{SC} output clock for the 10-bit parallel data. The serial data is low- and high-frequency equalized, the inverse scrambling performed (Figure 7.8), and deserialized.

The generator has an unbalanced output with a source impedance of 75 Ω; the signal must be 0.8 V ±10% peak-to-peak measured across a 75-Ω resistor connected to the output terminals. The receiver has an input impedance of 75 Ω.

TRS-ID

When using the serial interface, a special five-word sequence (known as the TRS-ID) must be inserted into the digital video stream during the horizontal sync time. The TRS-ID is present only following sync leading edges, which identify a horizontal transition, and occupies horizontal counts 790–794, inclusive (NTSC) or 967–971, inclusive (PAL). Table

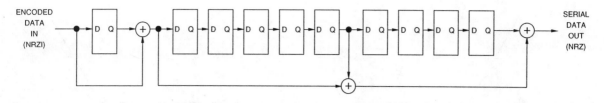

Figure 7.8. Typical Descrambler Circuit.

	D9 (MSB)	D8	D7	D6	D5	D4	D3	D2	D1	D0
TRS word 0	1	1	1	1	1	1	1	1	1	1
TRS word 1	0	0	0	0	0	0	0	0	0	0
TRS word 2	0	0	0	0	0	0	0	0	0	0
TRS word 3	0	0	0	0	0	0	0	0	0	0
line number ID	D8*	ep	line number ID							

D8* = inverted value of the D8 bit.
ep = even parity for D0–D7

Table 7.12. TRS-ID Format.

7.12 shows the TRS-ID format; Figures 7.9 through 7.14 show the TRS-ID locations for digital composite (M) NTSC and (B, D, G, H, I) PAL video signals, respectively.

The line number ID word at horizontal count 794 (NTSC) or 971 (PAL) is defined as shown in Table 7.13.

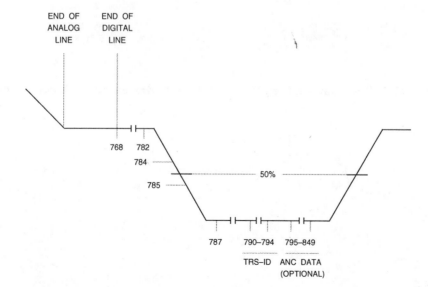

Figure 7.9. (M) NTSC TRS-ID and Ancillary Data Locations During Horizontal Sync Intervals (not to scale).

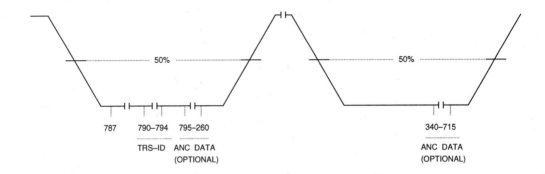

Figure 7.10. (M) NTSC TRS-ID and Ancillary Data Locations During Vertical Sync Intervals (not to scale).

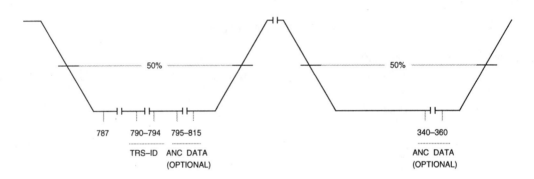

Figure 7.11. (M) NTSC TRS-ID and Ancillary Data Locations During Equalizing Pulse Intervals (not to scale).

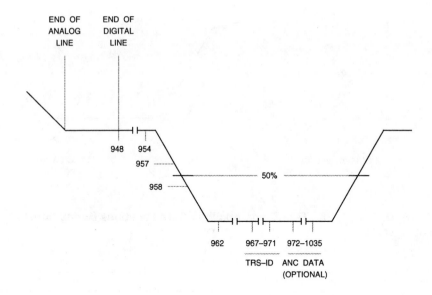

Figure 7.12. (B, D, G, H, I) PAL TRS-ID and Ancillary Data Locations During Horizontal Sync Intervals (not to scale).

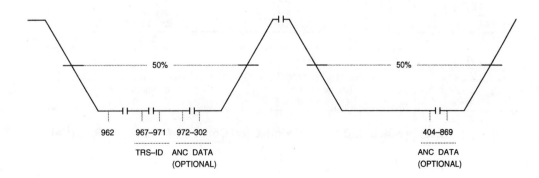

Figure 7.13. (B, D, G, H, I) PAL TRS-ID and Ancillary Data Locations During Vertical Sync Intervals (not to scale).

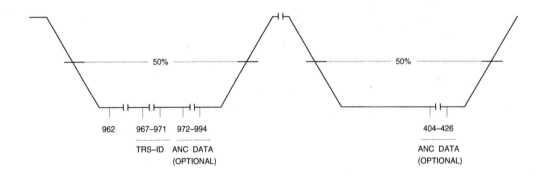

Figure 7.14. (B, D, G, H, I) PAL TRS-ID and Ancillary Data Locations During Equalizing Pulse Intervals (not to scale).

D2	D1	D0	NTSC	PAL
0	0	0	line 1–263 field 1	line 1–313 field 1
0	0	1	line 264–525 field 2	line 314–625 field 2
0	1	0	line 1–263 field 3	line 1–313 field 3
0	1	1	line 264–525 field 4	line 314–625 field 4
1	0	0	not used	line 1–313 field 5
1	0	1	not used	line 314–625 field 6
1	1	0	not used	line 1–313 field 7
1	1	1	not used	line 314–625 field 8

D7–D3	NTSC	PAL
$1 \leq x \leq 30$	line number 1–30 [264–293]	line number 1–30 [314–343]
$x = 31$	line number ≥ 31 [294]	line number ≥ 31 [344]
$x = 0$	not used	not used

Table 7.13. Line Number ID Word at Horizontal Count 794 (NTSC) or 971 (PAL).

PAL requires the reset of the TRS-ID position relative to horizontal sync on lines 1 and 314 due to the 25-Hz offset. All lines have 1135 samples except lines 313 and 625, which have 1137 samples. The two additional samples on lines 313 and 625 are numbered 1135 and 1136, and occur just prior to the first active picture sample (sample 0).

Due to the 25-Hz offset, the samples occur slightly earlier each line. Initial determination of the TRS-ID position should be done on line 1, field 1, or a nearby line. The TRS-ID location always starts at sample 967, but the distance from the leading edge of sync varies due to the 25-Hz offset.

Ancillary Data

Ancillary data enables the transmission of various control data (such as digital audio, scan line numbers, error checking, field number-

ing, etc.) during the sync intervals. Design of the digital video encoder must ensure that ancillary information is generated only when appropriate. Currently, ancillary data is only defined to be used with the serial transmission protocol.

General Format

Ancillary data may be present within the following word number boundaries (see Figures 7.9 through 7.14).

NTSC	PAL	
795–849	972–1035	horizontal sync period
795–815	972–994	equalizing pulse periods
340–360	404–426	
795–260	972–302	vertical sync periods
340–715	404–869	

The general ancillary data structure is shown in Table 7.14.

The ancillary data flag must be present if ancillary data is to be recognized (the value is $3FC_H$). There may be multiple ancillary data flags following the TRS-ID. Each flag identifies the beginning of another data block.

The data ID word identifies the type of user data; a value of FF_H for D0–D7 indicates audio data.

The data block number, if active, increments by one (according to modulo 255) for consecutive blocks of data with a common data ID or when data blocks with a common data ID are to be linked. If D0–D7 are set to zero, the data block number is inactive and is not to be used by the receiver to indicate continuity of the data.

The data count word represents the number of user data words that follow, up to a maximum of 255.

	D9 (MSB)	D8	D7	D6	D5	D4	D3	D2	D1	D0
ancillary data flag	1	1	1	1	1	1	1	1	0	0
data ID	D8*	ep				value of 0 to 255				
data block number	D8*	ep				value of 0 to 255				
data count	D8*	ep				value of 0 to 255				
8-bit word format										
user data n user data n + 1 :	D8* D8* :	ep ep :				user data word n user data word n + 1 :				
9-bit word format										
user data n user data n + 1 :	D8* D8* :					user data word n user data word n + 1 :				
check sum	D8*					Sum of D0–D8 of data ID through last user data word. Preset to all zeros; carry is ignored.				

D8* = inverted value of the D8 bit
ep = even parity for D0–D7

Table 7.14. Ancillary Data Structure.

The user data words are used to convey information as identified by the data ID word. The maximum number of user data words is 255, excluding the check sum. Note that user data words may consist of either 8-bit words plus even parity or 9-bit words positioned at D0–D8. The location of the LSB/MSB of user data is defined by a lookup table assigned to the individual data ID.

Digital Audio Format

Although digital audio may be transmitted as ancillary information, most professional digital composite VCRs accept digital audio using the AES/EBU audio protocol (AES3 or ANSI S4.40) with a sample rate of 48 kHz. The 48-kHz samples of the audio data are locked to the video as follows:

525–line systems: $48 \text{ kHz} = (1144/375) \ F_H$

625–line systems: $48 \text{ kHz} = (384/125) \ F_H$

If digital audio is to be transmitted as ancillary information, it should follow the format shown in Table 7.15.

Digital Decoding

The decoding of digital composite NTSC and PAL video signals to digital RGB or YCbCr data is similar to that used for the NTSC and PAL decoder discussed in Chapter 6. The major differences are: (a) only digital composite video data is input; (b) the pixel clock rate is 4x F_{SC} (14.32 MHz for NTSC, 17.73 MHz for PAL); and (c) sync genlocking is not required since the video clock is transmitted with the video data and the active video samples are aligned along the IQ (NTSC) or UV (PAL) axes. During the loss of an input signal, the decoder should provide the option to be transparent (so the input source can be monitored), to auto-freeze the output data (to compensate for short duration dropouts), or to autoblack the output data (to avoid potential problems driving a mixer or video tape recorder).

A useful system debugging feature for the decoder is the ability to generate both 75% amplitude, 100% saturation and 100% amplitude, 100% saturation color bars. These should be able to be generated using either the input video timing or internally generated video timing.

Where ranges of values are mentioned, it is assumed 8-bit (plus sign) data values are used; 10-bit (plus sign) data values will result in more accurate computations at the expense of more circuitry.

NTSC Considerations

As with the analog NTSC decoder (discussed in Chapter 6), the composite video is processed by a Y/C separator. The output of the Y/C separator is separate luminance (Y) and chrominance (C) information. Y has 70 subtracted from it to remove the sync and blanking information; the resulting Y has a range of 0–130. Chrominance has a range of 0 to ±82.

Since the pixel clock rate is four times the subcarrier frequency F_{SC}, and aligned along the ±I and ±Q axes, the subcarrier sin and cos values are 0 and ±1. There is no need for the sin and cos subcarrier ROMs and the associated p:q ratio counters used on the NTSC decoder discussed in Chapter 6. The 33° phase shift of the subcarrier during active video is automatically accommodated by aligning the pixel clock along the ± I and ±Q axes. At four-times F_{SC}, a 90° subcarrier phase shift is a single clock cycle; therefore, a one clock cycle delay implements a 90° phase shift. Although sync genlocking is not required, the subcarrier

	D9 (MSB)	D8	D7	D6	D5	D4	D3	D2	D1	D0
ancillary data flag	1	1	1	1	1	1	1	1	0	0
data ID	D8*	ep	1	1	1	1	1	1	1	1
data block number	D8*	ep	value of 0 to 255							
data count	D8*	ep	Number of data words, maximum value of 255							
3 data words for audio sample 1	D8*	A5	A4	A3	A2	A1	A0	CH 1	CH 0	Z
	D8*	A14	A13	A12	A11	A10	A9	A8	A7	A6
	D8*	P	C	U	V	A19	A18	A17	A16	A15
					:					
3 data words for audio sample n	D8*	A5	A4	A3	A2	A1	A0	CH 1	CH 0	Z
	D8*	A14	A13	A12	A11	A10	A9	A8	A7	A6
	D8*	P	C	U	V	A19	A18	A17	A16	A15
check sum	D8*	Sum of D0–D8 of data ID through last data word. Preset to all zeros; carry is ignored.								

A0–A19: digital audio samples, A19 = MSB
V: AES/EBU Validity bit
U: AES/EBU User Data bit
C: AES/EBU Channel Status bit
Z: AES/EBU Z flag: specifies beginning of 192-sample channel status packet

P: even parity bit of the other 26 bits of the audio sample
ep: even parity bit for D0–D7
D8*: inverted value of D8 bit
CH 0 and CH 1 specify the audio channel number, CH 1 = MSB

Table 7.15. Digital Audio Ancillary Format.

generator must be genlocked to the incoming subcarrier by monitoring the burst phase. After demodulation, I has a range of 0 to ±78, and Q has a range of 0 to ±68. The digital composite sync information is separated into horizontal sync (HSYNC*) and vertical sync (VSYNC*) outputs.

The I and Q color difference signals are lowpass filtered, with the same considerations as those used for the NTSC decoder discussed in Chapter 6. Note, however, that the lowpass filters should be optimized for a 14.32 MHz clock rate in this instance. As there may be many cascaded conversions, the filters should be designed to very tight tolerances to avoid a build-up of visual artifacts; departure from flat amplitude and group delay response due to filtering are amplified through successive stages. For example, if filters exhibiting –1 dB at 1 MHz and –3 dB at 1.3 MHz were employed, the overall response would be –8 dB (at 1 MHz) and –24 dB (at 1.3 MHz) after four stages (assuming two filters per stage). The passband flatness and group-delay characteristics are very important.

Processing for optional saturation, hue, contrast, and brightness is the same as for the NTSC decoder. Finally, the YIQ data is converted to either RGB or YCbCr using the same equations as those for the analog NTSC decoder. For computer applications, the gamma-correction factor may be removed to generate linear RGB data (values are normalized to have a value of 0 to 1):

for R', G', B' < 0.0812

$$R = R' / 4.5$$
$$G = G' / 4.5$$
$$B = B' / 4.5$$

for R', G', B' ≥ 0.0812

$$R = ((R' + 0.099) / 1.099)^{2.2}$$
$$G = ((G' + 0.099) / 1.099)^{2.2}$$
$$B = ((B' + 0.099) / 1.099)^{2.2}$$

PAL Considerations

As with the analog PAL decoder discussed in Chapter 6, the composite video is processed by a Y/C separator. The output of the Y/C separator is separate luminance (Y) and chrominance (C) information. Y has 64 subtracted from it to remove the sync and blanking information; the resulting Y has a range of 0 to 147. Chrominance has a range of 0 to ±93.

Since the pixel clock rate is four times the subcarrier frequency, F_{SC}, and aligned along the ±U and ±V axes, the subcarrier sin and cos values are 0 and ±1. There is no need for the sin and cos subcarrier ROMs and the associated p:q ratio counters used on the PAL decoder discussed in Chapter 6. At four times F_{SC}, a 90° subcarrier phase shift is a single clock cycle; therefore, a one clock cycle delay implements a 90° phase shift. Although sync genlocking is not required, the subcarrier generator must be genlocked to the incoming subcarrier by monitoring the burst phase, and the

PAL SWITCH must be implemented. After demodulation, U has a range of 0 to ±64, and V has a range of 0 to ±91. The digital composite sync information is separated into horizontal sync (HSYNC*) and vertical sync (VSYNC*) outputs.

The U and V color difference signals are lowpass filtered, with the same considerations as those used for the analog PAL decoder. Note, however, that the lowpass filters should be optimized for a 17.73 MHz clock rate in this instance. As there may be many cascaded conversions, the filters should be designed to very tight tolerances to avoid a buildup of visual artifacts; departure from flat amplitude and group delay response due to filtering are amplified through successive stages. The passband flatness and group-delay characteristics are very important.

Processing for optional saturation, hue, contrast, and brightness is the same as for the analog PAL decoder. Finally, the YUV data is converted to either R'G'B' or YCbCr using the following equations:

YUV to R'G'B'

$$R' = 1.735Y + 1.978V$$
$$G' = 1.735Y - 0.685U - 1.008V$$
$$B' = 1.735Y + 3.525U$$

YUV to YCbCr

$$Y = 1.490Y + 16$$
$$Cb = 1.748U + 128$$
$$Cr = 1.236V + 128$$

For computer applications, the gamma-correction factor may be removed to generate linear RGB data.

Although the PAL standard specifies a gamma of 2.8, a value of 2.2 is now used. Therefore, the same gamma-correction equations are used for both NTSC and PAL.

Professional video systems may use the R'G'B' color space, with R'G'B' having a nominal range of 16 to 235. Occasional values less than 16 and greater than 235 are allowed. In this instance, YUV may be converted to R'G'B' by scaling the YUV-to-RGB equations by 219/255 and adding an offset of 16:

$$R' = 1.490Y + 1.699V + 16$$
$$G' = 1.490Y - 0.588U - 0.866V + 16$$
$$B' = 1.490Y + 3.027U + 16$$

VLSI Solutions

See C7_VLSI

References

1. ANSI/SMPTE 244M–1993, *System M/ NTSC Composite Video Signals—Bit-Parallel Digital Interface.*
2. ANSI/SMPTE 259M–1993, *10-Bit 4:2:2 Component and 4F$_{SC}$ NTSC Composite Digital Signals—Serial Digital Interface.*
3. Gennum Corporation, GS9000 Datasheet, document number 560-26-3.
4. Gennum Corporation, GS9002 Datasheet, document number 560-27-2.
5. Sony Corporation, SBX1601A Datasheet, 1991.
6. Sony Corporation, SBX1602A Datasheet, 1991.
7. Sony Corporation, CXD8110K Datasheet, 1991.
8. Sony Corporation, CXD8129K Datasheet, 1991.
9. Watkinson, John, *The Art of Digital Video*, Focal Press, 1990.

4:2:2 Digital Component Video

In 4:2:2 digital component video, the video signals are in component (YCbCr) form, being encoded to composite form only when it is necessary for broadcasting or recording purposes. Advantages of using the 4:2:2 standard are several: a common color space (YCbCr), the same number of active pixels per scan line (720) regardless of the video standard (although the number of scan lines are still different), and a hierarchy of compatible coding standards. Although initially developed as a studio-level video interface, the 4:2:2 standard is now being used within video equipment and PCs to simplify the processing of video and the design of equipment for use worldwide.

The European Broadcasting Union (EBU) became interested in a standard for digital component video due to the difficulties of exchanging video material between the 625-line PAL and SECAM systems. The format held the promise that the digital video signals would be identical whether sourced in a PAL or SECAM country, allowing subsequent encoding to the appropriate digital composite form for broadcasting. Consultations with the Society of Motion Picture and Television Engi-

neers (SMPTE) resulted in the development of an approach to support international program exchange, including 525-line systems.

A series of demonstrations was carried out, using experimental equipment, to determine the quality and suitability for signal processing of various methods. From these investigations, the main parameters of the digital component coding and filtering standard were chosen (Recommendation ITU-R BT.601). More detailed specifications, such as ANSI/SMPTE 125M, EBU 3267 (which replaces EBU 3246 and EBU 3247) and Recommendation ITU-R BT.656, were then developed to define the actual transmission interfaces between equipment. ITU-R BT.801 describes test signals specifically designed for the 4:2:2 digital video environment.

This chapter discusses 4:2:2 encoder and decoder architectures, transmission of 4:2:2 digital component video, and ancillary data capabilities such as digital audio. Audio is transmitted digitally either over a separate digital channel (using the AES/EBU digital audio protocol) or during the digital video blanking intervals (as ancillary data).

Sampling Rate and Color Space Selection

Line-locked sampling of the analog component video signals is used to convert analog R′G′B′ or YUV video signals to 4:2:2 digital component. This technique produces a static orthogonal sampling grid in which samples on the current scan line fall directly beneath those on previous scan lines and fields (Figure 8.1). Another important feature is that the sampling is locked in phase so that one sample is coincident with the 50% amplitude point of the falling edge of analog horizontal sync (Figure 8.2). This ensures that different sources produce samples at nominally the same positions in the picture. Making this feature common to all members of the hierarchy simplifies conversion from one level to another. The component video signals chosen were luma (Y) and two color difference signals (Cb and Cr), which are scaled and offset versions of the Y, B′–Y, and R′–Y signals. This allows compatibility between various television signal standards and provides the ability to sample the Cb and Cr color difference signals at half the rate of the Y to reduce bandwidth and storage requirements.

Initially, several Y sampling frequencies were examined, including four times F_{sc}. However, the four-times F_{sc} sampling rates did not support the requirement of simplifying international exchange of programs, so they were dropped in favor of a single common sampling rate. Because the lowest sample rate possible (while still supporting quality video) was a goal, a 12-MHz sample rate was preferred for a long time, but eventually was considered to be too close to the Nyquist limit, complicating the filtering requirements. When the frequencies between 12 MHz and 14.3 MHz were exam-

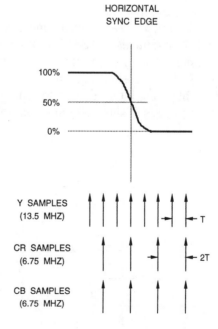

T = (1 / 13.5) MICROSECONDS

Figure 8.2. 4:2:2 YCbCr Samples Relative to the Analog Sync Position.

SCAN LINE

⦿ Y, CR, CB SAMPLE

● Y SAMPLE ONLY

Figure 8.1. 4:2:2 Orthogonal Sampling. The position of sampling sites on the scan lines of a 625-line interlaced system.

ined, it became evident that a 13.5-MHz sample rate for Y provided some commonality between 525- and 625-line systems. Cb and Cr, being color difference signals, do not require the same bandwidth as the luma, so are sampled at half the luma, or 6.75 MHz. The accepted notation for a digital component system with sampling frequencies of 13.5, 6.75, and 6.75 MHz for the luma and color difference signals, respectively, is 4:2:2 (Y:Cb:Cr).

With 13.5-MHz sampling, each scan line contains 858 samples (525-line systems) or 864 samples (625-line systems) and consists of a digital blanking interval followed by an active line period. Both the 525- and 625-line systems have 720 samples during the active line period, with 138 samples (525-line systems) or 144 samples (625-line systems) present during digital blanking. Having a common number of samples for the active line period simplifies the design of multistandard equipment and standards conversion. With a sample rate of 6.75 MHz for Cb and Cr, each active line period contains 360 Cr samples and 360 Cb samples.

With analog systems, problems may arise with repeated processing, causing an extension of the blanking intervals and softening of the blanking edges. Using 720 digital samples for the active line period accommodates the range of analog blanking tolerances of both the 525- and 625-line systems. Therefore, repeated processing may be done without affecting the digital blanking interval. Blanking to define the analog picture width need only be done once, preferably at the monitor or conversion to composite video.

Standards Hierarchy

A unique feature of Recommendation ITU-R BT.601 is the coexistence of a hierarchy of compatible coding standards, provided that conversion to 4:2:2 sampling is straightforward. In practice, this restricts the choices to sampling frequencies with simple relationships to 4:2:2 frequencies, such as 4:4:4, 4:1:1, or 2:1:1. Using simple fixed ratios between the sampling rates allows conversions between them to be achieved using simple fixed-value interpolators. This hierarchy (shown in Table 8.1; see also Tables 8.2 and 8.3) allows the development of systems for which 4:2:2 would be unsuitable or unnecessary and still ensure compatibility.

Interest grew in higher members of the 4:2:2 hierarchy, especially regarding high defi-

Standard	Y Sample Rate	Cb Sample Rate	Cr Sample Rate	RGB Sample Rate
4:4:4 (see Table 8.2)	13.5 MHz	13.5 MHz	13.5 MHz	13.5 MHz
4:2:2 (see Table 8.3)	13.5 MHz	6.75 MHz	6.75 MHz	–
4:1:1	13.5 MHz	3.375 MHz	3.375 MHz	–
2:1:1	6.75 MHz	3.375 MHz	3.375 MHz	–

Table 8.1. Digital Component Video Hierarchy.

Parameters	525/60 Systems	625/50 Systems
Coded signals: Y, Cb, Cr or R′, G′, B′	These signals are obtained from gamma precorrected signals, namely: Y, B′ – Y, R′ – Y or R′, G′, B′.	
Number of samples per total line: Y or R′, G′, B′ Cb, Cr	858 858	864 864
Sampling structure	Orthogonal, line, field and frame repetitive. The three sampling structures to be coincident and coincident also with the luma sampling structure of the 4:2:2 family member.	
Sampling frequency: Y or R′, G′, B′ Cb, Cr	13.5 MHz 13.5 MHz The tolerance for the sampling frequencies should coincide with the tolerance for the line frequency of the relevant color television standard.	
Form of coding	Uniformly quantized PCM, 8 or 10 bits per sample.	
Number of samples per digital active line: Y or R′, G′, B′ Cb, Cr	720 720	
Analog-to-digital horizontal timing relationship from end of digital active line to 0_H	16 Y clock periods	12 Y clock periods
Correspondence between video signal levels and quantization level for each sample: scale Y or R′, G′, B′ Cb, Cr Code-word usage	 0 to 255 (0 to 1023) 220 (877) quantization levels with the black level corresponding to level 16 (64) and the peak level corresponding to level 235 (940). The signal level may occasionally excurse beyond level 235 (940). 225 (897) quantization levels in the center part of the quantization scale with zero signal corresponding to level 128 (512). Code words 0 (0–3) and 255 (1020–1023) are used exclusively for synchronization.	

Table 8.2. Encoding Parameter Values for the 4:4:4 Member of the Family. 10-bit values are in parentheses and indicate 2 bits of fractional video data are used.

Parameters	525/60 Systems	625/50 Systems
Coded signals: Y, Cb, Cr	These signals are obtained from gamma precorrected signals, namely: Y, B′ – Y, R′ – Y or R′, G′, B′.	
Number of samples per total line: Y Cb, Cr	858 429	864 432
Sampling structure	Orthogonal, line, field and frame repetitive. Cb and Cr samples co-sited with odd (1st, 3rd, 5th, etc.) Y samples in each line.	
Sampling frequency: Y Cb, Cr	13.5 MHz 6.75 MHz The tolerance for the sampling frequencies should coincide with the tolerance for the line frequency of the relevant color television standard.	
Form of coding	Uniformly quantized PCM, 8 or 10 bits per sample, for the luma and each color difference signal.	
Number of samples per digital active line: Y Cb, Cr	720 360	
Analog-to-digital horizontal timing relationship from end of digital active line to 0_H	16 Y clock periods	12 Y clock periods
Correspondence between video signal levels and quantization level for each sample: scale Y Cb, Cr Code-word usage	 0 to 255 (0 to 1023) 220 (877) quantization levels with the black level corresponding to level 16 (64) and the peak level corresponding to level 235 (940). The signal level may occasionally excurse beyond level 235 (940). 225 (897) quantization levels in the center part of the quantization scale with zero signal corresponding to level 128 (512). Code words 0 (0–3) and 255 (1020–1023) are used exclusively for synchronization.	

Table 8.3. Encoding Parameter Values for the 4:2:2 Member of the Family. 10-bit values are in parentheses and indicate 2 bits of fractional video data are used.

nition television. In conversions involving higher scanning rates, a simple relationship between the positions of the picture sample points is as important as a simple relationship in clock frequencies.

A 4:4:4:4 hierarchy (commonly referred to as "4 × 4") is discussed later in this chapter. This implementation allows the transmission of four components of video data (either YCbCr or R′G′B′ and an additional component typically used for keying). Each component is sampled at 13.5 MHz with 10 bits of resolution.

YCbCr Coding Ranges

The selection of the coding ranges balances the requirements of adequate capacity for signals beyond the normal range and minimizing quantizing distortion. Although the black level of a video signal is reasonably well defined, the white level can be subject to variations due to video signal and equipment tolerances. Noise, gain variations, and transients produced by filtering can produce signal levels outside the nominal ranges.

Recommendation ITU-R BT.601 uses 8 bits per sample for each of the Y, Cb, and Cr components. Although 8-bit coding introduces some quantizing distortion, it was originally felt that most video sources contained suffi-

cient noise to mask most of the quantizing distortion. However, if the video source is virtually noise-free, the quantizing distortion is noticeable as contouring in areas where the signal brightness gradually changes. In addition, at least two additional bits of fractional YCbCr data were desirable to reduce rounding effects when transmitting between equipment in the studio editing environment. For these reasons, most studio equipment currently uses a 10-bit version of 4:2:2, allowing 2 bits of fractional YCbCr data to be maintained.

The 8-bit coding levels of Recommendation ITU-R BT.601 correspond to a range of 256 levels (0 to 255 decimal or 00_H to FF_H). Levels 0 and 255 are reserved for timing information, leaving levels 1 to 254 for the actual signal values. Initial proposals had equal coding ranges for all three YCbCr components. However, this was changed so the luma value had a greater margin for overloads at the white levels, as white level limiting is more visible than black. Thus, the nominal luma (and RGB) levels are 16 to 235, while the nominal color difference levels are 16 to 240 (with 128 equal to zero). Occasional excursions into the other levels are permissible, but never at the 0 and 255 levels. The YCbCr levels to generate a 75% amplitude, 100% saturation color bar signal are shown in Table 8.4. Here, 4:4:4 RGB signals have the same nominal levels as

	Nominal Range	White	Yellow	Cyan	Green	Magenta	Red	Blue	Black
Y	16 to 235	180	162	131	112	84	65	35	16
Cb	16 to 240 (128 = zero)	128	44	156	72	184	100	212	128
Cr	16 to 240 (128 = zero)	128	142	44	58	198	212	114	128

Table 8.4. 75% Amplitude, 100% Saturation YCbCr Color Bars.

luma to simplify the digital matrix conversions between R′G′B′ and YCbCr. To support checking of downstream equipment, it is convenient for the encoder to provide for the automatic generation of 75% amplitude, 100% saturation YCbCr color bars. Note that to achieve a true 8-bit result at the end of the processing chain, professional systems usually maintain at least 2 bits of fractional data, resulting in 10-bit words being transferred between systems. Although various techniques may be used to round the result of a mathematical operation to 8 bits, each rounding operation introduces some noise into the signal. By maintaining two fractional data bits, the noise due to rounding is minimized.

Encoding (Using 4:4:4 Sample Rates)

Digitizing analog RGB using 4:4:4 sample rates and converting to 4:2:2 YCbCr data digitally, as shown in Figure 8.3, have several advantages: support for digital RGB data (such as from a computer graphics frame buffer), stability of the RGB-to-YCbCr matrix (since it is digital rather than analog), and easier design of the analog circuitry (much more immune to temperature and power supply variations and tolerance drift).

The analog RGB video signals are lowpass filtered (to prevent aliasing), and the active video portions (black-to-white levels) of the RGB signals are digitized. The A/D converters are configured to generate a 16 to 235 output range. Any embedded sync information also must be stripped from the video signals and used to control the 27-MHz VCXO PLL (operating in a line-lock configuration) to generate the required timing signals.

Before the RGB-to-YCbCr matrix, ROM or RAM lookup tables may be used to implement any necessary gamma correction, since YCbCr must be derived from R′G′B′ data. Having the ability to bypass or reconfigure the lookup tables is almost a necessity, as both linear and gamma-corrected RGB sources are common.

Gamma-corrected digital RGB signals with a 16 to 235 range may be converted to YCbCr using the following equations:

$$Y = (77/256)R' + (150/256)G' + (29/256)B'$$

$$Cb = -(44/256)R' - (87/256)G' + (131/256)B' + 128$$

$$Cr = (131/256)R' - (110/256)G' - (21/256)B' + 128$$

These RGB-to-YCbCr equations ensure that the YCbCr data has the proper levels (16 to 235 for Y and 16 to 240 for Cr and Cb) for an R′G′B′ input range of 16 to 235. If the R′G′B′ data has a range of 0 to 255, as is commonly found in computer systems, or the A/D converters are configured to generate a 0 to 255 output range, the following equations may be more convenient to use:

$$Y = 0.257R' + 0.504G' + 0.098B' + 16$$

$$Cb = -0.148R' - 0.291G' + 0.439B' + 128$$

$$Cr = 0.439R' - 0.368G' - 0.071B' + 128$$

For both sets of equations, a minimum of 8 bits of fractional data should be maintained, with the final results rounded to the desired accuracy. Since computers commonly use linear RGB data, linear RGB data may be converted to gamma-corrected RGB data as follows (values are normalized to have a value of 0 to 1):

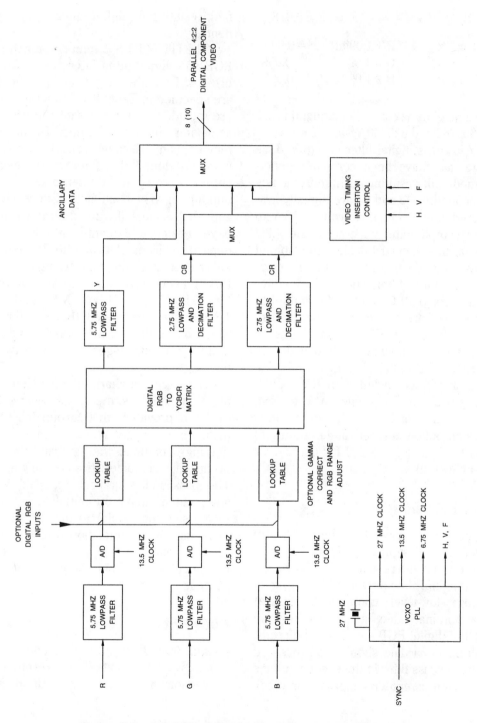

Figure 8.3. 4:2:2 Encoding Using 4:4:4 Sample Rates.

R, G, B < 0.018	R, G, B ≥ 0.018
$R' = 4.5 R$	$R' = 1.099 R^{0.45} - 0.099$
$G' = 4.5 G$	$G' = 1.099 G^{0.45} - 0.099$
$B' = 4.5 B$	$B' = 1.099 B^{0.45} - 0.099$

The same gamma-correction equations are used for 525/60 and 625/50 systems.

The Y lowpass digital filter is required, as the image may have been computer generated or modified, resulting in high-frequency luma components. Cb and Cr are digitally lowpass filtered and decimated from a 13.5 to 6.75 MHz sample rate, generating the 4:2:2 YCbCr data. In a standard design, the Cb and Cr lowpass and decimation filters are combined into a single filter, and a single filter may be used for both Cb and Cr by multiplexing. Not shown are the digital delay adjustments between Y and CbCr data to ensure the video data are pipelined—aligned due to the differences in digital filter delays. Saturation logic should be included in the YCbCr data paths to limit the range to 1 to 254, ensuring that the 0 and 255 codes are not generated (as an option, further range limiting of 16 to 235 for Y and 16 to 240 for Cb and Cr may be supported).

RGB and Y Filtering

Digital sampling requires that the bandwidth of the analog RGB signals be defined by pre-sampling lowpass filters, shown in Figure 8.3. The presampling filter prevents aliasing, generally from low-level components (noise) above the nominal video band. Also shown in Figure 8.3, if digital RGB data is used directly, the resulting luma data should be processed by a digital lowpass filter in the event an image may have been computer generated or modi-

fied, resulting in high-frequency luma components.

The ITU-R BT.601 template for the analog RGB and digital luma filters is shown in Figure 8.4. Both the target and practical limits are specified in Table 8.5. The practical limits are included to demonstrate the difficulty in achieving the target limits. Because there may be many cascaded conversions (up to 10 were envisioned), the filters were designed to adhere to very tight tolerances to avoid a buildup of visual artifacts. Successive A/D and D/A stages do not degrade the signal beyond calculable quantizing noise. However, departure from flat amplitude and group delay response due to filtering is amplified through successive stages. For example, if filters exhibiting –1 dB at 1 MHz and –3 dB at 1.3 MHz were employed, the overall response would be –8 dB (at 1 MHz) and –24 dB (at 1.3 MHz) after four stages (assuming two filters per stage).

Although the sharp cut-off results in ringing on luma edges, the visual effect should be minimal provided that group-delay performance is adequate. When cascading multiple filtering operations, the passband flatness and group-delay characteristics are very important. The passband tolerances, coupled with the sharp cut-off, make the template very difficult (some say impossible) to match. As a result, there usually is temptation to relax passband accuracy, but the best approach is to reduce the rate of cut-off and keep the passband as flat as possible.

CbCr Filtering

As with luma filtering, the Cb and Cr filtering requires a sharp cut-off to prevent repeated conversions from producing a cumulative reso-

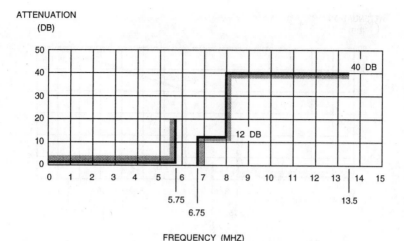

Figure 8.4. RGB and Luma Filter Template When Sampling at 13.5 MHz.

Frequency Range	ITU-R BT.601 Target	ITU-R BT.601 Practical Limits
Passband Ripple Tolerance		
1 kHz to 1 MHz	±0.005 dB	increasing from ±0.01 to ±0.025 dB
1 MHz to 5.5 MHz	±0.005 dB	±0.025 dB
5.5 MHz to 5.75 MHz	±0.005 dB	±0.05 dB
Passband Group Delay Tolerance		
1 kHz to 5.75 MHz	0 increasing to ±2 ns	±1 ns increasing to ±3 ns

Table 8.5. RGB and Luma Filter Ripple and Group Delay Tolerances When Sampling at 13.5 MHz.

lution loss. However, due to the low cut-off frequency, the sharp cut-off produces ringing that is more noticeable than for luma.

The template for the Cb and Cr digital filters used in Figure 8.3 is shown in Figure 8.5. Both the target and practical limits are specified in Table 8.6. The practical limits are included to demonstrate the difficulty in achieving the target limits. Since aliasing is less noticeable in color difference signals,

the attenuation at half the sampling frequency is only 6 dB. There is an advantage in using a skew-symmetric response passing through the –6 dB point at half the sampling frequency—this makes alternate coefficients in the digital filter zero, almost halving the number of taps, and also allows using a single digital filter for both the Cb and Cr signals. Use of a transversal digital filter has the advantage of providing perfect linear phase

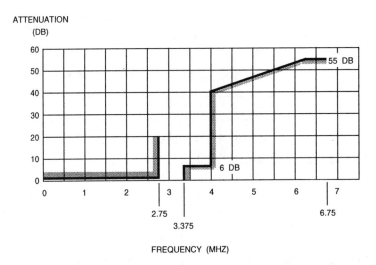

Figure 8.5. Color Difference Filter Template for Digital Filter for Sample Rate Conversion From 4:4:4 To 4:2:2 Color Difference Signals.

Frequency Range	ITU-R BT.601 Target	ITU-R BT.601 Practical Limits
Passband Ripple Tolerance		
1 kHz to 1 MHz	0 dB	increasing from 0 to ±0.05 dB
1 MHz to 2.75 MHz	0 dB	±0.05 dB
Passband Group Delay Tolerance		
1 kHz to 2.75 MHz	delay distortion is zero by design	
2.75 MHz to $F_{-3\,dB}$		

Table 8.6. Color Difference Filter Ripple and Group Delay Tolerances for Digital Filter for Sample Rate Conversion From 4:4:4 to 4:2:2 Color Difference Signals.

response, eliminating the need for group-delay correction. As with the luma filters, the passband flatness and group-delay characteristics are very important, and the best approach again is to reduce the rate of cut-off and keep the passband as flat as possible.

Encoding (Using 4:2:2 Sample Rates)

Analog R′G′B′ video may be converted to analog YUV and digitized at the 4:2:2 sample rates, as shown in Figure 8.6. This probably is less

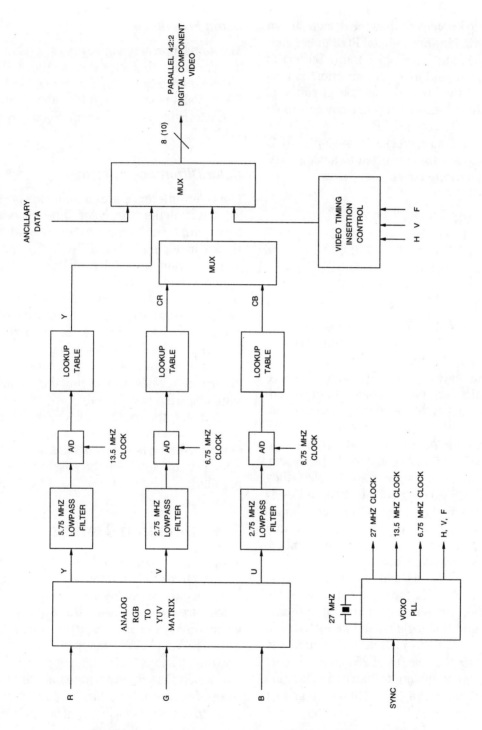

Figure 8.6. 4:2:2 Encoding using 4:2:2 Sample Rates.

expensive to implement than the design shown in Figure 8.3. However, digital RGB data (such as from a computer graphics frame buffer) is not supported, and more design effort is necessary to ensure that the analog circuitry is robust against temperature and power supply variations and tolerance drift.

The gamma-corrected analog RGB (R′G′B′) signals are converted to analog YUV using the following equations:

$$Y = 0.299R' + 0.587G' + 0.114B'$$
$$U = (0.5/0.886)(B' - Y) = 0.564(B' - Y)$$
$$= -0.169R' - 0.331G' + 0.500B'$$
$$V = (0.5/0.701)(R' - Y) = 0.713(R' - Y)$$
$$= 0.500R' - 0.419G' - 0.081B'$$

The YUV signals must be lowpass filtered and the active video portions of the YUV signals digitized. Not shown are the analog delay adjustments between the YUV data to ensure the video data are time-aligned due to the differences in analog filter delays. The A/D converters are configured to generate a 16 to 235 output range for Y and a 16 to 240 output range for Cb and Cr (with 128 equal to 0). As the analog color difference signals are bipolar (they have a normalized range of 0 to ±0.5), the A/D converters for the color difference signals must be configured to generate an output value of 128 when the input is 0. Any embedded sync information also must be stripped from the video signals, and used to control the 27-MHz VCXO PLL (operating in a line-lock configuration) to generate the required timing signals. Saturation logic should be included in the YCbCr data paths to limit the range to 1 to 254, ensuring that the 0 and 255 codes are not generated (as an option, further range limiting of 16 to 235 for Y and 16 to 240 for Cb and Cr may be supported).

Luma Filtering

The luma presampling lowpass analog filter has the same characteristics as the RGB presampling lowpass analog filters used in Figure 8.3, and all the same considerations apply. The characteristics are shown in Figure 8.4 and Table 8.5.

Color Difference Filtering

The color difference presampling lowpass analog filters define the color difference signal bandwidth. The template for the filters is shown in Figure 8.7 and Table 8.7. As with luma filtering, the color difference filtering requires a sharp cut-off to prevent repeated codings from producing a cumulative resolution loss. However, due to the low cut-off frequency, the sharp cut-off produces ringing that is more noticeable than for luma.

Since aliasing is less noticeable in color difference signals, the attenuation at half the sampling frequency is only 6 dB. As with the luma filters, the passband flatness and group-delay characteristics are very important. Once again, the best approach is to reduce the rate of cut-off and keep the passband as flat as possible.

Transmission Timing

Rather than digitize and transmit the entire horizontal blanking interval, a special four-word sequence is inserted into the digital video stream to indicate the start of active video (SAV) and end of active video (EAV). These EAV and SAV sequences indicate when horizontal and vertical blanking are present and which field is being transmitted, enabling most of the horizontal blanking interval to be used to transmit ancillary data such as line

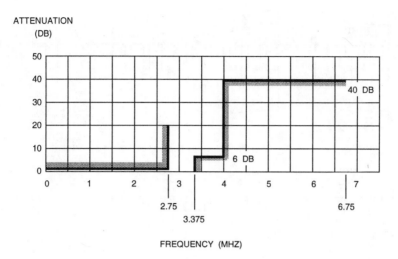

Figure 8.7. Color Difference Filter Template When Sampling at 6.75 MHz.

Frequency Range	ITU-R BT.601 Target	ITU-R BT.601 Practical Limits
Passband Ripple Tolerance		
1 kHz to 0.5 MHz	±0.01 dB	increasing from ±0.02 to ±0.05 dB
0.5 MHz to 2.75 MHz	±0.01 dB	±0.05 dB
Passband Group Delay Tolerance		
1 kHz to 2.75 MHz	increasing from 0 to ±4 ns	increasing from ±2 to ±6 ns
2.75 MHz to $F_{-3\ dB}$	±4 ns	±12 ns

Table 8.7. Color Difference Filter Ripple and Group Delay Tolerances When Sampling at 6.75 MHz.

numbering, digital audio data, error-checking data, and so on. (see Figures 8.8 through 8.15). Note that EAV and SAV sequences must have priority over active video data or ancillary data to ensure that correct video timing is always maintained at the receiver. The receiver decodes the EAV and SAV sequences to recover the video timing signals.

The video timing sequence at the encoder is controlled by three signals—H (horizontal blanking), V (vertical blanking), and F (even or odd field). A logical zero-to-one transition of the H control signal must trigger an EAV (end of active video) sequence while a logical one-to-zero transition must trigger an SAV (start of active video) sequence. The typical values of H, V, and F on different lines are shown in Figure 8.11 and Figure 8.15. F and V are only allowed to change at EAV sequences. Both 8-bit and 10-bit transmission interfaces are supported, with the 10-bit interface used to transmit 2 bits of fractional color data information to minimize cumulative processing errors and support 10-bit ancillary data.

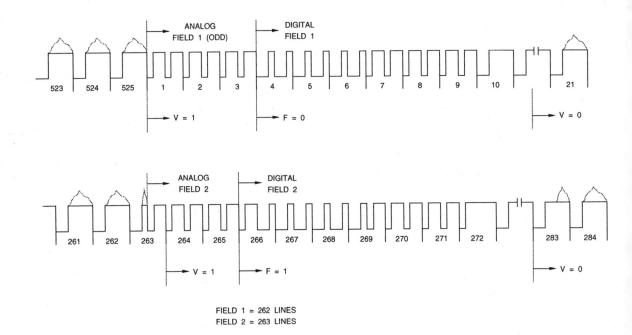

Figure 8.8. 525/60 V and F Timing. Note that the line numbering matches that used in standard practice for 525/60 video signals.

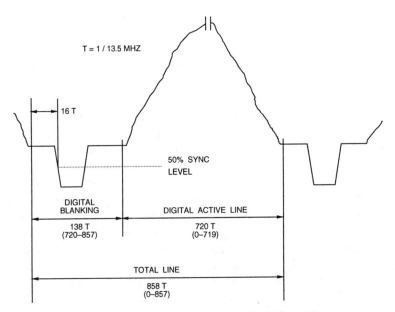

Figure 8.9. 525/60 Horizontal Sync Relationship.

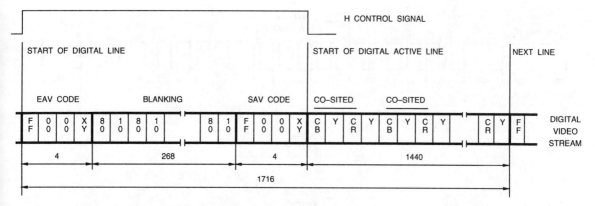

Figure 8.10. 525/60 Digital Horizontal Blanking (8-bit Transmission System).

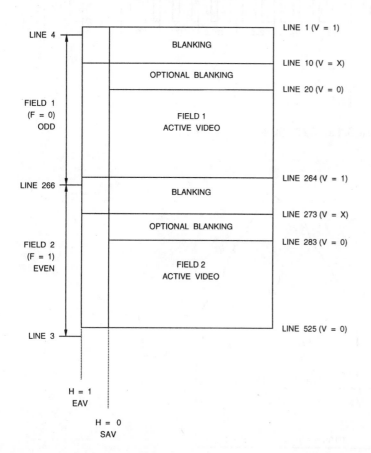

LINE NUMBER	F	V	H (EAV)	H (SAV)
1–3	1	1	1	0
4–19	0	1	1	0
20–263	0	0	1	0
264–265	0	1	1	0
266–282	1	1	1	0
283–525	1	0	1	0

Figure 8.11. 525/60 Digital Vertical Timing. F and V change state synchronously with the EAV sequence at the beginning of the digital line. Note that the digital line number changes state prior to start of horizontal sync, as shown in Figure 8.9.

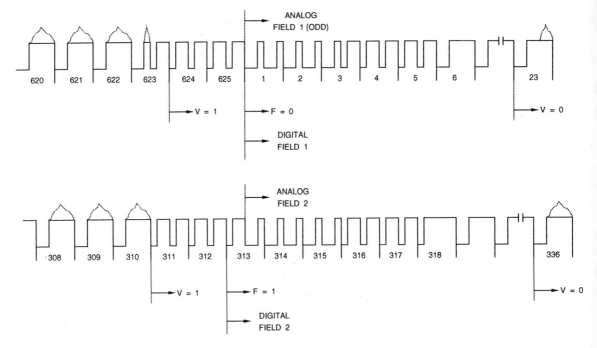

Figure 8.12. 625/50 V and F Timing.

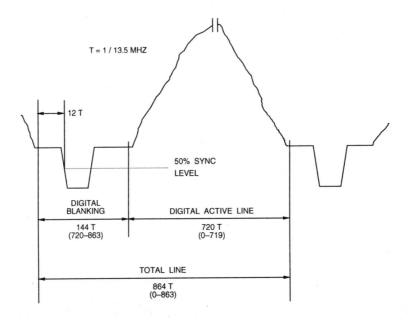

Figure 8.13. 625/50 Horizontal Sync Relationship.

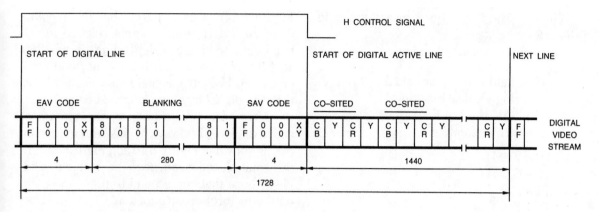

Figure 8.14. 625/50 Digital Horizontal Blanking (8-bit Transmission System).

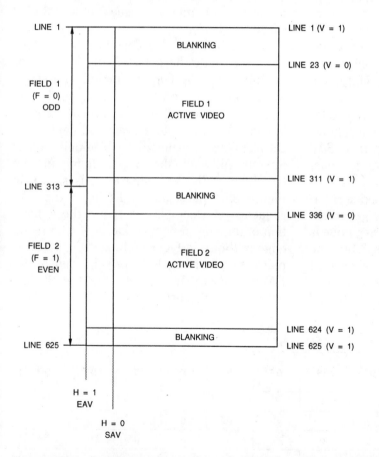

LINE NUMBER	F	V	H (EAV)	H (SAV)
1–22	0	1	1	0
23–310	0	0	1	0
311–312	0	1	1	0
313–335	1	1	1	0
336–623	1	0	1	0
624–625	1	1	1	0

Figure 8.15. 625/50 Digital Vertical Timing. F and V change state synchronously with the EAV sequence at the beginning of the digital line. Note that digital line number changes state prior to start of horizontal sync, as shown in Figure 8.13.

The EAV and SAV sequences are shown in Table 8.8.

The status word is defined as:

F = 0 for field 1; F = 1 for field 2
V = 1 during vertical blanking
H = 0 at SAV, H = 1 at EAV
P3–P0 = protection bits

> P3 = V ⊕ H
> P2 = F ⊕ H
> P1 = F ⊕ V
> P0 = F ⊕ V ⊕ H

where ⊕ represents the exclusive-OR function. These protection bits enable single-bit errors to be detected and corrected (and some multiple bit errors detected) at the receiver. Color and ancillary data may not use the 10-bit values 000_H–003_H and $3FC_H$–$3FF_H$ to avoid contention with 8-bit systems.

A potential timing problem at the encoder is the alignment of the H (horizontal blanking) control signal relative to the EAV and SAV sequences. The EAV and SAV sequences must occupy, respectively, the first four and last four words of the digital horizontal blanking interval. Although an EAV sequence is generated easily from a transition of H (the rising edge is shown in Figure 8.10 and Figure 8.14), the generation of the SAV sequence must start four words before the opposite transition of H (the falling edge is shown in Figure 8.10 and

Figure 8.14). This requires that the pipeline delay of the H control signal relative to the pixel data be changed depending on whether an EAV or SAV sequence is being generated, or that an H control signal four words shorter than the digital blanking interval be used.

After each SAV sequence, the stream of active data words always begins with a Cb sample, as shown in Figure 8.10 and Figure 8.14. In the multiplexed sequence, the co-sited samples (those that correspond to the same point on the picture) are grouped as Cb, Y, Cr. During all blanking intervals, unless ancillary data is present, Y values must be set to 16 (64 if a 10-bit system) and CbCr values set to 128 (512 if a 10-bit system).

At the receiver (decoder) the EAV and SAV sequences must be detected (by looking for the 8-bit FF_H 00_H 00_H preamble). The status word (optionally error corrected at the receiver, see Table 8.9) is used to recover the H, V, and F bits to produce even/odd field, vertical blanking, and horizontal blanking signals directly. Although the proper timing for the transition of H (the falling edge is shown in Figure 8.10 and Figure 8.14) from the SAV sequence is accomplished easily, the generation of the opposite transition of H (the rising edge is shown in Figure 8.10 and Figure 8.14) must start four words before the end of the EAV sequence. This requires that the pipeline delay of the H signal (relative to the pixel data)

	8-bit Data								10-bit Data	
	D9 (MSB)	D8	D7	D6	D5	D4	D3	D2	D1	D0
preamble	1	1	1	1	1	1	1	1	1	1
	0	0	0	0	0	0	0	0	0	0
	0	0	0	0	0	0	0	0	0	0
status word	1	F	V	H	P3	P2	P1	P0	0	0

Table 8.8. EAV and SAV Sequence.

Received D5–D2	Received F, V, H (Bits D8–D6)							
	000	001	010	011	100	101	110	111
0000	000	000	000	*	000	*	*	111
0001	000	*	*	111	*	111	111	111
0010	000	*	*	011	*	101	*	*
0011	*	*	010	*	100	*	*	111
0100	000	*	*	011	*	*	110	*
0101	*	001	*	*	100	*	*	111
0110	*	011	011	011	100	*	*	011
0111	100	*	*	011	100	100	100	*
1000	000	*	*	*	*	101	110	*
1001	*	001	010	*	*	*	*	111
1010	*	101	010	*	101	101	*	101
1011	010	*	010	010	*	101	010	*
1100	*	001	110	*	110	*	110	110
1101	001	001	*	001	*	001	110	*
1110	*	*	*	011	*	101	110	*
1111	*	001	010	*	100	*	*	*

* = uncorrectable error

Table 8.9. SAV and EAV Error Correction at Decoder.

be changed depending on whether an EAV or SAV sequence is being received, or that an H control signal four words shorter than the digital blanking interval be generated. The number of clock cycles between EAV sequences may be used to automatically configure the receiver for 525/60 or 625/50 operation.

Bit-Parallel Transmission Interface

In the parallel interface format, 8-bit or 10-bit data and a 27-MHz clock signal are transmitted using nine pairs (8-bit data) or eleven pairs (10-bit data) of cables. The individual bits are labeled Data 0–Data 9, with Data 9 being the most significant bit. The pin allocations for the signals are shown in Table 8.10. Equipment inputs and outputs both use 25-pin D-type subminiature female sockets so that interconnect cables can be used in either direction. Signal levels are compatible with ECL-compatible balanced drivers and receivers.

The generator must have a balanced output with a maximum source impedance of 110

Pin	Signal	Pin	Signal
1	clock	14	clock return
2	system ground A	15	system ground B
3	data 9	16	data 9 return
4	data 8	17	data 8 return
5	data 7	18	data 7 return
6	data 6	19	data 6 return
7	data 5	20	data 5 return
8	data 4	21	data 4 return
9	data 3	22	data 3 return
10	data 2	23	data 2 return
11	data 1	24	data 1 return
12	data 0	25	data 0 return
13	cable shield		

Table 8.10. Parallel Connector Contact Assignments. For 8-bit interfaces, data 9 through data 2 are used.

Ω; the signal must be between 0.8 V peak-to-peak and 2.0 V peak-to-peak measured across a 110-Ω resistor connected to the output terminals without any transmission line. The transmitted clock signal is a 27-MHz square wave, with a clock pulse width of 18.5 ±3 ns. The positive transition of the clock signal occurs midway between data transitions with a tolerance of ±3 ns (as shown in Figure 8.16)—a difficult problem to solve without using adjustable delay lines and performing periodic tweaking. At the receiver, the transmission line must be terminated by 110 ±10 Ω.

To permit reliable operation at interconnect lengths of 50–200 m, the line receiver may require equalization, which should conform to the nominal characteristics shown in Figure 8.17. This characteristic enables operation with a range of cable lengths down to zero.

Due to many additional timing constraints not discussed here, the reader should obtain the relevant specifications before attempting an actual design.

Bit-Serial Transmission Interfaces

Use of the serial interface allows the digital video data to be transmitted down a single transmission line, using either a standard 75-Ω video coaxial cable or optical fiber. The serial interface was developed because the parallel interface was impractical due to the size of cabling, large connectors, and limited cabling length. Equipment inputs and outputs both use BNC-type sockets so that interconnect cables can be used in either direction.

Due to many additional timing constraints not discussed here, the reader should obtain

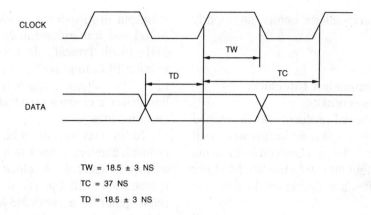

TW = 18.5 ± 3 NS

TC = 37 NS

TD = 18.5 ± 3 NS

Figure 8.16. Parallel Transmitted Waveforms (at Transmitter).

RELATIVE GAIN (DB)

FREQUENCY (MHZ)

**Figure 8.17. Line Receiver Equalization
Characteristics for Small Signals.**

any relevant specifications before attempting an actual design.

Bit-Serial Transmission Interface (243 Mbit per second)

Initially, an 8-bit serial protocol was developed (EBU 3247). However, it is no longer used as it did not support a 10-bit compatible environment; all equipment now uses the 270 Mbit per second serial interface described in the next section.

In the 243 Mbit-per-second serial protocol implementation (Figure 8.18), the 8-bit words are encoded to 9 bits as shown in Table 8.11 (to provide some measure for making the system polarity free). For some 8-bit words, alternate 9-bit encoded words exist, as shown in columns 9B and 9B*, each 9-bit word being the complement of the other. In such cases, the 9-bit word must be selected alternately from columns 9B and 9B* on each successive occasion that any such 8-bit word is conveyed (in the decoder, either 9-bit word must be converted back to the corresponding 8-bit word). The 9-bit parallel words then are serialized (the LSB

is output first) using a 243-MHz clock (9×27 MHz) and transmitted in NRZ form. The 243-MHz clock typically is generated locally by using a PLL, multiplying the 27-MHz clock by nine. The voltage at the output terminal of the line driver increases on a transition from 0 to 1 (positive logic).

At the receiver, the 9 bits of data are deserialized, converted back to 8 bits, and output at a 27-MHz data rate. As clock information is not transmitted with the serial data, the receiver must generate a local 243-MHz clock that is phase-locked to the data stream. The use of 9-bit patterns simplifies this task by introducing more frequent transitions than would be present in the normal 8-bit data. Phase-lock synchronization is handled by detecting the two all-zero words in the normal EAV and SAV sequences; encoded, each all-zero word contains a unique pattern—seven consecutive bits of all zeros or all ones. The 243-MHz PLL is continuously adjusted slightly each scan line to ensure that these patterns are detected and to avoid bit slippage. The 243-MHz clock is divided by nine to generate the 27-MHz output clock for the 8-bit parallel data.

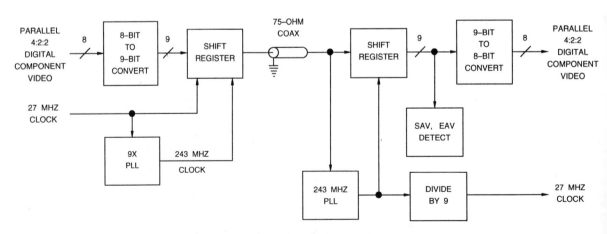

Figure 8.18. 243 Mbit-per-second Serial Interface Circuitry.

in	out	out	in	out	out	in	out	out	in	out	out	in	out	in	out	out
	9B	9B*		9B	9B*		9B	9B*		9B	9B*		9B		9B	9B*
00	0FE	101	2B	053		56	097		81	0AA		AC	12C	D7	0CC	
01	027		2C	1AC		57	168		82	055		AD	0D9	D8	139	
02	1D8		2D	057		58	099		83	1AA		AE	126	D9	0CE	
03	033		2E	1A8		59	166		84	0D5		AF	0E5	DA	133	
04	1CC		2F	059		5A	09B		85	12A		B0	11A	DB	0D8	
05	037		30	1A6		5B	164		86	095		B1	0E9	DC	131	
06	1C8		31	05B		5C	09D		87	16A		B2	116	DD	0DC	
07	039		32	05D		5D	162		88	0B5		B3	02E	DE	127	
08	1C5		33	1A4		5E	0A3		89	14A		B4	1D1	DF	0E2	
09	03B		34	065		5F	15C		8A	09A		B5	036	E0	123	
0A	1C4		35	19A		60	0A7		8B	165		B6	1C9	E1	0E4	
0B	03D		36	069		61	158		8C	0A6		B7	03A	E2	11D	
0C	1C2		37	196		62	025	1DA	8D	159		B8	1C5	E3	0E6	
0D	14D		38	026	1D9	63	0A1	15E	8E	0AC		B9	04E	E4	11B	
0E	0B4		39	08C	173	64	029	1D6	8F	153		BA	1B1	E5	0E8	
0F	14B		3A	02C	1D3	65	091	16E	90	0AE		BB	05C	E6	119	
10	1A2		3B	098	167	66	045	1BA	91	151		BC	1A3	E7	0EC	
11	0B6		3C	032	1CD	67	089	176	92	02A	1D5	BD	05E	E8	117	
12	149		3D	0BE	141	68	049	1B6	93	092	16D	BE	1A1	E9	0F2	
13	0BA		3E	034	1CB	69	085	17A	94	04A	1B5	BF	066	EA	113	
14	145		3F	0C2	13D	6A	051	1AE	95	094	16B	C0	199	EB	0F4	
15	0CA		40	046	1B9	6B	08A	175	96	0A8	157	C1	06C	EC	10D	
16	135		41	0C4	13B	6C	0A4	15B	97	0B7	148	C2	193	ED	076	
17	0D2		42	04C	1B3	6D	054	1AB	98	0F5	10A	C3	06E	EE	10B	
18	12D		43	0C8	137	6E	0A2	15D	99	0BB	144	C4	191	EF	0C7	
19	0D4		44	058	1A7	6F	052	1AD	9A	0ED	112	C5	072	F0	13C	
1A	129		45	0B1		70	056		9B	0BD	142	C6	18D	F1	047	
1B	0D6		46	14E		71	1A9		9C	0EB	114	C7	074	F2	1B8	
1C	125		47	0B3		72	05A		9D	0D7	128	C8	18B	F3	067	
1D	0DA		48	14C		73	1A5		9E	0DD	122	C9	07A	F4	19C	
1E	115		49	0B9		74	06A		9F	0DB	124	CA	189	F5	071	
1F	0EA		4A	06B		75	195		A0	146		CB	08E	F6	198	
20	0B2		4B	194		76	096		A1	0C5		CC	185	F7	073	
21	02B		4C	06D		77	169		A2	13A		CD	09C	F8	18E	
22	1D4		4D	192		78	0A9		A3	0C9		CE	171	F9	079	
23	02D		4E	075		79	156		A4	136		CF	09E	FA	18C	
24	1D2		4F	18A		7A	0AB		A5	0CB		D0	163	FB	087	
25	035		50	08B		7B	154		A6	134		D1	0B8	FC	186	
26	1CA		51	174		7C	0A5		A7	0CD		D2	161	FD	0C3	
27	04B		52	08D		7D	15A		A8	132		D3	0BC	FE	178	
28	1B4		53	172		7E	0AD		A9	0D1		D4	147	FF	062	19D
29	04D		54	093		7F	152		AA	12E		D5	0C6			
2A	1B2		55	16C		80	155		AB	0D3		D6	143			

Table 8.11. 8-bit to 9-bit Encoding Table.

The generator has an unbalanced output with a source impedance of 75 Ω; the signal must be 0.4 V to 0.7 V peak-to-peak measured across a 75-Ω resistor connected to the output terminals. The receiver has an input impedance of 75 Ω.

Bit-Serial Transmission Interface (270 Mbit per second)

To support both the 8-bit and 10-bit environment, a 270 Mbit-per-second serial protocol was developed as shown in Figure 8.19. This protocol makes use of 10 bits of parallel data latched at 27 MHz. A ten times PLL generates a 270-MHz clock from the 27-MHz clock signal. The 10 bits of data are serialized (LSB first) and processed using a scrambled NRZI format as follows:

$$G(x) = (x^9 + x^4 + 1)(x + 1)$$

The input signal to the scrambler (Figure 8.20) uses positive logic (the highest voltage represents a logical one; lowest voltage represents a logical zero). The formatted serial data is output at a 270 Mbit-per-second rate. At the receiver, phase-lock synchronization is done by detecting the EAV and SAV sequences. The 270-MHz PLL is continuously adjusted slightly each scan line to ensure that these patterns are detected and to avoid bit slippage. The 270-MHz clock is divided by ten to generate the 27-MHz output clock for the 10-bit parallel data. The serial data is low- and high-frequency equalized, inverse scrambling performed (Figure 8.21), and deserialized.

The generator has an unbalanced output with a source impedance of 75 Ω; the signal must be 0.8 V ±10% peak-to-peak measured across a 75-Ω resistor connected to the output terminals without any transmission line. The receiver has an input impedance of 75 Ω.

In an 8-bit environment, before serialization, 00_H and FF_H values must be expanded to the 10-bit values of 000_H and $3FF_H$, respectively. All other 8-bit data is appended with two least significant "0" bits before serialization.

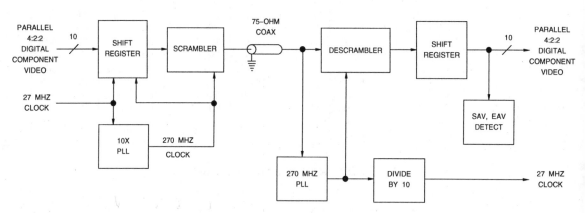

Figure 8.19. 270 Mbit-per-second Serial Interface Circuitry.

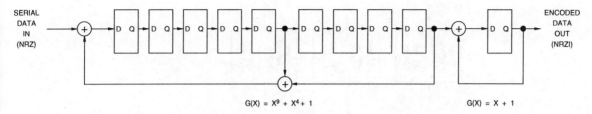

$$G(X) = X^9 + X^4 + 1 \qquad\qquad G(X) = X + 1$$

Figure 8.20. Typical Scrambler Circuit.

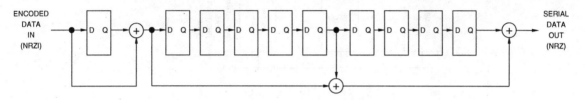

Figure 8.21. Typical Descrambler Circuit.

Decoding (Using 4:4:4 Sample Rates)

In digital decoding (shown in Figure 8.22) the 4:2:2 data stream is input and the video timing signals (H, V, and F) are recovered from the EAV and SAV sequences. At this time, any ancillary information also is detected and output for further processing. The decoder design should be robust enough to ignore 0 and 255 code words, except during EAV, SAV, and ancillary preamble sequences. During the loss of an input signal, the decoder should provide the option either to be transparent (so the input source can be monitored), to auto-freeze the output data (to compensate for short duration dropouts), or to autoblack the output data (to avoid potential problems driving a mixer or video tape recorder). A useful system debugging feature for the decoder is the ability to generate both 75% amplitude, 100% saturation and 100% amplitude, 100% saturation color bars. These should be able to be generated using either the input video timing or internally generated video timing.

The 4:2:2 YCbCr data is demultiplexed and converted to 4:4:4 YCbCr data by generating additional Cr and Cb samples (using interpolation filters) that are interleaved with the original Cb and Cr samples. Care must be taken that the original Cb and Cr samples pass through unchanged and that the interpolated values replace the values that were decimated by the encoding process. Not shown are the digital delay adjustments between YCbCr data to ensure that the video data are pipelined-aligned due to the differences in digital filter delays.

Using the inverse of the encoding equations, the 4:4:4 YCbCr data is converted to gamma-corrected digital R′G′B′:

$$R' = Y + 1.371(Cr - 128)$$
$$G' = Y - 0.698(Cr - 128) - 0.336(Cb - 128)$$
$$B' = Y + 1.732(Cb - 128)$$

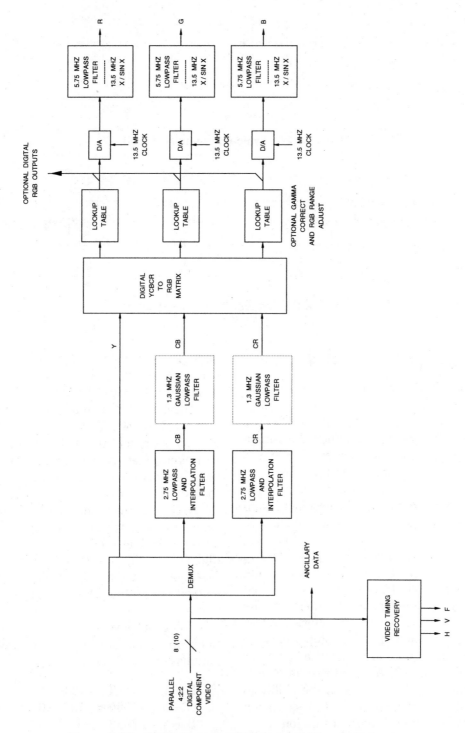

Figure 8.22. 4:2:2 Decoding Using 4:4:4 Sample Rates.

The resulting R'G'B' values have a nominal range of 16–235, with occasional excursions into the 1–15 and 236–254 values (due to Y and CbCr occasionally going outside the 16–235 and 16–240 ranges, respectively).

If the desired R'G'B' data range is 0–255, as commonly is found in computer systems, there are other alternatives. For example, the following equations may be used:

$$R' = 1.164(Y - 16) + 1.596(Cr - 128)$$
$$G' = 1.164(Y - 16) - 0.813(Cr - 128)$$
$$- 0.392(Cb - 128)$$
$$B' = 1.164(Y - 16) + 2.017(Cb - 128)$$

ROM lookup tables may be used to perform the multiplications and a minimum of 8 bits of fractional data should be maintained with the final results rounded to the desired accuracy. The R'G'B' data must be saturated at 255 (on overflow) and 0 (on underflow) to prevent any overflow and underflow errors from occurring due to Y and CbCr occasionally going outside the 16–235 and 16–240 ranges, respectively. After the YCbCr-to-RGB matrix, ROM or RAM lookup tables may be used to remove gamma correction.

For computer applications, the gamma-correction may be removed to generate linear RGB data (values are normalized to have a value of 0 to 1):

R', G', B' < 0.0812 R', G', B' ≥ 0.0812

$$R = R'/4.5 \qquad R = ((R' + 0.099)/1.099)^{2.2}$$
$$G = G'/4.5 \qquad G = ((G' + 0.099)/1.099)^{2.2}$$
$$B = B'/4.5 \qquad B = ((B' + 0.099)/1.099)^{2.2}$$

Although the PAL standard specifies a gamma of 2.8, a value of 2.2 is now used. Therefore, the same gamma-correction equations are used for 525/60 and 625/50 systems.

Having the ability to bypass or reconfigure the lookup tables is almost a necessity, as either linear or R'G'B' data may be needed by the system. The digital RGB data also may be converted to analog RGB signals by D/A converters and lowpass filtered.

RGB Filtering

The RGB analog lowpass filters after the D/A converters have the same characteristics as the analog RGB filters on the input of the A/D converters shown in Figure 8.3, and all the same considerations apply. The characteristics are shown in Figure 8.4 and Table 8.5. The output filter removes the high-level repeated spectra produced by the sampling process. The sample-and-hold action of the D/A converter introduces a (sin x)/x characteristic, which must be compensated for in the analog output filter. The filter characteristics in Figure 8.4 ignore the (sin x)/x correction required when used for the analog output filter.

CbCr Filtering

Two types of CbCr lowpass and interpolation filters are required for the decoding. If subsequent digital processing is to be done, lowpass filters having the same characteristics as the CbCr digital lowpass filters shown in Figure 8.3 should be used, and the same discussion applies. The characteristics for these sharp roll-off filters are shown in Figure 8.5 and Table 8.6. The stopband attenuation is –55

dB, rather than –40 dB as in the analog filtering case, because there is no attenuation from (sin *x*)/*x* sample-and-hold loss. If the data is to be used for the generation of composite video, slow roll-off Gaussian lowpass filters (having an attenuation of about 6 dB at 2 MHz) should be used to minimize ringing.

Interpolation to 13.5 MHz introduces no sample-and-hold loss, so (sin *x*)/*x* correction is not required for the interpolation filters. The Gaussian characteristics, where needed, may be incorporated with the interpolation filtering or implemented separately after the interpolation process.

Decoding (Using 4:2:2 Sample Rates)

In digital decoding (shown in Figure 8.23) the 4:2:2 data stream is input and the video timing signals (H, V, and F) recovered from the EAV and SAV sequences. At this time, any ancillary information also is detected and output for further processing. The decoder design should be robust enough to ignore 0 and 255 code words, except during EAV, SAV, and ancillary preamble sequences. During the loss of an input signal, the decoder should have the

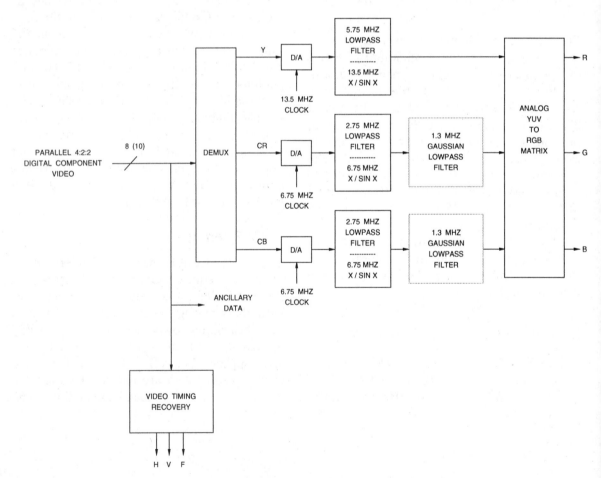

Figure 8.23. 4:2:2 Decoding using 4:2:2 Sample Rates.

option to either be transparent (so the input source can be monitored), auto-freeze the output data (to compensate for short duration dropouts), or autoblack the output data (to avoid potential problems driving a mixer or video tape recorder). A useful system debugging feature for the decoder is the ability to generate both 75% amplitude, 100% saturation and 100% amplitude, 100% saturation color bars. These should be able to be generated using either the input video timing or internally generated video timing. The 4:2:2 YCbCr data is demultiplexed into Y, Cr, and Cb, each driving a D/A converter to generate analog YUV data. The outputs of the D/A converters are lowpass filtered and include $(\sin x)/x$ correction as shown. The analog YUV data is converted to analog R'G'B' using the following equations:

$$R' = Y + 1.402V$$
$$G' = Y - 0.714V - 0.344U$$
$$B' = Y + 1.772U$$

Y Filtering

The luma analog lowpass filter after the D/A converter has the same characteristics as the analog RGB filters on the input of the A/D converters shown in Figure 8.3, and all the same considerations apply. The characteristics are shown in Figure 8.4 and Table 8.5. The output filter removes the high-level repeated spectra produced by the sampling process. The sample-and-hold action of the D/A converter introduces a $(\sin x)/x$ characteristic, which must be compensated for in the analog output filter. The filter characteristics in Figure 8.4 ignore the $(\sin x)/x$ correction required when used for the analog output filter.

Color Difference Filtering

The color difference analog lowpass filter after the D/A converters have the same characteristics as the analog color difference filters on the input of the A/D converters shown in Figure 8.6, and all the same considerations apply. The characteristics are shown in Figure 8.7 and Table 8.7. The output filters remove the high-level repeated spectra produced by the sampling process. The sample-and-hold action of the D/A converter introduces a $(\sin x)/x$ characteristic, which must be compensated for in the analog output filter. The filter characteristics in Figure 8.7 ignore the $(\sin x)/x$ correction required when used for the analog output filter.

If the analog YUV data is to be used for the generation of composite video, slow roll-off Gaussian lowpass filters (having an attenuation of about 6 dB at 2 MHz) should be used to minimize ringing.

Ancillary Data

Ancillary data enables the transmission of various control data (such as digital audio, scan line numbers, error checking, field numbering, etc.) during the blanking intervals. Design of the digital video encoder must ensure that ancillary information is not generated during active video or while the EAV and SAV sequences are present in the data stream. As the implementation of ancillary data formats is being continuously worked on and updated, a designer should obtain the latest specifications before starting a design.

Unless it is the intended function of a particular piece of equipment, ancillary data must not be modified by that equipment.

Audio Note

Although digital audio may be transmitted as ancillary information, most professional 4:2:2 digital VCRs accept digital audio using the AES/EBU audio protocol (AES3 or ANSI S4.40) with an audio sample rate of 48 kHz. The 48 kHz samples of the audio data are locked to the video as follows:

525-line system: 48 kHz = $(1144/375)\ F_H$

625-line system: 48 kHz = $(384/125)\ F_H$

General Format (525-Line Systems)

During horizontal blanking, up to 268 words, including preamble(s), can be transmitted in the interval starting with the end of the EAV and terminating with the beginning of SAV. Multiple ancillary sequences therefore may be sent in a horizontal blanking interval. Ancillary data use 10-bit format.

During vertical blanking, up to 1440 words, including preamble(s), may be transmitted in the interval starting with the end of the SAV and terminating with the beginning of EAV. Thus, multiple ancillary sequences may be sent in a vertical blanking interval. Only 8-bit ancillary data may be transmitted, even if a 10-bit transmission interface is used. Ancillary data is allowed only in the active portion of lines 1–13, 15–19, 264–276, and 278–282, and only if active video is not being transmitted.

Ancillary sequences consist of a preamble, followed by a data ID word (to indicate the type of data), the data word count, and finally, the actual data, as shown in Table 8.12. The format of information following the preamble is under study, and subject to change.

	8-bit Data								10-bit Data	
	D9 (MSB)	D8	D7	D6	D5	D4	D3	D2	D1	D0
preamble	0	0	0	0	0	0	0	0	0	0
	1	1	1	1	1	1	1	1	1	1
	1	1	1	1	1	1	1	1	1	1
data ID	x	x	x	x	x	x	x	x	x	x
data word count	0	L11	L10	L9	L8	L7	L6	op	0	0
	0	L5	L4	L3	L2	L1	L0	op	0	0
data word(s)	x	x	x	x	x	x	x	x	x	x
	:									
	x	x	x	x	x	x	x	x	x	x

Table 8.12. Ancillary Data Sequence.

The data ID specifies the ID number of the ancillary sequence, indicating the type of data being sent. It may not use the 8-bit values 00_H or FF_H (10-bit values 000_H–003_H and $3FC_H$–$3FF_H$).

The data word count indicates the data word count or video line number (the range is 1–1434), and is specified as a 12-bit binary value (L0–L11, L11 is the MSB); the "op" value is an odd parity bit for D3–D9. When used to transmit the video line number, the line number is transmitted by the data word count value and no data words follow.

Data words may not use the 8-bit values 00_H or FF_H (10-bit values 000_H–003_H and $3FC_H$–$3FF_H$).

Lines 14 and 277 are used for digital vertical interval timecode (DVITC) and video index. The DVITC is carried by the luma (Y) data in the active portion of lines 14 and 277. Note that these correspond to line numbers 11 and 274 in Figure 5.21, for the NTSC encoder discussed in Chapter 5. The 720-bit video index, which specifies things about the video signal such as format, filtering, and so on, is carried by the color difference (CbCr) data in the active portion of lines 14 and 277.

General Format (625-Line Systems)

During horizontal blanking, up to 280 words, including preamble(s), can be transmitted in the interval starting with the end of the EAV and terminating with the beginning of SAV. Multiple ancillary sequences therefore may be sent in a horizontal blanking interval. If a 10-bit transmission interface is used, either 8-bit or 10-bit data may be transmitted. If an 8-bit transmission interface is used, only 8-bit data may be transmitted.

During vertical blanking, up to 1440 words, including preamble(s), may be transmitted in the interval starting with the end of the SAV and terminating with the beginning of EAV. Multiple ancillary sequences may be sent in a vertical blanking interval. Only 8-bit ancillary data may be transmitted, even if a 10-bit transmission interface is used. Lines 20 and 333 are reserved for equipment self-checking purposes.

Ancillary sequences consist of a preamble, followed by a data ID word (to indicate the type of data), the data word count, and finally, the actual data, as shown in Table 8.12. The format of information following the preamble is under study and subject to change.

The data ID specifies the ID number of the ancillary sequence, indicating the type of data being sent. It may not use the 8-bit values 00_H or FF_H (10-bit values 000_H–003_H and $3FC_H$–$3FF_H$). An ancillary preamble followed by an 8-bit data ID value of 15_H indicates there is no further ancillary data on that scan line. Insertion of additional ancillary data on the scan line requires the replacement of the 15_H data ID with the desired data ID, inserting the data word count and data words, followed immediately by a preamble with a data ID of 15_H to indicate that there is no further ancillary data.

The data word count indicates the data word count or video line number (the range is 1–1434), and is specified as a 12-bit binary value (L0–L11, L11 is the MSB); the "op" value is an odd parity bit for D3–D9. When used to transmit the video line number, the line number is transmitted by the data word count value and no data words follow.

Data words may not use the 8-bit values 00_H or FF_H (10-bit values 000_H–003_H and $3FC_H$–$3FF_H$). Note that the original 8-bit specifications called for the LSB (D2) to be an odd parity bit; this has been deleted from the 10-bit specifications.

Video Test Signals

Several industry-standard video test signals are being developed for the 525/60 and 625/50 4:2:2 environment to help test the relative quality of the encoders and decoders and perform calibration. The test signals reviewed here are discussed in ITU-R BT.801.

100/0/75/0 Color Bars

This color bar test signal assumes a rise and fall time of 150 ns for Y and 300 ns for Cb and Cr (measured between the 10% and 90% points). The Y values are given in Table 8.13 and the Cb and Cr values are listed in Table 8.14. This test is valid for both 525/60 and 625/50 systems.

100/0/100/0 Color Bars

This color bar test signal assumes a rise and fall time of 150 ns for Y and 300 ns for Cb and Cr (measured between the 10% and 90% points). The Y values are given in Table 8.15 and the Cb and Cr values are listed in Table 8.16. This test is valid for both 525/60 and 625/50 systems.

White End-of-Line Porches

This test signal has no shaping of the Y at the ends of the digital active line and may be used to monitor the analog shaping of the line blanking by 4:2:2 decoders. Two pulses with a rise and fall time of 300 ns are placed 3 μs from the leading and trailing edges of 625/50 analog line blanking, allowing monitoring of the transitions. For this test, Cb and Cr both have values of 128. The Y values are given in Table 8.17.

Blue End-of-Line Porches

This test signal is a variation of the white end-of-line porches and may be used to monitor what happens for high transitions of Cb. For this test, Cr has a value of 110 and Y has a value of 41. The Cb values are given in Table 8.18. This test is valid for both 525/60 and 625/50 systems.

Red End-of-Line Porches

This test signal is a variation of the white end-of-line porches and may be used to monitor what happens for high transitions of Cr. For this test, Cb has a value of 90 and Y has a value of 81. The Cr values are given in Table 8.19. This test is valid for both 525/60 and 625/50 systems.

Yellow End-of-Line Porches

This test signal is a variation of the white end-of-line porches and may be used to monitor what happens for low transitions of Cb. For this test, Cr has a value of 146 and Y has a value of 210. The Cb values are given in Table 8.20. This test is valid for both 525/60 and 625/50 systems.

Cyan End-of-Line Porches

This test signal is a variation of the white end-of-line porches and may be used to monitor what happens for low transitions of Cr. For this test, Cb has a value of 166 and Y has a value of 170. The Cr values are given in Table 8.21. This test is valid for both 525/60 and 625/50 systems.

i	0–14	15	16	17	18–100	101	102	103	104–185
Y (i)	16	39	126	212	235	227	198	169	162
i	186	187	188	189	190–272	273	274	275	276–358
Y (i)	161	158	146	134	131	129	122	114	112
i	359	360	361	362–444	445	446	447	448–530	531
Y (i)	109	98	87	84	82	74	67	65	62
i	532	533	534–616	617	618	619	620–719		
Y (i)	50	38	35	33	25	18	16		

Table 8.13. Y Values for 100/0/75/0 Color Bars.

i	0–49	50	51	52	53–91	92	93	94	95
Cb (i)	128	119	86	53	44	44	56	100	145
Cr (i)	128	129	135	140	142	141	132	93	54
(i)	96–135	136	137	138	139	140–177	178	179	180
Cb (i)	156	148	114	81	73	72	73	84	128
Cr (i)	44	45	51	56	58	58	58	72	128
i	181	182	183–220	221	222	223	224	225–264	265
Cb (i)	172	183	184	183	175	142	108	100	111
Cr (i)	184	198	198	198	200	205	211	212	202
i	266	267	268	269–307	308	309	310	311–359	
Cb (i)	156	200	212	212	203	170	137	128	
Cr (i)	163	124	115	114	116	121	127	128	

Table 8.14. CbCr Values for 100/0/75/0 Color Bars.

i	0–14	15	16	17	18–100	101	102	103	104–186
Y (i)	16	39	126	212	235	232	223	213	210
i	187	188	189	190–271	272	273	274	275	276–357
Y (i)	206	190	174	170	169	167	157	147	145
i	358	359	360	361	362	363–444	445	446	447
Y (i)	144	141	126	110	107	106	104	94	84
i	448	449–530	531	532	533	534–616	617	618	619
Y (i)	82	81	77	61	45	41	38	28	19
i	620–719								
Y (i)	16								

Table 8.15. Y Values for 100/0/100/0 Color Bars.

i	0–49	50	51	52	53–92	93	94	95	96–135
Cb (i)	128	116	72	28	16	31	91	150	166
Cr (i)	128	130	137	144	146	133	81	29	16
(i)	136	137	138	139–177	178	179	180	181	182
Cb (i)	154	110	65	54	54	69	128	187	202
Cr (i)	18	25	32	34	35	54	128	202	221
i	183–221	222	223	224	225–264	265	266	267	268–307
Cb (i)	202	191	146	102	90	106	165	225	240
Cr (i)	222	224	231	238	240	227	175	123	110
i	308	309	310	311–359					
Cb (i)	228	184	140	128					
Cr (i)	112	119	126	128					

Table 8.16. CbCr Values for 100/0/100/0 Color Bars.

i	0–46	47	48	49	50	51	52	53	54
Y (i)	235	232	218	187	139	86	46	24	17
i	55–667	668	669	670	671	672	673	674	675
Y (i)	16	19	33	64	112	165	205	227	234
i	676–719								
Y (i)	235								

Table 8.17. Y Values for White End-of-Line Porches.

i	0–23	24	25	26	27–333	334	335	336	337
Cb (i)	240	232	191	143	128	130	152	204	236
i	338–359								
Cb (i)	240								

Table 8.18. Cb Values for Blue End-of-Line Porches.

i	0–23	24	25	26	27–333	334	335	336	337
Cr (i)	240	232	191	143	128	130	152	204	236
i	338–359								
Cr (i)	240								

Table 8.19. Cr Values for Red End-of-Line Porches.

i	0–23	24	25	26	27–333	334	335	336	337
Cb (i)	16	24	65	113	128	126	104	52	20
i	338–359								
Cb (i)	16								

Table 8.20. Cb Values for Yellow End-of-Line Porches.

i	0–23	24	25	26	27–333	334	335	336	337
Cr (i)	16	24	65	113	128	126	104	52	20
i	338–359								
Cr (i)	16								

Table 8.21. Cr Values for Cyan End-of-Line Porches.

End-of-Line Pulses

This test signal may be used to check the position of the digital active line relative to the analog line. The outside edges of the two internal pulses coincide with the ends of the line displayed on 625/50 systems. For this test, both Cb and Cr have a value of 128. The Y values are given in Table 8.22.

Black/White Ramp

This test signal may be used to check the existence and position of quantization levels 1–254 of the luma signal. For this test, both Cb and Cr have a value of 128. The Y values are given in Table 8.23. In instances where a calculation has a remainder, it is dropped and only the integer is used. This test is valid for both 525/60 and 625/50 systems.

i	0	1	2	3	4	5	6–9	10	11
Y (i)	16	44	154	235	154	44	16	17	64
i	12	13	14	15	16–705	706	707	708	709
Y (i)	185	229	121	31	16	17	64	185	229
i	710	711	712–713	714	715	716	717	718	719
Y (i)	121	31	16	44	154	235	154	44	16

Table 8.22. Y Values for End-of-Line Pulses.

i	0–20	21	22	23	24–59	60–87	88–99	100–535	536–549
Y (i)	16	14	9	3	1	$(i-56)/2$	16	$(i-66)/2$	235
i	550–585	586–599	600	601	602	603	604	605–719	
Y (i)	$(i-78)/2$	254	250	217	135	53	20	16	

Table 8.23. Y Values for Black/White Ramp.

CbYCrY Ramp

This test signal enables checking any demultiplexing and remultiplexing operations. The Cb, Y, Cr, and Y values are given in Table 8.24 for the 1440 samples of the multiplexed digital active line. This test is valid for both 525/60 and 625/50 systems.

Red Field

The Red Field signal consists of a 75% amplitude, 100% saturation red signal (Y = 65, Cb = 100, Cr = 212). This is useful as the human eye is sensitive to static noise intermixed in a red field. Distortions that cause small errors in picture quality can be visually examined for the effect on the picture. This test is valid for both 525/60 and 625/50 systems.

4:4:4:4 Digital Video

After the 4:2:2 digital component standards were developed, a need developed within the studio environment for a higher bandwidth transmission link to support full-bandwidth ITU-R BT.601 resolution video and graphics. In addition, support for an additional channel (of the same bandwidth as luma) to support such functions as keying was required. ITU-R BT.799 and SMPTE RP-175 define the 4:4:4:4 format (also referred to as 4 × 4) as a superset to the 4:2:2 hierarchy.

Note that 4 × 4 digital component video is similar to 4:2:2 digital component video. However, there are four fundamental differences. First, either YCbCr or R′G′B′ data may be transmitted. Second, an additional channel of data (such as keying) also may be transmitted. Third, 10-bit data is used to support the higher-quality requirements of the broadcast and graphics industry. Fourth, all four channels of data have the same bandwidth (5.75 MHz) and are sampled at 13.5 MHz. Table 8.25 describes the 4 × 4 parameters.

Coding Ranges

The 10-bit YCbCr levels to generate a 75% amplitude, 100% saturation color bar signal are shown in Table 8.26.

System Timing

The horizontal and vertical timing is the same as for ITU-R BT.601.

Multiplexing Structure

Two quasi-4:2:2-type transmission links are used. Link A contains all the Y samples plus those Cb and Cr samples located at even-numbered sample points. Link B contains samples from the keying channel and the Cb and Cr samples from the odd-numbered sampled points. Although it may be common to refer to Link A as 4:2:2 and Link B as 2:2:4, Link A is not a true 4:2:2 signal since the color difference data was sampled at 13.5 MHz, rather than 6.75 MHz.

Figure 8.24 shows contents of link A and link B when transmitting YCbCrK video data. Figure 8.25 illustrates the structure when transmitting RGBK video data. If the keying

i	0–253	254–507	508–761	762–1015	1016–1269	1270–1439
F (i)	i + 1	508 − i	i − 507	1016 − i	i − 1015	1524 − i

Table 8.24. YCbCr Values for CbYCrY Ramp.

Parameters	525/60 Systems	625/50 Systems
Coded signals: Y, Cb, Cr or R′, G′, B′	These signals are obtained from gamma precorrected signals, namely: Y, B′ – Y, R′ – Y or R′, G′, B′.	
Number of samples per total line: each of 3 video components keying channel (K)	858 858	864 864
Sampling structure	Orthogonal, line, field and frame repetitive. The three sampling structures to be coincident and coincident also with the luma sampling structure of the 4:2:2 family member.	
Sampling frequency: each of 3 video components keying channel (K)	13.5 MHz 13.5 MHz The tolerance for the sampling frequencies should coincide with the tolerance for the line frequency of the relevant color television standard.	
Form of coding	Uniformly quantized PCM, 10 bits per sample	
Number of samples per digital active line: each of 3 video components auxiliary channel	720 720	
Analog-to-digital horizontal timing relationship from end of digital active line to 0_H	16 Y clock periods	12 Y clock periods
Correspondence between video signal levels and quantization level for each sample (10-bit values): scale Y, R′, G′, B′, K Cb, Cr Code-word usage	0 to 1023 877 quantization levels with the black level corresponding to level 64 and the peak level corresponding to level 940. The signal level may occasionally excurse beyond level 940. 897 quantization levels in the center part of the quantization scale with zero signal corresponding to level 512. Code words 0–3 and 1020–1023 are used exclusively for synchronization.	

Table 8.25. Encoding Parameter Values for 4:4:4:4 Digital Component Video.

	Nominal Range	White	Yellow	Cyan	Green	Magenta	Red	Blue	Black
Y	64 to 940	720	644	524	448	336	260	140	64
Cb	64 to 960 (512 = zero)	512	176	624	288	736	100	848	512
Cr	64 to 960 (512 = zero)	512	568	176	232	792	848	456	512

Table 8.26. 75% Amplitude, 100% Saturation 10-bit YCbCr Color Bars.

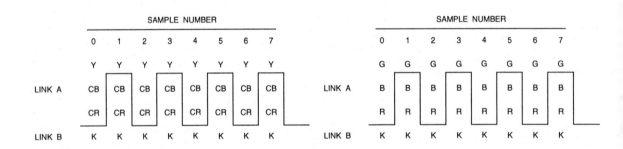

Figure 8.24. Link Content Representation for 4:4:4:4 YCbCrK Video Signals.

Figure 8.25. Link Content Representation for 4:4:4:4 RGBK Video Signals.

signal (K) is not present, the K sample values have a 10-bit value of 940.

The YCbCrK video data words are multiplexed in the order shown in Figure 8.26 and Figure 8.27. When RGBK video signals are transmitted, the G samples are sent in the Y locations, the R samples are sent in the Cr locations, and the B samples are sent in the Cb locations.

Bit-Parallel Transmission Interface
The bit-parallel interface consists of two bit-parallel interfaces for 4:2:2 video.

Bit-Serial Transmission Interface
The bit-serial interface consists of two bit-serial interfaces for 4:2:2 video.

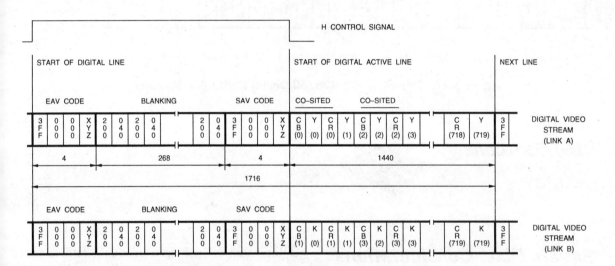

NOTE: IF "K" INFORMATION IS NOT PRESENT, THEN THE "K" SAMPLES MUST BE SET TO VALUE 940 (10-BIT VALUE).

Figure 8.26. 4:4:4:4 10-Bit 525/60 Digital Horizontal Blanking.

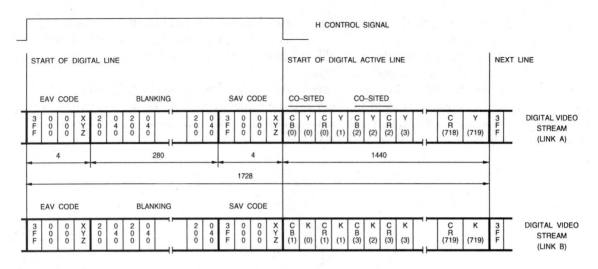

NOTE: IF "K" INFORMATION IS NOT PRESENT, THEN THE "K" SAMPLES MUST BE SET TO VALUE 940 (10-BIT VALUE).

Figure 8.27. 4:4:4:4 10-Bit 625/50 Digital Horizontal Blanking.

VLSI Solutions

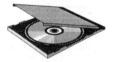

See C8_VLSI

Square Pixel Considerations

With the merger of computers and video, some of the terminology used by the video community has been adopted by the computer industry. However, although the same terms are used, they have a slightly different meaning, primarily due to the use of square pixels by computers. Table 8.27 illustrates some of the differences between the two markets. Tables 8.28 through 8.32 detail some of the square pixel formats used.

The QSIF square pixel format came about primarily because of the use of software decoding of compressed video—QSIF was about the maximum resolution that could be handled.

Optimization of software decoding and faster processors now allow the decoding of SIF resolution video.

Typically, the NTSC/PAL video source is decoded to YCbCr at full resolution. SIF or QSIF resolution then is generated by scaling down from full resolution. A few NTSC/PAL decoders now output SIF resolution directly. The SIF or QSIF data then is compressed.

Upon decompression, the SIF or QSIF resolution optionally may be scaled up to full resolution. If the data uses the YCbCr color space, the GUI accelerator converts it to the RGB color space prior to being displayed on the computer monitor.

Standard	Video Market		Computer Market	
	525-Line Systems	625-Line Systems	525-Line Systems	625-Line Systems
Full Resolution	720×480	720×576	640×480	768×576
SIF	352×240	352×288	320×240	384×288
QSIF	176×120	176×144	160×120	192×144

Table 8.27. Digital Component Video Resolutions.

Parameters	525-Line Systems	625-Line Systems
Coded signals: Y, Cb, Cr	These signals are obtained from gamma precorrected signals, namely: Y, B′ − Y, R′ − Y or R′, G′, B′.	
Number of samples per total line: Y Cb, Cr	780 780	944 944
Sampling structure	Orthogonal, line, field and frame repetitive. The three sampling structures to be coincident and coincident also with the luma sampling structure of the 4:2:2 structure.	
Sampling frequency: Y Cb, Cr	12.2727 MHz 12.2727 MHz	14.75 MHz 14.75 MHz
Form of coding	Uniformly quantized PCM, 8 bits per sample.	
Number of samples per digital active line: Y Cb, Cr	640 640	768 768
Number of active scan lines	480	576
Correspondence between video signal levels and quantization level for each sample: scale Y Cb, Cr	0 to 255 220 quantization levels with the black level corresponding to level 16 and the peak level corresponding to level 235. The signal level may occasionally excurse beyond level 235. 225 quantization levels in the center part of the quantization scale with zero signal corresponding to level 128.	

Table 8.28. Encoding Parameter Values for the "Full Resolution 4:4:4" Square Pixel Format.

Parameters	525-Line Systems	625-Line Systems
Coded signals: Y, Cb, Cr	These signals are obtained from gamma precorrected signals, namely: Y, B′ – Y, R′ – Y or R′, G′, B′.	
Number of samples per total line: Y Cb, Cr	780 390	944 472
Sampling structure	Orthogonal, line, field and frame repetitive. The three sampling structures to be coincident and coincident also with the luma sampling structure of the 4:2:2 structure.	
Sampling frequency: Y Cb, Cr	12.2727 MHz 6.1364 MHz	14.75 MHz 7.375 MHz
Form of coding	Uniformly quantized PCM, 8 bits per sample.	
Number of samples per digital active line: Y Cb, Cr	640 320	768 384
Number of active scan lines	480	576
Correspondence between video signal levels and quantization level for each sample: scale Y Cb, Cr	 0 to 255 220 quantization levels with the black level corresponding to level 16 and the peak level corresponding to level 235. The signal level may occasionally excurse beyond level 235. 225 quantization levels in the center part of the quantization scale with zero signal corresponding to level 128.	

Table 8.29. Encoding Parameter Values for the "Full Resolution 4:2:2" Square Pixel Format.

Parameters	525-Line Systems	625-Line Systems
Coded signals: Y, Cb, Cr	These signals are obtained from gamma precorrected signals, namely: Y, B′ – Y, R′ – Y or R′, G′, B′.	
Number of samples per total line: Y Cb, Cr	780 195	944 236
Sampling structure	Orthogonal, line, field and frame repetitive. The three sampling structures to be coincident and coincident also with the luma sampling structure of the 4:2:2 structure.	
Sampling frequency: Y Cb, Cr	12.2727 MHz 3.068 MHz	14.75 MHz 3.688 MHz
Form of coding	Uniformly quantized PCM, 8 bits per sample.	
Number of samples per digital active line: Y Cb, Cr	640 160	768 192
Number of active scan lines	480	576 .
Correspondence between video signal levels and quantization level for each sample: scale Y Cb, Cr	0 to 255 220 quantization levels with the black level corresponding to level 16 and the peak level corresponding to level 235. The signal level may occasionally excurse beyond level 235. 225 quantization levels in the center part of the quantization scale with zero signal corresponding to level 128.	

Table 8.30. Encoding Parameter Values for the "Full Resolution 4:1:1" Square Pixel Format.

Parameters	525-Line Systems	625-Line Systems
Coded signals: Y, Cb, Cr	These signals are obtained from gamma precorrected signals, namely: Y, B' – Y, R' – Y or R', G', B'.	
Number of samples per total line: Y Cb, Cr	390 195	472 236
Sampling structure	Orthogonal, line, field and frame repetitive. The three sampling structures to be coincident and coincident also with the luma sampling structure of the 4:2:2 structure.	
Sampling frequency: Y Cb, Cr	6.136 MHz 3.068 MHz	7.375 MHz 3.688 MHz
Form of coding	Uniformly quantized PCM, 8 bits per sample.	
Number of samples per digital active line: Y Cb, Cr	320 160	384 192
Number of active scan lines	240	288
Correspondence between video signal levels and quantization level for each sample: scale Y Cb, Cr	0 to 255 220 quantization levels with the black level corresponding to level 16 and the peak level corresponding to level 235. The signal level may occasionally excurse beyond level 235. 225 quantization levels in the center part of the quantization scale with zero signal corresponding to level 128.	

Table 8.31. Encoding Parameter Values for the "SIF Resolution 4:2:2" Square Pixel Format. This is actually a square pixel version of the ITU-R BT.601-derived 2:1:1 format.

Parameters	525-Line Systems	625-Line Systems
Coded signals: Y, Cb, Cr	These signals are obtained from gamma precorrected signals, namely: Y, B′ – Y, R′ – Y or R′, G′, B′.	
Number of samples per total line: Y Cb, Cr	195 97.5	236 118
Sampling structure	Orthogonal, line, field and frame repetitive. The three sampling structures to be coincident and coincident also with the luma sampling structure of the 4:2:2 structure.	
Sampling frequency: Y Cb, Cr	3.068 MHz 1.534 MHz	3.688 MHz 1.844 MHz
Form of coding	Uniformly quantized PCM, 8 bits per sample.	
Number of samples per digital active line: Y Cb, Cr	160 80	192 96
Number of active scan lines	120	144
Correspondence between video signal levels and quantization level for each sample: scale Y Cb, Cr	 0 to 255 220 quantization levels with the black level corresponding to level 16 and the peak level corresponding to level 235. The signal level may occasionally excurse beyond level 235. 225 quantization levels in the center part of the quantization scale with zero signal corresponding to level 128.	

Table 8.32. Encoding Parameter Values for the "QSIF Resolution 4:2:2" Square Pixel Format. This is actually a square pixel version of the ITU-R BT.601-derived 1:0.5:0.5 format.

16 × 9 Aspect Ratio

A 16 × 9 aspect ratio version of the 4:2:2 digital component video standards has been developed (SMPTE 267 M). The characteristics are shown in Table 8.33 and Figures 8.28 through 8.31.

Bit-Parallel Transmission Interface

The bit-parallel transmission interface is the same as previously discussed. The timing is slightly different, as illustrated in Figure 8.32, since an 18-MHz sample clock is used.

Parameters	525/60 Systems	625/50 Systems
Coded signals: Y, Cb, Cr	These signals are obtained from gamma precorrected signals, namely: Y, $B' - Y$, $R' - Y$ or R', G', B'.	
Number of samples per total line: Y Cb, Cr	1144 572	1152 576
Sampling structure	Orthogonal, line, field and frame repetitive. Cb and Cr samples co-sited with odd (1st, 3rd, 5th, etc.) Y samples in each line.	
Sampling frequency: Y Cb, Cr	18 MHz 9 MHz The tolerance for the sampling frequencies should coincide with the tolerance for the line frequency of the relevant color television standard.	
Form of coding	Uniformly quantized PCM, 10 bits per sample.	
Number of samples per digital active line: Y Cb, Cr	960 480	
Analog-to-digital horizontal timing relationship from end of digital active line to 0_H	21.5 Y clock periods	16 Y clock periods
Correspondence between video signal levels and quantization level for each sample: scale Y Cb, Cr Code-word usage	 0 to 1023 877 quantization levels with the black level corresponding to level 64 and the peak level corresponding to level 940. The signal level may occasionally excurse beyond level 940) 897 quantization levels in the center part of the quantization scale with zero signal corresponding to level 512. Code words 0–3 and 1020–1023 are used exclusively for synchronization.	

Table 8.33. Encoding Parameter Values for 16 × 9 4:2:2.

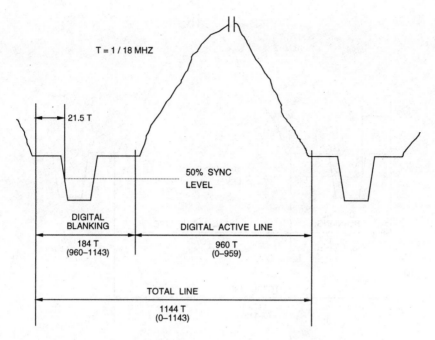

Figure 8.28. 525/60 16 x 9 Horizontal Sync Relationship.

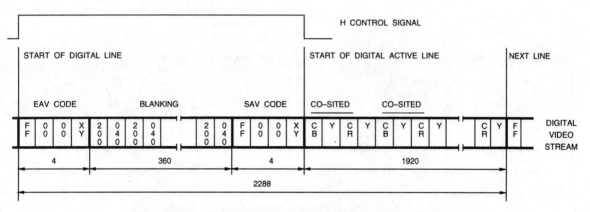

Figure 8.29. 525/60 16 x 9 Digital Horizontal Blanking.

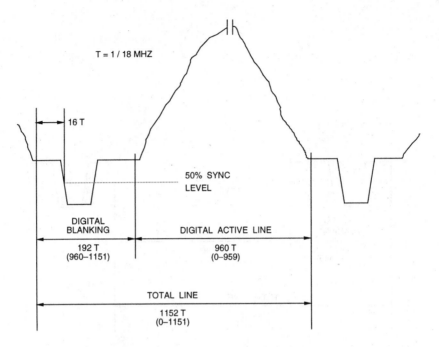

Figure 8.30. 625/50 16 x 9 Horizontal Sync Relationship.

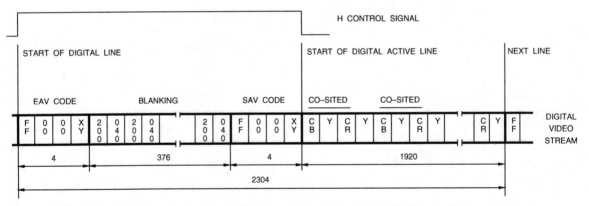

Figure 8.31. 625/50 16 x 9 Digital Horizontal Blanking (8-bit Transmission System).

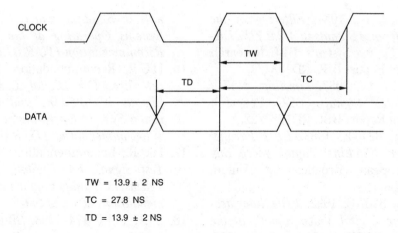

TW = 13.9 ± 2 NS

TC = 27.8 NS

TD = 13.9 ± 2 NS

Figure 8.32. 16 x 9 Parallel Transmitted Waveforms (at Transmitter).

525-Line Systems

During horizontal blanking, up to 360 words, including preamble(s), can be transmitted in the interval starting with the end of the EAV and terminating with the beginning of SAV. Multiple ancillary sequences therefore may be sent in a horizontal blanking interval. Ancillary data are of 10-bit format.

During vertical blanking, up to 1920 words, including preamble(s), may be transmitted in the interval starting with the end of the SAV and terminating with the beginning of EAV. Thus, multiple ancillary sequences may be sent in a vertical blanking interval. Only 8-bit ancillary data may be transmitted, even though a 10-bit transmission interface is used. Ancillary data is allowed only in the active portion of lines 1–13, 15–19, 264–276, and 278–282, and only if active video is not being transmitted.

Ancillary sequences consist of a preamble, followed by a data ID word (to indicate the type of data), the data word count, and finally, the actual data, as shown in Table 8.12. The format of information following the preamble is under study, and subject to change. The

DVITC and video index are also present on lines 14 and 277.

References

1. ANSI/SMPTE 125M–1995, *Television—Component Video Signal 4:2:2—Bit-Parallel Digital Interface.*
2. ANSI/SMPTE 259M–1993, *10-Bit 4:2:2 Component and 4F$_{SC}$ NTSC Composite Digital Signals—Serial Digital Interface.*
3. ANSI/SMPTE 261M–1993, *Television—10-Bit Serial Digital Television Signals: 4:2:2 Components and 4F$_{SC}$ NTSC Composite —AMI Transmission Interface.*
4. ANSI/SMPTE 266M–1994, *Television—4:2:2 Digital Component Systems—Digital Vertical Interval Time Code.*
5. ANSI/SMPTE 267M–1995, *Television—Bit-Parallel Digital Interface—Component Video Signal 4:2:2 16 × 9 Aspect Ratio.*
6. Benson, K, Blair, 1986. *Television Engineering Handbook*, McGraw-Hill, Inc.
7. Clarke, C. K. P., 1989, *Digital Video: Studio Signal Processing*, BBC Research Department Report BBC RD1989/14.

8. Devereux, V. G., 1984, *Filtering of the Colour-Difference Signals in 4:2:2 YUV Digital Video Coding Systems*, BBC Research Department Report BBC RD1984/4.

9. Devereux, V. G., 1987, *Limiting of YUV Digital Video Signals*, BBC Research Department Report BBC RD1987/22.

10. EBU Tech. 3246-E, 1983, *EBU Parallel Interface for 625-Line Digital Video Signals*, European Broadcasting Union, August, 1983.

11. EBU Tech. 3267-E, 1992, *EBU Interfaces for 625-Line Digital Video Signals at the 4:2:2 Level of CCIR Recommendation 601*, European Broadcasting Union, June, 1991.

12. Gennum Corporation, GS9000 Datasheet, document number 560-26-3.

13. Gennum Corporation, GS9002 Datasheet, document number 560-27-2.

14. ITU-R Recommendation BT.601, 1994, *Encoding Parameters of Digital Television for Studios.*

15. ITU-R Recommendation BT.656, 1994, *Interfaces for Digital Component Video Signals in 525-Line and 625-Line Television Systems Operating at the 4:2:2 Level of Recommendation ITU-R BT.601.*

16. ITU-R Recommendation BT.799, 1994, *Interfaces For Digital Component Video Signals in 525-Line and 625-Line Television Systems Operating at the 4:4:4 Level of Recommendation ITU-R BT.601.*

17. ITU-R Recommendation BT.801, 1992, *Test Signals For Digitally Encoded Color Television Signals Conforming with Recommendations 601 and 656.*

18. SMPTE RP 174–1993, *Bit-Parallel Digital Interface for 4:4:4:4 Component Video Signal (Single Link).*

19. SMPTE RP 175–1993, *Digital Interface for 4:4:4:4 Component Video Signal (Dual Link).*

20. Sony Corporation, SBX1601A Datasheet, 1991.

21. Sony Corporation, SBX1602A Datasheet, 1991.

Video Processing

Encoding and decoding analog and digital video actually may be the easiest tasks when it comes to getting video into or out of a computer system. Since most computer systems use noninterlaced video for their displays, interlaced consumer video must be converted to noninterlaced before being merged with other graphics or video information. Many applications need to use the noninterlaced video being displayed as an output to a VCR or other video storage device. Noninterlaced-to-interlaced conversion therefore may need to be performed. In addition, many computer displays have a vertical refresh rate of 70–80 Hz, whereas video has a vertical refresh rate of 25 or 30 Hz. Some form of frame rate matching may be required to minimize video movement artifacts.

Another not-so-subtle problem includes scaling the video to fit into a window. Many computer systems today use a graphical user interface (GUI) that allows multiple windows (of arbitrary sizes) to be displayed. Naturally, users expect video to behave like any other data source and expect it to fit into any size window as defined by the user.

Alpha mixing and chroma keying are used to mix multiple video signals or video and computer-generated text/graphics. Alpha mixing ensures a smooth crossover between sources, allows subpixel positioning of text, and limits source transition bandwidths to simplify eventual encoding to NTSC, PAL, or SECAM video signals.

This chapter discusses various techniques for deinterlacing video signals, scaling real-time video, alpha mixing, and several other considerations necessary to incorporate and process video within the computer environment.

Rounding Considerations

When two 8-bit values are multiplied together, a 16-bit result is generated. At some point, a result must be rounded to some lower precision (for example, 16 bits to 8 bits or 32 bits to 16 bits) in order to realize a cost-effective hardware implementation. If the lower resolution bits are discarded, contours may become visible in areas of solid colors. There are several rounding techniques: truncation, conventional rounding, error feedback rounding, and dynamic rounding.

Truncation

Truncation drops any fractional data during each rounding operation. As a result, after only a few rounding (truncation) operations, a significant error may be introduced.

Conventional Rounding

Conventional rounding means using the fractional data bits to determine whether to round up or round down. If the fractional data is 0.5 or greater, rounding up should be performed—positive numbers should be made more positive and negative numbers should be made more negative. If the fractional data is less than 0.5, rounding down should be performed—positive numbers should be made less positive and negative numbers should be made less negative.

Error Feedback Rounding

Error feedback rounding follows the principle of "never throw anything away." This is accomplished by storing the residue of a truncation and adding it to the next video sample. This approach substitutes less visible noise-like quantizing errors in place of contouring effects caused by simple truncation. An example of an error feedback rounding implementation is shown in Figure 9.1. In this example, 16 bits are reduced to 8 bits using error feedback.

Dynamic Rounding

This technique (a licensable Quantel patent) dithers the LSB according to the weighting of the discarded fractional bits. The original data word is divided into two parts, one representing the resolution of the final output word and one dealing with the remaining fractional data. The fractional data is compared to the output of a random sequence generator equal in resolution to the fractional data. The output of the comparator is a 1-bit random pattern weighted

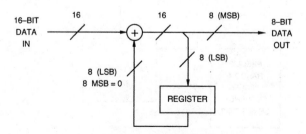

Figure 9.1. Error Feedback Rounding.

by the value of the fractional data, and serves as a carry-in to the adder. In all instances, only one LSB of the output word is changed, in a random fashion. An example of a dynamic rounding implementation is shown in Figure 9.2.

Interlaced-to-Noninterlaced Conversion (Deinterlacing)

Once a video signal has been input to a system, the user may want to display it at some point. A problem arises in that computers commonly use noninterlaced displays, whereas consumer video typically is interlaced. Some form of interlaced-to-noninterlaced conversion (commonly called deinterlacing or progressive scan conversion) is desirable. There are essentially three ways of performing deinterlacing: scan line duplication, scan line interpolation, and field processing. Note that deinterlacing must be performed on component (i.e., RGB, YUV, YIQ, YCbCr, etc.) video signals. Composite color video signals cannot be deinterlaced directly due to the presence of subcarrier phase information (which would be meaningless after processing); these signals must be decoded into component color signals, such as RGB or YCbCr, prior to deinterlacing.

Scan Line Duplication

Scan line duplication (Figure 9.3) simply duplicates the previous real scan line. Although the number of vertical scan lines is doubled, there is no increase in the vertical resolution. This method usually is acceptable for the color difference signals (such as CbCr, IQ, UV, etc.).

For each video component (for example, Y, Cr, and Cb), two line stores are required. While writing into line store number 1, line store number 2 is read out twice (the reading rate is twice the writing rate). Once line store number 2 is read out twice (at the same time line store number 1 is filled with new data), the role of the line stores switch—while writing into line store number 2, line store number 1 is read out twice.

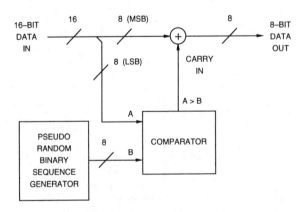

Figure 9.2. Dynamic Rounding.

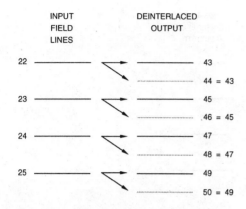

Figure 9.3. Deinterlacing Using Scan Line (Field-based) Duplication. Shaded scan lines are generated by duplicating the real scan line above it.

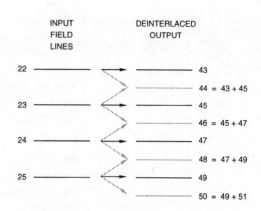

Figure 9.4. Deinterlacing Using Scan Line (Field-based) Interpolation. Shaded scan lines are generated by interpolating between the real scan lines above and below it.

Scan Line Interpolation

Scan line interpolation (Figure 9.4) positions interpolated scan lines between the original scan lines. Although the number of vertical scan lines is doubled, the vertical resolution is not. Some designs interpolate only luminance information, using line duplication for the color difference signals to lower cost.

For each video component, two line stores are required. While writing into line store number 1, line store number 2 is read out twice (the reading rate is twice the writing rate). One read cycle is used to generate a new scan line directly. During the next read cycle, the data is interpolated with the data in line store number 1 (being updated with the next original scan line). Once line store number 2 is read out twice (at the same time line store number 1 should be filled with new data), the role of the line stores switch—while writing into line store number 2, line store number 1 is read out twice.

Field Merging

This technique merges two consecutive fields together to produce a frame of video (Figure 9.5). At each field time, the scan lines of that field are merged with the scan lines of the previous field. The result is that for each field time, a new pair of fields combine to generate a frame (see Figure 9.6). Although simple to implement conceptually, and the vertical resolution is doubled to the full frame resolution, there will be artifacts in regions of movement. This is due to the time difference between two fields—a moving object may be located in a different position from one field to the next.

When the two fields are merged, there may be a "double image" of the moving object (see Figure 9.7). An ideal solution is to use field merging for still areas of the picture and scan line interpolation for areas of movement. To accomplish this, motion, on a pixel-by-pixel basis, must be detected over

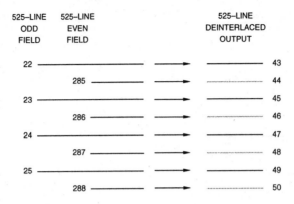

Figure 9.5. Deinterlacing Using Field Merging. Shaded scan lines are generated by using the real scan line from the next or previous field.

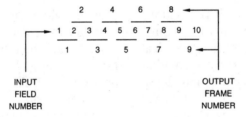

Figure 9.6. Producing Deinterlaced Frames at Field Rates.

the entire picture in real time. Motion can be detected by comparing the luminance value of a pixel with the value two fields earlier. Since we are combining two fields, and either or both may contain areas of motion, motion must be detected between two odd fields and two even fields. Four field stores therefore are required.

As two fields are combined, full vertical resolution is maintained in still areas of the picture, where the eye is most sensitive to detail. The pixel differences may have any value, from 0 (no movement and noise-free) to maximum (for example, a change from full intensity to black). A choice must be made when to use a pixel from the previous field (which is in the wrong location due to motion) or to interpolate a new pixel from adjacent scan lines in the current field. Sudden switching between methods is visible, so

OBJECT POSITION
IN FIELD ONE

OBJECT POSITION
IN FIELD TWO

OBJECT POSITIONS
IN MERGED FIELDS

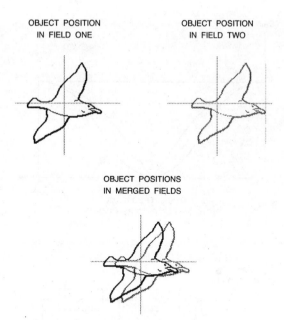

Figure 9.7. Movement Artifacts When Field Merging Is Used.

crossfading (also called soft switching) is used. At some magnitude of pixel difference, the loss of resolution due to a double image is equal to the loss of resolution due to interpolation. That amount of motion should result in the crossfader being at the 50/50 point. Less motion will result in a fade towards field merging and more motion in a fade towards the interpolated values.

Frequency Response Considerations

Various two-times vertical upsampling schemes for deinterlacing may be implemented by stuffing zero values between two valid lines and filtering, as shown in Figure 9.8. Line A shows the frequency response for line duplication, in which the lowpass filter coefficients for the filter shown are 1, 1, and 0. Interpolation, using lowpass filter coefficients of 0.5, 1.0, and 0.5, results in the frequency response curve of Line B; note that line duplication results in a better high-frequency response. Vertical filters with a better frequency response than the one for line duplication are possible, at the cost of more line stores and processing.

The best vertical frequency response is obtained when field merging is implemented. The spatial position of the lines are already correct and no vertical processing is required, resulting in a flat curve (Line C). Again, this applies only for stationary areas of the image.

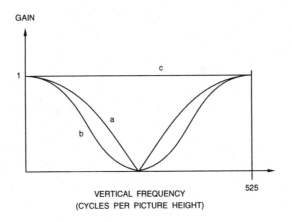

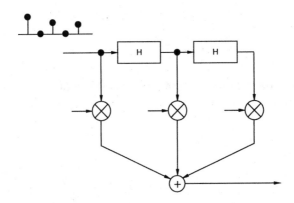

Figure 9.8. Frequency Response of Various Deinterlacing Filters: (a) Line Duplication, (b) Line Interpolation, (c) Field Merging.

Noninterlaced-to-Interlaced Conversion

Since the computer typically uses a noninterlaced display, the data usually must be converted to an interlaced format if consumer video is to be generated. The easiest approach is to throw every other scan line in each noninterlaced frame away, as shown in Figure 9.9. Although the cost is minimal, there are prob-

lems with this approach, especially when horizontal lines that are one or two noninterlaced scan lines wide are converted. Lines that are one noninterlaced scan line wide will flicker at the frame refresh rate (30 Hz for NTSC, 25 Hz for PAL and SECAM) when converted to interlaced. The reason is that they only are displayed every other field as a result of the simple conversion. This effect also may occur on the top and bottom edges of objects. Lines that are two noninterlaced scan lines wide will

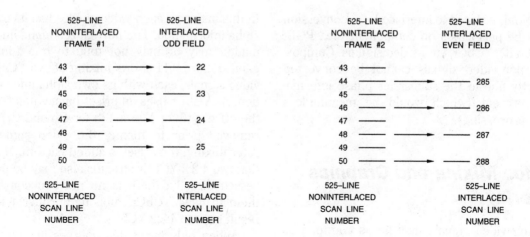

Figure 9.9. Basic Noninterlaced-to-Interlaced Conversion Using Line Decimation.

oscillate up and down between two interlaced scan lines at the frame refresh rate (30 Hz for NTSC, 25 Hz for PAL and SECAM) when converted to interlaced.

A better solution to the problem is to use two, or preferably three, scan lines of noninterlaced data to generate one scan line of interlaced data, as shown in Figure 9.10. In this way, fast transitions are smoothed out over several interlaced scan lines. This implementation does require line stores (for each video component) to store the video data until needed, as well as digital filters. Note that care must be taken at the beginning and end of each frame in the event that a fewer number of scan lines are available for filtering. However, the improvement in flicker reduction makes this the preferred implementation in almost all cases.

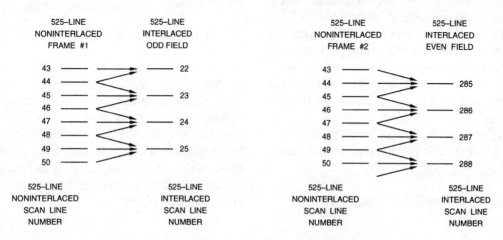

Figure 9.10. Noninterlaced-to-Interlaced Conversion using 3-Line Vertical Filtering.

Noninterlaced-to-interlaced conversion must be performed on component (i.e., RGB, YUV, YIQ, YCbCr, etc.) video signals. Composite color video signals cannot be converted directly due to the subcarrier phase information present (which would be meaningless after processing).

Video Mixing and Graphics Overlay

Mixing video signals may be as common as simply switching between two video sources. This is adequate if the resulting video is to be displayed on a computer monitor.

For most other applications, a technique known as alpha mixing should be used. Alpha mixing also may be used to fade to or from a specific color (such as black) or to overlay computer-generated text and graphics onto a video signal.

Alpha mixing should be used if the video is to be encoded to NTSC, PAL, or SECAM. Otherwise, ringing and blurring may appear at the source switching points, such as around the edges of computer-generated text and graphics. This is due to the color information being severely lowpass filtered within the NTSC/PAL encoder. If the filters have a sharp cut-off, a fast color transition will produce ringing. In addition, the intensity information will be bandwidth-limited to about 4–5 MHz somewhere along the video path, which slows down intensity transitions.

Mathematically, alpha mixing is implemented as (alpha is normalized to have values of 0–1):

$$out = (alpha_0)(in_0) + (alpha_1)(in_1) + ...$$

In this instance, each video source has its own alpha information. The normalized alpha information may or may not total to one (unity gain). Figure 9.11 shows mixing of two YCbCr video signals, each with its own alpha information. As YCbCr uses an offset binary notation, the offset (16 for Y and 128 for Cb and Cr) is removed prior to mixing the video signals. After mixing, the offset is added back in. Note that two 4:2:2 YCbCr streams also may be processed directly; there is no need to convert them to 4:4:4 YCbCr, mix, then convert the result back to 4:2:2 YCbCr.

When only two video sources are mixed (implementing a crossfader), and alpha_0 + alpha_1 = 1, a single alpha value may be used, mathematically shown as:

$$out = (alpha)(in_0) + (1 - alpha)(in_1)$$

When alpha = 0, the output is equal to the in_1 video signal; when alpha = 1, the output is equal to the in_0 video signal. When alpha is between 0 and 1, the two video signals are proportionally multiplied, and added together. Expanding and rearranging the above equation shows how a two-channel mixer (also called a crossfader) may be implemented using a single multiplier:

$$out = (alpha)(in_0 - in_1) + in_1$$

For either implementation, it may be desirable to bypass the appropriate multiplier when alpha = FF_H (assuming an 8-bit alpha value) to achieve precise unity gain. Figure 9.12 illustrates mixing two YCbCr sources using a single multiplier. Fading to and from a specific color is done using the two-channel mixer, by setting one of the sources to a constant desired color (such as black).

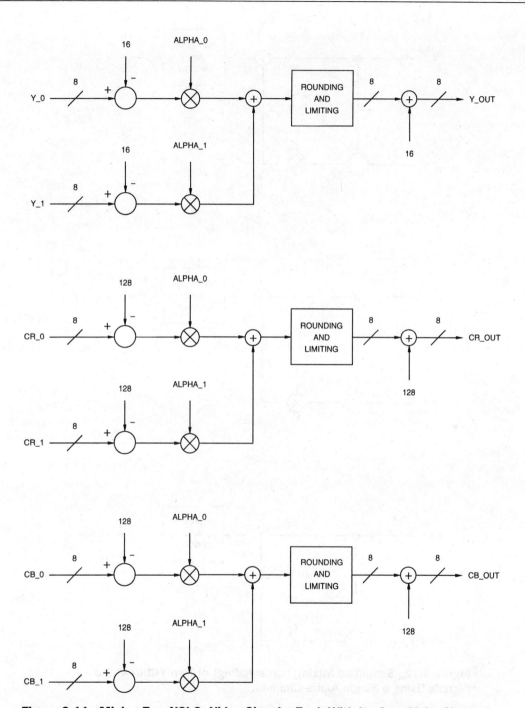

Figure 9.11. Mixing Two YCbCr Video Signals, Each With Its Own Alpha Channel.

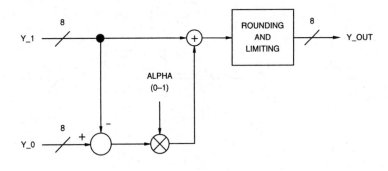

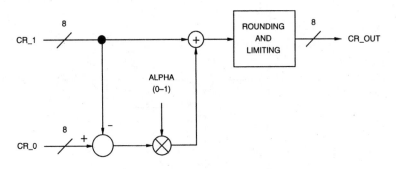

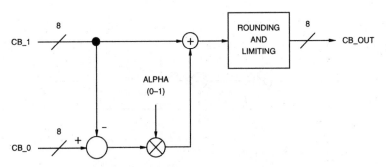

Figure 9.12. Simplified Mixing (Crossfading) of Two YCbCr Video Signals Using a Single Alpha Channel.

Figures 9.13 and 9.14 illustrate mixing two RGB video sources (RGB has a range of 0–255). Figures 9.15 and 9.16 show mixing two digital composite video signals.

A common problem in computer graphics systems that use alpha is that the frame buffer may or may not contain preprocessed RGB or YCbCr data; that is, the RGB or YCbCr data in the frame buffer already has been multiplied by alpha. Assuming an alpha value of 128 (50%), nonprocessed RGBA values for white are (255, 255, 255, 128); preprocessed RGBA values for white are (128, 128, 128, 128). Therefore, any mixing circuit that accepts RGB or YCbCr data from a frame buffer should be able to handle either format.

By adjusting the alpha values, slow to fast crossfades are possible, as shown in Figure 9.17. Large differences in alpha during each clock cycle result in a fast crossfade; smaller differences in alpha result in a slow crossfade. If using alpha mixing for special effects, such as wipes, the switching point (where 50% of each video source is used) must be able to be adjusted to an accuracy of less than one pixel to ensure smooth movement. By controlling the alpha values, the switching point can be effectively positioned anywhere, as shown in Figure 9.17a.

Text can be overlaid onto video by having the character generator control the alpha inputs. By setting one of the sources to the mixer to a constant color, the text will assume that color.

Luma and Chroma Keying

Keying involves specifying a desired foreground color; areas containing this color are replaced with a background image. Alternately, an area of any size or shape may be specified; foreground areas inside (or optionally outside) this area are replaced with a background image.

Luminance Keying

Luminance keying involves specifying a desired foreground luminance (or brightness) level; foreground areas containing luminance levels above (or optionally below) the keying level are replaced with the background image. Alternately, this hard keying implementation may be replaced with soft keying by specifying two luminance values of the foreground video signal: Y_H and Y_L ($Y_L < Y_H$). For keying the background into "white" foreground areas, foreground luminance values (Y_{FG}) above Y_H contain the background video signal; Y_{FG} values below Y_L contain the foreground video signal. For Y_{FG} values between Y_L and Y_H, linear mixing is done between the foreground and background video signals. This operation, using values normalized to 0–1, may be expressed as:

if $Y_{FG} > Y_H$ (background only)
$K = 1$

if $Y_{FG} < Y_L$ (foreground only)
$K = 0$

if $Y_H \geq Y_{FG} \geq Y_L$ (mix)
$K = (Y_{FG} - Y_L)/(Y_H - Y_L)$

For keying the background into "black" foreground areas, values above Y_H contain the foreground video signal; values below Y_L contain the background video signal. For values between Y_L and Y_H, linear mixing is done between the foreground and background video signals. By subtracting K from 1, the new luminance keying signal for keying into "black" foreground areas can be generated.

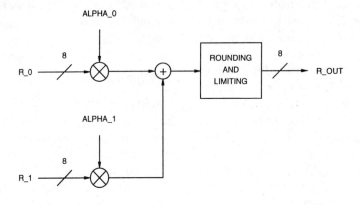

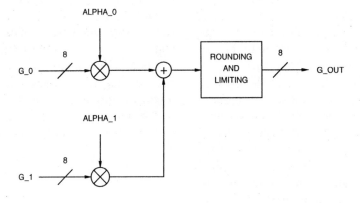

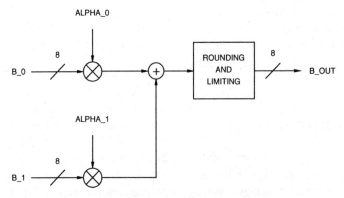

Figure 9.13. Mixing Two RGB Video Signals (RGB has a Range of 0–255), Each With Its Own Alpha Channel.

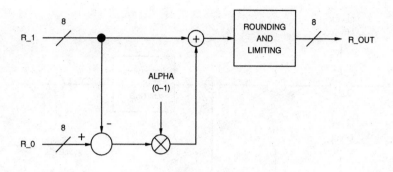

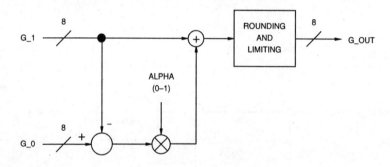

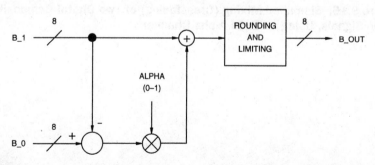

Figure 9.14. Simplified Mixing (Crossfading) of Two RGB Video Signals (RGB has a Range of 0–255), Using a Single Alpha Channel.

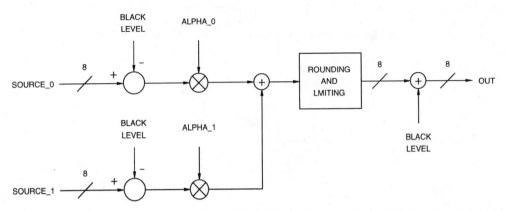

Figure 9.15. Mixing Two Digital Composite Video Signals, Each With Its Own Alpha Channel.

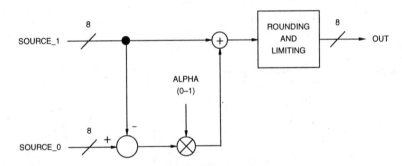

Figure 9.16. Simplified Mixing (Crossfading) of Two Digital Composite Video Signals, Using a Single Alpha Channel.

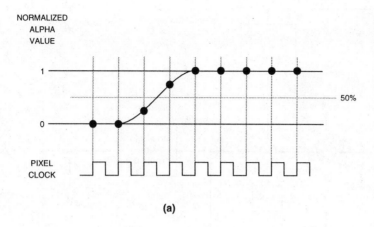

(a)

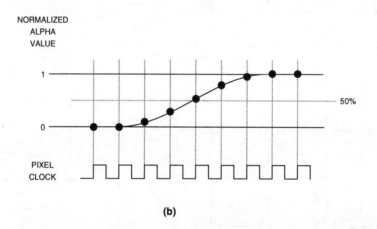

(b)

Figure 9.17. Controlling Alpha Values to Implement Fast (a) or Slow (b) Keying. In (a), the effective switching point lies between two samples. In (b), the transition is wider, but is aligned at a sample instant.

Figure 9.18 illustrates luminance keying for two YCbCr digital component video sources. Although chroma keying typically uses a suppression technique to remove information from the foreground image, this is not done when luminance keying as the magnitude of Cb and Cr usually are not related to the luminance level. Figure 9.19 illustrates luminance keying for RGB sources, which is more applicable for computer graphics. Y_{FG} may be obtained by the equation:

$$Y_{FG} = 0.299R' + 0.587G' + 0.114B'$$

In some applications, the red and blue data is ignored, resulting in Y_{FG} being equal to only the green data. Figure 9.20 illustrates one technique of luminance keying between two digital composite video sources.

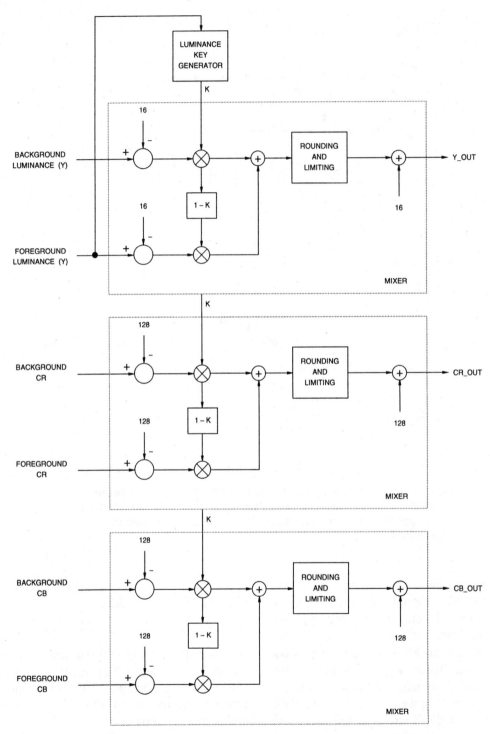

Figure 9.18. Luminance Keying of Two YCbCr Video Signals.

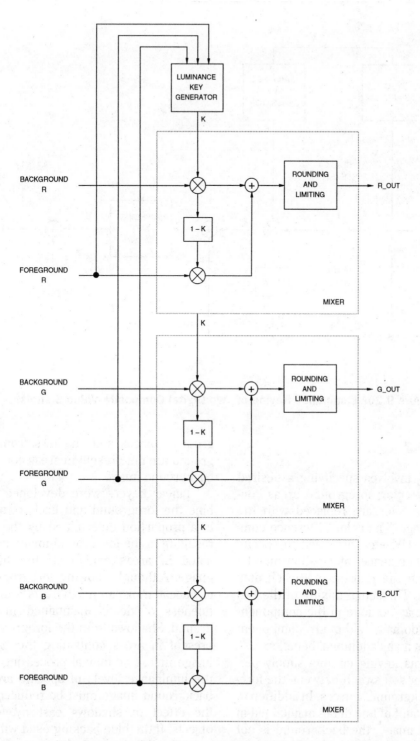

Figure 9.19. Luminance Keying of Two RGB Video Signals. RGB range is 0–255.

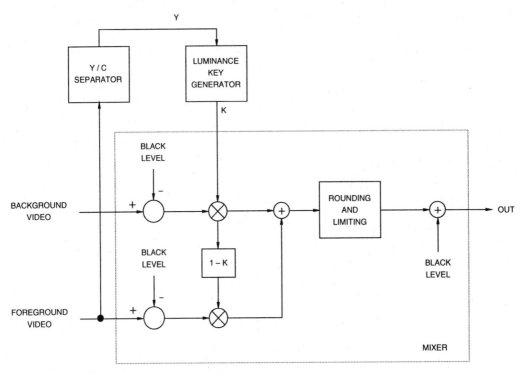

Figure 9.20. Luminance Keying of Two Digital Composite Video Signals.

Chroma Keying

Chroma keying involves specifying a desired foreground key color; foreground areas containing the key color are replaced with the background image. The color difference components (CbCr, UV, etc.) are used to specify the key color; luminance information may be used to increase the realism of the chroma keying function. The actual mixing of the two video sources may be done in the component or composite domain, although component mixing provides many additional benefits.

Early chroma keying circuits simply performed a hard or soft switch between the foreground and background sources. In addition to limiting the amount of fine detail maintained in the foreground image, the background is not visible through transparent or translucent fore-

ground objects, and shadows from the foreground are not present in areas containing the background image.

Linear keyers were developed that combine the foreground and background images in a proportion determined by the key level, resulting in the foreground image being attenuated in areas containing the background image. Although allowing foreground objects to appear transparent, there is a limit on the fineness of detail maintained in the foreground. Shadows from the foreground are not present in areas containing the background image unless additional processing is done—the luminance levels of specific areas of the background image must be reduced to create the effect of shadows cast by foreground objects. If the blue backing used with the foreground scene is evenly lit except for shadows

cast by the foreground objects, the effect on the background will be that of shadows cast by the foreground objects. This process, referred to as shadow chroma keying, or luminance modulation, enables the background luminance levels to be adjusted in proportion to the brightness of the blue backing in the foreground scene. This results in more realistic keying of transparent or translucent foreground objects by preserving the spectral highlights. Chroma keyers also are limited in their ability to handle foreground colors that are close to the key color without switching to the background image. Another problem may be a bluish tint to the foreground objects as a result of blue light reflecting off the blue backing or being diffused in the camera lens.

Chroma spill is difficult to remove since the spill color is not the original key color; some mixing occurs, changing the original key color slightly.

The best solution currently available to solve most of the chroma keying problems is to process the foreground and background images individually before combining them, as shown in Figure 9.21. Rather than choosing between the foreground and background, each is processed individually and then combined. The foreground key (K_{FG}) and background key (K_{BG}) signals have a range of 0 to 1. The garbage matte key signal (the term matte comes from the film industry) forces the mixer to output the foreground source in one of two ways. The first method is to reduce K_{BG} in pro-

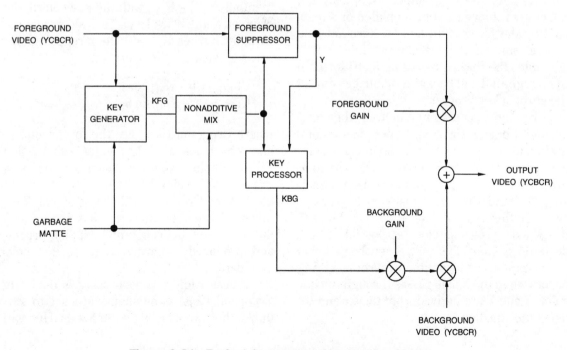

Figure 9.21. Typical Component Chroma Key Circuit.

portion to increasing K_{FG}. This provides the advantage of minimizing black edges around the inserted foreground. The second method is to force the background to black for all non-zero values of the matte key, and insert the foreground into the background "hole." This requires a cleanup function to remove noise around the black level, as this noise affects the background picture due to the straight addition process. The garbage matte is added to the foreground key signal (K_{FG}) using a nonadditive mixer (NAM). A nonadditive mixer takes the brighter of the two pictures, on a pixel-by-pixel basis, to generate the key signal. Matting is ideal for any source that generates its own keying signal, such as character generators, and so on.

Not shown in Figure 9.21 is the circuitry to initially subtract 16 (Y) or 128 (Cb and Cr) from the foreground and background video signals and the addition of 16 (Y) or 128 (Cb and Cr) after the final output adder. Any DC offset not removed will be amplified or attenuated by the foreground and background gain factors, shifting the black level. Figure 9.22 illustrates the major processing steps for both the foreground and background images during the chroma key process.

The key generator monitors the foreground Cb and Cr data, generating a foreground keying signal, K_{FG}. A desired key color is selected, as shown in Figure 9.23. The foreground Cr and Cb data are normalized (generating Cr′ and Cb′) and rotated θ degrees to generate the X and Z data, such that the positive X axis passes as close as possible to the desired key color. Typically, θ may be varied in 1° increments, and optimum chroma keying occurs when the X axis passes through the key color. X and Z are derived from the Cr and Cb using the equations:

$$X = Cb' \cos \theta + Cr' \sin \theta$$
$$Z = Cr' \cos \theta - Cb' \sin \theta$$

Since Cr′ and Cb′ are normalized to have a range of ±1, X and Z have a range of ±1. The foreground keying signal (K_{FG}) is generated from X and Z and has a range of 0–1:

$$K_{FG} = X - (|Z| / (\tan (\alpha / 2)))$$
$$K_{FG} = 0 \text{ if } X < (|Z| / (\tan (\alpha / 2)))$$

where α is the acceptance angle, symmetrically centered about the positive X axis, as shown in Figure 9.24. Outside the acceptance angle, K_{FG} is always set to zero. Inside the acceptance angle, the magnitude of K_{FG} linearly increases the closer the foreground color approaches the key color and as its saturation increases. Colors inside the acceptance angle are processed further by the foreground suppressor.

The foreground suppressor reduces foreground chrominance information by implementing $X = X - K_{FG}$, with the key color being clamped to the black level. To avoid processing Cr and Cb when $K_{FG} = 0$, the foreground suppressor performs the operations:

$$Cb_{FG} = Cb - K_{FG} \cos \theta$$
$$Cr_{FG} = Cr - K_{FG} \sin \theta$$

where Cr_{FG} and Cb_{FG} are the foreground Cr and Cb values after key color suppression. Prior implementations suppressed foreground information by multiplying Cr and Cb by a clipped version of the K_{FG} signal. This, however, generated in-band alias components due to the multiplication and clipping process and produced a harder edge at key color boundaries.

Unless additional processing is done, the Cr_{FG} and Cb_{FG} components are set to zero only if they are exactly on the X axis. Hue vari-

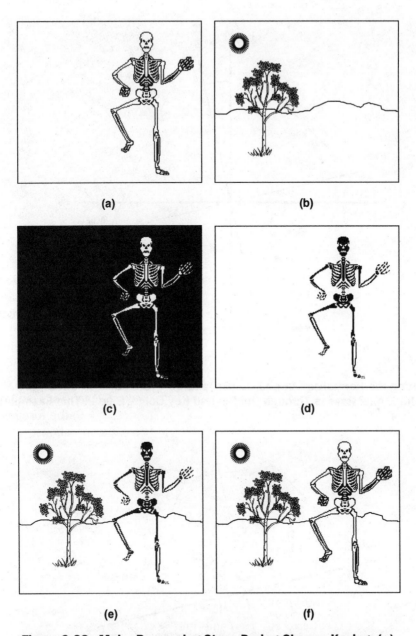

Figure 9.22. Major Processing Steps During Chroma Keying: (a) Original Foreground Scene, (b) Original Background Scene, (c) Suppressed Foreground Scene, (d) Background Keying Signal, (e) Background Scene After Multiplication by Background Key, (f) Composite Scene Generated by Adding (c) and (e).

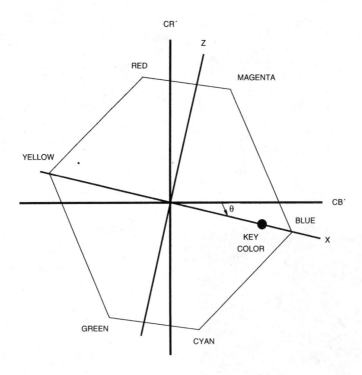

Figure 9.23. Rotating the Normalized Cr and Cb (Cr′ and Cb′) Axes by θ to Obtain the X and Z Axes, Such That the X Axis Passes Through the Desired Key Color (Blue in This Example).

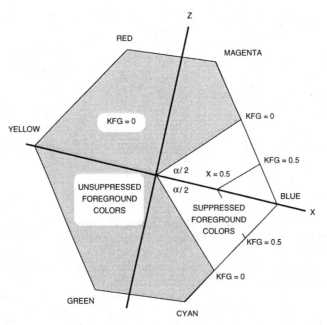

Figure 9.24. Foreground Key Values and Acceptance Angle.

ations due to noise or lighting will result in areas of the foreground not being entirely suppressed. Therefore, a suppression angle is set, symmetrically centered about the positive X axis. The suppression angle (β) typically is configurable from a minimum of zero degrees, to a maximum of about one third the acceptance angle (α). Any CbCr components that fall within this suppression angle are set to zero. Figure 9.25 illustrates the use of the suppression angle.

Foreground luminance, after being normalized to have a range of 0–1, is suppressed by:

$$Y_{FG} = Y' - y_S K_{FG}$$
$$Y_{FG} = 0 \text{ if } y_S K_{FG} > Y'$$

y_S is an programmable value and used to adjust Y_{FG}, which has a range of 0–1, so that it is clipped at the black level in the key color areas.

The foreground suppressor also removes key-color fringes on wanted foreground areas caused by chroma spill, the overspill of the key color, by removing discolorations of the wanted foreground objects. Ultimatte® improves on this process by measuring the difference between the blue and green colors, as the blue backing is never pure blue and there may be high levels of blue in the wanted foreground objects. Pure blue rarely is found in nature, and most natural blues have a higher content of green than red. For this reason, the red, green, and blue levels are monitored to differentiate between the blue backing and blue in wanted foreground objects. If the difference between blue and green is great enough, all three colors are set to zero to produce black; this is what happens in areas of the foreground containing the blue backing. If the difference between blue and green is not large, the blue is set to the green level unless the green exceeds red. This technique allows the removable of the bluish tint caused by the blue backing while being able to reproduce natural blues in the foreground. There is a price to pay, however. Magenta in the foreground is changed to red. A green backing can be used, but in this case, yellow in the foreground is modified. Usually, the clamping is released gradually to increase the blue content of magenta areas. As an example, a white foreground area normally would consist of equal levels of red, green, and blue. If the white area is affected by the key color (blue in this instance), it will have a bluish tint—the blue levels will be greater than the red or green levels. Since the green does not exceed the red, the blue level is made equal to the green, removing the bluish tint. Note that, in this instance, RGB data is used for processing the foreground image.

The key processor generates the initial background key signal (K'_{BG}) used to remove areas of the background image where the foreground is to be visible. K'_{BG} is adjusted to be zero in desired foreground areas and unity in background areas with no attentuation. It is generated from the foreground key signal K_{FG} by applying lift (k_L) and gain (k_G) adjustments followed by clipping at zero and unity values:

$$K'_{BG} = (K_{FG} - k_L)k_G$$

Figure 9.26 illustrates the operation of the background key signal generation. The transition band between $K'_{BG} = 0$ and $K'_{BG} = 1$ should be made as wide as possible to minimize discontinuities in the transitions between foreground and background areas.

For foreground areas containing the same CbCr values, but different luminance (Y) values, as the key color, the key processor may also reduce the background key value as the foreground luminance level increases, allow-

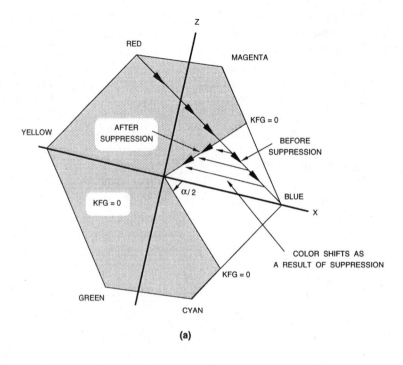

(a)

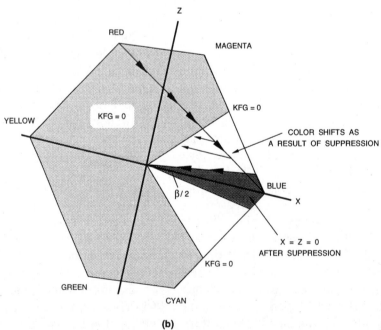

(b)

Figure 9.25. Suppression Angle Operation for a Gradual Change From a Red Foreground Object to the Blue Key Color: (a) Simple Suppression, (b) Improved Suppression Using a Suppression Angle.

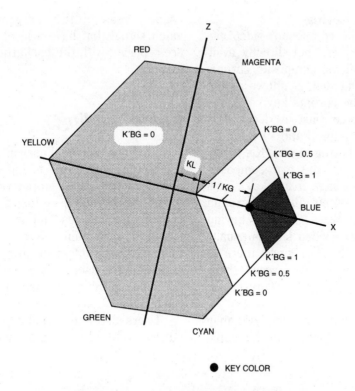

Figure 9.26. Background Key Generation.

ing turning off the background in foreground areas containing a "lighter" key color, such as light blue. This is done by:

$$K_{BG} = K'_{BG} - y_c Y_{FG}$$
$$K_{BG} = 0 \text{ if } y_c Y_{FG} > K_{FG}$$

To handle shadows cast by the foreground objects, and opaque or translucent foreground objects, the luminance levels of the blue backing of the foreground image is monitored. Where the luminance of the blue backing is reduced, the luminance of the background image also is reduced. The amount of background luminance reduction must be controlled so that defects in the blue backing (such as seams or footprints) are not interpreted as foreground shadows. Additional controls may be implemented to enable the foreground and background signals to be controlled independently. Examples are adjusting the contrast of the foreground so it matches the background or fading the foreground in various ways (such as fading to the background to make a foreground object vanish or fading to black to generate a silhouette).

In the computer graphics environment, there may be relatively slow, smooth edges—especially edges involving smooth shading. As smooth edges are easily distorted during the chroma keying process, a wide keying process usually is used in these circumstances. During wide keying, the keying signal starts before the edge of the graphic object.

Composite Chroma Keying

In some instances, the component video signals (such as YCbCr) are not directly available. For these situations, composite chroma keying may be implemented, as shown in Figure 9.27. To detect the chroma key color, the foreground video source must be decoded to produce the Cb and Cr (or U and V) color difference signals. The keying signal, K_{FG}, then is used to mix between the two composite video sources. The garbage matte key signal forces the mixer to output the background source by reducing K_{FG}. Chroma keying directly using composite video signals usually results in unrealistic keying, since there is inadequate color bandwidth. As a result, there is a lack of fine detail, and halos are present on edges.

High-end video editing systems also may make use of superblack keying. In this application, areas of the foreground composite video signal that have a level of 0 to –5 IRE are replaced with the background video information.

Video Scaling

With today's graphical user interfaces (GUIs), users want to be able to input live video, or play back previously stored video, in an arbitrarily-sized window. In this case, the standard consumer video resolutions may need to be scaled to fit within the window. Of course, there is the problem of how the system will respond if the user defines a window that does not maintain the proper aspect ratio, distorting the image.

Users also want the ability to store or output live video. In this case, the contents of a

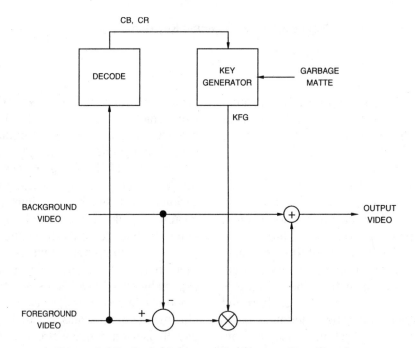

Figure 9.27. Typical Composite Chroma Key Circuit.

window, or the entire screen, may need to be scaled to the standard consumer video resolutions.

Note that scaling must be performed on component (i.e., RGB, YUV, YIQ, YCbCr, etc.) video signals. Composite color video signals cannot be processed directly due to the color subcarrier phase information present (which would be meaningless after processing).

When generating video, the user or software application must be concerned with such things as text size, line thickness, and so forth. For example, 9-point text on a 1280 × 1024 display will not be readable on a standard NTSC or PAL display due to the large amount of downscaling involved. Thin horizontal lines, easily visible on a 1280 × 1024 display, either disappear completely or oscillate up and down one scan line at a 25- or 30-Hz rate when converted to consumer video resolutions.

Table 9.1 illustrates common computer display and consumer video resolutions. When processing consumer video within the computer environment, it is common to use the "square pixel" format. This avoids the aspect ratio problem—for example, when circles on the computer display monitor become ellipses when stored on video tape.

Pixel Dropping and Duplication

The simplest form of scaling down is pixel dropping, where (m) out of every (n) pixels are thrown away both horizontally and vertically. For example, a scaling factor of one third (resulting in an image that is one ninth as large as the original), results in two out of every three pixels being discarded in both the horizontal and vertical directions. A modified version of the Bresenham line-drawing algorithm (described in most computer graphics books) typically is used to determine which pixels not to discard.

Simple upscaling can be accomplished by pixel duplication, where (m) out of every (n) pixels are duplicated both horizontally and vertically. Again, a modified version of the Bresenham line-drawing algorithm can be used to determine which pixels to duplicate.

The limited bandwidth of consumer video allows pixel dropping and duplication to be used for small up or down scaling factors. Scaling down more than about one half will result in the loss of detail, while scaling up more than about two times will introduce "blocks" within the image.

Scaling down using pixel dropping is not recommended if the resulting image is to be

Computer Resolutions	NTSC Resolutions		PAL Resolutions	
	Standard	MPEG	Standard	MPEG
640 × 480	640 × 480[1]	320 × 240[1]	720 × 576	352 × 288
800 × 600	720 × 480	352 × 240	768 × 576[1]	384 × 288[1]
1024 × 768		720 × 480		720 × 576
1280 × 1024				

Table 9.1. Common Resolutions for Computer Displays and Consumer Video Formats. [1]**Square Pixel Format.**

further processed due to the introduction of aliasing components. A "decimation filter" can be used, which bandwidth-limits the image horizontally and vertically before decimation. However, each scaling factor requires different filter coefficients.

Linear Interpolation

An improvement in video quality of scaled images is possible using linear interpolation (bilinear interpolation combines the linear interpolation process in both the horizontal and vertical dimensions). When an output sample falls between two input samples (horizontally or vertically), the output sample is computed by linearly interpolating between the two input samples. However, scaling to images smaller than one half of the original may still result in deleted pixels.

The linear interpolator is a poor bandwidth-limiting filter. Excess high-frequency detail is removed unnecessarily and too much energy above the Nyquist limit is still present, resulting in aliasing.

Anti-Aliased Resampling

The most desirable approach is to ensure the frequency content scales proportionally with the image size, both horizontally and vertically.

Figure 9.28 illustrates the fundamentals of an anti-aliased resampling process. The input data is upsampled by A and lowpass filtered to remove image frequencies created by the interpolation process. Filter B bandwidth-limits the signal to remove frequencies that will alias in the resampling process B. The ratio of B/A determines the scaling factor.

Filters A and B usually are combined into a single filter. The response of the filter largely determines the quality of the interpolation. The ideal lowpass filter would have a very flat passband, a sharp cutoff at half of the lowest sampling frequency (either input or output), and very high attenuation in the stopband. However, since such a filter generates ringing on sharp edges, it usually is desirable to roll off the top of the passband. This makes slightly softer pictures, but with less pronounced ringing.

Passband ripple and stopband attenuation of the lowpass filter provide some measure of scaling quality, but the subjective effect of ringing means a flat passband might not be as good as one might think. Lots of stopband attenuation is almost always a good thing.

There are essentially three variations of the general resampling structure. Each combines the elements of Figure 9.28 in various ways.

One approach is a variable-bandwidth anti-aliasing filter followed by a combined interpolator/resampler. In this case, the filter needs new coefficients for each scale factor—as the scale factor is changed, the quality of the image may vary. In addition, the overall response is poor if linear interpolation is used. However, the filter coefficients are time-invariant and there are no gain problems.

A second approach is a combined filter/interpolator followed by a resampler. Generally, the higher the order of interpolation, n, the better the overall response. The center of the filter transfer function always is aligned over the new output sample. With each scaling factor, the filter transfer function is stretched or compressed to remain aligned over n output samples. Thus, the filter coefficients, and the

Figure 9.28. General Anti-Aliased Resampling Structure.

number of input samples used, change with each new output sample and scaling factor. Dynamic gain normalization is required to ensure the sum of the filter coefficients is always equal to one.

A third approach is an interpolator followed by a combined filter/resampler. The input data is interpolated up to a common multiple of the input and output rates by the insertion of zero samples. This is filtered with a low-pass finite-impulse-response (FIR) filter to interpolate samples in the zero-filled gaps, then re-sampled at the required locations. This type of design usually is achieved with a "polyphase" filter, switching its coefficients as the relative position of input and output samples changes.

Field and Frame Rate Conversion

Personal computers and workstations usually operate the display in a noninterlaced fashion, with a refresh rate of 60–80 frames per second—obviously incompatible with consumer video refresh rates, which are interlaced with a refresh rate of 25 or 30 frames per second. To perform ideal frame rate conversion requires the interpolation of video fields or frames, which is currently very costly to implement. As a result, when displaying live video on the computer monitor, most systems currently do not compensate for the frame-rate differences other than attempting to ensure "tearing" does not occur frequently (see Chapter 2 for additional system-level discussions on frame-rate conversion). To ensure tearing does not occur, some high-end systems use multiple video frame stores. Note that processing must be performed on component (i.e., RGB, YUV, YIQ, YCbCr, etc.) video signals. Composite color video signals cannot be processed

directly due to the subcarrier phase information present (which would be meaningless after processing).

When generating live video, the problem becomes more complex. Although the video timing subsystem will usually support 60- or 50-Hz interlaced video timing, many of the newer computer display monitors do not support interlaced operation; even if they do, the flicker of large areas of white or highly saturated colors makes the computer display unpleasant to use. Therefore, the best solution is to configure the video timing subsystem for 60- or 50-Hz noninterlaced operation and perform noninterlaced-to-interlaced conversion prior to encoding. If the noninterlaced-to-interlaced conversion is implemented by vertical filtering, flicker of the interlaced image is also reduced.

For computer-generated images that have little or no movement between fields, field dropping or duplicating may be used to change the field rate. Simple field-rate conversion may be done by dropping or duplicating one out of every N fields, as done by some consumer multistandard VTRs. For example, the conversion of 60-Hz interlaced to 50-Hz interlaced operation may drop one out of every six fields, as shown in Figure 9.29, requiring a single field store. However, in areas where the original source has smooth or large amounts of movement, the resulting image will have jerky movement. The only solution to avoid the resulting jerky movement during field or frame-rate conversion is to interpolate temporally.

Conversion of 50-Hz interlaced to 60-Hz interlaced operation using temporal interpolation is illustrated in Figure 9.30. For every five fields of 50-Hz interlaced video, there are six fields of 60-Hz interlaced video. After both sources are aligned, two adjacent 50-Hz fields are mixed together to generate a new 60-Hz field. This technique is used in some inexpen-

sive standards converters to convert between 625/50 and 525/60 standards. Note that no motion analysis is done. Therefore, for example, if the camera operating at 625/50 pans horizontally past a narrow vertical object, you will see one object once every six 525/60 fields, and for the five fields in between, you will see two objects, one fading in while the other fades out. Prior to the temporal interpolation shown in Figure 9.31, vertical filtering was used to convert from 625 to 525 scan lines per frame. Figure 9.32 illustrates the spectral representation of the circuit in Figure 9.31.

More modern designs combine the vertical and temporal interpolation into a single, integrated design, as shown in Figure 9.33, with the corresponding spectral representation shown in Figure 9.34.

This example uses vertical, followed by temporal, interpolation. If temporal, followed by vertical, interpolation were implemented, the field stores would be half the size. However, the number of line stores would increase from four to eight. In either case, the first interpolation process must produce an intermediate, higher-resolution sequential format

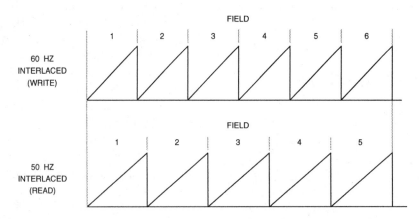

Figure 9.29. 60-Hz Interlaced to 50-Hz Interlaced Conversion Using a Single Field Store by Dropping One Out of Every Six Fields.

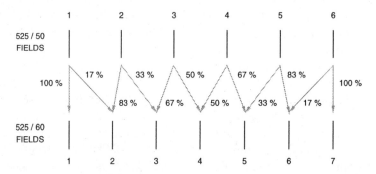

Figure 9.30. 50-Hz Interlaced to 60-Hz Interlaced Conversion Using Temporal Interpolation With no Motion Compensation.

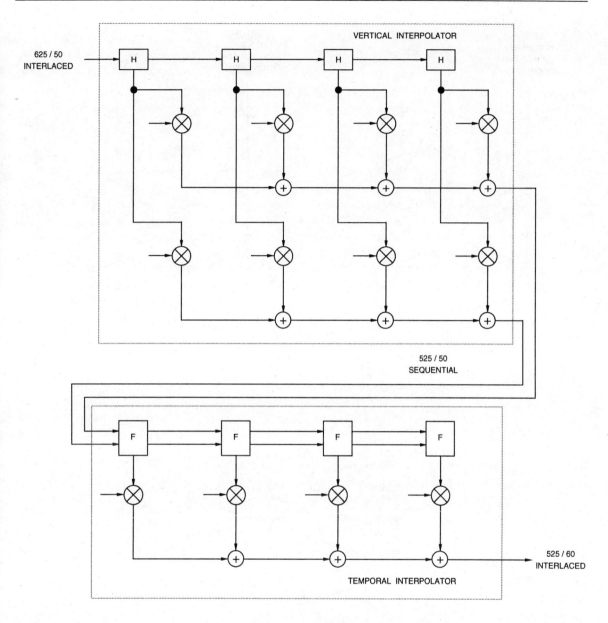

Figure 9.31. Typical 625/50 to 525/60 Conversion Using Vertical, Followed by Temporal, Interpolation.

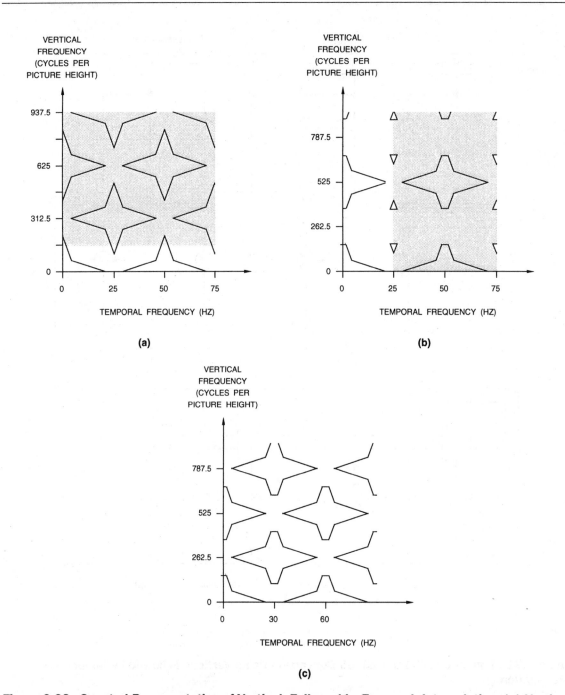

Figure 9.32. Spectral Representation of Vertical, Followed by Temporal, Interpolation: (a) Vertical Lowpass Filtering, (b) Resampling to Intermediate Sequential Format and Temporal Lowpass Filtering, (c) Resampling to Final Standard.

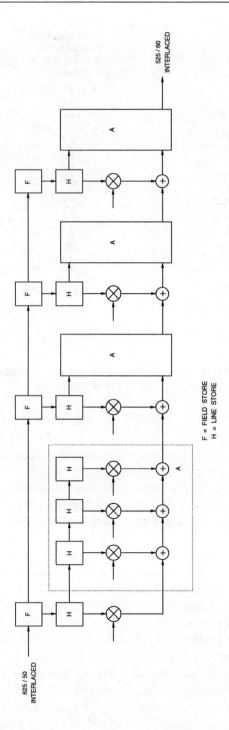

Figure 9.33. Typical 625/50 to 525/60 Conversion Using Combined Vertical and Temporal Interpolation.

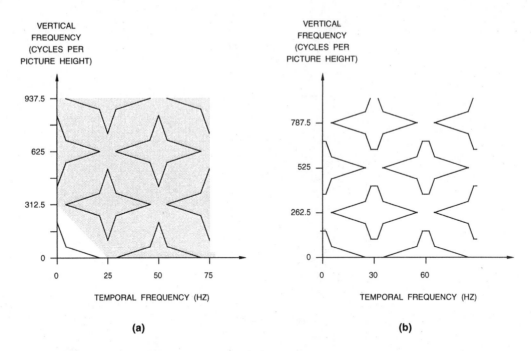

Figure 9.34. Spectral Representation of Combined Vertical and Temporal Interpolation: (a) Two-Dimensional Lowpass Filtering, (b) Resampling to Final Standard.

to avoid interlace components that would interfere with the second interpolation process. It is insufficient to interpolate, either vertically or temporally, using a mixture of lines from even and odd fields, due to the one-dimensional interpolation process not being able to compensate for the temporal offset of interlaced lines.

Newer, more expensive standard converters perform motion estimation on small blocks of pixels (typically 8 × 8 pixels) from one field to the next. The motion estimator generates a motion vector for each block of pixels, indicating the direction and amount of movement of each moving object between fields. When generating a new, interpolated field, the motion vectors are interpolated linearly based on the position of the new field. For example, looking at Figure 9.30, the motion vectors from 525/50 field 1 would be scaled by 5/6ths to indicate the position of moving objects in 525/60 field

2. Stationary objects would retain their position as indicated in 525/50 field 1. Further information may be needed from the field before and after 525/50 field 1 to properly fill in behind moved objects. Really fast motion may create artifacts; also, after a fast cut to a new scene, garbage may be generated for several fields.

For completeness, the transfer of film to video will also be covered. Film usually is recorded at 24 frames per second. When transferring to PAL or SECAM (50 Hz field rate), the best transfers repeat every 12th film frame for an extra video field. Usually, however, each film frame is mapped into 2 video fields, resulting in the video version of the movie being played back 4% faster.

When transferring film to NTSC (59.94-Hz field rate), 3-2 pulldown is used, as shown in Figure 9.35. The film playback speed may be slowed down by 0.1%. Two film frames gener-

Figure 9.35. Typical 3-2 Pulldown for Transferring Film to NTSC Video.

ate five video fields. In scenes of high-speed motion of objects, the specific film frame used for a particular video field may be manually adjusted, to minimize motion artifacts.

Analog laserdiscs may use a white flag signal to indicate the start of another sequence of related fields for optimum still-frame performance. During still-frame mode, the white flag signal tells the system to back up two fields (to use two fields that have no motion between them) to re-display the current frame.

Adjusting Hue, Contrast, Brightness, and Saturation

Working in a luminance and color difference color space (such as YCbCr), rather than the RGB color space, has the advantage of simplifying adjustment of contrast, brightness, hue,

and saturation. Figure 9.36 illustrates a typical circuit for enabling adjustment of contrast, brightness, hue, and saturation using the YCbCr color space.

Here, 16 is subtracted from the Y data to position the black level at 0. This removes the DC offset so adjusting the contrast does not vary the black level. Contrast is adjusted by multiplying the Y data by a constant. Brightness information is added or subtracted from the Y data. The brightness is adjusted after the contrast adjustment to avoid introducing a varying DC offset due to adjusting the contrast. Finally, 16 is added to position the black level back at 16.

The value 128 is subtracted from Cb and Cr to position the range about zero. Hue is implemented by mixing the Cb and Cr data:

$$Cb' = Cb \cos \theta + Cr \sin \theta$$
$$Cr' = Cr \cos \theta - Cb \sin \theta$$

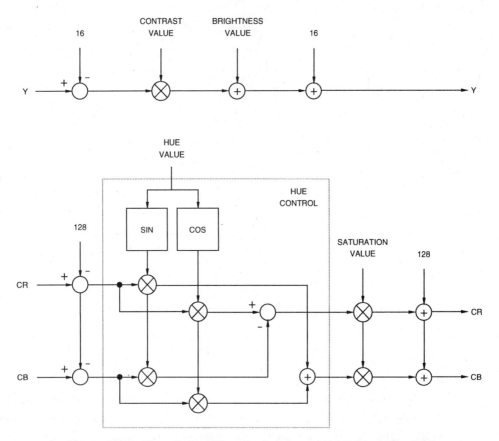

Figure 9.36. Hue, Saturation, Contrast, and Brightness Controls.

where θ is the desired hue angle. Saturation is adjusted by multiplying both Cb and Cr by a constant. Finally, 128 is added to both Cb and Cr to generate the desired 16 to 240 range.

Display Enhancement Processing

This section describes two processing steps that may be used to improve the viewing quality of digital images. Since they artificially increase the high-frequency component of the video signals, they should not be used if the video will be compressed, as the compression ratio will be affected.

Color Transient Improvement

Figure 9.37 illustrates a color transient improvement technique. The assumption is that the luminance and color difference transitions are normally aligned. However, the color difference transitions usually are degraded due to the narrow bandwidth of the color difference information, especially if the source was originally NTSC, PAL, or SECAM.

Figure 9.37. Color Transient Improvement.

By monitoring coincident luminance transitions, a faster edge is synthesized for the color difference transitions. These edges then are aligned with the luminance edge.

Small level details also may be increased without modifying larger transitions. Combined, these techniques allow a displayed picture to appear as though it has a bandwidth of 7–8 MHz, rather than 4–5 MHz.

Sharpness Enhancement

The apparent sharpness of a picture may be increased by increasing the amplitude of high-frequency luminance information.

As shown in Figure 9.38, a simple bandpass filter with selectable gain (also called a peaking filter) may be used. The frequency where maximum gain occurs may be selectable to be at the subcarrier frequency or at about 2.6 MHz. A coring circuit usually is used after the filter to reduce low-level noise.

Figure 9.39 illustrates a more complex sharpness control circuit. The high-frequency luminance is increased using a variable bandpass filter, with adjustable gain. The coring function (typically ±1 LSB) removes low-level noise. The modified luminance then is added to the original luminance signal.

VLSI Solutions

See C9_VLSI

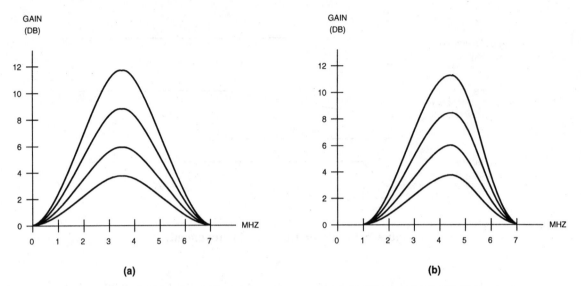

Figure 9.38. Simple Adjustable Sharpness Control: (a) NTSC, (b) PAL.

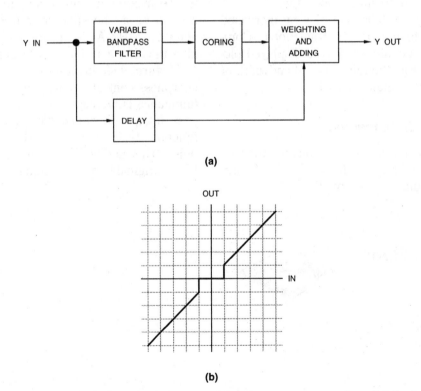

Figure 9.39. More Complex Sharpness Control: (a) Typical Implementation, (b) Coring Function.

References

1. Croll, M.G. et. al., 1987, *Accommodating the Residue of Processed or Computed Digital Video Signals Within the 8-bit CCIR Recommendation 601*, BBC Research Department Report BBC RD1987/12.
2. GEC Plessey Semiconductors, VP520 Datasheet, 6/93.
3. Genesis Microchip, gm865x1 Datasheet, 7/9/93.
4. Genesis Microchip, gm833x2 Datasheet, 11/93.
5. Genesis Microchip, gm833x3 Datasheet, 3/15/93.
6. Philips Semiconductors, *Desktop Video Data Handbook*, 1994.
7. Philips Semiconductors, SAA7140 Datasheet, 7/94.
8. Philips Semiconductors, SAA7168 Datasheet, 8/94.
9. Raytheon Semiconductor, TMC22080 Datasheet, Rev. E 9/93.
10. Sandbank, C. P., *Digital Television*, John Wiley & Sons, Ltd., New York, 1990.
11. Ultimatte®, Technical Bulletin No. 5, Ultimatte Corporation.
12. Watkinson, John, *The Art of Digital Video*, Focal Press, 1990.

MPEG 1

Advances in audio and video compression and decompression techniques, along with VLSI technology, are opening up new capabilities and markets. These include transmitting digital audio and video via satellite or cable, storing digital audio and video in computers, videophones, video CD players, and so on.

Three international standards made these advances possible: JPEG (Joint Photographic Expert Group), MPEG (Moving Pictures Expert Group), and ITU-T H.261 (video compression standard). Although each standard is tailored for a specific application, all have much in common. Since MPEG contains many of the same techniques as H.261 and baseline JPEG, multistandard VLSI devices are becoming commonplace.

In this chapter, we cover the basics of the MPEG 1 standard and compare it with JPEG and H.261.

Background

MPEG 1 was designed for storing and distributing audio and motion video, with emphasis on video quality. Features include random access, fast forward, and reverse playback. MPEG 1 is used as the basis for video CDs and many video games.

The original channel bandwidth and image resolution were set by media available at the time. The goal was playback of digital audio and video using a standard compact disc with a bit rate of 1.416 Mbps (1.15 Mbps of this is for video).

MPEG 1 is an ISO standard (ISO/IEC 11172), and consists of six parts:

system	ISO/IEC 11172-1
video	ISO/IEC 11172-2
audio	ISO/IEC 11172-3
low bit rate audio	ISO/IEC 13818-3
conformance testing	ISO/IEC 11172-4
simulation software	ISO/IEC 11172-5

The compressed bitstreams implicitly define the decompression algorithms. The compression algorithms are up to the individual manufacturers, allowing a proprietary advantage to be obtained within the scope of an international standard.

MPEG vs. JPEG

JPEG (ISO/IEC 10918) was designed for still continuous-tone grayscale and color images. It doesn't handle bi-level (black and white) images efficiently, and pseudo-color images have to be expanded into the unmapped color representation prior to processing. JPEG images may be of any resolution and color space, with both lossy and lossless algorithms available.

Since JPEG is such a general purpose standard, it has many features and capabilities. By adjusting the various parameters, compressed image size can be traded against reconstructed image quality over a wide range. Image quality ranges from "browsing" (100:1 compression ratio) to "indistinguishable from the source" (about 3:1 compression ratio). Typically, the threshold of visible difference between the source and reconstructed images is somewhere between a 10:1 to 20:1 compression ratio.

JPEG does not use a single algorithm, but rather a family of four, each designed for a certain application. The most familiar lossy algorithm is *sequential DCT*. Either Huffman encoding (baseline JPEG) or arithmetic encoding may be used. When the image is decoded, it is decoded left-to-right, top-to-bottom. Currently, most VLSI devices that implement JPEG support only baseline JPEG.

Progressive DCT is another lossy algorithm, requiring multiple scans of the image. When the image is decoded, a coarse approximation of the full image is available right away, with the quality progressively improving until complete. This makes it ideal for applications such as image database browsing. Either spectral selection, successive approximation, or both may be used. The spectral selection option encodes the lower frequency DCT coefficients first (to obtain an image quickly), followed by the higher-frequency ones (to add more detail). The successive approximation option encodes the more significant bits of the DCT coefficients first, followed by the less significant bits.

The *hierarchical* mode represents an image at multiple resolutions. For example, there could be 512×512, 1024×1024, and 2048×2048 versions of the image. Higher-resolution images are coded as differences from the next smaller image, requiring fewer bits than they would if stored independently. Of course, the *total* number of bits is greater than that needed to store just the highest-resolution image. Note that the individual images in a hierarchical sequence may be coded progressively if desired.

Also supported is a *lossless* spatial algorithm that operates in the pixel domain as opposed to the transform domain. A prediction is made of a pixel value using up to three neighboring samples. This prediction then is subtracted from the actual value and the difference is losslessly coded using either Huffman or arithmetic coding. Lossless operation achieves about a 2:1 compression ratio.

Because video is just a series of still images, and baseline JPEG encoders and decoders were readily available, people began to use baseline JPEG to compress real-time video (also called motion JPEG or MJPEG). However, this technique does not take advantage of the frame-to-frame redundancies to improve compression, as does MPEG.

Perhaps most important, JPEG is symmetrical, meaning the cost of encoding and decoding is roughly the same. MPEG, on the other hand, *was designed primarily for mastering a video once and playing it back many times on many platforms.* To minimize the cost of MPEG hardware decoders, MPEG was designed to be asymmetrical, with the encoding process requiring about 100 times the computing power of the decoding process.

If both video encoding and decoding must be done at many locations, and if the higher coded bit rate is acceptable, JPEG may be the better choice since it costs less to implement. However, note that there is currently no file standardization, except for the JPEG/JFIF file format, for MJPEG encoding and decoding.

Since MPEG was targeted for a specific application, the hardware usually supports only a few specific resolutions. Also, only one color space (YCbCr) is supported using 8-bit samples. MPEG also is optimized for a limited range of compression ratios.

If capturing video for editing, you can use either baseline JPEG or I-frame-only (intraframe) MPEG to real-time compress to disk. Most of the current video editing software supports JPEG, and some software now supports intraframe MPEG. Using JPEG requires that the system be able to transfer data and access the hard disk at bit rates of about 4 Mbps for SIF (Standard Input Format) resolution. Once the editing is done, the result can be converted into full MPEG for maximum compression.

A few full MPEG software editors are available. Most work by decoding the group of pictures (GOP) that contains the frame(s) to be edited and, after the editing is done, performing another MPEG encode on the GOP.

Using intraframe MPEG instead of JPEG to capture video for editing does have a couple of advantages. The current JPEG standard requires that the same quantization tables be used for every DCT block in the image. MPEG allows the quantization tables to be adjusted on a macroblock by macroblock basis. This allows more bits to be used in areas of the image where they are needed most, rather than averaging the "damage" over the entire image. It has been shown that the ability to vary quantization locally can produce subjective levels of image quality that equal JPEG at significantly lower bit rates—as much as an additional 2:1 compression, depending on the source material. Also, as this is the first step in the MPEG process, it lends itself well to a two-step compression process: intraframe capture to allow editing, then compressing the edited material using MPEG interframe coding.

If video editing is not required, then full MPEG may be used to real-time compress to disk. This reduces the bandwidth required to about 1.2 Mbps for SIF resolution. MPEG has the added advantage of supporting audio directly.

MPEG vs. H.261

The H.261 standard is designed for video teleconferencing where motion is more limited. A compressed bitstream implicitly defines the decompression algorithm. The compression algorithm is up to the individual manufacturers, allowing a proprietary advantage to be obtained within the scope of an international standard. Picture resolution is restricted to CIF (352×288) and QCIF (176×144) resolutions to ensure world-wide compatibility. Temporal rates are up to 29.97 frames per second and can vary dynamically. Note that H.261 is designed for very low data rates with little emphasis on quality and was targeted to work with channel bandwidths of 64k to 2M bits per second (bps). However, at bit rates of less than 500 kbps, H.261 video quality is better than MPEG due to MPEG's overhead.

H.261 is also known as Px64. "P" is an integer number meant to represent multiples of 64 kbps. This probably will be dropped as H.261 is used for other applications than ISDN video conferencing.

MPEG Quality Issues

How does MPEG video compare to TV, VHS, and laserdisc?

VHS video has much less luma and chroma bandwidth than MPEG. VHS video also is subject to video timing errors, noise, and reduced video quality due to high-speed duplication. It is superior to MPEG 1 in the vertical direction. (However, MPEG 2 can maintain full vertical resolution. MPEG 2 is covered in the next chapter.)

At bit rates of about 3–4 Mbps, "broadcast quality" is achievable with MPEG 1. However, sequences with complex spatial-temporal activity (such as sports) may require up to 5–6 Mbps due to the frame-based processing of MPEG 1. MPEG 2 allows similar "broadcast quality" at bit rates of about 4–6 Mbps by supporting field-based processing.

Laserdisc has better than 48 dB SNR, stable video timing, and fairly high resolution. In areas of little motion, MPEG 1 (SIF) at 1.5 Mbps looks about as good as laserdisc. In areas of fast motion and high detail, laserdisc reigns supreme.

Several factors affect the quality of MPEG-compressed video:

- the resolution of the original video source
- the bit rate (channel bandwidth) allowed after compression
- motion estimator effectiveness

One limitation of the quality of the compressed video is determined by the resolution of the original video source. If the original resolution was too low, there will be a general lack of detail.

Motion estimator effectiveness determines motion artifacts, such as a reduction in video quality when movement starts or when the amount of movement is above a certain threshold. Poor motion estimation will contribute to a general degradation of video quality.

Most importantly, the higher the bit rate (channel bandwidth), the more information that can be transmitted, allowing fewer motion artifacts to be present or a higher resolution image to be displayed. Generally speaking, decreasing the bit rate does not result in a "graceful degradation" of the decoded video quality. The video quality rapidly degrades, with the 8×8 blocks becoming clearly visible once the bit rate drops below a given threshold.

MPEG 1 handles film sources much better than video sources, due to the lower frame rate (24 vs. 30 Hz), the film source video being inherently progressive, and the spatial and temporal characteristics being more amenable to MPEG 1 processing. Film typically is digitized at 4000 pixels per line (the number of lines varies based on the film format) to preserve the grain structure of the film.

Audio Overview

MPEG 1 uses a family of three audio coding schemes, called Layer 1, Layer 2, and Layer 3, with increasing complexity and sound quality. The three layers are hierarchical: a Layer 3 decoder handles Layers 1, 2, and 3; a Layer 2 decoder handles only Layers 1 and 2; a Layer 1 decoder handles only Layer 1. All layers may accept digitized audio using 16, 22.05, 24, 32, 44.1 or 48 kHz sampling rates and 16 bits per sample.

For each layer, the bitstream format and the decoder are specified. The encoder is not specified to allow for future improvements. All layers work with similar bit rates:

Layer 1: 32–448 kbps
Layer 2: 8–384 kbps
Layer 3: 8–320 kbps

Two audio channels are supported with four modes of operation:

normal stereo
joint (intensity and/or ms) stereo
dual channel mono
single channel mono

For normal stereo, one channel carries the left audio signal and one channel carries the right audio signal. For intensity stereo (supported by all layers), high frequencies (above 2 kHz) are combined. The stereo image is preserved but only the temporal envelope is transmitted. For ms stereo (supported by Layer 3 only), one channel carries the sum signal (L+R) and the other the difference (L–R) signal. In addition MPEG 1 allows for pre-emphasis, copyright marks, and original/copy indication.

Sound Quality

To determine which layer should be used for a specific application, look at the available bit rate, as each layer was designed to support certain bit rates with a minimum degradation of sound quality.

Layer 1, a simplified version of Layer 2, has a target bit rate of about 192 kbps per audio channel or higher. DCC recorders use a version of Layer 1 known as "PASC."

Layer 2 is identical to MUSICAM, and has a target bit rate of about 128 kbps per audio channel. It was designed as a trade-off between sound quality per bit rate and encoder complexity. It is most useful for bit rates around 96–128 kbps per audio channel. Layer 2 probably will be used for the Digital Audio Broadcasting (DAB) network.

Layer 3 merges the best ideas of MUSICAM and ASPEC and has a target bit rate of about 64 kbps per audio channel. The Layer 3 format specifies a set of advanced features that all address a single goal: to preserve as much sound quality as possible even at relatively low bit rates. Layer 3 is already in use by various communication networks (ISDN, satellite links, etc.).

Listening tests reveal the audio quality differences between layers for various bit rates. Values were assigned according to the original versus decompressed audio quality: 5.0 = transparent, 4.0 = slight differences noticeable, 3.0 = slightly annoying, 2.0 = annoying, 1.0 = very annoying.

For low bit rates (60–64 kbps per channel), Layer 2 scored 2.1–2.6, whereas Layer 3 scored 3.6–3.8. It was difficult to find worst-case source material for Layer 3, whereas it was relatively easy to find it for Layer 2. For medium and high bit rates (120 kbps or more per channel), Layer 2 and Layer 3 scored about the same.

Background Theory

All layers use a coding scheme based on psychoacoustic principles—in particular, "masking" effects where, for example, a loud tone at one frequency prevents a person from hearing another, quieter, tone at a nearby frequency.

Suppose you have a strong tone with a frequency of 1000 Hz, and a second tone of 1100 Hz that is 18 dB lower in intensity. The 1100 Hz tone will not be heard; it is masked by the 1000 Hz tone. However, a tone at 2000 Hz 18 dB below the 1000-Hz tone will be heard. In order to have the 1000-Hz tone mask it, the 2000-Hz tone will have to be about 45 dB down. Any relatively weak sound near a strong sound is masked; the further you get from a sound, the smaller the masking effect.

Curves have been developed that plot the relative energy versus frequency that is masked (concurrent masking). Masking effects also occur before (premasking) and after (postmasking) a strong sound if there is a significant (30–40 dB) shift in level. The reason is believed to be that the brain needs processing time. Premasking time is about 2–5 ms; postmasking can last up to 100 ms.

Adjusting the noise floor reduces the amount of needed data, resulting in compression. CDs use 16 bits of resolution to achieve a signal-to-noise ratio (SNR) of about 96 dB, which just happens to match the dynamic range of the human ear pretty well (meaning most people will not hear noise during silence). If 8-bit resolution were used, there would be a noticeable noise during silent moments in the music or between words. However, noise isn't noticed during loud passages. due to the masking effect, which means that around a strong sound you can raise the noise floor since the noise will be masked anyway.

For a stereo signal, there usually is redundancy between channels. All layers may exploit these stereo effects by using a "joint stereo" mode, with the most flexible approach being used by Layer 3.

Audio Encoding—Layers 1 and 2

Figure 10.1 illustrates the general flow chart for Layers 1 and 2 encoding. Figure 10.2 illustrates the general flow chart for the filterbank used by Layers 1 and 2.

Filterbank

A filterbank performs time-to-frequency mapping. The frequency spectrum (0–20 kHz) is divided into 32 equally spaced subbands for each channel. Although performance would be better if the subbands were narrower in the lower frequencies and wider in the higher frequencies to better match the psychoacoustic properties of human hearing, the simpler approach of each subband being a constant width won out. The 512 $C(i)$ coefficients used in Figure 10.2 are specified in Table 10.1.

Scale Factors and Coding

The scale factor is calculated every 12 subband samples, and the maximum of the absolute value of these 12 samples is determined. The lowest value in Table 10.2 which is larger than this maximum is used as the scale factor.

For Layer 1, the index of the scale factor used is represented by 6 bits, MSB first.

For Layer 2, a "frame" is used, corresponding to 36 subband samples and thus containing three scale factors per subband. The two differences of the scale factor indexes ($dscf_1$ and $dscf_2$) are determined using Table 10.2:

$$dscf_1 = index_1 - index_2$$
$$dscf_2 = index_2 - index_3$$

The class of each of the differences is determined:

dscf	Class
$dscf \leq -3$	1
$-3 < dscf < 0$	2
$dscf = 0$	3
$0 < dscf < 3$	4
$dscf \geq 3$	5

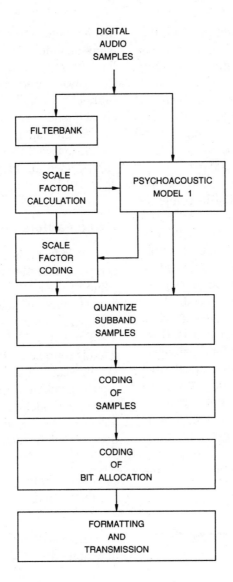

Figure 10.1. Audio Layers 1 and 2 Encoding Flow Chart.

Figure 10.2. MPEG Audio Layers 1 and 2 Filterbank Flow Chart.

i	C(i)	i	C(i)	i	C(i)
0	0.000000000	30	−0.000011444	60	−0.000090599
1	−0.000000477	31	−0.000012398	61	−0.000093460
2	−0.000000477	32	−0.000013828	62	−0.000096321
3	−0.000000477	33	−0.000014782	63	−0.000099182
4	−0.000000477	34	−0.000016689	64	0.000101566
5	−0.000000477	35	−0.000018120	65	0.000103951
6	−0.000000477	36	−0.000019550	66	0.000105858
7	−0.000000954	37	−0.000021458	67	0.000107288
8	−0.000000954	38	−0.000023365	68	0.000108242
9	−0.000000954	39	−0.000025272	69	0.000108719
10	−0.000000954	40	−0.000027657	70	0.000108719
11	−0.000001431	41	−0.000030041	71	0.000108242
12	−0.000001431	42	−0.000032425	72	0.000106812
13	−0.000001907	43	−0.000034809	73	0.000105381
14	−0.000001907	44	−0.000037670	74	0.000102520
15	−0.000002384	45	−0.000040531	75	0.000099182
16	−0.000002384	46	−0.000043392	76	0.000095367
17	−0.000002861	47	−0.000046253	77	0.000090122
18	−0.000003338	48	−0.000049591	78	0.000084400
19	−0.000003338	49	−0.000052929	79	0.000077724
20	−0.000003815	50	−0.000055790	80	0.000069618
21	−0.000004292	51	−0.000059605	81	0.000060558
22	−0.000004768	52	−0.000062943	82	0.000050545
23	−0.000005245	53	−0.000066280	83	0.000039577
24	−0.000006199	54	−0.000070095	84	0.000027180
25	−0.000006676	55	−0.000073433	85	0.000013828
26	−0.000007629	56	−0.000076771	86	−0.000000954
27	−0.000008106	57	−0.000080585	87	−0.000017166
28	−0.000009060	58	−0.000083923	88	−0.000034332
29	−0.000010014	59	−0.000087261	89	−0.000052929

Table 10.1a. MPEG Audio Layers 1 and 2 Analysis Window Coefficients.

i	C(i)	i	C(i)	i	C(i)
90	−0.000072956	120	−0.000954151	150	−0.000806808
91	−0.000093937	121	−0.000968933	151	−0.000956535
92	−0.000116438	122	−0.000980854	152	−0.001111031
93	−0.000140190	123	−0.000989437	153	−0.001269817
94	−0.000165462	124	−0.000994205	154	−0.001432419
95	−0.000191212	125	−0.000995159	155	−0.001597881
96	−0.000218868	126	−0.000991821	156	−0.001766682
97	−0.000247478	127	−0.000983715	157	−0.001937389
98	−0.000277042	128	0.000971317	158	−0.002110004
99	−0.000307560	129	0.000953674	159	−0.002283096
100	−0.000339031	130	0.000930786	160	−0.002457142
101	−0.000371456	131	0.000902653	161	−0.002630711
102	−0.000404358	132	0.000868797	162	−0.002803326
103	−0.000438213	133	0.000829220	163	−0.002974033
104	−0.000472546	134	0.000783920	164	−0.003141880
105	−0.000507355	135	0.000731945	165	−0.003306866
106	−0.000542164	136	0.000674248	166	−0.003467083
107	−0.000576973	137	0.000610352	167	−0.003622532
108	−0.000611782	138	0.000539303	168	−0.003771782
109	−0.000646591	139	0.000462532	169	−0.003914356
110	−0.000680923	140	0.000378609	170	−0.004048824
111	−0.000714302	141	0.000288486	171	−0.004174709
112	−0.000747204	142	0.000191689	172	−0.004290581
113	−0.000779152	143	0.000088215	173	−0.004395962
114	−0.000809669	144	−0.000021458	174	−0.004489899
115	−0.000838757	145	−0.000137329	175	−0.004570484
116	−0.000866413	146	−0.000259876	176	−0.004638195
117	−0.000891685	147	−0.000388145	177	−0.004691124
118	−0.000915051	148	−0.000522137	178	−0.004728317
119	−0.000935555	149	−0.000661850	179	−0.004748821

Table 10.1b. MPEG Audio Layers 1 and 2 Analysis Window Coefficients.

i	C(i)	i	C(i)	i	C(i)
180	−0.004752159	210	−0.006189346	240	−0.030526638
181	−0.004737377	211	−0.006937027	241	−0.031132698
182	−0.004703045	212	−0.007703304	242	−0.031706810
183	−0.004649162	213	−0.008487225	243	−0.032248020
184	−0.004573822	214	−0.009287834	244	−0.032754898
185	−0.004477024	215	−0.010103703	245	−0.033225536
186	−0.004357815	216	−0.010933399	246	−0.033659935
187	−0.004215240	217	−0.011775017	247	−0.034055710
188	−0.004049301	218	−0.012627602	248	−0.034412861
189	−0.003858566	219	−0.013489246	249	−0.034730434
190	−0.003643036	220	−0.014358521	250	−0.035007000
191	−0.003401756	221	−0.015233517	251	−0.035242081
192	0.003134727	222	−0.016112804	252	−0.035435200
193	0.002841473	223	−0.016994476	253	−0.035586357
194	0.002521515	224	−0.017876148	254	−0.035694122
195	0.002174854	225	−0.018756866	255	−0.035758972
196	0.001800537	226	−0.019634247	256	0.035780907
197	0.001399517	227	−0.020506859	257	0.035758972
198	0.000971317	228	−0.021372318	258	0.035694122
199	0.000515938	229	−0.022228718	259	0.035586357
200	0.000033379	230	−0.023074150	260	0.035435200
201	−0.000475883	231	−0.023907185	261	0.035242081
202	−0.001011848	232	−0.024725437	262	0.035007000
203	−0.001573563	233	−0.025527000	263	0.034730434
204	−0.002161503	234	−0.026310921	264	0.034412861
205	−0.002774239	235	−0.027073860	265	0.034055710
206	−0.003411293	236	−0.027815342	266	0.033659935
207	−0.004072189	237	−0.028532982	267	0.033225536
208	−0.004756451	238	−0.029224873	268	0.032754898
209	−0.005462170	239	−0.029890060	269	0.032248020

Table 10.1c. MPEG Audio Layers 1 and 2 Analysis Window Coefficients.

i	C(i)	i	C(i)	i	C(i)
270	0.031706810	300	0.007703304	330	0.004703045
271	0.031132698	301	0.006937027	331	0.004737377
272	0.030526638	302	0.006189346	332	0.004752159
273	0.029890060	303	0.005462170	333	0.004748821
274	0.029224873	304	0.004756451	334	0.004728317
275	0.028532982	305	0.004072189	335	0.004691124
276	0.027815342	306	0.003411293	336	0.004638195
277	0.027073860	307	0.002774239	337	0.004570484
278	0.026310921	308	0.002161503	338	0.004489899
279	0.025527000	309	0.001573563	339	0.004395962
280	0.024725437	310	0.001011848	340	0.004290581
281	0.023907185	311	0.000475883	341	0.004174709
282	0.023074150	312	−0.000033379	342	0.004048824
283	0.022228718	313	−0.000515938	343	0.003914356
284	0.021372318	314	−0.000971317	344	0.003771782
285	0.020506859	315	−0.001399517	345	0.003622532
286	0.019634247	316	−0.001800537	346	0.003467083
287	0.018756866	317	−0.002174854	347	0.003306866
288	0.017876148	318	−0.002521515	348	0.003141880
289	0.016994476	319	−0.002841473	349	0.002974033
290	0.016112804	320	0.003134727	350	0.002803326
291	0.015233517	321	0.003401756	351	0.002630711
292	0.014358521	322	0.003643036	352	0.002457142
293	0.013489246	323	0.003858566	353	0.002283096
294	0.012627602	324	0.004049301	354	0.002110004
295	0.011775017	325	0.004215240	355	0.001937389
296	0.010933399	326	0.004357815	356	0.001766682
297	0.010103703	327	0.004477024	357	0.001597881
298	0.009287834	328	0.004573822	358	0.001432419
299	0.008487225	329	0.004649162	359	0.001269817

Table 10.1d. MPEG Audio Layers 1 and 2 Analysis Window Coefficients.

I	C(i)	I	C(i)	I	C(i)
360	0.001111031	390	0.000980854	420	0.000116348
361	0.000956535	391	0.000968933	421	0.000093937
362	0.000806808	392	0.000954151	422	0.000072956
363	0.000661850	393	0.000935555	423	0.000052929
364	0.000522137	394	0.000915051	424	0.000034332
365	0.000388145	395	0.000891685	425	0.000017166
366	0.000259876	396	0.000866413	426	0.000000954
367	0.000137329	397	0.000838757	427	−0.000013828
368	0.000021458	398	0.000809669	428	−0.000027180
369	−0.000088215	399	0.000779152	429	−0.000039577
370	−0.000191689	400	0.000747204	430	−0.000050545
371	−0.000288486	401	0.000714302	431	−0.000060558
372	−0.000378609	402	0.000680923	432	−0.000069618
373	−0.000462532	403	0.000646591	433	−0.000077724
374	−0.000539303	404	0.000611782	434	−0.000084400
375	−0.000610352	405	0.000576973	435	−0.000090122
376	−0.000674248	406	0.000542164	436	−0.000095367
377	−0.000731945	407	0.000507355	437	−0.000099182
378	−0.000783920	408	0.000472546	438	−0.000102520
379	−0.000829220	409	0.000438213	439	−0.000105381
380	−0.000868797	410	0.000404358	440	−0.000106812
381	−0.000902653	411	0.000371456	441	−0.000108242
382	−0.000930786	412	0.000339031	442	−0.000108719
383	−0.000953674	413	0.000307560	443	−0.000108719
384	0.000971317	414	0.000277042	444	−0.000108242
385	0.000983715	415	0.000247478	445	−0.000107288
386	0.000991821	416	0.000218868	446	−0.000105858
387	0.000995159	417	0.000191212	447	−0.000103951
388	0.000994205	418	0.000165462	448	0.000101566
389	0.000989437	419	0.000140190	449	0.000099182

Table 10.1e. MPEG Audio Layers 1 and 2 Analysis Window Coefficients.

i	C(i)	i	C(i)	i	C(i)
450	0.000096321	470	0.000032425	490	0.000004768
451	0.000093460	471	0.000030041	491	0.000004292
452	0.000090599	472	0.000027657	492	0.000003815
453	0.000087261	473	0.000025272	493	0.000003338
454	0.000083923	474	0.000023365	494	0.000003338
455	0.000080585	475	0.000021458	495	0.000002861
456	0.000076771	476	0.000019550	496	0.000002384
457	0.000073433	477	0.000018120	497	0.000002384
458	0.000070095	478	0.000016689	498	0.000001907
459	0.000066280	479	0.000014782	499	0.000001907
460	0.000062943	480	0.000013828	500	0.000001431
461	0.000059605	481	0.000012398	501	0.000001431
462	0.000055790	482	0.000011444	502	0.000000954
463	0.000052929	483	0.000010014	503	0.000000954
464	0.000049591	484	0.000009060	504	0.000000954
465	0.000046253	485	0.000008106	505	0.000000954
466	0.000043392	486	0.000007629	506	0.000000477
467	0.000040531	487	0.000006676	507	0.000000477
468	0.000037670	488	0.000006199	508	0.000000477
469	0.000034809	489	0.000005245	509	0.000000477
				510	0.000000477
				511	0.000000477

Table 10.1f. MPEG Audio Layers 1 and 2 Analysis Window Coefficients.

Index	Scale Factor	Index	Scale Factor	Index	Scale Factor
0	2.00000000000000	21	0.01562500000000	42	0.00012207031250
1	1.58740105196820	22	0.01240157071850	43	0.00009688727124
2	1.25992104989487	23	0.00984313320230	44	0.00007689947814
3	1.00000000000000	24	0.00781250000000	45	0.00006103515625
4	0.79370052598410	25	0.00620078535925	46	0.00004844363562
5	0.62996052494744	26	0.00492156660115	47	0.00003844973907
6	0.50000000000000	27	0.00390625000000	48	0.00003051757813
7	0.39685026299205	28	0.00310039267963	49	0.00002422181781
8	0.31498026247372	29	0.00246078330058	50	0.00001922486954
9	0.25000000000000	30	0.00195312500000	51	0.00001525878906
10	0.19842513149602	31	0.00155019633981	52	0.00001211090890
11	0.15749013123686	32	0.00123039165029	53	0.00000961243477
12	0.12500000000000	33	0.00097656250000	54	0.00000762939453
13	0.09921256574801	34	0.00077509816991	55	0.00000605545445
14	0.07874506561843	35	0.00061519582514	56	0.00000480621738
15	0.06250000000000	36	0.00048828125000	57	0.00000381469727
16	0.04960628287401	37	0.00038754908495	58	0.00000302772723
17	0.03937253280921	38	0.00030759791257	59	0.00000240310869
18	0.03125000000000	39	0.00024414062500	60	0.00000190734863
19	0.02480314143700	40	0.00019377454248	61	0.00000151386361
20	0.01968626640461	41	0.00015379895629	62	0.00000120155435

Table 10.2. MPEG Audio Layers 1 and 2 Scale Factors.

The pair of classes specifies the entry point in Table 10.3. The column "Encoder Scale Factors" specifies three scale factors which are actually used. Numbers "1," "2," and "3" mean the first, second, and third scale factor within a frame; the number "4" means the maximum of the scale factors.

If two or three of the scale factors are the same, not all scale factors need to be transmitted for a certain subband within a frame. Only scale factors indicated in the "Transmission Pattern" column are transmitted. The information describing the number and position of the scale factors in each subband is the "Scale Factor Selection Information" column and is coded by a two-bit word.

Quantization and Coding of Subband Samples

A linear quantizer is used to quantize the subband samples. Each of the subband samples is normalized by dividing its value by the scale factor to obtain X and quantized using the formula:

- Calculate $AX + B$
- Take the N most significant bits
- Invert the MSB

A and B are found in Table 10.4 for Layer 1 and Table 10.5 for Layer 2. N represents the number of bits needed to encode the number of steps. Inverting the MSB avoids having a value of all 1s as that represents a synchronization word.

For Layer 2, Table 10.6 lists the number of steps to which the samples will be quantized, and shows whether grouping is used. If grouping is not used, the three samples are coded with individual codewords. If grouping is used, the three consecutive samples are coded as one codeword. Only one value V_m is transmit-

ted, MSB first, for this triplex. The relationships between V_m (m = 3, 5, 9) and the three consecutive subband samples (x, y, and z) are:

$$V_3 = 9z + 3y + x \qquad (V_3 \text{ in } 0...26)$$
$$V_5 = 25z + 5y + x \qquad (V_5 \text{ in } 0...124)$$
$$V_9 = 81z + 9y + x \qquad (V_9 \text{ in } 0...728)$$

Bit Allocation and Coding

Both the output samples from the filterbank and the signal-to-mask ratios (SMRs) from the psychoacoustic model are used to adjust the bit allocation to meet both the bit rate requirements and the masking requirements. At low bit rates, an attempt is made to use bits in a way that is psychoacoustically acceptable when the bit rate cannot be supported.

Before adjustment to a fixed bit rate, the number of available bits for subband samples and scale factors is determined. The allocation is an iterative procedure—in each iteration the number of levels of the subband samples of greatest benefit is increased. The goal is to minimize the total noise-to-mask ratio over the frame with the constraint that the number of bits used does not exceed the number of bits available for that frame.

For Layer 1, Table 10.4 lists the possible quantized subband steps and the corresponding number of bits allocated to the subband sample (the bit allocation index column).

For Layer 2, Table 10.6 lists the possible quantized subband steps. Table 10.7 shows which allocation table to use for various transmission bit rates versus audio sample rates. Tables 10.8 through 10.11 list the subband numbers and the corresponding values allocated to the subband sample.

First, the mask-to-noise ratio (MNR) for each subband is determined by subtracting the signal-to-mask ratio (SMR) from the signal-to-noise ratio (SNR):

dscf$_1$ Class	dscf$_2$ Class	Encoder Scale Factors			Transmission Pattern			Scale Factor Selection Information
1	1	1	2	3	1	2	3	0
1	2	1	2	2		1	2	3
1	3	1	2	2		1	2	3
1	4	1	3	3		1	3	3
1	5	1	2	3	1	2	3	0
2	1	1	1	3		1	3	1
2	2	1	1	1			1	2
2	3	1	1	1			1	2
2	4	4	4	4			4	2
2	5	1	1	3		1	3	1
3	1	1	1	1			1	2
3	2	1	1	1			1	2
3	3	1	1	1			1	2
3	4	3	3	3			3	2
3	5	1	1	3		1	3	1
4	1	2	2	2			2	2
4	2	2	2	2			2	2
4	3	2	2	2			2	2
4	4	3	3	3			3	2
4	5	1	2	3	1	2	3	0
5	1	1	2	3	1	2	3	0
5	2	1	2	2		1	2	3
5	3	1	2	2		1	2	3
5	4	1	3	3		1	3	3
5	5	1	2	3	1	2	3	0

Table 10.3. MPEG Audio Layer 2 Scale Factor Transmission Patterns.

Number of Subband Steps	A	B	Bits Per Subband Sample	Bit Allocation Index	Subband SNR (dB)
0	–	–	0	0	0.00
3	0.750000000	−0.250000000	2	1	7.00
7	0.875000000	−0.125000000	3	2	16.00
15	0.937500000	−0.062500000	4	3	25.28
31	0.968750000	−0.031250000	5	4	31.59
63	0.984375000	−0.015625000	6	5	37.75
127	0.992187500	−0.007812500	7	6	43.84
255	0.996093750	−0.003906250	8	7	49.89
511	0.998046875	−0.001953125	9	8	55.93
1023	0.999023438	−0.000976563	10	9	61.96
2047	0.999511719	−0.000488281	11	10	67.98
4095	0.999755859	−0.000244141	12	11	74.01
8191	0.999877930	−0.000122070	13	12	80.03
16383	0.999938965	−0.000061035	14	13	86.05
32767	0.999969482	−0.000030518	15	14	92.01
–	–	–	forbidden	15	–

Table 10.4. MPEG Audio Layer 1 Quantization Coefficients, Bit Allocations, and SNRs.

Number of Subband Steps	A	B	Subband SNR (dB)
0	–	–	0.00
3	0.750000000	−0.250000000	7.00
5	0.625000000	−0.375000000	11.00
7	0.875000000	−0.125000000	16.00
9	0.562500000	−0.437500000	20.84
15	0.937500000	−0.062500000	25.28
31	0.968750000	−0.031250000	31.59
63	0.984375000	−0.015625000	37.75
127	0.992187500	−0.007812500	43.84
255	0.996093750	−0.003906250	49.89
511	0.998046875	−0.001953125	55.93
1023	0.999023438	−0.000976563	61.96
2047	0.999511719	−0.000488281	67.98
4095	0.999755859	−0.000244141	74.01
8191	0.999877930	−0.000122070	80.03
16383	0.999938965	−0.000061035	86.05
32767	0.999969482	−0.000030518	92.01
63535	0.999984741	−0.000015259	98.01

Table 10.5. MPEG Audio Layer 2 Quantization Coefficients and SNRs.

Number of Subband Steps	Grouping	Samples per Codeword	Bits per Subband Codeword
3	yes	3	5
5	yes	3	7
7	no	1	3
9	yes	3	10
15	no	1	4
31	no	1	5
63	no	1	6
127	no	1	7
255	no	1	8
511	no	1	9
1023	no	1	10
2047	no	1	11
4095	no	1	12
8191	no	1	13
16383	no	1	14
32767	no	1	15
63535	no	1	16

Table 10.6. MPEG Audio Layer 2 Classes Of Quantization.

Bit Rate (kbps)	Sample Rate (Fs) (kHz)		
	48	44.1	32
32	Table 10.10	Table 10.10	Table 10.11
48	Table 10.10	Table 10.10	Table 10.11
56	Table 10.8	Table 10.8	Table 10.8
64	Table 10.8	Table 10.8	Table 10.8
80	Table 10.8	Table 10.8	Table 10.8
96	Table 10.8	Table 10.8	Table 10.9
112	Table 10.8	Table 10.9	Table 10.9
128	Table 10.8	Table 10.9	Table 10.9
160	Table 10.8	Table 10.9	Table 10.9
192	Table 10.8	Table 10.9	Table 10.9

Table 10.7. MPEG Audio Layer 2 Subband Quantization Selection.

Subband	nbal	Allocation Index															
		0	1	2	3	4	5	6	7	8	9	10	11	12	13	14	15
0	4	–	3	7	15	31	63	127	255	511	1023	2047	4095	8191	16383	32767	65535
1	4	–	3	7	15	31	63	127	255	511	1023	2047	4095	8191	16383	32767	65535
2	4	–	3	7	15	31	63	127	255	511	1023	2047	4095	8191	16383	32767	65535
3	4	–	3	5	7	9	15	31	63	127	255	511	1023	2047	4095	8191	65535
4	4	–	3	5	7	9	15	31	63	127	255	511	1023	2047	4095	8191	65535
5	4	–	3	5	7	9	15	31	63	127	255	511	1023	2047	4095	8191	65535
6	4	–	3	5	7	9	15	31	63	127	255	511	1023	2047	4095	8191	65535
7	4	–	3	5	7	9	15	31	63	127	255	511	1023	2047	4095	8191	65535
8	4	–	3	5	7	9	15	31	63	127	255	511	1023	2047	4095	8191	65535
9	4	–	3	5	7	9	15	31	63	127	255	511	1023	2047	4095	8191	65535
10	4	–	3	5	7	9	15	31	63	127	255	511	1023	2047	4095	8191	65535
11	3	–	3	5	7	9	15	31	65535								
12	3	–	3	5	7	9	15	31	65535								
13	3	–	3	5	7	9	15	31	65535								
14	3	–	3	5	7	9	15	31	65535								
15	3	–	3	5	7	9	15	31	65535								
16	3	–	3	5	7	9	15	31	65535								
17	3	–	3	5	7	9	15	31	65535								
18	3	–	3	5	7	9	15	31	65535								
19	3	–	3	5	7	9	15	31	65535								
20	3	–	3	5	7	9	15	31	65535								
21	3	–	3	5	7	9	15	31	65535								
22	3	–	3	5	7	9	15	31	65535								
23	2	–	3	5	65535												
24	2	–	3	5	65535												
25	2	–	3	5	65535												
26	2	–	3	5	65535												
27	0	–															
28	0	–															
29	0	–															
30	0	–															
31	0	–															

Table 10.8. MPEG Audio Layer 2 Subband Quantizations (sblimit = 27).

Subband	nbal	Allocation Index															
		0	1	2	3	4	5	6	7	8	9	10	11	12	13	14	15
0	4	–	3	7	15	31	63	127	255	511	1023	2047	4095	8191	16383	32767	65535
1	4	–	3	7	15	31	63	127	255	511	1023	2047	4095	8191	16383	32767	65535
2	4	–	3	7	15	31	63	127	255	511	1023	2047	4095	8191	16383	32767	65535
3	4	–	3	5	7	9	15	31	63	127	255	511	1023	2047	4095	8191	65535
4	4	–	3	5	7	9	15	31	63	127	255	511	1023	2047	4095	8191	65535
5	4	–	3	5	7	9	15	31	63	127	255	511	1023	2047	4095	8191	65535
6	4	–	3	5	7	9	15	31	63	127	255	511	1023	2047	4095	8191	65535
7	4	–	3	5	7	9	15	31	63	127	255	511	1023	2047	4095	8191	65535
8	4	–	3	5	7	9	15	31	63	127	255	511	1023	2047	4095	8191	65535
9	4	–	3	5	7	9	15	31	63	127	255	511	1023	2047	4095	8191	65535
10	4	–	3	5	7	9	15	31	63	127	255	511	1023	2047	4095	8191	65535
11	3	–	3	5	7	9	15	31	65535								
12	3	–	3	5	7	9	15	31	65535								
13	3	–	3	5	7	9	15	31	65535								
14	3	–	3	5	7	9	15	31	65535								
15	3	–	3	5	7	9	15	31	65535								
16	3	–	3	5	7	9	15	31	65535								
17	3	–	3	5	7	9	15	31	65535								
18	3	–	3	5	7	9	15	31	65535								
19	3	–	3	5	7	9	15	31	65535								
20	3	–	3	5	7	9	15	31	65535								
21	3	–	3	5	7	9	15	31	65535								
22	3	–	3	5	7	9	15	31	65535								
23	2	–	3	5	65535												
24	2	–	3	5	65535												
25	2	–	3	5	65535												
26	2	–	3	5	65535												
27	2	–	3	5	65535												
28	2	–	3	5	65535												
29	2	–	3	5	65535												
30	0	–															
31	0	–															

Table 10.9. MPEG Audio Layer 2 Subband Quantizations (sblimit = 30).

Subband	nbal	Allocation Index															
		0	1	2	3	4	5	6	7	8	9	10	11	12	13	14	15
0	4	–	3	5	9	15	31	63	127	255	511	1023	2047	4095	8191	16383	32767
1	4	–	3	5	9	15	31	63	127	255	511	1023	2047	4095	8191	16383	32767
2	3	–	3	5	9	15	31	63	127								
3	3	–	3	5	9	15	31	63	127								
4	3	–	3	5	9	15	31	63	127								
5	3	–	3	5	9	15	31	63	127								
6	3	–	3	5	9	15	31	63	127								
7	3	–	3	5	9	15	31	63	127								
8	0	–															
9	0	–															
10	0	–															
11	0	–															
12	0	–															
13	0	–															
14	0	–															
15	0	–															
16	0	–															
17	0	–															
18	0	–															
19	0	–															
20	0	–															
21	0	–															
22	0	–															
23	0	–															
24	0	–															
25	0	–															
26	0	–															
27	0	–															
28	0	–															
29	0	–															
30	0	–															
31	0	–															

Table 10.10. MPEG Audio Layer 2 Subband Quantizations (sblimit = 8).

Subband	nbal	Allocation Index															
		0	1	2	3	4	5	6	7	8	9	10	11	12	13	14	15
0	4	–	3	5	9	15	31	63	127	255	511	1023	2047	4095	8191	16383	32767
1	4	–	3	5	9	15	31	63	127	255	511	1023	2047	4095	8191	16383	32767
2	3	–	3	5	9	15	31	63	127								
3	3	–	3	5	9	15	31	63	127								
4	3	–	3	5	9	15	31	63	127								
5	3	–	3	5	9	15	31	63	127								
6	3	–	3	5	9	15	31	63	127								
7	3	–	3	5	9	15	31	63	127								
8	3	–	3	5	9	15	31	63	127								
9	3	–	3	5	9	15	31	63	127								
10	3	–	3	5	9	15	31	63	127								
11	3	–	3	5	9	15	31	63	127								
12	0	–															
13	0	–															
14	0	–															
15	0	–															
16	0	–															
17	0	–															
18	0	–															
19	0	–															
20	0	–															
21	0	–															
22	0	–															
23	0	–															
24	0	–															
25	0	–															
26	0	–															
27	0	–															
28	0	–															
29	0	–															
30	0	–															
31	0	–															

Table 10.11. MPEG Audio Layer 2 Subband Quantizations (sblimit = 12).

$$MNR = SNR - SMR$$

The SNR values for Layer 1 are also listed in Table 10.4. An iterative loop, executed until the number of available bits are used, determines the minimum MNR of all subbands, increases the quantization accuracy of the subband with the minimum MNR, and determines the new MNR for that subband.

For Layer 1, the possible number of bits allocated to each subband sample is listed in Table 10.4; the range is 0–15 (represented as four bits), excluding an allocation of 1 bit.

Layer 2 has more efficient coding, using only a limited number of possible quantizations, different for each subband, as shown in Tables 10.8–10.11. Only the allocation index, with word length "nbal," is transmitted MSB first.

Ancillary Data

A number of bits may be used for transmitting variable-length ancillary information. Use of ancillary data reduces the number of bits available for audio, which may result in a degradation of audio quality.

Psychoacoustic Model Overview

The encoder also applies psychoacoustic modelling to estimate the just-noticeable noise-level for each subband. Layers 1 and 2 typically use psychoacoustic model 1; Layer 3 typically uses a modified psychoacoustic model 2. These models are discussed in the MPEG 1 audio specification.

The available number of data bits are allocated to meet both the bit rate and masking requirements. For example, for the upper region of subband 8, suppose a 60-dB, 6500-Hz tone is present. The coder calculates the masking effect and determines that the masking threshold for the 8th subband is 35 dB below this tone. The acceptable SNR is thus 60 – 35 = 25 dB, or 4-bit resolution. In addition there are masking effects for subbands 9–13 and subbands 5–7, the effect decreasing with the distance from subband 8.

Masking effects are iteratively calculated until time runs out. Layer 1 works on 384 samples of sound at a time. Layers 2 and 3 work on 1152 samples of sound at a time. For some material, the 1152-sample window is a problem, such as when there are large differences in sound level within the 1152 samples. The masking is calculated on the strongest sound and the weak parts are lost due to quantization noise. This is perceived as a "noise-echo" by the ear. Layer 3 addresses this problem by using a smaller time window (about 4 ms) if it encounters this situation.

Audio Bitstream Generation

The encoded subband information is transferred in frames (Figure 10.3). The number of slots in a frame varies with the sample frequency (Fs) and bit rate. Each frame contains

header (32 bits)	optional error check (16 bits)	audio data	ancillary data

Figure 10.3. MPEG Audio Bitstream Layers 1 and 2 Frame Format.

information on 384 samples of the original input signal. A frame may carry audio information from one or two channels.

For Layer 1, the length of a slot is 32 bits. The number of slots in a frame is determined by:

$$\text{slots/frame} = (12 * \text{bit rate}) / Fs$$

If the result is not an integer number, the result is truncated and "padding" is required. Thus, the number of slots may vary between N and N + 1.

An overview of the Layer 1 and 2 frame formats is shown in Figure 10.3.

For Layer 2, the differences from Layer 1 are:

- the length of a slot is 8 bits

- scale factor selection information has been added

Details of the frame header are given in Figure 10.4. Details of the audio block for Layer 1 and Layer 2 are given in Figures 10.5 and 10.6, respectively, using pseudo-code.

Syncword (12 bits)

A bit string of "1111 1111 1111".

ID (1 bit)

Indicates ID of the algorithm. "1" = ISO/IEC 11172-3 audio; "0" = extension to lower sampling frequencies per ISO/IEC 13818-3.

Layer (2 bits)

Indicates which audio layer is used:

> "11" = Layer 1
> "10" = Layer 2
> "01" = Layer 3
> "00" = reserved

Protection_bit (1 bit)

Indicates whether 16 bits of redundancy has been added to enable error detection and correction. "1" = no redundancy; "0" = redundancy.

Bit_rate_index (4 bits)

Indicates the bit rate as shown in Table 10.12. "Free" format indicates a fixed bit rate which does not need to be in the list. The bit rate index indicates the total bit rate irrespective of the mode (stereo, joint_stereo, etc.).

Sampling_rate_index (2 bits)

Indicates the sampling rate rate:

Sampling Rate Index	Sampling Frequency (kHz)	
	ID = 0	ID = 1
00	22.05	44.1
01	24	48
10	16	32
11	reserved	reserved

Padding_bit (1 bit)

"1" indicates the frame has an additional slot to adjust the average bit rate to the sampling frequency, otherwise this bit will be "0." Padding is necessary with sampling rates of 22.05 and 44.1 kHz. Padding may also be required in the free format.

Private_bit (1 bit)

Bit for private use, not to be used in the future by ISO/IEC.

Mode (2 bits)

Indicates the mode:

> "00" = stereo
> "01" = joint_stereo (intensity_stereo and/or ms_stereo)
> "10" = dual_channel
> "11" = single_channel

Figure 10.4a. MPEG Audio Bitstream Header Definition.

Mode_extension (2 bits)

These bits are used by joint_stereo mode. For Layers 1 and 2, they indicate which subbands are in intensity_stereo. All other subbands are in stereo. For Layer 3, they indicate which type of joint stereo coding is applied.

For Layers 1 and 2:

"00" = subbands 4–31 "10" = subbands 12–31
"01" = subbands 8–31 "11" = subbands 16–31

For Layer 3:

"00" = intensity_stereo off; ms_stereo off
"01" = intensity_stereo on; ms_stereo off
"10" = intensity_stereo off; ms_stereo on
"11" = intensity_stereo on; ms_stereo on

Copyright (1 bit)

"1" indicates copyright protected; "0" indicates no copyright.

Original/copy (1 bit)

"1" indicates original; "0" indicates a copy.

Emphasis_index (2 bits)

Indicates type of de-emphasis to be used:

Emphasis Index	Emphasis Used
00	none
01	50/15 microseconds
10	reserved
11	CCITT J.17

Figure 10.4b. MPEG Audio Bitstream Header Definition.

Bit Rate Index	Bit Rate (kbits/sec)				
	ID = 1			ID = 0	
	Layer 1	Layer 2	Layer 3	Layer 1	Layers 2 and 3
0000	free	free	free	free	free
0001	32	32	32	32	8
0010	64	48	40	48	16
0011	96	56	48	56	24
0100	128	64	56	64	32
0101	160	80	64	80	40
0110	192	96	80	96	48
0111	224	112	96	112	56
1000	256	128	112	128	64
1001	288	160	128	144	80
1010	320	192	160	160	96
1011	352	224	192	176	112
1100	384	256	224	192	128
1101	416	320	256	224	144
1110	448	384	320	256	160
1111	–	–	–	–	–

Table 10.12a. MPEG Audio Bitstream Layers 1 and 2 Bit Rate Index Values.

Bit Rate Index	Layer 2 Allowed Modes
0000	all modes
0001	single channel
0010	single channel
0011	single channel
0100	all modes
0101	single channel
0110	all modes
0111	all modes
1000	all modes
1001	all modes
1010	al l modes
1011	stereo, intensity stereo, dual channel
1100	stereo, intensity stereo, dual channel
1101	stereo, intensity stereo, dual channel
1110	stereo, intensity stereo, dual channel
1111	–

Table 10.12b. MPEG Audio Bitstream Layers 1 and 2 Bit Rate Index Values.

```
for (sb = 0; sb < bound; sb++)
    for (ch = 0; ch < nch; ch++)
        allocation [ch] [sb]                                        (4 bits)

for (sb = bound; sb < 32; sb++)
    allocation [0] [sb]                                             (4 bits)
    allocation [1] [sb] = allocation [0] [sb]

for (sb = 0; sb < 32; sb++)
    for (ch = 0; ch < nch; ch++)
        if (allocation [ch] [sb] ≠ 0)
            scalefactor [ch] [sb]                                   (6 bits)

for (s = 0; s < 12; s++)
    for (sb = 0; sb < bound; sb++)
        for (ch = 0; ch < nch; ch++)
            if (allocation [ch] [sb] ≠ 0)
                sample [ch] [sb] [s]                                (2–15 bits)
    for (sb = bound; sb < 32; sb++)
        if (allocation [0] [sb] ≠ 0)
            sample [0] [sb] [s]                                     (2–15 bits)
```

allocation = bit allocation index from Table 10.4. Indicates the number of bits used to code the samples in subband [sb] of channel [ch].

scalefactor = scale factor index from Table 10.2. Indicates the factor of subband [sb] of channel [ch] by which the requantized samples should be multiplied.

sample = the s-th sample in subband [sb] of channel [ch].

nch = number of channels. 1 = single channel mode; 2 = other modes.

Figure 10.5. MPEG Audio Bitstream Layer 1 Audio Data Definition.

```
for (sb = 0; sb < bound; sb++)
    for (ch = 0; ch < nch; ch++)
        allocation [ch] [sb]                                    (2–4 bits)

for (sb = bound; sb < sblimit; sb++)
    allocation [0] [sb]                                         (2–4 bits)
    allocation [1] [sb] = allocation [0] [sb]

for (sb = 0; sb < sblimit; sb++)
    for (ch = 0; ch < nch; ch++)
        if (allocation [ch] [sb] ≠ 0)
            scfsi [ch] [sb]                                     (2 bits)

for (sb = 0; sb < sblimit; sb++)
    for (ch = 0; ch < nch; ch++)
        if (allocation [ch] [sb] ≠ 0)
            if (scfsi [ch] [sb] = 0)
                scalefactor [ch] [sb] [0]                       (6 bits)
                scalefactor [ch] [sb] [1]                       (6 bits)
                scalefactor [ch] [sb] [2]                       (6 bits)
            if ((scfsi [ch] [sb] = 1) or (scfsi [ch] [sb] = 3)
                scalefactor [ch] [sb] [0]                       (6 bits)
                scalefactor [ch] [sb] [2]                       (6 bits)
            if (scfsi [ch] [sb] = 2)
                scalefactor [ch] [sb] [0]                       (6 bits)
```

Figure 10.6a. MPEG Bitstream Layer 2 Audio Data Definition.

```
for (gr = 0; gr < 12; gr++)
    for (sb = 0; sb < bound; sb++)
        for (ch = 0; ch < nch; ch++)
            if (allocation [ch] [sb] ≠ 0)
                if (grouping [ch] [sb])
                    samplecode [ch] [sb] [gr]                    (5–10 bits)
                else
                    for (s = 0; s < 3; s++)
                        sample [ch] [sb] [3 * gr + s]            (3–16 bits)

    for (sb = bound; sb < sblimit; sb++)
        if (allocation [0] [sb] ≠ 0)
            if (grouping [ch] [sb])
                samplecode [0] [sb] [gr]                         (5–10 bits)
            else
                for (s = 0; s < 3; s++)
                    sample [0] [sb] [3 * gr + s]                 (3–16 bits)
```

allocation = bit allocation index from Tables 10.8 through 10.11. Indicates the number of bits used to code the samples in subband [sb] of channel [ch] and whether the information on three consecutive samples has been grouped into one code.

scfsi = scale factor selection information from Table 10.3. Provides information on the number of scale factors transferred for subband [sb] of channel [ch] and for which parts of the signal in this frame they are valid.

scalefactor = scale factor index from Table 10.2. Indicates the factor of subband [sb] of channel [ch] of part [p] by which the requantized samples should be multiplied.

sblimit = from Tables 10.8 through 10.11.

samplecode = coded representation of three consecutive samples in the granule [gr] in subband [sb] of channel [ch].

sample = the s-th sample in subband [sb] of channel [ch].

grouping = three consecutive samples of the current subband [sb] in channel [ch] in the current granule [gr] are coded and transmitted using one common codeword. Grouping [ch] [sb] is true if in the Bit Allocation table currently in use (see Tables 10.8 through 10.11) the value under the [sb] row and the allocation [sb] column is either 3, 5, or 9.

nch = number of channels. 1 = single channel mode; 2 = other modes.

Figure 10.6b. MPEG Audio Bitstream Layer 2 Audio Data Definition.

Video Encoding

MPEG 1 permits resolutions up to 4095 × 4095 at 60 frames per second (progressive scan). What many people think of as MPEG 1 is a subset known as Constrained Parameters Bitstream (CPB). The CPB is a limited set of sampling and bit rate parameters designed to standardize buffer sizes and memory bandwidths, allowing a nominal guarantee of interoperability for decoders and encoders, while still addressing the widest possible range of applications. Devices not capable of handling these are not considered to be true MPEG 1. Table 10.13 lists some of the constrained parameters.

The CPB limits video to 396 macroblocks (101,376 pixels). Therefore, MPEG 1 video typically is coded at SIF resolutions of 352 × 240 (NTSC) or 352 × 288 (PAL). During encoding, the original resolution of 704 × 480 (NTSC) or 704 × 576 (PAL) is scaled down to SIF resolution. This usually is handled by ignoring the even fields and scaling down the odd fields horizontally. During decoding, the SIF resolution is scaled up to recover the original 704 × 480 (NTSC) or 704 × 576 (PAL) resolution. Note that some entire active scan lines and pixels on a scan line are ignored to ensure the number of luminance samples can be evenly divided by 16. Table 10.14 lists some of the more common MPEG 1 resolutions. The square pixel formats are used by the computer industry.

The coded video rate is limited to 1.856 Mbps. However, the bit rate is the most often waived parameter, with some applications using up to 6 Mbps or higher.

Interlaced Video

MPEG 1 was designed to handle progressive-scanned video. Early on, in an effort to improve video quality, several schemes were devised by video designers to allow the use of both the even and odd fields.

Horizontal resolution	≤ 768 pixels
Vertical resolution	≤ 576 lines
Picture Area	≤ 396 macroblocks
Pel Rate	≤ 396 × 25 macroblocks/s
Picture Rate	≤ 30 Hz
Bit Rate	≤ 1.856 Mbps

Table 10.13. Some of the Constrained Parameters for MPEG 1.

Resolution	Refresh Rate (Hz)
352 × 240	29.97
352 × 240	23.976
352 × 288	25
*320 × 240	29.97
*384 × 288	25

Table 10.14. Common MPEG 1 Resolutions.
(Note: Asterisk indicates square pixel resolution.)

For example, the even and odd fields can be combined into a single frame of 704 × 480 (NTSC) or 704 × 576 (PAL) resolution and encoded. During decoding, the fields are separated. This, however, can result in motion artifacts due to a moving object being in slightly different places in the two fields. Coding the even and odd fields separately avoids motion artifacts, but reduces the compression ratio since the redundancy between fields isn't used to advantage.

There are many other schemes for handling interlaced video, so MPEG 2 defined a standard way of handling it (covered in Chapter 11).

YCbCr Color Space

Figure 10.7 illustrates the 4:2:0 YCbCr format used by MPEG 1. Gamma-corrected digital RGB (R′G′B′) signals with a 16 to 235 range may be converted to YCbCr using the following equations:

$$Y = (77/256)R' + (150/256)G' + (29/256)B'$$

$$Cb = -(44/256)R' - (87/256)G' + (131/256)B' + 128$$

$$Cr = (131/256)R' - (110/256)G' - (21/256)B' + 128$$

The above RGB-to-YCbCr equations ensure that the YCbCr data has the proper levels (16 to 235 for Y and 16 to 240 for Cr and Cb) for an R′G′B′ input range of 16 to 235.

If the R′G′B′ data has a range of 0–255, as is commonly found in computer systems, the following equations should be used:

$$Y = 0.257R' + 0.504G' + 0.098B' + 16$$

$$Cb = -0.148R' - 0.291G' + 0.439B' + 128$$

$$Cr = 0.439R' - 0.368G' - 0.071B' + 128$$

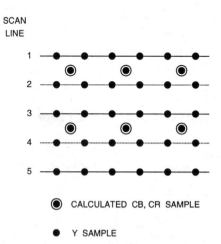

Figure 10.7. MPEG 1 4:2:0 Coded Picture Sampling. This shows the position of sampling sites on the scan lines of a progressive scan image.

Linear RGB data may be converted to gamma-corrected R'G'B' data as follows (values are normalized to have a value of 0 to 1):

R, G, B < 0.018	R, G, B ≥ 0.018
R' = 4.5 R	R' = 1.099 R^{0.45} − 0.099
G' = 4.5 G	G' = 1.099 G^{0.45} − 0.099
B' = 4.5 B	B' = 1.099 B^{0.45} − 0.099

Although the PAL standards specify a gamma of 2.8, a value of 2.2 is now used.

Encode Preprocessing

Better images can be obtained by preprocessing the video stream prior to MPEG encoding.

To avoid serious artifacts during encoding of a particular frame, prefiltering can be applied over the entire frame or just in specific problem areas. Prefiltering before compression processing is analogous to anti-alias filtering prior to A/D conversion. Prefiltering may take into account texture patterns, motion, and edges, and may be applied at the picture, slice, macroblock, or block level.

MPEG encoding works best on scenes with little fast or random movement and good lighting. For best results, foreground lighting should be clear and background lighting diffused. Foreground contrast and detail should be normal, but low contrast backgrounds containing soft edges are preferred. Editing tools typically allow you to preprocess potential problem areas.

The MPEG 1 specification has example filters for scaling down from ITU-R BT.601 to SIF resolution. In this instance, the even fields are ignored, throwing away half the vertical resolution, and a decimation filter is used to reduce the horizontal resolution of the remaining scan lines by a factor of two. Appropriate decimation of the Cb and Cr components must still be carried out.

Better video quality may be obtained by deinterlacing prior to scaling down to SIF resolution. When working on macroblocks (defined later), if the difference between macroblocks between two fields is small, average both to generate a new macroblock. Otherwise, use the macroblock area from the field of the same parity to avoid motion artifacts.

Inter-Picture Coding Overview

Coded Frame Types

There are four types of coded frames. I (intra) frames (~1 bit/pixel) are frames coded as a stand-alone still image. They allow random access points with-in the video stream. As such, I frames should occur about two times a second. I frames also should be used where scene cuts occur.

P (predicted) frames (~0.1 bit/pixel) are coded relative to the nearest previous I or P frame, resulting in forward prediction processing, as shown in Figure 10.8. P frames provide more compression than I frames, through the use of motion compensation, and are also a reference for B frames and future P frames.

B (bidirectional) frames (~0.015 bit/pixel) use the closest past and future I or P frame as a reference, resulting in bidirectional prediction, as shown in Figure 10.8. B frames provide the most compression and decrease noise by averaging two frames. Typically, there are two B frames separating I or P frames.

D (DC) frames are frames coded as a stand-alone still image, using only the DC component of the DCTs. D frames may not be in a sequence containing any other frame types and are rarely used.

A group of pictures (GOP) is a series of one or more coded frames intended to assist in

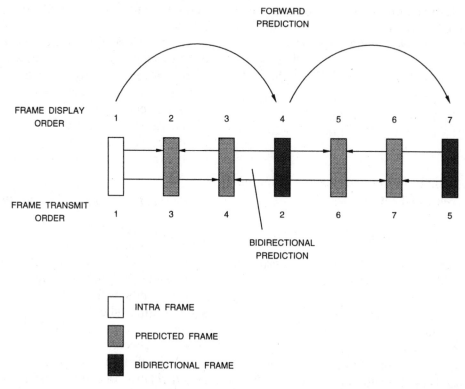

Figure 10.8. MPEG 1 I Frames, P Frames, and B Frames. Some frames are transmitted out of display sequence, complicating the interpolation process, and requiring frame reordering by the MPEG decoder.

random accessing and editing. The GOP value is configurable during the encoding process. The smaller the GOP value, the better the response to movement (since the I frames are closer together), but the lower the compression.

In the coded bitstream, a GOP must start with an I frame and may be followed by any number of I, P, or B frames in any order. In display order, a GOP must start with an I or B frame and end with an I or P frame. Thus, the smallest GOP size is a single I frame, with the largest size unlimited.

Originally, each GOP was to be coded and displayed independently of any other GOP. However, this is not possible unless no B frames precede I frames, or if they do, they use only backward motion compensation. This results in both open and closed GOP formats. A *closed GOP* is a GOP that can be decoded without using pictures of the previous GOP for motion compensation. An *open GOP* requires that they be available.

Motion Compensation
Motion compensation improves compression of P and B frames by removing temporal redundancies between frames. It works at the macroblock (defined later) level.

The technique relies on the fact that within a short sequence of the same general image, most objects remain in the same location,

while others move only a short distance. The motion is described as a two-dimensional motion vector that specifies where to retrieve a macroblock from a previously decoded frame to predict the pixel values of the current macroblock.

After a macroblock has been compressed using motion compensation, it contains both the spatial difference (motion vectors) and content difference (error terms) between the reference macroblock and macroblock being coded.

Note that there are cases where information in a scene cannot be predicted from the previous scene, such as when a door opens. The previous scene doesn't contain the details of the area behind the door. In cases such as this, when a macroblock in a P frame cannot be represented by motion compensation, it is coded the same way as a macroblock in an I frame (using intra-picture coding).

Macroblocks in B frames are coded using either the closest previous or future I or P frames as a reference, resulting in four possible codings:

- intra coding
 no motion compensation

- forward prediction
 closest previous I or P frame is the reference

- backward prediction
 closest future I or P frame is the reference

- bidirectional prediction
 two frames are used as the reference: the closest previous I or P frame and the closest future I or P frame.

Backward prediction is used to predict "uncovered" areas that do not appear in previous frames.

Intra-Picture Coding Overview

Image blocks and prediction error blocks have a high spatial redundancy. Several steps are used to remove this redundancy within a frame to improve the compression. The inverse of these steps is used by the decoder to recover the data.

Macroblock

A macroblock (shown in Figure 10.9) consists of a 16-pixel × 16-line set of Y components and the corresponding two 8-pixel × 8-line Cb and Cr components.

A block is an 8-pixel × 8-line set of Y, Cb, or Cr values. Note that a Y block refers to one-fourth the image size as the corresponding Cb or Cr blocks. Thus, a macroblock contains four Y blocks, one Cb block, and one Cr block.

DCT

Each 8 × 8 block (of pixels or error terms) is processed by the DCT (discrete cosine transform), resulting in an 8 × 8 block of horizontal and vertical frequency coefficients, as shown in Figure 10.10.

Quantizing

The 8 × 8 block of frequency coefficients are quantized, limiting the number of allowed values. Higher frequencies usually are quantized more coarsely (fewer allowed values) than low frequencies due to the human perception of quantization error. This results in many frequency coefficients being zero, especially at the higher frequencies. Note that each macroblock may use different quantization values.

Zig-Zag Scan

Zig-zag scanning, starting with the DC component, generates a linear stream of quantized frequency coefficients arranged in order of

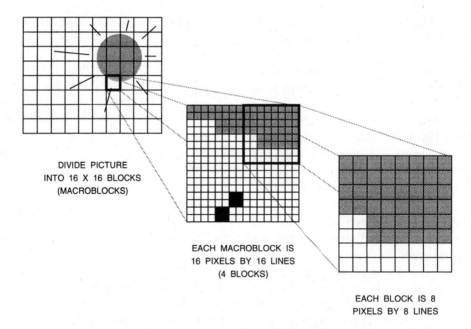

Figure 10.9. 16 x 16 Macroblocks and 8 x 8 Blocks.

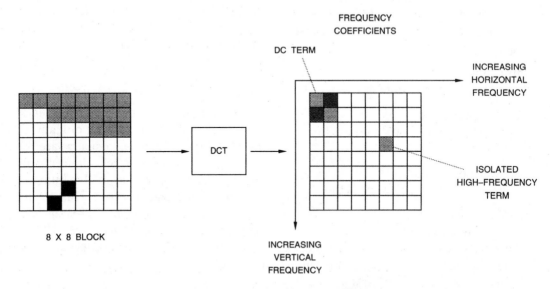

Figure 10.10. The DCT Processes the 8 x 8 Block of Pixels or Error Terms to Generate an 8 x 8 Block of Frequency Coefficients.

increasing frequency, as shown in Figure 10.11. This produces long runs of zero coefficients.

Run Length Coding

The linear stream of quantized frequency coefficients is converted into a series of (run, amplitude) pairs. Each pair indicates the number of zero coefficients and the amplitude of the non-zero coefficient that ended the run.

Huffman Coding

The (run, amplitude) pairs are coded using a variable-length code. This produces shorter codes for common pairs and longer codes of less common pairs.

Only pairs with a high probability of occurring are coded with a variable length code. Less likely pairs are coded as an escape symbol followed by fixed length codes to avoid long codewords and reduce the cost of implementation.

I Frame Coding

Macroblocks

There are two types of macroblocks in I frames, both using intracoding. One (called intra-d) uses the current quantizer scale; the other (called intra-q) defines a new value for the quantizer scale. They are identified in the coded bitstream by the codes in Table 10.15.

Type	QUANT	Code
intra-d	0	1
intra-q	1	01

Table 10.15. MPEG 1 VLC Table for I Frame Macroblock Type.

If the macroblock type is intra-q, the macroblock header specifies a 5-bit integer quan-

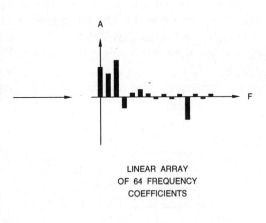

ZIG–ZAG SCAN OF
8 X 8 BLOCK OF
QUANTIZED
FREQUENCY
COEFFICIENTS

LINEAR ARRAY
OF 64 FREQUENCY
COEFFICIENTS

Figure 10.11. The 8 × 8 Block of Quantized Frequency Coefficients Are Zig-Zag Scanned To Arrange in Order of Increasing Frequency.

tizer scale factor. The decoder uses this to calculate the DCT coefficients from the transmitted quantized coefficients. Quantizer scale factors may range from 1 to 31, with zero not allowed.

If the macroblock type is intra-d, no quantizer scale is sent, and the decoder uses the current one.

DCT

An 8×8 DCT is performed on each 8×8 block of pels. Input pel values are 0 to 255, resulting in a range for the DC coefficient of 0 to 2,040 and a range of about –1,000 to +1,000 for the AC coefficients.

Quantizing

The 8×8 blocks of frequency coefficients are uniformly quantized. The quantizer step scale is derived from the quantization matrix and the quantizer scale and may be different for different coefficients and may change between macroblocks.

Since the eye is very sensitive to large luminance areas, the quantizer step size of the DC coefficients is fixed at eight. The DC quantized coefficient is determined by dividing the DC coefficient by eight and rounding to the nearest integer.

AC coefficients are quantized using the intra-quantization matrix.

Coding of Quantized DC Coefficients

After the DC coefficients have been quantized, they are losslessly coded.

Coding of luma blocks within a macroblock follows the order shown in Figure 10.12. The DC value of block 4 is the DC predictor for block 1 of the next macroblock. At the beginning of each slice, the DC predictor is set to 1,024.

The DC values of each Cb and Cr block are coded using the DC value of the corresponding block of the previous macroblock as a predictor. At the beginning of each slice, both DC predictors are set to 1,024.

The differential DC values are organized by their absolute value as shown in Table 10.16. The size, which specifies the number of additional bits to define the level uniquely, is transmitted by a variable-length code (VLC), and is different for Y and CbCr since the statistics are different. For example, a size of four is followed by four additional bits.

The decoder reverses the procedure to recover the quantized DC coefficients.

Coding of Quantized AC Coefficients

After the AC coefficients have been quantized, they are scanned in the zig-zag order shown in Figure 10.11 and coded using run length and level. The scan starts in position 1, as shown in Figure 10.11, as the DC coefficient in position 0 is coded separately.

Figure 10.12. MPEG 1 Macroblock Structure.

Differential DC	Size	Code (Y)	Code (CbCr)	Additional Code
−255 to −128	8	1111110	11111110	00000000 to 01111111
−127 to −64	7	111110	1111110	0000000 to 0111111
−63 to −32	6	11110	111110	000000 to 011111
−31 to −16	5	1110	11110	00000 to 01111
−15 to −8	4	110	1110	0000 to 0111
−7 to −4	3	101	110	000 to 011
−3 to −2	2	01	10	00 to 01
−1	1	00	01	0
0	0	100	00	
1	1	00	01	1
2 to 3	2	01	10	10 to 11
4 to 7	3	101	110	100 to 111
8 to 15	4	110	1110	1000 to 1111
16 to 31	5	1110	11110	10000 to 11111
32 to 63	6	11110	111110	100000 to 111111
64 to 127	7	111110	1111110	1000000 to 1111111
128 to 255	8	1111110	11111110	10000000 to 11111111

Table 10.16. MPEG 1 VLC Table for Differential DC, Size, VLC, and Additional Code.

The run lengths and levels are coded as shown in Table 10.17. The "s" bit denotes the sign of the level; 0 is positive and 1 is negative.

For run-level combinations not shown in Table 10.17, an escape sequence is used, consisting of the escape code, followed by the run-length from Table 10.18 and the level from Table 10.19.

After the last DCT coefficient has been coded, an EOB code is added to tell the decoder that there are no more quantized coefficients in this 8 × 8 block.

P Frame Coding

Macroblocks

There are eight types of macroblocks in P frames, as shown in Table 10.20, due to the additional complexity of motion compensation.

Skipped macroblocks are predicted macroblocks with a zero motion vector. Thus, no correction is available; the decoder copies skipped macroblocks from the previous frame into the current frame. The advantage of skipped macroblocks is that they require very few bits to transmit. They have no code; they are coded by having the macroblock address increment code skip over them.

If the QUANT column in Table 10.20 has a "1," the quantizer scale is transmitted. For the remaining macroblock types, the DCT correction is coded using the previous value for quantizer scale.

If the Motion Forward column in Table 10.20 has a "1," horizontal and vertical forward motion vectors are successively transmitted.

If the Coded Pattern column in Table 10.20 has a "1," the 6-bit coded block pattern is transmitted as a VLC. This tells the decoder which of the six blocks in the macroblock are coded ("1") and which are not coded ("0"). Table 10.21 lists the variable-length codes assigned to the 63 possible combinations. There is no code for when none of the blocks are coded; it is indicated by macroblock type. For macroblocks in I frames and for intra-code macro-

Run	Level	Code			
EOB		10			
0	1	1s	if first coefficient		
0	1	11s	not first coefficient		
0	2	0100	s		
0	3	0010	1s		
0	4	0000	110s		
0	5	0010	0110	s	
0	6	0010	0001	s	
0	7	0000	0010	10s	
0	8	0000	0001	1101	s
0	9	0000	0001	1000	s
0	10	0000	0001	0011	s
0	11	0000	0001	0000	s
0	12	0000	0000	1101	0s
0	13	0000	0000	1100	1s
0	14	0000	0000	1100	0s
0	15	0000	0000	1011	1s
0	16	0000	0000	0111	11s
0	17	0000	0000	0111	10s
0	18	0000	0000	0111	01s
0	19	0000	0000	0111	00s
0	20	0000	0000	0110	11s
0	21	0000	0000	0110	10s
0	22	0000	0000	0110	01s
0	23	0000	0000	0110	00s
0	24	0000	0000	0101	11s
0	25	0000	0000	0101	10s
0	26	0000	0000	0101	01s
0	27	0000	0000	0101	00s
0	28	0000	0000	0100	11s
0	29	0000	0000	0100	10s
0	30	0000	0000	0100	01s

Table 10.17a. MPEG 1 VLC Table for Quantized DCT AC Coefficients.

Run	Level	Code			
0	31	0000	0000	0100	00s
0	32	0000	0000	0011	000s
0	33	0000	0000	0010	111s
0	34	0000	0000	0010	110s
0	35	0000	0000	0010	101s
0	36	0000	0000	0010	100s
0	37	0000	0000	0010	011s
0	38	0000	0000	0010	010s
0	39	0000	0000	0010	001s
0	40	0000	0000	0010	000s
1	1	011s			
1	2	0001	10s		
1	3	0010	0101	s	
1	4	0000	0011	00s	
1	5	0000	0001	1011	s
1	6	0000	0000	1011	0s
1	7	0000	0000	1010	1s
1	8	0000	0000	0011	111s
1	9	0000	0000	0011	110s
1	10	0000	0000	0011	101s
1	11	0000	0000	0011	100s
1	12	0000	0000	0011	011s
1	13	0000	0000	0011	010s
1	14	0000	0000	0011	001s
1	15	0000	0000	0001	0011s
1	16	0000	0000	0001	0010s
1	17	0000	0000	0001	0001s
1	18	0000	0000	0001	0000s
2	1	0101	s		
2	2	0000	100s		
2	3	0000	0010	11s	
2	4	0000	0001	0100	s

Table 10.17b. MPEG 1 VLC Table for Quantized DCT AC Coefficients.

Run	Level	Code			
2	5	0000	0000	1010	0s
3	1	0011	1s		
3	2	0010	0100	s	
3	3	0000	0001	1100	s
3	4	0000	0000	1001	1s
4	1	0011	0s		
4	2	0000	0011	11s	
4	3	0000	0001	0010	s
5	1	0001	11s		
5	2	0000	0010	01s	
5	3	0000	0000	1001	0s
6	1	0001	01s		
6	2	0000	0001	1110	s
6	3	0000	0000	0001	0100s
7	1	0001	00s		
7	2	0000	0001	0101	s
8	1	0000	111s		
8	2	0000	0001	0001	s
9	1	0000	101s		
9	2	0000	0000	1000	1s
10	1	0010	0111	s	
10	2	0000	0000	1000	0s
11	1	0010	0011	s	
11	2	0000	0000	0001	1010s
12	1	0010	0010	s	
12	2	0000	0000	0001	1001s
13	1	0010	0000	s	
13	2	0000	0000	0001	1000s
14	1	0000	0011	10s	
14	2	0000	0000	0001	0111s
15	1	0000	0011	01s	
15	2	0000	0000	0001	0110s

Table 10.17c. MPEG 1 VLC Table for Quantized DCT AC Coefficients.

Run	Level	Code			
16	1	0000	0010	00s	
16	2	0000	0000	0001	0101s
17	1	0000	0001	1111	s
18	1	0000	0001	1010	s
19	1	0000	0001	1001	s
20	1	0000	0001	0111	s
21	1	0000	0001	0110	s
22	1	0000	0000	1111	1s
23	1	0000	0000	1111	0s
24	1	0000	0000	1110	1s
25	1	0000	0000	1110	0s
26	1	0000	0000	1101	1s
27	1	0000	0000	0001	1111s
28	1	0000	0000	0001	1110s
29	1	0000	0000	0001	1101s
30	1	0000	0000	0001	1100s
31	1	0000	0000	0001	1011s
ESC		0000	01		

Table 10.17d. MPEG 1 VLC Table for Quantized DCT AC Coefficients.

Run Length	Code	
0	0000	00
1	0000	01
2	0000	10
:	:	:
62	1111	10
63	1111	11

Table 10.18. MPEG 1 VLC Table for Run Length ESC Codes.

Level	Code				Level	Code			
−256	forbidden								
−255	1000	0000	0000	0001	255	0000	0000	1111	1111
−254	1000	0000	0000	0010	254	0000	0000	1111	1110
	:					:			
−129	1000	0000	0111	1111	129	0000	0000	1000	0001
−128	1000	0000	1000	0000	128	0000	0000	1000	0000
−127	1000	0001			127	0111	1111		
−126	1000	0010			126	0111	1110		
	:					:			
−2	1111	1110			2	0000	0010		
−1	1111	1111			1	0000	0001		
0	forbidden								

Table 10.19. MPEG 1 VLC Table for Level ESC Codes.

Type	Code	INTRA	Motion Forward	Coded Pattern	QUANT
pred-mc	1	0	1	1	0
pred-c	01	0	0	1	0
pred-m	001	0	1	0	0
intra-d	0001 1	1	0	0	0
pred-mcq	0001 0	0	1	1	1
pred-cq	0000 1	0	0	1	1
intra-q	0000 01	1	0	0	1
skipped	n/a				

Table 10.20. MPEG 1 VLC Table for P Frame Macroblock Type.

CBP	Code			CBP	Code		
60	111			62	0100	0	
4	1101			24	0011	11	
8	1100			36	0011	10	
16	1011			3	0011	01	
32	1010			63	0011	00	
12	1001	1		5	0010	111	
48	1001	0		9	0010	110	
20	1000	1		17	0010	101	
40	1000	0		33	0010	100	
28	0111	1		6	0010	011	
44	0111	0		10	0010	010	
52	0110	1		18	0010	001	
56	0110	0		34	0010	000	
1	0101	1		7	0001	1111	
61	0101	0		11	0001	1110	
2	0100	1		19	0001	1101	
35	0001	1100		38	0000	1100	
13	0001	1011		29	0000	1011	
49	0001	1010		45	0000	1010	
21	0001	1001		53	0000	1001	
41	0001	1000		57	0000	1000	
14	0001	0111		30	0000	0111	
50	0001	0110		46	0000	0110	
22	0001	0101		54	0000	0101	
42	0001	0100		58	0000	0100	
15	0001	0011		31	0000	0011	1
51	0001	0010		47	0000	0011	0
23	0001	0001		55	0000	0010	1
43	0001	0000		59	0000	0010	0
25	0000	1111		27	0000	0001	1
37	0000	1110		39	0000	0001	0
26	0000	1101					

Table 10.21. MPEG 1 VLC Table for CBP.

blocks in P and B frames, the coded block pattern is not transmitted, but is assumed to be a value of 63 (all blocks are coded).

To determine which type of macroblock to use, the encoder typically makes a series of decisions, as shown in Figure 10.13.

DCT
Intra block AC coefficients are transformed in the same manner as they are for I frames. Intra block DC coefficients are transformed differently; the predicted values are set to 1,024, unless the previous block was intra-coded.

Non-intra block coefficients represent differences between pel values rather than actual pel values. They are obtained by subtracting the motion compensated values of the previous frame from the values in the current macroblock. There is no prediction of the DC value.

Quantizing
Intra blocks are quantized in the same manner as they are for I frames.

Non-intra blocks are quantized using the quantizer scale and the non-intra quantization matrix. The AC and DC coefficients are quantized in the same manner.

Coding of Intra Blocks
Intra blocks are coded the same way as I frame intra blocks. There is a difference in the handling of the DC coefficients in that the predicted value is 128, unless the previous block was intra coded.

Coding of Non-Intra Blocks
The coded block pattern (CBP) is used to specify which blocks have coefficient data. These are coded similarly to the coding of intra blocks, except the DC coefficient is coded in the same manner as the AC coefficients.

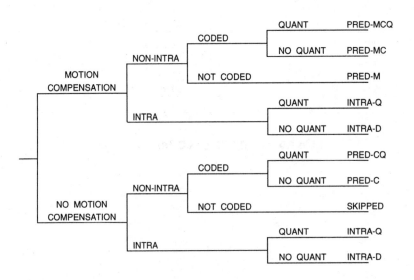

Figure 10.13. MPEG 1 P Frame Macroblock Type Selection.

B Frame Coding

Macroblocks

There are 12 types of macroblocks in B frames, as shown in Table 10.22, due to the additional complexity of backward motion compensation.

Skipped macroblocks are macroblocks having the same motion vector and macroblock type as the previous macroblock, which cannot be intra coded. The advantage of skipped macroblocks is that they require very few bits to transmit. They have no code; they are coded by having the macroblock address increment code skip over them.

If the QUANT column in Table 10.22 has a "1," the quantizer scale is transmitted. For the rest of the macroblock types, the DCT correction is coded using the previous value for the quantizer scale.

If the Motion Forward column in Table 10.22 has a "1," horizontal and vertical forward motion vectors are successively transmitted. If the Motion Backward column in Table 10.22 has a "1," horizontal and vertical backward motion vectors are successively transmitted. If both forward and backward motion types are present, the vectors are transmitted in this order:

> horizontal forward
> vertical forward
> horizontal backward
> vertical backward

If the Coded Pattern column in Table 10.22 has a "1," the 6-bit coded block pattern is transmitted as a VLC. This tells the decoder which of the six blocks in the macroblock are coded ("1") and which are not coded ("0"). Table 10.21 lists the variable-length codes assigned to the 63 possible combinations. There is no code for when none of the blocks are coded; this is indicated by the macroblock type. For macroblocks in I frames and for intra-code macroblocks in P and B frames, the coded block pattern is not transmitted, but is assumed to be a value of 63 (all blocks are coded).

To determine which type of macroblock to use, the encoder typically makes a series of decisions, shown in Figure 10.14.

Type	Code	INTRA	Motion Forward	Motion Backward	Coded Pattern	QUANT
pred-i	10	0	1	1	0	0
pred-ic	11	0	1	1	1	0
pred-b	010	0	0	1	0	0
intra-bc	011	0	0	1	1	0
pred-f	0010	0	1	0	0	0
pred-fc	0011	0	1	0	1	0
intra-d	0001 1	1	0	0	0	0
pred-icq	0001 0	0	1	1	1	1
pred-fcq	0000 11	0	1	0	1	1
pred-bcq	0000 10	0	0	1	1	1
intra-q	0000 01	1	0	0	0	1
skipped	n/a					

Table 10.22. MPEG 1 VLC Table for B Frame Macroblock Type.

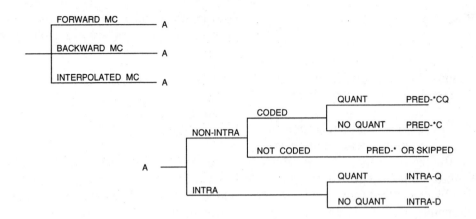

Figure 10.14. MPEG 1 B Frame Macroblock Type Selection.

Coding

DCT coefficients of blocks are transformed into quantized coefficients and coded in the same way they are for P frames.

D Frames

D frames contain only DC-frequency data and are intended to be used for fast visible search applications. The data contained in a D frame should be just sufficient for the user to locate the desired video.

Video Bitstream Generation

Figures 10.15 through 10.21 illustrate the video bitstream.

VIDEO SEQUENCE LAYER	
SEQUENCE HEADER	(see Figure 10.16)
GOP LAYER	(see Figure 10.17)
PICTURE LAYER	(see Figure 10.18)
SLICE LAYER	(see Figure 10.19)
MACROBLOCK LAYER	(see Figure 10.20)
BLOCK LAYER	(see Figure 10.21)
SEQUENCE_END_CODE = 000001B7 (HEX)	

Figure 10.15. MPEG 1 Video Bitstream.

Sequence_header_code (32 bits)

This has a value of 000001B3$_H$ and indicates the beginning of a sequence header.

Horizontal_size (12 bits)

This is the width of the viewable portion of the luma component. The left part of the viewable picture is left-aligned in the encoded picture. The width in macroblocks is defined as (horizontal_size + 15)/16.

Vertical_size (12 bits)

This is the height of the viewable portion of the luma component. The top part of the viewable picture is top-aligned in the encoded picture. The height in macroblocks is defined as (vertical_size + 15)/16.

Pel_aspect_ratio (4 bits)

Indicates the aspect ratio:

Pel Aspect Ratio	Height / Width	Example
0000	forbidden	
0001	1.0000	VGA
0010	0.6735	
0011	0.7031	16:9, 625-line
0100	0.7615	
0101	0.8055	
0110	0.8437	16:9. 525-line
0111	0.8935	
1000	0.9157	BT.601, 625-line
1001	0.9815	
1010	1.0255	
1011	1.0695	
1100	1.0950	BT.601, 525-line
1101	1.1575	
1110	1.2015	
1111	reserved	

Figure 10.16a. MPEG 1 Video Bitstream Sequence Header Definition.

Picture_rate (4 bits)

Indicates the picture rate:

Picture Rate	Pictures Per Second
0000	forbidden
0001	23.976
0010	24
0011	25
0100	29.97
0101	30
0110	50
0111	59.94
1000	60
1001	reserved
1010	reserved
1011	reserved
1100	reserved
1101	reserved
1110	reserved
1111	reserved

Bit_rate (18 bits)

An integer specifying the bitstream bit rate. measured in units of 400 bps, rounded upwards. A 0 value is not allowed; a value of $3FFFF_H$ specifies variable bit rate operation. If the constrained_parameters_flag bit is a "1," the bit rate shall be \leq1.856 Mbps.

Marker_bit (1 bit)

Always a "1."

Vbv_buffer_size (10 bits)

Defines the size of the Video Buffering Verifier needed to decode the sequence. It is defined as:

$$B = 16 * 1024 * vbv_buffer_size$$

If the constrained_parameters_flag bit is a "1," the vbv_buffer_size shall be \leq40 KB.

Constrained_parameters_flag (1 bit)

This bit is set to a "1" if the following constraints are met:

horizontal_size \leq768 pixels
vertical_size \leq576 pixels
((horizontal_size + 15)/16) * ((vertical_size + 15)/16) \leq396
((horizontal_size + 15)/16) * ((vertical_size + 15)/16) * picture_rate \leq396*25
picture_rate \leq30 pictures per second
forward_f_code \leq4
backward_f_code \leq4

Figure 10.16b. MPEG 1 Video Bitstream Sequence Header Definition.

Load_intra_quantizer_matrix (1 bit)

This bit is set to a "1" if an intra_quantizer_matrix follows. If set to a "0," the default values below are used until the next occurrence of a sequence header.

8	16	19	22	26	27	29	34
16	16	22	24	27	29	34	37
19	22	26	27	29	34	34	38
22	22	26	27	29	34	37	40
22	26	27	29	32	35	40	48
26	27	29	32	35	40	48	58
26	27	29	34	38	46	56	69
27	29	35	38	46	56	69	83

Intra_quantizer_matrix (8 * 64 bits)

An optional list of sixty-four 8-bit values that replace the default values shown above. A value of 0 is not allowed. The value for intra_quant [0,0] is always 8. These values take effect until the next occurrence of a sequence header.

Load_non_intra_quantizer_matrix (1 bit)

This bit is set to a "1" if a non_intra_quantizer_matrix follows. If set to a "0," the default values below are used until the next occurrence of a sequence header.

16	16	16	16	16	16	16	16
16	16	16	16	16	16	16	16
16	16	16	16	16	16	16	16
16	16	16	16	16	16	16	16
16	16	16	16	16	16	16	16
16	16	16	16	16	16	16	16
16	16	16	16	16	16	16	16
16	16	16	16	16	16	16	16

Non_intra_quantizer_matrix (8 * 64 bits)

An optional list of sixty-four 8-bit values that replace the previous default values shown. A value of 0 is not allowed. These values take effect until the next occurrence of a sequence header.

Extension_start_code (32 bits)

This optional bit string of $000001B5_H$ indicates the beginning of extension data. Extension data continues until the detection of another start code.

Sequence_extension_data (n * 8 bits)

Reserved. Present only if an extension_start_code is present.

User_data_start_code (32 bits)

This optional bit string of $000001B2_H$ indicates the beginning of user data. User data continues until the detection of another start code.

User_data (n * 8 bits)

Present only if an user_data_start_code is present. User data shall not contain a string of 23 or more zero bits.

Figure 10.16c. MPEG 1 Video Bitstream Sequence Header Definition.

Group_start_code (32 bits)

This has a value of 000001B8$_H$ and indicates the beginning of a group of pictures.

Time_code (25 bits)

The drop_frame_flag may be set to "1" only if the picture rate is 29.97 Hz.

Time Code	Range of Value	Number of Bits
drop_frame_flag		1
time_code_hours	0–23	5
time_code_minutes	0–59	6
marker_bit	1	1
time_code_seconds	0–59	6
time_code_pictures	0–59	6

Closed_gop (1 bit)

This flag may be set to "1" if the group of pictures has been encoded without motion vectors referencing the previous group of pictures. This bit allows support of editing the compressed bitstream.

Broken_link (1 bit)

This flag is set to a "0" during encoding. It is set to a "1" during editing when the B frames following the first I frame of a group of pictures cannot be correctly decoded.

Extension_start_code (32 bits)

This optional bit string of 000001B5$_H$ indicates the beginning of extension data. Extension data continues until the detection of another start code.

Group_extension_data (n * 8 bits)

Reserved. Present only if an extension_start_code is present.

User_data_start_code (32 bits)

This optional bit string of 000001B2$_H$ indicates the beginning of user data. User data continues until the detection of another start code.

User_data (n * 8 bits)

Present only if an user_data_start_code is present. User data shall not contain a string of 23 or more zero bits.

Figure 10.17. MPEG 1 Video Bitstream Group of Pictures Layer Definition.

Picture_start_code (32 bits)

This has a value of 00000100_H.

Temporal_reference (10 bits)

For the first frame in display order of each group of pictures, the temporal_reference value is 0. It is then incremented by one, modulo 1024, for each frame in display order.

Picture_coding_type (3 bits)

These bits indicate the frame type (I frame, P frame, B frame, or D frame). D frames are not to be used in the same video sequence as other frames.

Picture Coding Type	Coding Method
000	forbidden
001	I frame
010	P frame
011	B frame
100	D frame
101	reserved
110	reserved
111	reserved

Vbv_delay (16 bits)

For constant bit rates, vbv_delay sets the initial occupancy of the decoding buffer at the start of decoding a picture so that it doesn't overflow or underflow. For variable bit rates, vbv_delay has a value of $FFFF_H$.

If picture coding type is 2 (P frames) or 3 (B frames), then the following parameters are present:

Full_pel_forward_vector (1 bit)

If a "1," the motion vector values are based on integer pels, rather than half-pels. This flag is present only for picture_coding_types 2 and 3 (P and B frames).

Forward_f_code (3 bits)

This parameter is present only for picture_coding_types 2 and 3 (P and B frames). Values of 1 to 7 are used, with a value of zero forbidden. This parameter is used by the decoder to decode the forward motion vectors.

If picture coding type is 3 (B frames), then the following parameters are present:

Full_pel_backward_vector (1 bit)

If a "1," the motion vector values are based on integer pels, rather than half-pels. This flag is present only for picture_coding_type 3 (B frames).

Backward_f_code (3 bits)

This parameter is present only for picture_coding_type 3 (B frames). Values of 1 to 7 are used, with a value of 0 forbidden. This parameter is used by the decoder to decode the backward motion vectors.

Figure 10.18a. MPEG 1 Video Bitstream Picture Layer Definition.

Extra_bit_picture (1 bit)

As long as this flag is set to a "1," extra_information_picture data follows. A value of "0" for this flag indicates no extra_information_picture data is available.

Extra_information_picture (8 bits)

Reserved. Present only if extra_bit_picture = 1.

Extension_start_code (32 bits)

This optional bit string of $000001B5_H$ indicates the beginning of extension data. Extension data continues until the detection of another start code.

Picture_extension_data (n * 8 bits)

Reserved. Present only if an extension_start_code is present.

User_data_start_code (32 bits)

This optional bit string of $000001B2_H$ indicates the beginning of user data. User data continues until the detection of another start code.

User_data (n * 8 bits)

Present only if an user_data_start_code is present. User data shall not contain a string of 23 or more 0 bits.

Figure 10.18b. MPEG 1 Video Bitstream Picture Layer Definition.

Slice_start_code (32 bits)

The first 24 bits have a value of 000001_H. The last 8 bits are the slice_vertical_position, and have a value of 01_H–AF_H.

The slice_vertical_position specifies the vertical position in macroblock units of the first macroblock in the slice. The slice_vertical_position of the first row of macroblocks is one.

Quantizer_scale (5 bits)

This parameter has a value of 1 to 31 (a value of 0 is forbidden). It specifies the scale factor of the reconstruction level of the received DCT coefficients. The decoder uses this value until another quantizer_scale is received at the either the slice or macroblock layer.

Extra_bit_slice (1 bit)

As long as this flag is set to a "1," extra_information_slice data follows. A value of "0" for this flag indicates no extra_information_slice data is available, and data for the macroblock layer is next.

Extra_information_slice (8 bits)

Reserved. Present only if extra_bit_slice = 1.

Figure 10.19. MPEG 1 Video Bitstream Slice Layer Definition.

Macroblock_stuffing (n * 11 bits)
This optional parameter is a fixed bit string of "0000 0001 111" and may be used to increase the bit rate to match the storage or transmission requirements. Any number of macroblock_stuffing parameters may be used.

Macroblock_escape (n * 11 bits)
This optional parameter is a fixed bit string of "0000 0001 000" and is used when the difference between macroblock_address and previous_macroblock_address is greater than 33. It forces the value of macroblock_address_increment to be 33 greater than the value that will be decoded by subsequent macroblock_escape and macroblock_address_increment parameters. Any number of macroblock_escape parameters may be used.

Macroblock_address_increment (1–11 bits)
This is a variable-length word that specifies the difference between macroblock_address and previous_macroblock_address. It has a maximum value of 33. Values greater than 33 are encoded using the macroblock_escape parameter. The VLC codes are listed in Table 10.23.

Macroblock_type (1–6 bits)
This is a variable-length word that specifies the coding method and macroblock content. The VLC codes are listed in Table 10.24.

Quantizer_scale (5 bits)
This optional parameter has a value of 1 to 31 (a value of 0 is forbidden). It specifies the scale factor of the reconstruction level of the received DCT coefficients. The decoder uses this value until another quantizer_scale is received at the either the slice or macroblock layer. The quantizer_scale parameter is present only when Macroblock quant = 1 in Table 10.24.

Motion_horizontal_forward_code (1–11 bits)
This optional variable-length parameter is encoded and decoded according to Table 10.25. The decoded value is used to help decide if motion_horizontal_forward_r appears in the bitstream. This parameter is present only when Macroblock Motion Forward = 1 in Table 10.24.

 Motion_horizontal_forward_r (1–6 bits)
 This optional parameter is used to decode the forward motion vectors. This parameter is present only when Macroblock Motion Forward = 1, forward_f ≠ 1, and motion_horizontal_forward_code ≠ 0.

Motion_vertical_forward_code (1–11 bits)
This optional variable-length parameter is decoded according to Table 10.25. The decoded value is used to help decide if motion_vertical_forward_r appears in the bitstream. This parameter is present only when Macroblock Motion Forward = 1, in Table 10.24.

 Motion_vertical_forward_r (1–6 bits)
 This optional parameter is used to decode the forward motion vectors. This parameter is present only when Macroblock Motion Forward = 1, forward_f ≠ 1, and motion_vertical_forward_code ≠ 0.

Figure 10.20a. MPEG 1 Video Bitstream Macroblock Layer Definition.

Motion_horizontal_backward_code (1–11 bits)

This optional variable-length parameter is encoded and decoded according to Table 10.25. The decoded value is used to help decide if motion_horizontal_backward_r appears in the bitstream. This parameter is present only when Macroblock Motion Backward= 1 in Table 10.24.

Motion_horizontal_backward_r (1–6 bits)

This optional parameter is used to decode the backward motion vectors. This parameter is present only when Macroblock Motion Backward = 1, backward_f ≠ 1, and motion_horizontal_backward_code ≠ 0.

Motion_vertical_backward_code (1–11 bits)

This optional variable-length parameter is decoded according to Table 10.25. The decoded value is used to help decide if motion_vertical_backward_r appears in the bitstream. This parameter is present only when Macroblock Motion Backward = 1 in Table 10.24.

Motion_vertical_backward_r (1–6 bits)

This optional parameter is used to decode the backward motion vectors. This parameter is present only when Macroblock Motion Backward = 1, backward_f ≠ 1, and motion_vertical_backward_code ≠ 0.

Coded_block_pattern (3–9 bits)

This optional variable-length parameter is used to derive the variable coded block pattern (CBP) as shown in Table 10.26. It is present only if Macroblock Pattern = 1 in Table 10.24. If Macroblock Intra = 0, CBP = 0. Pattern_code [i] for i = 0 to 5 is derived from CBP:

pattern_code [i] = 0
if (CBP AND (1<<(5–i)) pattern_code [i] = 1
if (macroblock_intra) pattern_code [i] = 1

pattern_code [0]: upper left luma block is received in this macroblock.

pattern_code [1]: upper right luma block is received in this macroblock.

pattern_code [2]: lower left luma block is received in this macroblock.

pattern_code [3]: lower right luma block is received in this macroblock.

pattern_code [4]: Cb block is received in this macroblock.

pattern_code [5]: Cr block is received in this macroblock.

Block_layer_data

Block [i] data for i = 0 to 5 is inserted here.

End_of_macroblock (1 bit)

This optional parameter has a value of 1. It is present only for D frames.

Figure 10.20b. MPEG 1 Video Bitstream Macroblock Layer Definition.

Increment Value	Code	Increment Value	Code
1	1	17	0000 0101 10
2	011	18	0000 0101 01
3	010	19	0000 0101 00
4	0011	20	0000 0100 11
5	0010	21	0000 0100 10
6	0001 1	22	0000 0100 011
7	0001 0	23	0000 0100 010
8	0000 111	24	0000 0100 001
9	0000 110	25	0000 0100 000
10	0000 1011	26	0000 0011 111
11	0000 1010	27	0000 0011 110
12	0000 1001	28	0000 0011 101
13	0000 1000	29	0000 0011 100
14	0000 0111	30	0000 0011 011
15	0000 0110	31	0000 0011 010
16	0000 0101 11	32	0000 0011 001
		33	0000 0011 000

Table 10.23. MPEG 1 VLC Table for Macroblock_Address_Increment.

Macroblock Quant	Macroblock Motion Forward	Macroblock Motion Backward	Macroblock Pattern	Macroblock Intra	Code
0	0	0	0	1	1
1	0	0	0	1	01

Table 10.24a. MPEG 1 VLC Table for Macroblock_Type for I Frames. (Derived from Table 10.15.)

Macroblock Quant	Macroblock Motion Forward	Macroblock Motion Backward	Macroblock Pattern	Macroblock Intra	Code
0	1	0	1	0	1
0	0	0	1	0	01
0	1	0	0	0	001
0	0	0	0	1	00011
1	1	0	1	0	00010
1	0	0	1	0	00001
1	0	0	0	1	000001

Table 10.24b. MPEG 1 VLC Table for Macroblock_Type for P Frames. (Derived from Table 10.20.)

Macroblock Quant	Macroblock Motion Forward	Macroblock Motion Backward	Macroblock Pattern	Macroblock Intra	Code
0	1	1	0	0	10
0	1	1	1	0	11
0	0	1	0	0	010
0	0	1	1	0	011
0	1	0	0	0	0010
0	1	0	1	0	0011
0	0	0	0	1	00011
1	1	1	1	0	00010
1	1	0	1	0	000011
1	0	1	1	0	000010
1	0	0	0	1	000001

Table 10.24c. MPEG 1 VLC Table for Macroblock_Type for B Frames. (Derived from Table 10.22.)

Macroblock Quant	Macroblock Motion Forward	Macroblock Motion Backward	Macroblock Pattern	Macroblock Intra	Code
0	0	0	0	1	1

Table 10.24d. MPEG 1 VLC Table for Macroblock_Type for D Frames.

Code	VLC	Code	VLC
−16	0000 0011 001	1	010
−15	0000 0011 011	2	0010
−14	0000 0011 101	3	0001 0
−13	0000 0011 111	4	0000 110
−12	0000 0100 001	5	0000 1010
−11	0000 0100 011	6	0000 1000
−10	0000 0100 11	7	0000 0110
−9	0000 0101 01	8	0000 0101 10
−8	0000 0101 11	9	0000 0101 00
−7	0000 0111	10	0000 0100 10
−6	0000 1001	11	0000 0100 010
−5	0000 1011	12	0000 0100 000
−4	0000 111	13	0000 0011 110
−3	0001 1	14	0000 0011 100
−2	0011	15	0000 0011 010
−1	011	16	0000 0011 000
0	1		

Table 10.25. MPEG 1 VLC Table for Motion Vectors.

Coded Block Pattern	Code	Coded Block Pattern	Code	Coded Block Pattern	Code
60	111	9	0010 110	43	0001 0000
4	1101	17	0010 101	25	0000 1111
8	1100	33	0010 100	37	0000 1110
16	1011	6	0010 011	26	0000 1101
32	1010	10	0010 010	38	0000 1100
12	1001 1	18	0010 001	29	0000 1011
48	1001 0	34	0010 000	45	0000 1010
20	1000 1	7	0001 1111	53	0000 1001
40	1000 0	11	0001 1110	57	0000 1000
28	0111 1	19	0001 1101	30	0000 0111
44	0111 0	35	0001 1100	46	0000 0110
52	0110 1	13	0001 1011	54	0000 0101
56	0110 0	49	0001 1010	58	0000 0100
1	0101 1	21	0001 1001	31	0000 0011 1
61	0101 0	41	0001 1000	47	0000 0011 0
2	0100 1	14	0001 0111	55	0000 0010 1
62	0100 0	50	0001 0110	59	0000 0010 0
24	0011 11	22	0001 0101	27	0000 0001 1
36	0011 10	42	0001 0100	39	0000 0001 0
3	0011 01	15	0001 0011		
63	0011 00	51	0001 0010		
5	0010 111	23	0001 0001		

Table 10.26. MPEG 1 VLC Table for Coded Block Pattern (CBP).

Dct_dc_size_luminance (2–7 bits)

This optional variable-length parameter is used in intra coded blocks, with pattern_code [i] = i≤ 3. It specifies the number of bits in dct_dc_differential. The values are:

DCT DC Size Luminance	Code	DCT DC Size Luminance	Code
0	100	5	1110
1	00	6	1111 0
2	01	7	1111 10
3	101	8	1111 110
4	110		

Dct_dc_differential (1–8 bits)

If dct_dc_size_luminance = 0, dct_dc_differential is not present in the bitstream. It is present only if dct_dc_size_luminance is present, and not equal to zero.

Dct_dc_size_chrominance (2–8 bits)

This optional variable-length parameter is used in intra coded blocks, with pattern_code [i] = i≥ 4. It specifies the number of bits in dct_dc_differential. The values are:

DCT DC Size Chrominance	Code	DCT DC Size Chrominance	Code
0	00	5	1111 0
1	01	6	1111 10
2	10	7	1111 110
3	110	8	1111 1110
4	1110		

Dct_dc_differential (1–8 bits)

If dct_dc_size_chrominance = 0, dct_dc_differential is not present in the bitstream. It is present only if dct_dc_size_chrominance is present, and not equal to zero.

Figure 10.21a. MPEG 1 Video Bitstream Block Layer Definition.

Dct_coefficient_first (2–28 bits)

An optional variable-length parameter used in non-intra coded blocks, as defined in Tables 10.27 and 10.28 for the first coefficient. The variables run and level are derived from these tables. The zig-zag scanned quantized DCT coefficient list is updated as follows:

i = run
if (s = 0) dct_zz [i] = level
if (s = 1) dct_zz [i] = –level

Dct_coefficient_next (n * (3–28) bits)

N variable-length parameters present only for I, P, and B frames, and defined in Tables 10.27 and 10.28 for the coefficients after the first. The variables run and level are derived from these tables. The zig-zag scanned quantized DCT coefficient list is updated as follows:

i = i + run + 1
if (s = 0) dct_zz [i] = level
if (s = 1) dct_zz [i] = –level

If Macroblock Intra = 1 in Table 10.24, [i] is a zero before the first dct_coeff_next of the block. This parameter is not present for D frames.

End_of_block (2 bits)

Used to indicate that no additional non-zero coefficients are present. It is used even if dct_zz [63] is non-zero. The value of this parameter is the bit string "10."

Figure 10.21b. MPEG 1 Video Bitstream Block Layer Definition.

Run	Level	Code	Run	Level	Code
end_of_block		10	escape		0000 01
0 (note 2)	1	1 s	0	5	0010 0110 s
0 (note 3)	1	11 s	0	6	0010 0001 s
1	1	011 s	1	3	0010 0101 s
0	2	0100 s	3	2	0010 0100 s
2	1	0101 s	10	1	0010 0111 s
0	3	0010 1 s	11	1	0010 0011 s
3	1	0011 1 s	12	1	0010 0010 s
4	1	0011 0 s	13	1	0010 0000 s
1	2	0001 10 s	0	7	0000 0010 10 s
5	1	0001 11 s	1	4	0000 0011 00 s
6	1	0001 01 s	2	3	0000 0010 11 s
7	1	0001 00 s	4	2	0000 0011 11 s
0	4	0000 110 s	5	2	0000 0010 01 s
2	2	0000 100 s	14	1	0000 0011 10 s
8	1	0000 111 s	15	1	0000 0011 01 s
9	1	0000 101 s	16	1	0000 0010 00 s

Note 1: s = 0 for positive; s = 1 for negative.
Note 2: used for dct_coeff_first
Note 3: Used for dct_coeff_next.

Table 10.27a. MPEG 1 VLC Table for dct_coeff_first and dct_coeff_next.

Run	Level	Code	Run	Level	Code
0	8	0000 0001 1101 s	0	12	0000 0000 1101 0 s
0	9	0000 0001 1000 s	0	13	0000 0000 1100 1 s
0	10	0000 0001 0011 s	0	14	0000 0000 1100 0 s
0	11	0000 0001 0000 s	0	15	0000 0000 1011 1 s
1	5	0000 0001 1011 s	1	6	0000 0000 1011 0 s
2	4	0000 0001 0100 s	1	7	0000 0000 1010 1 s
3	3	0000 0001 1100 s	2	5	0000 0000 1010 0 s
4	3	0000 0001 0010 s	3	4	0000 0000 1001 1 s
6	2	0000 0001 1110 s	5	3	0000 0000 1001 0 s
7	2	0000 0001 0101 s	9	2	0000 0000 1000 1 s
8	2	0000 0001 0001 s	10	2	0000 0000 1000 0 s
17	1	0000 0001 1111 s	22	1	0000 0000 1111 1 s
18	1	0000 0001 1010 s	23	1	0000 0000 1111 0 s
19	1	0000 0001 1001 s	24	1	0000 0000 1110 1 s
20	1	0000 0001 0111 s	25	1	0000 0000 1110 0 s
21	1	0000 0001 0110 s	26	1	0000 0000 1101 1 s

Note 1: s = 0 for positive; s = 1 for negative.

Table 10.27b. MPEG 1 VLC Table for dct_coeff_first and dct_coeff_next.

Run	Level	Code	Run	Level	Code
0	16	0000 0000 0111 11 s	0	40	0000 0000 0010 000 s
0	17	0000 0000 0111 10 s	1	8	0000 0000 0011 111 s
0	18	0000 0000 0111 01 s	1	9	0000 0000 0011 110 s
0	19	0000 0000 0111 00 s	1	10	0000 0000 0011 101 s
0	20	0000 0000 0110 11 s	1	11	0000 0000 0011 100 s
0	21	0000 0000 0110 10 s	1	12	0000 0000 0011 011 s
0	22	0000 0000 0110 01 s	1	13	0000 0000 0011 010 s
0	23	0000 0000 0110 00 s	1	14	0000 0000 0011 001 s
0	24	0000 0000 0101 11 s	1	15	0000 0000 0001 0011 s
0	25	0000 0000 0101 10 s	1	16	0000 0000 0001 0010 s
0	26	0000 0000 0101 01 s	1	17	0000 0000 0001 0001 s
0	27	0000 0000 0101 00 s	1	18	0000 0000 0001 0000 s
0	28	0000 0000 0100 11 s	6	3	0000 0000 0001 0100 s
0	29	0000 0000 0100 10 s	11	2	0000 0000 0001 1010 s
0	30	0000 0000 0100 01 s	12	2	0000 0000 0001 1001 s
0	31	0000 0000 0100 00 s	13	2	0000 0000 0001 1000 s
0	32	0000 0000 0011 000 s	14	2	0000 0000 0001 0111 s
0	33	0000 0000 0010 111 s	15	2	0000 0000 0001 0110 s
0	34	0000 0000 0010 110 s	16	2	0000 0000 0001 0101 s
0	35	0000 0000 0010 101 s	27	1	0000 0000 0001 1111 s
0	36	0000 0000 0010 100 s	28	1	0000 0000 0001 1110 s
0	37	0000 0000 0010 011 s	29	1	0000 0000 0001 1101 s
0	38	0000 0000 0010 010 s	30	1	0000 0000 0001 1100 s
0	39	0000 0000 0010 001 s	31	1	0000 0000 0001 1011 s

Note 1: s = 0 for positive; s = 1 for negative.

Table 10.27c. MPEG 1 VLC Table for dct_coeff_first and dct_coeff_next.

Fixed Length Code	Run	Level
0000 00	0	
0000 01	1	
0000 10	2	
:	:	
1111 11	63	
forbidden		−256
1000 0000 0000 0001		−255
1000 0000 0000 0010		−254
:		:
1000 0000 0111 1111		−129
1000 0000 1000 0000		−128
1000 0001		−127
1000 0010		−126
:		:
1111 1110		−2
1111 1111		−1
forbidden		0
0000 0001		1
:		:
0111 1111		127
0000 0000 1000 0000		128
0000 0000 1000 0001		129
:		:
0000 0000 1111 1111		255

Note 1: s = 0 for positive; s = 1 for negative.

Table 10.28. Run, Level Encoding Following An Escape Code for dct_coeff_first and dct_coeff_next.

Advanced MPEG 1 Encoding Methods

Work is progressing at a number of companies on "advanced MPEG encoding" techniques to improve the decoded video quality. MPEG encoders that do not employ advanced encoding techniques usually result in decoded video with ringing around edges, color bleeding, and noise.

Liberal Interpretations of the Forward DCT

Looking at the DCT as a filter bank, one technique is basis vector shaping. The idea is to combine the data adaptive properties of pre-filtering and preprocessing into the transformation process, yet still be able to reconstruct a picture using the standard IDCT.

Frequency-Domain Enhancements

Enhancements are applied to the transform coefficients after the DCT stage and, optionally, the quantization stage. In effect, if you don't like the transformed results, change them into something that you do like.

Temporal Spreading of Quantization Error

The intent of this technique is the same as that behind the carefully selected color subcarrier timing used in the (M) NTSC and (B, D, G, H, I) PAL analog video standards. For objects and edges with no movement, noise does not remain stationary—it moves to give a more uniform effect and be less noticeable.

System Bitstream Multiplexing

The system multiplexer merges the audio and video bitstreams into a system bitstream, and formats it with control information into a specific protocol as defined by MPEG 1. The general organization of a MPEG 1 system bitstream is illustrated in Figures 10.22 through 10.25.

Packet data may contain either audio or video information. Up to 32 audio and 16 video streams may be multiplexed together. Two types of private data streams are also supported. One type is completely private; the other is used to support synchronization and buffer management.

Maximum packet sizes usually are about 2,048 bytes, although much larger sizes are supported. When stored on CD-ROM, the length of the packs coincides with the sectors. Typically, there is one audio packet for every six or seven video packets.

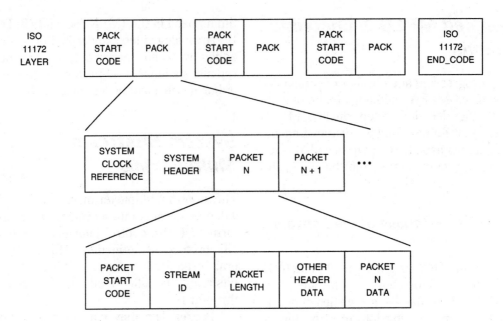

Figure 10.22. MPEG 1 System Bitstream Definition.

Pack_start_code (32 bits)
 This has a value of $000001BA_H$.

"0010" Bit Stream (4 bits)

System_clock_reference_32–30 (3 bits)
 The system_clock_reference (SCR) is a 33-bit number coded using three fields, separated by marker bits. SCR indicates the intended time of arrival of the last byte of the SCR field as the input of the decoder. The value of SCR is the number of periods of a 90 kHz system clock.

Marker_bit (1 bit)
 This always has a value of "1."

System_clock_reference_29–15 (15 bits)

Marker_bit (1 bit)
 This always has a value of "1."

System_clock_reference_14–0 (15 bits)

Marker_bits (2 bits)
 These two bits always have a value of "1."

Mux_rate (22 bits)
 This parameter specifies the rate at which the decoder receives the bitstream. It specifies units of 50 bytes/second, rounded upwards; a value of 0 is not allowed.

Marker_bit (1 bit)
 This always has a value of "1."

Figure 10.23. MPEG 1 System Bitstream Pack Layer Definition.

System_header_start_code (32 bits)
This has a value of 000001BB$_H$.

Header_length (16 bits)
This specifies the number of bytes in the system header following the header_length parameter.

Marker_bit (1 bit)
This always has a value of "1."

Rate_bound (22 bits)
This specifies an integer value greater than or equal to the maximum value of the mux_rate parameter. It may be used by the decoder to determine if it is capable of decoding the entire bitstream.

Marker_bit (1 bit)
This always has a value of "1."

Audio_bound (6 bits)
This specifies an integer value greater than or equal to the maximum number of simultaneously active audio streams.

Fixed_flag (1 bit)
This specifies fixed bitrate ("1") or variable bitrate ("0") operation.

CSPS_flag (1 bit)
This specifies whether the bitstream is a constrained system parameter stream ("1") or not ("0").

System_audio_lock_flag (1 bit)
This has a value of "1" if there is a constant relationship between the audio sampling rate and the decoder's system clock frequency.

System_video_lock_flag (1 bit)
This has a value of "1" if there is a constant relationship between the video picture rate and the decoder's system clock frequency.

Marker_bit (1 bit)
This always has a value of "1."

Video_bound (5 bits)
This specifies an integer value greater than or equal to the maximum number of simultaneously active video streams.

Reserved_byte (8 bits)
This always has a value of "1111 1111."

Figure 10.24a. MPEG 1 System Bitstream System Header Definition.

Stream_ID (8 bits)

This optional parameter indicates the type and number of the streams to which the following STD_buffer_bound_scale and STD_buffer_size_bound parameters refer to. A Stream_ID parameter, and the corresponding fixed_bits, STD_buffer_bound_scale and STD_buffer_size_bound parameters, are used for each stream.

Stream ID	Stream Type
1011 1000	all audio streams
1011 1001	all video streams
1011 1100	reserved stream
1011 1101	private stream 1
1011 1110	padding stream
1011 1111	private stream 2
110x xxxx	audio stream number xxxxx
1110 xxxx	video stream number xxxx
1111 xxxx	reserved data stream number xxxx

Fixed_bits (2 bits)

This parameter has a value of "11." It is present only if stream_ID is present.

STD_buffer_bound_scale (1 bit)

This parameter specifies the scaling factor used to interpret the STD_buffer_size_bound parameter. For an audio stream, it has a value of "0." For a video stream, it has a value of "1." For other stream types, it can be either a "0" or a "1." It is present only if stream_ID is present.

STD_buffer_size_bound (13 bits)

This parameter defines a value greater than or equal to the maximum decoder input buffer size. If STD_buffer_bound_scale = "0," then STD_buffer_size_bound measures the size bound in units of 128 bytes. If STD_buffer_bound_scale = "1," then STD_buffer_size_bound measures the size bound in units of 1024 bytes. It is present only if stream_ID is present.

Figure 10.24b. MPEG 1 System Bitstream System Header Definition.

Packet_start_code_prefix (24 bits)
This has a value of 000001_H.

Stream_ID (8 bits)
This specifies the type and number of the elementary stream as defined by the stream_ID.

Packet_length (16 bits)
This specifies the number of bytes remaining in the packet after the packet_length parameter.

If stream ID is not private stream 2, the following parameters may be present.

Stuffing_byte (n * 8 bits)
This optional parameter has a value of "1111 1111." 0–16 bytes may used.

STD_bits (2 bits)
These optional bits have a value of "01" and indicate the following STD_buffer_scale and STD_buffer_size parameters are present.

STD_buffer_scale (1 bit)
This optional parameter specifies the scaling factor used to interpret the STD_buffer_size parameter. For an audio stream, it has a value of "0." For a video stream, it has a value of "1." For other stream types, it can be either a "0" or a "1." It is present only if STD_bits is present.

STD_buffer_size (13 bits)
This optional parameter defines the size of the decoder input buffer. If STD_buffer_scale = "0," then STD_buffer_size measures the size in units of 128 bytes. If STD_buffer_scale = "1," then STD_buffer_size measures the size in units of 1024 bytes. It is present only if STD_bits is present.

PTS_bits (4 bits)
These optional bits have a value of "0010" and indicate the following presentation time stamps and marker bits are present.

Presentation_time_stamp_32–30 (3 bits)
The presentation_time_stamp (PTS) is a 33-bit number coded using three fields, separated by marker bits. PTS indicates the intended time of presentation by the decoder. The value of PTS is the number of periods of a 90 kHz system clock. It is present only if PTS_bits is present.

Marker_bit (1 bit)
This always has a value of "1." It is present only if PTS_bits is present.

Presentation_time_stamp_29–15 (15 bits)
It is present only if PTS_bits is present.

Marker_bit (1 bit)
This always has a value of "1." It is present only if PTS_bits is present.

Figure 10.25a. MPEG 1 System Bitstream Packet Layer Definition.

Presentation_time_stamp_14–0 (15 bits)

It is present only if PTS_bits is present.

Marker_bit (1 bit)

This always has a value of "1." It is present only if PTS_bits is present.

DTS_bits (4 bits)

These optional bits have a value of "0011" and indicate the following presentation time stamps, decoding time stamps, and marker bits are present.

Presentation_time_stamp_32–30 (3 bits)

The presentation_time_stamp (PTS) is a 33-bit number coded using three fields, separated by marker bits. PTS indicates the intended time of presentation by the decoder. The value of PTS is the number of periods of a 90 kHz system clock. It is present only if DTS_bits is present.

Marker_bit (1 bit)

This always has a value of "1." It is present only if DTS_bits is present.

Presentation_time_stamp_29–15 (15 bits)

It is present only if DTS_bits is present.

Marker_bit (1 bit)

This always has a value of "1." It is present only if DTS_bits is present.

Presentation_time_stamp_14–0 (15 bits)

It is present only if DTS_bits is present.

Marker_bit (1 bit)

This always has a value of "1." It is present only if DTS_bits is present.

Bit_field (4 bits)

These optional bits have a value of "0001." It is present only if DTS_bits is present.

Figure 10.25b. MPEG 1 System Bitstream Packet Layer Definition.

Decoding_time_stamp_32–30 (3 bits)

The decoding_time_stamp (DTS) is a 33-bit number coded using three fields, separated by marker bits. DTS indicates the intended time of decoding by the decoder of the first access unit that commences in the packet. The value of DTS is the number of periods of a 90 kHz system clock. It is present only if DTS_bits is present.

Marker_bit (1 bit)

This always has a value of "1." It is present only if DTS_bits is present.

Decoding_time_stamp_29–15 (15 bits)

It is present only if DTS_bits is present.

Marker_bit (1 bit)

This always has a value of "1." It is present only if DTS_bits is present.

Decoding_time_stamp_14–0 (15 bits)

It is present only if DTS_bits is present.

Marker_bit (1 bit)

This always has a value of "1." It is present only if DTS_bits is present.

NonPTS_nonDTS_bits (8 bits)

These optional bits have a value of "0000 1111" and are present if the PTS_bits parameter (and the corresponding parameters) or the DTS_bits parameter (and the corresponding parameters) are not present.

Packet_data_byte (n * 8 bits)

This is the contiguous bytes of data from the elementary stream specified by the packet layer stream_ID. The number of data bytes may be determined from the packet_length parameter.

Figure 10.25c. MPEG 1 System Bitstream Packet Layer Definition.

System Bitstream Demultiplexing

The system demultiplexer parses the incoming MPEG 1 system bitstream, demultiplexing the audio and video bitstreams.

Video Decoding

The video decoder essentially performs the inverse of the encoder. From the coded video bitstream, it reconstructs the I frames. Using I frames, additional coded data, and motion vectors, the P and B frames are generated. Finally, the frames are output in the proper order.

Fast Playback Considerations

Fast forward operation can be implemented by using D frames or the decoding only of I frames. However, decoding only I frames at the faster rate places a major burden on the transmission medium and the decoder.

Alternately, the source may be able to sort out the desired I frames and transmit just those frames, allowing the bit rate to remain constant.

Pause Mode Considerations

This requires the decoder to be able to control the incoming bitstream. If it doesn't, when playback resumes there may be a delay and skipped frames.

Reverse Playback Considerations

This requires the decoder to be able to decode each group of pictures in the forward direction, store them, and display them in reverse order. To minimize the storage requirements of the decoder, groups of pictures should be small or the frames may be reordered. Reordering can be done by transmitting frames in another order or by reordering the coded pictures in the decoder buffer.

Decode Postprocessing

The SIF data usually is converted to 720 × 480 (NTSC) or 720 × 576 (PAL) interlaced resolution using spatial upsampling. Suggested upsampling filters are discussed in the MPEG 1 specification. The original decoded lines correspond to the odd fields. Even fields use interpolated lines.

Most MPEG 1 decoders output YCbCr or R′G′B′ data. If driving a NTSC/PAL encoder that supports YCbCr as an input format, it is better to avoid converting to the R′G′B′ color space, if possible. Better video quality is obtained by minimizing the color space conversions.

If needed, conversion from YCbCr to R′G′B′ uses the inverse of the encoding equations:

$$R' = Y + 1.371(Cr - 128)$$

$$G' = Y - 0.698(Cr - 128) - 0.336(Cb - 128)$$

$$B' = Y + 1.732(Cb - 128)$$

The resulting gamma-corrected RGB (R′G′B′) values have a nominal range of 16 to 235, with occasional excursions into the 1 to 15 and 236 to 254 values (due to Y and CbCr occasionally going outside the 16 to 235 and 16 to 240 ranges, respectively).

If the desired R′G′B′ data range is 0 to 255, the following equations should be used:

$$R' = 1.164(Y - 16) + 1.596(Cr - 128)$$

$$G' = 1.164(Y - 16) - 0.813(Cr - 128) \\ - 0.392(Cb - 128)$$

$$B' = 1.164(Y - 16) + 2.017(Cb - 128)$$

The gamma correction may be removed to generate linear RGB data (values are normalized to have a value of 0 to 1):

$R', G', B' < 0.0812$	$R', G', B' \geq 0.0812$
$R = R'/4.5$	$R = ((R' + 0.099)/1.099)^{2.2}$
$G = G'/4.5$	$G = ((G' + 0.099)/1.099)^{2.2}$
$B = B'/4.5$	$B = ((B' + 0.099)/1.099)^{2.2}$

Audio Decoding

Initially, the audio decoder must synchronize to the audio bitstream by searching for the 12-bit sync word. The remainder of the header is used to configure the audio decoder for proper operation and CRC-checked.

Figures 10.26 and 10.27 illustrate the basic audio decoding for Layers 1 and 2.

Real-World Issues

Here are some problem areas that crop up frequently in real-world designs.

System Bitstream Termination

A common error is the improper placement of the sequence_end_code in the system bit-stream. When this happens, some decoders may not know that the end of the video occurred, and output garbage.

Another problem occurs when a system bitstream is shortened just by eliminating trailing frames, removing the sequence_end_code altogether. In this case, the decoder may be unsure when to stop.

Timecodes

Since some decoders rely on the timecode information, it should be implemented. To minimize problems, the video bitstream should start with a timecode of zero and increment by one each frame.

Variable Bit Rates

Although variable bit rates are supported, a constant bit rate should be used if possible. Since the vbv_delay doesn't make sense for a variable bit rate, the MPEG 1 standard specifies that it be set to the maximum value.

However, some decoders use the vbv_delay parameter with variable bit rates. This could result in a large (2–3 second) delay before starting video, causing the first 60–90 frames to be skipped.

Constrained Bitstreams

Most MPEG 1 decoders can handle only the constrained parameters subset of MPEG 1. To ensure maximum compatibility, only the constrained parameters subset should be used.

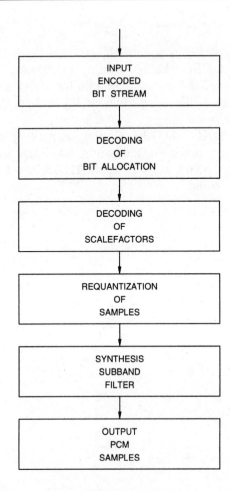

Figure 10.26. MPEG 1 Audio Layer 1 and 2 Decoder Flow Chart.

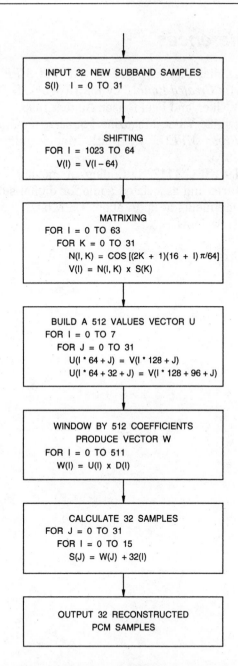

Figure 10.27 Synthesis Subband Filter Flow Chart.

References

1. Digital Video Magazine, *"Not All MPEGs Are Created Equal,"* by John Toebes, Doug Walker, and Paul Kaiser, August 1995.
2. Digital Video Magazine, *"Squeeze the Most From MPEG,"* by Mark Magel, August 1995.
3. ISO/IEC 11172-1, Coding of moving pictures and associated audio for digital storage media at up to about 1.5 Mbit/s, Part 1: Systems.
4. ISO/IEC 11172-2, Coding of moving pictures and associated audio for digital storage media at up to about 1.5 Mbit/s, Part 2: Video.
5. ISO/IEC 11172-3, Coding of moving pictures and associated audio for digital storage media at up to about 1.5 Mbit/s, Part 3: Audio.

MPEG 2

MPEG 2 extends MPEG 1 to cover a wider range of applications. The reader should review the MPEG 1 chapter to become familiar with the basics of MPEG before reading this chapter. Some of the major features and benefits of MPEG 2 are listed in Table 11.1.

The primary application targeted during the definition process was all-digital transmission of broadcast-quality video at bit rates of 4–9 Mbps. However, MPEG 2 is useful for many other applications, such as HDTV, and now supports bit rates of 1.5–60 Mbps.

MPEG 2 is an ISO standard (ISO/IEC 13818), and consists of eight parts (only the first three are officially released):

systems	ISO/IEC 13818-1
video	ISO/IEC 13818-2
audio	ISO/IEC 13818-3
conformance testing	ISO/IEC 13818-4
simulation software	ISO/IEC 13818-5
command and control	ISO/IEC 13818-6
new audio formats	ISO/IEC 13818-7
real-time interface	ISO/IEC 13818-9

As with MPEG 1, the compressed bitstreams implicitly define the decompression algorithms. The compression algorithms are up to the individual manufacturers, allowing a proprietary advantage to be obtained within the scope of an international standard.

In addition to audio/video multiplexing, a major feature of the Systems specification (ISO/IEC 13818-1) is the more accurate synchronization of audio, video, and data. Additional functions include random access, identification of information carried within the stream, procedures to support user access control, and error protection mechanisms.

The ITU adopted the Systems specification as ITU-T Recommendation H.222.1 (as part of its Broadband-ISDN audiovisual telecommunications terminal) and the Video specification as ITU-T Recommendation H.262.

The Digital Storage Media Command and Control (DSM-CC) extension (ISO/IEC 13818-6) will facilitate the managing of MPEG bitstreams and equipment by providing a common command and control interface. An example application is the control of remote video servers from home-based terminals. It is expected to become an International Standard in 1996.

The audio extension (ISO/IEC 13818-7) will add non-backwards-compatible audio modes, such as the Dolby Digital (AC-3 5.1 channel) standard. It is expected to become an International Standard in 1997.

Feature	Benefit
Decodes MPEG 1 bitstreams.	Previous source material does not become obsolete and still may be played back.
Both progressive or interlaced video sources are supported.	Higher vertical resolution and backwards compatibility.
Support for 4:2:0, 4:2:2, and 4:4:4 YCbCr formats.	Allows higher chrominance resolution, resulting in a sharper picture.
Horizontal and vertical resolutions may be specified and now must be a multiple of 16 for frame-coded pictures, and the vertical dimension must be a multiple of 32 for field-coded pictures.	
Supports frame resolutions up to 16383 × 16383.	
Aspect ratio may be specified.	Allows support for various aspect ratios, enabling the viewer to determine how to best process the decoded video for display.
A display window within the encoded video may be defined. Alternately, the encoded video may be defined as a window on a larger display.	Allows support of a 4:3 pan and scan of a 16:9 video, etc.
Source video type (NTSC, PAL, SECAM, MAC, component) may be indicated.	Allows original video signal to be recreated as accurately as possible.
Source video color primaries and opto-electronic transfer (gamma) characteristics may be indicated.	Enables colors to be reproduced as accurately as possible.
Syntax to signal a 3:2 pulldown process in the decoder to generate 30 fps from 24 fps source material.	Reduces transmission bit rate requirements. Also allows 24 fps video to be transmitted and processed as desired at the receiver for optimum viewing.

Table 11.1a. MPEG 2 Features and Benefits.

Feature	Benefit
Source composite video characteristics (V-axis, field sequence, subcarrier phase, burst amplitude, etc.) may be indicated.	Allows original video signal to be recreated as accurately as possible.
Optional alternate DCT scanning pattern.	Improves interlaced video performance.
Constant and variable bit rates are supported.	Allows using higher bit rates to maintain video quality during "difficult" scenes.
Editing of coded video is supported.	Reduces need to decode, edit, and re-encode a group of pictures to perform editing.
Coded bitstream is more resilient to errors.	Transmission of coded video streams in the "real world" is less likely to result in errors.
More accurate motion vectors, concealment motion vectors for I frames, improved DC precision, option of nonlinear macroblock quantization, and additional prediction modes.	Improves video quality and results in fewer errors.
Low Delay Mode in which no B frames are generated to eliminate the frame reordering delay at the decoder.	Supports applications such as real-time video teleconferencing.
Extends the stereo and mono coding of MPEG 1 audio to half sampling rates (16 kHz, 22.05 kHz, and 24 kHz).	Improves audio quality for bit rates at or below 64 kbps per channel.
Supports up to five full bandwidth audio channels. Adding additional modes not compatible with MPEG 1.	Support for home theater applications by being able to reproduce more accurately the surround-sound environment.

Table 11.1b. MPEG 2 Features and Benefits.

Notes:
1. ISO/IEC 13818-10 will be conformance testing of DSM-CC.
2. A 4:2:2 profile was added in early 1996. It was developed for studio and video distribution applications.
3. A multiview profile (MVP) is expected in mid-1996. It provides an efficient way of coding two video sequences from two cameras shooting the same scene, with a small angle between them.

The Real Time Interface (RTI) extension (ISO/IEC 13818-9) will define a common interface point to which terminal equipment manufacturers and network operators can design. RTI will specify a delivery model for the bytes of an MPEG-2 System stream at the input of a real decoder, whereas MPEG-2 System defines an idealized byte delivery schedule. It is expected to become an International Standard in 1996.

Audio Overview

MPEG 2 currently supports up to five full bandwidth channels compatible with MPEG 1 audio coding. It also extends the coding of MPEG 1 audio to half sampling rates (16 kHz, 22.05 kHz, and 24 kHz) for improved quality for bit rates at or below 64 kbps per channel. The half-sampling rates and the audio bitstream format are discussed in the MPEG 1 chapter.

Instead of the ISO/IEC 13818-3 multichannel standard, many systems plan to use multiple Layer 2 channels or the Dolby Digital (AC-3 5.1 channel) format for better audio quality at lower bit rates. For this reason, the multichannel formats are not covered here.

Video Overview

MPEG 2 defines various Profiles and Levels to avoid defining specific capabilities and algorithms. Profiles specify the syntax (i.e., algorithms), whereas Levels specify various parameters (resolution, frame rate, bit rate, etc.). Together, Main Profile and Main Level normalize function and complexity and should meet the needs of the majority of applications.

Levels

MPEG 2 supports four levels, which specify resolution, frame rate, coded bit rate, and so on for a given profile.

Low Level (LL)
MPEG 1 Constrained Parameters Bitstream (CPB) supports up to $352 \times 288 \times 30$ fps. Maximum bit rate is 4 Mbps.

Main Level (ML)
MPEG 2 Constrained Parameters Bitstream (CPB) supports up to $720 \times 576 \times 30$ fps. Maximum bit rate is 15–20 Mbps.

High 1440 Level
This Level supports up to $1440 \times 1152 \times 60$ fps and is intended for HDTV applications. Maximum bit rate is 60–80 Mbps.

High Level (HL)
High Level supports up to $1920 \times 1152 \times 60$ fps and is intended for HDTV applications. Maximum bit rate is 80–100 Mbps.

Profiles

MPEG 2 supports four profiles, which specify which coding syntax (algorithms) are used. Tables 11.2 through 11.9 illustrate the various combinations of levels and profiles allowed.

Simple Profile (SP)
Main profile without the B frames, intended for software applications and perhaps digital cable TV.

Main Profile (MP)
Intended for digital cable TV, digital satellite transmission, and so on. It will be supported by most MPEG 2 decoder chips and should sat-

Level	Profile				
	Nonscalable		Scalable		
	Simple	Main	SNR	Spatial	High
High	–	yes	–	–	yes
High 1440	–	yes	–	yes	yes
Main	yes	yes	yes	–	yes
Low	–	yes	yes	–	–

Table 11.2. MPEG 2 Acceptable Combinations of Levels and Profiles.

Constraint	Profile				
	Nonscalable		Scalable		
	Simple	Main	SNR	Spatial	High
Chroma Format	4:2:0	4:2:0	4:2:0	4:2:0	4:2:0 or 4:2:2
Picture Types	I, P	I, P, B	I, P, B	I, P, B	I, P B
Scalable Modes			SNR	SNR or Spatial	SNR or Spatial
Intra DC Precision (bits)	8, 9, 10	8, 9, 10	8, 9, 10	8, 9, 10	8, 9, 10, 11
Sequence Scalable Extension	no	no	yes	yes	yes
Repeat First Field	constrained		unconstrained		

Table 11.3. Some MPEG 2 Profile Constraints.

Level	Maximum Number of Layers	Profile		
		SNR	Spatial	High
High	All layers (base + enhancement) Spatial enhancement layers SNR enhancement layers	– 	– 	3 1 1
High 1440	All layers (base + enhancement) Spatial enhancement layers SNR enhancement layers	– 	3 1 1	3 1 1
Main	All layers (base + enhancement) Spatial enhancement layers SNR enhancement layers	2 0 1	–	3 1 1
Low	All layers (base + enhancement) Spatial enhancement layers SNR enhancement layers	2 0 1	–	–

Table 11.4. MPEG 2 Number of Permissible Layers for Scalable Profiles.

Profile	Profile			Profile at Level for Base Decoder
	Base Layer	Enhancement Layer 1	Enhancement Layer 2	
SNR	4:2:0	–	–	MP at same level
	4:2:0	SNR	–	
Spatial	4:2:0	–	–	MP at same level
	4:2:0	SNR, 4:2:0	–	
	4:2:0	Spatial, 4:2:0	–	MP at (level–1)
	4:2:0	SNR, 4:2:0	Spatial, 4:2:0	
	4:2:0	Spatial, 4:2:0	SNR, 4:2:0	
High	4:2:0 or 4:2:2	–	–	HP at same level
	4:2:0	SNR, 4:2:0	–	
	4:2:0	SNR, 4:2:2	–	
	4:2:2	SNR, 4:2:2	–	
	4:2:0	Spatial, 4:2:0	–	HP at (level–1)
	4:2:2	Spatial, 4:2:2	–	

Table 11.5. Some MPEG 2 Video Decoder Requirements for Various Profiles.

Level	Spatial Resolution Layer	Parameter	Profile			
			Simple	Main	SNR/Spatial	High
High	Enhancement	Samples per line Lines per frame Frames per second	–	1920 1152 60	–	1920 1152 60
	Lower	Samples per line Lines per frame Frames per second	–	–	–	960 576 30
High 1440	Enhancement	Samples per line Lines per frame Frames per second	–	1440 1152 60	1440 1152 60	1440 1152 60
	Lower	Samples per line Lines per frame Frames per second	–	–	720 576 30	720 576 30
Main	Enhancement	Samples per line Lines per frame Frames per second	720 576 30	720 576 30	720 576 30	720 576 30
	Lower	Samples per line Lines per frame Frames per second	–	–	–	352 288 30
Low	Enhancement	Samples per line Lines per frame Frames per second	–	352 288 30	352 288 30	–
	Lower	Samples per line Lines per frame Frames per second	–	–	–	–

Table 11.6. MPEG 2 Upper Limits of Resolution and Temporal Parameters. In the case of single layer or SNR scalability coding, the "Enhancement Layer" parameters apply.

Level	Maximum Bit Rate (Mbps)	Typical Pixel Resolutions	Frame Rate (Hz)	Typical Pixel Resolutions	Frame Rate (Hz)
High	80	1920×1080	23.976		
			24		
			29.97		
			30		
			59.94		
			60		
High 1440	60	1280×720	23.976		
			24		
			29.97		
			30		
			59.94		
			60		
		1440×1080	59.94		
			60		
Main	15	352×480	29.97	352×576	25
		544×480	29.97	544×576	25
		640×480^2	29.97		
		704×480	29.97	704×576	25
		720×480^1	29.97	720×576^1	25
Low	4	320×240^2	29.97		
		352×240	29.97	352×288	25

Table 11.7. Example Levels and Resolutions for MPEG 2 Main Profile. Shaded refresh rates indicate progressive scan operation.

[1] 704 active pixels per line.
[2] Square pixels.

Level	Spatial Resolution Layer	Profile			
		Simple	Main	SNR/Spatial	High
High	Enhancement	–	62.668800	–	62.668800 (4:2:2) 83.558400 (4:2:0)
	Lower	–	–	–	14.745600 (4:2:2) 19.660800 (4:2:0)
High 1440	Enhancement	–	47.001600	47.001600	47.001600 (4:2:2) 62.668800 (4:2:0)
	Lower	–	–	10.368000	11.059200 (4:2:2) 14.745600 (4:2:0)
Main	Enhancement	10.368000	10.368000	10.368000	11.059200 (4:2:2) 14.745600 (4:2:0)
	Lower	–	–	–	3.041280 (4:2:0)
Low	Enhancement	–	3.041280	3.041280	–
	Lower	–	–	–	–

Table 11.8. MPEG 2 Upper Limits for Luma Sample Rate (Msamples/second). In the case of single layer or SNR scalability coding, the "Enhancement Layer" parameters apply.

Level	Profile			
	Nonscalable		Scalable	
	Simple	Main	SNR/Spatial	High
High	–	80	–	100 (all layers) 80 (middle + base layers) 25 (base layer)
High 1440	–	60	60 (all layers) 40 (middle + base layers) 15 (base layer)	80 (all layers) 60 (middle + base layers) 20 (base layer)
Main	15	15	15 (both layers) 10 (base layer)	20 (all layers) 15 (middle + base layers) 4 (base layer)
Low	–	4	4 (both layers) 3 (base layer)	–

Table 11.9. MPEG 2 Upper Limits for Bit Rates (Mbits/second).

isfy 90% of the users. Typical resolutions are shown in Table 11.7.

SNR and Spatial Profiles

Adds support for SNR scalability and/or spatial scalability.

High Profile (HP)

Adds support for 4:2:2 chroma to Main+ profile.

Scalability

The MPEG 2 SNR, Spatial, and High profiles support four scalable modes of operation. These modes break MPEG 2 video into layers for the purpose of prioritizing video data. Scalability is currently (early 1996) not used. Coding efficiency decreases by about 2 dB (or about 30% more bits are required). Also, the bandwidth required to transmit resolutions greater than 720 × 576 is too great to be cost-effective at this time.

SNR Scalability

This mode is targeted for applications that desire multiple quality levels. All layers have the same spatial resolution. The base layer provides the basic video quality. The enhancement layer increases the video quality by providing refinement data for the DCT coefficients of the base layer.

Spatial Scalability

This mode is useful for simulcasting and software decoding of a lower resolution base layer. Each layer has a different spatial resolution. The base layer provides the basic spatial resolution and temporal rate. The enhancement layer uses the spatially interpolated base layer to increase the spatial resolution. For example, the base layer may implement 352 × 240 resolution video, with the enhancement layers used to generate 704 × 480 resolution video.

Temporal Scalability

This mode allows migration from low temporal rate to higher temporal rate systems. The base layer provides the basic temporal rate. The enhancement layer uses temporal prediction relative to the base layer. The base and enhancement layers can be combined to produce a full temporal rate output. All layers have the same spatial resolution and chroma formats. In case of errors in the enhancement layers, the base layer can easily be used for concealment.

Data Partitioning

This mode is targeted for cell loss resilience in ATM networks. It breaks the 64 quantized transform coefficients into two bitstreams. The first, higher priority bitstream contains critical lower-frequency DCT coefficients and side information such as headers and motion vectors. A second, lower-priority bitstream carries higher-frequency DCT coefficients that add more detail.

Transport and Program Streams

The MPEG 2 Systems Standard specifies methods for multiplexing the audio, video, and other data into a format suitable for transmission and storage.

The *Program Stream,* designed for applications where errors are unlikely, is similar to the MPEG 1 system bitstream. It contains audio and video (elementary) bitstreams merged into a single bitstream. The program stream, as well as the elementary bitstreams, may be a fixed or variable bit rate.

The *Transport Stream,* designed for use where data loss may be likely, also consists of audio and video bitstreams. It is well suited for transmission of digital audio and video over fiber, satellite, cable, ISDN, ATM, and other networks and also for storage on digital video tape and other devices.

Both the Transport Stream and Program Stream are based on a common packet structure, facilitating common decoder implementations and conversions. Both streams are designed to support a large number of known and anticipated applications, while retaining flexibility. The Program Stream is discussed in detail later in this chapter.

Video Encoding

YCbCr Color Space

MPEG 2 uses the YCbCr color space, supporting 4:2:0, 4:2:2, and 4:4:4 sampling. The 4:2:2 and 4:4:4 sampling options increase the chroma resolution over 4:2:0, resulting in better picture quality.

The 4:2:0 sampling structure for MPEG 2 is shown in Figures 11.1 through 11.4. The 4:2:2 and 4:4:4 sampling structures are standard, as discussed in Chapter 3. Most MPEG 2 encoders accept 4:2:2 YCbCr and use the 4:2:0 format for internal processing.

Optional Source Information

MPEG 2 allows optional transmission of several characteristics of the video source to enable more accurate reconstruction of the video.

Source Color Primaries

The color primaries of the source may be specified. This information is used to adjust the color processing after MPEG 2 decoding to compensate for the color primaries of the display.

Color primaries that may be specified include ITU-R BT.709, ITU-R BT.624 System M, ITU-R BT.624 Systems B and G, SMPTE 170M, SMPTE 240M, and "unspecified."

Source Opto-Electronic Transfer Characteristics

The opto-electronic transfer characteristics of the source may be specified. These are used to adjust the processing after MPEG 2 decoding to compensate for the gamma of the display.

Transfer characteristics that may be specified include ITU-R BT.709, ITU-R BT.470 System M, ITU-R BT.470 Systems B and G, SMPTE 170M, SMPTE 240M, linear, and "unspecified."

Source Matrix Coefficients

The matrix coefficients that the source used to convert from R′G′B′ to YCbCr may be specified. This information is used to select the proper YCbCr-to-RGB matrix after MPEG 2 decoding.

Matrix coefficients that may be specified include ITU-R BT.709, FCC, ITU-R BT.470 Systems B and G, SMPTE 170M, SMPTE 240M, and "unspecified."

Video Format

The video format of the original source may be specified. Formats specified include component, PAL, NTSC, SECAM, MAC, and "unspecified."

V-Axis

This characteristic indicates whether the original source was a PAL video. For example, this information could be obtained from an NTSC/PAL decoder that is driving the MPEG 2 encoder.

Field Sequence

This specifies which field of the four-field sequence (NTSC) or eight-field sequence (PAL) is used. For example, this information could be obtained from an NTSC/PAL decoder that is driving the MPEG 2 encoder. It is used

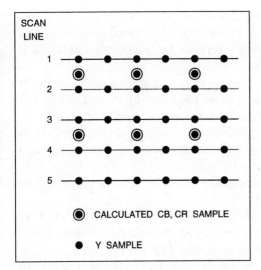

Figure 11.1. MPEG 2 4:2:0 Coded Picture Sampling.

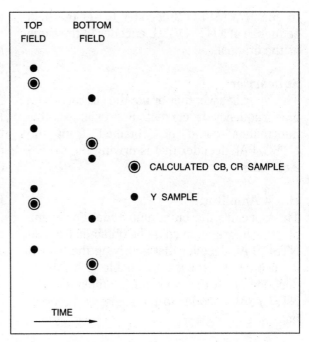

Figure 11.2. MPEG 2 4:2:0 Coded Picture Sampling. Interlaced frame with top_field_first = 1.

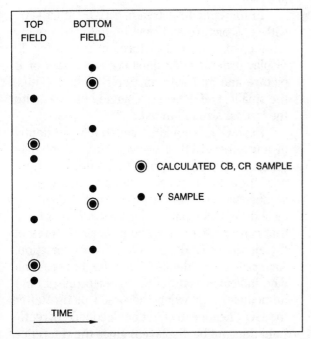

Figure 11.3. MPEG 2 4:2:0 Coded Picture Sampling. Interlaced frame with top_field_first = 0.

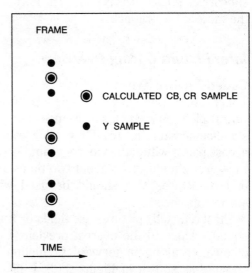

Figure 11.4. MPEG 2 4:2:0 Coded Picture Sampling. Progressive frame.

to enable a MPEG 2 decoder to set the field sequence of a NTSC/PAL encoder to the same as the original.

Subcarrier

This specifies whether or not the subcarrier-to-line frequency is correct. For example, this information could be obtained from the NTSC/PAL decoder that is driving the MPEG 2 encoder.

Burst Amplitude

This specifies the burst amplitude. For example, this information could be obtained from an NTSC/PAL decoder that is driving the MPEG 2 encoder. It is used to enable a MPEG 2 decoder to set the color burst amplitude of a NTSC/PAL encoder to the same as the original.

Subcarrier Phase

This specifies the subcarrier phase as defined in ITU-R BT.470. For example, this information could be obtained from an NTSC/PAL decoder that is driving the MPEG 2 encoder. It is used to enable a MPEG 2 decoder to set the color subcarrier phase of a NTSC/PAL encoder to the same as the original.

Inter-Picture Coding Overview

Coded Picture Types

There are three types of coded pictures. I (intra) pictures are fields or frames coded as a stand-alone still image. They allow random access points within the video stream. As such, I pictures should occur about two times a second. I pictures also should be used where scene cuts occur.

P (predicted) pictures are fields or frames coded relative to the nearest previous I or P picture, resulting in forward prediction processing, as shown in Figure 11.5. P pictures provide more compression than I pictures, through the use of motion compensation, and are also a reference for B pictures and future P pictures.

B (bidirectional) pictures are fields or frames that use the closest past and future I or P picture as a reference, resulting in bidirectional prediction, as shown in Figure 11.5. B pictures provide the most compression. and decrease noise by averaging two pictures. Typically, there are two B pictures separating I or P pictures.

D (DC) pictures are not supported in MPEG 2, except for decoding to support backwards compatibility with MPEG 1.

A group of pictures (GOP) is a series of one or more coded pictures intended to assist in random accessing and editing. The GOP value is configurable during the encoding process. The smaller the GOP value, the better the response to movement (since the I pictures are closer together), but the lower the compression.

In the coded bitstream, a GOP must start with an I picture and may be followed by any number of I, P, or B pictures in any order. In display order, a GOP must start with an I or B picture and end with an I or P picture. Thus, the smallest GOP size is a single I picture, with the largest size unlimited.

Each GOP should be coded independently of any other GOP. However, this is not true unless no B pictures precede the first I picture, or if they do, they use only backward motion compensation. This results in both open and closed GOP formats. A *closed GOP* is a GOP that can be decoded without using pictures of the previous GOP for motion compensation. An *open GOP*, identified by the broken_link flag, indicates that the first B pictures (if any) immediately following the first I picture after the GOP header may not be decoded correctly (and thus not be displayed) since the reference

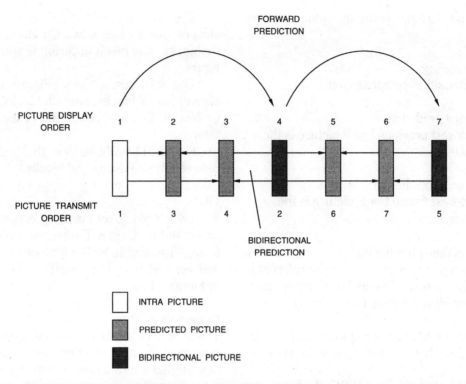

Figure 11.5. MPEG 2 I Pictures, P Pictures, and B Pictures. Some pictures can be transmitted out of sequence, complicating the interpolation process and requiring picture reordering by the MPEG decoder. Arrows show inter-frame dependencies.

picture used for prediction is not available due to editing.

Motion Compensation

Motion compensation improves compression of P and B pictures by removing temporal redundancies between pictures. It works at the macroblock (defined later) level.

The technique relies on the fact that within a short sequence of the same general image, most objects remain in the same location, whereas others move only a short distance. The motion is described as a two-dimensional motion vector that specifies where to retrieve a macroblock from a previously decoded frame to predict the pixel values of the current macroblock.

After a macroblock has been compressed using motion compensation, it contains both the spatial difference (motion vectors) and content difference (error terms) between the reference macroblock and the macroblock being coded.

Note that there are cases where information in a scene cannot be predicted from the previous scene, such as when a door opens. The previous scene doesn't contain the details of the area behind the door. In cases such as this, when a macroblock in a P picture cannot be represented by motion compensation, it is coded the same way as a macroblock in an I picture (using intra-picture coding).

Macroblocks in B pictures are coded using either the closest previous or future I or P pic-

tures as a reference, resulting in four possible codings:

> intra coding
>> no motion compensation
>
> forward prediction
>> closest previous I or P picture is the reference
>
> backward prediction
>> closest future I or P picture is the reference
>
> bidirectional prediction
>> two pictures are used as the reference: the closest previous I or P picture and the closest future I or P picture.

Backward prediction is used to predict "uncovered" areas that do not appear in previous frames.

Motion vectors for MPEG 2 always are coded in half-pixel units. MPEG 1 supports either half-pixel or full-pixel units.

Intra-Picture Coding Overview

Image blocks and prediction error blocks have a high spatial redundancy. Several steps are used to remove this redundancy within a picture to improve the compression. The same steps in reverse order are used by the decoder to recover the data.

Macroblock

Three types of macroblocks are available in MPEG 2:

The 4:2:0 macroblock (Figure 11.6) consists of four Y blocks, one Cb block, and one Cr block. The block ordering is shown in the figure.

The 4:2:2 macroblock (Figure 11.7) consists of four Y blocks, two Cb blocks, and two Cr blocks. The block ordering is shown in the figure.

The 4:4:4 macroblock (Figure 11.8) consists of four Y blocks, four Cb blocks, and four Cr blocks. The block ordering is shown in the figure.

Figure 11.9 illustrates the relationship between macroblocks and blocks.

DCT

Each 8×8 block (of pixels or error terms) is processed by the DCT (discrete cosine transform), resulting in an 8×8 block of horizontal and vertical frequency coefficients, as shown in Figure 11.10.

Quantizing

The 8×8 block of frequency coefficients is quantized, limiting the number of allowed values. Higher frequencies usually are quantized more coarsely (fewer allowed values) than low frequencies, due to the human perception of quantization error. This results in many frequency coefficients being zero, especially at the higher frequencies. Note that each macroblock may use different quantization values.

Zig-Zag Scan

Zig-zag scanning, starting with the DC component, generates a linear stream of quantized frequency coefficients arranged in order of increasing frequency, as shown in Figure 11.11 (also used in MPEG 1) or, alternately, as shown in Figure 11.12. This produces long runs of zero coefficients.

Run Length Coding

The linear stream of quantized frequency coefficients is converted into a series of [run, amplitude] pairs. Each pair indicates the num-

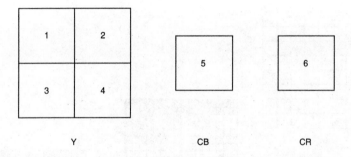

Figure 11.6. MPEG 2 4:2:0 Macroblock Structure.

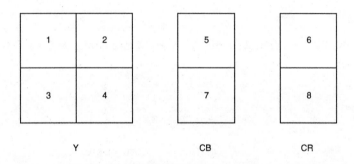

Figure 11.7. MPEG 2 4:2:2 Macroblock Structure.

Figure 11.8. MPEG 2 4:4:4 Macroblock Structure.

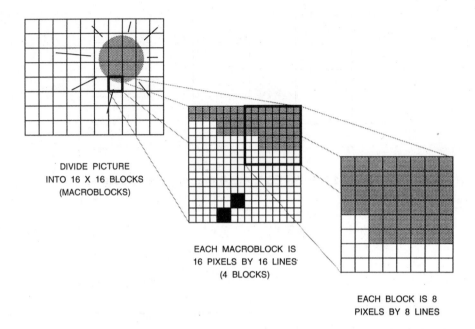

DIVIDE PICTURE
INTO 16 X 16 BLOCKS
(MACROBLOCKS)

EACH MACROBLOCK IS
16 PIXELS BY 16 LINES
(4 BLOCKS)

EACH BLOCK IS 8
PIXELS BY 8 LINES

Figure 11.9. The Relationship Between 16 x 16 Macroblocks and 8 x 8 Blocks.

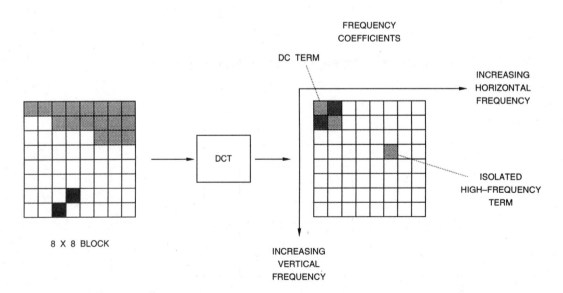

8 X 8 BLOCK

DCT

FREQUENCY
COEFFICIENTS

DC TERM

INCREASING
HORIZONTAL
FREQUENCY

ISOLATED
HIGH–FREQUENCY
TERM

INCREASING
VERTICAL
FREQUENCY

Figure 11.10. The DCT Processes the 8 x 8 Block of Pixels or Error Terms to Generate an 8 x 8 Block of Frequency Coefficients.

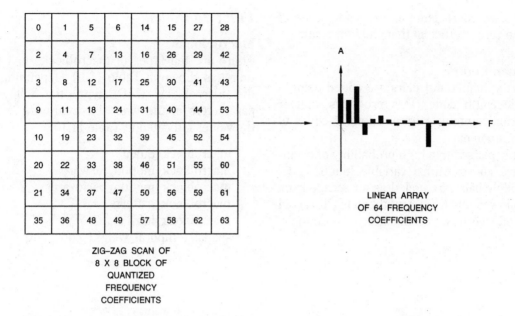

0	1	5	6	14	15	27	28
2	4	7	13	16	26	29	42
3	8	12	17	25	30	41	43
9	11	18	24	31	40	44	53
10	19	23	32	39	45	52	54
20	22	33	38	46	51	55	60
21	34	37	47	50	56	59	61
35	36	48	49	57	58	62	63

ZIG–ZAG SCAN OF
8 X 8 BLOCK OF
QUANTIZED
FREQUENCY
COEFFICIENTS

LINEAR ARRAY
OF 64 FREQUENCY
COEFFICIENTS

Figure 11.11. The 8 × 8 Block of Quantized Frequency Coefficients Are Zig-Zag Scanned to Arrange in Order of Increasing Frequency. This scanning order is the same as for MPEG 1 and typically is used for progressive pictures.

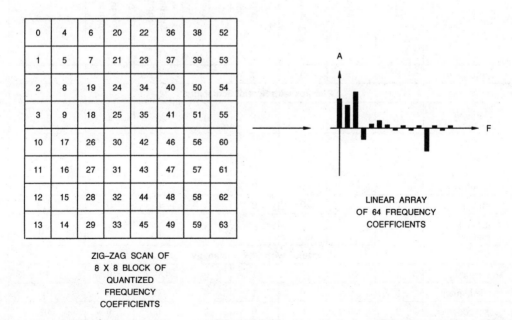

0	4	6	20	22	36	38	52
1	5	7	21	23	37	39	53
2	8	19	24	34	40	50	54
3	9	18	25	35	41	51	55
10	17	26	30	42	46	56	60
11	16	27	31	43	47	57	61
12	15	28	32	44	48	58	62
13	14	29	33	45	49	59	63

ZIG–ZAG SCAN OF
8 X 8 BLOCK OF
QUANTIZED
FREQUENCY
COEFFICIENTS

LINEAR ARRAY
OF 64 FREQUENCY
COEFFICIENTS

Figure 11.12. MPEG 2 Alternate Zig-Zag Scanning Order. This scanning order typically is used for interlaced pictures.

ber of zero coefficients and the amplitude of the non-zero coefficient that ended the run.

Huffman Coding

The [run, amplitude] pairs are coded using a variable-length code. This produces shorter codes for common pairs and longer codes of less common pairs.

Only pairs with a high probability of occurring are coded with a variable length code. Less likely pairs are coded as an escape symbol followed by fixed length codes to avoid long code words and reduce the cost of implementation.

I Picture Coding

Macroblocks

There are ten types of macroblocks in I pictures, as shown in Table 11.10. Depending on the macroblock (MB) type, the following parameters in the video bitstream are set to the values indicated in Table 11.10.

macroblock_quant
macroblock_motion_forward
macroblock_motion_backward
macroblock_pattern
macroblock_intra
spatial_temporal_weight_code_flag

Type	MB QUANT	MB Motion Forward	MB Motion Backward	MB Pattern	MB Intra	Spatial Temporal Weight Code Flag	Permitted Spatial Temporal Weight Class	Code
intra	0	0	0	0	1	0	0	1
intra, quant	1	0	0	0	1	0	0	01
I Pictures with Spatial Scalability								
coded, compatible	0	0	0	1	0	0	4	1
coded, compatible, quant	1	0	0	1	0	0	4	01
intra	0	0	0	0	1	0	0	0011
intra, quant	1	0	0	0	1	0	0	0010
not coded, compatible	0	0	0	0	0	0	4	0001
I Pictures with SNR Scalability								
coded	0	0	0	1	0	0	0	1
coded, quant	1	0	0	1	0	0	0	01
not coded	0	0	0	0	0	0	0	001

Table 11.10. MPEG 2 VLC Table for I Picture Macroblock Type.

The corresponding variable-length code also is used to specify the macroblock type.

If the Pattern column in Table 11.10 contains a "1," the 6-bit coded block pattern (CBP) is transmitted as a VLC. This tells the decoder which of the six blocks in the 4:2:0 macroblock are coded ("1") and which are not coded ("0"). Table 11.11 lists the variable-length codes assigned to the 63 possible combinations. No code exists for when none of the blocks are coded; this is indicated by the macroblock type. For 4:2:2 and 4:4:4 macroblocks, an additional 2 or 6 bits, respectively, are used to extend coded block pattern.

DCT

An 8 × 8 DCT is performed on each 8 × 8 block of pixels. For intra blocks (blocks within an intra macroblock) input values are 0 to 255, resulting in coefficient ranges after quantizing of –2,048 to 2,047.

Due to spatial and SNR scalability, non-intra blocks (blocks within a non-intra macroblock) are also possible. Non-intra block coefficients represent differences between pixel values rather than actual pixel values. They are obtained by subtracting the motion-compensated values from the previous picture from the values in the current macroblock.

Quantizing

The 8 × 8 blocks of frequency coefficients are quantized. The quantizer step scale is derived from the quantization matrix and the quantizer scale and may be different for different coefficients and may change between macroblocks.

Since the eye is sensitive to large luma areas, the quantizer step size of the DC coefficients is selectable to 8, 9, 10, or 11 bits of precision. The DC quantized coefficient is determined by dividing the DC coefficient by 8, 4, 2, or 1 and rounding to the nearest integer.

AC coefficients are quantized using two quantization matrices: one for intra macroblocks and one for non-intra macroblocks. When using 4:2:2 or 4:4:4 data, different matrices are used for Y and CbCr data. Each quantization matrix has a default set of values that may be overwritten.

If the QUANT column in Table 11.10 has a "1," the quantizer scale is transmitted. Otherwise, the DCT correction is coded using the previous value for quantizer scale.

Coding of Quantized DC Coefficients

After the DC coefficients have been quantized, they are losslessly coded.

Coding of luma blocks within a macroblock follows the order shown in Figures 11.6 through 11.8. The DC value of block 4 is the DC predictor for block 1 of the next macroblock. At the beginning of each slice, whenever a macroblock is skipped, or whenever a non-intra macroblock is encoded, the DC predictor is set to 128 (if 8 bits of DC precision), 256 (if 9 bits of DC precision), 512 (if 10 bits of DC precision), or 1,024 (if 11 bits of DC precision).

The DC values of each Cb and Cr block are coded using the DC value of the corresponding block of the previous macroblock as a predictor. At the beginning of each slice, whenever a macroblock is skipped, or whenever a non-intra block is encoded, the DC predictors are set to 128 (if 8 bits of DC precision), 256 (if 9 bits of DC precision), 512 (if 10 bits of DC precision), or 1,024 (if 11 bits of DC precision).

The DCT DC differential values are organized by their absolute value as shown in Table 11.12. The DCT DC size, which defines the number of additional bits to define the level uniquely, is transmitted by a VLC, and is differ-

CBP	Code			CBP	Code		
60	111			62	0100	0	
4	1101			24	0011	11	
8	1100			36	0011	10	
16	1011			3	0011	01	
32	1010			63	0011	00	
12	1001	1		5	0010	111	
48	1001	0		9	0010	110	
20	1000	1		17	0010	101	
40	1000	0		33	0010	100	
28	0111	1		6	0010	011	
44	0111	0		10	0010	010	
52	0110	1		18	0010	001	
56	0110	0		34	0010	000	
1	0101	1		7	0001	1111	
61	0101	0		11	0001	1110	
2	0100	1		19	0001	1101	
35	0001	1100		38	0000	1100	
13	0001	1011		29	0000	1011	
49	0001	1010		45	0000	1010	
21	0001	1001		53	0000	1001	
41	0001	1000		57	0000	1000	
14	0001	0111		30	0000	0111	
50	0001	0110		46	0000	0110	
22	0001	0101		54	0000	0101	
42	0001	0100		58	0000	0100	
15	0001	0011		31	0000	0011	1
51	0001	0010		47	0000	0011	0
23	0001	0001		55	0000	0010	1
43	0001	0000		59	0000	0010	0
25	0000	1111		27	0000	0001	1
37	0000	1110		39	0000	0001	0
26	0000	1101		0*	0000	0000	1

*Not to be used with 4:2:0 chrominance structure.

Table 11.11. MPEG 2 VLC Table for CBP.
These are the same as for MPEG 1.

DCT DC Differential	DCT DC Size	Code (Y)	Code (CbCr)	Additional Code
−2048 to −1024	11	111111111	1111111111	00000000000 to 01111111111
−1023 to −512	10	111111110	1111111110	0000000000 to 0111111111
−511 to −256	9	11111110	111111110	000000000 to 011111111
−255 to −128	8	1111110	11111110	00000000 to 01111111
−127 to −64	7	111110	1111110	0000000 to 0111111
−63 to −32	6	11110	111110	000000 to 011111
−31 to −16	5	1110	11110	00000 to 01111
−15 to −8	4	110	1110	0000 to 0111
−7 to −4	3	101	110	000 to 011
−3 to −2	2	01	10	00 to 01
−1	1	00	01	0
0	0	100	00	
1	1	00	01	1
2 to 3	2	01	10	10 to 11
4 to 7	3	101	110	100 to 111
8 to 15	4	110	1110	1000 to 1111
16 to 31	5	1110	11110	10000 to 11111
32 to 63	6	11110	111110	100000 to 111111
64 to 127	7	111110	1111110	1000000 to 1111111
128 to 255	8	1111110	11111110	10000000 to 11111111
256 to 511	9	11111110	111111110	100000000 to 111111111
512 to 1023	10	111111110	1111111110	1000000000 to 1111111111
1024 to 2047	11	111111111	1111111111	10000000000 to 11111111111

Table 11.12. MPEG 2 VLC Table for DCT DC Differential, DCT DC Size, and Additional Code.

ent for Y and CbCr since the statistics are different. For example, a size of 4 is followed by 4 additional bits.

Coding of Quantized AC Coefficients

After the AC coefficients have been quantized, they are scanned in the zig-zag order shown in Figure 11.11 or Figure 11.12 and coded using run length and level. The scan starts in position 1, as shown in Figures 11.11 and 11.12, since the DC coefficient in position 0 is coded separately.

The run lengths and levels are coded as shown in Table 11.13 or Table 11.14. The "s" bit denotes the sign of the level: 0 is positive and 1 is negative. For intra blocks, either Table 11.13 or Table 11.14 may be used, as specified by the intra_vlc_format flag in the bitstream. For non-intra blocks, only Table 11.13 is used.

For run-level combinations not shown in Tables 11.13 and 11.14, an escape sequence is used, consisting of the escape code, followed by the run-length from Table 11.15 and the level from Table 11.16.

After the last DCT coefficient has been coded, an EOB code ("10") is added to tell the decoder there are no more coefficients in this 8×8 block.

P Picture Coding

Macroblocks

There are 26 types of macroblocks in P pictures, as shown in Table 11.17, due to the additional complexity of motion compensation. Depending on the macroblock type, the following parameters in the video bitstream are set to the values indicated in Table 11.17.

 macroblock_quant
 macroblock_motion_forward
 macroblock_motion_backward
 macroblock_pattern

 macroblock_intra
 spatial_temporal_weight_code_flag

The corresponding variable-length code also is used to specify the macroblock type.

Skipped macroblocks are present when the macroblock_address_increment parameter in the bitstream is greater than 1. For P field pictures, the decoder predicts from the field of the same parity as the field being predicted, motion vector predictors are set to 0, and the motion vector is set to 0. For P frame pictures, the decoder sets the motion vector predictors to 0, and the motion vector is set to 0.

If the QUANT column in Table 11.17 has a "1," the quantizer scale is transmitted. Otherwise, the DCT correction is coded using the previous value for quantizer scale.

If the Motion Forward column in Table 11.17 has a "1," horizontal and vertical forward motion vectors are successively transmitted.

If the Pattern column in Table 11.17 has a "1," the 6-bit coded block pattern (CBP) is transmitted as a VLC. This tells the decoder which of the six blocks in the 4:2:0 macroblock are coded ("1") and which are not coded ("0"). Table 11.11 lists the variable-length codes assigned to the 63 possible combinations. No code exists for when none of the blocks are coded; this is indicated by the macroblock type. For 4:2:2 and 4:4:4 macroblocks, an additional 2 or 6 bits, respectively, are used to extend coded block pattern.

DCT

Input values are –255 to 255, resulting in coefficient ranges after quantizing of –2,048 to 2,047.

Intra-block (blocks within an intra macroblock) AC coefficients are transformed in the same manner as they are for I pictures. Intra-block DC coefficients are transformed differently; the predicted values are set to 1,024, unless the previous block was intra coded.

Run	Level	Code			
EOB		10			
0	1	1s	if first coefficient		
0	1	11s	not first coefficient		
0	2	0100	s		
0	3	0010	1s		
0	4	0000	110s		
0	5	0010	0110	s	
0	6	0010	0001	s	
0	7	0000	0010	10s	
0	8	0000	0001	1101	s
0	9	0000	0001	1000	s
0	10	0000	0001	0011	s
0	11	0000	0001	0000	s
0	12	0000	0000	1101	0s
0	13	0000	0000	1100	1s
0	14	0000	0000	1100	0s
0	15	0000	0000	1011	1s
0	16	0000	0000	0111	11s
0	17	0000	0000	0111	10s
0	18	0000	0000	0111	01s
0	19	0000	0000	0111	00s
0	20	0000	0000	0110	11s
0	21	0000	0000	0110	10s
0	22	0000	0000	0110	01s
0	23	0000	0000	0110	00s
0	24	0000	0000	0101	11s
0	25	0000	0000	0101	10s
0	26	0000	0000	0101	01s
0	27	0000	0000	0101	00s
0	28	0000	0000	0100	11s
0	29	0000	0000	0100	10s
0	30	0000	0000	0100	01s

Table 11.13a. MPEG 2 VLC Table Zero for Quantized DCT AC Coefficients. These are the same as for MPEG 1.

Run	Level	Code			
0	31	0000	0000	0100	00s
0	32	0000	0000	0011	000s
0	33	0000	0000	0010	111s
0	34	0000	0000	0010	110s
0	35	0000	0000	0010	101s
0	36	0000	0000	0010	100s
0	37	0000	0000	0010	011s
0	38	0000	0000	0010	010s
0	39	0000	0000	0010	001s
0	40	0000	0000	0010	000s
1	1	011s			
1	2	0001	10s		
1	3	0010	0101	s	
1	4	0000	0011	00s	
1	5	0000	0001	1011	s
1	6	0000	0000	1011	0s
1	7	0000	0000	1010	1s
1	8	0000	0000	0011	111s
1	9	0000	0000	0011	110s
1	10	0000	0000	0011	101s
1	11	0000	0000	0011	100s
1	12	0000	0000	0011	011s
1	13	0000	0000	0011	010s
1	14	0000	0000	0011	001s
1	15	0000	0000	0001	0011s
1	16	0000	0000	0001	0010s
1	17	0000	0000	0001	0001s
1	18	0000	0000	0001	000s
2	1	0101	s		
2	2	0000	100s		
2	3	0000	0010	11s	
2	4	0000	0001	0100	s

Table 11.13b. MPEG 2 VLC Table Zero for Quantized DCT AC Coefficients. These are the same as for MPEG 1.

Run	Level	Code			
2	5	0000	0000	1010	0s
3	1	0011	1s		
3	2	0010	0100	s	
3	3	0000	0001	1100	s
3	4	0000	0000	1001	1s
4	1	0011	0s		
4	2	0000	0011	11s	
4	3	0000	0001	0010	s
5	1	0001	11s		
5	2	0000	0010	01s	
5	3	0000	0000	1001	0s
6	1	0001	01s		
6	2	0000	0001	1110	s
6	3	0000	0000	0001	0100s
7	1	0001	00s		
7	2	0000	0001	0101	s
8	1	0000	111s		
8	2	0000	0001	0001	s
9	1	0000	101s		
9	2	0000	0000	1000	1s
10	1	0010	0111	s	
10	2	0000	0000	1000	0s
11	1	0010	0011	s	
11	2	0000	0000	0001	1010s
12	1	0010	0010	s	
12	2	0000	0000	0001	1001s
13	1	0010	0000	s	
13	2	0000	0000	0001	1000s
14	1	0000	0011	10s	
14	2	0000	0000	0001	0111s
15	1	0000	0011	01s	
15	2	0000	0000	0001	0110s

**Table 11.13c. MPEG 2 VLC Table Zero for Quantized DCT AC Coefficients.
These are the same as for MPEG 1.**

Run	Level	Code			
16	1	0000	0010	00s	
16	2	0000	0000	0001	0101s
17	1	0000	0001	1111	s
18	1	0000	0001	1010	s
19	1	0000	0001	1001	s
20	1	0000	0001	0111	s
21	1	0000	0001	0110	s
22	1	0000	0000	1111	1s
23	1	0000	0000	1111	0s
24	1	0000	0000	1110	1s
25	1	0000	0000	1110	0s
26	1	0000	0000	1101	1s
27	1	0000	0000	0001	1111s
28	1	0000	0000	0001	1110s
29	1	0000	0000	0001	1101s
30	1	0000	0000	0001	1100s
31	1	0000	0000	0001	1011s
ESC		0000	01		

**Table 11.13d. MPEG 2 VLC Table Zero for Quantized DCT AC Coefficients.
These are the same as for MPEG 1.**

Run	Level	Code			
EOB		0110			
0	1	10s			
0	2	110s			
0	3	0111	s		
0	4	1110	0s		
0	5	1110	1s		
0	6	0001	01s		
0	7	0001	00s		
0	8	1111	011s		
0	9	1111	100s		
0	10	0010	0011	s	
0	11	0010	0010	s	
0	12	1111	1010	s	
0	13	1111	1011	s	
0	14	1111	1110	s	

Table 11.14a. MPEG 2 VLC Table One for Quantized DCT AC Coefficients.

Run	Level	Code			
0	15	1111	1111	s	
0	16	0000	0000	0111	11s
0	17	0000	0000	0111	10s
0	18	0000	0000	0111	01s
0	19	0000	0000	0111	00s
0	20	0000	0000	0110	11s
0	21	0000	0000	0110	10s
0	22	0000	0000	0110	01s
0	23	0000	0000	0110	00s
0	24	0000	0000	0101	11s
0	25	0000	0000	0101	10s
0	26	0000	0000	0101	01s
0	27	0000	0000	0101	00s
0	28	0000	0000	0100	11s
0	29	0000	0000	0100	10s
0	30	0000	0000	0100	01s
0	31	0000	0000	0100	00s
0	32	0000	0000	0011	000s
0	33	0000	0000	0010	111s
0	34	0000	0000	0010	110s
0	35	0000	0000	0010	101s
0	36	0000	0000	0010	100s
0	37	0000	0000	0010	011s
0	38	0000	0000	0010	010s
0	39	0000	0000	0010	001s
0	40	0000	0000	0010	000s
1	1	010s			
1	2	0011	0s		
1	3	1111	001s		
1	4	0010	0111	s	
1	5	0010	0000	s	
1	6	0000	0000	1011	0s

Table 11.14b. MPEG 2 VLC Table One for Quantized DCT AC Coefficients.

Run	Level	Code			
1	7	0000	0000	1010	1s
1	8	0000	0000	0011	111s
1	9	0000	0000	0011	110s
1	10	0000	0000	0011	101s
1	11	0000	0000	0011	100s
1	12	0000	0000	0011	011s
1	13	0000	0000	0011	010s
1	14	0000	0000	0011	001s
1	15	0000	0000	0001	0011s
1	16	0000	0000	0001	0010s
1	17	0000	0000	0001	0001s
1	18	0000	0000	0001	0000s
2	1	0010	1s		
2	2	0000	111s		
2	3	1111	1100	s	
2	4	0000	0011	00s	
2	5	0000	0000	1010	0s
3	1	0011	1s		
3	2	0010	0110	s	
3	3	0000	0001	1100	s
3	4	0000	0000	1001	1s
4	1	0001	10s		
4	2	1111	1101	s	
4	3	0000	0001	0010	s
5	1	0001	11s		
5	2	0000	0010	0s	
5	3	0000	0000	1001	0s
6	1	0000	110s		
6	2	0000	0001	1110	s
6	3	0000	0000	0001	0100s
7	1	0000	100s		
7	2	0000	0001	0101	s

Table 11.14c. MPEG 2 VLC Table One for Quantized DCT AC Coefficients.

Run	Level	Code			
8	1	0000	101s		
8	2	0000	0001	0001	s
9	1	1111	000s		
9	2	0000	0000	1000	1s
10	1	1111	010s		
10	2	0000	0000	1000	0s
11	1	0010	0001	s	
11	2	0000	0000	0001	1010s
12	1	0010	0101	s	
12	2	0000	0000	0001	1001s
13	1	0010	0100	s	
13	2	0000	0000	0001	1000s
14	1	0000	0010	1s	
14	2	0000	0000	0001	0111s
15	1	0000	0011	1s	
15	2	0000	0000	0001	0110s
16	1	0000	0011	01s	
16	2	0000	0000	0001	0101s
17	1	0000	0001	1111	s
18	1	0000	0001	1010	s
19	1	0000	0001	1001	s
20	1	0000	0001	0111	s
21	1	0000	0001	0110	s
22	1	0000	0000	1111	1s
23	1	0000	0000	1111	0s
24	1	0000	0000	1110	1s
25	1	0000	0000	1110	0s
26	1	0000	0000	1101	1s
27	1	0000	0000	0001	1111s
28	1	0000	0000	0001	1110s
29	1	0000	0000	0001	1101s
30	1	0000	0000	0001	1100s
31	1	0000	0000	0001	1011s
ESC		0000	01		

Table 11.14d. MPEG 2 VLC Table One for Quantized DCT AC Coefficients.

Run Length	Code	
0	0000	00
1	0000	01
2	0000	10
:	:	:
62	1111	10
63	1111	11

**Table 11.15. MPEG 2 VLC Table for ESC Codes.
These are the same as for MPEG 1.**

Level	Code		
–2047	1000	0000	0001
–2046	1000	0000	0010
:			
–1	1111	1111	1111
forbidden	1000	0000	0000
1	0000	0000	0001
:			
2047	0111	1111	1111

Table 11.16. MPEG 2 VLC Table for ESC Codes.

Type	MB QUANT	MB Motion Forward	MB Motion Backward	MB Pattern	MB Intra	Spatial Temporal Weight Code Flag	Permitted Spatial Temporal Weight Class	Code
MC, coded	0	1	0	1	0	0	0	1
no MC, coded	0	0	0	1	0	0	0	01
MC, not coded	0	1	0	0	0	0	0	001
intra	0	0	0	0	1	0	0	0001 1
MC, coded, quant	1	1	0	1	0	0	0	0001 0
no MC, coded, quant	1	0	0	1	0	0	0	0000 1
intra, quant	1	0	0	0	1	0	0	0000 01
P Pictures with SNR Scalability								
coded	0	0	0	1	0	0	0	1
coded, quant	1	0	0	1	0	0	0	01
not coded	0	0	0	0	0	0	0	001

Table 11.17a. MPEG 2 VLC Table for P Picture Macroblock Type VLC.

Type	MB QUANT	MB Motion Forward	MB Motion Backward	MB Pattern	MB Intra	Spatial Temporal Weight Code Flag	Permitted Spatial Temporal Weight Class	Code
P Pictures with Spatial Scalability								
MC, coded	0	1	0	1	0	0	0	10
MC, coded, compatible	0	1	0	1	0	1	1, 2, 3	011
no MC, coded	0	0	0	1	0	0	0	0000 100
no MC, coded, compatible	0	0	0	1	0	1	1, 2, 3	0001 11
MC, not coded	0	1	0	0	0	0	0	0010
intra	0	0	0	0	1	0	0	0000 111
MC, not coded, compatible	0	1	0	0	0	1	1, 2, 3	0011
MC, coded, quant	1	1	0	1	0	0	0	010
No MC, coded, quant	1	0	0	1	0	0	0	0001 00
intra, quant	1	0	0	0	1	0	0	0000 110
MC, coded, compatible, quant	1	1	0	1	0	1	1, 2, 3	11
no MC, coded, compatible, quant	1	0	0	1	0	1	1, 2, 3	0001 01
no MC, not coded, compatible	0	0	0	0	0	1	1, 2, 3	0001 10
coded, compatible	0	0	0	1	0	0	4	0000 101
coded, compatible, quant	1	0	0	1	0	0	4	0000 010
not coded, compatible	0	0	0	0	0	0	4	0000 0011

Table 11.17b. MPEG 2 VLC Table for P Picture Macroblock Type.

Non-intra block (a block within a non-intra macroblock) coefficients represent differences between pixel values rather than actual pixel values. They are obtained by subtracting the motion-compensated values from the previous picture (reference macroblock) from the values in the current macroblock. There is no prediction of the DC value.

Quantizing

Intra blocks are quantized in the same manner as they are for intra blocks in I pictures.

Non-intra blocks are quantized using the quantizer scale and the non-intra quantization matrix. The AC and DC coefficients are quantized in the same manner.

Coding of Intra Blocks

Intra blocks are coded the same way as I picture intra blocks. There is a difference in the handling of the DC coefficients in that the predicted value is 128, unless the previous block was intra coded.

Coding of Non-Intra Blocks

The coded block pattern (CBP) is used to specify which blocks have coefficient data. These are coded similarly to the coding of intra blocks, except the AC and DC coefficients are coded in the same manner.

B Picture Coding

Macroblocks

There are 34 types of macroblocks in B pictures, as shown in Table 11.18, due to the additional complexity of backward motion compensation. Depending on the macroblock type, the following parameters in the video bitstream are set to the values indicated in Table 11.18.

macroblock_quant
macroblock_motion_forward
macroblock_motion_backward

macroblock_pattern
macroblock_intra
spatial_temporal_weight_code_flag

The corresponding variable-length code is also used to specify the macroblock type.

Skipped macroblocks are present when the macroblock_address_increment parameter in the bitstream is greater than 1. For B field pictures, the decoder predicts from the field of the same parity as the field being predicted. The direction of prediction (forward, backward, or bidirectional) is the same as the previous macroblock, motion vector predictors are unaffected, and the motion vectors are taken from the appropriate motion vector predictors. For B frame pictures, the direction of prediction (forward, backward, or bidirectional) is the same as the previous macroblock, motion vector predictors are unaffected, and the motion vectors are taken from the appropriate motion vector predictors.

If the QUANT column in Table 11.18 has a "1," the quantizer scale is transmitted. Otherwise, the DCT correction is coded using the previous value for quantizer scale.

If the Motion Forward column in Table 11.18 has a "1," horizontal and vertical forward motion vectors are successively transmitted. If the Motion Backward column in Table 11.18 has a "1," horizontal and vertical backward motion vectors are successively transmitted. If both forward and backward motion types are present, the vectors are transmitted in this order:

horizontal forward
vertical forward
horizontal backward
vertical backward

If the Pattern column in Table 11.18 has a "1," the 6-bit coded block pattern is transmitted as a VLC. This tells the decoder which of the

Type	MB QUANT	MB Motion Forward	MB Motion Backward	MB Pattern	MB Intra	Spatial Temporal Weight Code Flag	Permitted Spatial Temporal Weight Class	Code
interp, not coded	0	1	1	0	0	0	0	10
interp, coded	0	1	1	1	0	0	0	11
bwd, not coded	0	0	1	0	0	0	0	010
bwd, coded	0	0	1	1	0	0	0	011
fwd, not coded	0	1	0	0	0	0	0	0010
fwd, coded	0	1	0	1	0	0	0	0011
intra	0	0	0	0	1	0	0	0001 1
intra, coded, quant	1	1	1	1	0	0	0	0001 0
fwd, coded, quant	1	1	0	1	0	0	0	0000 11
bwd, coded, quant	1	0	1	1	0	0	0	0000 10
intra, quant	1	0	0	0	1	0	0	0000 01

Table 11.18a. MPEG 2 VLC Table for B Picture Macroblock Type.

Type	MB QUANT	MB Motion Forward	MB Motion Backward	MB Pattern	MB Intra	Spatial Temporal Weight Code Flag	Permitted Spatial Temporal Weight Class	Code
B Pictures with Spatial Scalability								
interp, not coded	0	1	1	0	0	0	0	10
interp, coded	0	1	1	1	0	0	0	11
bwd, not coded	0	0	1	0	0	0	0	010
bwd, coded	0	0	1	1	0	0	0	011
fwd, not coded	0	1	0	0	0	0	0	0010
fwd, coded	0	1	0	1	0	0	0	0011
bwd, not coded, compatible	0	0	1	0	0	1	1, 2, 3	0001 10
bwd, coded, compatible	0	0	1	1	0	1	1, 2, 3	0001 11
fwd, not coded, compatible	0	1	0	0	0	1	1, 2, 3	0001 00
fwd, coded, compatible	0	1	0	1	0	1	1, 2, 3	0001 01
intra	0	0	0	0	1	0	0	0000 110

Table 11.18b. MPEG 2 VLC Table for B Picture Macroblock Type.

Type	MB QUANT	MB Motion Forward	MB Motion Backward	MB Pattern	MB Intra	Spatial Temporal WeightCode Flag	Permitted Spatial Temporal Weight Class	Code
B Pictures with Spatial Scalability (continued)								
interp, coded, quant	1	1	1	1	0	0	0	0000 111
fwd, coded, quant	1	1	0	1	0	0	0	0000 100
bwd, coded, quant	1	0	1	1	0	0	0	0000 101
intra, quant	1	0	0	0	1	0	0	0000 0100
fwd, coded, compatible, quant	1	1	0	1	0	1	1, 2, 3	0000 0101
bwd, coded, compatible, quant	1	0	1	1	0	1	1, 2, 3	0000 0110 0
not coded, compatible	0	0	0	0	0	0	4	0000 0111 0

Table 11.18c. MPEG 2 VLC Table for B Picture Macroblock Type.

Type	MB QUANT	MB Motion Forward	MB Motion Backward	MB Pattern	MB Intra	Spatial Temporal Weight Code Flag	Permitted Spatial Temporal Weight Class	Code
B Pictures with Spatial Scalability (continued)								
coded, quant, compatible	1	0	0	1	0	0	4	0000 0110 1
coded, compatible	0	0	0	1	0	0	4	0000 0111 1
B Pictures with SNR Scalability								
coded	0	0	0	1	0	0	0	1
coded, quant	1	0	0	1	0	0	0	01
not coded	0	0	0	0	0	0	0	001

Table 11.18d. MPEG 2 VLC Table for B Picture Macroblock Type.

six blocks in the macroblock are coded ("1") and which are not coded ("0"). Table 11.11 lists the variable-length codes assigned to the 63 possible combinations. There is no code for when none of the blocks are coded; this is indicated by the macroblock type. For 4:2:2 and 4:4:4 macroblocks, an additional 2 or 6 bits respectively, are used to extend coded block pattern.

Coding

DCT coefficients and blocks are encoded similarly to P frames, except both past and future frames can be used as references for motion vectors.

Video Bitstream Generation

Figure 11.13 illustrates a block diagram of a typical MPEG 2 video encoder that supports main profile, main level. Figures 11.14 through 11.30 illustrate the syntax of the coded video bitstream.

Several extensions may be used to support various levels of capability. These extensions are:

sequence_extension
sequence_display_extension
quant_matrix_extension
sequence_scalable_extension
picture_display_extension
picture_coding_extension
picture_spatial_scalable_extension
picture_temporal_scalable_extension

If the first sequence header of a video sequence is not followed by an extension start code (000001B5$_H$), then the video bitstream must conform to the MPEG 1 video bitstream.

For MPEG 2 video bitstreams, an extension start code (000001B5$_H$) and a sequence extension must follow each sequence header.

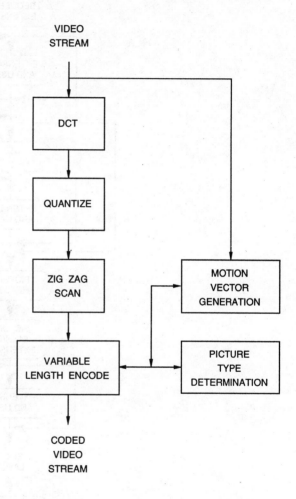

Figure 11.13. Simplified MPEG 2 Video Encoding Block Diagram.

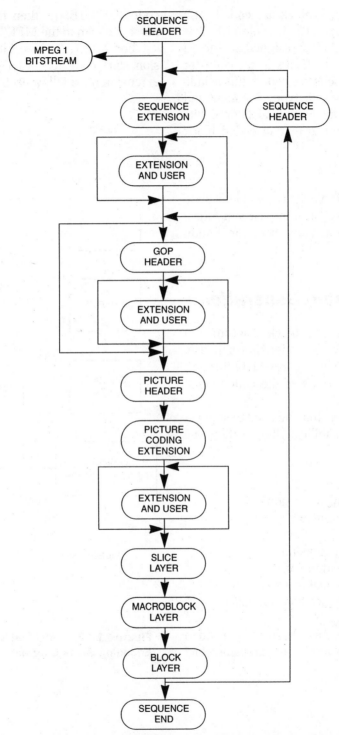

Figure 11.14. General MPEG 2 Video Bitstream Organization.

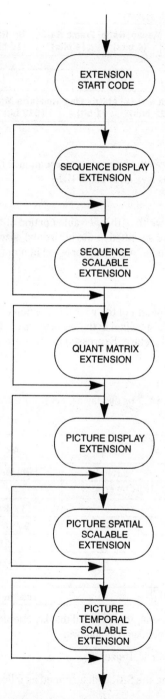

Figure 11.15. General MPEG 2 Video Bitstream Extension Data Organization.

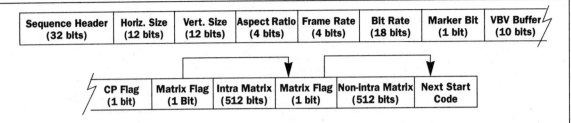

Sequence_header_code (32 bits)

This has a value of 000001B3$_H$ and indicates the beginning of a sequence header. The sequence_end_code, which terminates the video sequence, has a value of 000001B7$_H$.

Horizontal_size_value (12 bits)

This is the 12 least significant bits of the width of the viewable portion of the luma component. The two most significant bits of the 14-bit value are specified in the horizontal_size_extension. The left part of the viewable picture is left-aligned in the encoded picture. Expressed in units of pixels. A value of zero is not allowed.

Vertical_size_value (12 bits)

This is the 12 least significant bits of the height of the viewable portion of the luma component. The two most significant bits of the 14-bit value are specified in the vertical_size_extension. The top part of the viewable picture is top-aligned in the encoded picture. Expressed in units of scan lines. A value of zero is not allowed.

Aspect_ratio_information (4 bits)

Indicates either the sample aspect ratio (SAR) or display aspect ratio (DAR):

Aspect Ratio	SAR	DAR
0000	forbidden	forbidden
0001	1.0000	–
0010	–	3 / 4
0011	–	9 / 16
0100	–	1 / 2.21
0101	–	reserved
⋮	⋮	⋮
1111	–	reserved

If sequence_display_extension is not present, the decoded display should be mapped to the entire active portion of the display. The SAR then is calculated as follows:

$$SAR = DAR\ (horizontal_size\ /\ vertical_size)$$

If sequence_display_extension is present, the SAR is determined as follows:

$$SAR = DAR\ (display_horizontal_size\ /\ display_vertical_size)$$

Figure 11.16a. MPEG 2 Video Bitstream Sequence Header Definition.

Frame_rate_code (4 bits)
Indicates the frame rate:

Frame Rate	Frames Per Second
0000	forbidden
0001	23.976
0010	24
0011	25
0100	29.97
0101	30
0110	50
0111	59.94
1000	60
1001	reserved
:	:
1111	reserved

The actual frame rate is determined as follows:

frame_rate = frame_rate_value * (frame_rate_extension_n + 1) + (frame_rate_extension_d + 1)

When an entry is specified in the above table, frame_rate_extension_n and frame_rate_extension_d are 0. If progressive_sequence is "1," the time between two frames at the output of the decoder is the reciprocal of the frame_rate. If progressive_sequence is "0," the time between two frames at the output of the decoder is half of the reciprocal of the frame_rate.

Bit_rate_value (18 bits)
The 18 least significant bits of a 30-bit value. The 12 most significant bits are in the bit_rate_extension. This specifies the bitstream bit rate, measured in units of 400 bps, rounded upwards. A "0" value is not allowed. A value of $FFFF_H$ for the vbv_delay parameter indicates variable bit rate operation.

Marker_bit (1 bit)
Always a "1."

Vbv_buffer_size_value (10 bits)
The 10 least significant bits of a 18-bit value. The 8 most significant bits are in the vbv_buffer_size_extension. Defines the size of the Video Buffering Verifier needed to decode the sequence. It is defined as:

$$B = 16 * 1024 * vbv_buffer_size$$

Constrained_parameters_flag (1 bit)
This bit is set to a "0" since it has no meaning for MPEG 2.

Figure 11.16b. MPEG 2 Video Bitstream Sequence Header Definition.

Load_intra_quantizer_matrix (1 bit)

This bit is set to a "1" if an intra_quantizer_matrix follows. If set to a "0," the default values below are used for intra blocks (both Y and CbCr) until the next occurrence of a sequence header or quant_matrix_extension.

8	16	19	22	26	27	29	34
16	16	22	24	27	29	34	37
19	22	26	27	29	34	34	38
22	22	26	27	29	34	37	40
22	26	27	29	32	35	40	48
26	27	29	32	35	40	48	58
26	27	29	34	38	46	56	69
27	29	35	38	46	56	69	83

Intra_quantizer_matrix (64 * 8 bits)

An optional list of sixty-four 8-bit values that replace the default values shown above. A value of "0" is not allowed. The value for intra_quant [0,0] is always 8. These values take effect until the next occurrence of a sequence header or quant_matrix_extension. The order follows that shown in Figure 11.11. For 4:2:2 and 4:4:4 data formats, the new values are used for both the Y and CbCr intra matrix, unless a different CbCr intra matrix is loaded.

Load_non_intra_quantizer_matrix (1 bit)

This bit is set to a "1" if a non_intra_quantizer_matrix follows. If set to a "0," the default values below are used for non-intra blocks (both Y and CbCr) until the next occurrence of a sequence header or quant_matrix_extension.

16	16	16	16	16	16	16	16
16	16	16	16	16	16	16	16
16	16	16	16	16	16	16	16
16	16	16	16	16	16	16	16
16	16	16	16	16	16	16	16
16	16	16	16	16	16	16	16
16	16	16	16	16	16	16	16
16	16	16	16	16	16	16	16

Non_intra_quantizer_matrix (64 * 8 bits)

An optional list of sixty-four 8-bit values that replace the default values shown above. A value of "0" is not allowed. These values take effect until the next occurrence of a sequence header or quant_matrix_extension. The order follows that shown in Figure 11.11. For 4:2:2 and 4:4:4 data formats, the new values are used for both Y and CbCr non-intra matrix, unless a different CbCr non-intra matrix is loaded.

Figure 11.16c. MPEG 2 Video Bitstream Sequence Header Definition.

User_data_start_code (32 bits)
This optional bit string of $000001B2_H$ indicates the beginning of user data. User data continues until the detection of another start code.

User_data (n * 8 bits)
Present only if a user_data_start_code is present. User data shall not contain a string of 23 or more zero bits.

Figure 11.17. MPEG 2 Video Bitstream User Data Definition.

Ext. Start Code (32 bits)	Ext. ID (4 bits)	Profile Level (8 bits)	Progressive Sequence (1 bit)	Chroma Format (2 bits)	Horizontal Size Ext. (2 bits)	Vertical Size Ext. (2 bits)	Bit Rate Ext. (12 bits)	Marker Bit (1 bit)

VBV Size (8 bits)	Low Delay (1 bit)	Frame Rate Ext. N (2 bits)	Frame Rate Ext. D (5 bits)	Next Start Code

Extension_start_code (32 bits)

This bit string of $000001B5_H$ indicates the beginning of extension data beyond MPEG 1.

Extension_start_code_ID (4 bits)

This has a value of 0001 and indicates the beginning of a sequence extension. For MPEG 2 video bitstreams, a sequence extension must follow each sequence header.

Profile_and_level_indication (8 bits)

This specifies the profile and level:

> Bit 7: escape bit
> Bits 6–4: profile ID
> Bits 3–0: level ID

Profile ID	Profile	Level ID	Level
000	reserved	0000	reserved
001	high	:	:
010	spatial scalable	0011	reserved
011	SNR scalable	0100	high
100	main	0101	reserved
101	simple	0110	high 1440
110	reserved	0111	reserved
111	reserved	1000	main
		1001	reserved
		1010	low
		1011	reserved
		:	:
		1111	reserved

Figure 11.18a. MPEG 2 Video Bitstream Sequence Extension Definition.

Progressive_sequence (1 bit)
> A "1" indicates only progressive frame pictures are present. A "0" indicates both frame and field pictures may be present, and frame pictures may be progressive or interlaced.

Chroma_format (2 bits)
> Indicates the CbCr format:

Chroma Format	Meaning
00	reserved
01	4:2:0
10	4:2:2
11	4:4:4

Horizontal_size_extension (2 bits)
> The two most significant bits of horizontal_size in Figure 11.16.

Vertical_size_extension (2 bits)
> The two most significant bits of vertical_size in Figure 11.16.

Bit_rate_extension (12 bits)
> The 12 most significant bits of bit_rate in Figure 11.16.

Marker_bit (1 bit)
> Always a "1."

vbv_buffer_size_extension (8 bits)
> The eight most significant bits of vbv_buffer_size in Figure 11.16.

Low_delay (1 bit)
> A "1" indicates that no B pictures are present so the frame reordering delay is not present during decoding. This flag is ignored by decoders.

Frame_rate_extension_n (2 bits)
> See Frame_rate_code in Figure 11.16.

Frame_rate_extension_d (5 bits)
> See Frame_rate_code in Figure 11.16.

Figure 11.18b. MPEG 2 Video Bitstream Sequence Extension Definition.

Ext. ID (4 bits)	Video Format (3 bits)	Color Description (1 bit)	Color Primaries (8 bits)	Transfer Characteristics (8 bits)	Matrix Coefficients (8 bits)	Display Horizontal (14 bits)	Marker Bit (1 bit)	Display Vertical (14 bits)	Next Start Code

Extension_start_code (32 bits)

This optional bit string of 000001B5$_H$ indicates the beginning of a new set of extension data. Extension data continues until the detection of another start code. It is present only if this is the first (or only) extension, as shown in Figure 11.15.

Extension_start_code_ID (4 bits)

This has a value of 0010 and indicates the beginning of a sequence display extension. Information provided by this extension does not affect the decoding process, and may be ignored. It allows the display of the decoded pictures to be as accurate as possible.

Video_format (3 bits)

Indicates the source of the pictures prior to encoding.

Video Format	Meaning
000	component
001	PAL
010	NTSC
011	SECAM
100	MAC
101	unspecified
110	reserved
111	reserved

Color_description (1 bit)

A "1" indicates that the color_primaries, transfer_characteristics, and matrix_coefficients parameters are present in the bitstream.

Figure 11.19a. MPEG 2 Video Bitstream Sequence Display Extension Definition.

Color_primaries (8 bits)

Describes the chromaticity coordinates of the source primaries. If sequence_display_extension is not present, or color_description = "0," assume a value of 0000 0001 for color_primaries.

Value	Primaries
0000 0000	forbidden
0000 0001	ITU-R BT.709
0000 0010	unspecified
0000 0011	reserved
0000 0100	ITU-R BT.624 system M
0000 0101	ITU-R BT.624 system B, G
0000 0110	SMPTE 170M
0000 0111	SMPTE 240M
0000 1000	reserved
:	:
1111 1111	reserved

Transfer_characteristics (8 bits)

Describes the optoelectronic transfer characteristic of the source picture. If sequence_display_extension is not present, or color_description = "0," assume a value of 0000 0001.

Value	Opto-Electronic Transfer Characteristics
0000 0000	forbidden
0000 0001	ITU-R BT.709
0000 0010	unspecified
0000 0011	reserved
0000 0100	ITU-R BT.624 system M
0000 0101	ITU-R BT.624 system B, G
0000 0110	SMPTE 170M
0000 0111	SMPTE 240M
0000 1000	linear
0000 1001	reserved
:	:
1111 1111	reserved

Figure 11.19b. MPEG 2 Video Bitstream Sequence Display Extension Definition.

Matrix_coefficients (8 bits)

Describes the matrix coefficients used in deriving YCbCr from R′G′B′. If sequence_display_extension is not present, or color_description = "0," assume a value of 0000 0001.

Value	Matrix
0000 0000	forbidden
0000 0001	ITU-R BT.709
0000 0010	unspecified
0000 0011	reserved
0000 0100	FCC
0000 0101	ITU-R BT.624 system B, G
0000 0110	SMPTE 170M
0000 0111	SMPTE 240M
0000 1000	reserved
:	:
1111 1111	reserved

Display_horizontal_size (14 bits)

See display_vertical_size below.

Marker_bit (1 bit)

Always a "1."

Display_vertical_size (14 bits)

Display_horizontal_size and display_vertical_size define the active region of the display. If the display region is smaller than the encoded picture size, only a portion of the picture will be displayed. If the display region is larger than the picture size, the picture will be displayed on a portion of the display.

Figure 11.19c. MPEG 2 Video Bitstream Sequence Display Extension Definition.

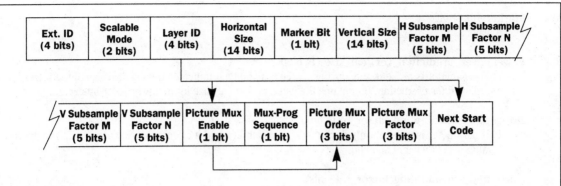

Extension_start_code (32 bits)

This optional bit string of 000001B5$_H$ indicates the beginning of a new set of extension data. Extension data continues until the detection of another start code. It is present only if this is the first (or only) extension, as shown in Figure 11.15.

Extension_start_code_ID (4 bits)

This has a value of 0101 and indicates the beginning of a sequence scalable extension. This extension specifies the scalability modes implemented for the video bitstream. If sequence_scalable_extension is not present in the bitstream, no scalability is used. The base layer of a scalable hierarchy does not have a sequence_scalable_extension, except in the case of data partitioning.

Scalable_mode (2 bits)

This indicates the scalability type of the video sequence.

Scalable Mode	Meaning
00	data partitioning
01	spatial scalability
10	SNR scalability
11	temporal scalability

Layer_ID (4 bits)

Identifies the layers in a scalable hierarchy. The base layer has an ID of 0000. During data partitioning, layer_ID 0000 is assigned to partition layer zero and layer_ID 0001 is assigned to partition layer one. If scalable_mode = "01," the following parameters are present.

Lower_layer_prediction_horizontal_size (14 bits)

This parameter is present only during spatial scalability. It indicates the horizontal size of the lower layer frame used for prediction. It contains the value in horizontal_size in the lower layer bitstream.

Figure 11.20a. MPEG 2 Video Bitstream Sequence Scalable Extension Definition.

Marker_bit (1 bit)

Always a "1."

Lower_layer_prediction_vertical_size (14 bits)

This parameter is present only during spatial scalability. It indicates the vertical size of the lower layer frame used for prediction. It contains the value in vertical_size in the lower layer bitstream.

Horizontal_subsampling_factor_m (5 bits)

This parameter is present only during spatial scalability, and it affects the spatial upsampling process. A value of 00000 is not allowed.

Horizontal_subsampling_factor_n (5 bits)

This parameter is present only during spatial scalability, and it affects the spatial upsampling process. A value of 00000 is not allowed.

Vertical_subsampling_factor_m (5 bits)

This parameter is present only during spatial scalability, and it affects the spatial upsampling process. A value of 00000 is not allowed.

Vertical_subsampling_factor_n (5 bits)

This parameter is present only during spatial scalability, and it affects the spatial upsampling process. A value of 00000 is not allowed.

If scalable_mode = "11," the following parameters are present:

Picture_mux_enable (1 bit)

This parameter is present only during temporal scalability. If set to a "1," the picture_mux_order and picture_mux_factor parameters are used for remultiplexing prior to display.

Mux_to_progressive_sequence (1 bit)

This parameter is present only during temporal scalability and when picture_mux_enable = "1." If set to a "1," it indicates the decoded pictures are to be temporally multiplexed to generate a progressive sequence for display. When temporal multiplexing is to generate an interlaced sequence, this flag is a "0."

Picture_mux_order (3 bits)

This parameter is present only during temporal scalability. Specifies the number of enhancement layer pictures prior to the first base layer picture. Used to assist the decoder in properly remultiplexing pictures prior to display.

Picture_mux_factor (3 bits)

This parameter is present only during temporal scalability. Denotes the number of enhancement layer pictures between consecutive base layer pictures. Used to assist the decoder in properly remultiplexing pictures prior to display.

Figure 11.20b. MPEG 2 Video Bitstream Sequence Scalable Extension Definition.

Start Code (32 bits)	Time Code (25 bits)	Closed GOP (1 bit)	Broken Link (1 bit)	Next Start Code

Group_start_code (32 bits)

This has a value of 000001B8$_H$ and indicates the beginning of a group of pictures.

Time_code (25 bits)

The drop_frame_flag may be set to "1" only if the picture rate is 29.97 Hz.

Time Code	Range of Value	Number of Bits
drop_frame_flag		1
time_code_hours	0–23	5
time_code_minutes	0–59	6
marker_bit	1	1
time_code_seconds	0–59	6
time_code_pictures	0–59	6

Closed_gop (1 bit)

This flag is a "1" if B pictures (if any) immediately following the first I picture of a GOP header are encoded using only backward prediction.

Broken_link (1 bit)

This flag is set to a "0" during encoding. This flag is set to a "1" if B pictures (if any) immediately following the first I picture of a GOP header may not be correctly decoded due to editing.

Figure 11.21. MPEG 2 Video Bitstream Group of Pictures Header Definition.

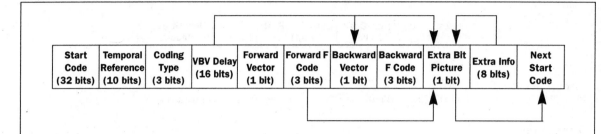

Picture_start_code (32 bits)

This has a value of 00000100$_H$.

Temporal_reference (10 bits)

For the first frame in display order, the temporal_reference value is zero. It is then incremented by one, modulo 1024, for each frame in the display order. When a frame is coded as two fields, the temporal reference of both fields is the same.

Picture_coding_type (3 bits)

These bits indicate the picture type (I picture, P picture, or B picture).

Picture Coding Type	Coding Method
000	forbidden
001	I picture
010	P picture
011	B picture
100	forbidden
101	reserved
110	reserved
111	reserved

Figure 11.22a. MPEG 2 Video Bitstream Picture Header Definition.

Vbv_delay (16 bits)

For constant bit rates, vbv_delay sets the initial occupancy of the decoding buffer at the start of decoding a picture so that it doesn't overflow or underflow. For variable bit rates, vbv_delay has a value of $FFFF_H$.

If picture_coding_type = "010" or "011," the following parameters are present:

Full_pel_forward_vector (1 bit)

Not used for MPEG 2, so has a value of "0."

Forward_f_code (3 bits)

Not used for MPEG 2, so has a value of "111."

If picture_coding_type = "011," the following parameters are present:

Full_pel_backward_vector (1 bit)

Not used for MPEG 2, so has a value of "0."

Backward_f_code (3 bits)

Not used for MPEG 2, so has a value of "111."

Extra_bit_picture (1 bit)

As long as this flag is set to a "1," extra_information_picture data follows. A value of "0" for this flag indicates no extra_information_picture data is available.

Extra_information_picture (8 bits)

Reserved. Present only if extra_bit_picture = "1."

Figure 11.22b. MPEG 2 Video Bitstream Picture Header Definition.

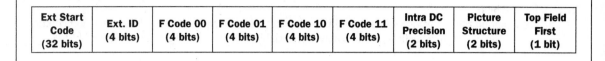

Ext Start Code (32 bits)	Ext. ID (4 bits)	F Code 00 (4 bits)	F Code 01 (4 bits)	F Code 10 (4 bits)	F Code 11 (4 bits)	Intra DC Precision (2 bits)	Picture Structure (2 bits)	Top Field First (1 bit)

Frame Pred (1 bit)	Conceal MV (1 bit)	Q Scale Type (1 bit)	Intra VLC Format (1 bit)	Alternate Scan (1 bit)	Repeat First Field (1 bit)	Chroma 420 (1 bit)	Progressive Frame (1 bit)

Composite Flag (1 bit)	V Axis (1 bit)	Field Sequence (3 bits)	Subcarrier (1 bit)	Burst Amplitude (7 bits)	Subcarrier Phase (8 bits)	Next Start Code

Extension_start_code (32 bits)

This bit string of $000001B5_H$ indicates the beginning of a new set of extension data.

Extension_start_code_ID (4 bits)

This has a value of 1000 and indicates the beginning of a picture coding extension.

f_code[0,0] (4 bits)

A 4-bit code, having a range of 0001–1001, that specifies the forward horizontal motion vector range. A value of 0000 is not allowed; a value of 1111 indicates this parameter is ignored.

f_code[0,1] (4 bits)

A 4-bit code, having a range of 0001–1001, that specifies the forward vertical motion vector range. A value of 0000 is not allowed; a value of 1111 indicates this parameter is ignored.

f_code[1,0] (4 bits)

A 4-bit code, having a range of 0001–1001, that specifies the backward horizontal motion vector range. A value of 0000 is not allowed; a value of 1111 indicates this parameter is ignored.

f_code[1,1] (4 bits)

A 4-bit code, having a range of 0001–1001, that specifies the backward vertical motion vector range. A value of 0000 is not allowed; a value of 1111 indicates this parameter is ignored.

Figure 11.23a. MPEG 2 Video Bitstream Picture Coding Extension Definition.

Intra_dc_precision (2 bits)

Intra DC Precision	Precision (Bits)
00	8
01	9
10	10
11	11

Picture_structure (2 bits)

Picture Structure	Meaning
00	reserved
01	top field
10	bottom field
11	frame picture

Top_field_first (1 bit)

Frame_pred_frame_dct (1 bit)
If a "1," only frame-DCT and frame prediction are used. For field pictures, it is always a "0." This parameter is a "1" if progressive_frame is "1."

Concealment_motion_vectors (1 bit)
If a "1," indicates motion vectors are coded for intra macroblocks.

Q_scale_type (1 bit)
Indicates which of two mappings between quantizer_scale_code and quantizer_scale are used by the decoder.

Intra_vlc_format (1 bit)
Indicates which table is to be used for decoding the DCT coefficients. Table 11.13 is used when intra_vlc_format = "0." Table 11.14 is used when intra_vlc_format = "1."

Alternate_scan (1 bit)
Indicates which zigzag scanning pattern is to be used by the decoder for transform coefficient data. "0" = Figure 11.11; "1" = Figure 11.12.

Repeat_first_field (1 bit)
This flag is applicable only to frame pictures; for field pictures it is set to "0."

Figure 11.23b. MPEG 2 Video Bitstream Picture Coding Extension Definition.

Chroma_420_type (1 bit)

If chroma_format is 4:2:0, this parameter is the same as progressive_frame. Otherwise, it is a "0."

Progressive_frame (1 bit)

If a "0," this indicates the two fields of the frame are interlaced fields, with a time interval between them. If a "1," the two fields of the frame are from the same instant in time.

Composite_display_flag (1 bit)

Indicates whether or not additional parameters follow.

V_axis (1 bit)

This flag is present only when composite_display_flag = "1." It is used when the original source was a PAL video signal. V_axis = "1" on a positive V sign, "0" otherwise.

Field_sequence (3 bits)

This parameter is present only when composite_display_flag = "1." It specifies the number of the field in the original four- or eight-field sequence.

Field Sequence	Frame	Field
000	1	1
001	1	2
010	2	3
011	2	4
100	3	5
101	3	6
110	4	7
111	4	8

Sub_carrier (1 bit)

This flag is present only when composite_display_flag = "1." A "0" indicates that the original sub-carrier-to-line frequency relationship was correct.

Burst_amplitude (7 bits)

This parameter is present only when composite_display_flag = "1." It specifies the original PAL or NTSC burst amplitude when quantized per ITU-R BT.601 (ignoring the MSB).

Sub_carrier_phase (8 bits)

This parameter is present only when composite_display_flag = "1." It specifies the original PAL or NTSC subcarrier phase as defined in ITU-R. BT.470. The value is defined as: $(360°/256) * n$, where n = subcarrier phase value.

Figure 11.23c. MPEG 2 Video Bitstream Picture Coding Extension Definition.

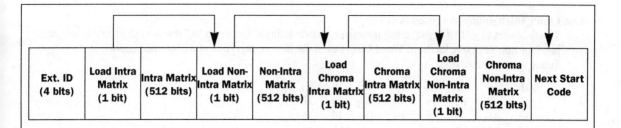

Ext. ID (4 bits)	Load Intra Matrix (1 bit)	Intra Matrix (512 bits)	Load Non-Intra Matrix (1 bit)	Non-Intra Matrix (512 bits)	Load Chroma Intra Matrix (1 bit)	Chroma Intra Matrix (512 bits)	Load Chroma Non-Intra Matrix (1 bit)	Chroma Non-Intra Matrix (512 bits)	Next Start Code

Extension_start_code (32 bits)

This optional bit string of 000001B5$_H$ indicates the beginning of a new set of extension data. Extension data continues until the detection of another start code. It is present only if this is the first (or only extension, as shown in Figure 11.15.

Extension_start_code_ID (4 bits)

This has a value of 0011 and indicates the beginning of a quant matrix extension. This extension allows quantizer matrices to be transmitted for the 4:2:2 and 4:4:4 chroma formats.

Load_intra_quantizer_matrix (1 bit)

This bit is set to a "1" if an intra_quantizer_matrix follows. If set to a "0," the default values below are used for intra blocks (both Y and CbCr) until the next occurrence of a sequence header or quant_matrix_extension.

8	16	19	22	26	27	29	34
16	16	22	24	27	29	34	37
19	22	26	27	29	34	34	38
22	22	26	27	29	34	37	40
22	26	27	29	32	35	40	48
26	27	29	32	35	40	48	58
26	27	29	34	38	46	56	69
27	29	35	38	46	56	69	83

Intra_quantizer_matrix (64 * 8 bits)

An optional list of sixty-four 8-bit values that replace the default values shown above. A value of "0" is not allowed. The value for intra_quant [0,0] is always 8. These values take effect until the next occurrence of a sequence header or quant_matrix_extension. The order follows that shown in Figure 11.11. For 4:2:2 and 4:4:4 data formats, the new values are used for both the Y and CbCr intra matrix, unless a different CbCr intra matrix is loaded.

Figure 11.24a. MPEG 2 Video Bitstream Quant Matrix Extension Definition.

Load_non_intra_quantizer_matrix (1 bit)

This bit is set to a "1" if a non_intra_quantizer_matrix follows. If set to a "0," the default values below are used for non-intra blocks (both Y and CbCr) until the next occurrence of a sequence header or quant_matrix_extension.

16	16	16	16	16	16	16	16
16	16	16	16	16	16	16	16
16	16	16	16	16	16	16	16
16	16	16	16	16	16	16	16
16	16	16	16	16	16	16	16
16	16	16	16	16	16	16	16
16	16	16	16	16	16	16	16
16	16	16	16	16	16	16	16

Non-intra_quantizer_matrix (64 * 8 bits)

An optional list of sixty-four 8-bit values that replace the default values shown above. A value of "0" is not allowed. These values take effect until the next occurrence of a sequence header or quant_matrix_extension. The order follows that shown in Figure 11.11. For 4:2:2 and 4:4:4 data formats, the new values are used for both the Y and CbCr non-intra matrix, unless a new CbCr non-intra matrix is loaded.

Load_chroma_intra_quantizer_matrix (1 bit)

This bit is set to a "1" if a chroma_intra_quantizer_matrix follows. If set to a "0," there is no change in the values used. If chroma_format is 4:2:0, this flag is a "0."

Chroma_intra_quantizer_matrix (64 * 8 bits)

An optional list of sixty-four 8-bit values that replace the previous or default values used for CbCr data. A value of "0" is not allowed. The value for chroma_intra_quant [0,0] is always 8. These values take effect until the next occurrence of a sequence header or quant_matrix_extension. The order follows that shown in Figure 11.11.

Load_chroma_non_intra_quantizer_matrix (1 bit)

This bit is set to a "1" if a chroma_non_intra_quantizer_matrix follows. If set to a "0," there is no change in the values used. If chroma_format is 4:2:0, this flag is a "0."

Chroma_non_intra_quantizer_matrix (64 * 8 bits)

An optional list of sixty-four 8-bit values that replace the previous or default values used for CbCr data. A value of "0" is not allowed. These values take effect until the next occurrence of a sequence header or quant_matrix_extension. The order follows that shown in Figure 11.11.

Figure 11.24b. MPEG 2 Video Bitstream Quant Matrix Extension Definition.

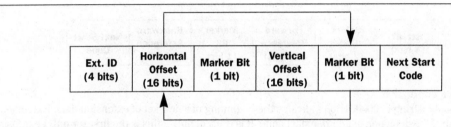

Ext. ID (4 bits)	Horizontal Offset (16 bits)	Marker Bit (1 bit)	Vertical Offset (16 bits)	Marker Bit (1 bit)	Next Start Code

Extension_start_code (32 bits)

This optional bit string of 000001B5$_H$ indicates the beginning of a new set of extension data. Extension data continues until the detection of another start code. It is present only if this is the first (or only) extension, as shown in Figure 11.15.

Extension_start_code_ID (4 bits)

This has a value of 0111 and indicates the beginning of a picture display extension. This extension does not affect the decoding process and may be ignored by decoders. It allows a display rectangle to be moved on a frame basis to support such applications as "pan-and-scan."

For i = 1 to N (N = 1, 2, or 3 depending on picture type), the following parameters are present:

Frame_center_horizontal_offset (16 bits)

Specifies the horizontal offset in units of 1/16th of a pixel. A positive value positions the center of the decoded picture to the right of the center of the display region.

Marker_bit (1 bit)

Always a "1."

Frame_center_vertical_offset (16 bits)

Specifies the vertical offset in units of 1/16th of a frame line. A positive value positions the center of the decoded picture below the center of the display region.

Marker_bit (1 bit)

Always a "1."

Figure 11.25. MPEG 2 Video Bitstream Picture Display Extension Definition.

Ext. ID (4 bits)	Select Code (2 bits)	Forward Reference (10 bits)	Marker Bit (1 bit)	Backward Reference (10 bits)	Next Start Code

Extension_start_code (32 bits)

This optional bit string of $000001B5_H$ indicates the beginning of a new set of extension data. Extension data continues until the detection of another start code. It is present only if this is the first (or only) extension, as shown in Figure 11.15.

Extension_start_code_ID (4 bits)

This has a value of 1010 and indicates the beginning of a picture temporal scalable extension.

Reference_select_code (2 bits)

Identifies reference frames or fields for prediction.

Forward_temporal_reference (10 bits)

Indicates the temporal reference of the lower layer to be used to provide the forward prediction. If more than 10 bits are required to specify the temporal reference, only the 10 LSBs are used.

Marker_bit (1 bit)

Always a "1."

Backward_temporal_reference (10 bits)

Indicates the temporal reference of the lower layer to be used to provide the backward prediction. If more than 10 bits are required to specify the temporal reference, only the 10 LSBs are used.

Figure 11.26. MPEG 2 Video Bitstream Picture Temporal Scalable Extension Definition.

Ext. ID (4 bits)	Temporal Reference (10 bits)	Marker Bit (1 bit)	Horizontal Offset (15 bits)	Marker Bit (1 bit)	Vertical Offset (15 bits)	Weight Index (2 bits)	Progressive Frame (1 bit)	Field Select (1 bit)	Next Start Code

Extension_start_code (32 bits)
This optional bit string of 000001B5$_H$ indicates the beginning of a new set of extension data. Extension data continues until the detection of another start code. It is present only if this is the first (or only) extension, as shown in Figure 11.15.

Extension_start_code_ID (4 bits)
This has a value of 1001 and indicates the beginning of a picture spatial scalable extension.

Lower_layer_temporal_reference (10 bits)
Indicates the temporal reference of the lower layer to be used to provide the prediction. If more than 10 bits are required to specify the temporal reference, only the 10 LSBs are used.

Marker_bit (1 bit)
Always a "1."

Lower_layer_horizontal_offset (15 bits)
Specifies the horizontal offset of the top-left corner of the upsampled lower layer picture relative to the enhancement layer picture. This parameter must be an even number for 4:2:0 and 4:2:2 formats. Expressed in units of the enhancement layer picture sample width.

Marker_bit (1 bit)
Always a "1."

Lower_layer_vertical_offset (15 bits)
Specifies the vertical offset of the top-left corner of the upsampled lower layer picture relative to the enhancement layer picture. This parameter must be an even number for 4:2:0 and 4:2:2 formats. Expressed in units of the enhancement layer picture sample height.

Figure 11.27a. MPEG 2 Video Bitstream Picture Spatial Scalable Extension Definition.

Spatial_temporal_weight_code_table_index (2 bits)

Indicates which spatial temporal weight codes are to be used.

Lower_layer_progressive_frame (1 bit)

This flag is "1" if the lower layer picture is progressive.

Lower_layer_deinterlaced_field_select (1 bit)

Used in conjunction with other parameters to assist with the decoder output processing of pictures:

Lower Layer Deinterlaced Field Select	Lower Layer Progressive Frame	Progressive Frame	Apply Deinterlace Process	Use For Prediction
0	0	1	yes	top field
1	0	1	yes	bottom field
1	1	1	no	frame
1	1	0	no	frame
1	0	0	yes	both fields

Figure 11.27b. MPEG 2 Video Bitstream Picture Spatial Scalable Extension Definition.

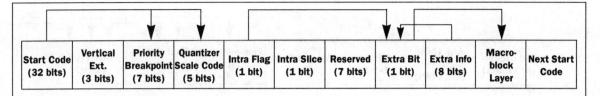

Start Code (32 bits)	Vertical Ext. (3 bits)	Priority Breakpoint (7 bits)	Quantizer Scale Code (5 bits)	Intra Flag (1 bit)	Intra Slice (1 bit)	Reserved (7 bits)	Extra Bit (1 bit)	Extra Info (8 bits)	Macro-block Layer	Next Start Code

Slice_start_code (32 bits)

The first 24 bits have a value of 000001_H. The last eight bits are the slice_vertical_position, and have a value of 01_H–AF_H.

The slice_vertical_position specifies the vertical position in macroblock units of the first macroblock in the slice. The slice_vertical_position of the first row of macroblocks is one.

Slice_vertical_position_extension (3 bits)

This parameter is present if the vertical size of the frame is greater than 2800 lines.

Priority_breakpoint (7 bits)

This parameter is only present when a sequence_scalable_extension has specified data partitioning mode. It specifies where in the bitstream to partition.

Quantizer_scale_code (5 bits)

This parameter has a value of 1 to 31 (a value of "0" is forbidden). It specifies the scale factor of the reconstruction level of the received DCT coefficients. The decoder uses this value until another quantizer_scale_code is received at either the slice or macroblock layer.

Intra_slice_flag (1 bit)

If this flag is set to a "1," intra_slice and reserved_bits data follows.

Intra_slice (1 bit)

Present only if intra_slice_flag = "1." Must be set to a "0" if any macroblocks in the slice are non-intra macroblocks.

Reserved_bits (7 bits)

Present only if intra_slice_flag = "1." These bits are always "0000000."

Extra_bit_slice (1 bit)

As long as this flag is set to a "1," extra_information_slice data follows. A value of "0" for this flag indicates no extra_information_slice data is available, and data for the macroblock layer is next.

Extra_information_slice (n * 8 bits)

Reserved. Present only if extra_bit_slice = "1."

Figure 11.28. MPEG 2 Video Bitstream Slice Layer Definition.

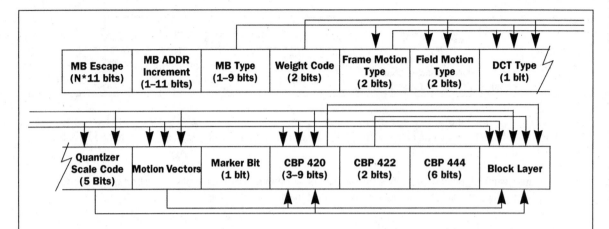

Macroblock_escape (n * 11 bits)

This optional parameter is a fixed bit string of "0000 0001 000" and is used when the difference between macroblock_address and previous_macroblock_address is greater than 33. It forces the value of macroblock_address_increment to be 33 greater than the value that will be decoded by subsequent macroblock_escape and macroblock_address_increment parameters. Any number of macroblock_escape parameters may be used.

Macroblock_address_increment (1–11 bits)

This is a variable-length word that specifies the difference between macroblock_address and previous_macroblock_address. It has a maximum value of 33. Values greater than 33 are encoded using the macroblock_escape parameter. The variable-length codes are listed in Table 11.19.

Macroblock_type (1–9 bits)

Variable-length code that indicates the method of coding and macroblock content according to Tables 11.10, 11,17, and 11.18.

The following parameter is present only if the Spatial Temporal Weight Code Flag = "1" in Tables 11.10, 11.17, and 11.18, and the spatial_temporal_weight_code_table_index ≠ "00" in Figure 11.27.

Spatial_temporal_weight_code (2 bits)

This parameter indicates, in the case of spatial scalability, how the spatial and temporal predictions are combined to do the prediction for the macroblock.

Figure 11.29a. MPEG 2 Video Bitstream Macroblock Layer Definition.

The following parameters are present only if MB Motion Forward or MB Motion Backward = "1" in Tables 11.10, 11.17, and 11.18.

The following parameter is present only if picture_structure = frame and frame_pred_frame_dct = "0."

Frame_motion_type (2 bits)
This parameter indicates the macroblock motion prediction, as shown in Table 11.20.

The following parameter is present only if picture_structure ≠ frame.

Field_motion_type (2 bits)
This parameter indicates the macroblock motion prediction, as shown in Table 11.21.

The following parameter is present only if decode_dct_type_flag ≠ 0.

Dct_type (1 bit)
This flag indicates whether the macroblock is frame or field DCT coded. "1" = field, "0" = frame.

The following parameter is present only if MB QUANT = "1" in Tables 11.10, 11.17, and 11.18.

Quantizer_scale_code (5 bits)

Optional Motion Vectors

The following parameter is present only if MB Intra = "1" in Tables 11.10, 11.17, and 11.18, and there are concealment motion vectors.

Marker_bit (1 bit)
This always has a value of "1."

The following parameters are present only if MB Pattern = "1" in Tables 11.10, 11.17, and 11.18.

Coded_block_pattern_420 (3–9 bits)
This variable-length parameter is used to derive the CBP as shown in Table 11.11.

If chroma_format = 4:2:2, the following parameter is present.

Coded_block_pattern_1 (2 bits)
For 4:2:2 data, this parameter is used to extend the coded block pattern by 2 bits.

If chroma_format = 4:4:4, the following parameter is present.

Coded_block_pattern_2 (6 bits)
For 4:4:4 data, this parameter is used to extend the coded block pattern by 6 bits.

Figure 11.29b. MPEG 2 Video Bitstream Macroblock Layer Definition.

Increment Value	Macroblock Address Increment Code	Increment Value	Macroblock Address Increment Code
1	1	17	0000 0101 10
2	011	18	0000 0101 01
3	010	19	0000 0101 00
4	0011	20	0000 0100 11
5	0010	21	0000 0100 10
6	0001 1	22	0000 0100 011
7	0001 0	23	0000 0100 010
8	0000 111	24	0000 0100 001
9	0000 110	25	0000 0100 000
10	0000 1011	26	0000 0011 111
11	0000 1010	27	0000 0011 110
12	0000 1001	28	0000 0011 101
13	0000 1000	29	0000 0011 100
14	0000 0111	30	0000 0011 011
15	0000 0110	31	0000 0011 010
16	0000 0101 11	32	0000 0011 001
		33	0000 0011 000
macroblock_escape			0000 0001 000

**Table 11.19. MPEG 2 VLC Table for Macroblock_Address_Increment.
This is the same as for MPEG 1.**

Frame Motion Type	Spatial Temporal Weight Class	Prediction Type	Motion Vector Count	MV Format
00		reserved		
01	0, 1	field	2	field
01	2, 3	field	1	field
10	0, 1, 2, 3	frame	1	frame
11	0, 2, 3	dual prime	1	field

Table 11.20. MPEG 2 Frame_motion_type Definition.

Field Motion Type	Spatial Temporal Weight Class	Prediction Type	Motion Vector Count	MV Format
00		reserved		
01	0, 1	field	1	field
10	0, 1	16 × 8 MC	2	field
11	0	dual prime	1	field

Table 11.21. MPEG 2 Field_motion_type Definition.

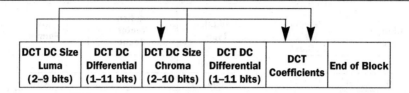

The following parameters are present for intra coded blocks, with pattern_code [i] = i < 4.

Dct_dc_size_luminance (2–9 bits)

This variable-length parameter specifies the number of bits in dct_dc_differential. The values are:

DCT DC Size Luminance	Code	DCT DC Size Luminance	Code
0	100	6	1111 0
1	00	7	1111 10
2	01	8	1111 110
3	101	9	1111 1110
4	110	10	1111 1111 0
5	1110	11	1111 1111 1

Dct_dc_differential (1–11 bits)

If dct_dc_size_luminance ≠ "0," this parameter is present. The values are shown in Table 11.12 (Additional Code Column).

This following parameters are present for intra coded blocks, with pattern_code [i] = i ≥ 4.

Dct_dc_size_chrominance (2–10 bits)

This variable-length parameter specifies the number of bits in dct_dc_differential. The values are:

DCT DC Size Chrominance	Code	DCT DC Size Chrominance	Code
0	00	6	1111 10
1	01	7	1111 110
2	10	8	1111 1110
3	110	9	1111 1111 0
4	1110	10	1111 1111 10
5	1111 0	11	1111 1111 11

Dct_dc_differential (1–11 bits)

If dct_dc_size_chrominance ≠ "0," this parameter is present. The values are shown in Table 11.12 (Additional Code Column).

For all other coded block types, DCT information follows until an End of Block code.

Figure 11.30. MPEG 2 Video Bitstream Block Layer Definition.
See also Figure 10.21 for DCT Format Details.

Program Stream

The program stream consists of one or more audio and/or video streams multiplexed together. Data from each audio and video stream is multiplexed and coded with data that allows them to be decoded in synchronization.

Data from audio and video streams is stored in PES packets. PES packets are then organized in packs. The general format of the program stream is shown in Figures 11.31 and 11.32. Figures 11.33 through 11.35 discuss the program stream contents in detail.

Private Data

Private data may be contained within the PES_packet_header, as indicated by the optional 16 bytes of PES_private_data.

Private data may also be contained within the PES_packet_data_byte fields. The stream_type table is used to indicate private data is present.

Private descriptors are also available.

Stream Descriptors

Stream descriptors may be used to extend the definitions of various streams. They are contained within the program stream map (shown in Figures 11.36 and 11.37). Their general format is:

> descriptor_tag (8 bits)
> descriptor_length (8 bits)
> data

Figures 11.38 through 11.49 illustrate the currently defined descriptors that are applicable to both a program and a transport stream.

Descriptor tag values of 0, 1, and 16–63 are reserved.

Descriptor tag values of 64–255 may be used for private user data.

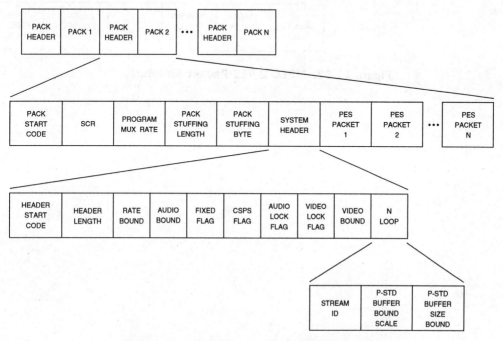

Figure 11.31. MPEG 2 Program Stream Structure.

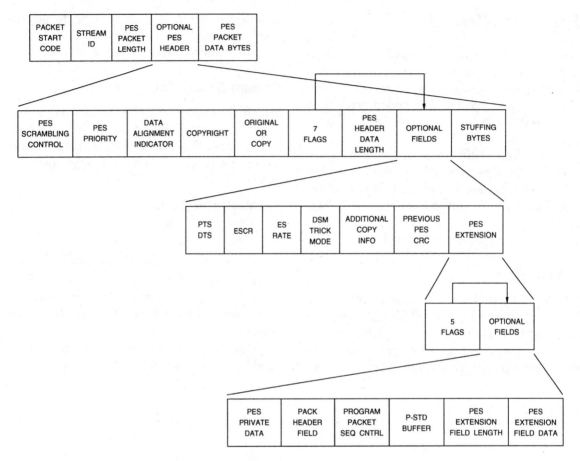

Figure 11.32. MPEG 2 PES Packet Structure.

Pack_start_code (32 bits)
This has a value of 000001BA$_H$ and indicates the beginning of a pack.

Marker_bits (2 bits)
These have a value of "01."

System_clock_reference_base [32–30] (3 bits)

Marker_bit (1 bit)
This has a value of "1."

System_clock_reference_base [29–15] (15 bits)

Marker_bit (1 bit)
This has a value of "1."

System_clock_reference_base [14–0] (15 bits)

Marker_bit (1 bit)
This has a value of "1."

System_clock_reference_extension (9 bits)
This parameter, along with the system_clock_reference_base parameter, comprises the system clock reference (SCR). The system_clock_reference_base parameter is specified in units of 1/300 multiplied by 90 kHz. The system_clock_reference_extension is specified in units of 27 MHz. SCR indicates the intended time of arrival of the byte containing the last bit of the system_clock_reference_base parameter at the input of the decoder.

Marker_bit (1 bit)
This has a value of "1."

Program_mux_rate (22 bits)
This 22-bit parameter specifies a value measured in 50 bytes per second, with a value of "0" forbidden. It indicates the rate at which the decoder receives the program stream.

Marker_bit (1 bit)
This has a value of "1."

Marker_bit (1 bit)
This has a value of "1."

Reserved (5 bits)
These have a value of "00000."

Pack_stuffing_length (3 bits)
This parameter specifies the number of stuffing bytes following this parameter.

Stuffing_byte (n * 8 bits)
0–7 stuffing bytes may be present. They are ignored by the decoder. Each byte has a value of "1111 1111."

Figure 11.33. MPEG 2 Program Stream Pack Header Definition.

System_header_start_code (32 bits)
 This has a value of $000001BB_H$ and indicates the beginning of a system header.

Header_length (16 bits)
 This parameter specifies the number of bytes of the system header following this field.

Marker_bit (1 bit)
 This has a value of "1."

Rate_bound (22 bits)
 This parameter specifies a value greater than or equal to the maximum value of the program_mux_rate parameter in Figure 11.33.

Marker_bit (1 bit)
 This has a value of "1."

Audio_bound (6 bits)
 This parameter specifies a value of 0 to 32 greater than or equal to the maximum number of active audio streams.

Fixed_flag (1 bit)
 A "1" indicates fixed bit rate operation. A "0" indicates variable bit rate operation.

CSPS_flag (1 bit)
 This flag is a "1" if the program stream is a "constrained system parameters stream" (CSPS).

System_audio_lock_flag (1 bit)
 This flag is a "1" if there is a specified, constant relationship between the audio sampling rate and the decoder system clock frequency.

System_video_lock_flag (1 bit)
 This flag is a "1" if there is a specified, constant relationship between the video picture rate and the decoder system clock frequency.

Marker_bit (1 bit)
 This has a value of "1."

Video_bound (5 bits)
 This parameter specifies a value of 0 to 16 greater than or equal to the maximum number of active video streams.

Reserved_byte (8 bits)
 This has a value of "1111 1111."

Figure 11.34a. MPEG 2 Program Stream System Header Definition.

Stream_ID (8 bits)

This optional parameter indicates the stream to which the P-STD_buffer_bound_scale and P-STD_buffer_size_bound parameters apply.

Stream ID	Stream
1011 1000	all audio streams
1011 1001	all video streams
1011 1100	program stream map
1011 1101	private stream 1
1011 1110	padding stream
1011 1111	private stream 2
110x xxxx	audio stream [x xxxx]
1110 xxxx	video stream [xxxx]
1111 0000	ECM stream
1111 0001	EMM stream
1111 0010	DSM_CC stream
1111 0011	ISO/IEC 13552 stream
1111 0100 – 1111 1110	reserved
1111 1111	program stream directory

Marker_bits (2 bits)

These have a value of "11." They are present only if stream_ID is present.

P-STD_buffer_bound_scale (1 bit)

This parameter is present only when stream_ID is present and indicates the scaling factor used for P_STD_buffer_size_bound. A "0" indicates the stream_ID specifies an audio stream. A "1" indicates the stream_ID specifies a video stream. For other types of stream IDs, the value may be either a "0" or a "1."

P-STD_buffer_size_bound (13 bits)

This parameter specifies a value greater than or equal to the maximum decoder input buffer size. It is present only when stream_ID is present. If P_STD_buffer_bound_scale is a "0," the unit is 128 bytes. If P_STD_buffer_bound_scale is a "1," the unit is 1024 bytes.

Figure 11.34b. MPEG 2 Program Stream System Header Definition.

Packet_start_code_prefix (24 bits)

This has a value of 000001_H and in conjunction with the stream_ID, indicates the beginning of a packet.

Stream_ID (8 bits)

This parameter specifies the type and number of elementary streams, as shown in Figure 11.34.

PES_packet_length (16 bits)

This parameter specifies the number of bytes in the PES packet following this parameter. A value of "0" indicates it is neither specified nor bounded, and is used only in transport streams.

If the stream ID is not program_stream_map, padding_stream, private_stream_2, ECM, EMM, or program_stream_directory, the following parameters are present:

Marker_bits (2 bits)

These have a value of "10."

PES_scrambling_control (2 bits)

This parameter specifies the scrambling mode. A value of "00" indicates no scrambling.

PES_priority (1 bit)

This flag specifies the priority. A "1" has a higher priority than a "0."

Data_alignment_indicator (1 bit)

A "1" indicates that a data_stream_alignment_descriptor immediately follows the PES packet header. See Figure 11.38.

Copyright (1 bit)

A "1" indicates that the material is copyrighted, and a copyright_descriptor is present. See Figure 11.39.

Original_or_copy (1 bit)

A "1" indicates that the material is original. A "0" indicates it is a copy.

PTS_DTS_flags (2 bits)

A value of "10" indicates a PTS (presentation time stamp) field is present in the PES packet header. A value of "11" indicates both a PTS and DTS (decoding time stamp) field are present. A value of "00" indicates neither a PTS or DTS field is present. A value of "01" is not allowed.

ESCR_flag (1 bit)

A "1" indicates the ESCR (elementary stream clock reference) base and extension fields are present in the PES packet header.

ES_rate_flag (1 bit)

A "1" indicates an ES_rate (elementary stream rate) field is present in the PES packet header.

Figure 11.35a. MPEG 2 Program Stream PES Packet Definition.

DSM_trick_mode_flag (1 bit)

A "1" indicates an 8-bit trick mode field is present.

Additional_copy_info_flag (1 bit)

A "1" indicates that an additional_copy_info field is present.

PES_CRC_flag (1 bit)

A "1" indicates that a CRC field is present.

PES_extension_flag (1 bit)

A "1" indicates that an extension field is present.

PES_header_data_length (8 bits)

Specifies the number of bytes in the optional fields and any stuffing bytes.

If the PTS_DTS_flags = "10," the following parameters are present:

Marker_bits (4 bits)

These have a value of "0010."

PTS [32–30] (3 bits)

Marker_bit (1 bit)

This has a value of "1."

PTS [29–15] (15 bits)

Marker_bit (1 bit)

This has a value of "1."

PTS [14–0] (15 bits)

The 33-bit presentation time stamp (PTS) indicates the intended time of display by the decoder. It is specified in periods of the 27-MHz clock divided by 300.

Marker_bit (1 bit)

This has a value of "1."

Figure 11.35b. MPEG 2 Program Stream PES Packet Definition.

If the PTS_DTS_flags = "11," the following parameters are present:

Marker_bits (4 bits)
These have a value of "0011."

PTS [32–30] (3 bits)

Marker_bit (1 bit)
This has a value of "1."

PTS [29–15] (15 bits)

Marker_bit (1 bit)
This has a value of "1."

PTS [14–0] (15 bits)

Marker_bit (1 bit)
This has a value of "1."

Marker_bits (4 bits)
These have a value of "0001."

DTS [32–30] (3 bits)

Marker_bit (1 bit)
This has a value of "1."

DTS [29–15] (15 bits)

Marker_bit (1 bit)
This has a value of "1."

DTS [14–0] (15 bits)
The 33-bit decoding time stamp (DTS) indicates the intended time of decoding. It is specified in periods of the 27-MHz clock divided by 300.

Marker_bit (1 bit)
This has a value of "1."

Figure 11.35c. MPEG 2 Program Stream PES Packet Definition.

If the ESCR_flag = "1," the following parameters are present:

Reserved (2 bits)
These have a value of "00."

ESCR_base [32–30] (3 bits)

Marker_bit (1 bit)
This has a value of "1."

ESCR_base [29–15] (15 bits)

Marker_bit (1 bit)
This has a value of "1."

ESCR_base [14–0] (15 bits)

Marker_bit (1 bit)
This has a value of "1."

ESCR_extension (9 bits)
The 9-bit elementary stream clock reference (ESCR) extension and the 33-bit ESCR base are combined into a 42-bit value. It indicates the intended time of arrival of the byte containing the last bit of ESCR_base. The value of ESCR_base specifies the number of 97-kHz clock periods. The value of ESCR_extension specifies the number of 27-MHz clock periods after the 90 kHz period starts.

Marker_bit (1 bit)
This has a value of "1."

If the ES_rate_flag = "1," the following parameters are present:

Marker_bit (1 bit)
This has a value of "1."

ES_rate (22 bits)
The 22-bit elementary stream rate (ES_rate) indicates the rate the decoder receives bytes of the PES packet. It is specified in units of 50 bytes per second.

Marker_bit (1 bit)
This has a value of "1."

Figure 11.35d. MPEG 2 Program Stream PES Packet Definition.

If the DSM_trick_mode_flag = "1," the following parameters are present:

Trick_mode_control (3 bits)
This parameter indicates which trick mode is applied to the video stream.

Trick Mode	Description
000	fast forward
001	slow motion
010	freeze frame
011	fast reverse
100	slow reverse
101	reserved
110	reserved
111	reserved

If trick_mode_control = "000" or "011," the following parameters are present:

Field_ID (2 bits)
This parameter indicates which fields are to be displayed.

Field ID	Description
00	top field only
01	bottom field only
10	complete frame
11	reserved

Intra_slice_refresh (1 bit)
A "1" indicates that there may be missing macroblocks between slices.

Frequency_truncation (2 bits)
Indicates that a restricted set of coefficients may have been used in coding the data.

Frequency Truncation	Description
00	only DC coefficients are non-zero
01	typically only the first 3 coefficients are non-zero
10	typically only the first 6 coefficients are non-zero
11	all coefficients may be non-zero

Figure 11.35e. MPEG 2 Program Stream PES Packet Definition.

If trick_mode_control = "001" or "100," the following parameter is present:

Field_rep_cntrl (5 bits)
This parameter indicates the number of times each field in an interlaced picture, or a progressive frame, should be displayed. A value of "00000" is not allowed.

If trick_mode_control = "010," the following parameters are present:

Field_ID (2 bits)
This parameter indicates which fields are to be displayed.

Field ID	Description
00	top field only
01	bottom field only
10	complete frame
11	reserved

Reserved (3 bits)
These have a value of "000."

If trick_mode_control = "101" or "110," or "111," the following parameter is present:

Reserved (5 bits)
These have a value of "00000."

If the additional_copy_info_flag = "1," the following parameters are present:

Marker_bit (1 bit)
This is always a "1."

Additional_copy_info (7 bits)
This contains private data regarding copyright information.

If the PES_CRC_flag = "1," the following parameter is present:

Previous_PES_packet_CRC (16 bits)

Figure 11.35f MPEG 2 Program Stream PES Packet Definition.

If the PES_extension_flag = "1," the following parameters are present:

PES_private_data_flag (1 bit)
A "1" indicates that private data is present.

Pack_header_field_flag (1 bit)
A "1" indicates that an MPEG 1 pack header or program stream pack header is in this PES packet header. If this flag is in a PES packet that is in a program stream, the flag is set to a "0."

Program_packet_sequence_counter_flag (1 bit)
A "1" indicates the program_packet_sequence_counter and original_stuff_length parameters are present.

P-STD_buffer_flag (1 bit)
A "1" indicates the P-STD_buffer_scale and P-STD_buffer_size parameters are present.

Reserved (3 bits)
These are always "000."

PES_extension_flag_2 (1 bit)
A "1" indicates that the PES_extension_field is present.

If PES_private_data_flag = "1," the following parameter is present:

PES_private_data (128 bits)
Private data, combined with the fields before and after, must not emulate the packet_start_code_prefix.

If pack_header_field_flag = "1," the following parameters are present:

Pack_field_length (8 bits)
Indicates the length, in bytes, of the following pack_header field.

Pack_header

Figure 11.35g. MPEG 2 Program Stream PES Packet Definition.

If program_packet_sequence_counter_flag = "1," the following parameters are present:

Marker_bit (1 bit)
This is always a "1."

Program_packet_sequence_counter (7 bits)
This value increments with each successive PES packet in a program stream or MPEG 1 system stream. It wraps around to zero after reaching its maximum value. No two consecutive PES packets can have the same values.

Marker_bit (1 bit)
This is always a "1."

MPEG1_MPEG2_identifier (1 bit)
A "1" indicates the PES packet has information from a MPEG 1 system stream. A "0" indicates the PES packet has information from a program stream.

Original_stuff_length (6 bits)
This parameter specifies the number of stuffing bytes used in the original PES or MPEG 1 packet header.

If P-STD_buffer_flag = "1," the following parameters are present:

Marker_bits (2 bits)
These are always "01."

P-STD_buffer_scale (1 bit)
Indicates the scaling factor for the following P-STD_buffer_size parameter. For audio streams, a value of "0" is present. For video streams, a value of "1" is present. For all other types of streams, a value of "0" or "1" may be used.

P-STD_buffer_size (13 bits)
This parameter specifies the size of the decoder input buffer. If P-STD_buffer_scale is a "0," the unit is 128 bytes. If P-STD_buffer_scale is a "1," the unit is 1024 bytes.

If PES_extension_flag_2 = "1," the following parameters are present:

Marker_bit (1 bit)
This is always a "1."

PES_extension_field_length (7 bits)
Indicates the number of bytes of the next field.

PES_extension_field_data (n * 8 bits)

Figure 11.35h. MPEG 2 Program Stream PES Packet Definition.

Stuffing_byte (n * 8 bits)

Always a value of "1111 1111." Up to 32 stuffing bytes may be used. They are ignored by the decoder.

PES_packet_data_byte (n * 8 bits)

Data from the audio, video, or other stream. The number of bytes is specified by the PES_packet_length parameter.

If the stream ID is program_stream_map, private_stream_2, ECM, EMM, or program_stream_directory, the following parameter is present:

PES_packet_data_byte (n * 8 bits)

Data from the audio, video, or other stream. The number of bytes is specified by the PES_packet_length parameter.

If the stream ID is padding_stream, the following parameter is present:

Padding_byte (n* 8 bits)

Each byte has a value of "1111 1111." The number of bytes is specified by the PES_packet_length parameters. It is ignored by the decoder.

Figure 11.35i. MPEG 2 Program Stream PES Packet Definition.

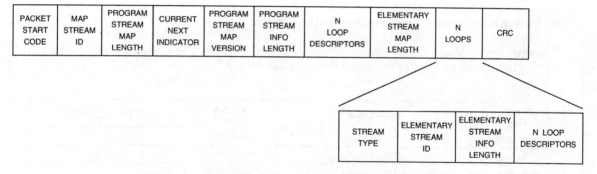

Figure 11.36. MPEG 2 Program Stream Map Structure.

Packet_start_code_prefix (24 bits)
This has a value of 000001_H and indicates the beginning of a stream map.

Map_stream_ID (8 bits)
These have a value of "1011 1100."

Program_stream_map_length (16 bits)
This parameter indicates the number of bytes following this parameter. It has a maximum value of 1024.

Current_next_indicator (1 bit)
A "1" indicates that the program stream map is currently applicable. A "0" indicates the program stream map is not applicable yet and will be the next one valid.

Reserved (2 bits)
These have a value of "00."

Program_stream_map_version (5 bits)
This parameter specifies the version number of the program stream map. It must be incremented by one when the program stream map changes, wrapping around to "0" after reaching a value of 31.

Reserved (7 bits)
These have a value of "000 0000."

Marker_bit (1 bit)
This always has a value of "1."

Program_stream_info_length (16 bits)
This parameter specifies the length of the descriptors following this parameter.

N descriptors (M bits)
Descriptors are discussed in Figures 11.38 through 11.49.

Elementary_stream_map_length (16 bits)
This parameter indicates the number of bytes following this parameter.

Figure 11.37a. MPEG 2 Program Stream Map Definition.

This loop is repeated N times, once for each stream type present.

Stream_type (8 bits)
This parameter specifies the type of stream as follows.

Stream Type	Description	Stream Type	Description
0000 0000	reserved	0000 1000	DSM CC
0000 0001	MPEG 1 video	0000 1001	auxiliary
0000 0010	MPEG 2 video	0000 1010	reserved
0000 0011	MPEG 1 audio	:	reserved
0000 0100	MPEG 2 audio	0111 1111	reserved
0000 0101	private sections	1000 0000	user private
0000 0110	private data in PES packets	:	user private
0000 0111	MHEG	1111 1111	user private

Elementary_stream_ID (8 bits)
This parameter specifies the value of the stream_ID parameter in the PES packet header of PES packets containing this stream.

Elementary_stream_info_length (16 bits)
This parameter specifies the length of the descriptors following this parameter.

N descriptors (M bits)
Descriptors are discussed in Figures 11.38 through 11.49.

CRC_32 (32 bits)

Figure 11.37b. MPEG 2 Program Stream Map Definition.

This descriptor provides a method of identifying the type of alignment in the stream.

Descriptor_tag (8 bits)
This parameter has a value of 6_{10}.

Descriptor_length (8 bits)
This parameter specifies the number of bytes following this field.

Alignment_type (8 bits)
This parameter specifies the audio or video alignment type as follows:

Alignment Type	Video Stream Description	Audio Stream Description
0000 0000	reserved	reserved
0000 0001	slice, picture, GOP, or SEQ	audio frame
0000 0010	picture, GOP, or SEQ	reserved
0000 0011	GOP or SEQ	
0000 0100	SEQ	
0000 0101	reserved	
:		
1111 1111		

Figure 11.38. MPEG 2 Data Stream Alignment Descriptor.

This descriptor provides a method of identification of works of art.

Descriptor_tag (8 bits)
This parameter has a value of 13_{10}.

Descriptor_length (8 bits)
This parameter specifies the number of bytes following this field.

Copyright_ID (32 bits)
This value is obtained from the Registration Authority.

Additional_copyright_info (n * 8 bits)
This optional data is defined by the copyright owner and is never changed.

Figure 11.39. MPEG 2 Copyright Descriptor.

This descriptor provides a method of identifying formats of private data.

Descriptor_tag (8 bits)
> This parameter has a value of 5_{10}.

Descriptor_length (8 bits)
> This parameter specifies the number of bytes following this field.

Format_identifier (32 bits)
> This value is obtained from the Registration Authority.

Additional_identification_info (n * 8 bits)
> This optional data is defined by the registration owner and is never changed.

Figure 11.40. MPEG 2 Registration Descriptor.

This descriptor provides displaying the video within a specified location of the display. It is useful when the video is not intended to use the full area of the display.

Descriptor_tag (8 bits)
> This parameter has a value of 7_{10}.

Descriptor_length (8 bits)
> This parameter specifies the number of bytes following this field.

Horizontal_size (14 bits)
> Horizontal size of the target background grid in pixels.

Vertical_size (14 bits)
> Vertical size of the target background grid in pixels.

Pel_aspect_ratio (4 bits)
> Aspect ratio as defined in the video sequence header.

Figure 11.41. MPEG 2 Target Background Grid Descriptor.

This descriptor provides a method to indicate the language(s) of the stream.

Descriptor_tag (8 bits)
This parameter has a value of 10_{10}.

Descriptor_length (8 bits)
This parameter specifies the number of bytes following this field.

ISO_639_language_code (n * 24 bits)
Identifies the language(s) used by the audio stream.

Audio_type (8 bits)
Identifies the audio type as follows:

00_H = reserved
01_H = no language
02_H = hearing impaired
03_H = visual impaired commentary
04_H–FF_H = reserved

Figure 11.42. MPEG 2 Language Descriptor.

This descriptor provides a method to indicate information about the system clock used to generate timestamps.

Descriptor_tag (8 bits)
This parameter has a value of 11_{10}.

Descriptor_length (8 bits)
This parameter specifies the number of bytes following this field.

External_clock_reference_indicator (1 bit)
A "1" indicates the system clock was derived from a reference that may be available at the decoder.

Reserved (1 bit)
Always a "0."

Clock_accuracy_integer (6 bits)
Combined with clock_accuracy_exponent, provides a fractional frequency accuracy of the system clock.

Clock_accuracy_exponent (3 bits)

Reserved (5 bits)
Always "00000."

Figure 11.43. MPEG 2 System Clock Descriptor.

Descriptor_tag (8 bits)
This parameter has a value of 12_{10}.

Descriptor_length (8 bits)
This parameter specifies the number of bytes following this field.

Mdv_valid_flag (1 bit)
A "1" indicates the multiplex_delay_variation field is valid.

Multiplex_delay_variation (15 bits)
This value is in units of (27 MHz / 300) clock periods. It is the peak-to-peak variation in multiplex delay of all packets in the stream.

Multiplex_strategy (3 bits)
Identifies the multiplexer strategy for the target utilization of the decoder demultiplex buffer:

000 = not specified
001 = early
010 = late
011 = middle
100–111 = reserved

Reserved (5 bits)
Always "00000."

Figure 11.44. MPEG 2 Multiplex Buffer Utilization Descriptor.

Descriptor_tag (8 bits)
This parameter has a value of 15_{10}.

Descriptor_length (8 bits)
This parameter specifies the number of bytes following this field. It will have a value of "0000 0100."

Private_data_indicator (32 bits)
This value is private and is not defined by the MPEG 2 specification.

Figure 11.45. MPEG 2 Private Data Descriptor.

This descriptor provides basic information about the video stream.

Descriptor_tag (8 bits)
This parameter has a value of 2_{10}.

Descriptor_length (8 bits)
This parameter specifies the number of bytes following this field.

Multiple_frame_rate_flag (1 bit)
A "1" indicates multiple frame rates may be present in the video stream.

Frame_rate_code (4 bits)
When the multiple_frame_rate flag is a "1," the indication of a specific frame rate also allows other frame rates to be present in the video stream.

Frame Rate Code	Indicated Frame Rate	May Also Include These Frame Rates
0000	forbidden	
0001	23.976	
0010	24.0	23.976
0011	25.0	
0100	29.97	23.976
0101	30.0	23.976, 24.0, 29.97
0110	50.0	25.0
0111	59.94	23.976, 29.97
1000	60.0	23.976, 24.0, 29.97, 30.0, 59.94
1001	reserved	
:	:	
1111	reserved	

MPEG_2_flag (1 bit)
A "1" indicates the video stream contains MPEG 2 video data. A "0" indicates the video stream contains MPEG 1 video data.

Constrained_parameter_flag (1 bit)
If the MPEG_2_flag is a "1," this flag must be a "0." If the MPEG_2_flag is a "0," this flag reflects the value of the constrained_parameter_flag in the MPEG 1 video stream.

Still_picture_flag (1 bit)
A "1" indicates the video stream contains only still pictures. A "0" indicates the video stream may have either still or moving pictures.

Figure 11.46a. MPEG 2 Video Stream Descriptor.

If the MPEG_2_flag = "1," the following parameters are present.

Profile_and_level_indication (8 bits)
This parameter reflects the profile_and_level_indication parameter in the video stream.

Chroma_format (2 bits)
This parameter reflects the chroma_format parameter in the video stream.

Frame_rate_extension_flag (1 bit)
A "1" indicates that either or both of the frame_rate_extension_n and frame_rate_extension_d parameters in the video stream are non-zero.

Reserved (5 bits)
These are always "00000."

Figure 11.46b. MPEG 2 Video Stream Descriptor.

This descriptor provides a method to indicate information about the audio stream.

Descriptor_tag (8 bits)
This parameter has a value of 3_{10}.

Descriptor_length (8 bits)
This parameter specifies the number of bytes following this field.

Free_format_flag (1 bit)
A "1" indicates the bitrate_index parameter in the audio stream is "0000."

ID (1 bit)
This bit is set to the same value as the ID fields in the audio stream.

Layer (2 bits)
This parameter is set to the same value as the layer fields in the audio stream.

Reserved (4 bits)
These are always "0000."

Figure 11.47. MPEG 2 Audio Stream Descriptor.

This descriptor provides a method to indicate information about the window characteristics of the video stream.

Descriptor_tag (8 bits)
 This parameter has a value of 8_{10}.

Descriptor_length (8 bits)
 This parameter specifies the number of bytes following this field.

Horizontal_offset (14 bits)
 Indicates the horizontal position of the top left pixel of the video window on the target background grid.

Vertical_offset (14 bits)
 Indicates the vertical position of the top left pixel of the video window on the target background grid.

Window_priority (4 bits)
 Indicates how video windows overlap. A value of "0000" is lowest priority and "1111" is highest priority. Higher priority windows are visible over lower priority windows.

Figure 11.48. MPEG 2 Video Window Descriptor.

This descriptor provides a method to indicate information about hierarchically coded audio and video which are multiplexed into multiple streams.

Descriptor_tag (8 bits)
This parameter has a value of 4_{10}.

Descriptor_length (8 bits)
This parameter specifies the number of bytes following this field.

Reserved (4 bits)
These are always "0000."

Hierarchy_type (4 bits)
Indicates the relationship between the hierarchy layer and its embedded layer as follows.

Hierarchy Type	Description
0000	reserved
0001	spatial scalability
0010	SNR scalability
0011	temporal scalability
0100	data partitioning
0101	extension bitstream
0110–1110	reserved
1111	base layer

Reserved (2 bits)
These are always "00."

Hierarchy_layer_index (6 bits)
Indicates a unique index of the stream.

Reserved (2 bits)
These are always "00."

Hierarchy_embedded_layer_index (6 bits)
Defines the hierarchical table index of the stream that must be accessed prior to decoding. This parameter is undefined for a hierarchy_type value of "1111."

Reserved (2 bits)
These are always "00."

Hierarchy_priority (6 bits)
Indicates the priority of the stream in a transmission hierarchy. The most important stream (base layer) is defined by the lowest value hierarchy_priority.

Figure 11.49. MPEG 2 Hierarchy Descriptor.

Program Stream Demultiplexing

The stream demultiplexer parses the incoming MPEG 2 program stream, demultiplexing the audio, video, and other information. Figure 11.50 illustrates the basic block diagram of this process.

A similar process is performed on a transport stream, if that transmission method is used.

Video Decoding

The video decoder essentially performs the inverse function as the encoder. From the coded bitstream, it reconstructs the I frames. Using I frames, additional coded data, and motion vectors, the P and B frames are generated. Finally, the frames are output in the proper order.

Figure 11.51 illustrates the block diagram of a basic MPEG 2 video decoder. Figure 11.52 illustrates the block diagram of a MPEG 2 video decoder that supports SNR scalability. Figure 11.53 illustrates the block diagram of a MPEG 2 video decoder that supports temporal scalability.

Motion Compensation

Motion compensation for MPEG 2 is more complex due to the introduction of fields. Basically, predictions from previously decoded pic-

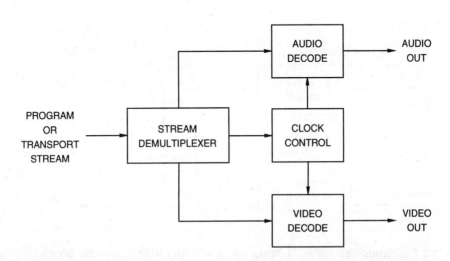

Figure 11.50. MPEG 2 Program Stream Demultiplexer Block Diagram.

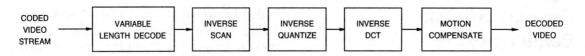

Figure 11.51. Simplified MPEG 2 Video Decoder Block Diagram.

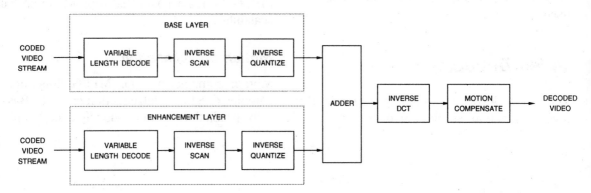

Figure 11.52. Simplified MPEG 2 SNR Scalability Video Decoder Block Diagram.

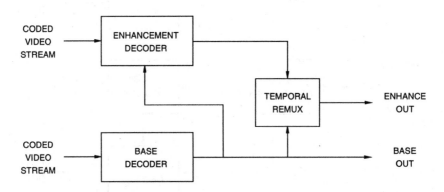

Figure 11.53. Simplified MPEG 2 Temporal Scalability Video Decoder Block Diagram.

tures are combined with coefficient data from the IDCT to recover the video samples. Figure 11.54 illustrates the basic motion compensation process.

The two major clasifications of prediction are *field* and *frame*. Within field pictures, only field predictions are used. Within frame pictures, either field or frame predictions can be used (selectable at the macroblock level).

Field Prediction
Prediction for P pictures is made from the two most recently decoded reference fields. The simplest case is shown in Figure 11.55, This is used when predicting the first picture of a frame or when using field prediction within a frame.

Predicting the second field of a frame also requires the two most recently decoded reference fields. This is shown in Figure 11.56 where the second picture is the bottom field and in Figure 11.57 where the second picture is the top field.

Field prediction for B pictures is made from the two fields of the two most recent reference frames, as shown in Figure 11.58.

Frame Prediction
Prediction for I and P pictures is made from the most recently decoded frame, as shown in Figure 11.59. The reference frame may have been coded as either two fields or a single frame.

Frame prediction for B pictures is made from the two most recent reference frames, as shown in Figure 11.60. Each reference frame may have been coded as either two fields or a single frame.

Special Prediction

16 × 8 motion compensation.
Two motion vectors (four for B pictures) per macroblock are used, one for the upper 16 × 8 region and one for the lower 16 × 8 region. It is only used with field pictures.

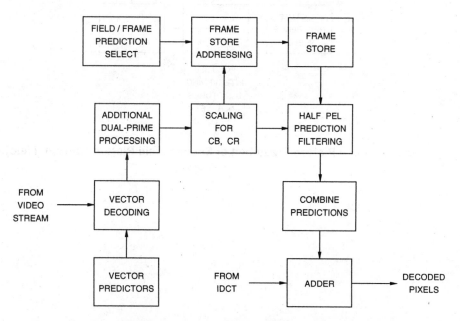

Figure 11.54. Simplified MPEG 2 Motion Compensation Process.

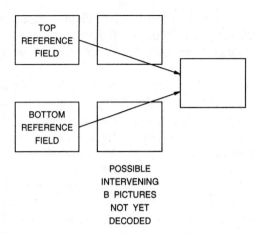

Figure 11.55. P Picture Prediction of First Field or Field Prediction for a Frame Picture.

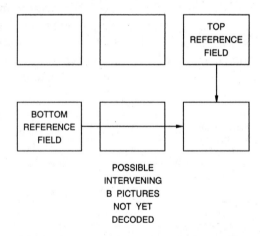

Figure 11.56. P Picture Prediction of Second Field Picture (Bottom Field).

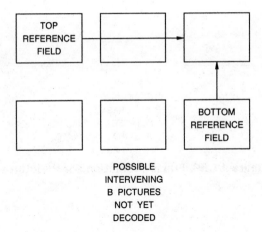

Figure 11.57. P Picture Prediction of Second Field Picture (Top Field).

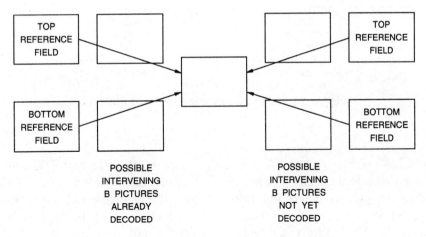

Figure 11.58. Field Prediction of B Field or Frame Pictures.

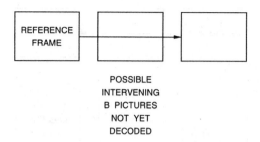

Figure 11.59. Frame Prediction For P Pictures.

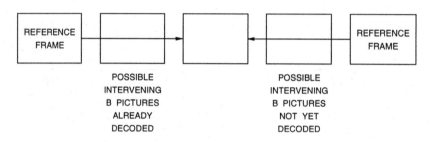

Figure 11.60. Frame Prediction For B Pictures.

Dual-prime

This is only used with P pictures that have no B pictures between the predicted and reference fields of frames. One motion vector is used, together with a small differential motion vector. All of the necessary predictions are derived from these.

Audio/Video Synchronization

Generally, audio/video are synchronized by comparing the PTS (presentation time stamp) with the STC (system time clock). Typically, the video decoder synchronizes the video data to the STC; the audio decoder synchronizes the audio data to the STC.

When the PTS and STC values are within 22.5 ms, the decoded picture is output. Otherwise, the picture is either repeated or the next B picture skipped. In the case where a B picture is not available, a P picture can be skipped.

Broadcast Applications

In this environment, the PCR (program reference clock) usually is used for synchronization. Its arrival time is determined by the encoding process and the broadcast path. The video decoder synchronizes its system time clock (STC) and the 27-MHz display clock to the PCR. If synchronization starts to drift, the video decoder's buffer either may overflow or

run out of compressed data. The video decoder prevents this by sensing the loss of synchronization, and then either dropping or repeating pictures to resynchronize to the PCR values.

Fine Synchronization

Fine synchronization may be achieved by locking the video decoder's 27-MHz display clock to the PCR using a PLL. The display clock is used to control the output of the video decoder.

The video decoder has an internal counter that implements the system time clock (STC). This counter has a resolution of 90 kHz and is driven by the display clock.

The STC is initialized at the beginning of the decoding process. Since the display clock is synchronized to the PCR, the STC will track PCR changes, except when the PCR changes rapidly, such as when changing a channel. Using the STC to measure the timing of the display VSYNC* pulses, and comparing that timing to a stored PTS value, enables the video decoder to choose the appropriate moment to decode and display a particular video picture. Audio synchronization can be handled by locking the audio subsystem to the display clock. Audio PTS values then are used to play the audio.

Coarse Synchronization

Coarse synchronization may be done without using a PLL. The STC can be made to stay in approximate synchronization with the PCR by continuously refreshing its contents based on the value of arriving PCR values.

Since the 27-MHz display clock is not synchronized with the PCR, the video decoder's PTS value (measured by the decoder's STC from the timing of the VSYNC* pulses) will drift with respect to the received PTS. If the PTS is not within 22.5 ms of the decoder's STC, the video decoder either skips the next B picture or repeats the current picture. Audio may be synchronized by monitoring the STC from the video decoder and adjusting the audio accordingly.

Computer Applications

The audio decoder should be the timing master, since dropping audio information is much more noticeable than dropping video information.

The audio PTS is inserted in the video decoder STC when the first audio sample is output. The video decoder receives the PTS from the audio decoder and adjusts to it with its next PTS. The sample of the video STC is taken with VSYNC* and compared to the associated PTS. If different by more than 22.5 ms, a video picture is either skipped or repeated.

16:9 Format Support

MPEG 2 video decoders support a feature that enables the display of a 16:9 aspect ratio video on a standard 4:3 aspect ratio 525/60 display.

During video encoding, the 16:9 source is scaled down (maintaining the 16:9 aspect ratio) to fit into a 720×480 resolution and compressed.

During video decoding, a 540×480 portion of the picture is extracted and horizontally scaled up to 720×480.

References

1. Digital Video Magazine, *"Not All MPEGs Are Created Equal,"* by John Toebes, Doug Walker, and Paul Kaiser, August 1995.
2. Digital Video Magazine, *"Squeeze the Most From MPEG,"* by Mark Magel, August 1995.
3. ISO/IEC 13818-1, Generic coding of moving pictures and associated audio information, Part 1: Systems.
4. ISO/IEC 13818-2, Generic coding of moving pictures and associated audio information, Part 2: Video.
5. ISO/IEC 13818-3, Generic coding of moving pictures and associated audio information, Part 3: Audio.
6. MPEG FAQ by Chad Fogg, August 1995.

Video Conferencing (ISDN)

This chapter is included in response to the growing interest in video teleconferencing, including interactive white board applications, based on personal computers. Advances in VLSI chips, software, various standards, and communications have enabled these applications to emerge, but when faster networks are commonly available, we will see rapid growth in these technologies.

The general features and attributes for video phones are specified in ITU-T F.720; ITU-T F.721 applies specifically to service via ISDN while ITU-T F.722 applies specifically to service via broadband networks.

The general features and attributes for video conferencing are specified in ITU-T F.730.

H.320

The ITU-T H.320 family of standards (Table 12.1) specify the requirements to ensure world-wide compatibility among video conferencing and video phone systems using ISDN. Although early dedicated teleconferencing systems initially used only proprietary algorithms, they now also support H.320, with some systems now supporting only H.320. Figure 12.1 illustrates a typical H.320 system.

Bit Rate Options and Infrastructure

Communication Modes
The various communication modes are listed in Table 12.2, based on the channel configuration and coding.

Video Phones
Table 12.3 lists terminal types of video phones. The terminal type is categorized according to the communication modes and the type of communication channels with which the terminal can communicate. The type of remote terminal is identified through the transfer rate capability exchange defined in H.242.

Video Codec
Per H.261.

Audio Codec
Per G.711, G.722, G.728, H.200/AV.253.

Audio Standard	Video Standard	Control Standard	Purpose
ITU-T G.711			64 kbps audio
ITU-T G.722			48, 56, or 64 kbps audio
ITU-T G.728			16 kbps audio
	ITU-T H.261		video codec standard
		ITU-T H.221	frame structure, protocol, and audio/video multiplexing
		ITU-T H.230	multiplexing frames of audio, video, user data, and signal information onto a digital channel
		ITU-T H.231	multipoint control unit (MCU) description
		ITU-T H.242	protocols for setup and disconnect, in-band protocol, fault recovery, and channel management
		ITU-T H.243	control between H.231 MCU and H.320 codecs using ISDN B channels
		ITU-T H.233	encryption
		ITU-T H.234	encryption key handling

Table 12.1. H.320 Family of Standards.

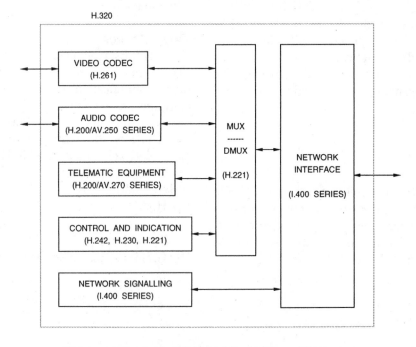

Figure 12.1. Typical H.320 Visual Phone System.

Phone Mode		Channel Rate (kbps)	ISDN Channel	Audio Coding	Video Coding
a	a_0	64	B	G.711	–
a	a_1	64	B	G.728	H.261
b	b_1	128	2B	G.711	H.261
b	b_2	128	2B	G.722	H.261
b	b_3	128	2B	G.728	H.261
q	q_1	$n \times 64$ ($n = 3, 4, 5, 6$)	nB	G.711	H.261
q	q_2	$n \times 64$ ($n = 3, 4, 5, 6$)	nB	G.722	H.261
q	q_3	$n \times 64$ ($n = 3, 4, 5, 6$)	nB	G.728	H.261
g		384	H_0	G.722	H.261
h		768	$2H_0$	G.722	H.261
i		1152	$3H_0$	G.722	H.261
j		1536	$4H_0$	G.722	H.261
k		1536	H_{11}	G.722	H.261
l		1920	$5H_0$	G.722	H.261
m		1920	H_{12}	G.722	H.261

Table 12.2. H.320 Communication Modes.

Phone Mode		Type X									Type Y					Type Z	
Transfer	Audio	a	b_1	$b_{2/3}$	b_4	b_5	q_1	$q_{2/3}$	q_4	q_5	1	2	3	4	5	α	β
a_0	G.711	x	x	x	x	x	x	x	x	x							
a_1	G.728	x	x	x			x	x									
b_1	G.711		x	x	x	x	x	x	x	x							
b_2	G.722			x		x		x		x							
b_3	G.728	x	x				x	x									
q_1	G.711						x	x	x	x							
q_2	G.722							x		x							
q_3	G.728						x	x									
g	G.722										x	x	x	x	x		
h	G.722											x	x	x	x		
i	G.722												x	x	x		
j	G.722													x	x		
k	G.722															x	
l	G.722														x		
m	G.722																x

Table 12.3. H.320 Video Phone Terminal Types.

Frame Structure
Per H.221.

Control and Indication (C&I)
An identified subset of H.230 is used.

Communication Procedure
Per H.242.

Call Control Arrangements

To establish communication between terminals, in-band and out-band procedures according to H.242 and other relevant standards are used.

The different stages of a call are referred according to a point-to-point configuration where terminal X is the calling terminal and Y the called terminal.

Establishment of Call—Normal Procedure
The main steps for a call are:

phase A: call setup, out-band signalling
phase B1: mode initialization on initial
 channel
phase CA: call setup of additional
 channel(s) if needed
phase CB1: initialization on additional
 channel(s)
phase B2 (or CB2): establishment of
 common parameters
phase C: video phone communication
phase D: termination phase
phase E: call release

Phase A: Call Setup
After user initialization, the calling terminal performs a call setup procedure. As soon as the terminal receives an indication that the connection is established, a bidirectional channel is opened, and H.221 framing is overlaid on the channel.

Following a connection being made, a terminal starts working in the following modes defined in H.221:

type X: mode OF (A-law or µ-law),
type Y and type Z: mode OF (A-law or
 µ-law) audio only.

The in-band procedure is now activated.

Phase B1: Mode Initialization
Phase B1–1
Using procedures provided in H.242, framed PCM audio is transmitted in both directions, and terminal capabilities are exchanged.

Phase B1–2 (Terminal Procedure)
Determination of the appropriate mode is transmitted. This is normally the highest common mode (see Table 12.4), but a lower compatible mode may be used instead.

In the case that both terminals have the capability to work on additional channel(s), terminal X typically initiates the request. This action may be suspended until user X has given the go-ahead. User Y may also control additional channel requests.

If either user does not wish the call to proceed to two or more channels, the user must

X_a	Xb_1	Xb_2	Xb_3	Xb_4	Xb_5	Terminal Type
a_1	a_1	a_1	a_1	a_0	a_0	X_a
	b_3	b_3	b_3	b_1	b_1	Xb_1
		b_2 or b_3	b_2 or b_3	b_1	b_2	Xb_2
		b_2 or b_3	b_2 or b_3	b_1	b_2	Xb_3
				b_1	b_1	Xb_4
					b_2	Xb_5

Table 12.4. H.320 Video Phone Default Communication Modes Using a B or 2B Channel.

configure the terminal so that only single-channel capability is declared in phase B1–1.

Phase B1–3 (Mode Switching)
Both terminals switch to the mode they have identified in phase B1–2. If both terminals have not adopted the common mode, an asymmetric communication will result.

Phase CA: Call Setup of the Additional Channels
If additional channels have been requested, these are again phase A (hence the nomenclature "Phase CA"). On each of the additional channels, H.221 framing is overlaid. During phase CA, an intermediate audio/video mode may be used on the initial channel.

Phase CB1: Mode Initialization on Additional Channels
Phase CB1–11
Using H.242 procedures, frame and multi-frame alignments are done.

Phase CB1–12
Channels are synchronized.

Phase CB1–2 (Terminal Procedure)
Determination of the appropriate mode is transmitted. This is normally the highest com-

mon mode, but a lower compatible mode may be used instead.

Phase CB1–3 (Mode Switching)
Both terminals switch to the mode they have identified in phase B1–2. If both terminals have not adopted the common mode, an asymmetric communication will result.

Phase B2 or CB2: Establishment of Common Parameters
This phase establishes common operational parameters specific to video phones, such as encryption, after phase B1 is finished. The capabilities of the receiving terminal are first indicated; the sending terminal then decides the operational parameters and controls the receiving terminal. BAS codes for this purpose are defined in H.221.

Phase C: Video Phone Communication
If more than one channel is used, there will be intermediate phases CA, CB1, and CB2. If additional channels are dropped during the call, there will be intermediate phases CD and CE. This applies to any channel, initial or additional, for which phases B1 and B2 have been completed and phase D not yet started.

Mode Switching

On an action by either user (for example, starting a FAX machine) a different mode, rather than the highest common mode, may be used. Switching to this new mode is done according to H.242.

Capability Change

A user may change the capability of the terminal during the call (for example, by connecting or switching on auxiliary equipment). The terminal initiates the capability exchange procedure as defined in H.242.

Phase D : Termination Phase

Phase D1 (Terminal Procedure)

When one user hangs up, the terminal invokes phase D2 directly.

Phase D2 (Mode Switching)

Mode OF is forced according to H.242.

Phase E : Call Termination (Release)

The terminal initiating the hang-up sends messages over the D channel with respect to all channels and stops transmission over them. At the other terminal, the first disconnect message received will idle all channels. The actual disconnection occurs at reception of the other disconnect messages.

Control and Indication (C&I) Signals

C&I signals are a subset from the general set contained within H.221 and H.230 and are shown in Table 12.5. They are used for signalling between terminals, resulting in a change in operation (control) or information regarding the operation of the system (indication). They are one or two 8-bit words transmitted using bit-allocation signals (BAS).

Freeze Picture Request (VCF)

This signal usually is transmitted prior to a "video-off" mode switch to prepare the video decoder. It also may be transmitted by a MCU prior to video switching.

The video decoder should complete updating the current video frame, then freeze the picture until receiving a freeze picture release signal or a time-out of at least six seconds has expired. To continue picture freezing, the encoder should send VCF repeatedly with an appropriate period.

Fast Update Request (VCU)

This signal is sent by a MCU after doing a video switch and at the start of communication. The decoder should execute the fast-update mode as soon as possible.

Video Indicate Suppressed (VIS)

This signal is used to indicate that the video channel does not contain a normal image.

Video Indicate Active (VIA)

This signal is used to indicate that the video channel contains a normal image.

Audio Indicate Muted (AIM)

This signal indicates that the audio channel does not contain a normal audio signal.

Audio Indicate Active (AIA)

This signal is used to indicate that the audio channel contains a normal audio signal.

Video Loop Request (LCV)

On receiving this signal, the system connects the output of the video decoder to the input of the video encoder.

BAS Code	C&I Signal	C/I	Source	Sink	Picture Sync	Defined
	Video					
	picture format	I	decoder	encoder	no	H.221
	picture format	C	encoder	decoder	yes	H.261
101 10110	minimum decodable picture interval	I	decoder	encoder	no	H.221
010 10000	video command, freeze picture request (VCF)	C	encoder or MCU	decoder	no	H.221
010 10001	video command, fast update request (VCU)	C	decoder or MCU	encoder	no	H.221
	freeze picture release control	C	encoder	decoder	yes	H.261
	Multipoint Conferences					
111 10001 001 00000	multipoint command conference (MCC)	C	MCU	terminal	no	H.230
111 10001 001 00001	cancel MCC	C	MCU	terminal	no	H.230
111 10001 001 10100	multipoint command symmetrical data transmission (MCS)	C	MCU	terminal	no	H.230
111 10001 001 10101	multipoint command negating MCS (MCN)	C	MCU	terminal	no	H.230
	Maintenance					
010 10011	loopback command, video loop request (LCV)	C	terminal	terminal	no	H.221
010 10100	loopback command, digital loop request (LCD)	C	terminal	terminal	no	H.221
010 10101	loopback command off (LCO)	C	terminal	terminal	no	H.221
	Conference					
	split screen indication	I	sending terminal	receiving terminal	yes	H.261
	Terminal					
	document camera indication	I	sending terminal	receiving terminal	yes	H.261
111 10001 000 00011	audio indicate active (AIA)	I	sending terminal	receiving terminal	no	H.230
111 10001 000 00010	audio indicate muted (AIM)	I	sending terminal	receiving terminal	no	H.230
111 10001 000 10001	video indicate active (VIA)	I	sending terminal	receiving terminal	no	H.230
111 10001 000 10000	video indicate suppressed (VIS)	I	sending terminal	receiving terminal	no	H.230

Table 12.5. H.320 Video Phone C&I Signals.

Digital Loop Request (LCD)

On receiving this signal, the system disconnects the output of the multiplexer from the outgoing path, replacing it with the input to the demuliplexer. If multiple channels are used, it is done for each channel.

Loopback Command Off (LCO)

On receiving this signal, the system disconnects all loops, restoring audio, video, and data paths to the normal condition.

Multipoint Command Conference (MCC)

The system receiving a MCC signal makes the outgoing and incoming transfer rates the same. The outgoing and incoming audio rates also are made equal.

Symmetrical Data Transmission (MCS)

This signal is sent by a MCU when setting up data broadcasting. On receiving this signal, a system prepares itself for data reception and ensures that the outgoing and incoming data channels are the same rate.

Negating MCS (MCN)

This signal is sent by a MCU when data broadcasting is done. On receiving it, a system closes outgoing data channels.

Connecting to Other Phones

Calls may be made to and received from ISDN phones and PSTN (Public Switched Telephone Network) phones. If video is not supported, the result will be an audio-only call.

H.261

ITU-T H.261 covers the video compression and decompression portion of video conferencing

and video phones at the rates of $p \times 64$ kbps, where p is in the range 1–30. The video encoder provides a self-contained digital bitstream which is combined with other signals (such as defined in H.221). The video decoder performs the reverse process. The primary specifications of H.261 regarding YCbCr video data are listed in Table 12.6. The 4:2:0 YCbCr sampling is shown in Figure 12.2.

In an attempt to reduce the cost of implementing H.261 in the United States, a few companies are pursuing a version of CIF known as CIF240 that has 240 lines per frame, rather than 288. However, CIF240 is incompatible with the world-wide standards.

The maximum picture rate may be restricted by having 0, 1, 2, or 3 non-transmitted pictures between transmitted ones.

Coding Algorithm

A typical encoder block diagram is shown in Figure 12.3. The basic functions are prediction, block transformation, and quantization.

The prediction error or the input picture is subdivided into 8×8 blocks that are segmented as transmitted or non-transmitted. Four luminance blocks and the two spatially corresponding color difference blocks are combined to form a macroblock as shown in Figure 12.4.

The criteria for choice of mode and transmitting a block are not recommended and may be varied dynamically as part of the coding strategy. Transmitted blocks are transformed and resulting coefficients are quantized and variable length coded.

Prediction

The prediction is interpicture and may be augmented by motion compensation and a spatial filter.

Parameters	CIF	QCIF
Coded signals: Y, Cb, Cr	These signals are obtained from gamma precorrected signals, namely: Y, $B' - Y$, $R' - Y$ or R', G', B'.	
Active resolution (Y)	352×288	176×144
Frame refresh rate	29.97 Hz	
YCbCr sampling structure	4:2:0	
Form of YCbCr coding	Uniformly quantized PCM, 8 bits per sample.	

Table 12.6. H.261 YCbCr Parameters.

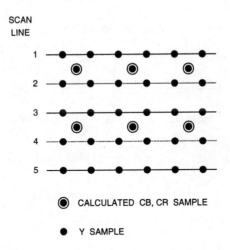

Figure 12.2. H.261 4:2:0 YCbCr Sampling.

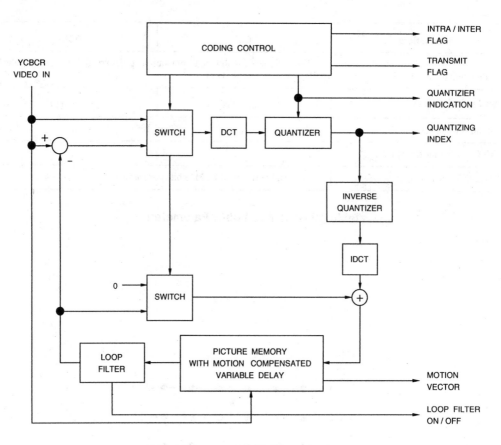

Figure 12.3. Typical H.261 Encoder.

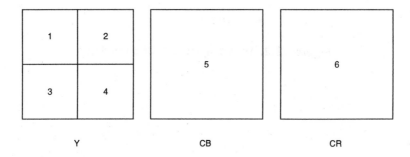

Figure 12.4. H.261 Arrangement of Blocks in a Macroblock.

Motion Compensation

Motion compensation is optional in the encoder. The decoder must support acceptance of one motion vector per macroblock. Motion vectors are restricted—all pixels referenced by them must be within the coded picture area.

The horizontal and vertical components of motion vectors have integer values not exceeding ±15. The motion vector is used for all four Y blocks in the macroblock. The motion vector for both the Cb and Cr blocks is derived by halving the component values of the macroblock vector.

A positive value of the horizontal or vertical component of the motion vector indicates that the prediction is formed from pixels in the previous picture that are spatially to the right or below the pixels being predicted.

Loop Filter

The prediction process may use a 2D spatial filter that operates on pixels within a predicted 8 × 8 block.

The filter is separated into horizontal and vertical functions. Both are non-recursive with coefficients of 0.25, 0.5, 0.25 except at block edges where one of the taps fall outside the block. In such cases, the filter coefficients are changed to 0, 1, 0. Full arithmetic precision should be retained with rounding to 8-bit integer values at the filter output. Values whose fractional part is one-half should be rounded up.

The filter is switched on or off for all six blocks in a macroblock according to the macroblock type.

DCT, IDCT

Transmitted blocks are first processed by an 8 × 8 DCT. The output from the inverse DCT ranges from −256 to +255 after clipping, represented using 9 bits.

The procedures for computing the transforms are not defined, but the inverse transform must meet the specified error tolerance.

Quantization

The number of quantizers is 1 for the INTRA DC coefficient and 31 for all other coefficients. Within a macroblock, the same quantizer is used for all coefficients except the one for INTRA DC. The INTRA DC coefficient usually is the transform value linearly quantized with a step size of 8 and no dead zone. Each of the other 31 quantizers is also linear, but with a central dead zone about zero and a step size of an even value in the range of 2 to 62.

Clipping of Reconstructed Picture

Clipping functions are used to prevent quantization distortion of transform coefficient amplitudes, possibly causing arithmetic overflows in the encoder and decoder loops. The clipping function is applied to the reconstructed picture, formed by summing the prediction and the prediction error. Clippers force pixel values less than 0 to be 0, and force pixel values greater than 255 to be 255.

Coding Control

Although not included as part of H.261, several parameters may be varied to control the rate of coded video data. These include processing prior to coding, the quantizer, block significance criterion, and temporal subsampling. Temporal subsampling is performed by discarding complete pictures.

Forced Updating

This is achieved by forcing the use of the INTRA mode of the coding algorithm. To control the accumulation of inverse transform mismatch errors, a macroblock should be forcibly updated at least once every 132 times it is transmitted.

Video Multiplexer

Unless specified otherwise, the most significant bits are transmitted first. This is bit 1 and is the leftmost bit in the code tables. Unless specified otherwise, all unused or spare bits are set to "1."

The video multiplexer is a hierarchical structure with four layers. From top to bottom the layers are:

> Picture
> Group of Blocks
> Macroblock
> Block

Picture Layer

Data for each picture consists of a picture header followed by data for group of blocks (GOBs). The structure is shown in Figure 12.5. Picture headers for dropped pictures are not transmitted.

Picture Start Code (PSC)

PSC is a 20-bit word with a value of 0000 0000 0000 0001 0000.

Temporal Reference (TR)

TR is a 5-bit number representing 32 possible values. It is generated by incrementing the value in the previously picture header by one plus the number of non-transmitted pictures (at 29.97 Hz). The arithmetic is performed with only the five LSBs.

Type Information (PTYPE)

Six bits of information about the picture are:

Bit 1 Split screen indicator
"0" = off, "1" = on

Bit 2 Document camera indicator
"0" = off, "1" = on

Bit 3 Freeze picture release
"0" = off, "1" = on

Bit 4 Source format
"0" = QCIF, "1" = CIF

Bit 5 Optional still image mode
"0" = on, "1" = off

Bit 6 Spare

Extra Insertion Information (PEI)

PEI is a bit which when set to "1" indicates the presence of the following optional data field.

Spare Information (PSPARE)

If PEI is set to "1," then 9 bits follow consisting of 8 bits of data (PSPARE) and another PEI bit to indicate if a further 9 bits follow, and so on.

Group of Blocks Layer

Each picture is divided into groups of blocks (GOBs). A GOB comprises one-twelfth of the CIF picture area or one-third of the QCIF picture area (see Figure 12.6). A GOB relates to 176 pixels by 48 lines of Y and the corresponding 88 pixels by 24 lines of Cb and Cr.

| PSC | TR | PTYPE | PEI | PSPARE | PEI | GOB DATA |

Figure 12.5. H.261 Picture Layer Structure.

CIF		QCIF
1	2	1
3	4	3
5	6	5
7	8	
9	10	
11	12	

Figure 12.6. H.261 Arrangement of Group of Blocks in a Picture.

Data for each GOB consists of a GOB header followed by macroblock data, as shown in Figure 12.7. Each GOB header is transmitted once between picture start codes in the CIF or QCIF sequence numbered in Figure 12.6, even if no macroblock data is present in that GOB.

Group of Blocks Start Code (GBSC)
GBSC is a 16-bit word with a value of 0000 0000 0000 0001.

Group Number (GN)
GN is four bits indicating the position of the group of blocks. The bits are the binary representation of the number in Figure 12.6. Numbers 13, 14, and 15 are reserved for future use.

Quantizer Information (GQUANT)
GQUANT is a fixed length codeword of 5 bits that indicates the quantizer to be used in the group of blocks until overridden by any subsequent MQUANT. The codewords are the binary representations of the values of QUANT, ranging from 1 to 31.

Extra Insertion Information (GEI)
GEI is a bit which, when set to "1," indicates the presence of the following optional data field.

Spare Information (GSPARE)
If GEI is set to "1," then 9 bits follow consisting of 8 bits of data (GSPARE) and then another GEI bit to indicate if a further 9 bits follow, and so on.

Macroblock Layer
Each GOB is divided into 33 macroblocks as shown in Figure 12.8. A macroblock relates to 16 pixels by 16 lines of Y and the corresponding 8 pixels by 8 lines of Cb and Cr.

Data for a macroblock consists of a MB header followed by data for blocks (see Figure 12.9).

| GBSC | GN | GQUANT | GEI | GSPARE | GEI | MB DATA |

Figure 12.7. H.261 Group of Blocks Layer Structure.

1	2	3	4	5	6	7	8	9	10	11
12	13	14	15	16	17	18	19	20	21	22
23	24	25	26	27	28	29	30	31	32	33

Figure 12.8. H.261 Arrangement of Macroblocks in a GOB.

MBA	MTYPE	MQUANT	MVD	CBP	BLOCK DATA

Figure 12.9. H.261 Macroblock Layer Structure.

Macroblock Address (MBA)

MBA is a variable length codeword indicating the position of a macroblock within a group of blocks. The transmission order is shown in Figure 12.8. For the first macroblock in a GOB, MBA is the absolute address in Figure 12.8. For subsequent macroblocks, MBA is the difference between the absolute addresses of the macroblock and the last transmitted macroblock. The code table for MBA is given in Table 12.7.

A codeword is available for bit stuffing immediately after a GOB header or a coded macroblock (called MBA stuffing). This codeword is discarded by decoders.

The variable length codeword for the start code is also shown in Table 12.7. MBA is always included in transmitted macroblocks. Macroblocks are not transmitted when they contain no information for that part of the picture.

Type Information (MTYPE)

MTYPE is a variable length codeword containing information about the macroblock and data elements that are present. Macroblock types, included elements, and variable length codewords are listed in Table 12.8. MTYPE is always included in transmitted macroblocks.

Quantizer (MQUANT)

MQUANT is present only if indicated by MTYPE. It is a 5-bit codeword indicating the quantizer to use for this and any following blocks in the group of blocks, until overridden by any subsequent MQUANT. Codewords for MQUANT are the same as for GQUANT.

Motion Vector Data (MVD)

Motion vector data is included for all motion-compensated (MC) macroblocks. MVD is obtained from the macroblock vector by subtracting the vector of the preceding macroblock. The vector of the previous macroblock is regarded as zero for the following situations:

(a) Evaluating MVD for macroblocks 1, 12, and 23.

(b) Evaluating MVD for macroblocks where MBA does not represent a difference of 1.

MBA	Code			MBA	Code			
1	1			17	0000	0101	10	
2	011			18	0000	0101	01	
3	010			19	0000	0101	00	
4	0011			20	0000	0100	11	
5	0010			21	0000	0100	10	
6	0001	1		22	0000	0100	011	
7	0001	0		23	0000	0100	010	
8	0000	111		24	0000	0100	001	
9	0000	110		25	0000	0100	000	
10	0000	1011		26	0000	0011	111	
11	0000	1010		27	0000	0011	110	
12	0000	1001		28	0000	0011	101	
13	0000	1000		29	0000	0011	100	
14	0000	0111		30	0000	0011	011	
15	0000	0110		31	0000	0011	010	
16	0000	0101	11	32	0000	0011	001	
				33	0000	0011	000	
		MBA stuffing		0000	0001	111		
		start code		0000	0000	0000	0001	

Table 12.7. H.261 VLC Table for Macroblock Addressing.

Prediction	MQUANT	MVD	CBP	TCOEFF	Code		
Intra				x	0001		
Intra	x			x	0000	001	
Intra			x	x	1		
Intra	x		x	x	0000	1	
Intra + MC		x			0000	0000	1
Intra + MC		x	x	x	0000	0001	
Intra + MC	x	x	x	x	0000	0000	01
Intra + MC + FIL		x			001		
Intra + MC + FIL		x	x	x	01		
Intra + MC + FIL	x	x	x	x	0000	01	

Table 12.8. H.261 VLC Table for MTYPE.

(c) MTYPE of the previous macroblock was not motion-compensated.

Motion vector data consists of a variable length codeword for the horizontal component, followed by a variable length codeword for the vertical component. The variable length codes are listed in Table 12.9.

Coded Block Pattern (CBP)

The variable-length CBP is present if indicated by MTYPE. It indicates which blocks in the macroblock have at least one transform coefficient transmitted. The pattern number is represented as:

$$32 \cdot P1 + 16 \cdot P2 + 8 \cdot P3 + 4 \cdot P4 + 2 \cdot P5 + P6$$

where Pn = 1 for any coefficient present for block n, else 0. Block numbering is given in Figure 12.4.

The code words for the CBP number are given in Table 12.10.

Block Layer

A macroblock is made up of four luminance blocks, a Cb block, and a Cr block (see Figure 12.4).

Data for an 8 pixel × 8 line block consists of codewords for the transform coefficients fol-

Vector Difference	Code			Vector Difference	Code		
−16 & 16	0000	0011	001	1	010		
−15 & 17	0000	0011	011	2 & −30	0010		
−14 & 18	0000	0011	101	3 & −29	0001	0	
−13 & 19	0000	0011	111	4 & −28	0000	110	
−12 & 20	0000	0100	001	5 & −27	0000	1010	
−11 & 21	0000	0100	011	6 & −26	0000	1000	
−10 & 22	0000	0100	11	7 & −25	0000	0110	
−9 & 23	0000	0101	01	8 & −24	0000	0101	10
−8 & 24	0000	0101	11	9 & −23	0000	0101	00
−7 & 25	0000	0111		10 & −22	0000	0100	10
−6 & 26	0000	1001		11 & −21	0000	0100	010
−5 & 27	0000	1011		12 & −20	0000	0100	000
−4 & 28	0000	111		13 & −19	0000	0011	110
−3 & 29	0001	1		14 & −18	0000	0011	100
−2 & 30	0011			15 & −17	0000	0011	010
−1	011						
0	1						

Table 12.9. H.261 VLC Table for MVD.

CBP	Code		CBP	Code	
60	111		62	0100	0
4	1101		24	0011	11
8	1100		36	0011	10
16	1011		3	0011	01
32	1010		63	0011	00
12	1001	1	5	0010	111
48	1001	0	9	0010	110
20	1000	1	17	0010	101
40	1000	0	33	0010	100
28	0111	1	6	0010	011
44	0111	0	10	0010	010
52	0110	1	18	0010	001
56	0110	0	34	0010	000
1	0101	1	7	0001	1111
61	0101	0	11	0001	1110
2	0100	1	19	0001	1101

Table 12.10a. H.261 VLC Table for CBP.

CBP	Code		CBP	Code		
35	0001	1100	38	0000	1100	
13	0001	1011	29	0000	1011	
49	0001	1010	45	0000	1010	
21	0001	1001	53	0000	1001	
41	0001	1000	57	0000	1000	
14	0001	0111	30	0000	0111	
50	0001	0110	46	0000	0110	
22	0001	0101	54	0000	0101	
42	0001	0100	58	0000	0100	
15	0001	0011	31	0000	0011	1
51	0001	0010	47	0000	0011	0
23	0001	0001	55	0000	0010	1
43	0001	0000	59	0000	0010	0
25	0000	1111	27	0000	0001	1
37	0000	1110	39	0000	0001	0
26	0000	1101				

Table 12.10b. H.261 VLC Table for CBP.

lowed by an end of block (EOB) marker as shown in Figure 12.10. The order of block transmission is shown in Figure 12.4.

Transform Coefficients (TCOEFF)

When MTYPE indicates INTRA, transform coefficient data is present for all six blocks in a macroblock. Otherwise, MTYPE and CBP signal which blocks have coefficient data transmitted for them. The quantized DCT coefficients are transmitted as shown in Figure 12.11.

The most common combinations of successive zeros (RUN) and the following value (LEVEL) are encoded using variable length codes, listed in Table 12.11. Since CBP indicates blocks with no coefficient data, EOB cannot occur as the first coefficient. The last bit "s" denotes the sign of the level: "0" = positive, "1" = negative.

Other combinations of (RUN, LEVEL) are encoded using a 20-bit word: 6 bits of escape (ESC), 6 bits of RUN, and 8 bits of LEVEL, as shown in Table 12.12.

Two code tables are used for the variable length coding: one is used for the first transmitted LEVEL in INTER, INTER + MC, and INTER + MC + FIL blocks; another is used for all other LEVELs, except for the first one in INTRA blocks, which is fixed-length coded with 8 bits.

All coefficients, except for INTRA DC, have reconstruction levels (REC) in the range –2048 to 2047. Reconstruction levels are recovered by the following equations, and the results are clipped. QUANT ranges from 1 to 31 and is transmitted by either GQUANT or MQUANT.

Figure 12.10. H.261 Block Layer Structure.

0	1	5	6	14	15	27	28
2	4	7	13	16	26	29	42
3	8	12	17	25	30	41	43
9	11	18	24	31	40	44	53
10	19	23	32	39	45	52	54
20	22	33	38	46	51	55	60
21	34	37	47	50	56	59	61
35	36	48	49	57	58	62	63

Figure 12.11. H.261 Transmission Order for Transform Coefficients.

Run	Level	Code			
EOB		10			
0	1	1s	if first coefficient in block*		
0	1	11s	if not first coefficient in block		
0	2	0100	s		
0	3	0010	1s		
0	4	0000	110s		
0	5	0010	0110	s	
0	6	0010	0001	s	
0	7	0000	0010	10s	
0	8	0000	0001	1101	s
0	9	0000	0001	1000	s
0	10	0000	0001	0011	s
0	11	0000	0001	0000	s
0	12	0000	0000	1101	0s
0	13	0000	0000	1100	1s
0	14	0000	0000	1100	0s
0	15	0000	0000	1011	1s

Table 12.11a. H.261 VLC Table for TCOEFF.
***Never used in INTRA macroblocks.**

Run	Level	Code			
1	1	011s			
1	2	0001	10s		
1	3	0010	0101	s	
1	4	0000	0011	00s	
1	5	0000	0001	1011	s
1	6	0000	0000	1011	0s
1	7	0000	0000	1010	1s
2	1	0101	s		
2	2	0000	100s		
2	3	0000	0010	11s	
2	4	0000	0001	0100	s
2	5	0000	0000	1010	0s
3	1	0011	1s		
3	2	0010	0100	s	
3	3	0000	0001	1100	s
3	4	0000	0000	1001	1s

Table 12.11b. H.261 VLC Table for TCOEFF.

Run	Level	Code			
4	1	0011	0s		
4	2	0000	0011	11s	
4	3	0000	0001	0010	s
5	1	0001	11s		
5	2	0000	0010	01s	
5	3	0000	0000	1001	0s
6	1	0001	01s		
6	2	0000	0001	1110	s
7	1	0001	00s		
7	2	0000	0001	0101	s
8	1	0000	111s		
8	2	0000	0001	0001	s
9	1	0000	101s		
9	2	0000	0000	1000	1s
10	1	0010	0111	s	
10	2	0000	0000	1000	0s

Table 12.11c. H.261 VLC Table for TCOEFF.

Run	Level	Code			
11	1	0010	0011	s	
12	1	0010	0010	s	
13	1	0010	0000	s	
14	1	0000	0011	10s	
15	1	0000	0011	01s	
16	1	0000	0010	00s	
17	1	0000	0001	1111	s
18	1	0000	0001	1010	s
19	1	0000	0001	1001	s
20	1	0000	0001	0111	s
21	1	0000	0001	0110	s
22	1	0000	0000	1111	1s
23	1	0000	0000	1111	0s
24	1	0000	0000	1110	1s
25	1	0000	0000	1110	0s
26	1	0000	0000	1101	1s
ESC		0000	01		

Table 12.11d. H.261 VLC Table for TCOEFF.

Run	Code	Level	Code
0	0000 00	−128	forbidden
1	0000 01	−127	1000 0001
:	:	:	:
63	1111 11	−2	1111 1110
		−1	1111 1111
		0	forbidden
		1	0000 0001
		2	0000 0010
		:	:
		127	0111 1111

Table 12.12. H.261 Run, Level Codes.

```
QUANT = odd:
   for LEVEL > 0
      REC = QUANT*(2*LEVEL + 1)
   for LEVEL < 0
      REC = QUANT*(2*LEVEL − 1)

QUANT = even:
   for LEVEL > 0
      REC = (QUANT*(2*LEVEL + 1)) − 1
   for LEVEL < 0
      REC = (QUANT*(2*LEVEL − 1)) + 1
   for LEVEL = 0
      REC = 0
```

For INTRA DC blocks, the first coefficient is typically the transform value quantized with a step size of 8 and no dead zone, resulting in an 8-bit coded value, n. Black has a coded value of 0001 0000 (16), and white has a coded value of 1110 1011 (235). A transform value of 1024 is coded as 1111 1111. Coded values of 0000 0000 and 1000 0000 are not used. The decoded value is $8n$, except an n value of 255 results in a reconstructed transform value of 1024.

Still Image Transmission

H.261 allows the transmission of a still image of four times the resolution of the currently selected video format. If the video format is QCIF, a still image of CIF resolution may be transmitted; if the video format is CIF, a still image of 704 ×576 resolution may be transmitted.

G.728

ITU-T G.728 defines the algorithm for the encoding and decoding of audio signals at 16 kbps, using low-delay excited linear prediction (LD-CELP).

The G.728 encoder accepts 64 kbps A-law or μ-law PCM digital audio, generating 16 kbps LD-CELP digital audio.

The G.728 decoder accepts 16 kbps LD-CELP digital audio, generating 64 kbps A-law or μ-law PCM digital audio.

A system supporting G.728 also must support G.711 audio. However, a video conferencing system should support all three audio standards (G.711, G.722, and G.728).

G.722

ITU-T G.722 defines the algorithm for the encoding and decoding of 7-kHz audio signals at 48, 56, and 64 kbps, using sub-band adaptive differential pulse code modulation (SB-ADPCM).

The G.722 encoder digitizes the 7-kHz analog audio signal to 14 bits using a 16-kHz sampling rate. A SB-ADPCM encoder then reduces the bit rate to 48, 56, or 64 kbps.

The G.722 decoder accepts 48, 56, or 64 kbps SB-ADPCM digital audio, generating 14-bit digital audio with a 16-kHz sampling rate. This may then be converted to analog audio.

A system supporting G.722 also must support G.711 audio. However, a video conferencing system should support all three audio standards (G.711, G.722, and G.728).

G.711

ITU-T G.711 defines the algorithm for the encoding and decoding of 3.5-kHz audio signals at 64 kbps, using A-law or μ-law.

The G.711 encoder digitizes the 3.5-kHz analog audio signal to 13 bits using an 8-kHz sampling rate. It is then converted to 8-bit A-law PCM or μ-law PCM resulting in a bit rate of 64 kbps.

The G.711 decoder accepts 64 kbps A-law PCM or μ-law PCM digital audio, generating 13-bit digital audio with a 8-kHz sampling rate. This may then be converted to analog audio.

A video conferencing system should support all three audio standards (G.711, G.722, and G.728).

H.221

ITU-T H.221 covers the frame structure for audio, video, and data streams across 1–6 ISDN B channels (64 kbps each), 1–5 H_0 channels (switched 384 kbps each), an H_{11} (switched 1.526 Mbps) channel, or an H_{12} channel (switched 1.920 Mbps).

Overview

The 64-kbps B channel is divided into eight subchannels of 8 kbps each (Figure 12.12). The eighth subchannel is called the service channel (SC).

An H_0, H_{11}, or H_{12} channel may be thought of as having of a number of 64 kbps channels. In this case, the lowest numbered 64 kbps channel looks like a single-64 kbps B channel. The remaining 64 kbps channels have no such organization.

If multiple B or H_0 channels are used, the first or initial channel used (I channel) controls the overall transmission. If a single B or H_0 channel is used, it is also referred to as the I channel. The TS1 channel of H_{11} and H_{12} channels are also referred to as the I channel.

For countries using 56 kbps channels, available bit rates are 8-kbps less. Communications between 64-kbps systems and 56-kbps systems are defined within H.221.

Frame Alignment Signal (FAS)

This signal structures the I channel, and other framed 64-kbps channels, into frames of 80 octets each.

Bits 1–8 of the service channel in each frame are referred to as FAS. The FAS contains framing and error check information.

Bit Rate Allocation Signal (BAS)

Bits 9–16 of the service channel in each frame are referred to as BAS. The BAS allows the transmission of data to describe the capability of a system, to structure the capacity of the channel, and to synchronize multiple channels. The BAS also is used for control and indication (C&I) signals.

Bit Number								Octet Number
1	**2**	**3**	**4**	**5**	**6**	**7**	**8 (SC)**	
								1
							FAS	:
								8
								9
							BAS	:
								16
								17
							ECS	:
								24
								25
								:
								80

Figure 12.12. H.221 Frame Structure for a Single 64-kbps B channel. Each bit number corresponds to an 8-kbps subchannel. The BAS code indicates how the remaining bits are used for audio, video, or data.

H.221 and H.230 define the various BAS codes. They can be broken down into several categories:

> Audio command
> Transfer rate command
> Video and other command
> Data command
> Terminal capability
> Escape codes

Each BAS code is assigned eight error correction bits, implementing a double error correcting code. The 8-bit BAS code (b0–b7) is sent in even-numbered frames; the eight error correction bits (p0–p7) are sent in the odd-numbered frames, as shown in Figure 12.13.

Upon receiving a BAS code in an even frame, and its error-correcting code in the next (odd) frame, a receiver accepts the mode

Bit Position	Even Frame	Odd Frame
9	b0	p2
10	b3	p1
11	b2	p0
12	b1	p4
13	b5	p3
14	b4	p5
15	b6	p6
16	b7	p7

Figure 12.13. H.221 BAS (b0–b7) and Error Correction (p0–p7) Bit Positions.

change starting with the next even frame. This allows mode changing to occur in 20 ms.

Encryption Control Signal (ECS)

Encryption capability is supported using a 800-bps ECS, provided by allocating bits 17–24 of the service channel. When implemented, ECS reduces the audio, video, and data transmission rates available by 800 bps.

Remaining Capacity

The remaining bits are used to support a variety of transfers, under the control of the BAS. For a single 64-kbps channel, these include:

56 kbps audio
16 kbps audio and 46.4 kbps video
48 kbps audio and 14.4 kbps data
56 kbps still pictures or data
Low speed (300–62.4k bps) general data

High speed (64–1536 kbps) general data transfers and higher video rates may be supported using up to six B channels or a H_0 channel.

Video occupies all capacity not allocated for other functions, such as audio or data.

Figures 12.14 through 12.18 show various uses of a single 64-kbps channel. Figure 12.19 illustrates how two 64-kbps channels may be used to transfer video at 76.8 kbps. The rest of the capacity may be used for audio and data.

Frame Alignment Signal (FAS)

The FAS bits from 16 frames are combined into a multiframe. Each multiframe is broken down into eight submultiframes (SMF). This is illustrated in Figure 12.20, in addition to the FAS bit assignments for each multiframe.

N1–N4 specify the multiframe number from 0–15, and is also set to 0 when the numbering is inactive. N5 indicates whether multiframe numbering is active (N5 = 1) or inactive (N5 = 0).

L1–L2 specify the channel number from 1–6.

The "TEA" bit (terminal equipment alarm) is set to 1 while a terminal equipment fault exists, not allowing incoming signals to be received and processed.

The "R bit" is reserved for future use and is set to 0.

C1–C4 are optional cyclic redundancy check (CRC) bits. When CRC is not used, these bits are set to 1.

The "E" bit is used to transmit an indication whether the most recent CRC block

Audio Bit Rate	Bit Number							
	1	**2**	**3**	**4**	**5**	**6**	**7**	**8 (SC)**
G.711	MSB	LSB
G.722 (64 kbps)	H	H	L	L	L	L	L	L
G.722 (56 kbps)	H	H	L	L	L	L	L	
G.722 (48 kbps)	H	H	L	L	L	L		

Figure 12.14. H.221 Bit Numbering and Positions for G.711 and G.722 Audio Within a Single 64-kbps Channel. H = high-band audio, L = low-band audio.

Bit Number								Octet Number
1	**2**	**3**	**4**	**5**	**6**	**7**	**8 (SC)**	
						1	FAS	**1**
						:		:
						8		**8**
						9	BAS	**9**
						:		:
						16		**16**
						17	18	**17**
						19	20	**18**
						:	:	:
						143	144	**80**

Figure 12.15. H.221 Frame: Bit Numbering and Positions for 14.4 kbps Low Speed Data Within a Single 64-kbps Channel.

Bit Number								Octet Number
1	**2**	**3**	**4**	**5**	**6**	**7**	**8 (SC)**	
1	2	3	4	5	6	7		**1**
:	:	:	:	:	:	:	FAS	:
50	51	52	53	54	55	56		**8**
57	58	59	60	61	62	63		**9**
:	:	:	:	:	:	:	BAS	:
106	107	108	109	110	111	112		**16**
113	114	115	116	117	118	119	–	**17**
:	:	:	:	:	:	:	:	:
554	555	556	557	558	559	560	–	**80**

Figure 12.16. H.221 Frame: Bit Numbering and Positions for 56 kbps Low Speed Data Within a Single 64-kbps Channel.

Bit Number								Octet Number
1	**2**	**3**	**4**	**5**	**6**	**7**	**8 (SC)**	
1	2	3	4	5	6	7		**1**
:	:	:	:	:	:	:	FAS	:
50	51	52	53	54	55	56		**8**
57	58	59	60	61	62	63		**9**
:	:	:	:	:	:	:	BAS	:
106	107	108	109	110	111	112		**16**
113	114	115	116	117	118	119	120	**17**
:	:	:	:	:	:	:	:	:
617	618	619	620	621	622	623	624	**80**

Figure 12.17. H.221 Frame: Bit Numbering and Positions for 62.4 kbps Low Speed Data Within a Single 64-kbps Channel.

	Bit Number				Octet Number
	1	**2**	**3–7**	**8 (SC)**	
	09	08			**1**
	07	06			**2**
	:	:			:
	01	00			**5**
	19	18			**6**
Speech Coder Frame 0 (2.5 ms)	:	:		FAS and BAS	:
	11	10			**10**
	29	28			**11**
	:	:			:
	21	20			**15**
	39	38			**16**
	:	:			:
	31	30			**20**
Speech Coder Frame 1	09	08			**21**
	:	:			:
	31	30			**40**
Speech Coder Frame 2	09	08			**41**
	:	:			:
	31	30			**60**
Speech Coder Frame 3	09	08			**61**
	:	:			:
	31	30			**80**

Figure 12.18. H.221 Frame: Bit Numbering and Positions for G.728 16 kbps Audio Within a Single 64-kbps Channel.

Initial Channel			Additional Channel								Octet
Bit Number			Bit Number								Number
1–6	7	8	1	2	3	4	5	6	7	8 (SC)	
	1		2	3	4	5	6	7	8		1
	:	FAS	:	:	:	:	:	:	:	FAS	:
	57		58	59	60	61	62	63	64		8
	65		66	67	68	69	70	71	72		9
	:	BAS	:	:	:	:	:	:	:	BAS	:
	121		122	123	124	125	126	127	128		16
	129	130	131	132	133	134	135	136	137	138	17
	:	:									:
	759	760	761	762	763	764	765	766	767	768	80

Figure 12.19. H.221 Frames: Bit Numbering and Positions for 76.8 kbps H.261 Video Using Two 64-kbps Channels.

SMF Number	Frame Number	FAS Bit Number							
		1	2	3	4	5	6	7	8
1	0	N1	0	0	1	1	0	1	1
	1	0	1	A	E	C1	C2	C3	C4
2	2	N2	0	0	1	1	0	1	1
	3	0	1	A	E	C1	C2	C3	C4
3	4	N3	0	0	1	1	0	1	1
	5	1	1	A	E	C1	C2	C3	C4
4	6	N4	0	0	1	1	0	1	1
	7	0	1	A	E	C1	C2	C3	C4
5	8	N5	0	0	1	1	0	1	1
	9	1	1	A	E	C1	C2	C3	C4
6	10	L1	0	0	1	1	0	1	1
	11	1	1	A	E	C1	C2	C3	C4
7	12	L2	0	0	1	1	0	1	1
	13	L3	1	A	E	C1	C2	C3	C4
8	14	TEA	0	0	1	1	0	1	1
	15	R	1	A	E	C1	C2	C3	C4

Figure 12.20. H.221 Multiframe FAS Bit Assignments.

received contained errors (E = 1) or not (E = 0). E also is set to 0 when CRC is not used.

The "A" bit indicates whether there is a loss of multiframe alignment (0 = alignment, 1 = loss of alignment). Multiframe alignment is used to number and synchronize two or more channels.

H.230

ITU-T H.230 covers the definition and requirements of additional control and indication (C&I) signals, along with their corresponding BAS codes. Each H.230 BAS code is transmitted after the H.221 escape code.

H.320 uses a subset (listed in Table 12.5) of the C&I signals specified by H.230, so the H.230 recommendation is not covered in detail here.

H.231

ITU-T H.231 covers the multipoint control unit (MCU) that allows bridging three or more H.320 systems together in a simultaneous conference.

H.242

ITU-T H.242 covers the protocol for making a connection and disconnecting it when the session is done. It also covers in-band information exchange, how to recover from faults, how to add/remove channels, and transferring calls.

H.243

ITU-T H.243 covers the procedures for connecting three or more H.320 systems, using digital channels up to 2 Mbps.

Implementation Considerations

Figure 12.21 illustrates implementing a typical H.320 conferencing system for the PC assuming separate ISDN and graphics card are used.

Self-View Window

One consideration is the implementation of a self-view window so the user can see what is transmitted. Ideally, the video in this window is reversed left-to-right so as not to confuse the user.

With horizontal reversal, the self-view window behaves as a mirror, with which most users are familiar. Without horizontal reversal, the user may confuse the left and right directions while watching the video.

This window should be able to be scaled to any size and positioned anywhere on the screen.

One problem is how to transmit two video windows (the self-view window and the main conferencing window) to a graphics card. Most video interfaces only support a single video stream. This can be solved by using the design in Figure 12.21. GUI accelerator manufacturers are working on video interfaces to support multiple video streams.

Window Scaling

The main conferencing window should be able to be scaled to any size and positioned anywhere on the screen. Usually, this is handled by the GUI accelerator on the graphics board.

Conference Recording

The ability to store the video conferencing session to video tape or hard disk should be supported. Possibly, there also should be a beep

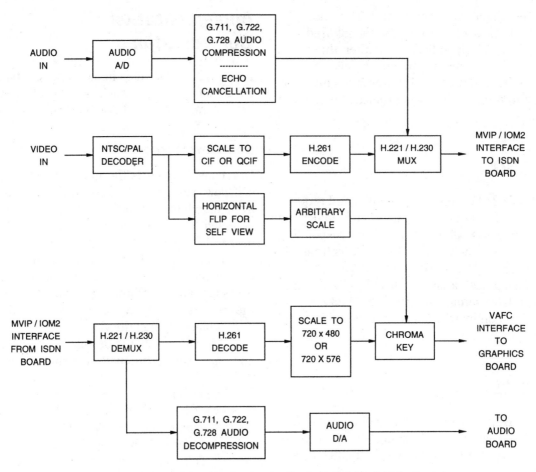

Figure 12.21. Block Diagram of a Typical H.320 Add-In Board.

every couple of seconds, or a flashing "you are being recorded" message.

The ability to play back a previously recorded video conferencing session for either or both users to view is also a useful feature.

H.263 Support

Since H.263 (discussed in Chapter 13) can transmit video more efficiently, expect H.320 to be modified to support the use of H.263.

PCI Data Transfer Support

With PCI systems now available, there are several options for transferring data over the PCI bus. If a PCI bus is supported, there are some additional features that could be implemented for hardware and software flexibility.

Audio

The audio compressor chip should support the ability to input uncompressed audio from

either the audio A/D converter or via software through the PCI bus. The compressed audio then may be output to either the H.221/H.230 multiplexer or via software through the PCI bus.

The audio decompressor chip should support the ability to input compressed audio from either the H.221/H.230 demultiplexer or via software through the PCI bus. The uncompressed audio then may be output to either the audio D/A converter or via software through the PCI bus.

Video

The H.261 compressor chip should support the ability to input uncompressed video from either the NTSC/PAL decoder or via software through the PCI bus. The compressed video then may be output to either the H.221/H.230 multiplexer or via software through the PCI bus.

The H.261 decompressor chip should support the ability to input compressed video from either the H.221/H.230 demultiplexer or via software through the PCI bus. The uncompressed video then may be output to either the graphics board or via software through the PCI bus.

System

The H.221/H.230 multiplexer chip should support the ability to input compressed audio and video bitstreams from either audio and video compressors or via software through the PCI bus. The system bitstreams then may be output to either the ISDN interface or via software through the PCI bus.

The H.221/H.230 demultiplexer chip should support the ability to input system bitstreams from either the ISDN interface or via software through the PCI bus. The demultiplexed compressed bitstreams then may be output to either the audio/video decompressors or via software through the PCI bus.

Temporal Pre-Processing

By performing temporal filtering after the NTSC/PAL decoder to remove low-level noise generated by the camera, an increase in compression ratio up to 10× is possible. Performing anti-aliased horizontal and vertical scaling to CIF also improves the compression ratio.

Pixel Clock Jitter

Pixel clock jitter is a major consideration in selecting an NTSC/PAL decoder to drive the H.261 video compressor. If the pixel clock jitter is over about 10 ns, there could be frame-to-frame differences in still areas large enough to be considered as movement by the H.261 video compressor. Without temporal processing, this will reduce the compression ratio, possibly requiring the use of a smaller image or, at the least, resulting in a lower frame rate.

References

1. ITU-T Recommendation G.711, *Pulse Code Modulation (PCM) of Voice Frequencies.*
2. ITU-T Recommendation G.722, *7 kHz Audio-Coding With 64 kbit/s.*
3. ITU-T Recommendation G.728, *Coding of Speech at 16 kbit/s Using Low-Delay Code Excited Linear Prediction.*
4. ITU-T Recommendation H.221, *Frame Structure for a 64 to 1920 kbit/s Channel in Audiovisual Teleservices*, 3/93.
5. ITU-T Recommendation H.230, *Frame-Synchronous Control and Indication Signals for Audiovisual Systems*, 3/93.
6. ITU-T Recommendation H.233, *Confidentiality System for Audiovisual Services*, 3/93.
7. ITU-T Recommendation H.242, *System for Establishing Communication Between Audiovisual Terminals Using Digital Channels Up To 2 Mbit/s*, 3/93.

8. ITU-T Recommendation H.243, *Procedures for Establishing Communication Between Three or More Audiovisual Terminals Using Digital Channels up to 2 Mbit/s*, 3/93.

9. ITU-T Recommendation H.261, *Video Codec for Audiovisual Services at p × 64 kbits*, 3/93.

10. ITU-T Recommendation H.320, *Narrow-Band Visual Telephone Systems and Terminal Equipment*, 3/93.

Video Conferencing (GSTN)

Work has started on standards for video conferencing over the General Switched Telephone Network (GSTN), also referred to as the Public Switched Telephone Network (PSTN) and the Plain Old Telephone System (POTS).

H.324

ITU-T Recommendation H.324 covers low bit rate multimedia communication, typically over conventional phone lines using a v.34 28.8-kbps modem. Table 13.1 lists the relevant standards and their function. Figure 13.1 illustrates the block diagram of a typical H.324 system.

H.263

ITU-T Recommendation H.263 covers the video compression and decompression portion of video conferencing and video phones over normal phone lines.

The video encoder provides a self-contained digital bitstream which is combined with other signals (defined in H.223). The video decoder performs the reverse process. The primary specifications of H.263 regarding YCbCr video data are listed in Table 13.2. The 4:2:0 YCbCr sampling is shown in Figure 13.2.

H.263 is about two times more efficient than H.261 in generating compressed video. For this reason, expect H.320 to be modified to support H.263 fairly quickly.

Coding Algorithm

A typical encoder block diagram is shown in Figure 13.3. The basic functions are prediction, block transformation, and quantization.

The prediction error or the input picture are subdivided into 8×8 blocks which are segmented as transmitted or non-transmitted. Four luminance blocks and the two spatially corresponding color difference blocks are combined to form a macroblock as shown in Figure 13.4.

The criteria for choice of mode and transmitting a block are not recommended and may be varied dynamically as part of the coding strategy. Transmitted blocks are transformed and resulting coefficients are quantized and variable length coded.

Audio Standard	Video Standard	Control Standard	Purpose
ITU-T G.723			audio codec standard
	ITU-T H.263 ITU-T H.261		video codec standard
		ITU-T H.223	multiplexing protocol
		ITU-T H.245	control protocol
		ITU-T V.8	protocols for starting and ending data transmission sessions over GSTN
		ITU-T V.34	28.8 kbps modem specification
		ITU-T T.120	real-time audiographics conferencing
		ITU-T T.84 ISO/IEC 10918-3	still image file transfer
		ITU-T T.434	point-to-point file transfer
		ITU-T H.233	encryption
		ITU-T H.234	encryption key handling

Table 13.1. H.324 Family of Standards.

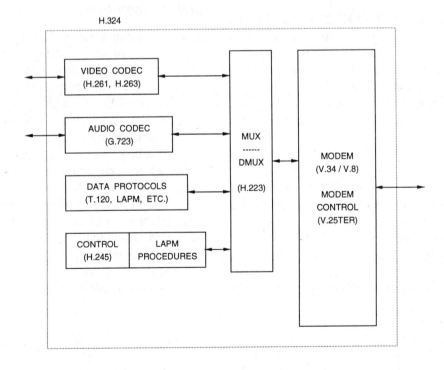

Figure 13.1. Typical H.324 Visual Phone System.

Parameters	16CIF	4CIF	CIF	QCIF	SQCIF
Coded signals: Y, Cb, Cr	These signals are obtained from gamma precorrected signals, namely: Y, B′ − Y, R′ − Y or R′, G′, B′.				
Active resolution (Y)	1408×1152	704×576	352×288	176×144	128×96
Frame refresh rate	29.97 Hz				
YCbCr sampling structure	4:2:0				
Form of YCbCr coding	Uniformly quantized PCM, 8 bits per sample.				

Table 13.2. H.263 YCbCr Parameters.

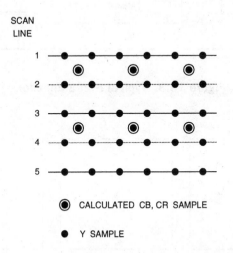

Figure 13.2. H.263 4:2:0 YCbCr Sampling.

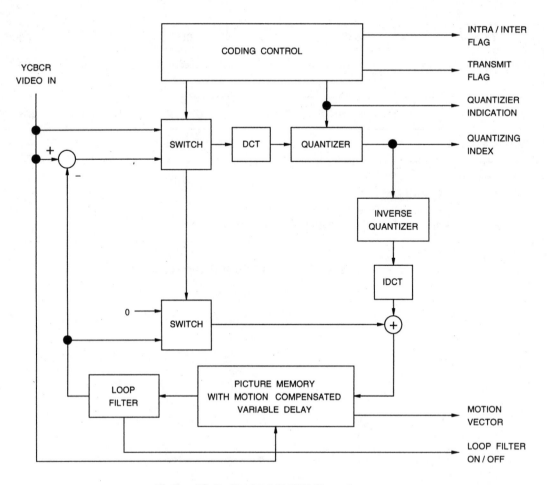

Figure 13.3. Typical H.263 Encoder.

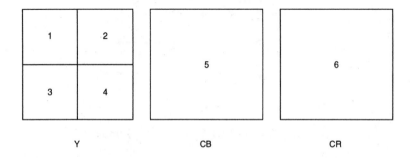

Figure 13.4. H.263 Arrangement of Blocks in a Macroblock.

Prediction

The prediction is interpicture and may include motion compensation. The coding mode using prediction is called INTER; the coding mode using no prediction is called INTRA.

INTRA coding is signalled at the picture level (I frame for INTRA or P frame for INTER) or at the macroblock level in P frames. In the PB frame mode, B frames always use INTER mode.

Motion Compensation

Motion compensation is optional in the encoder. The decoder must support accepting one motion vector per macroblock (one or four motion vectors per macroblock in the advanced prediction mode). Motion vectors are restricted such that all pixels referenced by them are within the coded picture area, unless the unrestricted motion vector mode is used.

The horizontal and vertical components of motion vectors have integer or half-integer values not exceeding –16 to +15.5. A positive value of the horizontal or vertical component of the motion vector typically indicates that the prediction is formed from pixels in the previous frame which are spatially to the right or below the pixels being predicted. However, for backward motion vectors in B frames, a positive value of the horizontal or vertical component of the motion vector indicates that the prediction is formed from pixels in the next frame which are spatially to the left or above the pixels being predicted.

Quantization

The number of quantizers is 1 for the first INTRA coefficient and 31 for all other coefficients. Within a macroblock, the same quantizer is used for all coefficients except the first one of INTRA blocks. The first INTRA coefficient is usually the transform DC value linearly quantized with a step size of 8 and no dead zone. Each of the other 31 quantizers are also linear, but with a central dead zone around zero and a step size of an even value in the range of 2 to 62.

Coding Control

Although not included as part of H.263, several parameters may be varied to control the rate of coded video data. These include processing prior to coding, the quantizer, block significance criterion, and temporal subsampling. Temporal subsampling is performed by discarding complete pictures.

Forced Updating

This is achieved by forcing the use of the INTRA mode. For control of accumulation of inverse transform mismatch errors, a macroblock should be forcibly updated at least once every 132 times it is transmitted.

Video Multiplexer

Unless specified otherwise, the most significant bits are transmitted first. Bit 1, the leftmost bit in the code tables, is the most significant. Unless specified otherwise, all unused or spare bits are set to "1."

The video multiplexer is arranged in a hierarchical structure with four layers. From top to bottom the layers are:

> Picture
> Group of Blocks
> Macroblock
> Block

Picture Layer

Data for each picture consists of a picture header followed by data for a group of blocks (GOBs), followed by an end-of-sequence (EOS) and stuffing bits (STUF). The structure is shown in Figure 13.5. Picture headers for dropped pictures are not transmitted.

Picture Start Code (PSC)

PSC is a 22-bit word with a value of 0000 0000 0000 0000 1 00000. It must be byte-aligned; therefore, 0–7 zero bits are added before the start code to ensure the first bit of the start code is the first, and most significant, bit of a byte.

Temporal Reference (TR)

TR is an 8-bit number representing 256 possible values. It is generated by incrementing its value in the previously transmitted picture header by one and adding the number of nontransmitted 29.97 Hz pictures since the last transmitted one. The arithmetic is performed with only the eight LSBs. In the PB-frames mode, TR only addresses P frames.

Type Information (PTYPE)

Thirteen bits of information about the picture are:

Bit 1 "0"

Bit 2 "1"

Bit 3 Split screen indicator
"0" = off, "1" = on

Bit 4 Document camera indicator
"0" = off, "1" = on

Bit 5 Freeze picture release
"0" = off, "1" = on

Bit 6–8 Source format
"000" = SQCIF
"001" = QCIF
"010" = CIF
"011" = 4CIF
"100" = 16CIF
"101" = reserved
"110" = reserved
"111" = reserved

Bit 9 Picture Coding Type
"0" = intra, "1" = inter

Bit 10 Optional unrestricted motion vector mode
"0" = off, "1" = on

Bit 11 Optional syntax-based arithmetic coding mode
"0" = off, "1" = on

PSC	TR	PTYPE	PQUANT	CPM	PLCI	TRB	DBQUANT	PEI	PSPARE	PEI	GOB DATA	EOS	STUF

Figure 13.5. H.263 Picture Layer Structure.

Bit 12 Optional advanced prediction mode
"0" = off, "1" = on

Bit 13 Optional PB frames mode
"0" = normal picture,
"1" = PB frame

If bit 9 is set to "0," bit 13 must be set to "0." If bit 12 is set to "1," bit 10 must be set to "1." Bits 10–13 are optional modes that are negotiated between the encoder and decoder.

Quantizer Information (PQUANT)
PQUANT is a 5-bit number (value of 1–31) representing the quantizer QUANT to be used until updated by a subsequent GQUANT or DQUANT.

Continuous Presence Multipoint (CPM)
CPM is a 1-bit value that indicates the use of CPM. "0" is off, "1" is on.

Picture Logical Channel Indicator (PLCI)
PLCI is a 2-bit number representing the logical channel number until the next picture or GOB start code. PLCI is present only if CPM mode is enabled.

Temporal Reference of B Frames (TRB)
TRB is present if PTYPE indicates PB frame. TRB is a 3-bit value of the [number + 1] of non-transmitted pictures (at 29.97 Hz) since the last P or I frame and before the B frame.

Quantizer Information for B Frames (DBQUANT)
DBQUANT is present if PTYPE indicates PB frame. DBQUANT is a 2-bit value indicating the relationship between QUANT and BQUANT as shown in Table 13.3. The division is done using truncation. BQUANT has a range of 1–31. If the result is less than 1 or greater than 31, BQUANT is clipped to 1 and 31, respectively.

DBQUANT	BQUANT
00	(5 * QUANT) / 4
01	(6 * QUANT) / 4
10	(7 * QUANT) / 4
11	(8 * QUANT) / 4

Table 13.3. H.263 DBQUANT Codes and QUANT/BQUANT Relationship.

Extra Insertion Information (PEI)
PEI is a bit which when set to "1" signals the presence of the following optional data field.

Spare Information (PSPARE)
If PEI is set to "1," then 9 bits follow consisting of 8 bits of data (PSPARE) and another PEI bit to indicate if a further 9 bits follow, and so on.

End of Sequence (EOS)
EOS is a 22-bit word with a value of 0000 0000 0000 0000 1 11111. EOS must be byte aligned by inserting 0–7 zero bits before the code so that the first bit of the EOS code is the first, and most significant, bit of a byte.

Stuffing (STUF)
STUF is a variable-length word of zero bits. The last bit of STUF must be the last, and least significant, bit of a byte.

Group of Blocks Layer

Each picture is divided into groups of blocks (GOBs). A GOB comprises 16 lines for SQCIF, QCIF, and CIF, 32 lines for 4CIF, and 64 lines for 16CIF pictures. Thus, a CIF picture contains 18 GOBs (288/16). GOB numbering starts with 0 at the top of picture, and increases going down vertically.

Data for each GOB consists of a GOB header followed by one row of macroblock data for SQCIF, QCIF, and CIF, as shown in Figure 13.6. A GOB contains two macroblock rows for 4CIF and four macroblock rows for 16CIF. Macroblock data is transmitted in increasing macroblock number order. A decoder can signal an encoder to transmit only non-empty GOB headers.

Group of Blocks Start Code (GBSC)

GBSC is a 17-bit word with a value of 0000 0000 0000 0000 1. It must be byte-aligned; therefore, 0–7 zero bits are added before the start code to ensure the first bit of the start code is the first, and most significant, bit of a byte.

Group Number (GN)

GN has 5 bits indicating the binary representation of the number of the GOB. For GOB [0], the GOB header (GBSC, GN, GFID, GQUANT) is empty. Group number 31 is used by the EOS; group numbers 18–30 are reserved.

GOB Logical Channel Indicator (GLCI)

GLCI is a 2-bit number representing the logical channel number until the next picture or GOB start code. GLCI is present only if CPM mode is enabled.

GOB Frame ID (GFID)

GFID has 2 bits indicating the frame ID. It must have the same value in every GOB header of a given frame. If PTYPE is the same as for the previous frame, GFID must have the same value as the previous frame.

Quantizer Information (GQUANT)

GQUANT is a fixed length codeword of 5 bits that indicates the quantizer QUANT to be used in the group of blocks until overridden by any subsequent DQUANT. The codewords are the binary representations of the values of QUANT, ranging from 1 to 31.

Macroblock Layer

Each GOB is divided into macroblocks. A macroblock relates to 16 pixels by 16 lines of Y and the corresponding 8 pixels by 8 lines of Cb and Cr. Macroblock numbering increases left-to-right and top-to-bottom. Macroblock data is transmitted in increasing macroblock numbering order.

Data for a macroblock consists of a MB header followed by data for blocks (see Figure 13.7).

GBSC	GN	GLCI	GFID	GQUANT	MB DATA

Figure 13.6. H.263 Group of Blocks (GOB) Structure.

COD	MCBPC	MODB	CBPB	CBPY	DQUANT	MVD	MVD$_2$	MVD$_3$	MVD$_4$	MVDB	BLOCK DATA

Figure 13.7. H.263 Macroblock Structure.

Coded Macroblock Indication (COD)

COD is a single bit that indicates whether or not the block is coded. "0" indicates coded; "1" indicates not coded, and the rest of the macroblock layer is empty. COD is present only in pictures that PTYPE indicates INTER.

If not coded, the decoder processes the macroblock as an INTER block with motion vectors equal to zero for the whole block and no coefficient data.

Macroblock Type and Coded Block Pattern for Chrominance (MCBPC)

MCBPC is a variable-length word about the macroblock type and the coded block pattern for chrominance. It is present when indicated by COD or when PTYPE indicates INTRA.

Codewords for MCBPC are listed in Tables 13.4 and 13.5. A codeword is available for bit stuffing, and should be discarded by decoders. The macroblock types (MB Type) are listed in Tables 13.6 and 13.7.

The coded block pattern for chrominance (CBPC) signifies when a non-INTRA DC transform coefficient is transmitted for Cb or Cr. A "1" indicates a non-INTRA DC coefficient is present that block.

Macroblock Mode for B Blocks (MODB)

MODB is present for macroblock types 0–4 if PTYPE indicates PB frame. It is a variable length codeword indicating whether B coefficients and/or vectors are transmitted for this macroblock. Table 13.8 lists the codewords for MODB.

MB Type	CBPC (Cb, Cr)	Code		
3	0, 0	1		
3	0, 1	001		
3	1, 0	010		
3	1, 1	011		
4	0, 0	0001		
4	0, 1	0000	01	
4	1, 0	0000	10	
4	1, 1	0000	11	
stuffing		0000	0000	1

Table 13.4. H.263 VLC Table for MCBPC for INTRA Frames.

MB Type	CBPC (Cb, Cr)	Code		
0	0, 0	1		
0	0, 1	0011		
0	1, 0	0010		
0	1, 1	0001	01	
1	0, 0	011		
1	0, 1	0000	111	
1	1, 0	0000	110	
1	1, 1	0000	0010	1
2	0, 0	010		
2	0, 1	0000	101	
2	1, 0	0000	100	
2	1, 1	0000	0101	
3	0, 0	0001	1	
3	0, 1	0000	0100	
3	1, 0	0000	0011	
3	1, 1	0000	011	
4	0, 0	0001	00	
4	0, 1	0000	0010	0
4	1, 0	0000	0001	1
4	1, 1	0000	0001	0
stuffing		0000	0000	1

Table 13.5. H.263 VLC Table for MCBPC for INTER Frames.

Frame Type	MB Type	Name	COD	MCBPC	CBPY	DQUANT	MVD	MVD$_{2-4}$
inter	not coded		x					
inter	0	inter	x	x	x		x	
inter	1	inter + q	x	x	x	x	x	
inter	2	inter4v	x	x	x		x	x
inter	3	intra	x	x	x			
inter	4	intra + q	x	x	x	x		
inter	stuffing		x	x				
intra	3	intra		x	x			
intra	4	intra + q		x	x	x		
intra	stuffing			x				

Table 13.6. H.263 Macroblock Types and Data Elements for Normal Frames.

Frame Type	MB Type	Name	COD	MCBPC	MODB	CBPY
inter	not coded		x			
inter	0	inter	x	x	x	x
inter	1	inter + q	x	x	x	x
inter	2	inter4v	x	x	x	x
inter	3	intra	x	x	x	x
inter	4	intra + q	x	x	x	x
inter	stuffing		x	x		

Table 13.7a. H.263 Macroblock Types and Data Elements for PB Frames.

Frame Type	MB Type	Name	CBPB	DQUANT	MVD	MVDB	MVD$_{2-4}$
inter	not coded						
inter	0	inter	x		x	x	
inter	1	inter + q	x	x	x	x	
inter	2	inter4v	x		x	x	x
inter	3	intra	x		x	x	
inter	4	intra + q	x	x	x	x	
inter	stuffing						

Table 13.7b. H.263 Macroblock Types and Data Elements for PB Frames.

CBPB	MVDB	Code
		0
	x	10
x	x	11

Table 13.8. H.263 VLC Table for MODB.

Coded Block Pattern for B Blocks (CBPB)
The 6-bit CBPB is present if indicated by MODB. Each bit in CBPB corresponds to one of the six blocks in a macroblock (as shown in Figure 13.4). The left-most bit of CBPB corresponds to block number 1.

For each bit in CBPB, it is a "1" if any coefficient is present for the corresponding block.

Coded Block Pattern for Luminance (CBPY)
CBPY is a variable-length codeword specifying the Y blocks in the macroblock for which at least one non-INTRA DC transform coefficient is transmitted.

Table 13.9 lists the codes for CBPY. Y_N is a "1" if any non-intra DC coefficient is present for that Y block. Y block numbering is as shown in Figure 13.4.

Quantizer Information (DQUANT)
DQUANT is a 2-bit codeword signifying the change in QUANT. Table 13.10 lists the differential values for the codewords.

QUANT has a range of 1 to 31. If the value of QUANT as a result of the indicated change is less than 1 or greater than 31, it is made 1 and 31, respectively.

Motion Vector Data (MVD)
Motion vector data is included for all INTER macroblocks and INTRA blocks when in PB frame mode.

Motion vector data consists of a variable length codeword for the horizontal component, followed by a variable length codeword for the vertical component. The variable length codes are listed in Table 13.11.

Motion Vector Data (MVD_{2-4})
The three codewords MVD_2, MVD_3, and MVD_4 are present if indicated by PTYPE and MCBPC. Each consists of a variable length codeword for the horizontal component followed by a variable length codeword for the vertical component. The variable length codes are listed in Table 13.11.

Motion Vector Data for B Macroblock (MVDB)
MVDB is present if indicated by MODB. It consists of a variable length codeword for the horizontal component followed by a variable length codeword for the vertical component of each vector. The variable length codes are listed in Table 13.11.

Unrestricted Motion Vector Mode
The default prediction mode has the motion vectors restricted such that all pixels referenced by them are within the picture area.

The unrestricted motion vector mode removes this restriction, allowing motion vectors to point outside the picture area. This mode is indicated by PTYPE and is signalled via H.245.

CBPY (Y1, Y2, Y3, Y4)		Code	
INTRA	**INTER**		
0, 0, 0, 0	1, 1, 1, 1	0011	
0, 0, 0, 1	1, 1, 1, 0	0010	1
0, 0, 1, 0	1, 1, 0, 1	0010	0
0, 0, 1, 1	1, 1, 0, 0	1001	
0, 1, 0, 0	1, 0, 1, 1	0001	1
0, 1, 0, 1	1, 0, 1, 0	0111	
0, 1, 1, 0	1, 0, 0, 1	0000	10
0, 1, 1, 1	1, 0, 0, 0	1011	
1, 0, 0, 0	0, 1, 1, 1	0001	0
1, 0, 0, 1	0, 1, 1, 0	0000	11
1, 0, 1, 0	0, 1, 0, 1	0101	
1, 0, 1, 1	0, 1, 0, 0	1010	
1, 1, 0, 0	0, 0, 1, 1	0100	
1, 1, 0, 1	0, 0, 1, 0	1000	
1, 1, 1, 0	0, 0, 0, 1	0110	
1, 1, 1, 1	0, 0, 0, 0	11	

Table 13.9. H.263 VLC Table for CBPY.

Differential Value of QUANT	DQUANT
−1	00
−2	01
1	10
2	11

Table 13.10. H.263 DQUANT Codes for QUANT Differential Values.

Vector Difference		Code			
−16	16	0000	0000	0010	1
−15.5	16.5	0000	0000	0011	1
−15	17	0000	0000	0101	
−14.5	17.5	0000	0000	0111	
−14	18	0000	0000	1001	
−13.5	18.5	0000	0000	1011	
−13	19	0000	0000	1101	
−12.5	19.5	0000	0000	1111	
−12	20	0000	0001	001	
−11.5	20.5	0000	0001	011	
−11	21	0000	0001	101	
−10.5	21.5	0000	0001	111	
−10	22	0000	0010	001	
−9.5	22.5	0000	0010	011	
−9	23	0000	0010	101	
−8.5	23.5	0000	0010	111	
−8	24	0000	0011	001	
−7.5	24.5	0000	0011	011	
−7	25	0000	0011	101	
−6.5	25.5	0000	0011	111	
−6	26	0000	0100	001	
−5.5	26.5	0000	0100	011	
−5	27	0000	0100	11	
−4.5	27.5	0000	0101	01	
−4	28	0000	0101	11	
−3.5	28.5	0000	0111		
−3	29	0000	1001		
−2.5	29.5	0000	1011		
−2	30	0000	111		
−1.5	30.5	0001	1		
−1	31	0011			
−0.5	31.5	011			
0		1			

Table 13.11a. H.263 VLC Table for MVD.

Vector Difference		Code			
0.5	−31.5	010			
1	−31	0010			
1.5	−30.5	0001	0		
2	−30	0000	110		
2.5	−29.5	0000	1010		
3	−29	0000	1000		
3.5	−28.5	0000	0110		
4	−28	0000	0101	10	
4.5	−27.5	0000	0101	00	
5	−27	0000	0100	10	
5.5	−26.5	0000	0100	010	
6	−26	0000	0100	000	
6.5	−25.5	0000	0011	110	
7	−25	0000	0011	100	
7.5	−24.5	0000	0011	010	
8	−24	0000	0011	000	
8.5	−23.5	0000	0010	110	
9	−23	0000	0010	100	
9.5	−22.5	0000	0010	010	
10	−22	0000	0010	000	
10.5	−21.5	0000	0001	110	
11	−21	0000	0001	100	
11.5	−20.5	0000	0001	010	
12	−20	0000	0001	000	
12.5	−19.5	0000	0000	1110	
13	−19	0000	0000	1100	
13.5	−18.5	0000	0000	1010	
14	−18	0000	0000	1000	
14.5	−17.5	0000	0000	0110	
15	−17	0000	0000	0100	
15.5	−16.5	0000	0000	0011	0

Table 13.11b. H.263 VLC Table for MVD.

When a pixel referenced by a motion vector is outside the picture area, a pixel at the edge of the picture area is used instead. The edge pixel is found by limiting the motion vector to the last full pixel position within the picture area. Motion vector limiting is done on a pixel basis and separately for the horizontal and vertical components.

Advanced Prediction Mode

The default prediction mode uses one motion vector per macroblock. In advanced prediction mode, MCBPC specifies either one or four motion vectors per macroblock. Advanced prediction mode is indicated by PTYPE and is signalled via H.245.

In advanced prediction mode, if one motion vector is used for a macroblock, it is defined as four motion vectors with the same value. If four motion vectors are used for a macroblock, the first motion vector is the MVD codeword and applies to Y_1 in Figure 13.4. The second motion vector is the MVD_2 codeword that applies to Y_2, the third motion vector is the MVD_3 codeword that applies to Y_3, and the fourth motion vector is the MVD_4 codeword that applies to Y_4. The motion vector for Cb and Cr of the macroblock is derived from the four Y motion vectors.

Block layer

A macroblock is made up of four luminance blocks, a Cb block, and a Cr block (see Figure 13.4). The structure of the block layer is shown in Figure 13.8. The order of block transmission is shown in Figure 13.9.

The INTRA DC coefficient is present for every block of the macroblock if MCBPC indicates macroblock type 3 or 4.

TCOEF is present if indicated by MCBPC or CBPY.

DC Coefficient for INTRA Blocks (INTRADC)

INTRADC is an 8-bit value. The values and their corresponding reconstruction levels are listed in Table 13.12.

Transform Coefficient (TCOEF)

An event is a combination of a last non-zero coefficient indication (LAST = "0" if there are more non-zero coefficients in this block; LAST = "1" if this is the last non-zero coefficient in this block), the number of successive zeros preceding the coefficient (RUN), and the non-zero coefficient (LEVEL).

The most common events are coded using a variable length code, shown in Table 13.13. The "s" bit indicates the sign of the level; "0" for positive, and "1" for negative.

Other combinations of (LAST, RUN, LEVEL) are encoded using a 22-bit word: 7 bits of escape (ESC), 1 bit of LAST, 6 bits of RUN, and 8 bits of LEVEL. The codes for RUN and LEVEL are shown in Table 13.14.

All coefficients, except for INTRA DC, have reconstruction levels (REC) in the range −2048 to 2047. Reconstruction levels are recovered by the following equations, and the results are clipped.

if LEVEL = 0, REC = 0

if QUANT = odd:
$$|REC| = QUANT * (2 * |LEVEL| + 1)$$

if QUANT = even:
$$|REC| = QUANT * (2 * |LEVEL| + 1) - 1$$

After calculation of |REC|, the sign is added to obtain REC. Sign(LEVEL) is specified

Figure 13.8. H.263 Block Layer Structure.

0	1	5	6	14	15	27	28
2	4	7	13	16	26	29	42
3	8	12	17	25	30	41	43
9	11	18	24	31	40	44	53
10	19	23	32	39	45	52	54
20	22	33	38	46	51	55	60
21	34	37	47	50	56	59	61
35	36	48	49	57	58	62	63

Figure 13.9. H.263 Transmission Order for Transform Coefficients.

INTRADC Value	Reconstruction Level
0000 0000	not used
0000 0001	8
0000 0010	16
0000 0011	24
:	:
0111 1111	1016
1111 1111	1024
1000 0001	1032
:	:
1111 1101	2024
1111 1110	2032

**Table 13.12. H.263 Reconstruction Levels
for INTRADC.**

Last	Run	Level	Code			
0	0	1	10s			
0	0	2	1111	s		
0	0	3	0101	01s		
0	0	4	0010	111s		
0	0	5	0001	1111	s	
0	0	6	0001	0010	1s	
0	0	7	0001	0010	0s	
0	0	8	0000	1000	01s	
0	0	9	0000	1000	00s	
0	0	10	0000	0000	111s	
0	0	11	0000	0000	110s	
0	0	12	0000	0100	000s	
0	1	1	110s			
0	1	2	0101	00s		
0	1	3	0001	1110	s	
0	1	4	0000	0011	11s	
0	1	5	0000	0010	001s	
0	1	6	0000	0101	0000	s
0	2	1	1110	s		
0	2	2	0001	1101	s	
0	2	3	0000	0011	10s	
0	2	4	0000	0101	0001	s
0	3	1	0110	1s		
0	3	2	0001	0001	1s	
0	3	3	0000	0011	01s	
0	4	1	0110	0s		
0	4	2	0001	0001	0s	
0	4	3	0000	0101	0010	s
0	5	1	0101	1s		
0	5	2	0000	0011	00s	
0	5	3	0000	0101	0011	s
0	6	1	0100	11s		
0	6	2	0000	0010	11s	
0	6	3	0000	0101	0100	s
0	7	1	0100	10s		

Table 13.13a. H.263 VLC Table for TCOEF.

Last	Run	Level	Code			
0	7	2	0000	0010	10s	
0	8	1	0100	01s		
0	8	2	0000	0010	01s	
0	9	1	0100	00s		
0	9	2	0000	0010	00s	
0	10	1	0010	110s		
0	10	2	0000	0101	0101	s
0	11	1	0010	101s		
0	12	1	0010	100s		
0	13	1	0001	1100	s	
0	14	1	0001	1011	s	
0	15	1	0001	0000	1s	
0	16	1	0001	0000	0s	
0	17	1	0000	1111	1s	
0	18	1	0000	1111	0s	
0	19	1	0000	1110	1s	
0	20	1	0000	1110	0s	
0	21	1	0000	1101	1s	
0	22	1	0000	1101	0s	
0	23	1	0000	0100	010s	
0	24	1	0000	0100	011s	
0	25	1	0000	0101	0110	s
0	26	1	0000	0101	0111	s
1	0	1	0111	s		
1	0	2	0000	1100	1s	
1	0	3	0000	0000	101s	
1	1	1	0011	11s		
1	1	2	0000	0000	100s	
1	2	1	0011	10s		
1	3	1	0011	01s		
1	4	1	0011	00s		
1	5	1	0010	011s		
1	6	1	0010	010s		
1	7	1	0010	001s		

Table 13.13b. H.263 VLC Table for TCOEF.

Last	Run	Level	Code			
1	8	1	0010	000s		
1	9	1	0001	1010	s	
1	10	1	0001	1001	s	
1	11	1	0001	1000	s	
1	12	1	0001	0111	s	
1	13	1	0001	0110	s	
1	14	1	0001	0101	s	
1	15	1	0001	0100	s	
1	16	1	0001	0011	s	
1	17	1	0000	1100	0s	
1	18	1	0000	1011	1s	
1	19	1	0000	1011	0s	
1	20	1	0000	1010	1s	
1	21	1	0000	1010	0s	
1	22	1	0000	1001	1s	
1	23	1	0000	1001	0s	
1	24	1	0000	1000	1s	
1	25	1	0000	0001	11s	
1	26	1	0000	0001	10s	
1	27	1	0000	0001	01s	
1	28	1	0000	0001	00s	
1	29	1	0000	0100	100s	
1	30	1	0000	0100	101s	
1	31	1	0000	0100	110s	
1	32	1	0000	0100	111s	
1	33	1	0000	0101	1000	s
1	34	1	0000	0101	1001	s
1	35	1	0000	0101	1010	s
1	36	1	0000	0101	1011	s
1	37	1	0000	0101	1100	s
1	38	1	0000	0101	1101	s
1	39	1	0000	0101	1110	s
1	40	1	0000	0101	1111	s
	ESC		0000	011		

Table 13.13c. H.263 VLC Table for TCOEF.

Run	Code	Level	Code
0	0000 00	−128	forbidden
1	0000 01	−127	1000 0001
:	:	:	:
63	1111 11	−2	1111 1110
		−1	1111 1111
		0	forbidden
		1	0000 0001
		2	0000 0010
		:	:
		127	0111 1111

Table 13.14. H.263 Run, Level Codes.

by the "s" bit in the TCOEF code in Table 13.13.

$$REC = sign(LEVEL) * |REC|$$

For INTRA DC blocks, the reconstruction level is:

$$REC = 8 * LEVEL$$

Arithmetic Coding Mode

In addition to the variable length codes, H.263 supports arithmetic coding. This mode is indicated by PTYPE and is signalled via H.245.

In the arithmetic coding mode, all of the variable length coding is replaced with arithmetic coding. This may result in a lower bit rate since the requirement of a fixed number of bits for information is removed. The syntax of the picture, group of blocks, and macroblock layers remains exactly the same. The syntax of the block layer is changed slightly in that any number of TCOEF entries may be present.

PB Frames

Like MPEG, H.263 supports PB frames. A PB frame consists of one P frame (predicted from the previous P frame) and one B frame (bidirectionally predicted from the previous and current P frame).

When PB frames are INTRA coded, the P frames are INTRA coded whereas the B frames are INTER coded with prediction as for an INTER block.

At the block layer, a macroblock has 12 blocks. The six P blocks are transmitted first as normal, followed by data for the six B blocks. INTRADC is not present for B blocks, but is for every P block of the macroblock if MCBPC indicates MB type 3 or 4. TCOEF is present for P blocks if specified by MCBPC or CBPY; TCOEF is present for B blocks if specified by CBPB.

G.723

ITU-T G.723 defines the algorithms for the encoding and decoding of audio signals at 5.3 and 6.3 kbps, using low-delay excited linear prediction (LD-CELP).

The G.723 encoder accepts 16-bit PCM digital audio with a bandwidth of 8 kHz, generating 6.3 kbps MP-MLQ digital audio or 5.3 kbps ACELP digital audio.

The G.723 decoder accepts 6.3 kbps MP-MLQ digital audio or 5.3 kbps ACELP digital audio, generating 16-bit PCM digital audio with a bandwidth of 8 kHz.

H.245

ITU-T H.245 covers the syntax and semantics of multimedia information, as well as the negotiation protocols. Information messages include receiving terminal preferences, logical channel signalling, and control and indication.

H.245 supports a range of applications, including storage and retrieval, messaging services, and multimedia services. T.120 information is carried within the data stream and supports a different set of functions than H.245. The two therefore are complementary.

H.223

ITU-T H.223 covers the frame structure, format of fields, and procedures for the packet multiplexing. Communication may be between two H.324 terminals, or between a H.324 terminal and a multipoint control unit (MCU) or interworking adapter (IWA).

Information is transmitted by up to 256 uni-directional logical channels, each numbered by a Logical Channel Number (LCN) of 0–255. LCN 0 is dedicated to the H.245 control channel.

H.321

Work is progressing on ITU-T Recommendation H.321, which covers video conferencing over ATM networks.

H.322

Work is also being done on ITU-T Recommendation H.322, which covers video conferencing over guaranteed-bandwidth LANs, such as IEEE 802.9. It should be completed in 1996.

H.323

ITU-T Recommendation H.322 will cover video conferencing over traditional shared-media LANs. It should be completed in 1996.

Implementation Considerations

Figure 13.10 illustrates implementing a typical H.324 conferencing system for the PC.

Self-View Window

One consideration is the implementation of a self-view window so the user can see what is transmitted. Ideally, the video in this window is reversed left-to-right so as not to confuse the user.

With horizontal reversal, the self-view window behaves as a mirror, with which most users are familiar. Without horizontal reversal, the user may confuse the left and right directions while watching the video.

This window should be able to be scaled to any size and positioned anywhere on the screen.

One problem is how to transmit two video windows (the self-view window and the main conferencing window) to a graphics card. Most video interfaces only support a single video stream. This can be solved by using the design

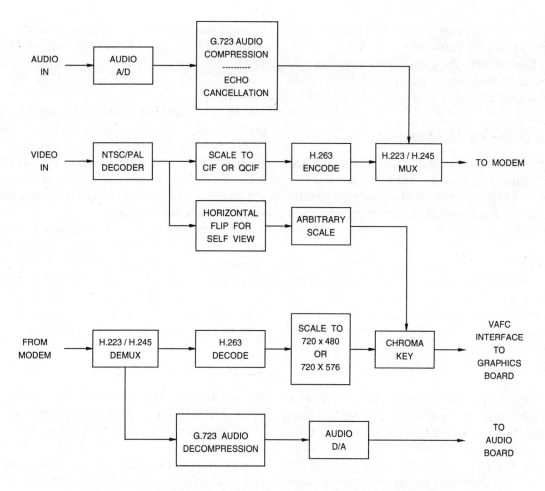

Figure 13.10. Block diagram of a Typical H.324 Add-In Board.

in Figure 13.10. GUI accelerator manufacturers are working on video interfaces to support multiple video streams.

Window Scaling

The main conferencing window should be able to be scaled to any size and positioned any-where on the screen. Usually, this is handled by the GUI accelerator on the graphics board.

Conference Recording

The ability to store the video conferencing session to video tape or hard disk should be supported. Possibly, there should also be a beep

every couple of seconds, or a flashing "you are being recorded" message.

The ability to play back a previously recorded video conferencing session for either or both users to view is also a useful feature.

PCI Data Transfer Support

With PCI systems now available, there are several options for transferring data over the PCI bus. If a PCI bus is supported, there are some additional features that could be implemented for hardware and software flexibility.

Audio

The audio compressor chip should support the ability to input uncompressed audio from either the audio A/D converter or via software through the PCI bus. The compressed audio may then be output to either the H.223/H.245 multiplexer or via software through the PCI bus.

The audio decompressor chip should support the ability to input compressed audio from either the H.223/H.245 demultiplexer or via software through the PCI bus. The uncompressed audio may then be output to either the audio D/A converter or via software through the PCI bus.

Video

The H.263 compressor chip should support the ability to input uncompressed video from either the NTSC/PAL decoder or via software through the PCI bus. The compressed video may then be output to either the H.223/H.245 multiplexer or via software through the PCI bus.

The H.263 decompressor chip should support the ability to input compressed video from either the H.223/H.245 demultiplexer or via software through the PCI bus. The uncom-

pressed video may then be output to either the graphics board or via software through the PCI bus.

System

The H.223/H.245 multiplexer chip should support the ability to input compressed audio and video bitstreams from either audio and video compressors or via software through the PCI bus. The system bitstreams may then be output to either the modem interface or via software through the PCI bus.

The H.223/H.245 demultiplexer chip should support the ability to input system bitstreams from either the modem interface or via software through the PCI bus. The demultiplexed compressed bitstreams may then be output to either the audio/video decompressors or via software through the PCI bus.

Temporal Pre-Processing

By performing temporal filtering after the NTSC/PAL decoder to remove low-level noise generated by the camera, an increase in compression ratio up to 10x is possible. Performing anti-aliased horizontal and vertical scaling to CIF also improves the compression ratio.

Pixel Clock Jitter

Pixel clock jitter is a major consideration in selecting a NTSC/PAL decoder to drive the H.263 video compressor. If the pixel clock jitter is over about 10 ns. there could be frame-to-frame differences in still areas of images large enough to be considered as movement by the H.263 video compressor. Without temporal processing, this will reduce the compression ratio, possibly requiring the use of a smaller image, or, at the least, resulting in a lower frame rate.

References

1. Draft for ITU-T Recommendation G.723, *Dual Rate Speech Coder for Multimedia Communications Transmitting at 5.3 & 6.3 kbps.*
2. Draft for ITU-T Recommendation H.223, *Multiplexing Protocol for Low Bitrate Multimedia Communication.*
3. Draft for ITU-T Recommendation H.245, *Control Protocol for Multimedia Communication.*
4. Draft for ITU-T Recommendation H.263, *Video Coding for Low Bitrate Communication.*
5. Draft for ITU-T Recommendation H.324, *Terminal for Low Bitrate Multimedia Communication.*

High Definition Production Standards

SMPTE 240M

The SMPTE 240M standard attempts to standardize the production of 1125-line high-definition source material in the United States. It was developed prior to ITU-R BT.709, which is attempting to standardize worldwide HDTV production standards. However, as of early 1996, most HDTV equipment uses the SMPTE 240M parameters. The main timing parameters are:

Total scan lines per frame:	1125
Active lines per frame:	1035
Scanning format:	2:1 interlaced
Aspect ratio:	16:9
Field rate:	59.94 or 60.00 Hz
Total pixels per line:	2200
Active pixels per line:	1920
Pixel clock frequency:	74.17 or 74.25 MHz

The chromaticity reference of the primaries are specified to be:

G: x = 0.310 y = 0.595
B: x = 0.155 y = 0.070
R: x = 0.630 y = 0.340

where x and y are CIE 1931 chromaticity coordinates. Reference white was chosen to match that of CIE illuminate D_{65}:

$$x = 0.3127 \qquad y = 0.3290$$

The long-term goal is to use the primaries in ITU-R BT.709.

The optoelectronic transfer characteristics of the reference camera are specified to be:

$$V = 1.1115L^{0.45} - 0.1115 \qquad \text{for } L \geq 0.0228$$
$$V = 4.0L \qquad \text{for } L < 0.0228$$

where V is the video signal output of the reference camera and L is the light input to the ref-

erence camera, both normalized to reference white. Therefore, the electro-optical transfer characteristics of the reference receiver are specified to be:

$$L = ((V + 0.1115)/1.1115)^{1/0.45} \text{ for } V \geq 0.0913$$
$$L = V/4.0 \qquad\qquad \text{for } V < 0.0913$$

where V is the video signal driving the reference receiver and L is the light output from the reference receiver, both normalized to reference white. Note that this is slightly different from ITU-R BT. 709.

Y, Pr, and Pb are derived from R'G'B' signals as follows:

$$Y = 0.212R' + 0.701G' + 0.087B'$$
$$Pr = (R' - Y)/1.576$$
$$Pb = (B' - Y)/1.826$$

Conversion between YPbPr and gamma-corrected RGB also may be expressed using matrix notation:

$$\begin{bmatrix} G' \\ B' \\ R' \end{bmatrix} = \begin{bmatrix} 1.000 & -0.227 & -0.477 \\ 1.000 & 1.826 & 0.000 \\ 1.000 & 0.000 & 1.576 \end{bmatrix} \begin{bmatrix} Y \\ Pb \\ Pr \end{bmatrix}$$

$$\begin{bmatrix} Y \\ Pb \\ Pr \end{bmatrix} = \begin{bmatrix} 0.701 & 0.087 & 0.212 \\ -0.384 & 0.500 & -0.116 \\ -0.445 & -0.055 & 0.500 \end{bmatrix} \begin{bmatrix} G' \\ B' \\ R' \end{bmatrix}$$

These coefficients are slightly different from those used in ITU-R BT.709.

The analog video signals for Y, R', G', and B' have the following levels assigned (note the use of the trilevel sync pulse):

Reference black level:	0 mV
Reference white level:	700 mV
Synchronizing level:	± 300 mV

The bandwidth of the analog Y, R', G', and B' signals is 30 MHz. The analog video signals for Pr and Pb have the following levels assigned:

Reference zero level:	0 mV
Reference peak levels	±350 mV
Synchronizing level:	±300 mV

The bandwidth of the analog Pr and Pb signals is 30 MHz for analog-originating equipment and 15 MHz for digital originating equipment.

The horizontal timing is illustrated in Figure 14.1. All events are specified in terms of the reference clock period, and at the midpoint of transitions. The major timing events of a video line, and the reference clock count at which they occur, are:

Rising edge of sync (timing reference):	0
Trailing edge of sync:	44
Start of active video:	192
End of active video:	2112
Leading edge of sync:	2156

The duration of video and sync waveforms, as shown in Figure 14.2, are:

	clocks	μsec[1]	μsec[2]
a	44	0.593	0.593
b	88	1.185	1.186
c	44	0.593	0.593
d	132	1.778	1.780
e	192	2.586	2.588
sync rise time	4	0.054	0.054
total line	2200	29.63	29.66
active line	1920	25.86	25.88

[1]1125/60 systems. [2]1125/59.94 systems.

Figures 14.3 and 14.4 illustrate the field synchronizing pulse and field blanking intervals, respectively.

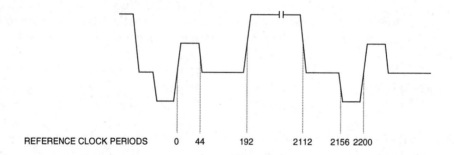

REFERENCE CLOCK PERIODS 0 44 192 2112 2156 2200

Figure 14.1. SMPTE 240M Major Timing Events Within a Video Line.

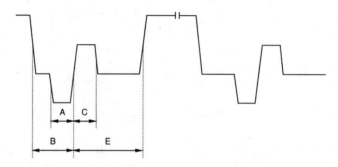

Figure 14.2. SMPTE 240M Horizontal Sync Timing.

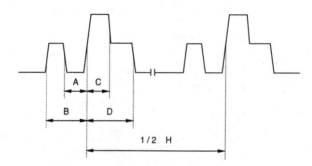

Figure 14.3. SMPTE 240M Field Sync Timing.

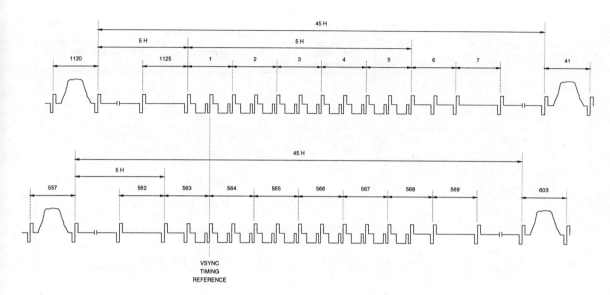

Figure 14.4. SMPTE 240M Field Blanking Intervals.

SMPTE 260M

The SMPTE 260M standard has been developed defining the digital representation and bit-parallel interface for 1125/60 high-definition production systems. It is based on the SMPTE 240M analog production standard.

SMPTE 260M is similar to normal 4:2:2 digital component video. The analog YPbPr video signals in the SMPTE 240M standard are digitized to YCbCr using sampling ratios of 22:11:11; a 74.25-MHz sampling for luminance is used rather than 13.5 MHz. Provisions also are made to allow auxiliary data (such as an alpha channel and sampled at 74.25 MHz) to be transmitted with the YCbCr data. 22:22:22 digital R′G′B′ data may be transmitted. Table 14.1 lists the parameter values for SMPTE 260M.

Encoding

The analog YPbPr or R′G′B′ signals are low-pass filtered and the active video portions digitized, as shown in Figures 14.5 and 14.6. Not shown are the analog delay adjustments between the YPbPr data to ensure the video data are time-aligned due to the differences in analog filter delays. The A/D converters are configured to generate a 64–940 (040_H to $3AC_H$) 10-bit output range for Y and auxiliary data, or R′G′B′, and a 64–960 (040_H to $3C0_H$) 10-bit output range for Cb and Cr (with 512 or 200_H corresponding to zero). As the analog PbPr color difference signals are bipolar (they have a normalized range of 0 to ±0.5), the A/D converters for the color difference signals must be configured to generate an output value of 512 or 200_H when the input is 0. Sync information also must be stripped from the video signals, and used to control the 74.25-MHz VCXO PLL (operating in a line-lock configuration) to generate the required timing signals. Saturation logic (the lookup tables in Figures 14.5 and 14.6) should be included in the YCbCr data paths to ensure that the 0–3 (000_H to 003_H) and 1020–1023 ($3FC_H$ to $3FF_H$) codes are not generated.

Parameters	1150/60 systems
Coded signals: Y, Cb, Cr or R', G', B'	These signals are obtained from gamma precorrected signals, namely: Y, Pb, Pr or R', G', B'.
Number of samples per total line: Y or R', G', B' auxiliary Cb, Cr	2200 2200 1100
Sampling structure	Orthogonal, line, field and frame repetitive. Cb and Cr samples co-sited with odd (1st, 3rd, 5th, etc.) Y samples in each line.
Sampling frequency: Y or R', G', B' auxiliary Cb, Cr	74.25 MHz 74.25 MHz 37.125 MHz The tolerance for the sampling frequencies is ±10 ppm.
Form of coding	Uniformly quantized PCM, 8 or 10 bits per sample.
Number of samples per digital active line: Y or R', G', B' auxiliary Cb, Cr	1920 1920 960
Analog-to-digital horizontal timing relationship from end of analog active line to 0_H	88 Y clock periods
Correspondence between video signal levels and quantization level for each sample: scale Y or R', G', B' and auxiliary Cb, Cr Codeword usage	 0 to 255 (0 to 1023) 220 (877) quantization levels with the black level corresponding to level 16 (64) and the peak level corresponding to level 235 (940). 225 (897) quantization levels in the center part of the quantization scale with zero signal corresponding to level 128 (512). Codewords 0 (0–3) and 255 (1020–1023) are used exclusively for synchronization.

Table 14.1. Encoding Parameter Values for SMPTE 260M. 10-bit values are in parentheses.

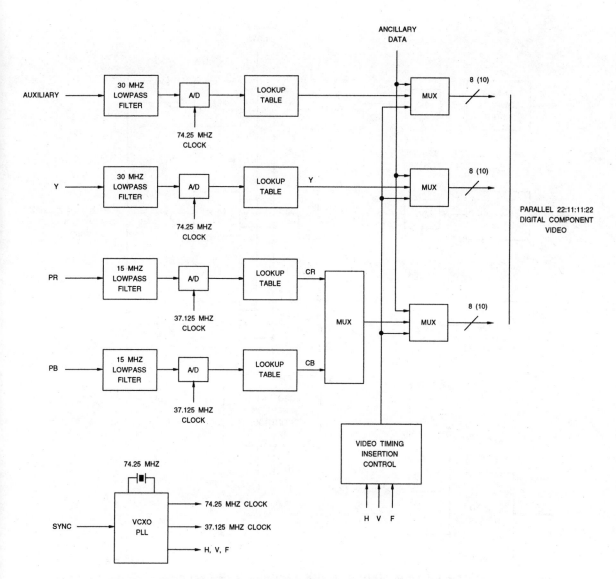

Figure 14.5. SMPTE 260M 22:11:11 YCbCr Encoding. The auxiliary (keying) channel is optional.

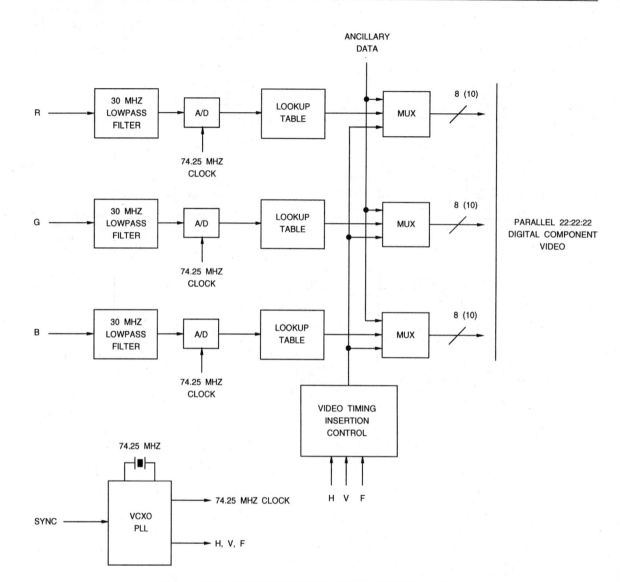

Figure 14.6. SMPTE 260M 22:22:22 RGB Encoding.

Luminance or RGB Filtering

Digital sampling requires that the bandwidth of the analog luminance and auxiliary, or R′G′B′, signals be defined by pre-sampling lowpass filters, shown in Figure 14.7 and Table 14.2. The pre-sampling filter prevents aliasing, generally from low-level components (noise) above the nominal video band.

The SMPTE 260M template for the analog RGB, luminance, and auxiliary filters is shown in Figure 14.7 and Table 14.2. Successive A/D and D/A stages do not degrade the signal beyond calculable quantizing noise. However, departure from flat amplitude and group delay response due to filtering is amplified through successive stages.

Although the sharp cut-off results in ringing on luminance edges, the visual effect should be minimal provided that group-delay performance is adequate. When cascading multiple filtering operations, the passband flatness and group-delay characteristics are very important. There usually is temptation to relax passband accuracy, but the best approach is to reduce the rate of cut-off and keep the passband as flat as possible.

Color Difference Filtering

The color difference presampling lowpass analog filters define the color difference signal bandwidth. The SMPTE 260M template for the filters is shown in Figure 14.8 and Table 14.3. As with luminance filtering, the color difference filtering requires a sharp cut-off to prevent repeated codings from producing a cumulative resolution loss. However, due to the low cut-off frequency, the sharp cut-off produces ringing that is more noticeable than for luminance.

Since aliasing is less noticeable in color difference signals, the attenuation at half the sampling frequency is only 6 dB. Again, the best approach is to reduce the rate of cut-off and keep the passband as flat as possible.

Transmission Timing

Three channels are used to transmit either R′G′B′ or YCbCr data (the CbCr data is time-multiplexed). If transmitting YCbCr data, an optional keying channel also may be transmitted.

As with ITU-R BT.656, rather than digitize and transmit the entire horizontal blanking interval, the same four-word sequence is inserted into the digital video streams to indicate the start of active video (SAV) and end of active video (EAV). Figure 14.9 illustrates the 1125/60 V and F timing for the SMPTE 240M analog video signals and the SMPTE 260M digital video signals. The EAV and SAV words are the same as those used with Chapter 8. However, in this instance, they are transmitted on each channel, as shown in Figure 14.10.

The values of V and F on different lines are shown in Figure 14.11. F and V are allowed to change only at EAV sequences. Both 8-bit and 10-bit transmission interfaces are supported, with the 10-bit interface used to transmit 2 bits of fractional color data information to minimize cumulative processing errors and support 10-bit ancillary data.

During the blanking intervals when EAV, SAV, and ancillary data is not present, the data words shall have a value of 16 (64 for a 10-bit system) for Y and R′G′B′ data words. CbCr data words shall have a value of 128 (512 for a 10-bit system).

Bit-Parallel Transmission Interface

The parallel interface transmits 8-bit or 10-bit data and a 74.25-MHz clock signal. Either digital R′G′B′ or Y and multiplexed CbCr data may be transmitted; if transmitting YCbCr data, 8 or 10 bits of auxiliary data (such as a keying channel) also may be transmitted.

The pin allocations for the signals are shown in Tables 14.4 and 14.5 (data bit 9 is the most significant bit). Equipment inputs and

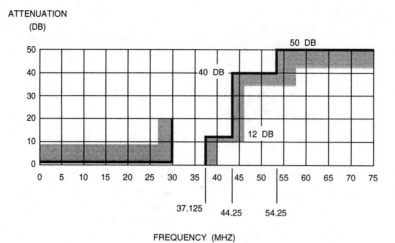

Figure 14.7. SMPTE 260M RGB and Luminance Filter Template When Sampling at 74.25 MHz.

Frequency Range	Passband Ripple Tolerance
100 kHz to 30 MHz	±0.05 dB
Frequency Range	**Passband Group Delay Tolerance**
100 kHz to 20 MHz	±1 ns
20 MHz to 30 MHz	±1.5 ns

Table 14.2. SMPTE 260M RGB and Luminance Filter Ripple and Group Delay Tolerances When Sampling at 74.25 MHz.

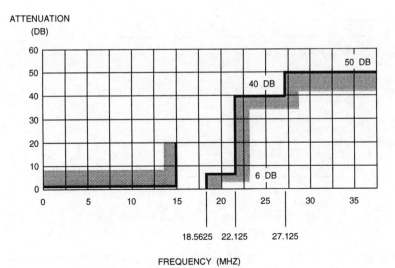

Figure 14.8. SMPTE 260M Color Difference Filter Template When Sampling at 37.125 MHz.

Frequency Range	Passband Ripple Tolerance
100 kHz to 15 MHz	±0.05 dB
Frequency Range	**Passband Group Delay Tolerance**
100 kHz to 10 MHz	±1 ns
10 MHz to 15 MHz	±1.5 ns

Table 14.3. SMPTE 260M Color Difference Filter Ripple and Group Delay Tolerances When Sampling at 37.125 MHz.

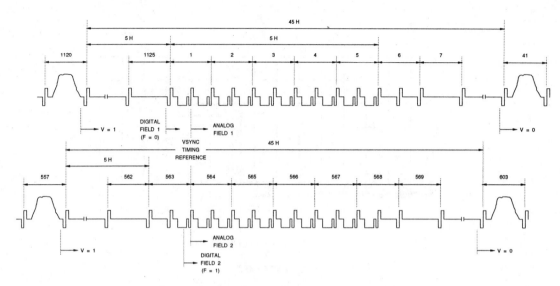

Figure 14.9. SMPTE 260M V and F Timing.

T = 1 / 74.25 MHZ

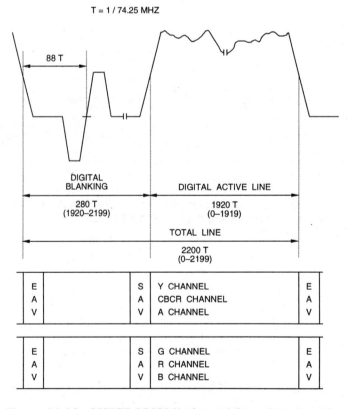

Figure 14.10. SMPTE 260M Horizontal Sync Relationship.

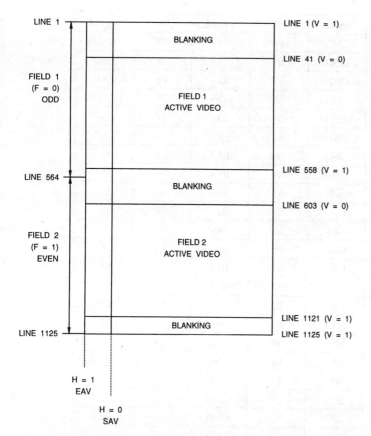

LINE NUMBER	F	V	H (EAV)	H (SAV)
1–40	0	1	1	0
41–557	0	0	1	0
558–563	0	1	1	0
564–602	1	1	1	0
603–1120	1	0	1	0
1121–1125	1	1	1	0

Figure 14.11. SMPTE 260M Digital Vertical Timing. F and V change state synchronously with the EAV sequence at the beginning of the digital line. Note that digital line number changes state prior to start of horizontal sync, as shown in Figure 14.10.

Pin	Signal	Pin	Signal	Pin	Signal	Pin	Signal
1	clock +	25	GND	49	B4 +	73	GND
2	G9 +	26	GND	50	B3 +	74	GND
3	G8 +	27	GND	51	B2 +	75	GND
4	G7 +	28	GND	52	B1 +	76	GND
5	G6 +	29	GND	53	B0 +	77	GND
6	G5 +	30	GND	54	R9 +	78	GND
7	G4 +	31	GND	55	R8 +	79	B4 –
8	G3 +	32	GND	56	R7 +	80	B3 –
9	G2 +	33	clock –	57	R6 +	81	B2 –
10	G1 +	34	G9 –	58	R5 +	82	B1 –
11	G0 +	35	G8 –	59	R4 +	83	B0 –
12	B9 +	36	G7 –	60	R3 +	84	R9 –
13	B8 +	37	G6 –	61	R2 +	85	R8 –
14	B7 +	38	G5 –	62	R1 +	86	R7 –
15	B6 +	39	G4 –	63	R0 +	87	R6 –
16	B5 +	40	G3 –	64	GND	88	R5 –
17	GND	41	G2 –	65	GND	89	R4 –
18	GND	42	G1 –	66	GND	90	R3 –
19	GND	43	G0 –	67	GND	91	R2 –
20	GND	44	B9 –	68	GND	92	R1 –
21	GND	45	B8 –	69	GND	93	R0 –
22	GND	46	B7 –	70	GND		
23	GND	47	B6 –	71	GND		
24	GND	48	B5 –	72	GND		

Table 14.4. SMPTE 260M Parallel Connector Contact Assignments for a RGB System. For 8-bit interfaces, bits 9 through 2 are used.

Pin	Signal	Pin	Signal	Pin	Signal	Pin	Signal
1	clock +	25	GND	49	aux4 +	73	GND
2	Y9 +	26	GND	50	aux3 +	74	GND
3	Y8 +	27	GND	51	aux2 +	75	GND
4	Y7 +	28	GND	52	aux1 +	76	GND
5	Y6 +	29	GND	53	aux0 +	77	GND
6	Y5 +	30	GND	54	CbCr9 +	78	GND
7	Y4 +	31	GND	55	CbCr8 +	79	aux4 –
8	Y3 +	32	GND	56	CbCr7 +	80	aux3 –
9	Y2 +	33	clock –	57	CbCr6 +	81	aux2 –
10	Y1 +	34	Y9 –	58	CbCr5 +	82	aux1 –
11	Y0 +	35	Y8 –	59	CbCr4 +	83	aux0 –
12	aux9 +	36	Y7 –	60	CbCr3 +	84	CbCr9 –
13	aux8 +	37	Y6 –	61	CbCr2 +	85	CbCr8 –
14	aux7 +	38	Y5 –	62	CbCr1 +	86	CbCr7 –
15	aux6 +	39	Y4 –	63	CbCr0 +	87	CbCr6 –
16	aux5 +	40	Y3 –	64	GND	88	CbCr5 –
17	GND	41	Y2 –	65	GND	89	CbCr4 –
18	GND	42	Y1 –	66	GND	90	CbCr3 –
19	GND	43	Y0 –	67	GND	91	CbCr2 –
20	GND	44	aux9 –	68	GND	92	CbCr1 –
21	GND	45	aux8 –	69	GND	93	CbCr0 –
22	GND	46	aux7 –	70	GND		
23	GND	47	aux6 –	71	GND		
24	GND	48	aux5 –	72	GND		

Table 14.5. SMPTE 260M Parallel Connector Contact Assignments for a YCbCr System. For 8-bit interfaces, bits 9 through 2 are used.

outputs both use 93-pin female sockets so that interconnect cables can be used in either direction. Signal levels are compatible with 10KH ECL-compatible balanced drivers and receivers. Transmission distances up to 20m may be used; transmission distances greater than 20m may require equalization.

The generator must have a balanced output with a maximum source impedance of 110 Ω; the signal must be between 0.6 V peak-to-peak and 2.0 V peak-to-peak measured across a 110-Ω resistor connected to the output terminals without any transmission line. The transmitted clock signal is a 74.25-MHz square wave, with a clock pulse width of 6.734 ±1.5 ns. The positive transition of the clock signal occurs as shown in Figure 14.12. At the receiver, the transmission line must be terminated by 110 ±10 Ω.

Ancillary Data
Ten-bit ancillary data may be transmitted during the blanking intervals. The ancillary data format is the same as that used in Chapter 8. However, in this instance, they are transmitted on each channel, as shown in Figure 14.10.

Some differences from the Chapter 8 ancillary format are that the data word count or line number range is 1–1914, instead of 1–1434. Ancillary data words may not use the 10-bit values of 0–3 (000_H to 003_H) and 1020–1023 ($3FC_H$ to $3FF_H$).

ITU-R BT.709 (Analog)

Work is progressing on Recommendation ITU-R BT.709. The goal is a single world-wide standard for studio and international program exchange of 1125/60 and 1250/50 sources.

The chromaticity coordinates (CIE 1931) are different from those specified by the SMPTE 240M production standard:

G: x = 0.300 y = 0.600
B: x = 0.150 y = 0.060
R: x = 0.640 y = 0.330

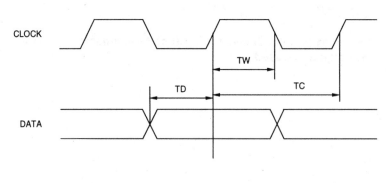

TW = 6.734 ± 1.5 NS
TC = 13.468 NS
TD = 6.734 ± 1.0 NS

Figure 14.12. SMPTE 260M Parallel Transmitted Waveforms (at Transmitter).

Reference white was chosen to match that of CIE illuminate D_{65}:

$x = 0.3127$ $y = 0.3290$

A long-term goal of using these primaries, rather than those used by SMPTE 240M, has been agreed to by manufacturers.

The optoelectronic transfer characteristics of the reference camera are currently:

$V = 1.099L^{0.45} - 0.099$ for $L \geq 0.018$
$V = 4.5L$ for $L < 0.018$

where V is the video signal output of the reference camera and L is the light input to the reference camera, both normalized to reference white.

1125/60 Systems

Y, Pb, and Pr are derived from R′G′B′ signals as follows:

$Y = 0.2125R' + 0.7154G' + 0.0721B'$
$Pb = 0.5389 (B' - Y)$
$Pr = 0.6349 (R' - Y)$

It is uncertain if these luma coefficients will be used, or if users will stay with those specified in SMPTE 240M.

The main timing parameters are:

Total scan lines per frame:	1125
Active lines per frame:	1035
Scanning format:	2:1 interlaced
Aspect ratio:	16:9
Field rate:	60.00 Hz
Total pixels per line:	2200
Active pixels per line:	1920
Pixel clock frequency:	74.25 MHz

The analog video signals for Y, R′, G′, and B′ have the following levels assigned (note the use of the trilevel sync pulse):

Reference black level:	0 mV
Reference white level:	700 mV
Synchronizing level:	±300 mV

The analog video signals for Pr and Pb have the following levels assigned:

Reference zero level:	0 mV
Reference peak levels	±350 mV
Synchronizing level:	±300 mV

The sync is present all three signals.

The horizontal timing is illustrated in Figure 14.13. All events are specified in terms of the reference clock period, and at the midpoint of transitions. The major timing events of a video line, and the reference clock count at which they occur, are:

Rising edge of sync (timing reference):	0
Trailing edge of sync:	44
Start of active video:	192
End of active video:	2112
Leading edge of sync:	2156

The duration of video and sync waveforms, as shown in Figure 14.14, are:

	clocks	μsec
a	44	0.593
b	88	1.185
c	44	0.593
d	132	1.778
e	192	2.586
sync rise time	4	0.054
total line	2200	29.63
active line	1920	25.86

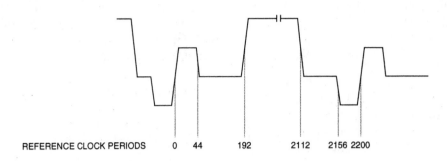

REFERENCE CLOCK PERIODS 0 44 192 2112 2156 2200

Figure 14.13. BT.709 1125/60 Major Timing Events Within a Video Line.

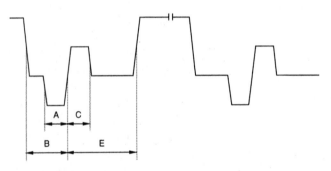

Figure 14.14. BT.709 1125/60 Horizontal Sync Timing.

Figures 14.15 and 14.16 illustrate the field synchronizing pulse and field blanking intervals, respectively.

1250/50 Systems

Y, Pb, and Pr are derived from R′G′B′ signals as follows:

$$Y = 0.299R' + 0.587G' + 0.114B'$$
$$Pb = 0.564 \ (B' - Y)$$
$$Pr = 0.713 \ (R' - Y)$$

The intent is to change to the equations:

$$Y = 0.2125R' + 0.7154G' + 0.0721B'$$
$$Pb = 0.5389 \ (B' - Y)$$
$$Pr = 0.6349 \ (R' - Y)$$

The main timing parameters are:

Total scan lines per frame:	1250
Active lines per frame:	1152
Scanning format:	2:1 interlaced
Aspect ratio:	16:9
Field rate:	50.00 Hz
Total pixels per line:	2304
Active pixels per line:	1920
Pixel clock frequency:	72.00 MHz

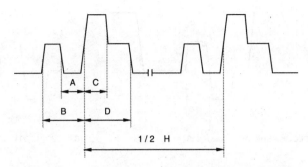

Figure 14.15. BT.709 1126/60 Field Sync Timing.

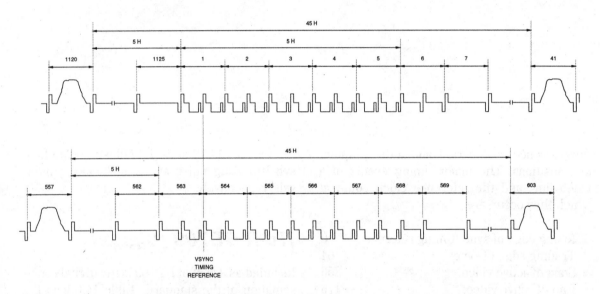

Figure 14.16. BT.709 1126/60 Field Blanking Intervals.

The analog video signals for Y, R′, G′, and B′ have the following levels assigned (note the use of the trilevel sync pulse):

Reference black level:	0 mV
Reference white level:	700 mV
Synchronizing level:	±300 mV

The analog video signals for Pr and Pb have the following levels assigned:

Reference zero level:	0 mV
Reference peak levels	±350 mV
Synchronizing level:	±300 mV

For R′G′B′ signals, the sync may be present on just green or all three signals. For YPbPr signals, the sync may be present on just Y or all three signals. The goal is require sync to be present on all three signals.

The horizontal timing is illustrated in Figure 14.17. All events are specified in terms of

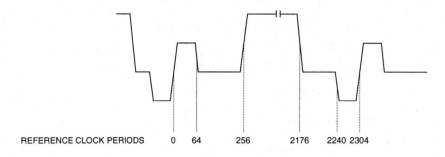

REFERENCE CLOCK PERIODS 0 64 256 2176 2240 2304

Figure 14.17. BT.709 1250/50 Major Timing Events Within a Video Line.

the reference clock period, and at the midpoint of transitions. The major timing events of a video line, and the reference clock count at which they occur, are:

Rising edge of sync (timing reference):	0
Trailing edge of sync:	64
Start of active video:	256
End of active video:	2176
Leading edge of sync:	2240

The duration of video and sync waveforms, as shown in Figure 14.18, are:

	clocks	μsec
A	64	0.890
B	128	1.780
C	64	0.890
D	256	3.560
sync rise time	4	0.056
total line	2304	32.00
active line	1920	26.67

Figures 14.19 and 14.20 illustrate the field synchronizing pulse and field blanking intervals, respectively.

ITU-R BT.709 (Digital)

Included as a part of BT.709 is the digital representation of the standard. Table 14.6 lists the digital parameters. Filter characteristics are not shown here, but are the same as those specified in ITU-R BT.1120.

ITU-R BT.1120

This standard has been developed to standardize the digital representation and bit-parallel interface for 1125/50 and 1250/60 equipment. BT.1120 is an interim solution, reflecting current implementations, until BT.709 can be completed.

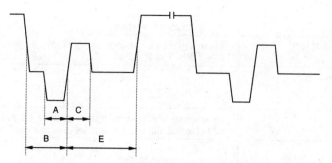

Figure 14.18. BT.709 1250/50 Horizontal Sync Timing.

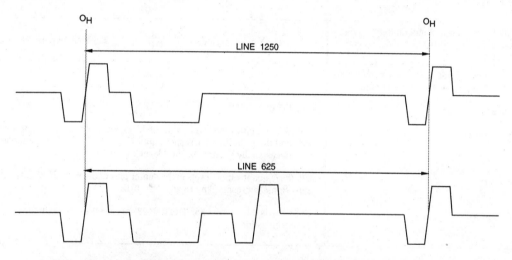

Figure 14.19. BT.709 1250/50 Frame and Field ID Timing.

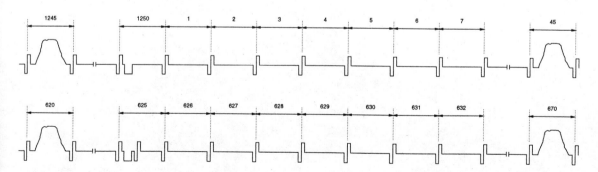

Figure 14.20. BT.709 1250/50 Field Blanking Intervals.

Parameters	1125/60 systems	1250/50 systems
Coded signals: Y, Cb, Cr or R′G′B′	These signals are obtained from gamma precorrected signals, namely: Y, B′ − Y, R′ − Y or R′, G′, B′.	
Number of samples per total line: Y or R′, G′, B′ Cb, Cr	2200 1100	2304 1152
Sampling structure	Orthogonal, line, field and frame repetitive. Cb and Cr samples co-sited with odd (1st, 3rd, 5th, etc.) Y samples in each line.	
Sampling frequency: Y, R′, G′, B′ Cb, Cr	74.25 MHz 37.125 MHz	72.00 MHz 36.00 MHz
Form of coding	Uniformly quantized PCM, 8 or 10 bits per sample.	
Number of samples per digital active line: Y, R′, G′, B′ Cb, Cr	1920 960	
Analog-to-digital horizontal timing relationship from 0_H to start of digital active line.	192 Y clock periods	256 Y clock periods
Correspondence between video signal levels and quantization level for each sample: scale Y, R′, G′, B′ Cb, Cr Codeword usage	0 to 255 (0 to 1023) 220 (877) quantization levels with the black level corresponding to level 16 (64) and the peak level corresponding to level 235 (940). The signal level may occasionally excurse beyond level 235 (940). 225 (897) quantization levels in the center part of the quantization scale with zero signal corresponding to level 128 (512). Codewords 0 (0–3) and 255 (1020–1023) are used exclusively for synchronization.	

Table 14.6. Encoding Parameter Values for ITU-R BT.709. 10-bit values are in parentheses and indicate 2 bits of fractional video data are used.

1125/60 Systems

The 1125/60 specifications reflect many of the 1125/60 specifications of SMPTE 260M. Table 14.7 lists the parameters for 1125/60 operation. Figures 14.21 and 14.22 and Tables 14.8 and 14.9 specify the filtering characteristics, which are the same as those for SMPTE 260M.

Transmission Timing

Three channels are used to transmit either R'G'B' or YCbCr data (the CbCr data is time-multiplexed). If transmitting YCbCr data, an optional keying channel also may be transmitted.

As with ITU-R BT.656, rather than digitize and transmit the entire horizontal blanking

Parameters	1125/60 systems	1250/50 systems
Coded signals: Y, Cb, Cr or R'G'B'	These signals are obtained from gamma precorrected signals, namely: Y, B' – Y, R' – Y or R', G', B'.	
Number of samples per total line: Y or R', G', B' Cb, Cr	2200 1100	2304 1152
Sampling structure	Orthogonal, line, field and frame repetitive. Cb and Cr samples co-sited with odd (1st, 3rd, 5th, etc.) Y samples in each line.	
Sampling frequency: Y, R', G', B' Cb, Cr	74.25 MHz 37.125 MHz	72.00 MHz 36.00 MHz
Form of coding	Uniformly quantized PCM, 8 or 10 bits per sample.	
Number of samples per digital active line: Y, R', G', B' Cb, Cr	1920 960	
Analog-to-digital horizontal timing relationship from 0_H to start of digital active line.	192 Y clock periods	256 Y clock periods
Correspondence between video signal levels and quantization level for each sample:		
scale	0 to 255 (0 to 1023)	
Y, R', G', B'	220 (877) quantization levels with the black level corresponding to level 16 (64) and the peak level corresponding to level 235 (940). The signal level may occasionally excurse beyond level 235 (940).	
Cb, Cr	225 (897) quantization levels in the center part of the quantization scale with zero signal corresponding to level 128 (512).	
Codeword usage	Codewords 0 (0–3) and 255 (1020–1023) are used exclusively for synchronization.	

Table 14.7. Encoding Parameter Values for ITU-R BT.1120. 10-bit values are in parentheses and indicate 2 bits of fractional video data are used.

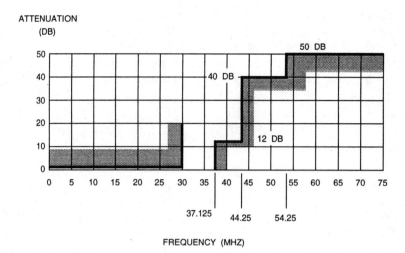

Figure 14.21. ITU-R BT.1120 1125/60 RGB and Luminance Filter Template When Sampling at 74.25 MHz.

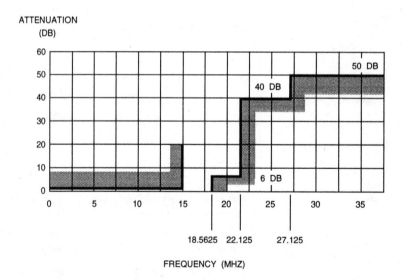

Figure 14.22. ITU-R BT.1120 1125/60 Color Difference Filter Template When Sampling at 37.125 MHz.

Frequency Range	Passband Ripple Tolerance
100 kHz to 30 MHz	±0.05 dB
Frequency Range	**Passband Group Delay Tolerance**
100 kHz to 20 MHz	±1 ns
20 MHz to 30 MHz	±1.5 ns

Table 14.8. ITU-R BT.1120 1125/60 RGB and Luminance Filter Ripple and Group Delay Tolerances When Sampling at 74.25 MHz.

Frequency Range	Passband Ripple Tolerance
100 kHz to 15 MHz	±0.05 dB
Frequency Range	**Passband Group Delay Tolerance**
100 kHz to 10 MHz	±1 ns
10 MHz to 15 MHz	±1.5 ns

Table 14.9. ITU-R BT.1120 1125/60 Color Difference Filter Ripple and Group Delay Tolerances When Sampling at 37.125 MHz.

interval, the same four-word sequence is inserted into the digital video streams to indicate the start of active video (SAV) and end of active video (EAV). The EAV and SAV words are the same as those used in Chapter 8. However, in this instance, they are transmitted on each channel, as shown in Figure 14.23.

The values of V and F on different lines are shown in Figure 14.24. F and V are allowed to change only at EAV sequences. Both 8-bit and 10-bit transmission interfaces are supported, with the 10-bit interface used to transmit 2 bits of fractional color data information to minimize cumulative processing errors and support 10-bit ancillary data.

During the blanking intervals when EAV, SAV, and ancillary data is not present, the data words shall have a value of 16 (64 for a 10-bit system) for Y and R'G'B' data words. CbCr data words will have a value of 128 (512 for a 10-bit system).

Bit-Parallel Transmission Interface

The parallel interface transmits 8-bit or 10-bit data and a 74.25-MHz clock signal. Either digital R'G'B' or Y and multiplexed CbCr data may be transmitted; if transmitting YCbCr data, 8 or 10 bits of auxiliary data (such as a keying channel) also may be transmitted.

The pin allocations for the signals are shown in Tables 14.10 and 14.11 (data bit 9 is the most significant bit). Equipment inputs and outputs both use 93-pin female sockets so that interconnect cables can be used in

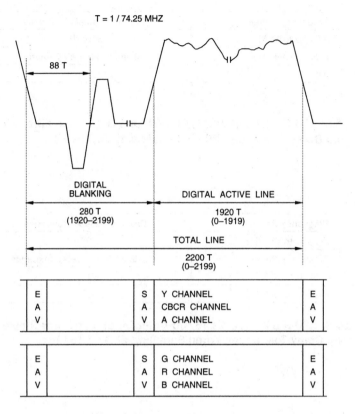

Figure 14.23. ITU-R BT.1120 1125/60 Horizontal Sync Relationship.

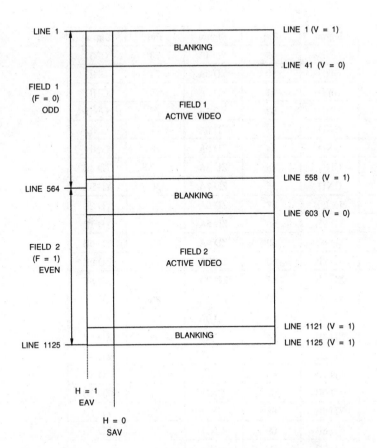

LINE NUMBER	F	V	H (EAV)	H (SAV)
1–40	0	1	1	0
41–557	0	0	1	0
558–563	0	1	1	0
564–602	1	1	1	0
603–1120	1	0	1	0
1121–1125	1	1	1	0

Figure 14.24. ITU-R BT.1120 1125/60 Digital Vertical Timing. F and V change state synchronously with the EAV sequence at the beginning of the digital line. Note that digital line number changes state prior to start of horizontal sync, as shown in Figure 14.23.

Pin	Signal	Pin	Signal	Pin	Signal	Pin	Signal
1	clock A	25	GND	49	YD 4A	73	GND
2	XD 9A	26	GND	50	YD 3A	74	GND
3	XD 8A	27	GND	51	YD 2A	75	GND
4	XD 7A	28	GND	52	YD 1A	76	GND
5	XD 6A	29	GND	53	YD 0A	77	GND
6	XD 5A	30	GND	54	ZD 9A	78	GND
7	XD 4A	31	GND	55	ZD 8A	79	YD 4B
8	XD 3A	32	GND	56	ZD 7A	80	YD 3B
9	XD 2A	33	clock B	57	ZD 6A	81	YD 2B
10	XD 1A	34	XD 9B	58	ZD 5A	82	YD 1B
11	XD 0A	35	XD 8B	59	ZD 4A	83	YD 0B
12	YD 9A	36	XD 7B	60	ZD 3A	84	ZD 9B
13	YD 8A	37	XD 6B	61	ZD 2A	85	ZD 8B
14	YD 7A	38	XD 5B	62	ZD 1A	86	ZD 7B
15	YD 6A	39	XD 4B	63	ZD 0A	87	ZD 6B
16	YD 5A	40	XD 3B	64	GND	88	ZD 5B
17	GND	41	XD 2B	65	GND	89	ZD 4B
18	GND	42	XD 1B	66	GND	90	ZD 3B
19	GND	43	XD 0B	67	GND	91	ZD 2B
20	GND	44	YD 9B	68	GND	92	ZD 1B
21	GND	45	YD 8B	69	GND	93	ZD 0B
22	GND	46	YD 7B	70	GND		
23	GND	47	YD 6B	71	GND		
24	GND	48	YD 5B	72	GND		

Table 14.10. ITU-R BT.1120 1125/60 Parallel Connector Contact Assignments. For 8-bit interfaces, bits 9 through 2 are used.

Transmission Signal Set	Component	Signal Line Assignments		Cable
		10-bit System	8-bit System	
Y, Cb, Cr	Y	XD (9–0)	XD (9–2)	21 pairs
	Cb, Cr	ZD (9–0)	ZD (9–2)	
Y, Cb, Cr with auxiliary channel	Y	XD (9–0)	XD (9–2)	31 pairs
	Cb, Cr	ZD (9–0)	ZD (9–2)	
	auxiliary	YD (9–0)	YD (9–2)	
R′, G′, B′	G′	XD (9–0)	XD (9–2)	
	B′	YD (9–0)	YD (9–2)	
	R′	ZD (9–0)	ZD (9–2)	

Table 14.11. ITU-R BT.1120 1125/60 Parallel Connector Contact Assignments.

either direction. Signal levels are compatible with 10KH ECL-compatible balanced drivers and receivers.

The generator must have a balanced output with a maximum source impedance of 110 Ω; the signal must be between 0.6V peak-to-peak and 2.0V peak-to-peak measured across a 110-Ω resistor connected to the output terminals without any transmission line. The transmitted clock signal is a 74.25-MHz square wave, with a clock pulse width of 6.734 ±1.5 ns. The positive transition of the clock signal occurs as shown in Figure 14.25. At the receiver, the transmission line must be terminated by 110 ±10 Ω.

1250/50 Systems

Table 14.7 lists the parameters for 1250/50 operation. Figures 14.26 and 14.27 and Tables

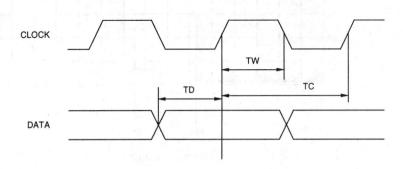

TW = 6.734 ± 1.5 NS

TC = 13.468 NS

TD = 6.734 ± 1.0 NS

Figure 14.25. ITU-R BT.1120 1125/60 Parallel Transmitted Waveforms (at Transmitter).

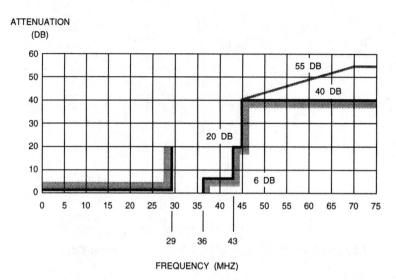

Figure 14.26. ITU-R BT.1120 1250/50 RGB and Luminance Filter Template When Sampling at 72 MHz. In a digital implementation for sample rate conversion, attenuation should be at least 55 dB above 70 MHz.

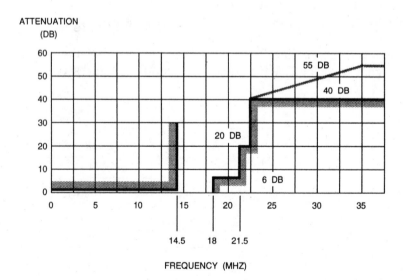

Figure 14.27. ITU-R BT.1120 1250/50 Color Difference Filter Template When Sampling at 36 MHz. In a digital implementation for sample rate conversion, attenuation should be at least 55 dB above 35 MHz.

14.12 and 14.13 specify the filtering characteristics, which are the same as those specified in ITU-R BT.709.

Transmission Timing

Two channels are used to transmit YCbCr data (the CbCr data is time-multiplexed).

As with ITU-R BT.656, rather than digitize and transmit the entire horizontal blanking interval, the same four-word sequence is inserted into the digital video streams to indicate the start of active video (SAV) and end of active video (EAV). The EAV and SAV words are the same as those used in Chapter 8. However, in this instance, they are transmitted on each channel, as shown in Figure 14.28.

The values of V and F on different lines are shown in Figure 14.29. F and V are only allowed to change at EAV sequences. Ten-bit transmission interfaces are used to transmit optionally 2 bits of fractional color data information to minimize cumulative processing errors and support 10-bit ancillary data.

During the blanking intervals when EAV, SAV, and ancillary data is not present, the data words shall have a value of 16 (64 for a 10-bit system) for Y data words. CbCr data words shall have a value of 128 (512 for a 10-bit system).

Bit-Parallel Transmission Interface

The parallel interface transmits 10-bit YCbCr data and a 36-MHz clock signal.

The pin allocations for the signals are shown in Tables 14.14 and 14.15 (data bits 9 and 19 are the most significant bits). Equipment inputs and outputs both use 50-pin

Frequency Range	Passband Ripple Tolerance
5 kHz to 27 MHz	increasing from ±0.01 to ±0.125 dB
27 MHz to 29 MHz	+0.5 dB, −1 dB
Frequency Range	Passband Group Delay Tolerance
5 kHz to 27 MHz	increasing from ±0.5 to ±2 ns
27 MHz to 30 MHz	±20 ns

Table 14.12. ITU-R BT.1120 1250/50 RGB and Luminance Filter Ripple and Group Delay Tolerances When Sampling at 72 MHz.

Frequency Range	Passband Ripple Tolerance
5 kHz to 13.5 MHz	increasing from ±0.01 to ±0.125 dB
13.5 MHz to 14.5 MHz	+0.5 dB, −1 dB
Frequency Range	Passband Group Delay Tolerance
5 kHz to 13.5 MHz	increasing from ±1 to ± 4 ns
13.5 MHz to 15 MHz	±40 ns

Table 14.13. ITU-R BT.1120 1250/50 Color Difference Filter Ripple and Group Delay Tolerances When Sampling at 36 MHz.

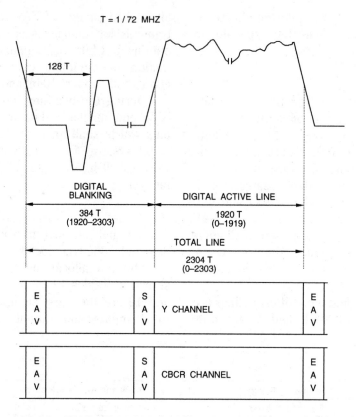

Figure 14.28. ITU-R BT.1120 1250/50 Horizontal Sync Relationship.

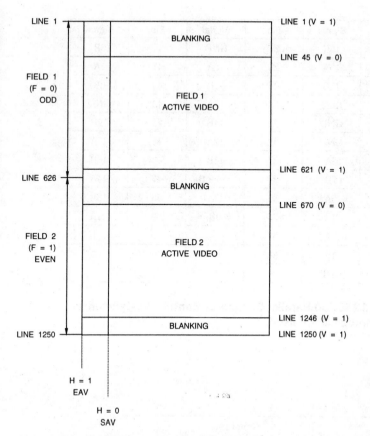

LINE NUMBER	F	V	H (EAV)	H (SAV)
1–44	0	1	1	0
45–620	0	0	1	0
621–625	0	1	1	0
626–669	1	1	1	0
670–1245	1	0	1	0
1246–1250	1	1	1	0

Figure 14.29. ITU-R BT.1120 1250/50 Digital Vertical Timing. F and V change state synchronously with the EAV sequence at the beginning of the digital line. Note that digital line number changes state prior to start of horizontal sync, as shown in Figure 14.28.

Pin	Signal	Pin	Signal	Pin	Signal	Pin	Signal
1	clock A	14	15B	27	GND	40	3B
2	GND	15	13A	28	18A	41	1A
3	9A	16	12B	29	17B	42	0B
4	8B	17	10A	30	15A	43	GND
5	6A	18	GND	31	14B	44	19B
6	5B	19	GND	32	12A	45	17A
7	3A	20	8A	33	11B	46	16B
8	2B	21	7B	34	clock B	47	14A
9	0A	22	5A	35	GND	48	13B
10	GND	23	4B	36	9B	49	11A
11	19A	24	2A	37	7A	50	10B
12	18B	25	1B	38	6B		
13	16A	26	GND	39	4A		

Table 14.14. ITU-R BT.1120 1250/50 Parallel Connector Contact Assignments. For 8-bit interfaces, bits 9 through 2 are used.

Transmission Signal Set	Component	Signal Line Assignments		Cable
		10-bit System	8-bit System	
Y, Cb, Cr	Y	9–0	9–2	21 pairs
	Cb, Cr	19–10	19–12	

Table 14.15. ITU-R BT.1120 1250/50 Parallel Connector Contact Assignments.

female sockets so that interconnect cables can be used in either direction. Signal levels are compatible with 100K ECL-compatible balanced drivers and receivers.

The generator must have a balanced output with a maximum source impedance of 100 Ω; the signal must be between 0.8V peak-to-peak and 2.0V peak-to-peak measured across a 100-Ω resistor connected to the output terminals without any transmission line. The transmitted clock signal is a 36-MHz square wave, with a clock pulse width of 13.889 ns. The positive transition of the clock signal occurs as shown in Figure 14.30. At the receiver, the transmission line must be terminated by 100 ±10 Ω.

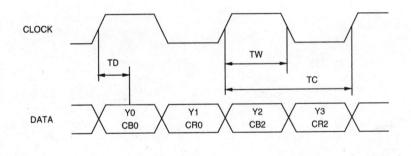

TW = 13.889 NS

TC = 27.778 NS

TD = 6.944 NS

Figure 14.30. ITU-R BT.1120 1250/50 Parallel Transmitted Waveforms (at Transmitter).

References

1. ANSI/SMPTE 240M, 1994, *Signal Parameters—1125/60 High-Definition Production Systems.*
2. ANSI/SMPTE 260M, 1992, *Digital Representation and Bit-Parallel Interface—1125/60 High-Definition Production System.*
3. ITU-R Recommendation BT.709, 1994, *Basic Parameter Values for the HDTV Standard for the Studio and for International Programme Exchange.*
4. ITU-R Recommendation BT.1120, 1994, *Digital Interfaces for 1125/60/2:1 and 1250/50/2:1 HDTV Studio Signals.*

Appendix A
Video Test and Measurement Methods

This appendix describes standard NTSC/PAL test and measurement methods used for quantifying signal distortions and rating the performance of video devices. It does not provide detailed instructions on how to use particular measurement instruments. It is assumed that you know the basics of waveform monitor and vectorscope operation. For specific equipment operating instructions, consult your instrument manuals.

that all users have access to at least a vectorscope and either a waveform monitor or an oscilloscope equipped with TV trigger capabilities. All of the measurements discussed also may be made automatically using a Tektronix VM700 Video Measurement Set, a sophisticated test and measurement instrument that digitizes the video signal and automatically analyzes it in the digital domain, or other automated video measurement instruments.

Equipment Requirements

Two instruments, a vectorscope and a waveform monitor, are the most commonly used for testing video signals. A vectorscope demodulates the signal and displays R′–Y versus B′–Y, allowing you to accurately evaluate the chroma portion of the signal. A waveform monitor provides video triggering capabilities and filters that allow you to separately evaluate the chroma and luma portion of the signal. In describing the test procedures, it is assumed

Measurement Techniques

There is no one standard that completely defines NTSC or PAL signals. A number of organizations publish documents that provide recommended limits on distortion levels, that can serve as guidelines. For (M) NTSC, SMPTE 170M and FCC 73.699 are frequently used specifications. ITU-R BT.470 is the most commonly used PAL standard, although governments of the various countries that use PAL also issue their own standards documents.

Definitions for expressing the magnitude of distortions can vary from standard to standard. Make sure that you are clear about the definitions in whatever standards you use, to avoid misunderstandings about one or more of the measurements taken and how the amount of distortion is to be expressed. It is recommended that you record this information along with the measurements taken.

Although most instruments are stable over time, you should verify the calibration of your waveform monitor and vectorscope before each measurement session. Many instruments have internally generated calibration signals to facilitate this process. Refer to your instrument's manual for detailed procedures. Many instruments specify a warm-up time of 20 or 30 minutes before calibration is undertaken. The more sophisticated instruments, such as the VM700, do not require operator calibration, but still need a warm-up time.

Color Bars

NTSC

Two types of NTSC color bars are in common use, 75% and 100% bars. The names refer to the maximum amplitudes of the red, green, and blue signals when they form the six primary and secondary colors that make up the color bars. For 75% bars, the maximum amplitude of the R′G′B′ signals is 75% of the peak white level; the signals can extend to 100% of peak white for 100% bars. The 75% bars are most commonly used.

In the R′G′B′ format, colors are saturated if at least one of the primaries is at zero. Both 75% and 100% color bars are 100% saturated. A parameter completely independent of the 75%/100% amplitude distinction is the white bar level. It typically is specified as 75% or 100%,

but either white level can be associated with either of the two bar types.

Both chroma and luma amplitudes in the composite signal vary according to the 75%/100% definition. The ratio between chroma and luma, however, stays constant in order to maintain 100% saturation.

The maximum available signal level is 100 − 7.5, or 92.5 IRE. 75% of 92.5 is 69.4 IRE; when this is added to the 7.5 IRE pedestal, it gives 77 IRE, which is the 75% signal level.

Figure A.1 shows a typical vectorscope color bar display for full-screen EIA color bars. The accuracy and consistency of dot placement within the targets is the primary indicator of signal quality. Fine dots positioned exactly in the signal crosshairs and clean vector edges are indicative of superior signals. Figure A.2 shows typical (M) NTSC measurements (luma level, chroma level, and chroma phase) for a NTSC encoder generating full-screen EIA color bars.

Another commonly used test signal is the split-field SMPTE signal, composed of standard color bars for the top 2/3 of the field, reverse blue bars for the next 1/12 of the field, and the IYQB signal for the remainder of the field.

PAL

Three types of PAL color bars commonly are used: 100%, 95%, and 75% EBU bars. The maximum amplitudes of the R′, G′, and B′ signals are sometimes used to distinguish the different bars. It is extremely important to know which type of bars are being used and to select the correct setting on your vectorscope or other measurement instrument.

Since there is much room for confusion concerning which parameters are being specified, it is best to use the following four parameters to define PAL color bar signals,

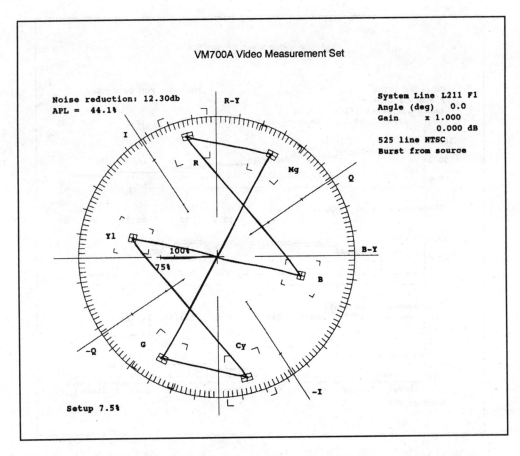

Figure A.1. Typical (M) NTSC Vectorscope Display for Full-screen EIA Color Bars.

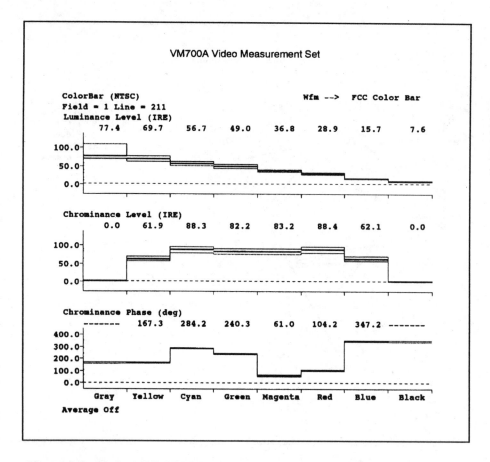

Figure A.2. Typical (M) NTSC Measurements for Encoder Generating Full-screen EIA Color Bars.

where E_R', E_G' and E_B' are the three color signals:

- maximum value of E_R', E_G' or E_B' for an uncolored bar

- minimum value of E_R', E_G', or E_B' for an uncolored bar

- maximum value of E_R', E_G' or E_B' for a colored bar

- minimum value of E_R', E_G', or E_B' for a colored bar

Each parameter is expressed as a percentage of the maximum voltage excursion allowable, or 700 mV.

Figure A.3 shows a typical (B, D, G, H, I) PAL vectorscope display for full-screen EBU color bars.

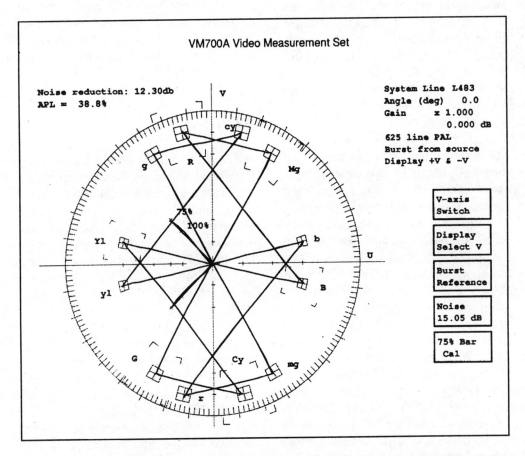

Figure A.3. Typical (B, D, G, H, I) PAL Vectorscope Display for Full-screen EBU Color Bars.

Timing Measurements

For (M) NTSC, recommended limits for video timing parameters are specified by the FCC and by 170M; however, the standards define the various time intervals differently. Be sure you know which standard applies to the test you are performing. The 170M specifications generally are more stringent. BT.470 is the most commonly accepted standard for PAL timing specifications. Important timing parameters include horizontal and vertical synchronization pulse widths, rise times, fall times, and the position and number of cycles in the burst.

Numerous problems can result from inaccurate timing. Although small errors in pulse widths will not affect the quality of the video image, if the errors become large, picture breakup can occur. If signals rise or fall too sharply or too slowly, problems can occur with equipment attempting to lock to the signals. Edges that are too sharp also can cause ringing problems. Although TV is relatively forgiving of many timing errors, studio equipment and many other video applications demand a signal that adheres closely to specifications.

A waveform monitor can be used to measure pulse widths by comparing the waveform to the marks along the horizontal baseline of the graticule. For sufficient resolution, you should magnify the waveform display horizontally. For NTSC measurements between the 90% points of the transition, use the waveform monitor's variable gain control to normalize the sync height to 100 IRE. Then position the blanking level at +10 IRE and read the measurement from the baseline marks. For measurements to be taken at the 50% points, place the top of the pulse at +20 IRE and the bottom at −20 IRE and read the pulse width from the horizontal scale. Most PAL pulse width measurements are made between the 50% points of the transition and usually can be made with the vertical gain in the calibrated position. Some waveform monitors have cursors to assist with measuring time intervals. Automated measurement instruments, such as the VM700, have settings for automatically making and displaying standard interval timing measurements.

Many standards specify rise and fall times of the sync pulse, measurements that are indicators of how fast the transitions occur. These measurements are typically made between the 10% and 90% points of the transition. The same methods described for measuring pulse widths can be generally applied to rise and fall time measurements. Figure A.4 shows horizontal sync and burst interval detail for (M) NTSC, and Figure A.5 shows the same information for (B, D, G, H, I) PAL.

SCH Phase

SCH phase, which stands for SubCarrier-to-Horizontal phase, defines the timing relationship between the 50% point of the leading edge of sync and the zero crossings of the reference subcarrier. Errors in SCH phase are expressed in degrees of subcarrier phase. As specified by 170M, SCH phase should be within ±10 degrees, but much tighter tolerances usually are found, often within a few degrees, in both NTSC and PAL systems. In actuality, consistency is more important for SCH phase than the actual percentage, as long as the percentage falls within the specification.

This relationship is important when signals from two or more sources are combined or switched sequentially. To prevent color shifts or horizontal jumps, correct timing of the sync edges and matching of the burst phases is essential. These conditions can only be met simultaneously if the SCH phase relationship of the signals is the same.

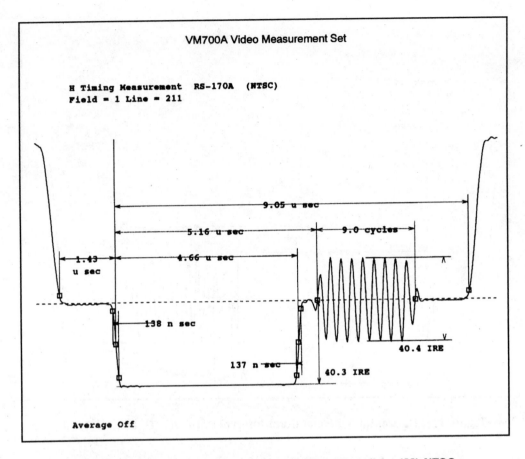

Figure A.4. Horizontal Sync and Burst Interval Detail for (M) NTSC.

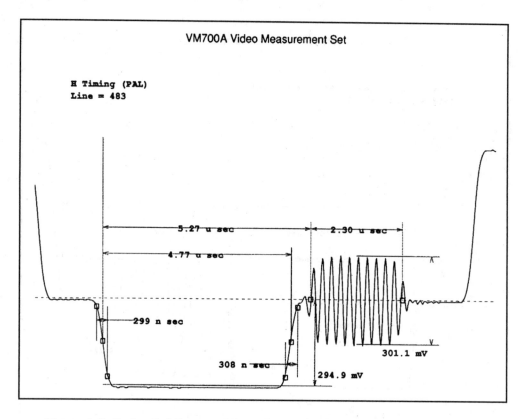

Figure A.5. Horizontal Sync and Burst Interval Detail for (B, D, G, H, I) PAL.

For (M) NTSC signals, the exact SCH phase relationship for a given line only repeats itself once every four fields (two frames). The four-field sequences of the signals must be properly aligned—a condition termed "color framed." Proper color framing and SCH phase relationship are essential for correct sync timing and burst phase matching conditions to be met. For (B, D, G, H, I) PAL signals, an eight-field sequence exists because of the relationships between the line, field, and subcarrier frequencies; the exact SCH phase relationship for a given line repeats itself once every eight fields (four frames).

Some measurement instruments have a polar SCH display consisting of the burst vector and a dot that represents horizontal sync. The phase relationship can be read directly from the graticule. Automated instruments like the VM700 allow you to display SCH phase directly.

Frequency Response

These measurements, also called gain/frequency distortion or amplitude versus frequency response, allow you to evaluate a system's amplitude response over the entire video spectrum. They measure the ability of a system to transfer components of different frequencies without affecting their amplitudes. Variation in amplitude can be given in dB or percent (or IRE for NTSC systems). The reference is normally white (0 dB or 100%). Frequency response measurements must contain three components—amplitude, frequency at which the measurement was taken, and reference frequency. Problems in frequency response can cause a number of unwanted picture effects, such as flicker, brightness inaccuracies, horizontal streaking and smearing, or fuzzy vertical edges.

Various test signals can be used to measure frequency response; this appendix, however, only treats the Multiburst signal. Multiburst measurements of frequency response can be made with a waveform monitor by measuring the peak-to-peak amplitudes of the packets. Multiburst usually includes six packets of discrete frequencies falling within the video passband. The signal allows a fast approximation of a system's frequency response. It is essential to select one standard reference level and use it consistently throughout the testing, as there is little agreement among the various measurement standards on what reference level to use.

Either the white bar or the first packet can be used as the reference with full-amplitude Multiburst. With reduced-amplitude Multiburst, some standards recommend normalizing the white bar to 100 IRE. The difference between peak-to-peak amplitude of each packet and the nominal level is the distortion at that frequency. The VM700 provides amplitude versus frequency response information for Multiburst automatically.

Noise Measurements

Noise is usually expressed as signal-to-noise ratio (SNR), given in dB, as it is the amount of noise in relation to the signal amplitude that causes problems, rather than the absolute amount of noise. Noisy pictures can be snowy or grainy, or sparkles of color may appear.

Since noise does not lend itself well to straightforward amplitude measurements, a number of special techniques have been developed to measure it. Specialized equipment, such as the VM700, is required to completely characterize the noise performance of a video system.

Nonlinear Distortion Measurements

All of the following tests measure *nonlinear distortion*, a term given to amplitude-dependent waveform distortions. Since amplifiers and other electronic circuits maintain linearity only over a certain range, they tend to clip or compress large signals, resulting in nonlinear distortion of various types. These distortions also may show up as crosstalk and intermodulation effects between the luma and chroma portions of the signal. The three most familiar and frequently measured nonlinear distortions are differential phase, differential gain, and luma nonlinearity. Also discussed here are chroma nonlinear phase, chroma nonlinear gain, and chroma-to-luma intermodulation.

Luma Nonlinearity

Also called differential luma, *luma nonlinearity* appears when luma gain is affected by luma level—a nonlinear relationship exists between the input and output signals in the luma channel. This results when the system is not able to process luma uniformly over the complete range of amplitude. luma nonlinearity is expressed as a percentage.

Luma nonlinearity is particularly noticeable in color images since color saturation, to which the eye is fairly sensitive, is affected. (Color saturation is always affected when the ratio between chroma amplitude and luma amplitude is incorrectly transferred.) This distortion is less noticeable in black-and-white pictures. However, if large amounts of distortion are present, a loss of detail in highlights and shadows might become noticeable.

For this measurement, a differentiated step (usually called a "diff step") filter is required; it is found on many waveform monitors. A diff step filter creates a spike corresponding to each luma step transition. The amplitude of each spike is directly related to the step height of each transition. luma nonlinearity can be measured by determining the difference in amplitude between the largest and smallest spike, and expressing this as a percentage of the largest spike. For example, a waveform with a maximum spike of 300 mV and a minimum spike of 295 mV would have a luma nonlinearity of

$$(300 - 295)/300 = 0.0167, \text{ or } 1.67\%.$$

Differential Phase and Gain

Differential phase distortion (often called "diff phase" or "DP") occurs when a system cannot uniformly process the high-frequency chroma information at all luma levels. Differential phase is characterized by distortion in the hue phase angle and is expressed in degrees of subcarrier phase, peak to peak. (It is important to be clear that the peak-to-peak phase error is being specified, which is the most common usage, and not maximum deviation from zero.)

This type of distortion causes changes in hue to occur with changes in the picture brightness. In high-luma parts of the picture, colors may not reproduce correctly. (Most PAL systems use some type of delay-line decoders, so reasonable amounts of differential phase distortion cannot be detected in the picture.)

When differential phase is present, the chroma phase will be different on the different luma levels. A simple measurement of differential phase can be made on any vectorscope. Simply increase the gain of the vectorscope until the signal vector is brought out to the graticule circle. The distortion in the hue phase angle then can be read directly off the graticule circle. Some vectorscopes provide a separate region on the vectorscope display to facilitate differential phase and gain measurements. In this case, the vectorscope display should be rotated until the signal vector is in the appropriate region.

Differential gain ("diff gain" or "DG") occurs if chroma gain is affected by luma level and is a result of the system not being able to process the high-frequency chroma signal uniformly at all luma levels. It is characterized by distortion in the saturation level and is expressed in percent. When differential gain is present, color saturation depends too heavily on luma level. At the higher luma levels, saturation is not reproduced properly.

The measurement of differential gain can be made at the same time as differential phase. Differential gain is displayed on a vectorscope as elongation of the vector in the radial direction. The percentage can be read directly off the vectorscope display, as most vectorscopes have special marks on the graticule for this purpose.

Although these procedures will yield a crude value for differential phase and gain, equipment such as a VM700, or a vectorscope with special differential phase and gain modes is required for accurate measurement.

Figure A.6 shows typical differential phase and gain plots for an NTSC encoder, generating full-screen EIA color bars.

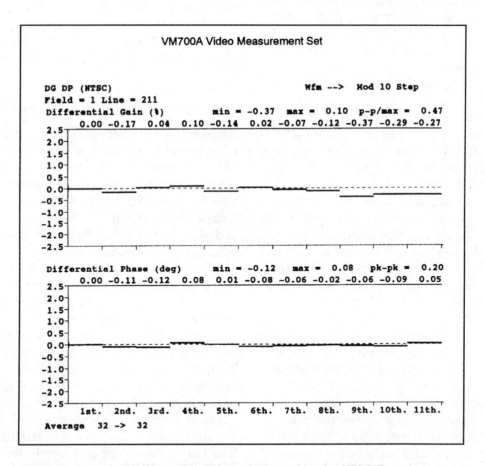

Figure A.6. Typical Differential Gain and Phase Plot for NTSC Encoder Generating Full-screen EIA Color Bars.

Chroma Nonlinear Phase and Gain

Chroma nonlinear phase distortion occurs when a signal's chroma phase is affected by the chroma amplitude. It is a result of the system's inability to process all amplitudes of high-frequency chroma information uniformly. This distortion is expressed in degrees of subcarrier phase. To measure these values, a signal with three chroma packets with the same phase but different amplitudes on a 50 IRE pedestal is used.

This distortion can cause hue shift as color saturation increases. It is most commonly seen in high-amplitude chroma signals. For PAL systems, the effects of chroma nonlinear phase are averaged out in delay-line decoders, as with diff phase, and hue shifts are not detectable in the picture.

Chroma nonlinear phase distortion can be measured using a standard vectorscope. The three chroma packets will produce three dots on the vectorscope display. Change the gain of the vectorscope to bring the largest vector out to the graticule circle. The largest difference, in degrees, between any two signal vectors is the chroma nonlinear phase distortion. As with differential phase, the vectorscope display may be rotated to facilitate this reading.

Chroma nonlinear gain distortion is characterized by a change in a signal's chroma gain due to changes in chroma amplitude. That is, the relationship between input and output chroma amplitudes does not remain constant when the input amplitude is changed. It is expressed in IRE or percent. This distortion shows up in the picture as incorrect color saturation.

Chroma nonlinear gain distortion can be measured using either a waveform monitor or an oscilloscope. It is measured by determining the difference in amplitude between a packet and its ideal value.

The three chroma packets in the modulated pedestal test signal should have amplitudes of 20, 40, and 80 IRE units (NTSC systems). When using an oscilloscope, the amplitude of the 40 IRE packet can be measured and recorded. With a waveform monitor, the gain of the monitor should be varied until the center packet is displayed as 40 IRE units. With the value of the center packet determined, the errors in the two other packets can then be determined. On an oscilloscope, the amplitudes of these two packets should be measured in the same manner as the 40 IRE packet. The waveform monitor graticule can be directly read to determine the amplitude of these two packets. The chroma nonlinear gain distortion is the largest deviation from nominal value of the other two packets. It is expressed as a percentage of the nominal value of the packet exhibiting the largest error, or in IRE.

Chroma-to-Luma Intermodulation

Chroma-to-luma intermodulation, also called cross-modulation, occurs when a signal's luma value is affected by superimposed chroma. It can be caused by clipping of high-amplitude chroma peaks or by quadrature distortion. Video image effects of this distortion can include variations in brightness caused by color saturation inaccuracies.

The test is run using the same signal as that used for chroma nonlinear phase and gain distortion. The distortion can be measured by passing the video signal through a chroma filter and examining the output. If you are using an oscilloscope, measure the largest deviation from the 50 IRE pedestal. This voltage, expressed as a percentage of the 50 IRE voltage, is the chroma-to-luma intermodulation value. If a waveform monitor is used, expand the signal until the pedestal is at 100 IRE units. The largest difference in the pedestal level is the error. It may be expressed as a percentage or in IRE units.

Appendix B
SCART and
S-Video Connectors

SCART Connector

Many consumer audio/video components in Europe support one or two 21-pin SCART connectors, illustrated in Figure B.1. (SCART is also known as Peritel.) This connection allows mono or stereo audio, composite video, S-video, and RGB video to be transmitted between equipment using a single cable.

There are now several types of SCART pinouts, depending on the specific functions implemented. Pinout details are shown in Tables B.1 through B.5.

Figure B.1. SCART Connector.

Pin	Function	Pin	Function
1	audio right out	12	data 1
2	audio right in	13	red ground
3	audio left out	14	data ground
4	audio ground	15	red
5	blue ground	16	RGB control
6	audio left in	17	video ground
7	blue	18	RGB control ground
8	function select	19	composite video out
9	green ground	20	composite video in
10	data 2	21	safety ground
11	green		

Table B.1. SCART Connector Signals (Stereo Audio, Composite and RGB Video).

Pin	Function	Pin	Function
1	audio mono out	12	data 1
2	audio mono in	13	red ground
3	audio mono out	14	data ground
4	audio ground	15	red
5	blue ground	16	RGB control
6	audio mono in	17	video ground
7	blue	18	RGB control ground
8	function select	19	composite video out
9	green ground	20	composite video in
10	data 2	21	safety ground
11	green		

Table B.2. SCART Connector Signals (Mono Audio, Composite and RGB Video).

Pin	Function	Pin	Function
1	audio right out	12	data 1
2	audio right in	13	ground
3	audio left out	14	data ground
4	audio ground	15	
5	ground	16	
6	audio left in	17	video ground
7		18	
8	function select	19	composite video out
9	ground	20	composite video in
10	data 2	21	safety ground
11			

Table B.3. SCART Connector Signals (Stereo Audio, Composite Video).

Pin	Function	Pin	Function
1	audio right out	12	data 1
2	audio right in	13	ground
3	audio left out	14	data ground
4	audio ground	15	chrominance video
5	ground	16	
6	audio left in	17	video ground
7		18	
8	function select	19	composite video out
9	ground	20	luminance video
10	data 2	21	safety ground
11			

Table B.4. SCART Connector Signals (Stereo Audio, Composite and Y/C Video).

Pin	Function	Pin	Function
1	audio right out	12	HD Vsync in/out
2	audio right in	13	red HD ground
3	audio left out	14	HD sync ground
4	audio ground	15	red HD in/out
5	blue HD ground	16	HD Hsync in/out
6	audio left in	17	composite ground
7	blue HD in/out	18	composite ground
8	HD status (in/out)	19	composite video out
9	green HD ground	20	composite video in
10		21	safety ground
11	green HD in/out		

Table B.5. SCART Connector Signals (EUREKA 95 GOLDEN SCART).

S-Video Connector

The RCA video connector transfers a composite video signal, made by adding the intensity (Y) and color (C) video signals together. The TV then has to separate these Y and C video signals in order to display the picture. The problem is that the Y/C separation process is never perfect. Typical artifacts include crawling dots on highly saturated vertical edges and color strobing on moving tweed patterns.

Higher-quality video components support a 4-pin S-video connector, illustrated in Figure B.2 (the female connector viewpoint). This connector keeps the intensity (Y) and color (C) video signals separate, eliminating the Y/C separation process (and its associated artifacts) in the TV. As a result, the picture is sharper and has less noise. More intensity (Y) bandwidth is also available, increasing the horizontal detail. S-video works with both NTSC and PAL video signals.

1, 2 = GND
3 = Y
4 = C

Figure B.2. S-Video Connector.

Appendix C
Multimedia PC (MPC)
Specifications

The first Multimedia PC (MPC) specification was published by the Multimedia PC Marketing Council in 1991 to encourage the adoption of a standard multimedia computing platform as an extension of the desktop PC already used by millions of people. The resulting MPC standard was adopted around the world.

In 1993, the council published the Level 2 specification (MPC2) as an enhanced multimedia computer standard. In 1994, the council added a CD-ROM drive and sound card audio cable standard, applying to both levels, to simplify the connection of MPC CD-ROM drives and sound cards that are purchased separately.

June 1995 saw the introduction of the Level 3 specification (MPC3). The Level 1 and Level 2 specifications continue in effect; unless all level [n] requirements are included, the system is considered a level [n −1] machine.

The MPC specifications are the result of industry-wide discussion and debate. This consensus makes the MPC specification valuable in helping to create a growing installed base of standardized multimedia computers and a strong incentive for Multimedia PC software investment and development. The MPC specifications also serve as a guide to consumers purchasing multimedia PCs, upgrade kits and components.

Multimedia PC Level 1 (MPC1) Minimum Requirements

Hardware

386SX or higher processor
2 MB of RAM
30 MB hard drive
VGA or VGA+ display
Two button mouse
101 key keyboard
CD-ROM drive

- CD-DA outputs, sustained 150 kB/sec transfer rate without consuming more than 40% of CPU bandwidth in the process.
- Average seek time of 1 second or less.
- MSCDEX 2.2 driver or equivalent that implements the extended audio APIs.
- Subchannel Q support (P, R-W optional).

Audio board

- 8-bit DAC, linear PCM sampling, 22.05 and 11.025 kHz rate, DMA/FIFO with interrupt.
- 8-bit ADC, linear PCM sampling, 11.025 kHz rate, microphone level input.
- Music synthesizer.
- On-board analog audio mixing capabilities.

Serial port, parallel port
MIDI I/O port
Joystick port
Headphones or speakers connected to your computer system

System Software

Binary compatibility with Windows 3.0 plus Multimedia Extensions or Windows 3.1

CD-ROM/Sound Card Audio Cable Standard for MPC Components

The following cable standards apply only to MPC components (CD-ROM drives or sound cards sold separately). Full systems and upgrade kits are not required to observe the following specification:

- A Multimedia PC CD-ROM drive component must include a minimum 24-inch cable to connect the drive's analog audio output connector to an MPC sound card's analog audio input connector. The cable's open sound card connector must be a female 4 pin Molex 70066-G, 70400-G, or 70430-G connector with 2.54 mm pitch, or the equivalent, with the following pin assignments: pin 1, left signal; pin 2, ground; pin 3, ground; pin 4, right signal.

- A Multimedia PC sound card component must be capable of mating with the CD-ROM audio cable by having a 2.54-mm pitch Molex 70553 male connector on the card (or the equivalent), or by including a short patch cable. The patch cable must plug into the non-standard sound card connector and have an open male connector (Molex 70107-A, or the equivalent) for attaching to the CD-ROM cable female connector. The pin assignments on the sound card connectors must be complementary to the CD-ROM audio cable connectors.

Multimedia PC Level 2 (MPC2) Minimum Requirements

Hardware

25-MHz 486SX or compatible microprocessor

4 MB of RAM (8 MB recommended)

3.5-inch floppy drive

160 MB hard drive

Video display resolution of at least 640 × 480 with 65,536 (64K) colors

Two button mouse

101 key keyboard (or functional equivalent)

CD-ROM drive

- Doublespeed with CD-DA outputs (capable of sustained 300 KB/sec transfer rate).
- No more than 40% of the CPU bandwidth may be consumed when maintaining a sustained transfer rate of 150 KB/sec.
- Average seek time of 400 milliseconds or less.
- 10,000 hours MTBF.
- CD-ROM XA ready (mode 1 capable, mode 2 form 1 capable, mode 2 form 2 capable).
- Multisession capable.
- MSCDEX 2.2 driver or equivalent that implements the extended audio APIs.
- Subchannel Q support (P, R-W optional).

Audio board

- 16-bit DAC, linear PCM sampling; 44.1, 22.05, and 11.025 kHz rate, DMA/FIFO buffered transfer capability.
- 16 bit ADC, linear PCM sampling; 44.1, 22.05, and 11.025 kHz rate, DMA/FIFO buffered transfer capability; microphone input.
- Music synthesizer.
- On-board analog audio mixing capabilities.
- CD-ROM XA audio capability is recommended.
- Support for the IMA adopted ADPCM software algorithm is recommended.

Serial port

Parallel port

MIDI I/O port

Joystick port

Headphones or speakers connected to your computer system

System Software

Binary compatibility with Windows 3.0 plus Multimedia Extensions or Windows 3.1

CD-ROM/Sound Card Audio Cable Standard for MPC Components

Same cable standard as Level 1 (full systems and upgrade kits are not required to observe this specification).

Multimedia PC Level 3 (MPC3) Minimum Requirements

The MPC3 Specification defines the minimum system functionality for Level 3 compliance, but is not a recommendation for any particular system configuration. MPC3 does not replace the MPC1 and MPC2 specification; rather, it defines an updated platform suitable for delivering enhanced multimedia functionality.

Hardware

75-MHz Pentium™ Processor or other microprocessor capable of running x86 binaries at a comparable level

8 MB of RAM
3.5-inch, 1.44 MB floppy drive
540 MB hard drive

- 15 ms access time.
- 1.5 MB/second sustained throughput.
CD-ROM Drive
- Sustained 600 KB/sec transfer rate
- Average access time of 250 ms (in 4x mode).
- No more than 40% of the CPU bandwidth may be consumed while maintaining a sustained transfer rate of 600 KB/sec and no more than 20% of the CPU bandwidth may be consumed while maintaining a transfer rate of 300 KB/sec. The CPU usage requirement should be achieved for read block sizes no less than 16 K and a lead time of no more than is required to load the CD-ROM buffer with 1 read block of data.
- Must be capable of reading Compact Disc Audio (Red Book) discs, as well as Compact Disc Mode 1 and Mode 2 (form 1 and form 2) formatted discs, including mixed mode and multisession media as well as CD-ROM, CD-ROM XA, Photo CD, CD Recordable (part II), Video CD and CD-i disks. Data must be transferred to the host system in block sizes of 2048, 2336 and/or 2352 bytes, as appropriate for each CD format.
- The drive and included driver software must be compatible with Microsoft's MSCDEX version 2.2 or later (or equivalent), implement the extended audio APIs and be capable of reading Q channel information.
- CD-ROM drive with CD-DA (Red Book) outputs and volume control.
- CD-ROM drive must have on-board buffers and implement read-ahead buffering.
- Sequential access time: An application via the standard operating system access methods must have the ability to read sequential, error free, 16K blocks every 33.3 ms with each read taking no more than 13.3 ms.
- Background CPU utilization: The driver must not use CPU cycles except in response to a host system request.

Audio

16-bit Digital-to-Analog Converter (DAC) with

- Linear PCM sampling.
- DMA or FIFO buffered transfer capability with interrupt on buffer empty.
- 44.1, 22.05 and 11.025 kHz sample rate mandatory; stereo channels.
- No more than 10% of the CPU bandwidth required to output 22.05 and 11.025 kHz.
- It is recommended that no more than 15% of the CPU bandwidth be required to output 44.1 kHz.

16 bit Analog-to-Digital Converter (ADC) with
- Linear PCM sampling.
- 44.1, 22.05, and 11.025 kHz sample rate mandatory.
- DMA or FIFO buffered transfer capability with interrupt on buffer full.
- Microphone input.

Wavetable capability required

CPU utilization for 16 bit stereo sound and wavetable cannot exceed 10%

CD-ROM drive with CD-DA (Red Book) outputs and volume control

Internal synthesizer capabilities with multi-voice, multi-timbral capacity, 6 simultaneous melody voices plus 2 simultaneous percussive voices

Internal mixing capabilities to combine input from three (recommended four) sources and present the output as a stereo, line-level audio signal at the back panel. The four sources are:
- CD Red Book.
- synthesizer.
- DAC (waveform).
- (recommended but not required) an auxiliary input source.

Each input must have at least a 3-bit volume control (8 steps) with a logarithmic taper. (4 bit or greater volume control is recommended.)

If all sources are sourced with –10 dB (consumer line level: 1 milliwatt into 600 ohms = 0 dB) without attenuation, the mixer will not clip and will output between 0 dB and +3 dB

Individual audio source and master digital volume control registers and extra line-level audio sources are highly recommended

(Guidelines for synthesizer implementation available on request; includes MIDI playback support.)

Speakers

If external speakers are included in the system, the following are required:
- Must be at least a two-piece system.
- Frequency response from 120 Hz to 17.5 kHz.
- Power rating must be measured and tested at a minimum of 3 watts/channel at 100 Hz, 1 kHz and 10 kHz at 1% THD; 6 watts RMS (3W + 3W) into 4 ohms, at 1% THD, at 1 kHz, with both channels driven.
- Sound pressure level must be measured at 1/2-meter on axis from speaker and should be capable of an SPL of 92 dB from 250 Hz to 7.5 kHz.
- Input connectors are as follows:
 — 3.5 mm stereo jack where tip is left channel, sleeve is right channel and body is ground or audio input using 3.5 mm stereo jack with industry standard channel orientation, supplied with at least a six foot cable to attach to computer sound source.
 — Speaker connector must be mono type where tip is positive and body is ground or left speaker output 3.5 mm mono jack where tip is positive and case is negative.
 — If stereo headphone output jack is included, it must mute the speaker when headphone is used.
- Noise ratio must be at least 65 dB.
- Input sensitivity requires no more than 300 millivolts for rated power output.
- Volume, treble, and bass controls included.
- Input impedance must be greater than 5000 ohms.

In a three-piece system, the satellites shall have the same requirements as above.

Subwoofer Requirements:

- Frequency response must be at least 40 Hz to 250 Hz (\pm 3 dB).
- Power minimum is 15 watts at 1% THD.
- Power ratings should be measured at 40 Hz and 100 Hz at 1% THD.
- Input sensitivity must be adjustable from 300 millivolts to one volt for maximum output power.
- Both inputs must be mixed in the woofer circuitry.
- Input impedance must be greater than 1000 ohms.

Graphics Performance

Color space conversion and scaling capability are required.

Direct access to frame buffer for video-enabled graphics subsystem required with a resolution of 352×240 at 30 fps (or 352×288 at 25 fps) at 15 bits/pixel, unscaled, without cropping.

Test suite will test for acceptable graphics performance.

Video Playback

MPEG1 (hardware or software) with OM-1 compliance required.

Direct access to frame buffer required with a resolution of 352×240 at 30 fps (or 352×288 at 25 fps) at 15 bits/pixel, unscaled, without cropping.

All codecs—hardware and/or software—must support a synchronized audio/video stream with a resolution of 320×240, 15 bits/pixel, 30 frames/second, unscaled, without dropping a frame.

Test suite will test for acceptable video playback performance.

User Input

Standard 101-key IBM-style keyboard, with standard DIN connector, or keyboard which delivers identical functionality utilizing key-combinations

Two-button mouse with bus or serial connector, with at least one additional communication port remaining free.

I/O

Standard 9-pin or 25-pin asynchronous serial port, programmable up to 57.6K baud, switchable interrupt channel.

Standard 25-pin bi-directional parallel port with interrupt capability.

One MIDI port with In, Out, and through, must have interrupt support for input and FIFO transfer.

IBM-style analog or digital joystick port.

System Software

Multimedia PC system software must offer binary compatibility with Windows 3.11.

System must offer binary compatibility with DOS version 6.0 or higher.

Minimum Full-System Configuration

A full Multimedia PC Level 3 system requires the following elements and components, all of which must meet the full functional specifications outlined above:

CPU
RAM
Hard drive
Floppy drive
CD-ROM drive

Audio
Graphics performance
Video playback
User input
I/O
System software

Minimum Upgrade Kit Configuration

A Multimedia PC Level 3 Upgrade Kit requires the following elements and components, all of which must meet the full functional specifications outlined above:

CD-ROM Drive
Audio
I/O

(Providing system software with Upgrade Kits is optional.)

Upgrade Components

Upgrade components must meet the full functional specifications outlined above.

Sound Card
Must use MPC audio cable (see below)
CD-ROM Drive
Must use MPC audio cable (see below)
Video Playback Card
Speakers

CD-ROM/Sound Card Audio Cable Standard for MPC Components

The following cable standards apply only to MPC components (CD-ROM drives or sound cards sold separately). Full systems and upgrade kits are not required to observe the following specification:

- A Multimedia PC CD-ROM drive component must include a minimum 24-inch cable to connect the drive's analog audio output connector to an MPC sound card's analog audio input connector. The cable's open sound card connector must be a female 4-pin Molex 70066-G, 70400-G, or 70430-G connector with 2.54-mm pitch, or the equivalent, with the following pin assignments: pin 1, left signal; pin 2, ground; pin 3, ground; pin 4, right signal.

- A Multimedia PC sound card component must be capable of mating with the CD-ROM audio cable by having a 2.54-mm pitch Molex 70553 male connector on the card (or the equivalent), or by including a short patch cable. The patch cable must plug into the non-standard sound card connector and have an open male connector (Molex 70107-A, or the equivalent) for attaching to the CD-ROM cable female connector. The pin assignments on the sound card connectors must be complementary to the CD-ROM audio cable connector.

For more information, contact:

Multimedia PC Marketing Council, Inc.
1730 M Street, NW
Suite 707
Washington, DC 20036
http://www.spa.org/mpc/

Appendix D
Macrovision
Anti-Taping Process

Macrovision has developed, and is continually refining, an anti-taping process for VHS video tapes and digital video systems. The digital video source may be from a satellite, digital VCR, cable system, and so on.

Macrovision works due to the differences in the way VCRs and televisions operate. The automatic gain control (AGC) circuits within a television are designed to respond slowly to change; those for a VCR are designed to respond quickly to change. The Macrovision technique attempts to take advantage of this by modifying the video signal so that a television will still display it properly, yet a VCR will not record a viewable picture.

The basic operation of Macrovision is explained in this appendix. Note that the Macrovision specifications now allow configuring the process to allow changes to be easily made; note that the specifications are more complex than described here.

Sync Pulse Adjustment

Outside of the vertical blanking intervals, the amplitude of sync pulses are reduced to 30 IRE.

VBI (Vertical Blanking Interval) Pulses

For NTSC, any or all scan lines between 7 and 21 and between 270 and 284 may have VBI pulses. For PAL, any or all scan lines between 7 and 21 and between 319 and 333 may have VBI pulses. VBI pulses are divided into three categories: pseudo sync pulses, AGC pulses, and AGC pulse cycling.

For each scan line, 0–4 (NTSC) or 0–6 (PAL) pseudo sync pulses are added. These are designed to trick the sync detection cir-

cuits of the VCR into believing a horizontal sync is occurring.

For each scan line, 0–4 (NTSC) or 0–6 (PAL) AGC pulses are added immediately after a pseudo sync pulse. The AGC pulses continuously vary in amplitude, cycling about every 20 seconds. These are designed to trick the AGC circuits of the VCR into believing the blanking level is incorrect, and the gain should be adjusted.

EOF (End of Field) Pulses

EOF pulses may be present for up to 15 scan lines before and after the vertical sync pulse. EOF pulses are AGC pulses added immediately following the normal horizontal sync or equalizing pulse. Again, the AGC pulses continuously vary in amplitude, cycling about every 20 seconds. These are designed to trick the AGC circuits of the VCR into believing the

blanking level is incorrect, and the gain should be adjusted.

Color Burst Processing

The color burst is modified on specific scan lines. This is designed so that a TV will display the proper colors, but a VCR cannot lock to the burst.

Macrovision Address

For information on adding Macrovision to specific products, please contact:

Macrovision Corporation
1341 Orleans Drive
Sunnyvale, CA 94089
(408) 743-8600

Appendix E
PAL/SECAM Widescreen Signalling (WSS)

To facilitate the handling of various aspect ratios of program material received by TVs, a widescreen signalling (WSS) system has been developed for 625-line PAL and SECAM systems (ITU-R BT.1119).

The first part of line 23 is used to transmit the WSS information, as shown in Figure E.1.

WSS Information

Data Timing

The clock frequency is 5 MHz (±100 Hz). The signal waveform should be a sine-squared pulse, with a half-amplitude duration of 200 ±10 ns. The signal amplitude is 500 mV ± 5%.

The NRZ data bits are processed by a bi-phase code modulator, such that one data period equals 6 elements at 5 MHz.

Data Content

The WSS consists of a run-in code, a start code, and 14 bits of data, as shown in Table E.1.

Run-In

The run-in consists of 29 elements at 5 MHz of a specific sequence, shown in Table E.1.

Start Code

The start code consists of 24 elements at 5 MHz of a specific sequence, shown in Table E.1.

Group A Data

The group A data consists of 4 data bits that specify the aspect ratio. Each data bit generates 6 elements at 5 MHz. Data bit b0 is the LSB.

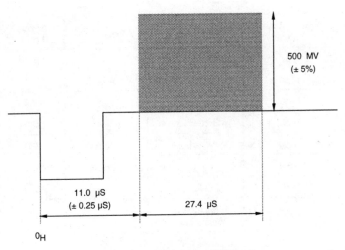

Figure E.1. WSS Line 23 Timing.

Table E.2 lists the data bit assignments and usage. The number of active lines listed in Table E.2 are for the exact aspect ratio (a = 1.33, 1.56, or 1.78).

The aspect ratio label indicates a range of possible aspect ratios (a):

4:3	$a \leq 1.46$
14:9	$1.46 < a \leq 1.66$
16:9	$1.66 < a \leq 1.90$
>16:9	$a > 1.90$

Run-In	29 elements at 5 MHz	1 1111 0001 1100 0111 0001 1100 0111 (1F1C 71C7$_H$)
Start Code	24 elements at 5 MHz	0001 1110 0011 1100 0001 1111 (1E 3C1F$_H$)
Group 1 (Aspect Ratio)	24 elements at 5 MHz "0" = 000 111 "1" = 111 000	b3, b2, b1, b0
Group 2 (Enhanced Services)	24 elements at 5 MHz "0" = 000 111 "1" = 111 000	b7, b6, b5, b4 (b5, b6, b7 = "0" since they are reserved)
Group 3 (Subtitles)	18 elements at 5 MHz "0" = 000 111 "1" = 111 000	b10, b9, b8
Group 4 (Reserved)	18 elements at 5 MHz "0" = 000 111 "1" = 111 000	b13, b12, b11 (b11, b12, b13 = "0" since they are reserved)

Table E.1. WSS Information.

b3, b2, b1, b0	Aspect Ratio Label	Format	Position	Active Lines	Minimum Requirements
1000	4:3	full format	–	576	case 1
0001	14:9	letterbox	center	504	case 2
0010	14:9	letterbox	top	504	case 2
1011	16:9	letterbox	center	430	case 3
0100	16:9	letterbox	top	430	case 3
1101	> 16:9	letterbox	center	–	case 4
1110	14:9	full format	center	576	–
0111	16:9	full format (anamorphic)	–	576	–

Table E.2. Group A (Aspect Ratio) Data Bit Assignments and Usage.

To allow automatic selection of the display mode, a 16:9 receiver should support the following minimum requirements:

Case 1: The 4:3 aspect ratio picture should be centered on the display, with black bars on the left and right sides.

Case 2: The 14:9 aspect ratio picture should be centered on the display, with black bars on the left and right sides. Alternately, the picture may be displayed using the full display width by using a small (typically 8%) horizontal geometrical error.

Case 3: The 16:9 aspect ratio picture should be displayed using the full width of the display.

Case 4: The >16:9 aspect ratio picture should be displayed as in Case 3 or use the full height of the display by zooming in.

Group B Data
The group B data consists of four data bits that specify enhanced services. Each data bit generates six elements at 5 MHz. Data bit b4 is the LSB.

b4:
0 camera mode
1 film mode

Group C Data
The group C data consists of three data bits that specify subtitles. Each data bit generates six elements at 5 MHz. Data bit b8 is the LSB.

b8:
0 no subtitles within teletext
1 subtitles within teletext

b10, b9:
00 no open subtitles
01 subtitles inside active image
10 subtitles outside active image
11 reserved

Appendix F
CD-ROM Contents

The CD-ROM included with this book contains files to assist in testing and evaluating various video subsystems.

Test Directory

These files contain still images at various resolutions that can be loaded into a frame buffer, NTSC or PAL encoded, and displayed on a TV or monitor. They allow the evaluation of the video subsystem, including the NTSC/PAL encoder. Figures F.1 through F.20 show the test images.

Still Test Images

Gamma _RGB Directory
These TIFF files contain 24-bit gamma-corrected RGB data. The RGB range is 0 to 255. The following resolutions have a gamma pre-correction of 1/2.2:

640×480	720×480
320×240	352×240
240×180	

The following resolutions have a gamma pre-correction of 1/2.8:

768×576	720×576
384×288	352×288

Note the color bars do not contain the –7.5 IRE (NTSC) or –2 IRE (PAL) PLUGE signal due to the limitations of using the RGB color space. The I and Q values are also slightly incorrect due to the limitations of using the RGB color space.

The filenames are listed in Table F.1.

Linear_RGB Directory
These TIFF files contain 24-bit linear RGB data. The RGB range is 0 to 255.

Note the color bars do not contain the –7.5 IRE (NTSC) or –2 IRE (PAL) PLUGE signal due to the limitations of using the RGB color space. The I and Q values are also slightly incorrect due to the limitations of using the RGB color space.

The filenames are listed in Table F.2.

NTSC Test Signal	Resolution				
	Square Pixels			Rectangular Pixels	
	640 x 480	**320 x 240**	**240 x 180**	**720 x 486**	**352 x 240**
100% color bars	0000	0100	0200	0300	0400
75% color bars	0001	0101	0201	0301	0401
100% color wheel	0002	0102	0202	0302	0402
75% red frame	0003	0103	0203	0303	0403
linear Y ramp	0004	0104	0204	0304	0404
75% Y bars	0005	0105	0205	0305	0405
10-step luminance staircase	0006	0106	0206	0306	0406
needle	0007	0107	0207	0307	0407
color test	0008	0108	0208	0308	0408
linear yellow ramp	0009	0109	0209	0309	0409
overscan measurement	0010	0110	0210	0310	0410
text samples	0011	0111	0211	0311	0411
100% fast edges	0012	0112		0312	0412
100% anti-aliased edges	0013	0113	0213	0313	0413
75% fast edges	0014	0114	0214	0314	0414
75% anti-aliased edges	0015	0115	0215	0315	0415
88% fast edges	0016	0116	0216	0316	0416
88% anti-aliased edges	0017	0117	0217	0317	0417
classroom picture	0018	0118	0218	0318	0418
anti-aliased classroom picture	0019	0119	0219	0319	0419

Table F.1a. File Names for 24-bit Gamma-Corrected RGB Still Image NTSC Video Test Files.

NTSC Test Signal	Resolution			
	Square Pixels		Rectangular Pixels	
	768 x 576	384 x 288	720 x 576	352 x 288
100% color bars	1000	1100	1300	1400
75% color bars	1001	1101	1301	1401
100% color wheel	1002	1102	1302	1402
75% red frame	1003	1103	1303	1403
linear Y ramp	1004	1104	1304	1404
75% Y bars	1005	1105	1305	1405
10-step luminance staircase	1006	1106	1306	1406
needle	1007	1107	1307	1407
color test	1008	1108	1308	1408
linear yellow ramp	1009	1109	1309	1409
overscan measurement	1010	1110	1310	1410
text samples	1011	1111	1311	1411
100% fast edges	1012	1112	1312	1412
100% anti-aliased edges	1013	1113	1313	1413
75% fast edges	1014	1114	1314	1414
75% anti-aliased edges	1015	1115	1315	1415
88% fast edges	1016	1116	1316	1416
88% anti-aliased edges	1017	1117	1317	1417
classroom picture	1018	1118	1318	1418
anti-aliased classroom picture	1019	1119	1319	1419

Table F.1b. File Names for 24-bit Gamma-Corrected RGB Still Image PAL Video Test Files.

NTSC Test Signal	Resolution				
	Square Pixels			Rectangular Pixels	
	640 x 480	320 x 240	240 x 180	720 x 486	352 x 240
100% color bars	2000	2100	2200	2300	2400
75% color bars	2001	2101	2201	2301	2401
100% color wheel	2002	2102	2202	2302	2402
75% red frame	2003	2103	2203	2303	2403
linear Y ramp	2004	2104	2204	2304	2404
75% Y bars	2005	2105	2205	2305	2405
10-step luminance staircase	2006	2106	2206	2306	2406
needle	2007	2107	2207	2307	2407
color test	2008	2108	2208	2308	2408
linear yellow ramp	2009	2109	2209	2309	2409
overscan measurement	2010	2110	2210	2310	2410
text samples	2011	2111	2211	2311	2411
100% fast edges	2012	2112		2312	2412
100% anti-aliased edges	2013	2113	2213	2313	2413
75% fast edges	2014	2114	2214	2314	2414
75% anti-aliased edges	2015	2115	2215	2315	2415
88% fast edges	2016	2116	2216	2316	2416
88% anti-aliased edges	2017	2117	2217	2317	2417
classroom picture	2018	2118	2218	2318	2418
anti-aliased classroom picture	2019	2119	2219	2319	2419

Table F.2a. File Names for 24-bit Linear RGB Still Image NTSC Video Test Files.

NTSC Test Signal	Resolution			
	Square Pixels		Rectangular Pixels	
	768 x 576	384 x 288	720 x 576	352 x 288
100% color bars	3000	3100	3300	3400
75% color bars	3001	3101	3301	3401
100% color wheel	3002	3102	3302	3402
75% red frame	3003	3103	3303	3403
linear Y ramp	3004	3104	3304	3404
75% Y bars	3005	3105	3305	3405
10-step luminance staircase	3006	3106	3306	3406
needle	3007	3107	3307	3407
color test	3008	3108	3308	3408
linear yellow ramp	3009	3109	3309	3409
overscan measurement	3010	3110	3310	3410
text samples	3011	3111	3311	3411
100% fast edges	3012	3112	3312	3412
100% anti-aliased edges	3013	3113	3313	3413
75% fast edges	3014	3114	3314	3414
75% anti-aliased edges	3015	3115	3315	3415
88% fast edges	3016	3116	3316	3416
88% anti-aliased edges	3017	3117	3317	3417
classroom picture	3018	3118	3318	3418
anti-aliased classroom picture	3019	3119	3319	3419

**Table F.2b. File Names for 24-bit Linear RGB Still Image
PAL Video Test Files.**

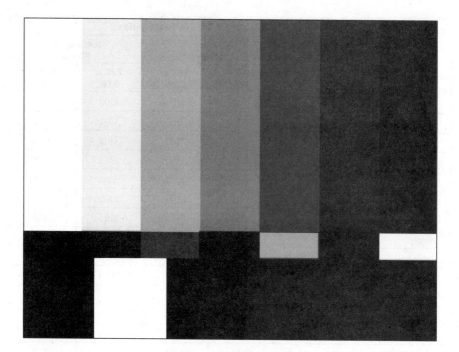

Figure F.1. Test Signal xx00.

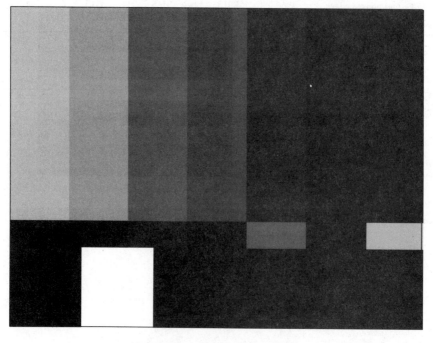

Figure F.2. Test Signal xx01.

t Signal xx02.

Figure F.4. Test Signal xx03.

Figure F.5. Test Signal xx04.

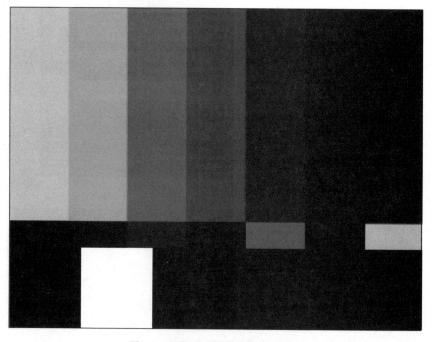

Figure F.6. Test Signal xx05.

Figure F.7. Test Signal xx06.

Figure F.8. Test Signal xx07.

Figure F.9. Test Signal xx08.

Figure F.10. Test Signal xx09.

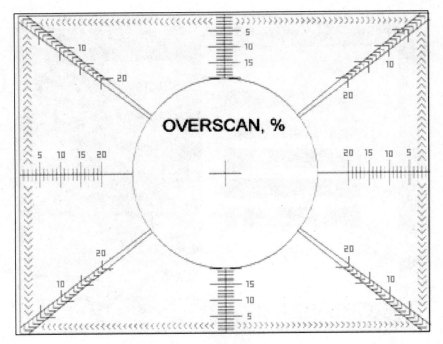

Figure F.11. Test Signal xx10.

Figure F.12. Test Signal xx11.

Figure F.13. Test Signal xx12.

Figure F.14. Test Signal xx13.

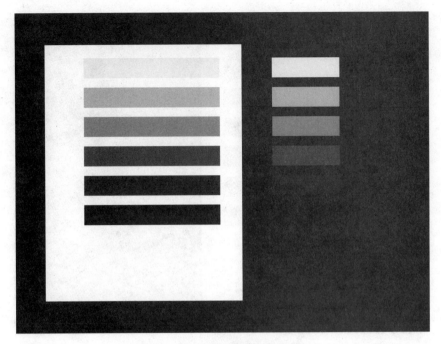

Figure F.15. Test Signal xx14.

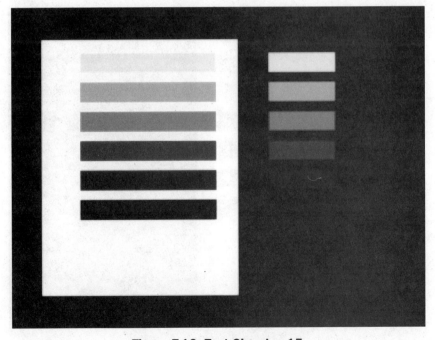

Figure F.16. Test Signal xx15.

Figure F.17. Test Signal xx16.

Figure F.18. Test Signal xx17.

Figure F.19. Test Signal xx18.

Figure F.20. Test Signal xx19.

Usage of Still Test Images

100% Color Bars. This test signal is used to measure the hue and color saturation accuracy. The transitions between colors are determined by the quality of any filters in the signal path. The sharper the transitions are without ringing, the better the filters. Since this pattern is computer-generated, there may be flicker along horizontal edges when viewed on a TV or an interlaced monitor. Unless the video signal is RF modulated, it should pass through the system with no problems. If it is RF modulated, the yellow and cyan colors will be affected.

75% Color Bars. This test signal is also used to measure the hue and color saturation accuracy. Again, the transitions between colors are affected by the quality of any filters in the signal path. The sharper the transitions are without ringing, the better the filters. Since this pattern is computer-generated, there may be flicker along horizontal edges when viewed on a TV or an interlaced monitor. Even if the video signal is RF modulated, it should pass through the system with no problems.

100% Color Wheel. This nonstandard test signal may be used to visually see how well the system handles highly saturated colors. Unless the video signal is RF modulated, it should pass through the system with no problems.

75% Red Frame. This test signal is used to visually look for static noise present in the system. Even if it is RF modulated, it should pass through the system with no problems.

Linear Y Ramp. This test signal is used to test luma nonlinearity and the linearity of any A/D and D/A converters present in the system. Even if it is RF modulated, it should pass through the system with no problems.

75% Y Bars. This test signal is also used to measure luma nonlinearity and to perform monitor adjustment. Since this pattern is computer-generated, there may be flicker along horizontal edges when viewed on a TV or an interlaced monitor. Even if it is RF modulated, it should pass through the system with no problems.

10-step Y Staircase. This test signal is also used to measure luma nonlinearity. Even if it is RF modulated, it should pass through the system with no problems.

Needle. This test signal allows determining the frequency response of the system. Even if the video signal is RF modulated, it should pass through the system with no problems.

Color Test. This test signal contains a multiburst pattern to help determine the frequency response of the system. It also allows the evaluation of color reproduction and fine detail. Even if the video signal is RF modulated, it should pass through the system with no problems.

Linear Yellow Ramp. This nonstandard test signal may be used to assist with determining the ability of the system to handle the full range of video levels without clipping or compression. Unless the video signal is RF modulated, it should pass through the system with no problems.

Overscan Measurement. This test signal may be used to visually determine the amount of overscan a TV or monitor has. Even if the video signal is RF modulated, it should pass through the system with no problems.

Text Samples. This nonstandard test signal contains both normal and anti-aliased text of several sizes, and illustrates the need for "fat,

wide" text for video. Notice that the anti-aliased text is difficult to read on a TV or interlaced monitor due to its being too thin. Even if the video signal is RF modulated, it should pass through the system with no problems.

100% Fast Edges. This nonstandard test signal may be used to determine how any filters in the system respond to fast edges of highly saturated (100%) colors. With good filters, there should be no ringing along the color edges. Use of sharp cut-off filters results in ringing. Since this pattern is computer-generated, there may be flicker along horizontal edges when viewed on a TV or an interlaced monitor. Unless the video signal is RF modulated, it should pass through the system with no problems.

100% Anti-Aliased Edges. This nonstandard test signal is a Gaussian-filtered version of the "100 Fast Edges," and illustrates how using slow edges removes flicker in interlaced displays and any ringing on color edges due to filtering. Unless the video signal is RF modulated, it should pass through the system with no problems.

75% Fast Edges. This nonstandard test signal may be used to determine how any filters in the system respond to fast edges of normal (75%) colors. With good filters, there should be no ringing along the color edges. Use of sharp cut-off filters results in ringing. Since this pattern is computer-generated, there may be flicker along horizontal edges when viewed on a TV or an interlaced monitor. Even if the video signal is RF modulated, it should pass through the system with no problems.

75% Anti-Aliased Edges. This nonstandard test signal is a Gaussian-filtered version of the "75% Fast Edges," and illustrates how using slow edges removes flicker in interlaced displays and any ringing on color edges due to filtering. Even if the video signal is RF modulated, it should pass through the system with no problems.

88% Fast Edges. This nonstandard test signal may be used to determine how any filters in the system respond to fast edges of highly saturated (88%) colors. The colors are the equivalent of 75% linear RGB values, common in computer graphics. With good filters, there should be no ringing along the color edges. Use of sharp cut-off filters results in ringing. Since this pattern is computer-generated, there may be flicker along horizontal edges when viewed on a TV or an interlaced monitor. Unless the video signal is RF modulated, it should pass through the system with no problems.

88% Anti-Aliased Edges. This nonstandard test signal is a Gaussian-filtered version of the "88% Fast Edges," and illustrates how using slow edges removes flicker in interlaced displays and any ringing on color edges due to filtering. Unless the video signal is RF modulated, it should pass through the system with no problems.

Classroom Picture. This nonstandard test signal may be used to determine how the system responds to very fine detail, various sharp edges, subtle shading, and highly saturated colors. There should be no ringing along the color edges and little loss of detail. There may be some flicker when viewed on a TV or an interlaced monitor due to the fine detail and sharp edges present. Unless the video signal is RF modulated, it should pass through the system with no problems.

Anti-Aliased Classroom Picture. This nonstandard test signal is a Gaussian-filtered version of "Classroom Picture," and illustrates how using slow edges removes flicker in interlaced displays. There should be very little loss of detail and no ringing on color edges. Unless the video signal is RF modulated, it should pass through the system with no problems.

Jitter Example Images

All file types are 24-bit gamma-corrected RGB TIFF (the RGB range is 0–255) and are 10 frames long. They must be converted to the proper YCbCr format for driving a H.261, H.263, MPEG 1, or MPEG 2 encoder. Two resolutions are represented: 352 × 240 and 352 × 288. For each resolution, three versions of sequence images are provided: 0 ns, 5 ns, and 10 ns.

Usage

The sequence of images in the "0 ns" directory may be used to evaluate the performance of a video compression system assuming an ideal NTSC/PAL decoder (no jitter) and no video noise (ideal source).

The sequence of images in the "5 ns" directory may be used to evaluate the performance of a video compression system assuming a studio-quality NTSC/PAL decoder (5 ns of pixel clock jitter) and little video noise (up to +/–3 codes out of 255).

The sequence of images in the "10 ns" directory may be used to evaluate the performance of a video compression system assuming a consumer-quality NTSC/PAL decoder (10 ns of pixel clock jitter) and typical video noise (up to +/–6 codes out of 255).

By comparing the compression ratios of the three image sequences, the quality of the temporal processing may be evaluated. With no temporal preprocessing, the "0 ns" and "5 ns" sequences should yield similar compression ratios. The "10 ns" sequence will have a poorer compression ratio. With good temporal preprocessing, all three sequences should yield similar compression ratios. This demonstrates that with better NTSC/PAL decoders, or by adding temporal preprocessing, higher compression ratios can be easily achieved.

Quicktime Directory

This directory contains flattened QuickTime movies generated from the gamma_RGB images. Resolutions are 320 × 240 and 240 × 180. Each movie has a duration of 2 minutes.

H.261 Directory

This directory contains source code for a H.261 software encoder and decoder. Also included are several video bitstreams and several CIF and QCIF sequence images. Ftp and http addresses for additional video bitstreams are also provided.

H.263 Directory

This directory contains source code for a H.263 software encoder and decoder. Also included are several video bitstreams and several CIF, QCIF, and SQCIF sequence images. Ftp and http addresses for additional video bitstreams are also provided.

MPEG_1 Directory

This directory contains source code for an MPEG 1 video encoder and decoder and a system bitstream multiplexer and demultiplexer.

Also included are ftp and http addresses for additional video bitstreams.

MPEG_2 Directory

This directory contains source code for a MPEG 2 video encoder and decoder.

Also included are ftp and http addresses for audio, video, and system bitstreams.

Sequence Directory

Various image sequences are provided as test source material for H.261, H.263, MPEG 1 and MPEG 2 encoders.

SQCIF (128×96, 4:2:0)
QCIF (176×144, 4:2:0)
CIF (352×288, 4:2:0)
NTSC SIF (352×240, 4:2:0)
PAL SIF (352×288, 4:2:0)
NTSC 601 (720×480, 4:2:2)
PAL 601 (720×576, 4:2:2)

Tools Directory

This directory contains various software tools. Included is the source code to convert ITU-R BT.601 4:2:2 data to SIF 4:2:0 data, eyuv_to_ppm, ppm_to_eyuv, vid_to_eyuv, and vid_to_ppm.

Glossary

To assist the beginner, this glossary offers many of the video terms commonly used. Definitions are simplified, so you do not have to be a video wizard to understand them. Some of the material in this glossary is copyrighted by Brooktree Corporation, and is used with their permission.

AC Coupled AC coupling is a method of inputting a video signal to any circuit in a way that removes the DC offset, or the overall voltage level that the video signal "rides" on.

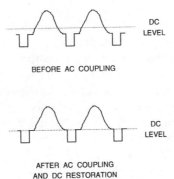

BEFORE AC COUPLING

AFTER AC COUPLING
AND DC RESTORATION

You can see in the figure that not knowing the DC offset means that we don't know exactly where the video signal is. One way to find the signal is to remove the DC offset by AC coupling and then do DC restoration to add a known DC offset (one that we selected). Another reason AC coupling is important is that it can remove harmful DC offsets.

Active Video The part of the video waveform that isn't specified to be blanking, burst, or sync information. Most, if not all, of active video actually is visible on the display screen.

A/D, ADC These are short for analog-to-digital converter. This device is what most digital systems currently use to get video and audio into a computer. An ADC for digitizing video must be very fast, capable of sampling at 10 to 150 million samples per second (MSPS). There are two main types of ADCs: flash and sigma delta.

AFC

Automatic frequency control. Commonly used to lock onto and track a desired frequency.

AGC

Automatic gain control. Used to keep the output signal of a circuit constant as the input signal amplitude varies.

Alpha

See Alpha Channel and Alpha Mix.

Alpha Channel

The alpha channel is used to specify an alpha value for each color pixel. The alpha value is used to control the blending, on a pixel-by-pixel basis, of two images.

new pixel = (alpha)(pixel A color) + (1 – alpha)(pixel B color)

Alpha typically has a normalized value of 0 to 1. In a computer environment, the alpha values can be stored in additional bit planes of frame-buffer memory. When you hear about 32-bit frame buffers, what this really means is that there are 24 bits of color, 8 each for red, green, and blue, along with an 8-bit alpha channel. Also see Alpha Mix.

Alpha Mix

This is a way of combining two images. How the mixing is performed is provided by the alpha channel. The little box that appears over the left-hand shoulder of a news anchor is put there by an alpha mixer. Wherever the pixels of the little box appear in the frame buffer, an alpha number of "1" is put in the alpha channel. Wherever they don't appear, an alpha number of "0" is placed. When the alpha mixer sees a "1" coming from the alpha channel, it displays the little box. Whenever it sees a "0," it displays the news anchor. Of course, it doesn't matter if a "1" or a "0" is used, but you get the point.

AM

Short for amplitude modulation.

Amplitude Modulation

A method of encoding data onto a carrier, such that the amplitude of the carrier is proportionate to the data.

Anti-Aliasing Filter

A filter (typically a lowpass filter) used to band-limit the signal before sampling to less than half the sampling rate.

Aperture Delay

Aperture delay is the time from an edge of the input clock of the ADC until the time the part actually takes the sample. The smaller this number, the better.

Aperture Jitter

The uncertainty in the aperture delay. This means the aperture delay time changes a little bit over time, and that little bit of change is the aperture jitter.

Artifacts

In the video domain, artifacts are blemishes, noise, snow, spots, whatever. When you have an image artifact, something is wrong with the picture from a visual stand-

point. Don't confuse this term with not having the display adjusted properly. For example, if the hue control is set wrong, the picture will look bad, but this is not an artifact. An artifact is some physical disruption of the image.

Aspect Ratio

The ratio of the width of the picture to the height. For most current TV sets, this ratio is 4:3. For HDTV, the ratio will be 16:9. The aspect ratio, along with the number of vertical scan lines that make up the image, determines what sample rate should be used to digitize the video signal.

Asynchronous

Refers to circuitry without a common clock or timing signal.

Audio Modulation

Refers to modifying a carrier with audio information so that it may be mixed with the video information and transmitted.

Audio Subcarrier

A specific frequency that is modulated with audio data before being mixed with the video data and transmitted.

Authoring Platform

A computer that has been outfitted with the right hardware for creating material to be viewed in a multimedia box. The video quality of the authoring platform has to be high enough that the playback equipment is the limiting factor.

Automatic Frequency Control (AFC)

See AFC.

Automatic Gain Control (AGC)

See AGC.

Back Porch

The area of the video waveform between the rising edge of the horizontal sync and right before the active video.

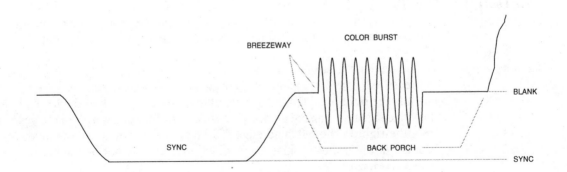

Bandpass Filter A circuit that allows only a selected range of frequencies to pass through.

Bandwidth The range of frequencies a circuit will respond to or pass through. It may also be the difference between the highest and lowest frequencies of a signal.

Baseband When applied to audio and video, baseband means an audio or video signal that has not been RF modulated (to channel 3 or 4, for example).

BBC British Broadcasting Corporation.

(B, D, G, H, I) PAL PAL stands for Phase Alternation Line, Picture Always Lousy, or Perfect At Last depending on your viewpoint. PAL is to Europe as NTSC is to North America. In other words, PAL is the video standard used in Europe and many other countries. There are a few differences. PAL uses 625 lines per frame while NTSC has 525 lines. Therefore, PAL has higher vertical resolution. The frame rate of NTSC is about 30 frames per second while for PAL it is 25. This means the update rate for NTSC is higher and therefore there is more flicker with PAL. PAL uses the YUV color space while NTSC uses YIQ or YUV. That's no big deal, just a little mathematical difference. It is becoming increasingly important for imaging systems suppliers to produce equipment that can be sold worldwide without many manufacturing difficulties. This implies that the equipment must be designed from the start to accommodate both standards.

BITC This stands for Burned-In Time Code. It means that the time code information is displayed within a portion of the picture, and can be viewed on any monitor or TV.

Black Burst Black burst is a composite video signal with a totally black picture. Black burst is used to sync video equipment together so that video output is aligned. Black burst tells the video equipment the vertical sync, horizontal sync, and the chroma burst information.

Black Level This level represents the darkest an image can get. This defines what black is for the particular image system. If for some reason the video dips below this level, it is referred to as blacker-than-black. You could say that sync is blacker-than-black.

Blanking On the screen, the scan line moves from the left edge to the right edge, jumps back to the left edge, and starts out all over again, on down the screen. When the scan line hits the right-hand limit and is about to be brought back to the left-hand edge, the video signal is blanked so that you can't "see" the return path of the scan beam from the right to the left-hand edge. To blank the video signal, the video level is brought down to the blanking level, which may or may not be the black level if a pedestal is used.

Blanking Level That level of the video waveform defined by the system to be where blanking occurs. This could be the black level if a pedestal is not used or below the black level if a pedestal is used.

Blooming This is an effect, sometimes caused when video becomes whiter-than-white, in which a line that is supposed to be nice and thin becomes fat and fuzzy on the screen.

Breezeway That portion of the video waveform between the rising edge of the horizontal sync and the start of color burst.

Brightness This is the intensity of the video level and refers to how much light is emitted by the display.

Burst See Color Burst.

Burst Gate This is a signal that tells the system where the color burst is located within the scan line.

B$'$–Y In color television, the blue-minus-luma signal, also called a color difference signal. When added to the luma (Y) signal, it produces the blue primary signal.

Carrier A signal which is modulated with data to be transmitted.

CATV Community antenna television, now generally meaning cable TV.

CBC Canadian Broadcasting Corporation.

CCIR Comité Consultatif International des Radiocommunications or International Radio Consultative Committee. The CCIR no longer exists—it has been absorbed into the parent body, the ITU.

CCIR 601 Now known as Recommendation ITU-R BT.601, this is a recommendation developed by the International Radio Consultative Committee for the digitization of color video signals. ITU-R BT.601 deals with color space conversion from R$'$G$'$B$'$ to YCbCr, the digital filters used for limiting the bandwidth, the sample rate (defined as 13.5 MHz), and the horizontal resolution (720 active pixels).

Checksum An error-detecting scheme which is the sum of the data values transmitted. The receiver computes the sum of the received data values and compares it to the transmitted sum. If they are equal, the transmission was error-free.

Chroma The (M) NTSC or (B, D, G, H, I) PAL video signal contains two pieces that make up what you see on the screen: the black and white (luma) part, and the color part. Chroma is the color part.

Chroma Bandpass

In an (M) NTSC or (B, D, G, H, I) PAL video signal the luma (black and white) and the chroma (color) information are combined. If you want to decode an NTSC or PAL video signal, the luma and chroma must be separated. The chroma bandpass filter removes the luma from the video signal, leaving the chroma relatively intact. This works reasonably well except in certain images where the luma information and chroma information overlap, meaning that we have luma and chroma stuff at the same frequency. The filter can't tell the difference between the two and passes everything within a certain area. If there is luma in that area, it's let through too. This can make for a funny-looking picture. Next time you're watching TV and someone is wearing a herringbone jacket or a shirt with thin, closely spaced stripes, take a good look. You'll see a rainbow color effect moving through that area. What's happening is that the chroma demodulator thinks the luma is chroma. Since the luma isn't chroma, the TV can't figure out what color it is and it shows up as a rainbow pattern. This problem can be overcome by using a comb filter.

Chroma Burst

See Color Burst.

Chroma Demodulator

After the (M) NTSC or (B, D, G, H, I) PAL video signal makes its way through the Y/C separator, by either the chroma bandpass, chroma trap, or comb filter method, the colors must be decoded. That's what a chroma demodulator does. It takes the chroma output of the Y/C separator and recovers two color difference signals (typically I and Q or U and V). To do this, the chroma demodulator uses the color subcarrier. Now, with the luma information and color difference signals, the video system can figure out what colors to put on the screen.

Chroma Key

This is a method of combining two video images. An example of chroma keying in action is the nightly news weatherman standing in front of a giant weather map. In actuality, the weatherman is standing in front of a solid, bright-blue background and his (or her) image is projected on top of the computer-generated map. This is how it works: a TV camera is pointed at the person or object that you want to project on top of the artificial background (e.g., the weather map). The background doesn't actually have to be artificial. It can be another real image—it doesn't really matter. As mentioned, our imaginary weatherman is standing in front of a bright-blue background. This person and a bright-blue background image are fed along with the image of the artificial background into a box. Inside the box, a decision is made. Wherever it sees the bright-blue background, it displays the artificial background. Wherever it does not see bright blue, it shows the original image. So, whenever the weatherman moves around, he's moving around in front of the bright-blue background. The box figures out where he is and where he isn't, and displays the appropriate image.

Chroma Trap

In an (M) NTSC or (B, D, G, H, I) PAL video signal the luma (black and white) and the chroma (color) information are combined together. If you want to decode the video signal, the luma and chroma must be separated. The chroma trap is a method for separating the chroma from the luma, leaving the luma relatively

intact. How does this work? The (M) NTSC or (B, D, G, H, I) PAL signal is fed to a bandstop filter. For all practical purposes, a bandstop filter allows some types of information (actually certain frequencies) to pass through but not others. The bandstop filter is designed with a response, or stop, to remove the chroma so that the output of the filter only contains the luma. Another name for a bandstop filter is a trap. Since this trap stops chroma, it's called a chroma trap. The sad part about all of this is that not only does the filter remove chroma, it removes luma as well if it exists within the region where the stop exists. The filter only knows ranges and, depending on the image, the luma information may overlap the chroma information. The filter can't tell the difference between the luma and chroma, so it stops both when they are in the same range. What's the big deal? Well, you lose luma and this means that the picture is degraded somewhat. Using a comb filter for a Y/C separator is better than a chroma trap or chroma bandpass. See the Chroma Bandpass and the Y/C Separator definitions.

Chrominance In video, the terms chrominance and chroma are commonly (and incorrectly) interchanged. See chroma.

CIF Common Interface Format. This video format was developed to easily allow video phone calls between countries. The CIF format has a resolution of 352 × 288 active pixels and a refresh rate of 30,000/1001 frames per second.

Clamp This is basically another name for the DC-restoration circuit. It can also refer to a switch used within the DC-restoration circuit. When it means DC restoration, then it's usually used as "clamping." When it's the switch, then it's just "clamp."

Clipping Logic A circuit used to prevent illegal conversion. Some colors can exist in one color space but not in another. Right after the conversion from one color space to another, a color space converter might check for illegal colors. If any appear, the clipping logic is used to chop off, or clip, part of the information until a legal color can be represented. Since this circuit clips off some information and is built using logic, it's not too hard to see how the name "clipping logic" was developed.

Closed Captioning A service which decodes text information transmitted with the audio and video signal and displays it at the bottom of the display. See the EIA 608 specification for (M) NTSC usage of closed captioning.

CMYK This is a color space primarily used in color printing. CMYK is an acronym for Cyan, Magenta, Yellow, and blacK. The CMYK color space is subtractive, meaning that cyan, magenta, yellow, and black pigments or inks are applied to a white surface to remove color information from the white surface to create the final color. The reason black is used is because even if a printer could put down hues of cyan, magenta, and yellow inks perfectly enough to make black (which it can't for large areas), it would be too expensive since colored inks cost more than black inks. So, when black has to be made, instead of putting down a lot of CMY, they just use black. So, what is a printing term doing here? The reason is that a lot of color systems are being hooked up to color printers. The display screen uses RGB but the printer uses CMYK. A color space conversion needs to be performed for true WYSIWYG ("wizzy-wig"—What You See Is What You Get) performance in a color system that has a printer.

Color Bars This is a test pattern used to check whether a video system is calibrated correctly. A video system is calibrated correctly if the colors are the correct brightness, hue, and saturation. This can be checked with a vectorscope, or by looking at the RGB levels.

Color Burst That portion of the video waveform that sits between the breezeway and the start of active video. The color burst tells the color decoder how to decode the color information contained in that line of active video. By looking at the color burst, the decoder can determine what's blue, orange, or magenta. Essentially, the decoder figures out what the correct color is. If you've ever seen a TV picture in which the colors were just not right, a reason might be that the TV can't find the color burst and doesn't know how to make the correct color.

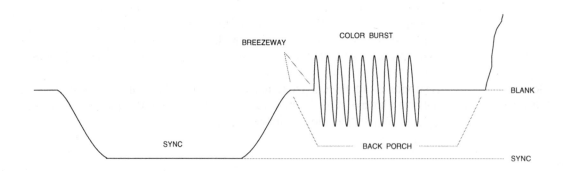

Color Decoder

This is the circuit in the video system that uses the chroma portion of a video signal to derive the two color difference signals. The color decoder sits right after the Y/C separator and before the color space converter. The color decoder needs a reference signal that is accurately phase-locked to the color burst. If it isn't locked well enough, then the color decoder can't figure out the right colors. Also called a Chroma Demodulator.

Color Demodulator

See Color Decoder and Chroma Demodulator.

Color Difference

All of the color spaces used in color video require three components. These might be R′G′B′, YIQ, YUV or Y(R′ − Y)(B′ − Y). In the Y(R′ − Y)(B′ − Y) color space, the R′ − Y and B′ − Y components often are referred to as color difference signals for obvious reasons. They are made by subtracting the luma (Y) from the red and blue components. I and Q and U and V are also color difference signals since they are scaled versions of R′ − Y and B′ − Y. All the Ys in each of the YIQ, YUV and Y(R′ − Y)(B′ − Y) are basically the same.

Color Edging

Extraneous colors that appear along the edges of color pictures, but don't have a color relationship to those areas.

Color Encoder

The color encoder does the exact opposite of the color decoder. It takes the two color difference signals, such as I and Q or U and V, and combines them into the chroma signal. The color encoder, or what may be referred to as the color modulator, uses the color subcarrier to do the encoding.

Color Key

This is essentially the same thing as Chroma Key.

Color Killer

A color killer is a circuit that shuts off the color decoder in a video system if the incoming video does not contain color information. How does this work? The color killer looks for the color burst and if it can't find it, it shuts off the color decoder. For example, let's say that a color TV is going to receive material recorded in black and white. Since the black and white signal does not contain a color burst, the color decoder is shut off. Why is a color killer used? Well, in the old days, the color decoder would still generate a tiny little bit of color if a black and white transmission was received, due to small errors in the color decoder, causing a black and white program to have faint color spots throughout the picture.

Color Modulator

Take a look at the Color Encoder definition.

Color Purity	This term is used to describe how close a color is to the theoretical. For example, in the YUV color space, color purity is specified as a percentage of saturation and ±θ, where θ is an angle in degrees, and both quantities are referenced to the color of interest. The smaller the numbers, the closer the actual color is to the color that it's really supposed to be. For a studio-grade device, the saturation is ±2% and the hue is ±2°. On a vectorscope, if you're in that range, you're studio grade.
Color Space	A color space is a mathematical representation for a color. No matter what color space is used—RGB, YIQ, YUV, and so on—orange is still orange. What changes is how you represent orange in a video system. For example, the RGB color space is based on a Cartesian coordinate system and the HSI color space is based on a polar coordinate system.
Color Subcarrier	The color subcarrier is a clock signal used to run the color encoder or color decoder. For (M) NTSC the frequency of the color subcarrier is about 3.58 MHz and for (B, D, G, H, I) PAL it's about 4.43 MHz. In the color encoder, a portion of the color subcarrier is used to create the color burst, while in the color decoder, the color burst is used to reconstruct the color subcarrier.
Color Temperature	Color temperature is measured in degrees Kelvin. If a TV has a color temperature of 8,000 degrees Kelvin, that means the whites have the same shade as a piece of pure carbon heated to that temperature. Low color temperatures have a shift towards red; high color temperature have a shift towards blue. The standard for (M) NTSC in the United States is 6,500 degrees Kelvin. Thus, professional TV monitors use a 6,500-degree color temperature. However, most consumer TVs have a color temperature of 9,000 degrees Kelvin or higher, resulting in a bluish cast. By adjusting the color temperature of the TV, more accurate colors are produced, at the expense of picture brightness.
Comb Filter	This is another method of performing a Y/C separation. A comb filter is used in place of a chroma bandpass or chroma trap. The comb filter provides better video quality since it does a better job of separating the luma from chroma. It reduces the amount of creepy-crawlies or zipper artifacts. It's called a comb filter because the frequency response looks like a comb. The important thing to remember is that the comb filter is a better method for Y/C separation than chroma bandpass or chroma trap.
Compact Disk Interactive (CD-I)	Instead of a PC with special hardware, CD-I is a dedicated box that you buy just like any other piece of consumer audio or video gear.
Comparator	This is a circuit or functional block that is a basic component of flash ADCs. A comparator has two inputs, X and Y, along with one output, which we will call Z. The comparator implements the following mathematical function:

If $A - B > 0$, then $Z = 1$
If $A - B < 0$, then $Z = 0$

What does this mean? A comparator "compares" A to B. If A is larger than B, the output of the comparator is a "1." If A is smaller than B, then the output is a "0." If $A = B$, the output Z may be undefined and oscillate between 1 and 0 wildly until that condition is removed, it may be a "1," or it may be a "0." It depends on how the comparator was designed.

Composite TV Signal

The combination of color video, audio, and timing signals.

Composite Video

A single signal that contains color video and timing information. If a video system is to receive video correctly, it must have several pieces of the puzzle in place. It must have the picture that is to be displayed on the screen, and it must be displayed with the correct colors. This piece is called the active video. The video system also needs information that tells it where to put each pixel. This is called sync. The display needs to know when to shut off the electron beam so the viewer can't see the spot retrace across the display. This piece of the video puzzle is called blanking. Now, each piece could be sent in parallel over three separate connections, and it would still be called video and would still look good on the screen. This is a waste, though, because all three pieces can be combined together so that only one connection is needed. Composite video is a video stream that combines all of the pieces required for displaying an image into one signal, thus requiring only one connection. (M) NTSC and (B, D, G, H, I) PAL are examples of composite video. Both are made up of: active video, horizontal sync, horizontal blanking, vertical sync, vertical blanking, and color burst. RGB is not an example of composite video, even though each red, green, and blue signals may each contain sync and blank information, because all three signals are required to display the picture with the right colors.

Compression Ratio

Compression ratio is a number used to tell how much information is squeezed out of an image when it has been compressed. For example, suppose we start with a 1-Mbyte image and compress it down to 128 kbytes. The compression ratio would be:

$$1,048,576 / 131,072 = 8$$

This represents a compression ratio of 8:1; 1/8 of the original amount of storage is now required. For a given compression technique—MPEG, for example—the higher the compression ratio, the worse the image looks. This has nothing to do with which compression method is better, for example JPEG versus MPEG. Rather, it depends on the application. A video stream that is compressed using MPEG at 100:1 may look better than the same video stream compressed to 100:1 using JPEG.

Contouring	This is an image artifact caused by not having enough bits to represent the image. The reason the effect is called "contouring" is because the image develops lines that look like a geographical contour map. In a black-and-white imaging system, contouring may be noticed at 6 bits per pixel or less, while in a color system it may be 18 bits per pixel or less.
Contrast	A video term referring to how far the whitest whites are from the blackest blacks in a video waveform. If the peak white is far away from the peak black, the image is said to have high contrast. With high contrast, the image is very stark and very "contrasty," like a black-and-white tile floor. If the two are very close to each other, the image is said to have poor, or low, contrast. With poor contrast, an image may be referred to as being "washed out"—you can't tell the difference between white and black, and the image looks gray.
Creepy-crawlies	Yes, this is a real video term! Creepy-crawlies refers to a specific image artifact that is a result of the (M) NTSC system. When the nightly news is on, and a little box containing a picture appears over the anchorperson's shoulder, or when some computer-generated text shows up on top of the video clip being shown, get up close to the TV and check it out. Along the edges of the box, or along the edges of the text, you'll notice some jaggies "rolling" up (could be down) the picture. That's the creepy-crawlies. Some people refer to this as zipper because it looks like one.
Cross Color	This occurs when the NTSC/PAL decoder incorrectly interprets high-frequency luma information (brightness) to be chroma information (color), resulting in color being displayed where it shouldn't.
Cross Luma	This occurs when the NTSC/PAL decoder incorrectly interprets chroma information (color) to be high-frequency luma information (brightness).
Cross Modulation	A condition when one signal erroneously modulates another signal.
Crosstalk	Interference from one signal that is detected on another.
D-1, D-5	These are noncompressed component video tape formats (19-mm tape for D-1 and 0.5" tape for D-5) for very high-end digital video tape decks.
D-2, D-3	These are noncompressed composite video tape formats (19-mm tape for D-2 and 0.5" tape for D-3) for medium- to high-end digital video tape decks.
D/A, DAC	These are short for digital-to-analog converter.

dB
Abbreviation for decibels, a standard unit for expressing relative power, voltage, or current.

$$dB = 10 \log_{10} (P1/P2)$$

dBm
Measure of power in communications. 0 dBm = 1 mW, with a logarithmic relationship as the values increase or decrease. In a 50-ohm system, 0 dBm = 0.223 volts.

dBw
Decibels referenced to 1 watt.

DC Restoration
DC restoration is what you have to do to a video waveform after it has been AC coupled and has to be digitized. Since the video waveform has been AC coupled, we no longer know absolutely where it is. For example, is the bottom of the sync tip at –5 V or at 100 V? Is the back porch at 3.56 V or at 0 V? In fact, not only don't we know where it is, it also changes over time, since the voltage level of the active video changes over time. Since the resistor ladder on the flash ADC is tied to a pair of voltage references, such as REF– to 0 volts and REF+ to 1.3 volts, the video waveform needs to be referenced to some known DC level; otherwise, we couldn't digitize it correctly. DC restoration is essentially putting back a DC component that was removed to make an AC-coupled signal. We don't have to put back the original DC value—it could be a different one. In decoding (M) NTSC or (B, D, G, H, I) PAL video, the DC level for DC restoration is such that the sync tip is set to the ADCs REF– level. Therefore, when sync tip is digitized it will be assigned the number 0 and when peak white is digitized, it will be assigned the number 196. (This assumes that the gains are correct, but that's another problem.)

DCT
This is short for Discrete Cosine Transform, used in the JPEG, MPEG, H.261, and H.263 image compression algorithms.

Decibel
One-tenth of a Bel, used to define the ratio of two powers, voltages, or currents, in terms of gains or losses. It is 10x the log of the power ratio and 20x the voltage or current ratio.

Decimation
When a video waveform is digitized so that 100 pixels are produced, but only every other one is stored or used, the video waveform is decimated by a factor of 2:1. The image is now 1/4 of its original size, since 3/4 of the data is missing. If only one out of five pixels were used, then the image would be decimated by a factor of 5:1, and the image would be 1/25 its original size. Decimation, then, is a quick-and-easy method for image scaling and is in fact the method used by low-cost systems that scale video into a window.

Decimation can be performed in several ways. One way is the method just described, where data literally is thrown away. Even though this technique is easy to implement and cheap to build, it generally introduces image artifacts unacceptable to medium- to high-end customers. Another method is to use a decimation filter. This reduces the image artifacts to an acceptable level by smoothing them out, but is more costly to implement than the method of just throwing data away.

Decimation Filter	See "Decimation" above. A decimation filter is a filter designed to provide decimation without the artifacts associated with throwing data away (the method of throwing data away is the example described in the decimation definition).
Deemphasis	Also referred to as post-emphasis and post-equalization. Deemphasis performs a frequency-response characteristic that is complementary to that introduced by pre-emphasis.
Deemphasis Network	A circuit used to restore the pre-emphasized frequency response to its original form.
Demodulation	The process of recovering an original signal from a modulated carrier.
Demodulator	In video, demodulation is the technique used to recover the color difference signals in (M) NTSC or (B, D, G, H, I) PAL systems. See the definitions for Chroma Demodulator and Color Decoder; those are two other names for a demodulator used in a video application.
Differential Gain	Differential gain is how much the color saturation changes when the luma level changes (it isn't supposed to). The result on the screen will be incorrect color saturation. For a video system, the better the differential gain—that is, the smaller the number specified—the better the system is at figuring out the correct color.
Differential Phase	Differential phase is how much the hue changes when the luma level changes (it isn't supposed to). The result on the screen will be incorrect colors. For a video system, the better the differential phase—that is, the smaller the number specified—the better the system is at figuring out the correct color.
Digital Component Video	Digital video using separate color components, such as YCbCr or R'G'B'. See CCIR 601. Sometimes incorrectly referred to as D-1.
Digital Composite Video	Digital video that is essentially the digitized waveform of (M) NTSC or (B, D, G, H, I) PAL video signals, with specific digital values assigned to the sync, blank, and white levels. Sometimes incorrectly referred to as D-2 or D-3.
Digital Video Interactive (DVI)	DVI is a multimedia system being marketed by Intel. It is not just an image-compression scheme, but includes everything that is necessary to implement a multimedia playback station. Intel's DVI offering is represented by chips, boards, and software.
Direct Broadcast Satellite (DBS)	A service that transmits multiple channels of television programming from a satellite to direct to the home.

Discrete Cosine Transform (DCT)

A DCT is just another way to represent an image. Instead of looking at it in the time domain—which, by the way, is how we normally do it—it is viewed in the frequency domain. It's analogous to color spaces, where the color is still the color but is represented differently. Same thing applies here—the image is still the image, but it is represented in a different way.

Why do JPEG, MPEG, H.261, and H.263 base part of their compression schemes on the DCT? Because it is more efficient to represent an image that way. In the same way that the YCbCr color space is more efficient than RGB in representing an image, the DCT is more efficient at image representation.

Discrete Time Oscillator (DTO)

A discrete time oscillator is a digital version of the voltage-controlled oscillator.

Dot Pitch

The distance between screen pixels measured in millimeters. The shorter the distance, the better the resolution. It is specified in pixels/mm.

Drop Field Scrambling

This method is identical to the sync suppression technique, except there is no suppression of the horizontal blanking intervals. Sync pulse suppression only takes place during the vertical blanking interval. The descrambling pulses still go out for the horizontal blanking intervals (to fool unauthorized descrambling devices). If a descrambling device is triggering on descrambling pulses only, and does not know that the scrambler is using the drop field scrambling technique, it will try to reinsert the horizontal intervals (which were never suppressed). This is known as double reinsertion, which causes compression of the active video signal. An unauthorized descrambling device creates a washed-out picture and loss of neutral sync during drop field scrambling.

Double Buffering

As the name implies, you need two buffers—for video, this means two frame buffers. While one of the buffers is being displayed, the other buffer is operated on by a filter, for example. When the filter is finished, the buffer that was just operated on is displayed while the first buffer is now operated on. This goes back and forth, back and forth. Since the buffer that contains the correct image (already operated on) is always displayed, the viewer does not see the operation being performed and just sees a perfect image all the time.

Downconverter

A circuit used to lower one or more high-frequency signals to a lower, intermediate range.

Downlink

The frequency carrier satellites use to transmit data to Earth stations.

Dynamic Range

The weakest to the strongest signals a circuit will accept as input or generate as an output.

EIA

Electronics Industries Association.

Equalization Pulses

These are two groups of pulses, one that occurs before the serrated vertical sync and another group that occurs after. These pulses happen at twice the normal horizontal scan rate. They exist to ensure correct 2:1 interlacing in early televisions.

Fade

Fading is a method of switching from one video source to another. Next time you watch a TV program (or a movie), pay extra attention when the scene is about to end and go on to another. The scene fades to black, then a fade from black to another scene occurs. Fading between scenes without going to black is called a dissolve. One way to do a fade is to use an alpha mixer.

Field

An interlaced TV screen is made using two fields, each one containing half of the scan lines needed to make up one frame of video. Each field is displayed in its entirety—therefore, the odd field is displayed, then the even, then the odd, and so on. Fields only exist for interlaced scanning systems. So for (M) NTSC, which has 525 lines per frame, a field has 262.5 lines, and two fields make up a 525-line frame.

Filter

In general, a filter is a used to remove unwanted material from a signal. If you have some high frequencies, such as noise, in with the signal that you really want, then a lowpass filter is used. A lowpass filter "passes" frequencies below a certain point and stops frequencies above that same point. A highpass filter does just the opposite—it stops low frequencies and passes the high frequencies. A bandpass filter lets through frequencies within a certain range or "band," but stops frequencies outside of the band.

Finite Impulse Response (FIR) Filter

This definition won't teach you how to design one of these, but will at least get you the basic information. A FIR filter is a type of digital filter. FIRs can be any type, such as lowpass, highpass or bandpass. Digital filters in general are much better than analog filters. Sometimes the only way to design a very high-quality filter is with an FIR—it would be impossible to design using analog components. A FIR filter is very, very good, it's digital, and it's somewhat expensive to build.

Flash A/D

A fast method for digitizing something. The signal to be digitized is provided as the source for one input of a whole bank of comparators. The other input is tied to a tap of a resistor ladder, with each comparator tied to its own tap. This way, when the input voltage is somewhere between the top and bottom voltages connected to the ladder, the comparators output a thermometer code. This means that all the comparators output a "yes" up to the input voltage and a "no" above that. The ADC then takes this string of Yes's and No's and converts them into a binary number which tells where the Yes's turned into No's. See the definition of Resistor Ladder for more details, if you're interested.

Flicker

Flicker occurs when the refresh rate of the video is too low. It's the same effect produced by an old fluorescent light fixture. For flicker to disappear, the update rate, or the video frame rate, must be at least 24 scene changes (frames) per second. This is fast enough so that the eyeball can't keep up with the individual frames. The two problems with flicker are that it's distracting and tiring to the eyes.

FM

Abbreviation for frequency modulation. This technique sends data as patterns of frequency variations of a carrier signal.

Frame

A frame of video is essentially one picture or "still" out of a video stream. In (M) NTSC, a frame of video is made up of 525 individual scan lines. For (B, D, G, H, I) PAL, it's 625 scan lines. If you get up close to your TV screen, you'll be able to see the individual lines that make up the picture. For (M) NTSC, after 525 lines are painted on the screen, the next frame appears; then after that one, the next; and so on, and so on. By playing these individual frames fast enough, it looks like people are "moving" on the screen. It's the same principle as flip cards, cartoons, and movies.

Frame Buffer

A frame buffer is a big bunch of memory, used to hold the image for the display. How much memory are we talking about? Well, let's assume a horizontal resolution of 640 pixels and 480 scan lines, and we'll use the RGB color space. This works out to be:

$$640 \times 480 \times 3 = 921,600 \text{ bytes or } 900 \text{ KB}$$

So, 900 kbytes are needed to store one frame of video at that resolution.

Frame Rate

The frame rate of a video source is how fast the source repaints the screen with a new frame. For example, with the (M) NTSC system, the screen is repainted once about every 30th of a second for a frame rate of about 30 frames per second. For (B, D, G, H, I) PAL, the frame rate is 25 frames per second. For computer displays, the frame rate is usually 72–75 frames per second.

Frame Rate Conversion

Frame rate conversion is the act of converting one frame rate to another. One real example that poses a difficult problem is that the frame rate of (M) NTSC, about 30 frames per second, is different from a typical computer's display, which may be anywhere from 72 to 75 frames per second (or Hz if you prefer). Therefore, some frame-rate conversion process must be performed before (M) NTSC video can be shown correctly on a computer display. Without frame rate conversion, the screen might look as if it "stalls" every now and then. If there is motion within the video, the objects that are moving might appear cut in half.

Frequency Modulation

See FM.

Front Porch

This is the area of the video waveform that sits between the start of horizontal blank and the falling edge (start of) horizontal sync.

Gamma

The characteristics of the displays using phosphors (as well as some cameras) are nonlinear. A small change in voltage when the voltage level is low produces a change in the output display brightness level, but this same small change in voltage at a high voltage level will not produce the same magnitude of change in the brightness output. This effect, or actually the difference between what you should have and what you actually measured, is known as gamma.

Gamma Correction	Computers like to number crunch on linear RGB data. Before being displayed, this linear RGB data must be processed (gamma corrected) to compensate for the gamma of the display.
GCR	Ghost cancellation reference signal. A reference signal on (M) NTSC scan lines 19 and 282 and (B, D, G, H, I) PAL scan line 318 that allows the removal of ghosting from TVs. Filtering is employed to process the transmitted GCR signal and determine how to filter the entire video signal to remove the ghosting. ITU-R BT.1124 defines the standard each country uses.
Genlock	A video signal provides all of the information necessary for a decoder to reconstruct the picture. This includes brightness, color, and timing information. To decode the video signal properly, the decoder must be "genlocked" to the video signal. The decoder looks at the color burst of the video signal and reconstructs the original color subcarrier that was used by the encoder. This is needed to properly decode the color information. The decoder also generates a pixel clock (done by looking at the sync information within the video signal) that was the same as the pixel clock used by the encoder. The pixel clock is used to clock pixel data out of the decoder into a memory for display or into another circuit for processing. The circuitry within the decoder that does all of this work is called the genlock circuit. Although it sounds simple, the genlock circuit must be able to handle very bad video sources, such as the output of VCRs. In reality, the genlock circuit is the most complex section of a video decoder.
Gray Scale	The term gray scale has several meanings. It some instances it means the luma component of color video signals. In other cases, it means a black-and-white video signal.
H.320, H.261	ITU-T H.320 is a family of standards developed for video teleconferencing systems using ISDN. It references H.261 (for video); G.711, G.722, and G.728 (for audio); H.221, H.230, H.231, H.233, H.234, H.242, and H.243 (for control). The standard allows a system from one manufacturer to "talk" to a system from another manufacturer, just as two different FAX machines can "talk" to each other.
H.324, H.263	ITU-T H.324 is a family of standards developed for multimedia communication systems using conventional phone lines. It references H.263 (for video); G.723 (for audio); H.223 and H.245 (for control).
Hi-8	Hi-8 is a videotape format that uses an 8-mm wide tape. It provides better image quality than VHS.
High-Definition Television (HDTV)	This term describes several advanced standards proposals to allow high-resolution TV to be received in the home.

Highpass Filter
A circuit that passes, without attenuation, frequencies above a specific frequency (the cutoff frequency). Frequencies below the cutoff frequency are reduced in amplitude to eliminate them.

Horizontal Blanking
During the horizontal blanking interval, the video signal is at the blank level so as not to display the electron beam when it sweeps back from the right to the left side of the screen.

Horizontal Scan Rate
This is how fast the scanning beam in a display or a camera is swept from side to side. In the (M) NTSC system this rate is 63.556 ms, or 15.734 kHz. That means the scanning beam in your home TV moves from side to side 15,734 times a second.

Horizontal Sync
This is the portion of the video signal that tells the display where to place the image in the left-to-right dimension. The horizontal sync pulse tells the receiving system where the beginning of the new scan line is. Check to see if your TV at home has a horizontal hold control. If it does, give it a twist and observe what happens. When the picture rolls around like that, it's demonstrating what the picture would look like if there weren't any horizontal sync, or if the receiver couldn't find it.

HSI
HSI stands for Hue, Saturation and Intensity. It is a color space used to represent images. HSI is based on polar coordinates, while the RGB color space is based on a three-dimensional Cartesian coordinate system. The intensity, analogous to luma, is the vertical axis of the polar system. The hue is the angle and the saturation is the distance out from the axis. HSI is more intuitive to manipulate colors as opposed to the RGB space. For example, in the HSI space, if you want to change red to pink, you decrease the saturation. In the RGB space, what would you do? My point exactly. In the HSI space, if you wanted to change the color from purple to green, you would adjust the hue. Take a guess what you would have to do in the RGB space. However, the key thing to remember, as with all color spaces, is that it's just a way to represent a color—nothing more, nothing less.

HSL
This is similar to HSI, except that HSL stands for Hue, Saturation, and Lightness.

HSV
This is similar to HSI, except that HSV stands for Hue, Saturation, and Value.

HSYNC
Check out the Horizontal Sync definition.

Hue
In technical terms, hue refers to the wavelength of the color. That means that hue is the term used for the base color—red, green, yellow, and so on. Hue is completely separate from the intensity or the saturation of the color. For example, a red hue could look brown at low saturation, bright red at a higher level of saturation, or pink at a high brightness level. All three "colors" have the same hue.

Huffman Coding

Huffman coding is a method of data compression. It doesn't matter what the data is—it could be image data, audio data, or whatever. It just so happens that Huffman coding is one of the techniques used in JPEG, MPEG, H.261, and H.263 to help with the compression. This is how it works. First, take a look at the data that needs to be compressed and create a table that lists how many times each piece of unique data occurs. Now assign a very small codeword to the piece of data that occurs most frequently. The next largest codeword is assigned to the piece of data that occurs next most frequently. This continues until all of the unique pieces of data are assigned unique codewords of varying lengths. The idea is that data that occurs most frequently is assigned a small codeword, and data that rarely occurs is assigned a long code word, resulting in space savings.

Illegal Video

Some colors that exist in the RGB color space can't be represented in the video domain. For example, 100% saturated red in the RGB space (which is the red color on full strength and the blue and green colors turned off) can't exist in the (M) NTSC video signal, due to color bandwidth limitations. The (M) NTSC encoder must be able to determine that an illegal color is being generated and stop that from occurring, since it may cause over-saturation and blooming.

Image Buffer

For all practical purposes, an image buffer is the same as a frame buffer. An image is acquired by the computer and stored in the image buffer. Once it is in the image buffer, it can typically be annotated with text or graphics or manipulated in some way, just like anything else in a frame buffer.

Image Compression

Image compression is used to reduce the amount of memory required to store an image. For example, an image that has a resolution of 640 × 480 and is in the RGB color space at 8 bits per color, requiring 900 kbytes of storage. If this image can be compressed at a compression ratio of 20:1, then the amount of storage required is only 45 kbytes. There are several methods of image compression, but the most popular will be JPEG and MPEG as they become the accepted standards. H.261 and H.263 are the image compression standards to be used by video telephones.

Improved Definition Television (IDTV)

IDTV (also called enhanced definition television or EDTV) is different from HDTV. IDTV is a system that improves the display of NTSC or PAL systems by adding processing in the receiver; standard (M) NTSC or (B, D, G, H; I) PAL signals are transmitted.

Input Level

For flash ADCs, the input level is the voltage range required of the input video for proper operation of the part. For example, if the required input level for an 8-bit ADC is 0 to 10 V, then an input voltage level of 0 V is assigned the code 0 and an input voltage of 10 V is assigned the code 255. It is important that the voltage range of the input signal matches that of the ADC. Let's take a case where the voltage range of the signal is 0 V to 5 V and the ADC's input range is 0 V to 10 V. When the input level is 0 V, the output of the ADC will be the number 0, and when the input signal is at its maximum of 5 V, the output of the ADC will be 127. In this example, one-half of the ADC is wasted because the numbers 128 through 255 can't be generated since the input level of the source never gets high enough. The problem exists in the other direction also. Let's take an example where the input voltage level has the range of 0 V to 10 V, but the input range of the ADC is only 0 V to 5 V. When the input level is 0 V, the output of the ADC will be the number 0, but when the input signal is in the range of 5 V to 10 V, the output of the ADC will be stuck at 255, since the input is outside of the range for the ADC.

Intensity

This is the same thing as brightness.

Interlaced

An interlaced raster system is one where two (in general—it could be more, but we'll stick with two) interleaved fields are used to scan out one video frame. Therefore, the number of lines in a field are one-half of the number of lines in a frame. In (M) NTSC, there are 262.5 lines per field (525 lines per frame) while there are 312.5 lines per field in (B, D, G, H, I) PAL. Each field is drawn on the screen consecutively—first one field, then the other.

Why did the founding fathers (oops, persons) of video decide to go with an interlaced system? It has to do with frame rate. A large TV screen that was updated at 30 frames per second would flicker, meaning that the image would begin to fade away before the next one was drawn on the screen. By using two fields, each containing one-half of the information that makes up the frame and each field being drawn on the screen consecutively, the field update rate is 60 fields per second. At this update rate, the eye blends everything together into a smooth, continuous motion.

Interlace: field 1 (lines 1, 3, 5, 7) is scanned, then field 2 (lines 0, 2, 4, 6).

Interpolation Interpolation is a mathematical way of regenerating missing or needed information. Let's say that an image needs to be scaled up by a factor of two, from 100 pixels to 200 pixels. We can do this by interpolation. The missing pixels are generated by interpolating between the two pixels that are on either side of the pixel that needs to be generated. After all of the "missing" pixels have been interpolated—presto!—200 pixels exist where only 100 existed before, and the image is twice as big as it used to be. There are many methods of interpolation; the method described here is an example of simple averaging.

IRE Unit An arbitrary unit used to describe the amplitude characteristics of a video signal. Pure white is defined to be 100 IRE and the blanking level is defined to be 0 IRE.

JBIG JBIG (Joint Bi-level Image Experts Group) losslessly compresses binary (one bit per pixel) images. The intent of JBIG is to replace the current group 3 and 4 fax algorithms. JBIG can be used on grey-scale or color images by applying the algorithm one bit-plane at a time.

Jitter Short-term variations in the characteristics (such as frequency, amplitude, etc.) of a signal.

JPEG JPEG stands for Joint Photographic Experts Group. However, what people usually mean when they use the term "JPEG" is the image compression standard developed by an international body. JPEG was developed to compress still images, such as photographs, a single video frame, something scanned into the computer, and so forth. You can run JPEG at any speed that the application requires. For a still picture database such as mugshots, the algorithm doesn't have to be too fast. If you run JPEG fast enough, though, you can compress motion video—which means that JPEG would have to run at 30 frames per second. You might want to do this if you were designing a video editing or authoring platform. Now, JPEG running at 30 frames per second is not as efficient as MPEG running at 30 frames per second because MPEG was designed to take advantage of certain aspects of motion video. So in a video editing platform, you would have to trade off the lower bit rate (high compression) of MPEG with the ability to do frame-by-frame edits in JPEG (but not in MPEG). Both standards have their place in an image compression strategy and both standards will probably exist in a box simultaneously.

Line Store A line store is a memory buffer used to hold one line of video. If the horizontal resolution of the screen is 640 pixels and RGB is used as the color space, the line store would have to be 640 locations long by 3 bytes wide. This amounts to one location for each pixel and each color plane. Line stores are typically used in filtering algorithms. For example, a comb filter is made up of one or more line stores. The DCT used in the JPEG, MPEG, H.261, and H.263 compression algorithms could use eight line stores since processing is done on blocks of 8×8 pixels.

Linearity

Linearity is a basic measurement of how well an ADC or DAC is performing. Linearity typically is measured by making the ADC or DAC represent a diagonal line. The actual output of the device is compared to what is the ideal the output. The difference between the actual diagonal line and the ideal line is a measure of the linearity. The smaller the number, the better. Linearity is typically specified as a range or percentage of LSBs (Least Significant Bits).

Locked

When a PLL is accurately producing horizontal syncs that are lined up precisely with the horizontal syncs of the incoming video source, the PLL is said to be "locked." When a PLL is locked, the PLL is stable and there is minimum jitter in the generated pixel clock.

Longitudinal Timecode

See LTC.

Loop Filter

A loop filter is used in a PLL design to smooth out tiny bumps in the output of the phase comparator that might drive the loop out of lock. The loop filter helps to determine how well the loop locks, how long it takes to lock, and how easy it is to knock the loop out of lock.

Lossless

Lossless is a term used with image compression. Lossless image compression is when the decompressed image is exactly the same as the original image. It's lossless because you haven't lost anything.

Lossy

Lossy image compression is the exact opposite of lossless. The regenerated image is different from the original image. The differences may or may not be noticeable, but if the two images are not identical, the compression was lossy.

Lowpass Filter

A circuit that passes, without attenuation, frequencies below a specific frequency (the cutoff frequency). Frequencies above the cutoff frequency are reduced in amplitude to eliminate them.

LTC

Longitudinal Time Code. Timecode information is stored on audio tracks, requiring an entire field's time to store the timecode information.

Luma

As mentioned in the definition of chroma, the (M) NTSC and (B, D, G, H, I) PAL video systems use a signal that has two pieces: the black and white part, and the color part. The black and white part is called luma. It was the luma component that allowed color TV broadcasts to be received by black-and-white TVs and still remain viewable.

Luminance

In video, the terms luminance and luma are commonly (and incorrectly) interchanged. See luma.

Media Engine This is the host processor or a DSP processor that coordinates all of the video and audio activities in a multimedia platform. The media engine is used to coordinate the audio with the video, control multiple video inputs, and control the compression and decompression hardware.

MESECAM Middle East SECAM or (B, G, D, K) SECAM. The French use (L) SECAM.

MHEG MHEG is an acronym for Multimedia Hypermedia Expert Group. MHEG standardizes a multimedia information interchange format called "Coded Representation of Multimedia and Hypermedia Information Objects" (ISO/IEC 13522).

MJPEG MJPEG is an acronym for Motion JPEG. JPEG compression or decompression is applied real-time to video at up to 25 or 30 frames per second. Each frame of video is processed individually.

(M) NTSC Never Twice the Same Color, Never The Same Color, or National Television Standards Committee, depending on who you're talking to. To make it simple, (M) NTSC is the video standard used in North America and some other parts of world to get video into your home and to record onto video tape.

One of the requirements for the color television broadcast standard that the NTSC (National Television Standards Committee) created in the 1950s was that it had to be capable of being received on a black-and-white set. When it came down to selecting what color space to use for this new color TV standard, RGB couldn't be used since all three colors, or planes, are independent. This means that each plane—red, green, or blue—has the same chance, or probability, of representing the picture as any other, so all three are needed. How could a black-and-white set, that receives only one plane, receive three? The answer was, it couldn't.

The NTSC decided to make a new color space based on a black-and-white component and two color difference signals. Since, in the RGB space, each color has as good a chance of representing the image as any other color (equal bandwidth), the black-and-white component is made up of portions of all three colors. This black-and-white component often is referred to as the luma. The two color difference signals were developed by taking the red signal and subtracting the luma, and taking the blue signal and also subtracting out the luma. Thus, the color space for NTSC is a luma component (Y) with red minus luma (R'−Y) and blue minus luma (B'−Y).

After a little bit of mathematics, the R'−Y component turns into an I component and the B'−Y component turns into a Q component. I and Q are modulated and added together to create the chroma, which contains all of the color information for the picture. The color information then is added to the black-and-white information. Therefore, the (M) NTSC system is just like a black-and-white sketch with a water color wash painted over it for color.

The (M) NTSC system uses 525 lines per frame, a 29.97 frame per second update rate, and the YIQ color space. Modern (M) NTSC encoders and decoders also may use the YUV color space for processing.

Modulator

A modulator is basically a circuit that combines two different signals in such a way that they can be pulled apart later. What does this have to do with video? Let's take the (M) NTSC system as an example, although the example applies equally as well to (B, D, G, H, I) PAL. The (M) NTSC system uses the YIQ color space, with the I and Q signals containing all of the color information for the picture. Two 3.58-MHz color subcarriers (90° out of phase) are modulated by the I and Q components and added together to create the chroma part of the (M) NTSC video.

Moiré

This is a type of image artifact. A moiré effect occurs when a pattern is created on the screen where there really shouldn't be one. A moiré pattern typically is generated when two different frequencies beat together to create a new, unwanted frequency.

Monochrome

A monochrome signal is a video source having only one component. Although usually meant to be the luma (or black-and-white) video signal, the red video signal coming into the back of a computer display is monochrome because it has only one component.

Monotonic

This is a term that is used to describe ADCs and DACs. An ADC or DAC is said to be monotonic if for every increase in input signal, the output increases also. The output should not decrease. Any ADC or DAC that is nonmonotonic—meaning that the output does decrease for an increase in input—is bad! Nobody wants a nonmonotonic ADC or DAC.

Motion Estimation

Motion estimation is trying to figure out where an object has moved to from one video frame to the other. Why would you want to do that? Well, let's take an example of a video source showing a ball flying through the air. The background is a solid color that is different from the color of the ball. In one video frame the ball is at one location and in the next video frame the ball has moved up and to the right by some amount. Now let's assume that the video camera has just sent the first video frame of the series. Now, instead of sending the second frame, wouldn't it be more efficient to send only the position of the ball? Nothing else moves, so only two little numbers would have to be sent instead of 900 kbytes (the amount of storage required for a whole frame of video). This is the essence of motion estimation. By the way, motion estimation is an integral part of MPEG, H.261, and H.263.

Motion JPEG

See MJPEG.

MPEG

MPEG stands for Moving Picture Experts Group. This is an ISO (International Standards Organization) body that is developing compression algorithms for motion video. MPEG differs from JPEG in that MPEG takes advantage of the redundancy on a frame-to-frame basis of a motion video sequence, where JPEG does not.

MPEG 2	MPEG 2 extends the MPEG 1 standard to cover a wider range of applications.
MPEG 3	MPEG 3 was originally targeted for HDTV applications. This has now been incorporated into MPEG 2.
MPEG 4	The goal is to establish a universal, efficient coding of different forms of audiovisual data, called audiovisual objects. A set of coding tools for audiovisual objects will be developed to support various functionalities, such as object-based interactivity and scalability. A syntactic description of audiovisual objects will also be developed, allowing a way of describing the coded representation of the objects and how they were coded. This information can be conveyed to a decoder, enabling new algorithms to be downloaded for execution. It is expected in late 1998.
Multimedia	Multimedia describes a system that uses combinations of text, graphics, still pictures, video, and audio in an interactive way to provide information. With this definition, a video game is not multimedia because it does not provide information, even though it is highly interactive. Video editing, even though it is interactive and deals with audio and video, is not multimedia because video editing is creating information, not supplying it. A good example of multimedia is an electronic encyclopedia. A student sits down at a computer, browses through a list of entries, and selects the one that is needed. A text passage is displayed on the screen along with a picture (the picture could be graphic based or a still or moving image). After reading for a while, the student clicks on the headphone icon to listen to an audio segment, which may contain a speech delivered by the person who is being researched. A click on a different icon produces a video clip showing this political leader in action at the last rally. All of the aspects described in the example are required for true multimedia. Accept no substitutes.
Noise	Any random fleck that shows up in the display. The noise may also be referred to as snow, flecks, blips, hash.
Noninterlaced	This is a method of scanning out a video display that is the total opposite of interlaced. All of the lines in the frame are scanned out sequentially, one right after the other. The term field does not apply in a noninterlaced system. Another term for a noninterlaced system is progressive scan.
NTSC	See (M) NTSC.
OIRT	Organisation Internationale de Radiodiffision-Télévision.
PAL	See (B, D, G, H, I) PAL.
PALplus	PALplus is 16:9 aspect ratio version of PAL, and is compatible with standard (B, D, G, H, I) PAL. Normal PAL video signals have 576 active scan lines. If a film is broadcast, usually 432 or fewer active scan lines are used. PALplus uses these

unused "black" scan lines for additional picture information. The PALplus decoder mixes it with the visible picture, resulting in a 16:9 picture with the full PAL resolution of 576 active scan lines. Widescreen TVs without the PALplus decoder, and standard PAL TVs, show a standard picture with about 430 active scan lines.

PALplus is compatible with standard studio equipment. The number of pixels of a PALplus picture is the same as in standard PAL, only the aspect ratio is different.

Pedestal

Pedestal is an offset used to separate the active video from the blanking level. When a video system uses a pedestal, the black level is above the blanking level by a small amount. When a video system doesn't use a pedestal, the black and blanking levels are the same. (M) NTSC uses a pedestal, (B, D, G, H, I) PAL and SECAM do not.

Phase Adjust

This is a term used to describe a method of adjusting the color in a (M) NTSC video signal. The phase of the color subcarrier is moved, or adjusted, relative to the color burst. This adjustment affects the hue of the picture.

Phase Comparator

This is a circuit used in a PLL to tell how well two signals line up with each other. For example, say we have two signals, A and B, with signal A connected to the positive (+) input of the phase comparator and signal B connected to the minus (−) input. If both signals are exactly the same, the output of the phase comparator is 0; they are perfectly aligned. Now, if signal A is just a little bit faster than signal B, then the output of the phase comparator is a 1, showing that A is faster than B. If signal A is slower than B, then the output of the phase comparator is a −1, designating that B is faster. Read the Phase-Locked Loop definition to see how a phase comparator is used in a circuit.

Phase-Locked Loop

A phase-locked loop (PLL) is the heart of any genlocked system. Very simply, a PLL is a means of providing a very stable pixel clock that is based or referenced to some other signal. Let's say that we want to design a video system with a horizontal resolution of 100 pixels. Assume that, in order to get the 100 pixels across the display, if the horizontal sync rate were perfect, we would need a pixel clock of 5 MHz. If we didn't have a PLL and the horizontal rate were to shrink a little (the horizontal width gets smaller), we would get less than 100 pixels because we didn't adjust the pixel clock. Or, conversely, if the horizontal rate were to become a little longer (the image widens just a little), we would get more than 100 pixels. This is definitely bad news, because the time between horizontal syncs usually does vary just a tiny little bit, small enough that you may not notice it on your TV, but a computer would notice. So, from line to line, the number of pixels would change. A PLL guarantees that the same number of pixels appears on every line by changing the pixel clock frequency to match the horizontal sync rate.

First, a voltage controlled oscillator (VCO) or voltage controlled crystal oscillator (VCXO) is used and the free-running frequency is set to the pixel clock rate needed if the horizontal rate was always to be perfect. The output of the VCO or VCXO is then used as the system pixel clock. This pixel clock is also used as the

input to a circuit that takes the pixel clock frequency and divides it down to the horizontal sync frequency. So, at this point, we have a new signal whose frequency is the same as the frequency of horizontal sync. This newly generated signal, along with horizontal sync, are inputs to a phase comparator. The output of the phase comparator tells how well the output of the clock divider lines up with the incoming horizontal sync. The output of the phase comparator is fed to a loop filter to remove tiny little bumps that might throw the system out of whack. The output of the loop filter then becomes the control voltage for the VCO or VCXO.

With this arrangement, if the incoming horizontal rate is just a little too fast, the phase comparator generates a signal that is then filtered and tells the VCO/VCXO to speed up a little bit. The VCO/VCXO does, which then speeds up the pixel clock just enough to ensure that the horizontal resolution is 100 pixels. This pixel clock is divided down to the horizontal sync rate and is then phase compared again.

Pixel

A pixel, which is short for picture element, is the smallest division that makes up the raster scan line for computers. For example, when the horizontal resolution is defined as 640, that means that there are 640 individual locations, or spots, that make up the horizontal scan line. A pixel is also referred to as a pel. A "square" pixel is one that has an aspect ratio of 1:1, or the width is equal to the height. Square pixels are needed in computers so that when the software draws a square in the frame buffer, it looks like a square on the screen. If the pixels weren't square, the box would look like a rectangle. NTSC, PAL, and SECAM television systems use rectangular pixels.

Pixel Clock

The pixel clock is used to divide the incoming horizontal line of video into pixels. This pixel clock has to be stable (a very small amount of jitter) relative to the incoming video or the picture will not be stored correctly. The higher the frequency of the pixel clock, the more pixels that will appear across the screen.

Pixel Drop Out

This can be a real troublemaker, since it can cause image artifacts. In some instances, a pixel drop out looks like black spots on the screen, either stationary or moving around. Several things can cause pixel drop out, such as the ADC not digitizing the video correctly. Also, the timing between the ADC and the frame buffer might not be correct, causing the wrong number to be stored in the buffer. For that matter, the timing anywhere in the video stream might cause a pixel drop out.

PLL

See Phase-Locked Loop.

Primary Colors

A set of colors that can be combined to produce any desired set of intermediate colors, within a limitation call the "gamut." The primary colors for color television are red, green, and blue.

Pseudo Color

Pseudo color is a term used to describe a technique that applies color, or shows color, where it does not really exist. We are all familiar with the satellite photos that show temperature differences across a continent or the multicolored cloud motion

sequences on the nightly weather report. These are real-world examples of pseudo color. The color does not really exist. The computer uses a lookup table RAM to add the color so information, such as temperature or cloud height, is viewable.

Px64 This is basically the same as H.261.

QCIF Quarter Common Interface Format. This video format was developed to allow the implementation of cheaper video phones. The QCIF format has a resolution of 176 × 144 active pixels and a refresh rate of 29.97 frames per second.

QSIF The computer industry, which uses square pixels, has defined QSIF to be 160 x 120 (NTSC) or 192 x 144 (PAL) active pixels, with a refresh rate of whatever the computer is capable of supporting.

Quad Chroma Quad chroma refers to a technique where the pixel clock is four times the frequency of the chroma burst. For (M) NTSC this means that the pixel clock is 14.31818 MHz (4 × 3.57955 MHz), while for (B, D, G, H, I) PAL the pixel clock is 17.73444 MHz (4 × 4.43361 MHz). The reason these are popular pixel clock frequencies is that, depending on the method chosen, they make the chroma (color) decoding easier.

Quadrature Modulation The modulation of two carrier components, which are 90° apart in phase, by separate modulating functions.

Quantization The process of converting a continuous analog signal into a set of discrete levels (digitizing).

Quantizing Noise Also called quantization distortion. This is the inherent uncertainty introduced during quantization since only discrete, rather than continuous, levels are generated.

Raster Essentially, a raster is the series of scan lines that make up a TV picture or a computer's display. You may from time to time hear the term raster line—it's the same as scan line. All of the scan lines that make up a frame of video form a raster.

RC Time Code Rewritable time code, used in consumer video products.

Real Time If a system incorporating a computer operates fast enough that it seems like there isn't a computer in the loop, then that computer system is operating in real time. How fast "real time" really is changes depending on who or what is using the system. For example, a fighter pilot flying the latest computer-controlled jet moves the stick to perform a roll maneuver. The stick then tells a computer its position, the computer makes some decisions, and then it tells the flaps and rudder what adjustments to make to perform the move. Since all of this happens fast enough so that

the pilot thinks the stick is connected directly to the flaps and rudder, the plane is a real-time system.

What's the definition of real time for video? Well, for NTSC it's about 30 frames per second, with each frame made up of 525 individual scan lines. That's roughly equivalent to 30 Mbytes of data per second that must be processed.

Residual Subcarrier

This is the amount of color subcarrier information in the color data after decoding a composite color video signal. The number usually appears as $-n$ dB. The larger "n" is, the better.

Resistor Ladder

A resistor ladder is a string of resistors used for defining voltage references. In the case of 8-bit flash ADCs, the resistor ladder is made up of 256 individual resistors, each having the same resistance. If a voltage representing the number 1 is attached to one end of the ladder and the other end is attached to 0, each junction between resistors is different from the other by 1/256. So, if we start at the top of the ladder, the value is 1. If we move down one rung, the value is 0.99609, the next rung's value is 0.99219, the next rung's is 0.98828 and so on down the ladder until we reach 0 (the other end of the ladder). A resistor ladder is an important part of a flash ADC because each rung of the ladder, or tap, is connected to one side of a comparator, in effect providing 256 references. The definition of flash ADCs helps out here.

Resolution

This is a basic measurement of how much information is on the screen. It is usually described as "some number" by "some number." The first "some number" is the horizontal (across the screen) resolution and the second "some number" is the vertical resolution (down the screen). The higher the number, the better, since that means there's more detail to see. Some typical examples:

NTSC VHS:	240×485
NTSC broadcast:	330×485
NTSC laserdisc:	400×485
ITU-R BT.601 (525/60):	720×485
Computer screen:	1280×1024

Retrace

Retrace is what the electron beam does when it gets to the right-hand edge of the display to get back to the left-hand edge. Retrace happens during the blanking time.

RGB

Abbreviation for red, green, blue.

RS-170, SMPTE 170M

RS-170 is the United States standard that was used for black-and-white TV, and defines voltage levels, blanking times, the width of the sync pulses, and so forth. The specification spells out everything required for a receiver to display a monochrome picture. The output of those little black-and-white security cameras hanging from ceilings conforms to the RS-170 specification. Now, SMPTE 170 Mis essentially the same specification, modified for color TV by adding the color com-

ponents. When the NTSC decided on the color broadcast standard, they modified RS-170 just a tiny little bit so that color could be added, with the result being called SMPTE 170M. This tiny little change was so small that the existing black-and-white TVs didn't even notice it.

RS-343

RS-343 does the same thing as RS-170, defining a specification for video, but the difference is that RS-343 is for higher-resolution video (computers) while RS-170 is for lower-resolution video (TV).

Run Length Coding

Run length coding is a type of data compression. Let's say that this page is wide enough to hold a line of 80 characters. Now, imagine a line that is almost blank except for a few words. It's 80 characters long, but it's just about all blanks—let's say 50 blanks between the words "coding" and "medium." These 50 blanks could be stored as 50 individual codes, but that would take up 50 bytes of storage. An alternative would be to define a special code that said a string of blanks is coming and the next number is the amount of blanks in the string. So, using our example, we would need only 2 bytes to store the string of 50 blanks, the first special code byte followed by the number 50. We compressed the data; 50 bytes down to 2. This is a compression ration of 25:1. Not bad, except that we only compressed one line out of this entire document, so we should expect that the total compression ratio would be much less.

Run length coding all by itself as applied to images is not as efficient as using a DCT for compression, since long runs of the same "number" or series rarely exist in real-world images. The only advantage of run length coding over the DCT is that it is easier to implement. Even though run length coding by itself is not efficient for compressing images, it is used as part of the JPEG, MPEG, H.261, and H.263 compression schemes.

R´–Y

In color television, the red-minus-luma signal, also called a color difference signal. When added to the luma (Y) signal, it produces the red primary signal.

SABC

South Africa Broadcasting Corporation.

S-VHS, SVHS

S-VHS is an enhancement to regular VHS video tape decks. S-VHS provides better resolution and less noise than VHS. S-VHS video tape decks support separate luma (Y) and chroma (C) video inputs and outputs, although this is not required. It does, however, improve the quality by not having to continuously merge and then separate the luma and chroma signals.

S-Video

Separate Video, also called Y/C video.

Sample

To obtain values of a signal at periodic intervals. Also the value of a signal at a given moment in time.

Sample and Hold	A circuit that samples a signal and holds the value until the next sample is taken.
Sample Rate	Sample rate is how often the ADC will take a sample of the video. The sample rate is determined by the pixel clock.
SAP	Abbreviation for secondary audio program. Generally used to transmit audio in a second language.
Saturation	Saturation is the amount of color present. For example, a lightly saturated red looks pink, while a fully saturated red looks like the color of a red crayon. Saturation does not mean the brightness of the color, just how much "pigment" is used to make the color. The less "pigment," the less saturated the color is, effectively adding white to the pure color.
Scaling	Scaling is the act of changing the effective resolution of the image. For example, let's take a TV size resolution of 640 × 480 and display that image as a smaller picture on the same screen, so that multiple pictures can be shown simultaneously. We could scale the original image down to a resolution of 320 × 240, which is 1/4 of the original size. Now, four pictures can be shown at the same time. That was an example of "scaling down." Scaling up is what occurs when a snapshot is enlarged into an 8" × 10" glossy. There are many different methods for image scaling, and some "look" better than others. In general, though, the better the algorithm "looks," the harder or more expensive it is to implement.
Scan Line	A scan line is an individual sweep across the face of the display by the electron beam that makes the picture. An example of a scan line is what happens in a copier. When you press the copy button, a mirror "scans" the document by moving across the length of the page. Same concept with television—an electron beam "scans" the screen to produce the image on the display. It takes 525 of these scan lines to make up a NTSC TV picture.
SCART	This is a 21-pin connector supported by many consumer audio/video components in Europe. It allows mono or stereo audio, composite video, S-video, and RGB video to be transmitted between equipment.
SECAM	This is another TV format similar to PAL. The major differences between the two are that in SECAM the chroma is FM modulated and the R′–Y and B′–Y signals are transmitted line sequentially. SECAM stands for Sequentiel Couleur Avec Mémoire or Sequential Color with Memory.
Secondary Audio Program	See SAP.

Serration Pulses
These are pulses that occur during the vertical sync interval, at twice the normal horizontal scan rate. The reason these exist was to ensure correct 2:1 interlacing in early televisions.

Setup
Setup is the same thing as Pedestal.

SIF
Standard (or Source) Input Format. This video format was developed to allow the storage and transmission of digital video. The 625/50 SIF format has a resolution of 352 × 288 active pixels and a refresh rate of 25 frames per second. The 525/59.94 SIF format has a resolution of 352 × 240 active pixels and a refresh rate of 29.97 frames per second. Note that MPEG 1 allows resolutions up to 4095 × 4095 active pixels. However, there is a "constrained subset" of parameters defined as SIF.

The computer industry, which uses square pixels, has defined SIF to be 320 × 240 (NTSC) or 384 × 288 (PAL) active pixels, with a refresh rate of whatever the computer is capable of supporting.

Signal-to-Noise Ratio (SNR)
Signal-to-noise ratio is the magnitude of the signal divided by the amount of unwanted stuff that is interfering with the signal (the noise). SNR usually is described in decibels, or "dB," for short; the bigger the number, the better looking the picture.

Silent Radio
Silent Radio is a service that feeds data that often is seen in hotels and bars. It's usually a large red sign that shows current news, events, scores, etc. It is present on (M) NTSC lines 10, 11, 273, and 274, and uses encoding similar to EIA-608.

Split Sync Scrambling
Split sync is a video scrambling technique, usually used with either horizontal blanking inversion, active video inversion, or both. In split sync, the horizontal sync pulse is "split," with the second half of the pulse at +100 IRE instead of the standard –40 IRE. Depending on the scrambling mode, either the entire horizontal blanking interval is inverted about the +30 IRE axis, the active video (after color burst and until the beginning of front porch blanking) is inverted about the +30 IRE axis, both are inverted, or neither is inverted. By splitting the horizontal sync pulse, a reference of both –40 IRE and +100 IRE is available to the descrambler.

Since a portion of the horizontal sync is still at –40 IRE, some sync separators may still lock on the shortened horizontal sync pulses. However, the timing circuits that look for color burst a fixed interval after the beginning of horizontal sync may be confused. In addition, if the active video is inverted, some video information may fall below 0 IRE, possibly confusing sync detector circuits.

The burst is always present at the correct frequency and timing. However, the phase is shifted 180 degrees when the horizontal blanking interval is inverted.

Starsight
A national electronic "TV guide look-alike" subscription service. It allows you to sort the guide by your order of preference and delete stations you never watch. Although it's a national service, it is regionalized. The decoders in Houston only download data for Houston—move to Dallas and you only get Dallas. It is present on (M) NTSC lines 14 and 277 and uses encoding similar to EIA-608.

Subcarrier	A secondary signal containing additional information that is added to a main signal.
Subsampled	Subsampled means that a signal has been sampled at a lower rate than some other signal in the system. A prime example of this is the YCbCr color space used in ITU-R BT.601. For every two luma (Y) samples, only one Cb and Cr sample is taken. This means that the Cb and Cr signals are subsampled.
Sync	Sync is a fundamental, you gotta have it, piece of information for displaying any type of video. This goes for TVs, workstations, or PCs. Essentially, the sync signal tells the display where to put the picture. The horizontal sync, or HSYNC for short, tells the display where to put the picture in the left-to-right dimension, while the vertical sync (VSYNC) tells the display where to put the picture from top-to-bottom.
Sync Generator	A sync generator is a circuit that provides sync signals. A sync generator may have genlock capability, or it may not.
Sync Noise Gate	A sync noise gate is used to define an area within the video waveform where the sync stripper is to look for the sync pulse. Anything outside of this defined window will be rejected by the sync noise gate and won't be passed on to the sync stripper. The main purpose of the sync noise gate is to make sure that the output of the sync stripper is nice, clean, and correct.
Sync Stripper	A composite video signal contains video information, which is the picture to be displayed, and timing (sync) information that tells the receiver where to put this video information on the display. A sync stripper pulls out the sync information from the composite video signal and throws the rest away.
Synchronous	Refers to two or more events that happen in a system or circuit at the same time.
TDF	Télédiffusion de France.
Tessellated Sync	This is what the Europeans call serrated sync. See the definitions of Serration Pulses and Composite Sync.
Timebase Corrector	Certain video sources have their sync signals screwed up. The most common of these sources is the VCR. A timebase corrector "heals" a video signal that has bad sync. (I guess you could call a timebase corrector a "sync doctor.") This term is included because more and more companies making video capture cards are providing this function.
True Color	True color means that each pixel in an image is individually represented using three color components, such as RGB or YCbCr. In addition, the color components of each pixel may be independently modified.

Underscan

Most televisions use overscanning, resulting in some of the video being lost beyond the edges of the screen. Underscanning modifies the video timing so that the entire video signal appears in a rectangle centered on the television screen with a black border. The resolutions for square-pixel underscan and overscan images are:

NTSC overscan:	640×480
NTSC underscan:	512×384
PAL overscan:	768×576
PAL underscan:	640×480

Uplink

The carrier used by Earth stations to transmit information to a satellite.

VBI

See Vertical Blanking Interval.

Vectorscope

A vectorscope is used to determine the color purity of a (M) NTSC or (B, D, G, H, I) PAL video system. If you've read the YIQ or YUV definitions, then you know that the I and Q (or U and V) components are the axis of a Cartesian coordinate system. The vectorscope is essentially a Cartesian coordinate display scope. The vectorscope looks at the I and Q signals and puts a point of light where the two signals say the color is. On a vectorscope, six little boxes correspond to the six colors in the standard color bar pattern: yellow, cyan, magenta, green, red, and blue. If the input to the video system is a color bar pattern from a test generator and the output is displayed on a vectorscope, then the accuracy of the color system can be checked. Each point of light that represents the corresponding color should be within the little box—certainly, the closer the better. If the spot makes it within the little box, that represents an error of less than ±2°. That means you can't notice the error with your eyeball.

Vertical Blanking Interval

During the vertical blanking interval, the video signal is at the blank level so as not to display the electron beam when it sweeps back from the bottom to the top side of the screen.

Vertical Scan Rate

For noninterlaced video, this is the same as the Frame Rate. For interlaced video, this is usually considered to be twice the Frame Rate.

Vertical Interval Timecode

See VITC.

Vertical Sync

This is the portion of the composite video signal that tells the receiver where the top of the picture is.

Video Carrier

A specific frequency that is modulated with video data before being mixed with the audio data and transmitted.

Video CD

Standard compact discs that hold approximately an hour of digital audio and video information. The audio and video are compressed and stored using MPEG 1.

Video Mixing	Video mixing is taking two independent video sources and merging them together.
Video Modulation	Converting a baseband video signal to an RF signal.
Video Module Interface	A standard video interface to simplify interfacing video ICs together. It is based on the Philips SAA7111 output interface and timing.
Video Program System	See VPS.
Video Quality	Video quality is a phrase that means "how good does the picture look?" A video image that has a high signal-to-noise ratio and is free of any image artifacts has high image quality. The typical VCR has marginal image quality.
Video Waveform	The video waveform is what the signal "looks" like to the receiver or TV. The video waveform is made up of several parts (sync, blanking, video, etc.) that are all required to make up a TV picture that can be displayed accurately.
VITC	Vertical Interval Time Code. Timecode information stored on specific scan lines during the vertical blanking interval.
VMI	See Video Module Interface.
Voltage Controlled Crystal Oscillator (VCXO)	A VCXO is just like a voltage-controlled oscillator except that a VCXO uses a crystal to set the free-running frequency. This means that a VCXO is more stable than a VCO but it's also more expensive to implement.
Voltage Controlled Oscillator (VCO)	A VCO is a special type of oscillator that changes its frequency depending on a control signal, usually a voltage. A VCO has what's called a free-running frequency which is the frequency that the oscillator runs at when the control voltage is at midrange, normal operating condition. If the control voltage rises above midrange, the VCO increases the frequency of the output clock, and if the control voltage falls below midrange, then the VCO lowers the frequency of the output clock. See the definition of a Phase-Locked Loop.
VPS	Video Program System used in Germany. Information is included in the video signal to automatically control VCRs.
White Level	This level defines what white is for the particular video system.
WSS	Wide Screen Signalling. It is used on (B, D, G, H, I) PAL scan line 23 to specify several new PAL video signal formats. WSS can tell the TV if PALplus processing is to be done, whether the signal is "Film Mode" or "Camera Mode," whether PAL clean encoding was performed, the aspect ratio, type of subtitles, and so on.

Y/C Video The Y/C designation is shorthand for luma (Y) and chroma (C). You will also see this term used in the description of the S-VHS video tape format.

Y/C Separator A Y/C separator is used in a decoder to pull the luma and chroma apart in an (M) NTSC or (B, D, G, H, I) PAL system. This is the first thing that any NTSC or PAL receiver must do. The composite video signal is first fed to the Y/C separator so that the chroma can then be decoded further.

YCbCr YCbCr is the color space defined by Recommendation ITU-R BT.601. Y is the luma component and the Cb and Cr components are color difference signals. Cb and Cr are scaled versions of U and V in the YUV color space.

4:2:2 YCbCr means that Y has been sampled at 13.5 MHz, while Cb and Cr were each sampled at 6.75 MHz. Thus, for every two samples of Y, there is one sample each of Cb and Cr. 4:1:1 YCbCr means that Y has been sampled at 13.5 MHz, while Cb and Cr were each sampled at 3.375 MHz. Thus, for every four samples of Y, there is one sample each of Cb and Cr. 2:1:1 YCbCr means that Y has been sampled at 6.75 MHz, while Cb and Cr were each sampled at 3.375 MHz. Thus, for every two samples of Y, there is one sample each of Cb and Cr. Many people use the YCbCr notation, rather than Y'CbCr or Y'Cb'Cr'. The technically correct notation is Y'Cb'Cr' since all three components are derived from R'G'B'.

YIQ YIQ is the color space used in the (M) NTSC color system. The Y component is the black-and-white portion of the image. The I and Q parts are the color difference components; these are effectively nothing more than a "watercolor wash" placed over the black-and-white, or luma, component. Many people use the YIQ notation, rather than Y'IQ or Y'I'Q'. The technically correct notation is Y'I'Q' since all three components are derived from R'G'B'.

YUV YUV is the color space used by the (B, D, G, H, I) PAL color system (it may also be used in the NTSC system). As with the YIQ color space, the Y is the luma component while the U and V are the color difference components. Many people use the YUV notation when they actually mean YCbCr data. Also, many people use the YUV notation, rather than Y'UV or Y'U'V'. The technically correct notation is Y'U'V' since all three components are derived from R'G'B'.

YUV9 Intel's compressed YUV format, providing a compression ratio of up to 3:1.

Zeroing Zeroing is what's done to the bank of comparators in a CMOS flash ADC to keep them accurate. Without zeroing, the comparators build up enough of an error that the output of the flash ADC would not be correct any more. To solve the problem, the comparators are "zeroed," or the accumulated error is removed.

Zipper See the definition for Creepy-Crawlies.

Zoom Zoom is a type of image scaling. Zooming is making the picture larger so that you can see more detail. The examples described in the definition of scaling are also examples that could be used here.

Index